TONY DUQUETTE

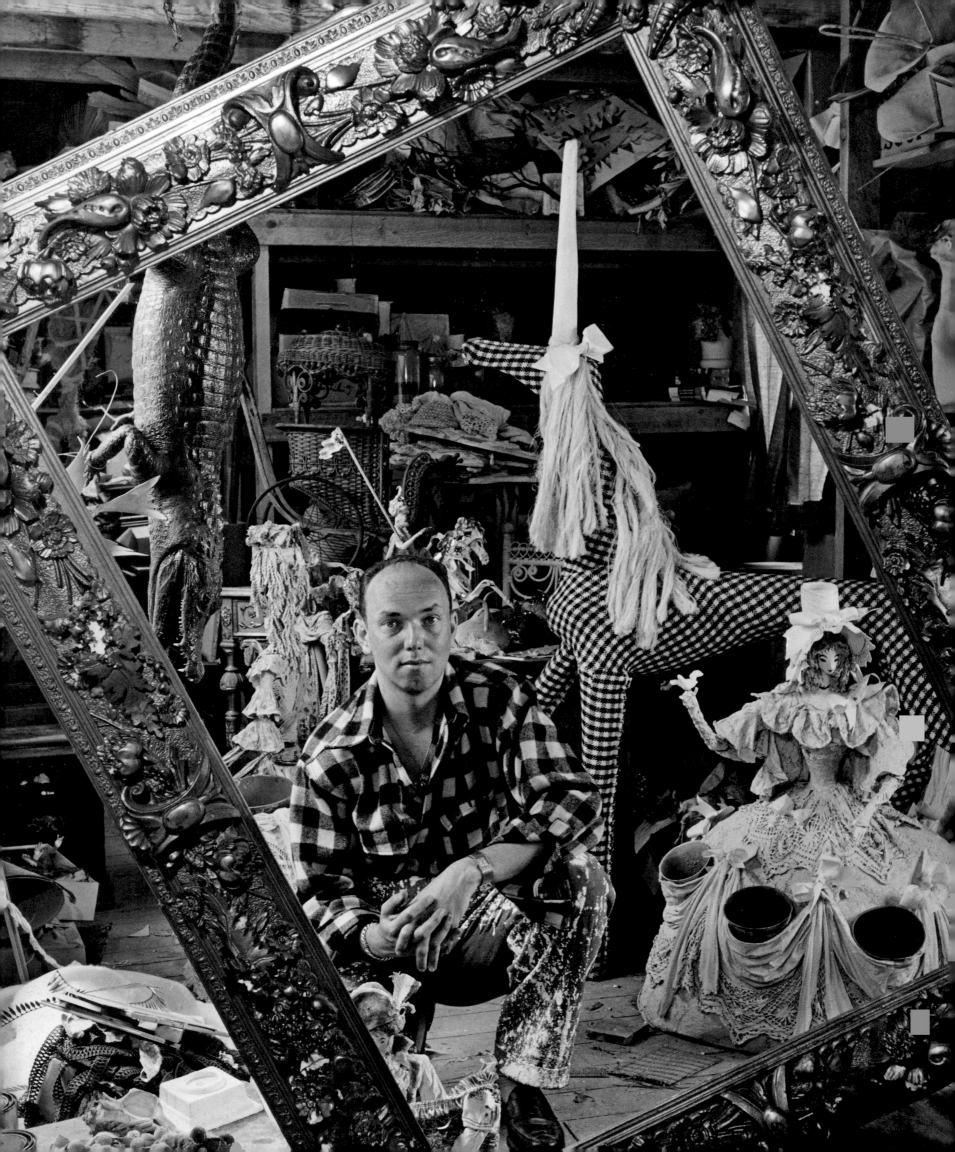

TONY DUQUETTE

BY WENDY GOODMAN AND HUTTON WILKINSON

FOREWORD BY DOMINICK DUNNE

ABRAMS, NEW YORK

CONTENTS

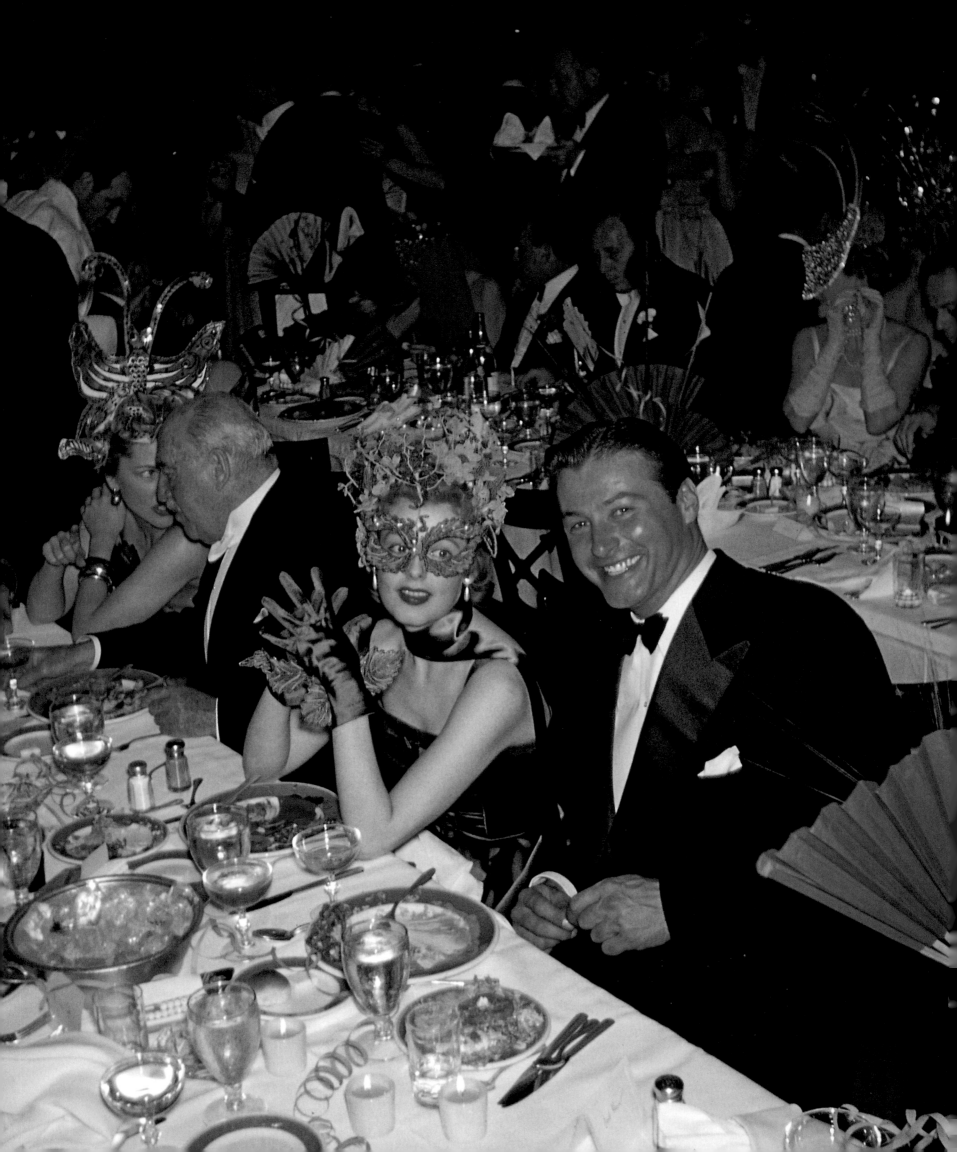

FOREWORD

DOMINICK DUNNE

TONY DUQUETTE WAS ONE OF THE FIRST PEOPLE I met when I moved to Los Angeles in 1957. A friend of mine, Marguerite Littman, was living as a paying guest in Tony and his wife, Beegle's, astonishing West Hollywood studio, which had once been the private soundstage of silent film star Norma Talmadge. Marguerite is a Louisiana lady of great style and wit who is now a leading London hostess; at the time she was between marriages and taught movie stars how to speak with a Southern accent, such as Elizabeth Taylor when she made 1957's *Raintree County*.

The only thing I knew about Tony then was that he had designed the tiny birdcages that Norma Shearer wore in her wigs in MGM's great *Marie Antoinette*. But Tony came with great word-of-mouth references. *Marie Antoinette*'s gown designer, Adrian, was one of the first to spot Tony's special genius, and Adrian did the costumes for all the great MGM stars of the era, including Greta Garbo, Joan Crawford, and Jean Harlow. The famous Lady Mendl, who lived out World War II in Beverly Hills, was another discerning eye who spotted Tony's talent early on and became his great friend.

Tony and Beegle took me up and started inviting me to their extraordinary parties, which were total fantasies. Every inch of that studio became a dream. I remember great golden Buddhas, shiny dark-green walls, and Venetian mirrors. He sometimes dressed like a doge in the most elaborate robes, which he knew exactly how to wear.

At the far end of the studio was a stage with a velvet curtain and footlights. When ancient trumpets announced dinner, the velvet curtains parted and the stage became the dining room. We sat behind footlights at tables filled with beautiful objects. The guests became actors in Tony's fantasy. I loved being in his play; it was a very special experience.

The years passed and houses changed. There were fires. Beegle died. But the last time I saw him, in a different house in Beverly Hills, I experienced his magic all over again, just as I had the first time, twenty-five years earlier. He always made me gasp.

OPPOSITE Arlene Dahl, wearing her specially designed Tony Duquette mask and headdress, and Lex Barker at the Ball Masque, 1950.

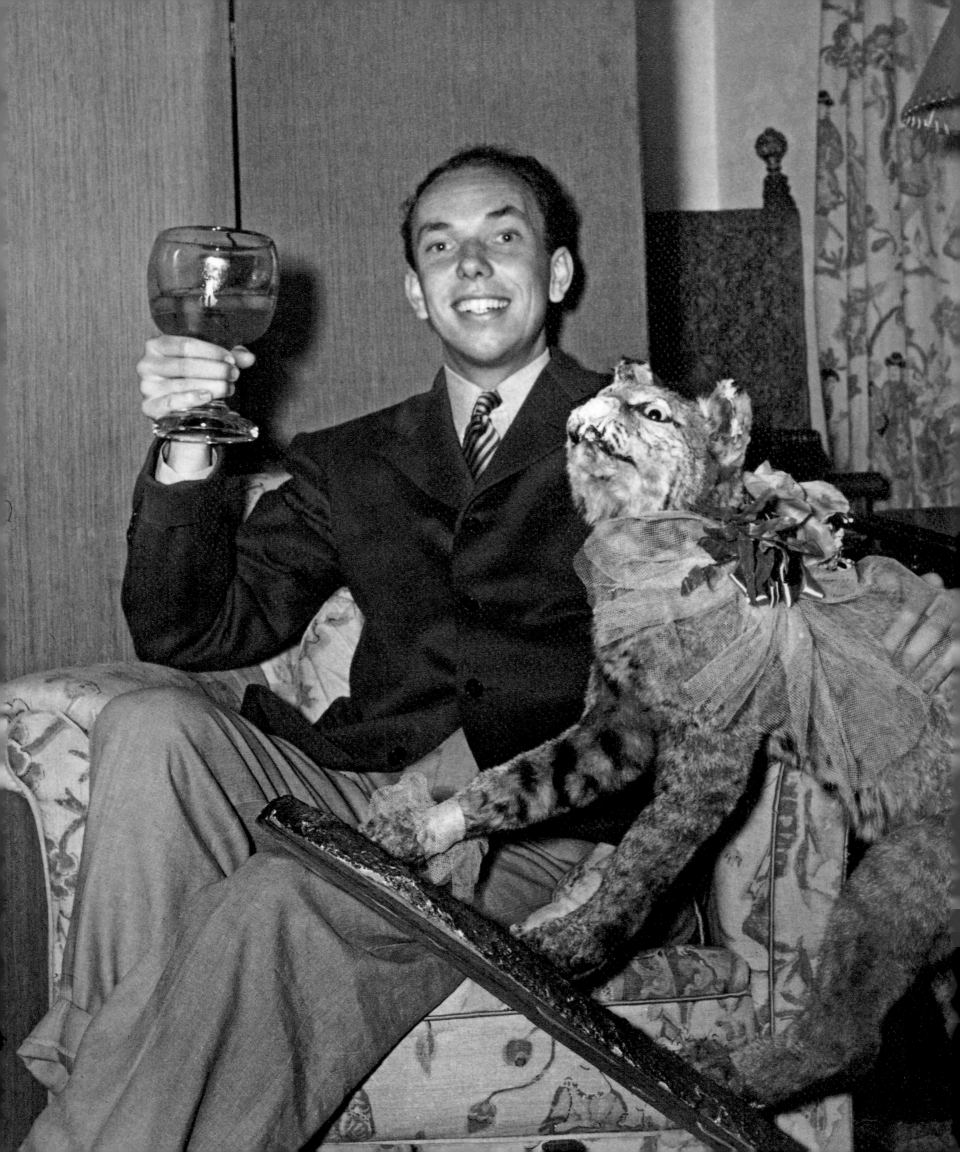

PREFACE

WENDY GOODMAN

EVERYTHING FUELED TONY DUQUETTE'S omnivorous creativity. He plucked his ideas like wildflowers from a Marrakech souk or a Los Angeles 99-cent store, from grand Hollywood Regency style or a studio's back-lot castoffs, and he arranged it all in otherworldly bouquets previously seen only in his own vivid imagination. His refrain, "Beauty, not luxury, is what I value," forged a singular streak of fabulous décor, costumes, jewelry, and interiors.

Yet I had never even heard of Tony until one of his creations practically slapped me in the face in 1990. *House & Garden* had sent me out to Los Angeles to meet up with its West Coast editor, Joyce Macrae, to do a story on guest rooms. And while standing in Hutton and Ruth Wilkinson's plush, fabric-tented visitor's lair, I turned around and spied the most unusual piece of furniture I had ever seen.

It was a mammoth black-and-green-painted secretary with large inlaid glass jewels, and looked like something from the Palace of Versailles had just returned from a year abroad in Jaipur. And I knew instantly that this bewitching article had changed my life.

"Who did this?" I asked, transfixed. Hutton answered as if stating the obvious, "Don't you know Tony Duquette?" I didn't, but made it my business to meet him on that trip.

OPPOSITE Portrait of Tony Duquette with stuffed bobcat, c. 1935. Hollywood's wild child of design, Duquette reveled in annoying his square friends, going to parties with his oversize, mangy, fleabitten stuffed cat, which was part of his "collection of horrors."

Entering Sortilegium, Tony's 150-acre ranch, was like visiting another planet. Here, one structure after another was a unique architectural hybrid, combining Georgian, Regency, and Oriental styles into a fantasyland in the Malibu mountains. And every inch of this conjured realm reflected Tony's eclectic élan: a lemon juicer lent a distinctive silhouette as a finial topping a pagoda; antlers were transformed into functional chandeliers or decoratively adorned a free-standing gazebo; surplus navy metal held aloft metal angel sculptures. Such odd bits and pieces of recycled machinery, morphed into parts of strange pavilions that looked as if they might house rare species of night-blooming flowers, defining a whole new vocabulary of decorative arts. Everywhere I looked some beguiling new magic caught my eye. From that day on Tony Duquette and the treasury of his work would become a personal obsession.

I ended up calling *House & Garden*'s editor, Nancy Novogrod, back in New York, telling her what I had seen and that I wanted to do a story on Tony, his wife, Beegle, and their ranch. Many great photographers and writers had documented Tony's world, but that was to be my first time—one of many—and it began a deep friendship with Tony and Beegle and Hutton and Ruth.

This book started as an idea in the garden of Tony and Beegle's Beverly Hills home, Dawnridge, while listening to Tony and Hutton talk about a world that had disappeared but was still very much alive in the Duquette domain, a world where Hollywood's theatrical fantasies didn't stop on the screen or stage but extended into people's lives and homes. Hutton unearthed a rich trove of materials in the Aladdin's cave of Tony's archives. Hutton and Ruth were not only Tony and Beegle's best friends, but they had also worked and traveled with them over the last thirty years. Along with friends such as Tim Street-Porter and Annie Kelly, Hutton and Ruth kept Tony going until the end of his life, especially after he lost Beegle in 1995.

During the course of my research on this book I visited Dawnridge many times, spending nights there alone. I always hoped that Tony would visit, or at least offer a sign that he was happy with the book as it progressed.

I never felt his ghost, but did have one experience worth noting. I had just finished reading a letter of Elsie de Wolfe's describing the famous eighteenth-century Barozzi furniture collection in Venice, and how she thought it must have influenced Tony when he went there in 1947. I immediately thought I had to find a book on this collection, but imagined that would entail foraging through an esoteric design library at some point in the future.

I got up from my chair, stretched, and distractedly stood in front of Tony's vast library wall. One small book caught my eye. It was a slender, leather-bound volume without writing on the spine. I pulled it from the shelf and opened it. Tony's signature was scrawled in dark blue ink on the first page, where he had also written, "Venice, 1947." I was holding the catalogue of the Barozzi collection that Tony had picked up on the very trip Elsie described in her letter.

I stopped wondering if Tony would visit. And now I know that simply turning around at the right moment can magically open a door to a whole new world.

INTRODUCTION

HUTTON WILKINSON

WHEN I WAS IN SEVENTH GRADE I DISCOVERED Tony and Elizabeth Duquette from a magazine article published in the "Home" magazine section of the *Los Angeles Times*. I will never forget coming to the table that Sunday morning to find my father having breakfast with the newspaper spread out before him. I selected the magazine section, which he had discarded, and there was Tony, sitting on a throne from the Chapultepec Palace on the stage of his studio, surrounded by mother-of-pearl, mirrors, and crystal chandeliers. "This is what I am interested in," I proclaimed to my father, showing him the article.

"You are 100 percent crazy," he told me, and went back to the newspaper.

I clipped that article—with its pictures of Beegle posing in the dining room and Tony hanging from a Chinoiserie chandelier in the workroom—and carefully saved them and stored the information at the back of my mind. Later in art school I would play a game with my teacher. "How would you do this project if you were Tony Duquette," she would ask me—and only me, not the other students. This was a game just for her and me.

One day she put a note in my locker that said, "Tony Duquette is looking for volunteer assistants to help him on a project." I immediately quit school and my paying job and went to work for Tony as an unpaid volunteer for two years. The first project was his Personal Culture exhibition at the Los Angeles Municipal Art Gallery, for which I joined a team of other volunteers to help Tony glue, paste, paint, and create amazing sculptures and decorative fantasies.

After the opening night party I was the only volunteer who came back to help clean up the mess. That was when Tony realized that I was serious and really wanted to learn and be part of his business. I realized then that while all my friends were going to school and attending beer parties, I was actually meeting with millionaires like Norton Simon and Doris Duke and being invited as a guest to Tony and Beegle's amazing black-tie dinners and dances. Mine was a true apprenticeship in the Renaissance sense.

THE EARLY YEARS

Of his bones are coral made;
Those are pearls that were his eyes;
Nothing of him that doth fade, but
Doth suffer a sea change into something
Rich and strange.

William Shakespeare, *The Tempest*

TONY DUQUETTE NEVER GREW UP. From the beginning he enjoyed the undivided attention of a free-spirited, artistic mother who worshiped him. Tony and his mother were an inseparable team during the first four years of his life, before the arrival of his sister and brothers, allowing his eccentric, energetic personality to take root like a hothouse flower. He spent his life realizing his childhood passions.

Anthony Michael Duquette was born June 11, 1914, in Los Angeles. Elsa Fuhrer delivered him by cesarean section, and she was warned not to have any more children. She had three more babies—all by cesarean delivery, a medical record at the time.

Elsa was a concert cellist from a renowned musical family in California. She and her two sisters toured regionally, performing at clubs and concert halls. Her mother's brother (Tony's great-uncle) was the artist Peter Paul Marshall, who was connected to the Pre-Raphaelite movement through his association with William Morris. Marshall helped cofound Morris's first interior design firm—Morris, Marshall, Faulkner and Co.—in 1861. Thus the Pre-Raphaelites' romantic idealism was in Tony's blood—not surprising when you see that his monumental work was fueled with a passion for the mysteries of the natural world.

I

OPPOSITE Portrait of Tony Duquette as a toddler, 1917.

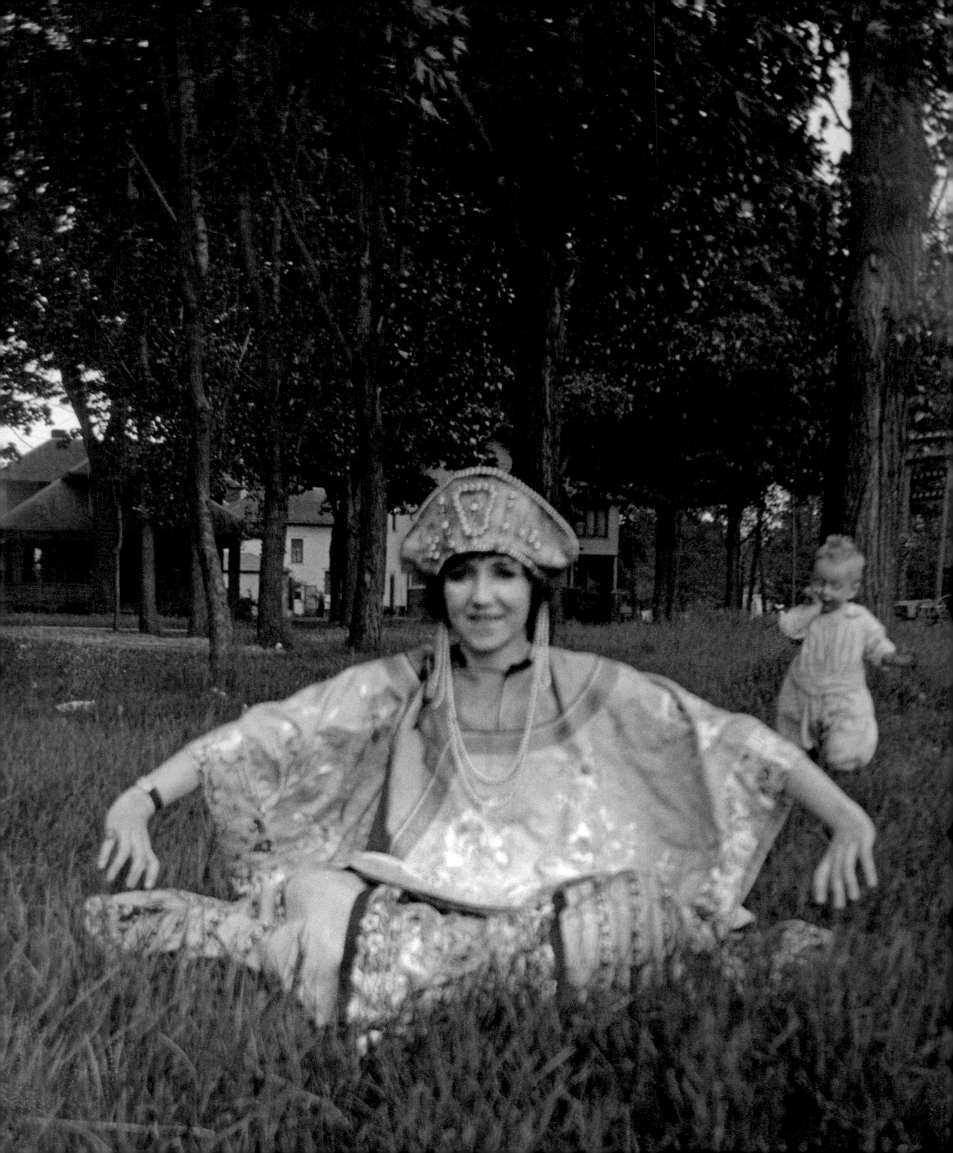

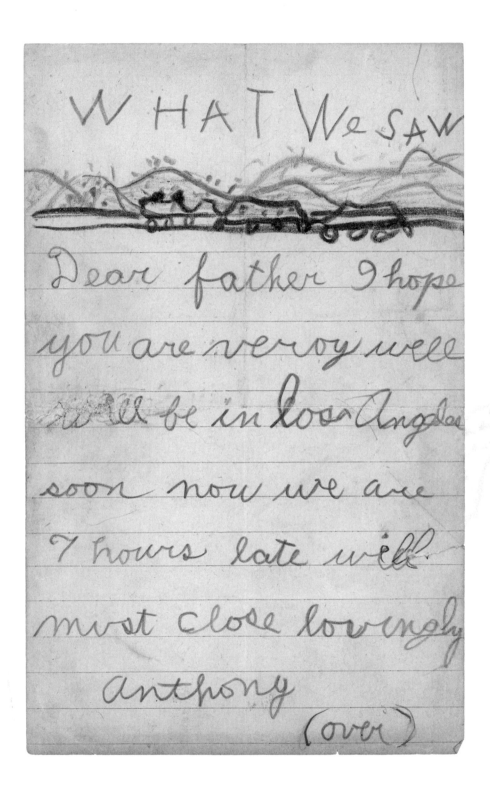

OPPOSITE Elsa Fuhrer Duquette dressed in the style of the Russian Ballet with her son, Tony Duquette, in the woods near Three Rivers, Michigan, c. 1915.

ABOVE A childhood letter from Tony to his father written on the train between Chicago and Los Angeles, c. 1920. Tony had a very loving relationship with his father, who championed his son and wife's eccentricities.

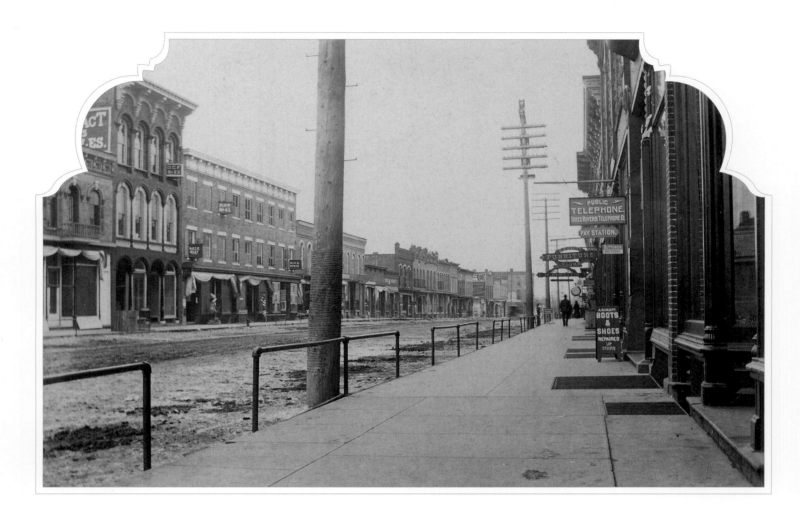

Tony's father, like his mother, was also a musician. Frank Flanders Duquette came from Mendon, Michigan, where his father owned the biggest dry-goods store in town. After attending Notre Dame University and earning a law degree, he lost much of his sight, owing to what is suspected to have been a detached retina. Frank Duquette then went to work for an oil company and moved to Los Angeles, where he met Elsa.

Whatever dreams and ambitions Elsa harbored for herself were put on hold when Frank took her back to Michigan. Frank was an only child and felt a responsibility to help with his ailing mother, who had cancer. They settled in Three Rivers, near Mendon, where Frank's family lived in a Victorian house built by his father.

A photograph of the town's main street, taken when Tony was a boy, looks as if it could be any American small town. There are rows of two- and three-story buildings unchanged from the 1870s. The empty street looks as if a horse-drawn carriage could be just around the corner.

For Tony, Three Rivers provided an enchanted setting: the woods and wildlife fed his imagination and stirred longings to build fantasy worlds, portents of bigger things to

ABOVE Main Street in Three Rivers, Michigan, c. 1914.

OPPOSITE Elsa Fuhrer Duquette with cello, posing in front of an art deco screen painted by the ten-year-old Tony Duquette, c. 1924.

OVERLEAF Tony Duquette's Puppet Show, c. 1920s, showing his costumes and sets for *Marco Polo*. Tony's marionettes were famous and traveled from town to town in Michigan.

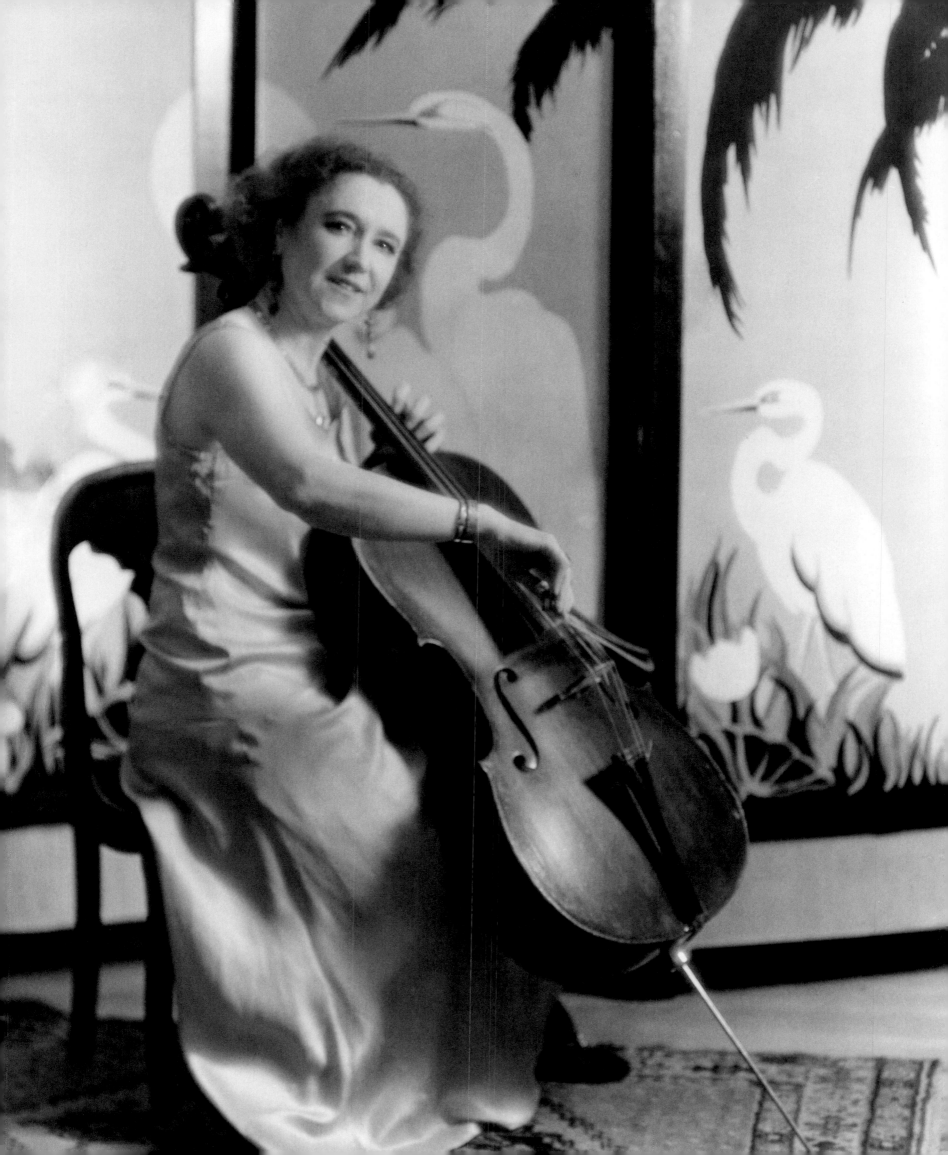

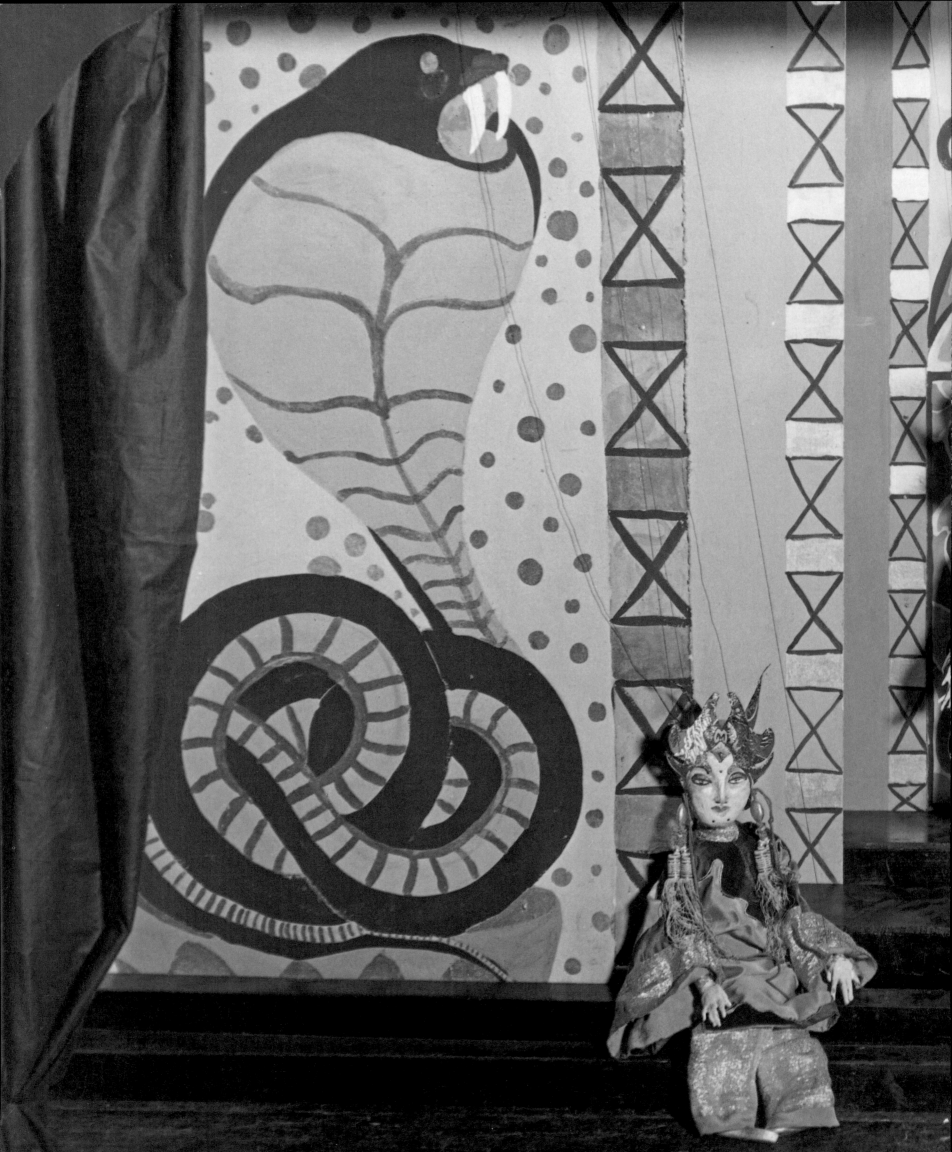

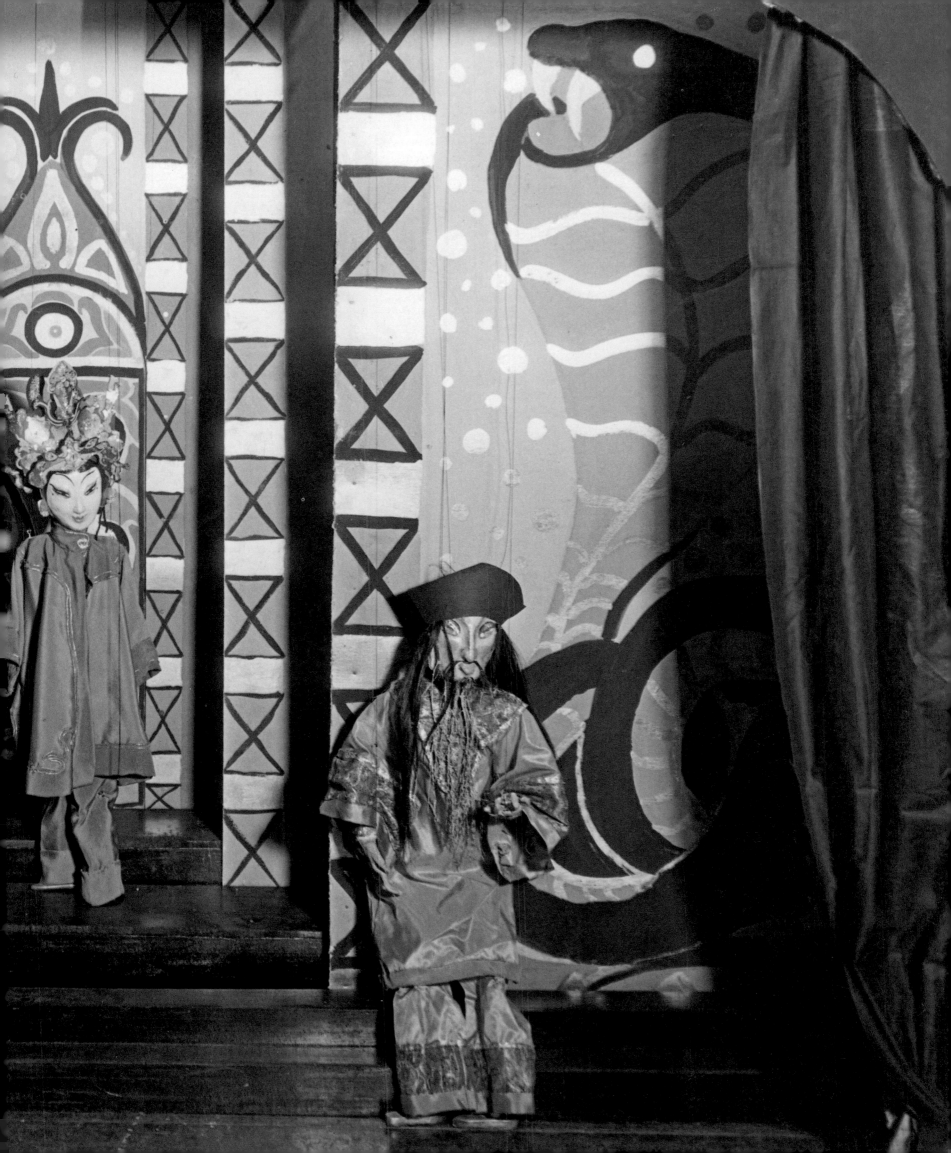

come. "Tony was really magical to me," says his brother Frank. Frank remembers how Tony would constantly entertain him, their sister, Jeanne, and their baby brother, Lucien, with treasures pulled from a magic box that Tony had painted after an Egyptian sarcophagus. Tony's hand puppet Nebuchadnezzer "lived" in it.

Tony's unique talents started to bud by the time he was seven. He staged intricate puppet shows, first produced at home and then in bigger venues, as a traveling show for neighboring schools. Tony put on his own elaborate productions of *Scheherazade*, inspired by his family's reminiscences of Sergei Diaghilev's legendary 1910 Ballet Russe production, with Leon Bakst's sets and costumes.[1] And after hearing about David Belasco's *Du Barry*, Tony carved and costumed puppet figures as he imagined the play took place on the stage. "It wasn't difficult to get actors to work in my plays," Tony said. "With my brothers and sister, I was always assured of three."

His fourth-grade sketches interpreting Longfellow's poem *The Song of Hiawatha* also won rave reviews. He had seen Gloria Swanson on film and was impressed with her gown of ermine tails. Tony's sketch for Minnehaha's costume detailed a tunic in white kid trimmed with ermine. In the end, Tony fashioned his stage version for the costume by trimming her tunic with strips of cotton dipped in black ink.

In the eighth grade Tony performed *The Birds' Christmas Carol*, from the book by Kate Douglas Wiggin, making all the food out of clay. Even at a tender age, he had very definite ideas concerning materials; when he was eight he saved up his pennies to buy his mother a bolt of taffeta from his grandfather's dry-goods store—prophetic of the insatiable shopper he would become.

The experience taught him early on about earning his expense money. Later, he would pay for his first furniture purchase, a twenty-five-dollar Chinese cabinet, by selling pictures he painted on fabric for five dollars each. He earned his way one summer as the society reporter for the *Sturges Daily Journal*, at five cents per printed inch, and laboriously reported every detail of his subjects' dress and party décor in order to stretch his reportage and gain extra pennies.

Tony's work, no matter what form it took, was always fun and inventive, customized by his imagination. And it didn't go unnoticed by the adults around him. Tony attended elementary school in Three Rivers, and he was remembered by one of his teachers, Miss Mildred Snyder, as the most famous of her pupils. "I could write a book about Anthony," she told the local paper in a 1964 interview. "I had him from second grade through high school, and I recall how he really began to blossom in seventh and eighth grades. Anthony was a violinist as well as an artist. I remember what Anthony said to me the last day of high school. His profound words were, 'The present is past and the future is dim.'"

That reference to a dim future may have alluded to a secret drama that couldn't unfold in the small town of Three Rivers. The then eighteen-year-old Tony had gotten a local girl pregnant. She was whisked out of town to have the baby, who was put up for adoption. Afterward, Tony's parents got him out of town as soon as they could, ensuring that he could sustain his free-spirited ambitions. (Decades passed before Tony ever met his son face-to-face; by the time he finally did, he was nearing the end of his life.)

Before accepting a scholarship to attend the Chouinard School of Art in Los Angeles, Tony

ABOVE Interior views of the Duquette family home on Oxford Avenue in Los Angeles, c. 1940 shows Duquette's own version of Hollywood Regency.

OVERLEAF Bullock's Department store, photographed in different seasons by Dick Whittington of Los Angeles, c. 1935. It was Duquette's job to make the store interiors "change seasons" to correspond to the east coast fashions the "perenially summer" west coast store was selling.

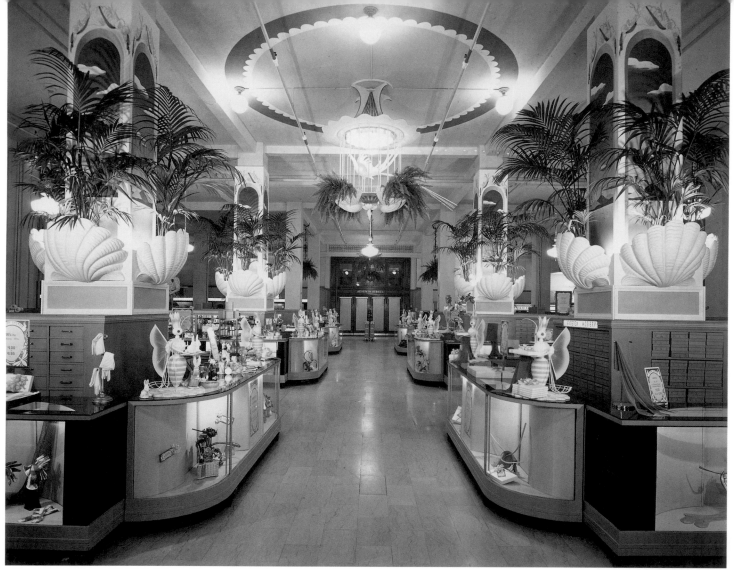

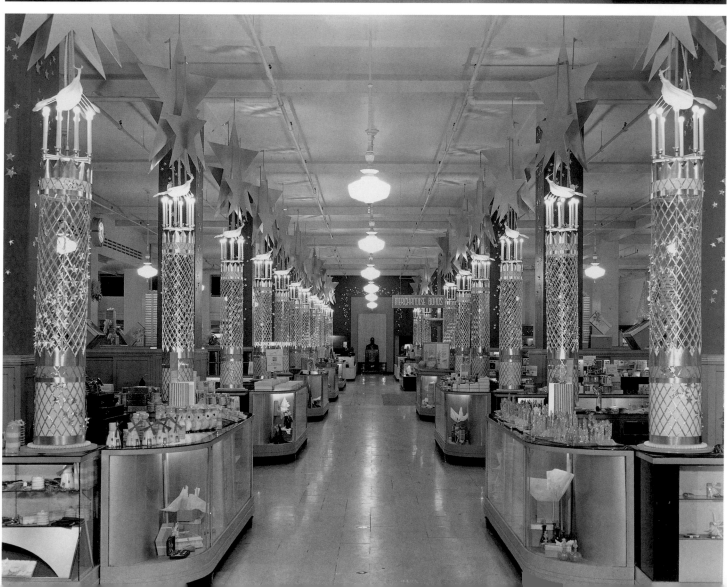

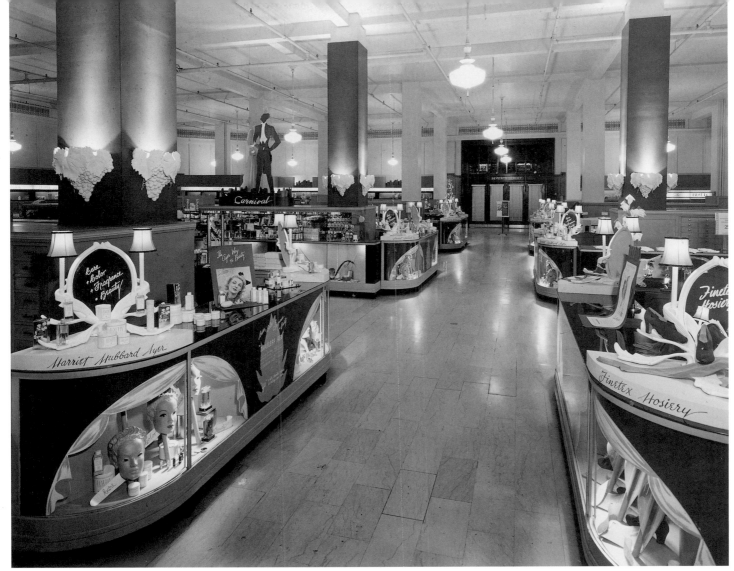

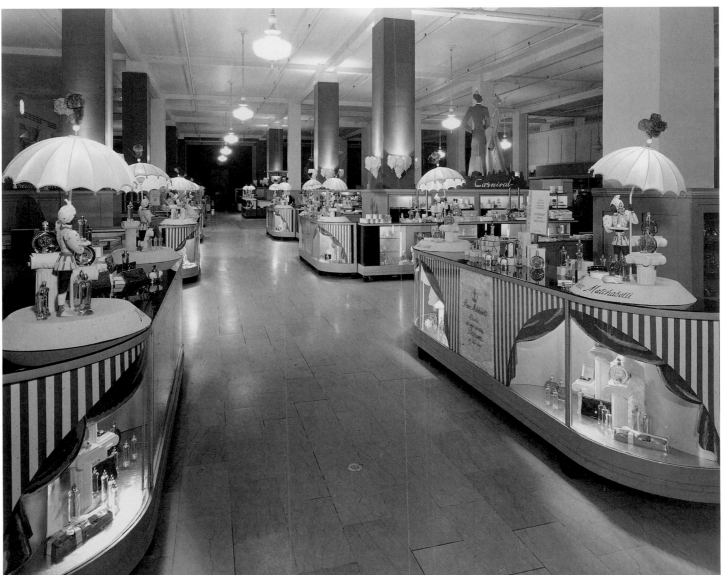

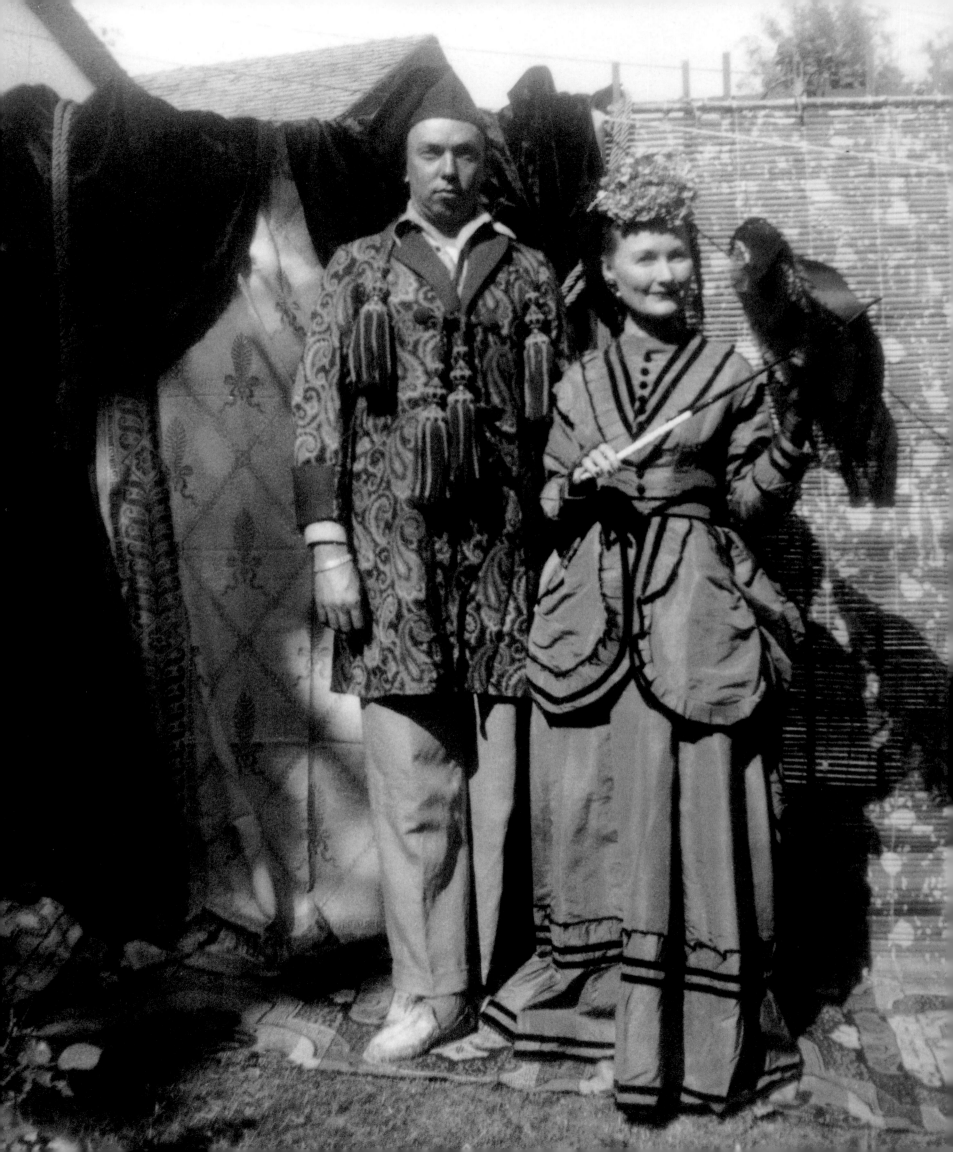

turned down a scholarship to go to the Yale University School of Drama. He lived at his aunt Lucy's Los Angeles house during his Chouinard years, 1933–35. Always one to take over a household, Tony transformed Lucy's home during his stay. In the early 1940s he finally managed to move his parents to a house on Oxford Avenue in Los Angeles, in which he created his own version of English Regency lavishness, combining brilliant yellow walls, acid green stripes, and dipped-plaster pelmets hung with painted plaster tassels. In one bedroom he painted the walls with giant cabbage roses and swags, as a background for the family's old Victorian furniture.

The Oxford Avenue family house was just another project where Tony proved himself to be a gracious (if unconventional) host, greeting guests with an ever-present stuffed cat on his arm. When his aunt Henrietta first saw the house she screamed, "Brighton!"—the worst insult she could hurl at the time. Tony, of course, was delighted that she would compare what he had devised to what he considered the greatest of all fantasies: the Royal Pavilion at Brighton.

Chouinard was a defining moment in Tony's career. Mrs. Nelbert Murphy Chouinard founded the school in 1921, and in 1929 the architectural firm of Morgan, Walls, and Clement built the Art Deco building where Tony took classes. Other well-known Chouinard students included costume designer Edith Head, fashion designer Rudi Gernreich, and American sportswear maven Bonnie Cashin. In 1961, Walt and Roy Disney merged Chouinard with the Los Angeles Conservatory of Music,

to form the California Institute of the Arts. (Tony eventually became a member of the Cal Arts Alumni Association's Board of Trustees, in 1965.)

Tony's classmate and friend Leonora Pierotti remembers his offbeat eccentricity: "He used to come to school and pick a different character to be each day," Pierotti said. "I only remember one day he said, 'Today, I am Little Lord Fauntleroy.' He read so much and he used to play the roles of the characters he was reading about. Tony was working in display at J.W. Robinson's department store before the war and then I got him over to Bullock's, where I had a job as the color expert and interior stylist. He did the store's interior decorations and he had Beegle as his assistant."

By this time Tony had also met his muse and soul mate, the ravishing Elizabeth Johnstone. She was a fellow artist at Chouinard, and she would become his bride on Valentine's Day, 1949. He nicknamed Elizabeth Beegle, as he felt she represented the soaring poetry of the eagle and the industry of the bee.

Tony's first postgraduate job was working in display and advertising for Robinson's and Bullock's department stores. Tony would eventually meet Billy Haines, who in turn would introduce Tony to James Pendleton, another prominent interior designer. This series of introductions would ultimately lead to meeting such design bastions as Elsie de Wolfe, Adrian, and Vincente Minnelli in 1941, and each one would eventually help Tony realize his own life's dreams.

OPPOSITE Tony Duquette and Elizabeth "Beegle" Johnstone dressed in costumes of their own invention, photographed while both artists were students at Chouinard, circa 1935.

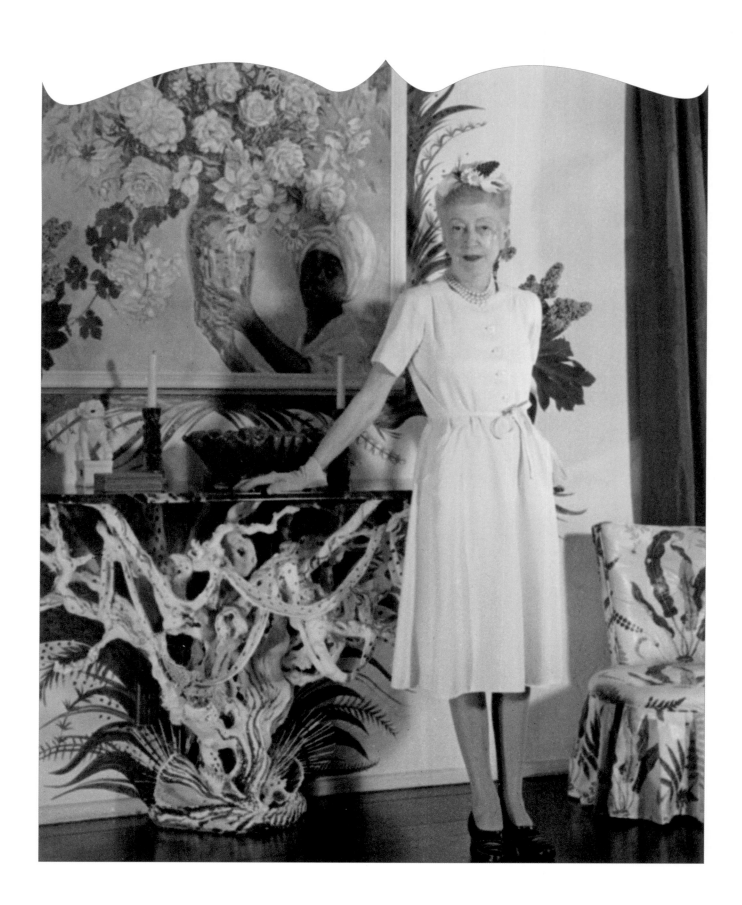

BREEDING GROUND

The meuble is divine. Your niche awaits you
one hundred years from now in the hall of fame.
Gratefully. Elsie Mendl.

Western Union telegram to Tony, November 16, 1942

INTERIOR DECORATING PIONEER Elsie de Wolfe, who became
Lady Mendl through her marriage to Sir Charles Mendl,
became Tony's archangel, shaping his future with all
the dexterity and determination of a potter at her wheel.
When she met Tony in 1941, she was determined to make
him hers. She felt she had discovered a genius, she
promoted him, and everybody was going to know why.

De Wolfe, "the first Lady of Interior Decoration," was
born in 1865.[1] A former actress, she established herself as
a professional decorator in 1905 with an impressive debut
commission to outfit Stanford White's Colony Club in
New York, the first women-only club. Her mantra was "I
believe in optimism and plenty of white paint," and she
was on a mission to flush out the Victorian clutter of
her era and breathe fresh life into rooms. "I was an ugly
child born in an ugly age," she declared, a sentiment that
fueled her goal of living a life dedicated to the pursuit
of beauty.

OPPOSITE Elsie de Wolfe, photographed in her Beverly Hills
home, After All, 1945, in front of the grape root vine console she
commissioned from Tony Duquette, with its en suite trompe l'oeil
picture frame.

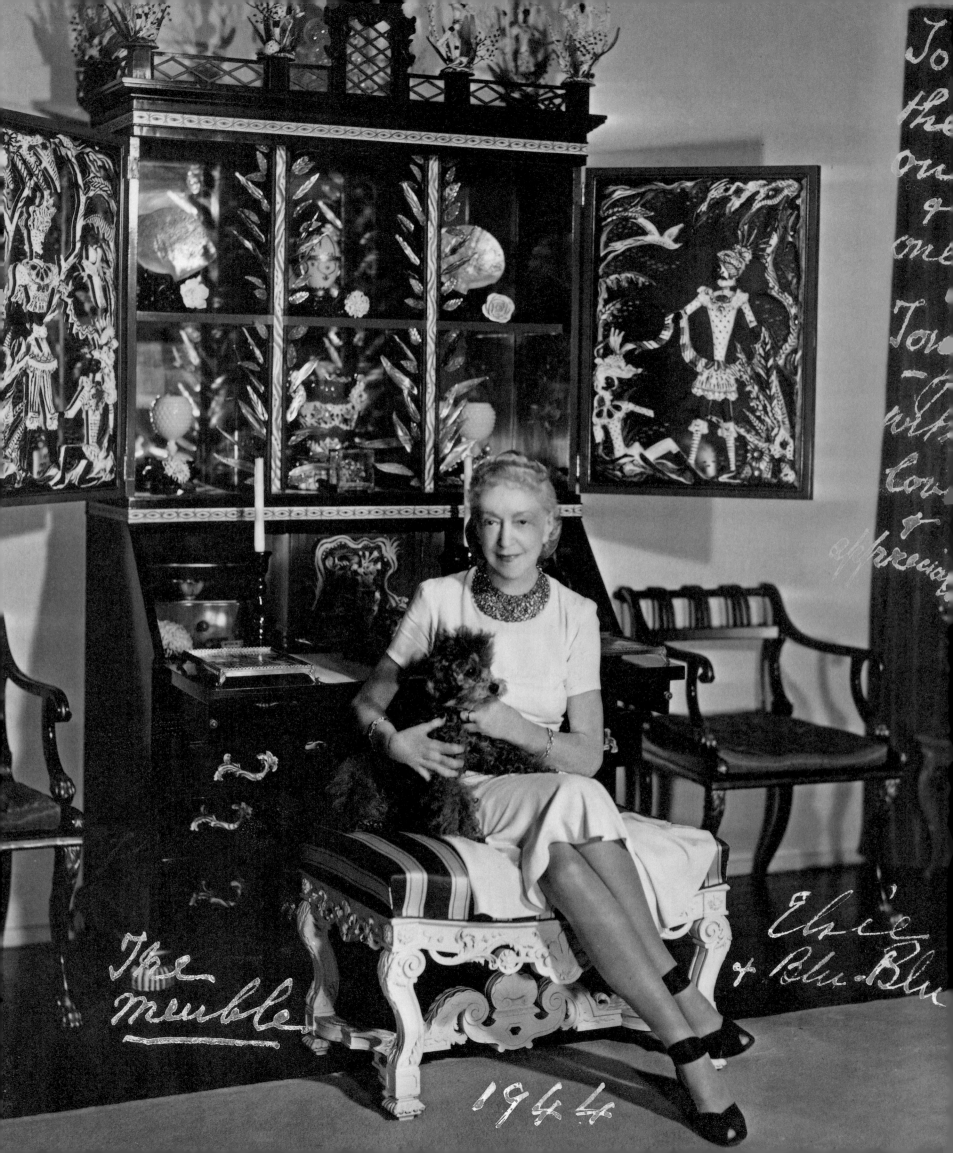

The *Meuble*

Elsie + Blu-Blu

To the one & only Tony — with love & appreciation

1944

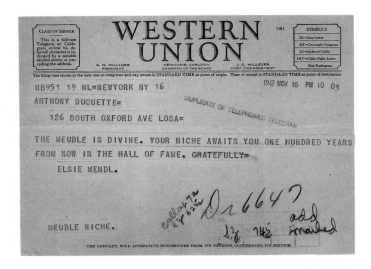

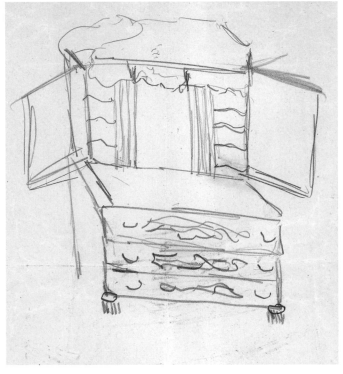

"Elsie was small, but she was a pretty authoritative big-time dame," Diana Vreeland wrote in her preface to the biography by Jane S. Smith, *Elsie de Wolfe: A Life in the High Style*. Ms. de Wolfe was self-made, opinionated, and wielded her point of view like a saber.

For the Colony Club, de Wolfe shocked the ladies with her use of unabashed doses of glazed cotton chintz (which was then familiar to Americans as a staple of English country house décor), wicker furniture (then unheard of for interiors), and a garden trellis as wall paneling to adorn what would have formerly been a staid tearoom.[2] Her initiatives with interiors were radical to a 1905 public, but she was soon applauded for her self-taught knowledge and self-confidence, deemed modern at the time.

In 1913 Elsie was hired by Henry Clay Frick to decorate the private family rooms of his gleaming new Fifth Avenue mansion, designed by Carrère and Hastings, working with a budget that stretched into the millions. Here she could indulge her robber-baron patron with her knowledge and passion for eighteenth-century French furniture. Frick paid her a ten-percent commission on everything he bought through her. That year Elsie also published her book *The House in Good Taste*, in which she spelled out her mission in no uncertain terms: "My business is [...] to preach to you the beauty of suitability. Suitability, suitability, suitability."

Her commissions also included decorating Condé Nast's Park Avenue penthouse and helping her friend the Duchess of Windsor with her homes in Paris, Cap d'Antibes, and Nassau. Her newfound fortune enabled her to lavish attention on the true love of her life. In 1907 Elsie and her close friend Elisabeth Marbury, who Elsie met as an actress and who became one of the leading theatrical agents of

ABOVE "The meuble is divine"—Western Union telegram from Elsie de Wolfe to Tony Duquette, November 16, 1942.

BELOW Original sketch of les meilleurs meubles by Tony Duquette, as commissioned by Elsie de Wolfe.

OPPOSITE Elsie de Wolfe posing with "Blu Blu" in front of her "meuble," which she commissioned from Tony Duquette in 1942. Tony loved this photo because Elsie signed it "to the one and only Tony."

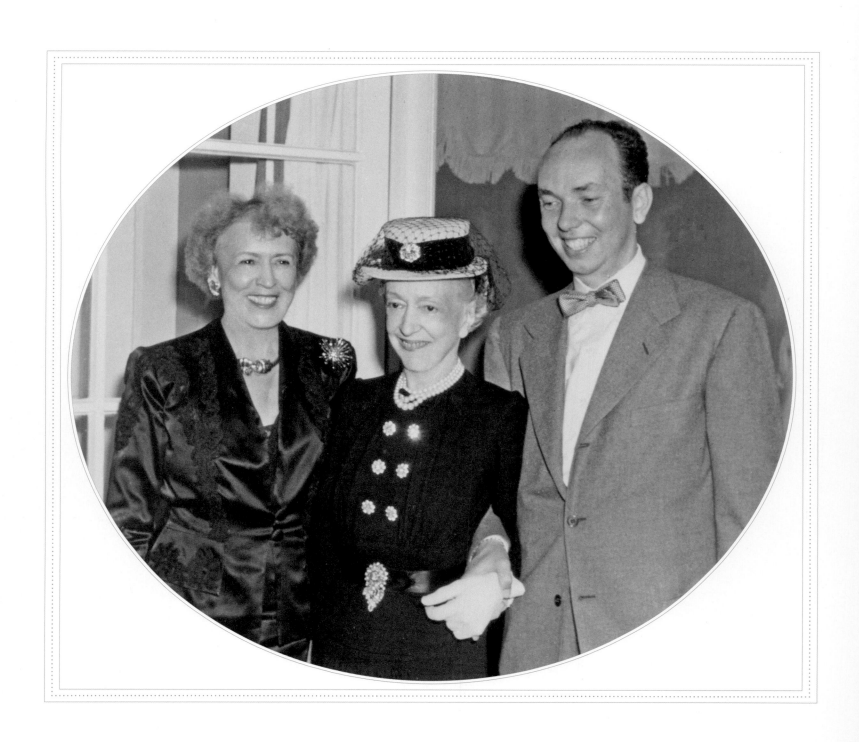

ABOVE Cobina Wright, Elsie de Wolfe, and Tony Duquette at the opening of his first one-man exhibition at the Mitch Leisen Gallery, c. 1947.

OVERLEAF Elsie de Wolfe in bed with Blu Blu at After All, c. 1950. She used to call Tony and say, "Kid, you've got to get over here right away... Mother needs more ivy leaves painted on her walls."

her day, bought a run-down villa in Versailles: the Villa Trianon. Originally built for Marie Antoinette's surgeon and later home to Louis d'Orleans, a son of King Louis Philippe, the villa became her passion and sustained her until the end of her life.[3]

Elsie had a talent for conjuring up a fresh new spirit in all the homes she inhabited. When in 1892 she and Marbury moved into their first house, the former residence of Washington Irving, on New York's Irving Place, her dramatic redecorating job would signal a sea change from musty Victorian to clean modern, where dark and heavy tones were replaced by white paint and pared-down décor. After living there for twenty years, she and Marbury moved to a town house on East 55th Street. All her houses were showcases, but the Villa Trianon uniquely gave Elsie the perfect setting in which to fulfill her life's ambition of creating beauty and composing the world to her own specifications—allowing her to reign like a queen.

Elsie was a self-made woman, determined to carve out her own legacy at a time when class and background were the conventional stepping-stones to power and status. But she was as pragmatic as she was ambitious, and when it became clear to her that her career as an actress would never give her the access she wanted to mainstream society, she cultivated a business doing what she did best. Friendships with Anne Morgan—J. P. Morgan's daughter—and Anne Vanderbilt furthered Elsie's and Elisabeth's ingress into the world of intellect and money. Elsie, of course, did their houses, maintaining her reign as the arbiter of good taste.

Elsie spent two years in France during World War I, nursing wounded soldiers at the Villa Trianon, which she had temporarily converted into a hospital. Her efforts earned her a Croix de Guerre and a Legion of Honor. In 1926 she married Sir Charles Mendl, a press attaché to the British Embassy in Paris. The marriage and Elsie's new title extended her legend as the hostess of the day, throwing the chicest parties in the duo's apartment in Paris and at the Villa Trianon. In 1939 Elsie gave her last great party before the war. For the circus-themed ball, the famed French decorator Stéphane Boudin lent the interiors of the villa's new ballroom a Neobaroque elegance, accented by striped green-and-white curtains, white leather banquets, ornamental blackamoors, and plaster palm trees.[4]

When the Nazis occupied France, Elsie and her husband fled the country for America, and in their absence the Villa Trianon was taken over to serve as the Nazi headquarters at Versailles. Across the Atlantic, Elsie opted not to live in New York or Washington, but rather to dwell among the movie stars—whom she deemed the "royalty of America." Sir Charles and Lady Mendl settled in Los Angeles, where they purchased what Elsie described as "the ugliest house in Beverly Hills," which she claimed they paid less for than "the cost of one object on my dining room table in Paris." Elsie, naturally, never met a house she couldn't whip into shape, and she christened the Beverly Hills residence After All. Tony Duquette's role in transforming this ugly duckling into a brilliant swan would be one of his first personal triumphs.

Tony had been firmly planted under Elsie's wing ever since she had spied his work—a dining table centerpiece composed of four figures—at a dinner party at the home of interior designer James Pendleton. Tony did freelance projects for Pendleton at the suggestion of Billy Haines, who felt Tony's unique Neobaroque designs were better suited to Pendleton's designs than his own. Elsie's

ARLENE DAHL remembers arriving in Hollywood in 1946 for a Warner Bros. screen test as young ingenue and being invited to Sunday lunch at After All. A car picked her up and brought her to 1018 Benedict Canyon Drive.[5]

It was the first time I had seen green and white canvas framing the door. We walked in and I noticed that there was a black lacquered floor. I'd never seen one before. And sitting on a little green taffeta cushion loveseat by the white mirrored fireplace was this tiny little vision, with light blue hair and two little poodles beside her. Charles said, "I want you to meet Elsie, my wife," and Elsie threw out her hand and said, "Come here dear, call me Mother." I had lost my mother two years before so I mean it really hit home. I came over and she was very polite. She seated me on the opposite loveseat. And she said, "There is a very good friend that I want you to meet, he is coming for lunch and his name is Tony Duquette. And what you see here is most of his handiwork." I looked at the ceiling and there was a chandelier which he had made out of Peking glass flowers and then, of course, that wonderful lacquered secretary near one of the walls. Everything was emerald green and black and white. That was her color scheme.

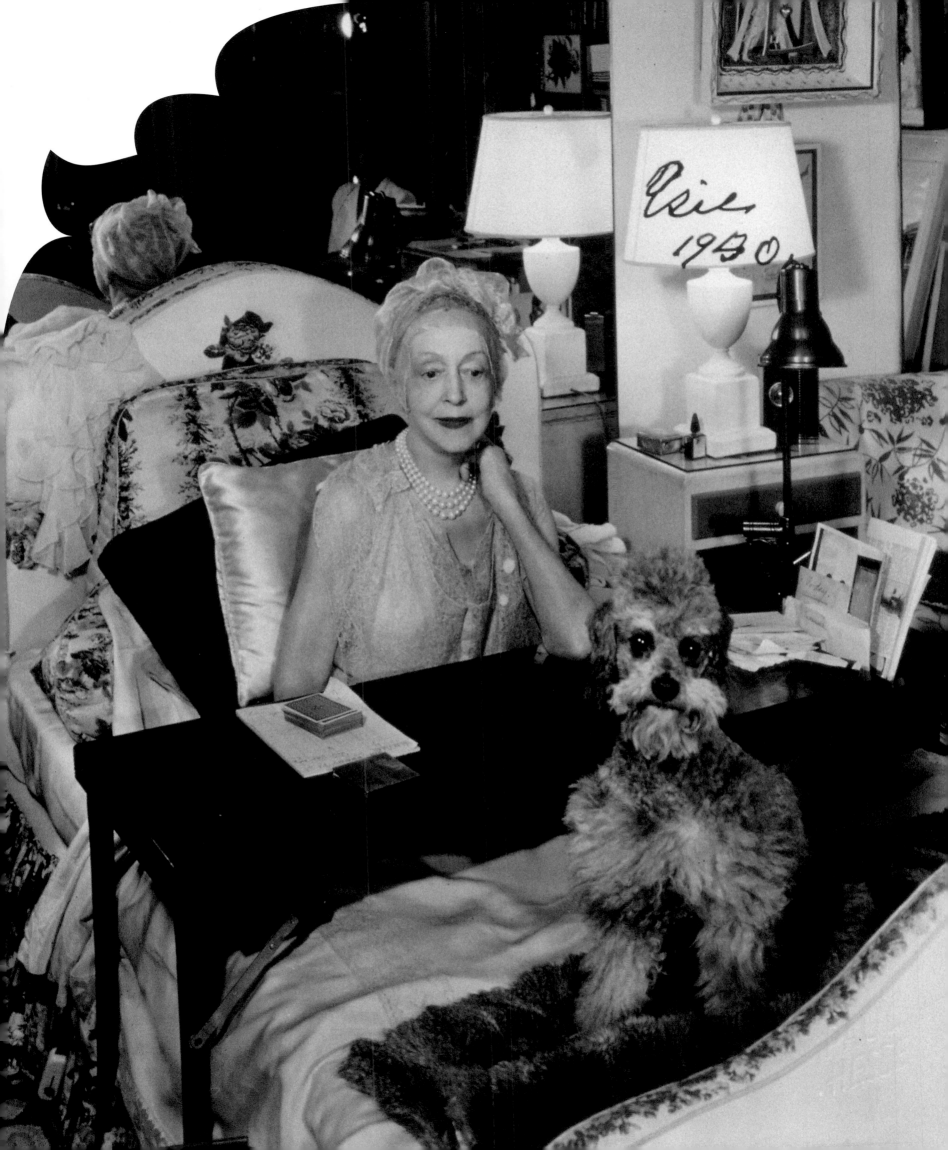

enthusiasm for Tony's work led to her now-famous command the following day, when Elsie's secretary Hilda West summoned Tony to meet Lady Mendl because she wanted him to make her a "meuble." She meant *les meilleurs meubles*—a French expression for a piece of grand furniture—but her American accent, much to the enchantment of her Versailles friends, sometimes got the better of her French. Tony was only too happy to oblige, but after receiving his instructions he turned to Hilda West and confessed that he had no idea what a "meuble" was. She told him what it was and that Lady Mendl believed every room should contain one great piece of furniture. Tony didn't hold back, conjuring up his own brew of Baroque style that led to his later being dubbed a "do-it-yourself di Medici."

The now-famous "meuble" was a custom designed secretary made by Los Angeles cabinet-maker Eric Bolen to Tony's specifications, then decorated with Tony's Neobaroque fantasy details. It was painted in black and green lacquer by the well-known Bandy and Bell, who also did finishes for James Pendleton and Billy Haines. The desk was adorned with three-dimensional painted blackamoors and twined Peking-glass leaves set with seashells, paste jewels, and mirrors. The cabinet cornice was decorated with figures Tony made out of wire, painted plaster, and plaster-dipped fabric and lace. Tony referred to them as "ashtray men," although they had nothing to do with smoking or cigarettes. Elsie called the figures her "household gods." Sir Charles Mendl dubbed Tony's decorative style "Duquettery"—a play on *marquetry*—a term he'd use from then on.

Prior to his professional emergence, Tony's Los Angeles life was a path of discovery and enchantment. He was perfectly suited to Hollywood's intoxicating escapism and fantasy. "There were lots of quite forceful fantasists in

his immediate circle, who sort of gravitated to him, from Elsie de Wolfe to Gilbert Adrian to Doris Duke," *Vogue* editor Hamish Bowles said. "I mean, they are all people who in various ways traded in fantasy, whether they are reinventing themselves or costuming the movies in the most fantastical ways or indulging extraordinary whims."[6]

Everything delighted Tony at the start of his career. He noted seeing Mrs. Robinson wearing a Poiret dress and looking in the window at him when he was setting up at J.W. Robinson's. Eventually he daringly left this secure advertising-and-store-display job—which paid seventeen dollars a week—to move to Bullock's. And it was during his time at Bullock's that Tony had his father drive him to Billy Haines's shop on Sunset Boulevard so he could show Haines some of his original work.

The work he brought, a pair of painted plaster bas-relief blackamoors, was not quite right for Haines, but he nevertheless put it in the window of his shop to see if there was any interest. Haines also arranged for Tony to meet James Pendleton, who was going to be staying at the Beverly Hills Hotel while his house, the Regency-style pavilion designed by John Woolf (later owned by Robert Evans), was being finished. Haines described the house as a "hunting lodge," which Tony took to mean a log cabin.

Tony wasn't prepared for the sophisticated house Woolf and Pendleton were designing. Nevertheless, he seized this opportunity to dazzle Pendleton, presenting the decorator with an antique Victorian wicker chair, painted white and upholstered in real gardenias. The

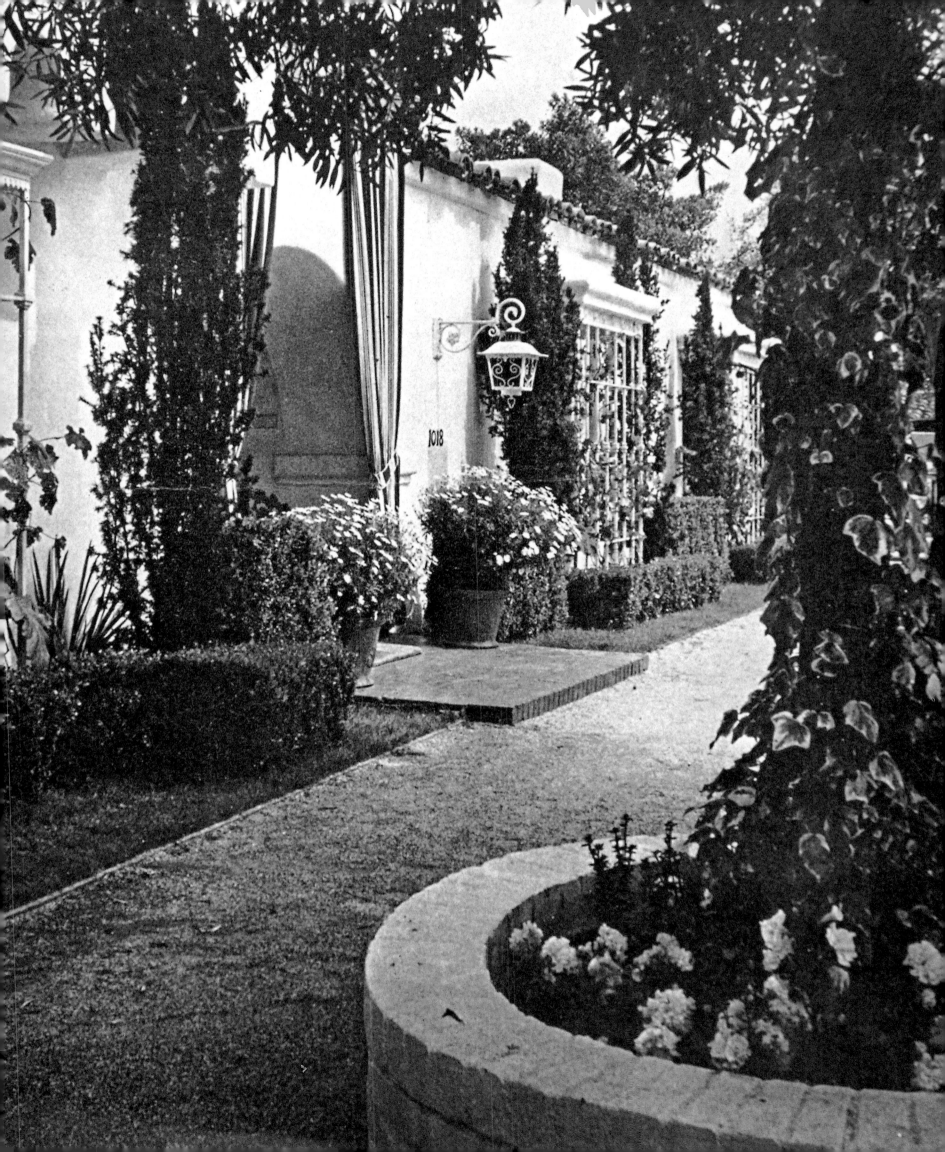

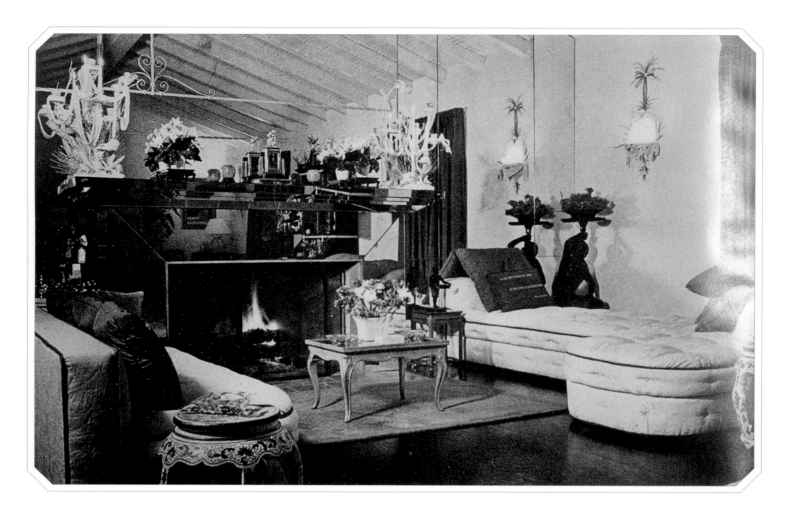

finishing touch was a stuffed dove carrying a note of introduction in its beak, which Tony had wired to the top of the chair. Duly intrigued, Pendleton made an appointment to visit Tony's family home on Oxford Avenue, where he arrived in a chauffeured limousine with his wife Dodo, the Weyerhaeuser heiress. According to Tony, Dodo was wearing "a real Adrian suit, with real sable furs and a hat by John Fredericks."

Pendleton not only bought everything he saw—including the screens, lamps, chests of drawers, and *bas-reliefs*—but also commissioned the now-famous garniture for his dining room table that was to change Tony's fortunes forever. The table garniture represented the continents America, Europe, Africa, and Asia. "Everyone who sat at that dining room table

hired me," Tony said. "Adrian, George Cukor, Elsie de Wolfe, Vincente Minnelli, everyone. It made me famous!"

Meanwhile, the blackamoors in the windows at Billy Haines's shop were causing a sensation; they ended up being copied for a new nightclub being built by the dancer Katherine Dunham and her husband, who fancied himself a decorator. To make up for Tony's

ABOVE After All. Interior photograph of fireplace in Elsie de Wolfe's Beverly Hills home, with its Tony Duquette dipped-plaster candelabra. Elsie always claimed hers was the first entirely mirrored fireplace in America.

OPPOSITE After All. Interior photograph of entrance to Elsie de Wolfe's Beverly Hills home. Note the Tony Duquette lantern- and mermaid-decorated balcony.

OVERLEAF LEFT Original sketch of Tony Duquette crown with green lucite stars designed for Elsie de Wolfe.

OVERLEAF RIGHT Commission in correspondence from Elsie de Wolfe.

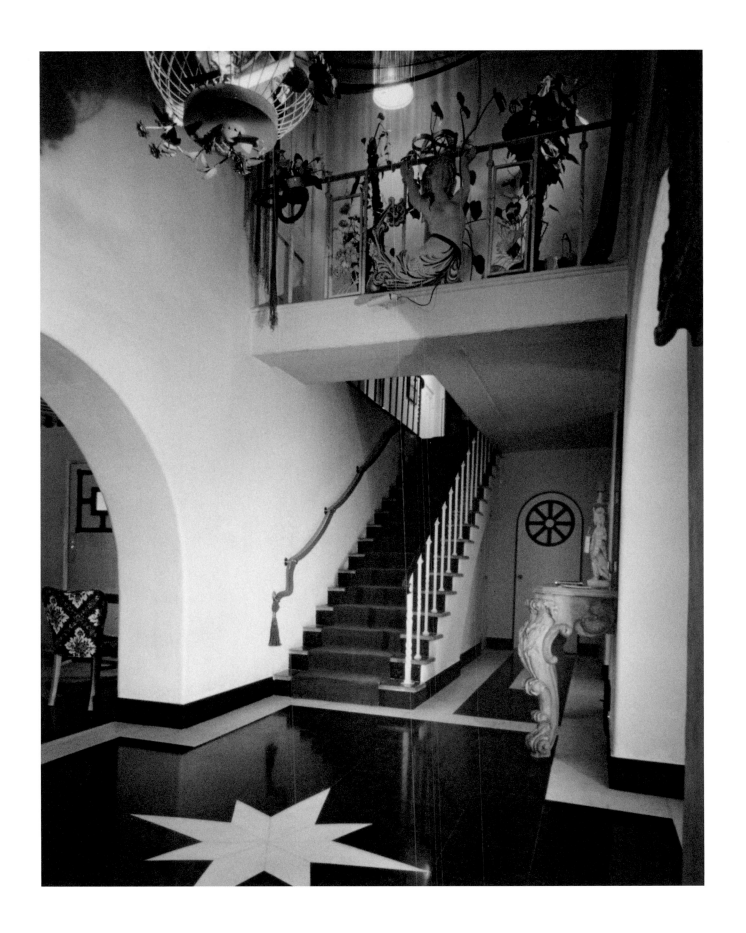

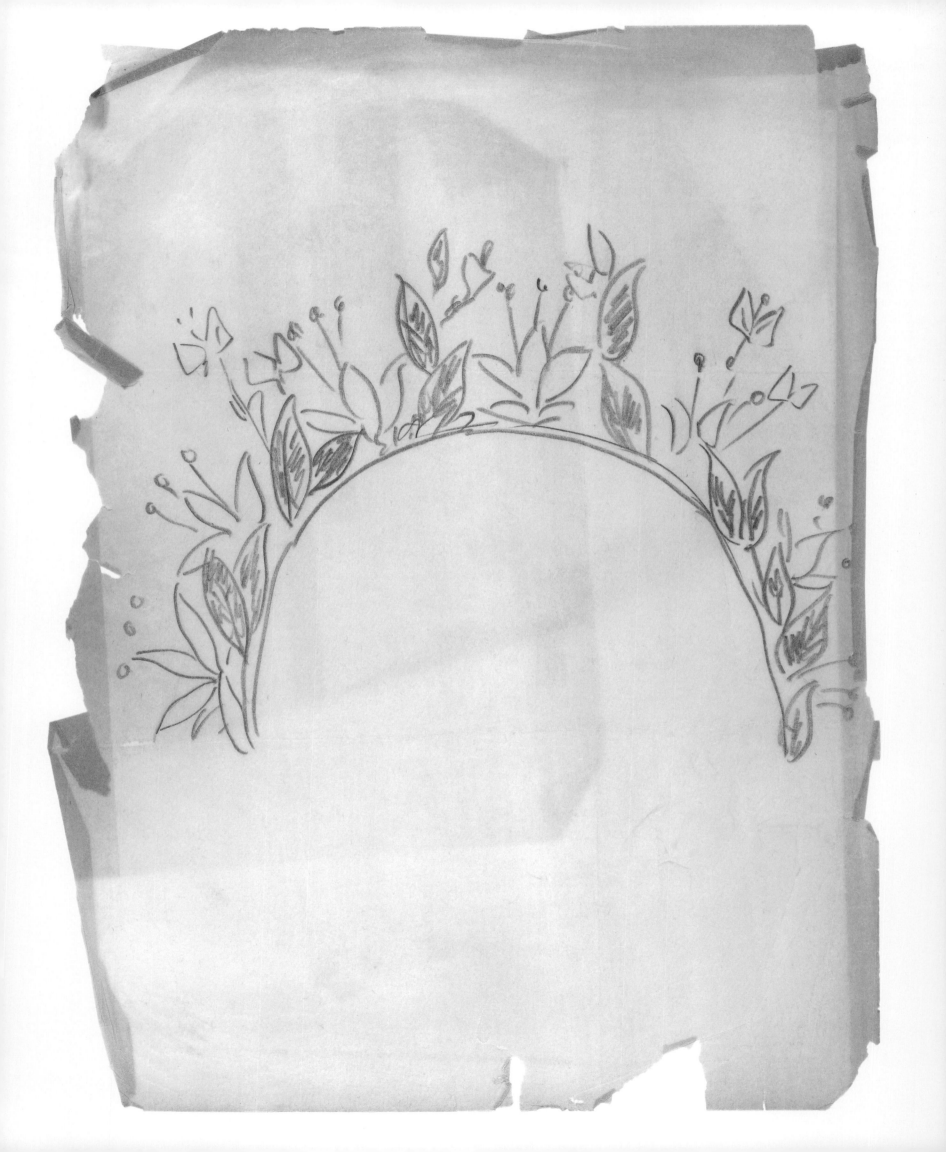

AFTER ALL
1018 BENEDICT CANON DRIVE
BEVERLY HILLS, CALIFORNIA

August 22, 1944.

You know how grateful I am
to you, dear Tony, that you got the tassels
done!! It was wonderful with all you had
on your shoulders --- Adrian's windows, etc.,
etc.,etc.

Now listen, Kid. I am crazy
to have my emerald leaf crown for Elsa's big
party on the 9th of September. Is that a
possible thing? It would be my contribution
(to celebrate the liberation of France.)

Affectionately,

Elsie

COLLECTION FOR

FALL

1952

ABOVE Program cover for Adrian fall collection, c. 1952.

LEFT Design for Adrian window displays by Tony Duquette, c. 1945.

OPPOSITE One of the Adrian display windows on Beverly Drive in Beverly Hills, designed by Tony Duquette with dipped plaster, caparisoned Indian elephants and a *bas relief* mural of a mogul procession.

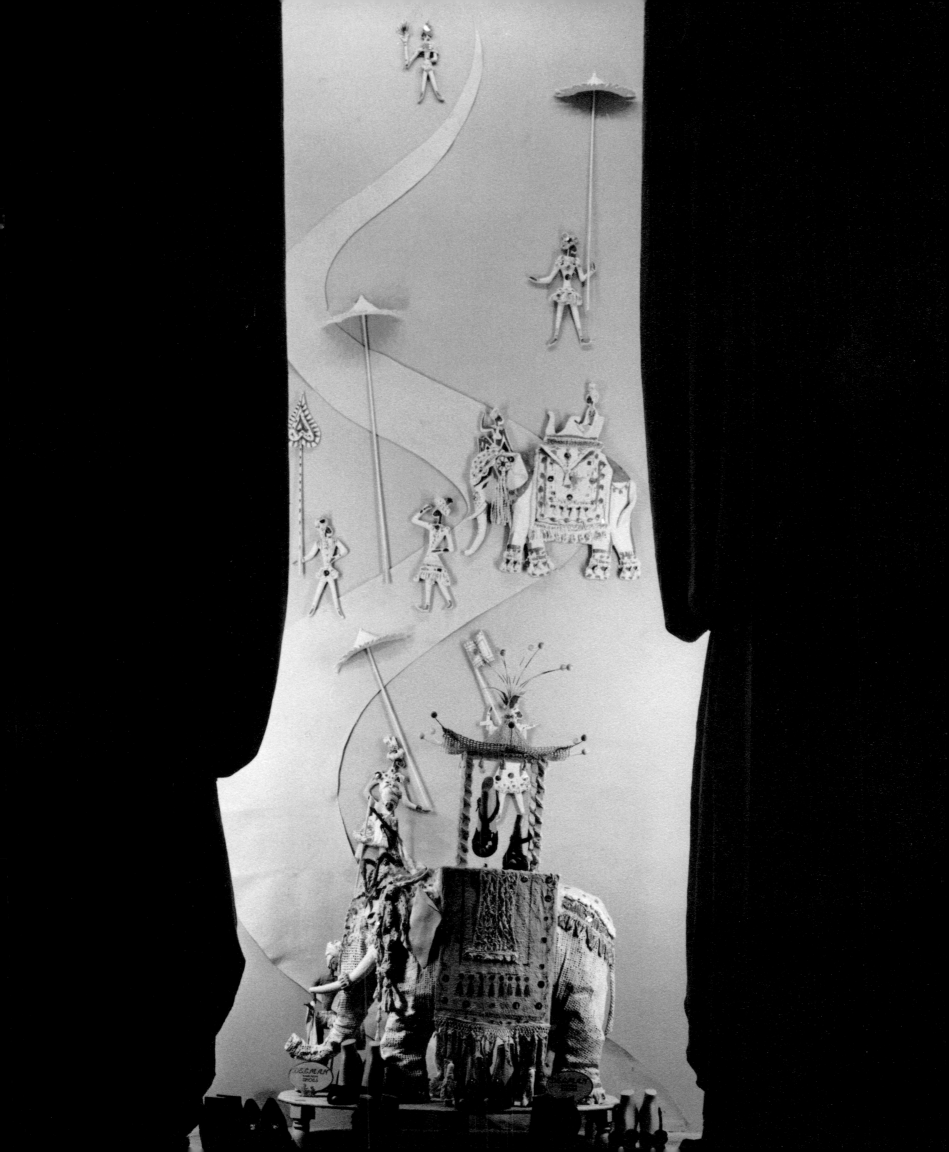

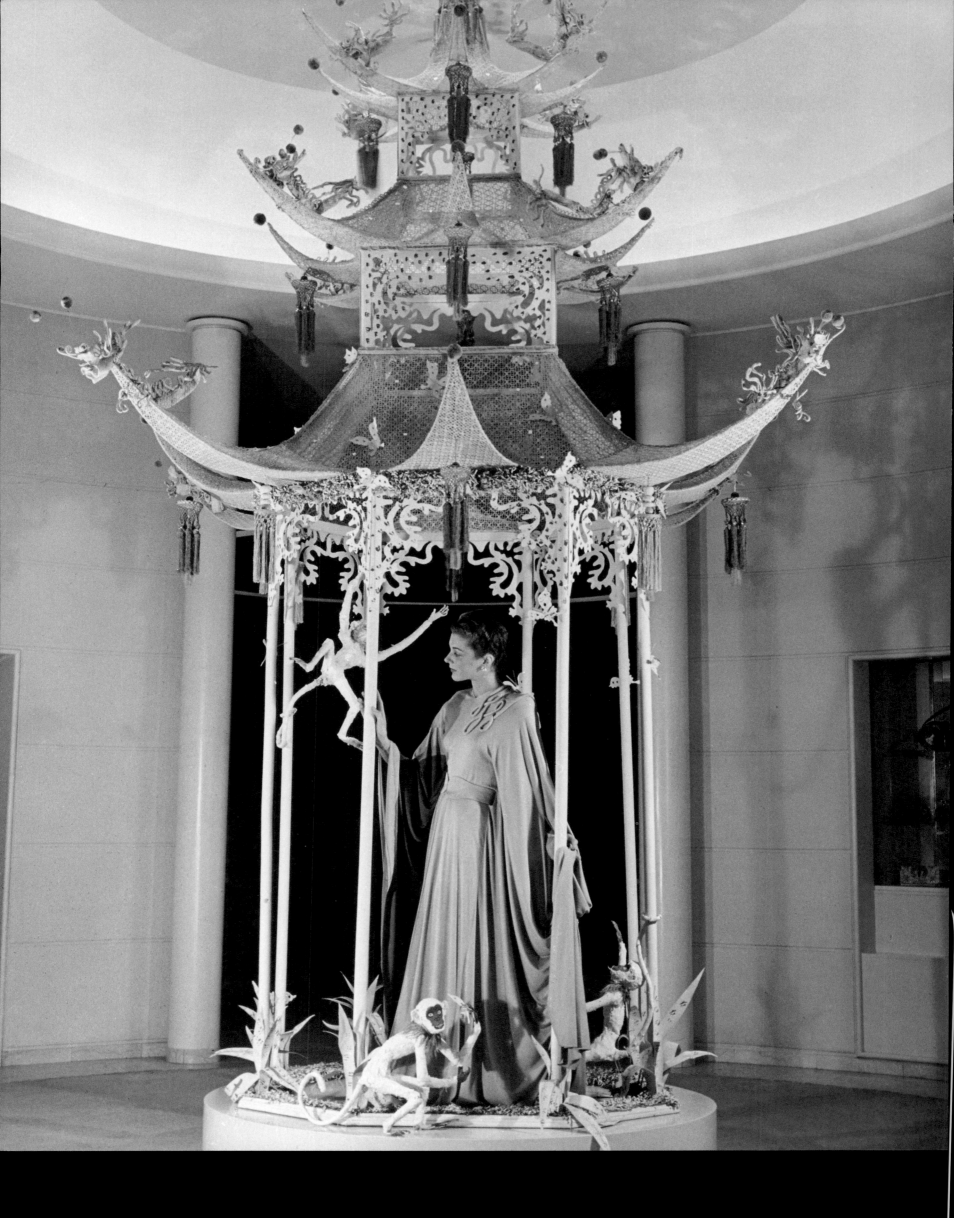

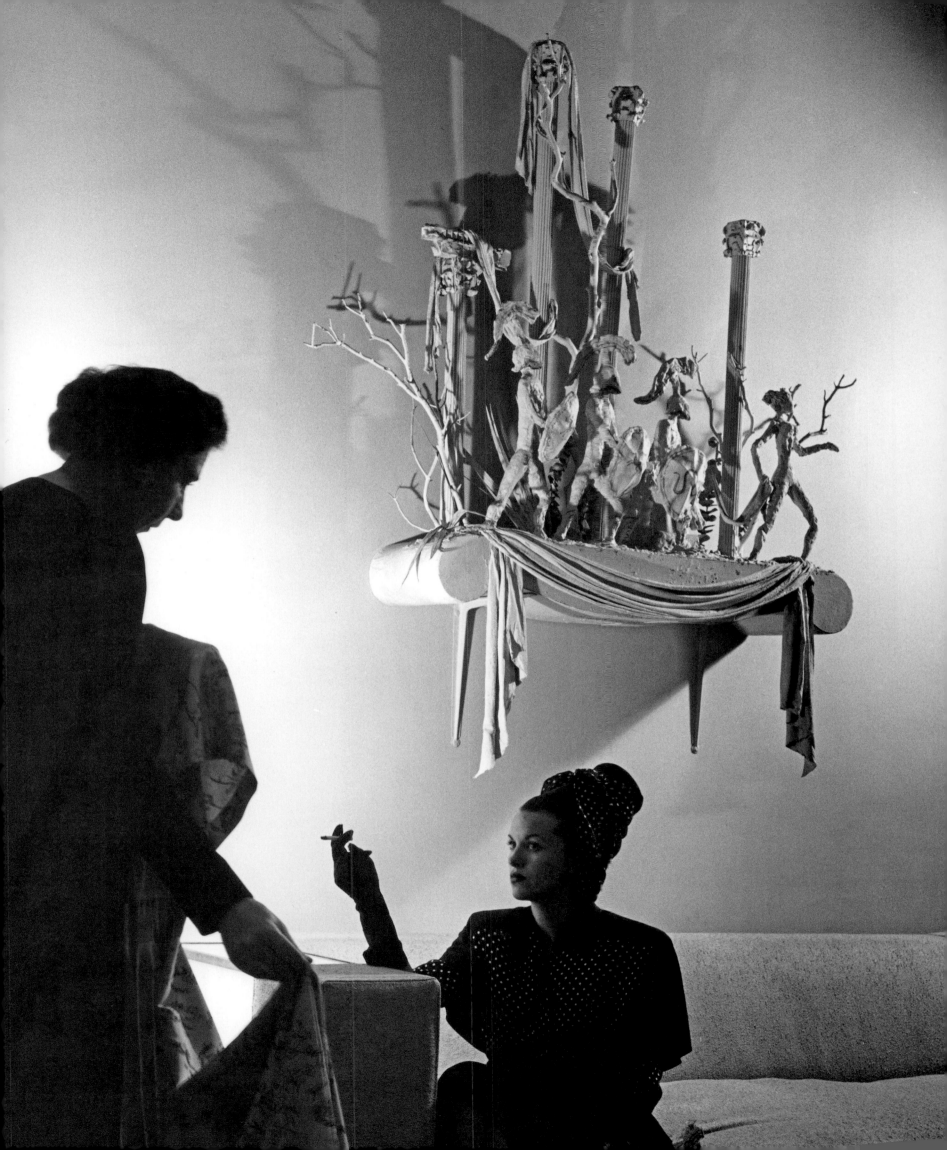

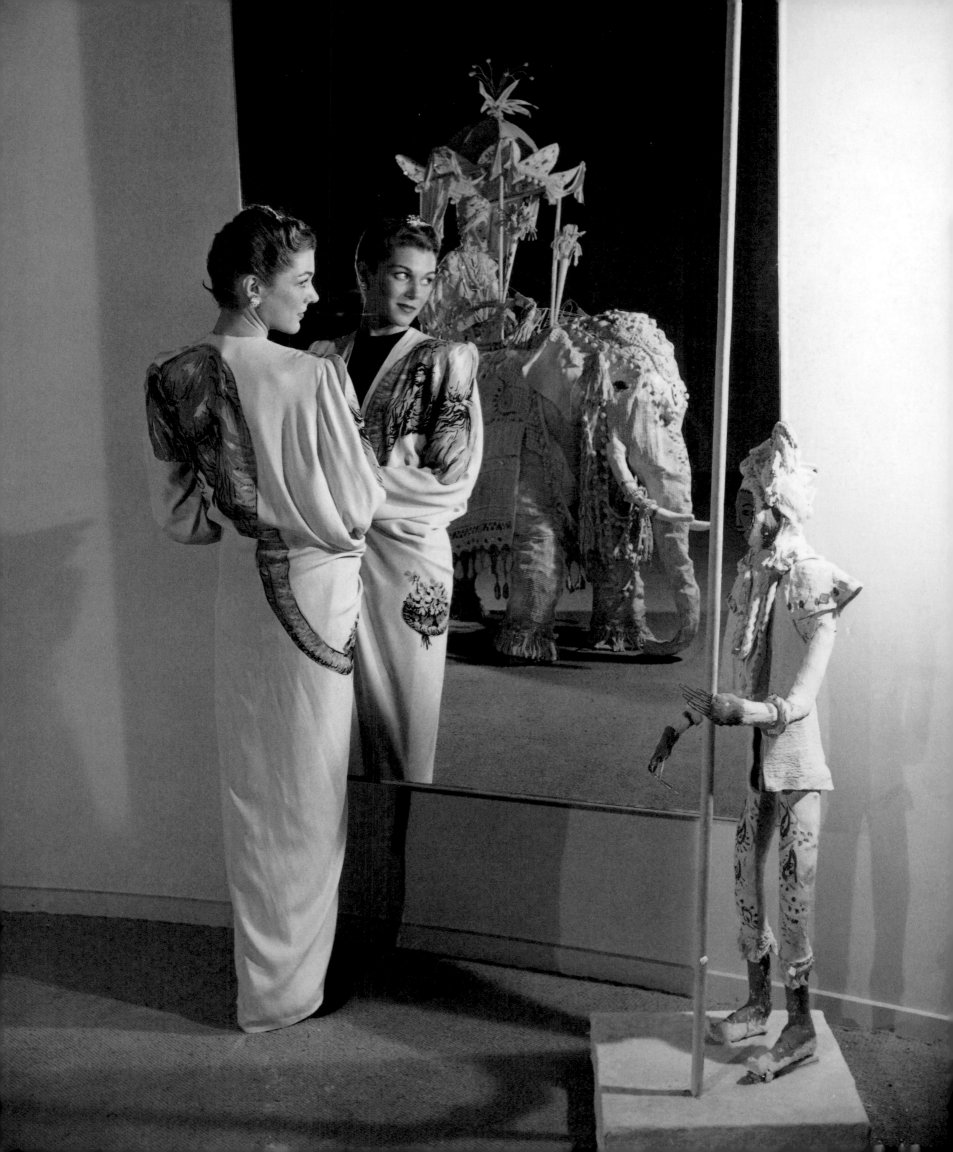

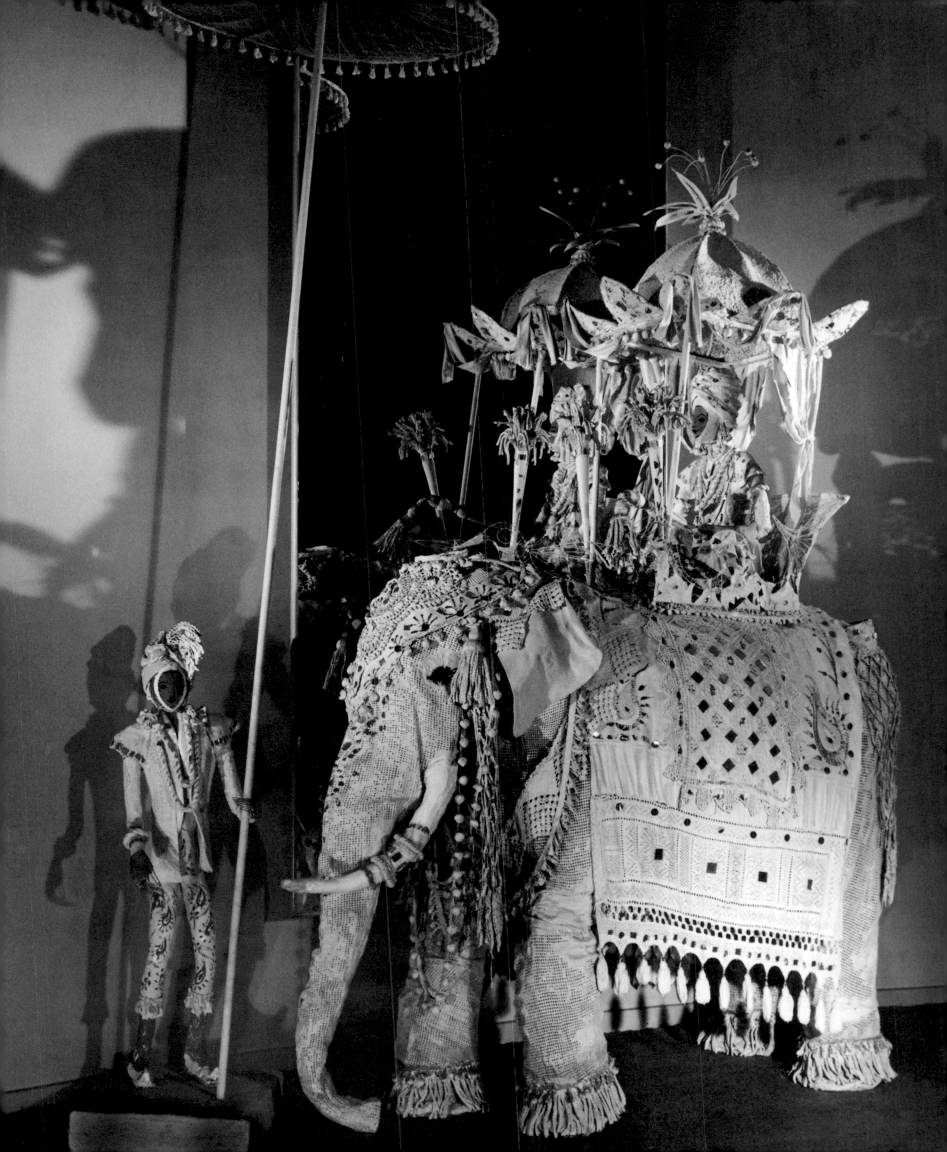

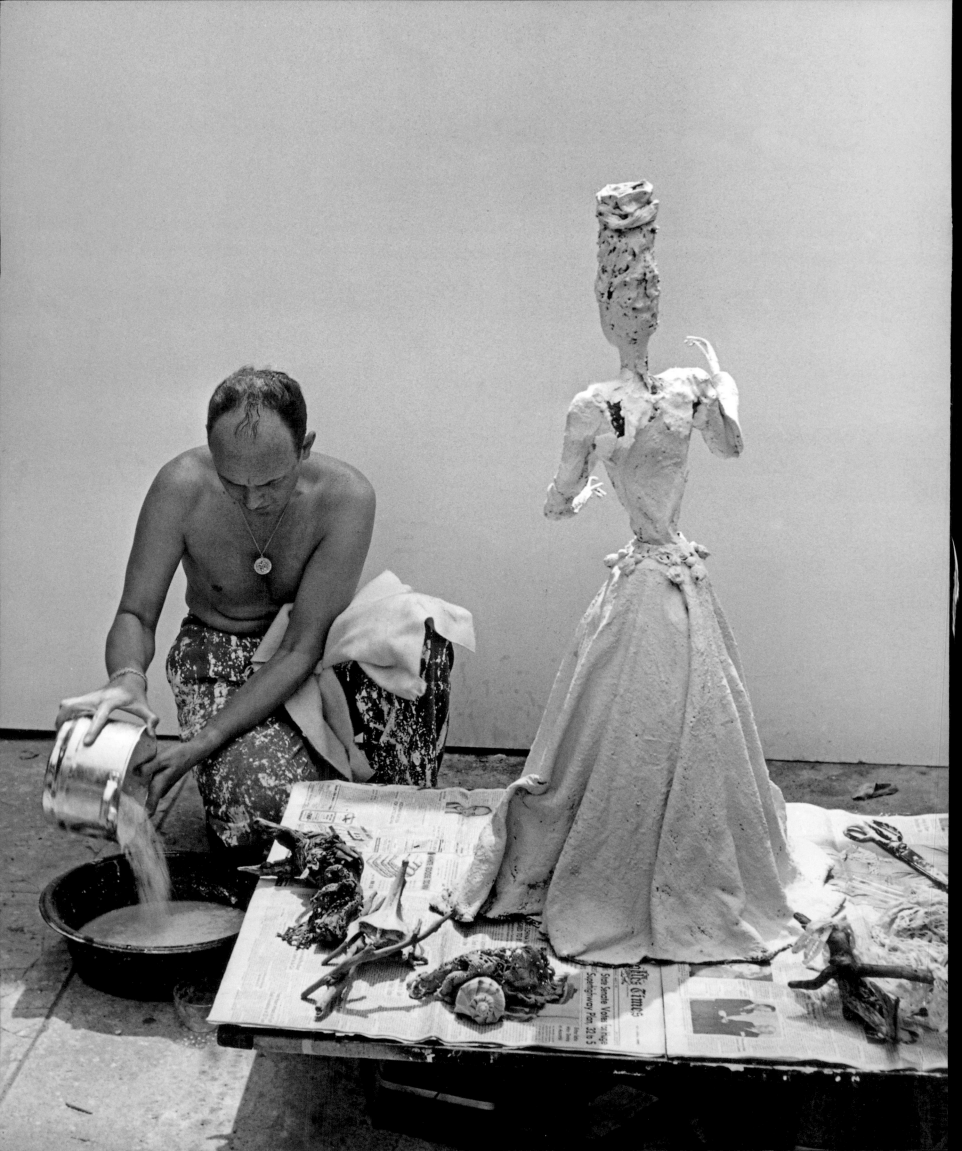

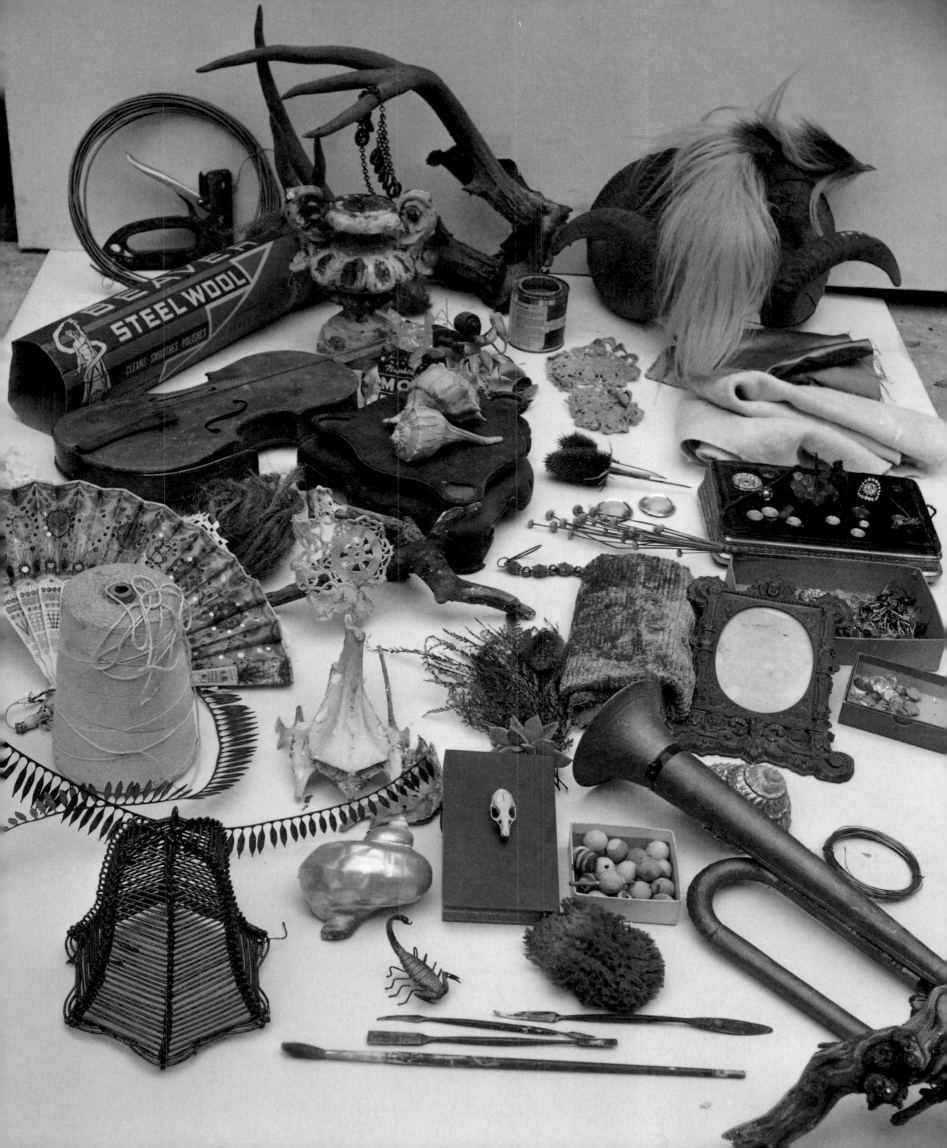

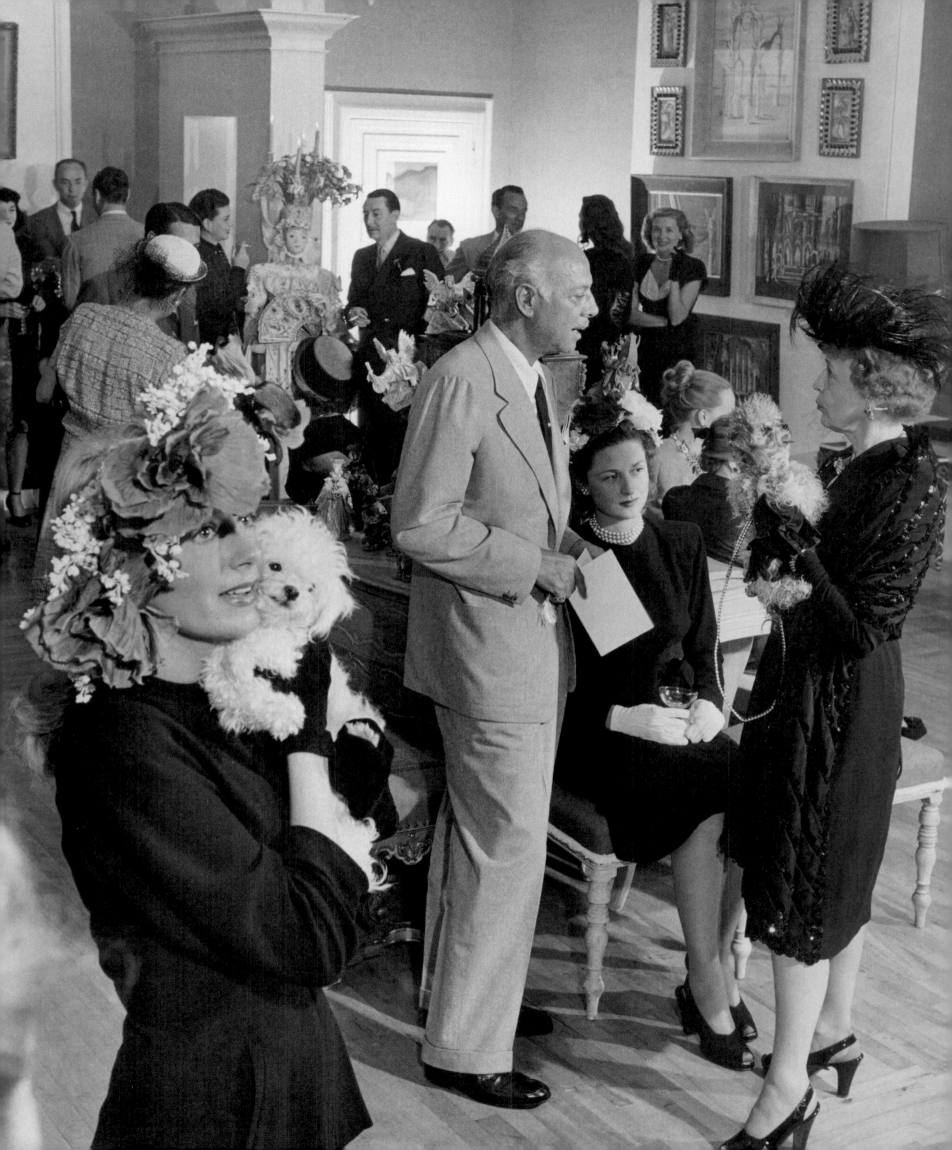

designs being hijacked, Haines offered him a job helping with the décor of the Mocambo Club, which opened on the Sunset Strip in 1941.[7] Glamour prevailed in new restaurants and nightclubs such as Romanoff's, Ciro's, and Mocambo, where Tony's eccentric décor fancifully intrigued everyone who mattered: Carole Lombard and Clark Gable, Marlene Dietrich, Judy Garland, Cary Grant, Lana Turner, Lena Horne, Cole Porter—all would have danced and dined amid Tony's towering, playful figures.

But it was also his association with Adrian that gave Tony's career further momentum and propelled his fame. Having worked with the studio since 1928 and establishing himself as Hollywood's leading costume designer, Adrian left MGM in 1941. Some of his iconic designs had included costumes for Greta Garbo in *Camille* (1936) and for Katharine Hepburn in *The Philadelphia Story* (1940), and, his unequaled masterpiece, the authentic fabrications of the extraordinary gowns for *Marie Antoinette* (1937) with Norma Shearer.

Adrian opened his own salon on Beverly Drive in 1942 with his business partner Woody Fuerte. Tony's association with Adrian continued

uninterrupted until Adrian closed his doors in the early 1950s. Tony said that in all those years, Adrian's only directive to him was, "Amaze me."

"There was no budget," Tony later reported. "I had carte blanche. I never had a client like Adrian before or since."

Things were swinging for the gangly kid from Three Rivers—but then Pearl Harbor was attacked and America entered the war. "I felt that it was the end of the world and that life as I knew it was over," Tony said. His enlistment never included duty overseas, however; thus he was able to continue his work during leaves. Tony also had his own convertible while enlisted, and he would spend his time off sitting inside, sketching ideas for MGM and Bullock's. One day, as he was sitting in his car with the top down, high on a hill, sketching, he suddenly realized that he was surrounded by military police with their guns drawn. "Put down the sketchbook and step out of the car," they ordered. They thought he was an enemy spy, sketching the fortifications. They were more than a little bit angry to discover that Tony's sketchbook was covered with pictures of Santa Claus for Bullock's holiday advertising.

After the war, in 1947, Tony had his first one-man exhibition at the Mitch Leisen Gallery in Beverly Hills. Now it was his turn to keep company with Hollywood's royalty. The exhibition was mounted on the eve of Tony's first trip to Europe, on which he was accompanying Sir Charles and Lady Mendl on a visit to Elsie's beloved Villa Trianon, which she had not seen since before the war. And what Tony discovered there, amid his midnight tours of the Versailles gardens, was just the beginning of his true-life adventure deep into the magical world of his own invention.

PRECEDING PAGES
LEFT To highlight Adrian's Chinoiserie-inspired collection, Tony Duquette built a towering plaster-lace pagoda in the entrance hall, replete with painted plaster monkeys.

RIGHT An Adrian client sitting under a Duquette *bas relief*.

LEFT AND RIGHT A dipped-plaster elephant with attendant holding parasol, created by Tony Duquette for the Adrian salon on Beverly Drive in Beverly Hills.

LEFT Tony Duquette at work in his studio constructing a window display for Robinson's department store.

RIGHT Duquette's materials of found objects.

OPPOSITE Opening night of Tony Duquette's exhibition at Mitch Leisen's gallery, c. 1947.

ABOVE Tony Duquette, Hedda Hopper, with Duquette goblets, and friend on opening night of Duquette's exhibition at Mitch Leisen's gallery, c. 1947.

OPPOSITE Installation view of exhibition at Mitch Leisen's gallery, c. 1947.

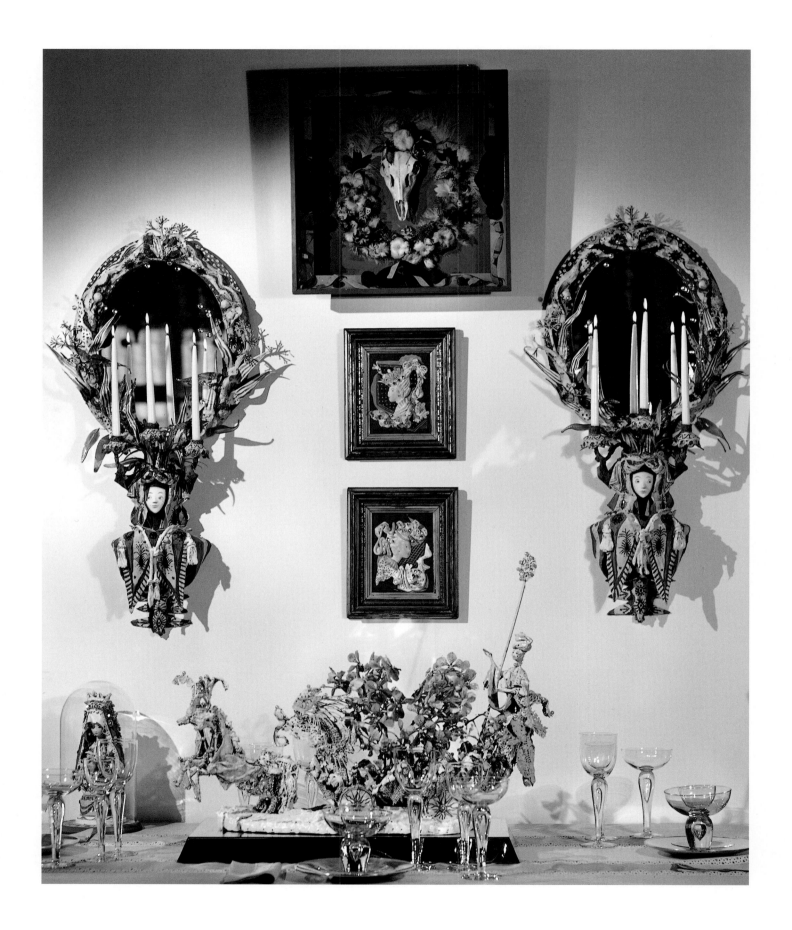

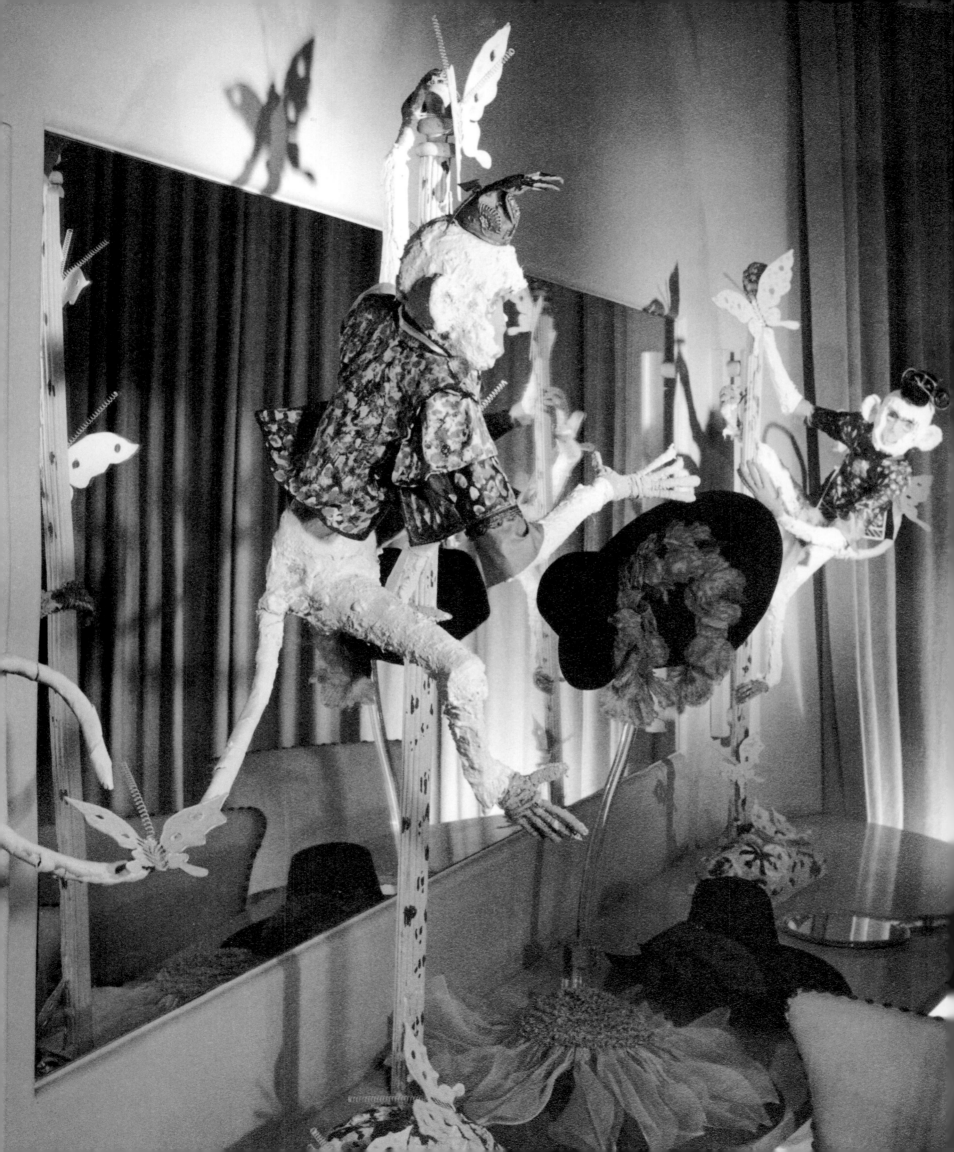

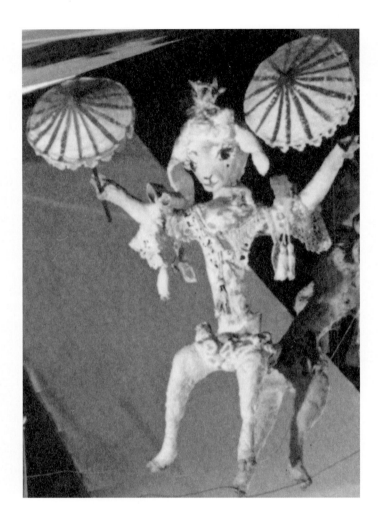

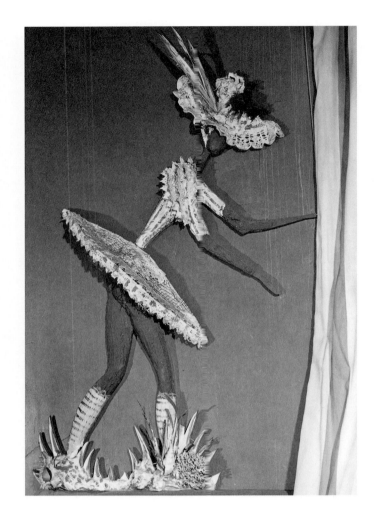

ABOVE Interior details of the Duquette-decorated club Mocambo, c. 1941.

LEFT Tony Duquette monkeys decorate Adrian's Salon, c. 1950s.

OVERLEAF Elsie de Wolfe's letter to Margaret Case of *Vogue* declaring Tony Duquette's genius.

COPY OF LADY MENDL'S LETTER
TO MISS MARGARET CASE OF "VOGUE", N.Y.
 Graybar Building,
 Lexington Avenue at 43d Street.

April 5, 1943.

Dearest Margaret:

I am so thrilled and delighted
with the pictures of the downstairs and the
garden, which are complete and are very beauti-
ful, but my bedroom, alas, is not finished and
probably will not be until the end of this coming
week. However, I will do my best, but this is
not a thing that can be hurried and is worthy
of the time being spent on it, I really think.

The interest taken in the house
amazes me when people have so many other things
to think about as they have now. I have asked
Kitty Miller to see you when she returns and give
you full details. She leaves here on Tuesday and
has had a grand time --- much entertained -- out
every night.

I want you very specially to mention
the young genius whom we have discovered here. You
perhaps saw some of his plastic work at Christmas.
Mr. Pendleton launched it at that time in New York --
bust of the Madonna, lovely vases in the shape of
beautiful women's heads, etc.,etc. Well, this boy,
who has never been out of California, has -- at
my suggestion -- made a meuble, modern Baroque,
inspired from the Venetian Baroque of the 17th
Century and the Collection of Baroque furniture
known as the Barozzi Collection, which I always
went to see when I was in Venice. This piece of
furniture -- a standing desk -- has made a sensation.
It is entirely new .. I personally have never seen
anything like it, and I think this kid has a great
career and it is nice for "Vogue" to help launch
him. Believe me, I am not handing you a lemon --
on the contrary, a great orange which you will be
proud to have mothered later.

If by any chance you could arrange
in the same issue of "Vogue" in which the house is
published to put a little picture of him under your

heading "People Are Talking About". I know you
like novelties for this column. You can speak of
Nini Munn, who knows about him and bought the two
flower vases of womens' heads at Christmas, and also
Mr. Pendleton, for whom he did many things for his
house here, as well as things for the N. Y. Shop.
He has also done a great deal of work here for Bill
Haines at the night club "Mocambo's", etc.,etc. and
has done the decorations in Adrian's shop, which are
magnificent; also the new so-called "Polo Supper
Club" at the Beverly Hills Hotel - -- but I am the
first and only person, darling, to possess an original
piece of furniture made by him.

 Any day now he may be called for the
army and the only thing the kid has asked of me is
that if he doesn't come back, will I please leave
the black writing desk to a Museum. West knows all
about this. The boy's name is TONY DUQUETTE.

 I have made an appointment or Wed-
nesday to be photographed by Mr. Gottlieb, and I
have all your detail about this.

 All affection,

 Yours,

 (signed) ELSIE

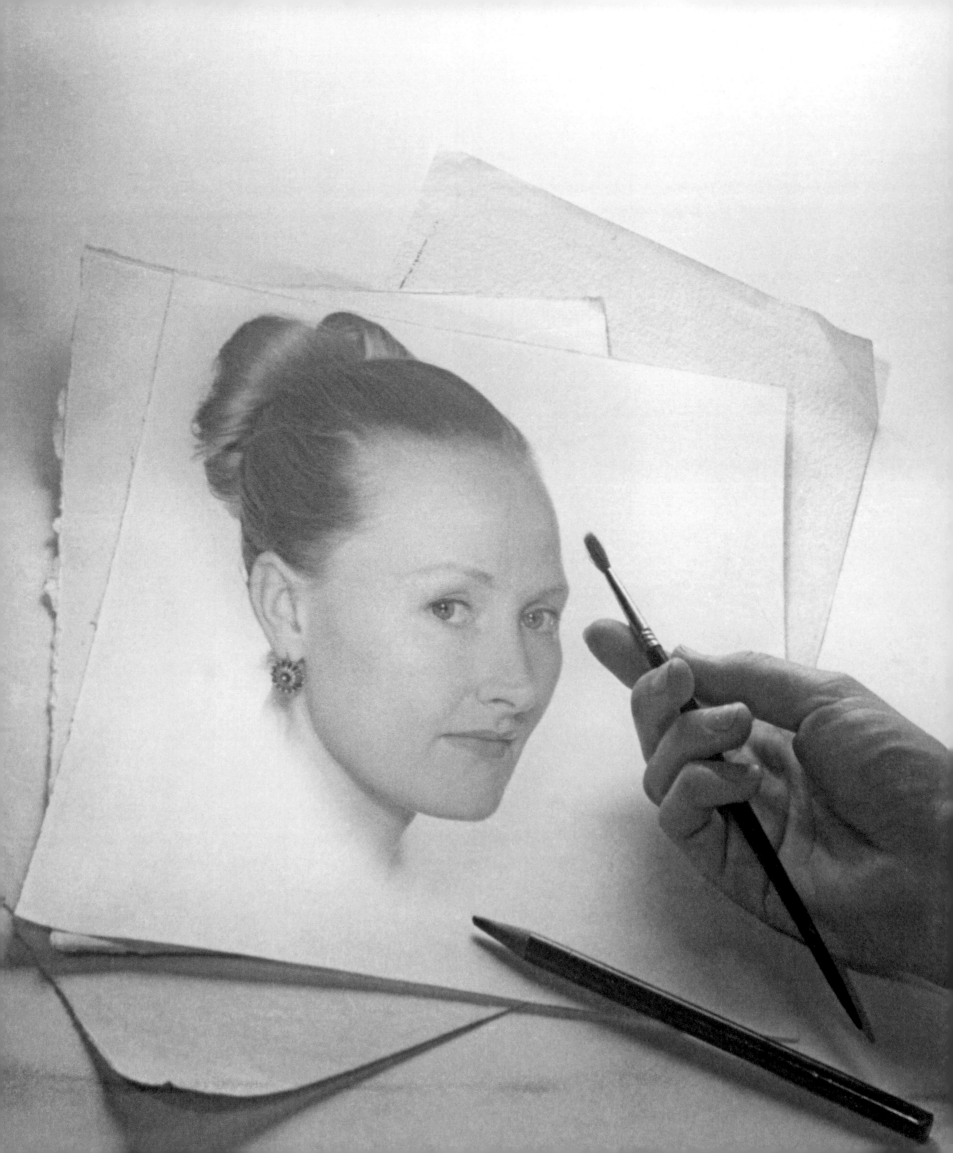

THE MUSE

When Tony heard about me Tony came to see me. And he said, "You are going to dress Beegle." And he kept on buying and buying. They would come to every collection. They bought samples because she was very slim. There was a complete incredible beauty about her. Not only that, it was her personality, quiet and reserved. She let him ride the wave and the balance was her beauty.

Gustave Tassell

It's hard to imagine what Tony Duquette must have thought the first time he saw artist Elizabeth Johnstone. Tony's friendship with her brother, Ronald Johnstone, also a Chouinard student, led to their first meeting; Tony hired Elizabeth to help him with a project he was doing at Bullock's Department Store. With her "flawless, opalescent skin and moon blond hair" she had the face of a Renaissance painting and the mystery of a cloistered nun. Years later Tony likened her to a Flemish Primitive.

Tony was flamboyant and extroverted; Elizabeth was the exact opposite. If Tony could have dreamed up his perfect mate, her beauty, talent, and character would have fallen short of the real-life ideal he found in Elizabeth. Everything about her was tinged with an elusive aura. "Beegle was the love of his life," said Liza Minnelli, Tony's self-appointed goddaughter, who knew Tony and Beegle since her childhood.

OPPOSITE Elizabeth Johnstone portrait. Tony Duquette holds paintbrush. Tony nicknamed her Beegle because she embodied the industry of the bee and the soaring poetry of the eagle.

3

Nobody seems to have really known her well, but recollections of her warmth and sweetness are unanimous. "She was funny, just darling to be with," said Tony's sister, Jeanne. "She was just there. Everybody just adored her, but you couldn't get close to her. She didn't push [her talent] herself. Tony did all the pushing. You never heard a word against anybody, or any opinions at all."

She definitely had opinions, mostly about beauty and art, but she had strong opinions about chocolate and music and clothes, the shape of a person's head—not politics but about life.... She was also very protective of Tony and would fight back if anyone dared make a remark against him or his work.

Terry Stanfill met both Tony and Beegle when her husband, Dennis, was head of 20th Century Fox, and they become close friends. "She was so beautiful," Stanfill said. "She was always so perfectly groomed, beautiful features, and gentle. She was gentle and loving."

Beegle could be mischievous—and she must have had a temper, as evidenced in a rare couplet Tony penned about his enigmatic wife: "Beegle dear, so meek and mild / A friend of hell if ever riled."

She was also a dedicated artist, happiest when painting alone in her studio, which only Tony was allowed to enter. And while she never took an interest in domesticity (even though she and Tony ended up with multiple residences throughout their lives), she was always his devoted comrade-in-arms, there to help him complete his vision, whatever it entailed.

Her childhood is somewhat mysterious. She was born on May 25, 1917, in Los Angeles. When her mother, Clarice, married her second husband, she sent Beegle to live with one of

her close friends in Seattle, Washington, for vague reasons. That friend, Mrs. Pittock, who was rich, owned some real estate in downtown Seattle—known as the Pittock block—which Beegle inherited in part and received income from until it was sold in the 1980s.

Mrs. Pittock adored Beegle and raised her as a daughter. Beegle recalled spending time in the woods, loving nature and all animals—even, for a spell, rats. One day, though, the young Elizabeth was feeding a rat she had befriended, when she found herself surrounded by hundreds of its friends. She quickly realized that she would have to be more discriminating with her affections. But Beegle and Tony still managed to collect a menagerie of pets over

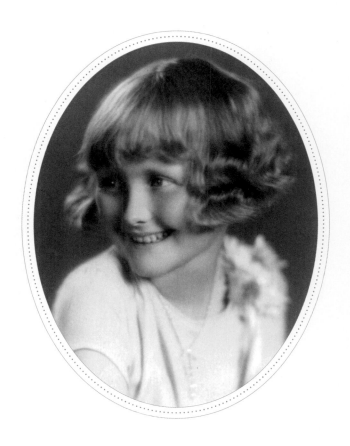

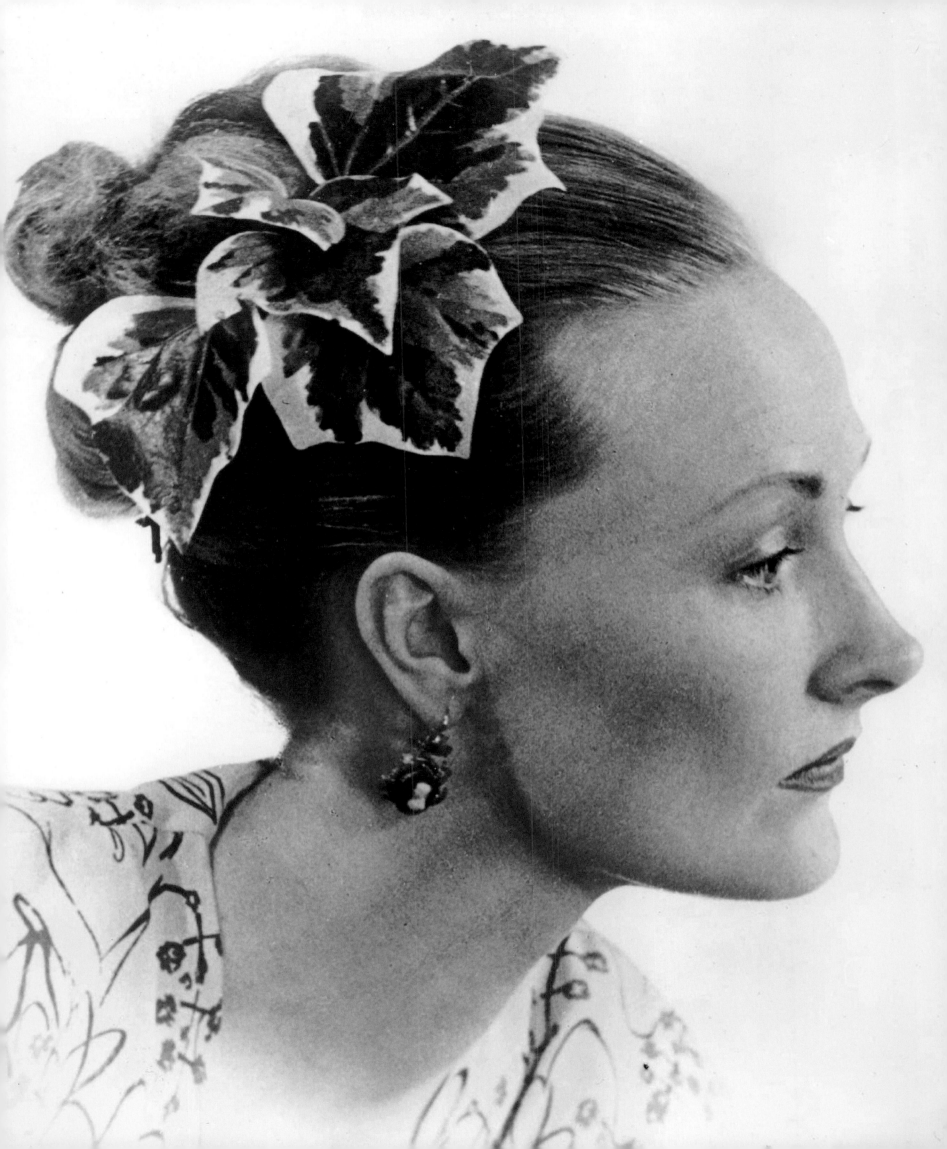

the years, including cats named Kabuki, Weak Eyes, and Catmandu; a dog christened Foxy; an owl known as Emu; and a peacock called Sebastian, who roamed the studio at teatime.

Beegle loved her surrogate mother very much, but her devotion to her real mother never waned. In fact, toward the end of Clarice's life, Beegle bought her a house down the street from the studio she and Tony had on Keith Avenue in Los Angeles.

Like her brother, Beegle attended Chouinard; after graduating she got a job at Disney, moved into her own apartment, and bought a convertible Packard. Later, she took an apartment in the house belonging to Tony's aunt Lucy and decorated it, with Tony's help—outfitting it in what Tony would always reverentially refer to as "the rose chintz."

The couple married on Valentine's Day, 1949, at Pickfair, the Beverly Hills home of Mary Pickford and Buddy Rogers, the matron of honor and best man, respectively. The fabled estate had also been the setting for the wedding of Lord and Lady Mountbatten some years before.

After a small family ceremony at four o'clock, at which Tony's father gave Beegle away, there was a cocktail party at six o'clock, which the one hundred guests were surprised to discover was, in fact, a wedding reception. The guests included Tony's inner circle of Hollywood and San Francisco society. Elsie Mendl rose from her sickbed to attend with her husband, Sir Charles, and her secretary, Hilda West. Hollywood was represented by James and Dodo Pendleton, Louella Parsons, Hedda Hopper, Agnes Moorehead, and Gloria Swanson. Mrs. George Delatour came from San Francisco, joined by writer Charles Brackett and socialite Ogden Goelet.

Beegle looked like a fairy-tale bride, a cross between a Spanish infanta and a medieval princess, in a floor-length gown of antique rose point lace, worn over a pale apricot dress of silk faille. She wore a coronet of jewels and gilded wheat, made for her by her milliner friend Mr. John, and she carried a bouquet of orchids and wheat stalks. Tony designed her ring, a heart-shaped amethyst with a large, old family diamond in the center. The newlyweds would spend their honeymoon in Cuernavaca, Mexico, as the guests of actress Merle Oberon and Italian industrialist Bruno Pagliai. Some months later they followed their honeymoon up with a trip to Elsie Mendl's Villa Trianon.

Early photographs of Beegle show a porcelain beauty dressed in her own inimitable style. She became Tony's perfect design accomplice, wearing his creations and jewelry to far better advantage than any actress or socialite could. On her way into a dinner party thrown by Elsie Mendl, Beegle plucked a sprig of ivy from the garden path approaching the front door and placed it in her hair. Man Ray was so captivated by the sight of her that he insisted on photographing her in exactly the same outfit and hair ornament the next day. He called the photograph of Beegle *Young Girl with Ivy Leaf*.

Photographs of Beegle in the 1950s show her wearing an ever-present rope of pearls, tied together with a large ribbon at the neck. In one interview, Beegle said she was always "happiest wearing things over a hundred years old." She collected vintage clothing, and like Tony, she recycled objects to suit her needs. A grenadier's cartridge case became an evening bag—along with antique brass hand-warmers and old-fashioned cash boxes she lined with velvet and brocade.

OPPOSITE Beegle wearing a collar and hair ornaments made of silk butterflies that she hand-painted, c. 1945.

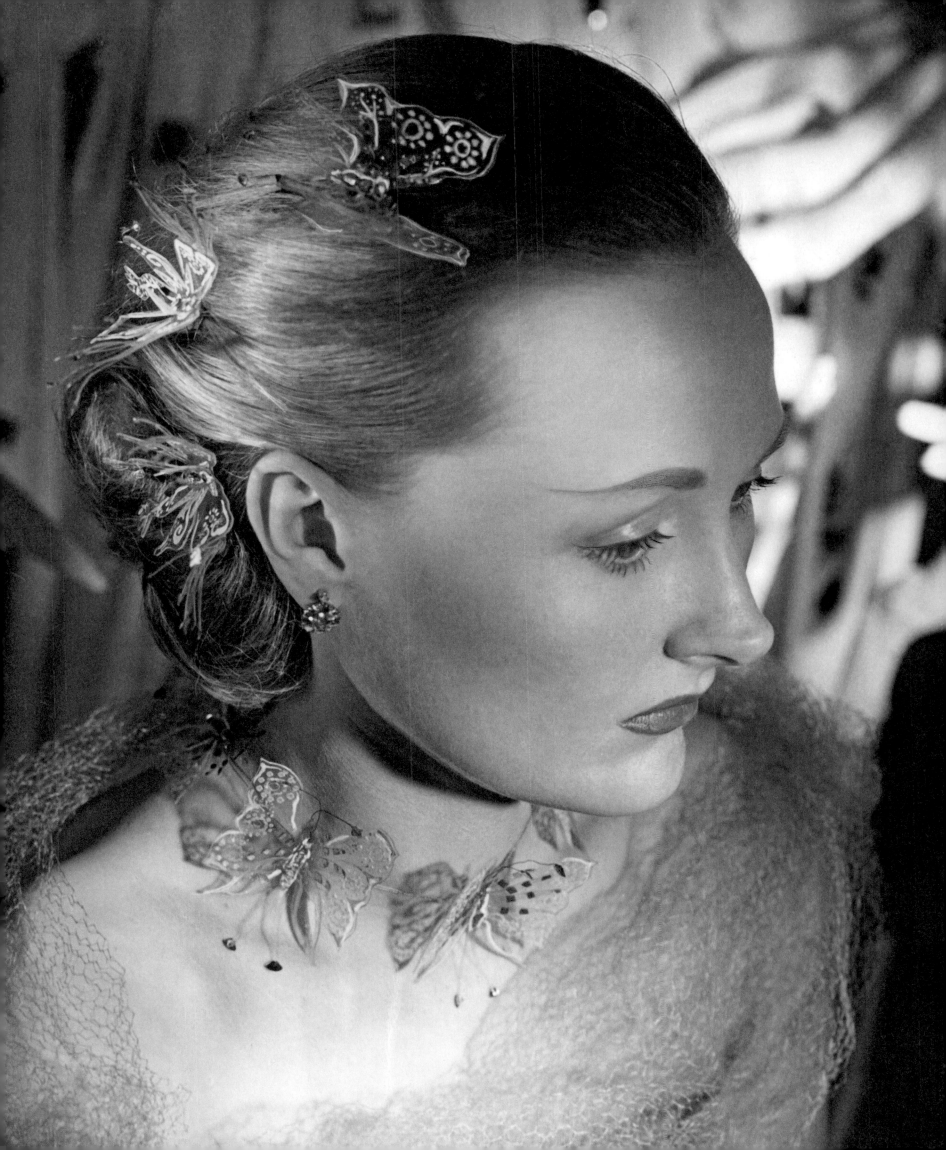

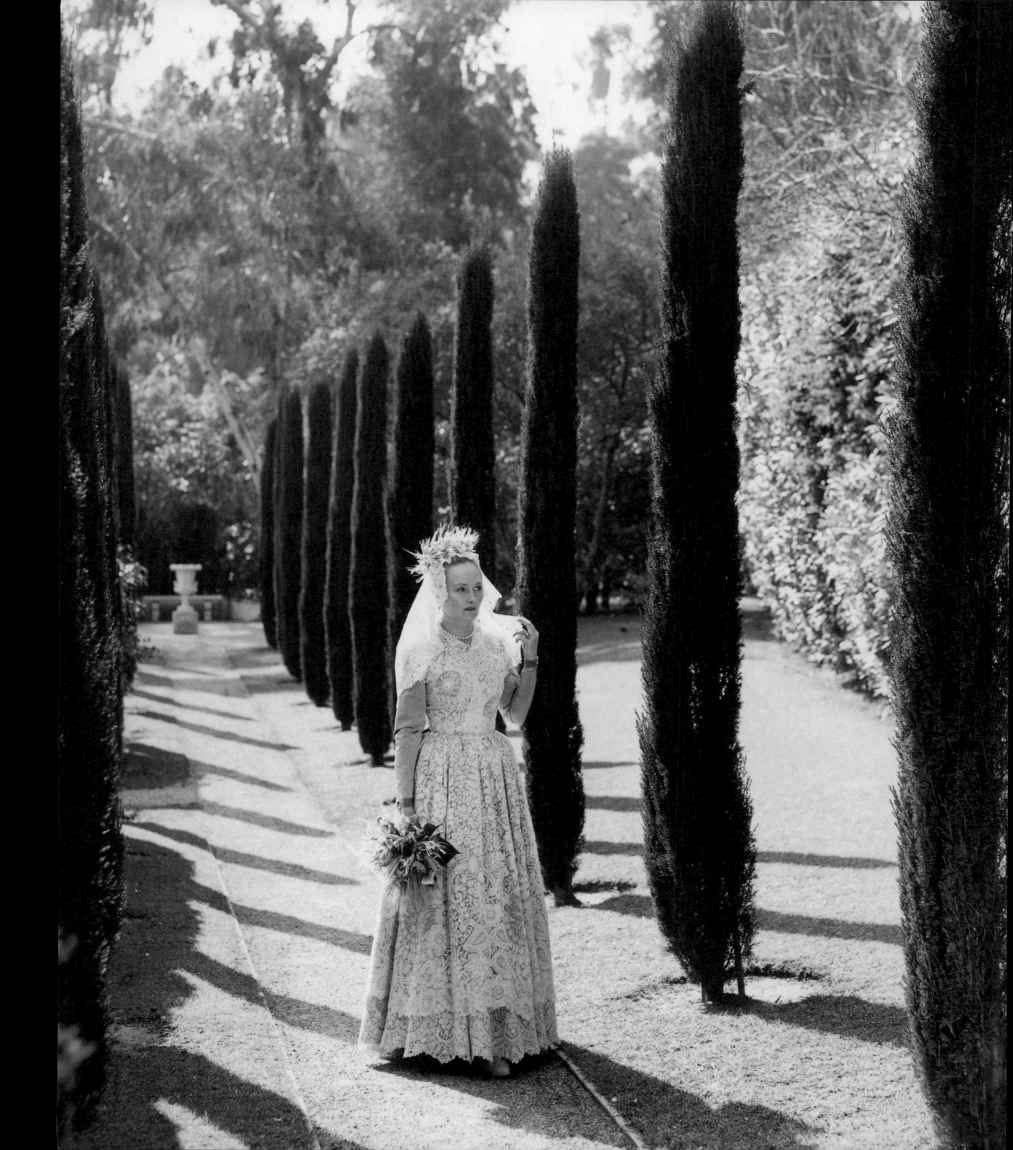

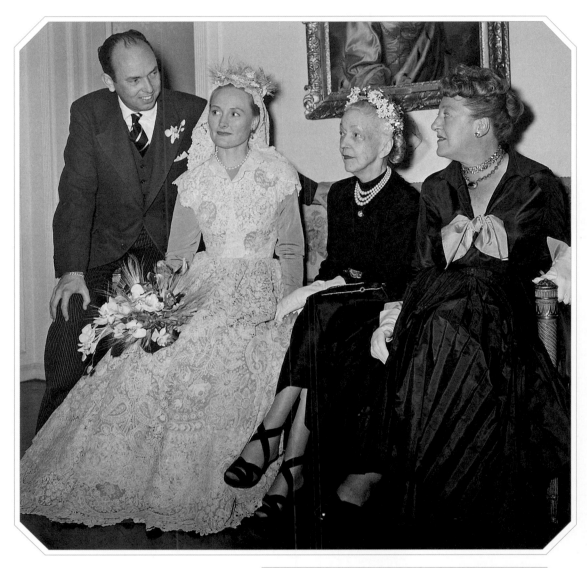

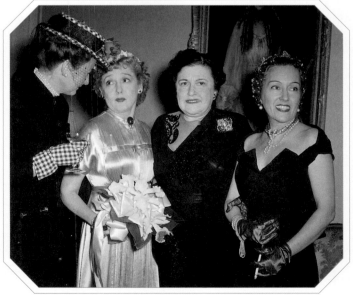

OPPOSITE Beegle had her official wedding portrait taken in the Pendletons' garden in Beverly Hills.

ABOVE Cocktail party following the private wedding ceremony. Tony and Elizabeth "Beegle" Duquette with Elsie de Wolfe and Hilda West.

RIGHT Hostess Mary Pickford poses with Louella Parsons, Gloria Swanson, and a guest.

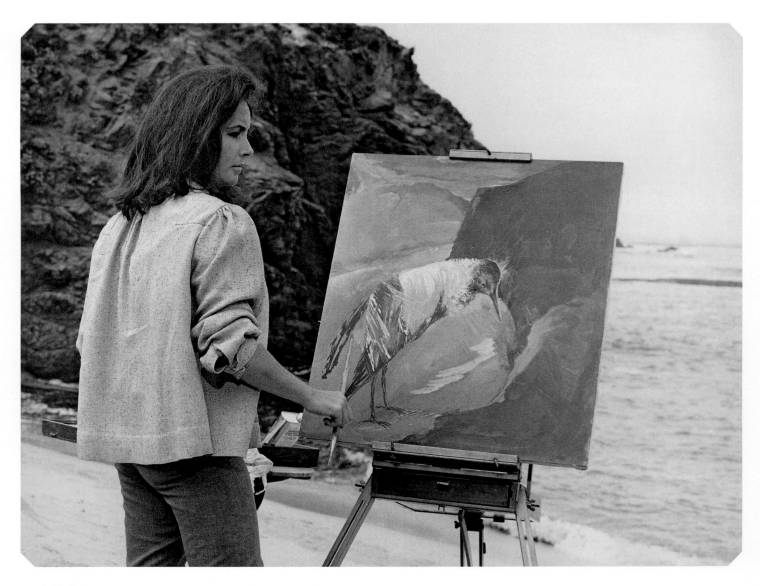

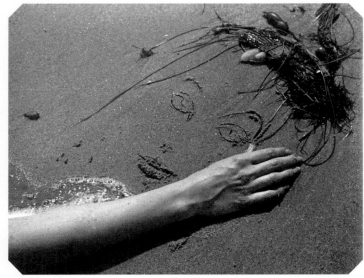

ABOVE Beegle painted all of Elizabeth Taylor's canvases in the film *The Sandpiper* (1965).

OPPOSITE A painting by Elizabeth Beegle Duquette, c. 1960.

LEFT Tony Duquette's photograph of Beegle's hand and drawing in the sand.

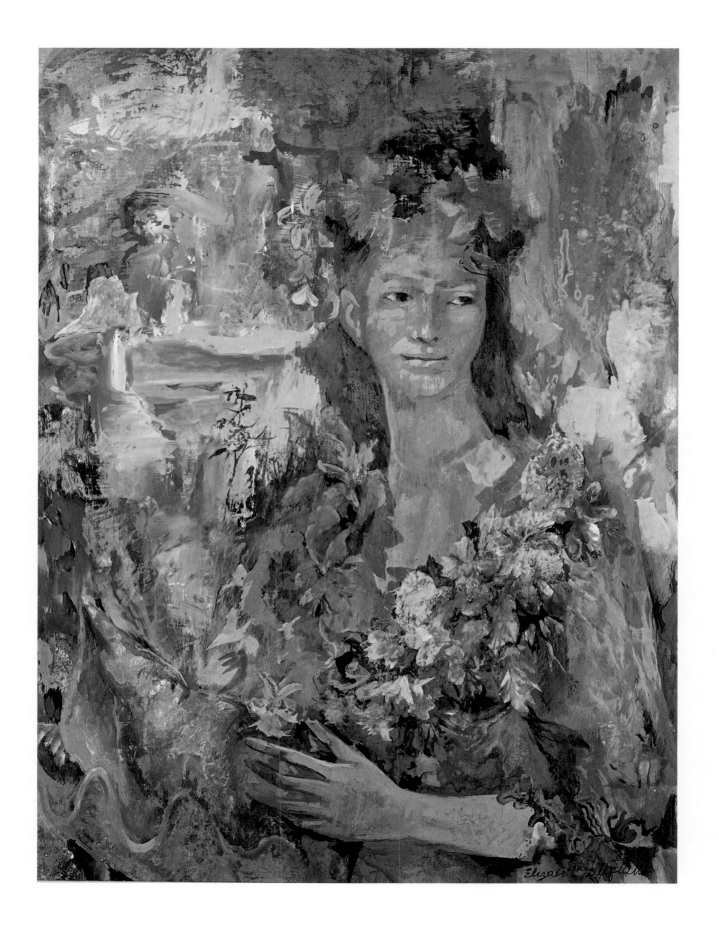

When she wasn't dressed by one of her favorite Hollywood couturiers—Adrian, Galanos, or Gustave Tassell—Beegle liked to wear Chinese robes and Indian saris at home. She didn't think twice about making an evening dress out of old castle draperies, and would instruct her tailor to make her suits with the fabric inside out if the reverse color was to her liking. She liked to accessorize her dinner dresses with a vest she had made from an eighteenth-century gentleman's coat, and her 1890 Worth peacock blue robe became a favorite evening wrap. She was acknowledged as one of Los Angeles's leading style makers, receiving the *Los Angeles Mirror News* "Best Dressed for Her Life Award" in 1959.[1] Excepting in one photograph, Beegle was never seen without her hair pulled straight back and gathered into a tight chignon, in the shape of a golden croissant, at the back of her head. She never wore clothes that reflected trends or fads but always stayed true to her own sense of freedom and independence.

Beegle was a serious artist and dedicated herself to painting until the last years of her life, when she became ill with Parkinson's disease, but it wasn't until 1957 that she had her first one-woman show, at San Francisco's M. H. de Young Museum. Her gouache paintings usually depicted spiritlike children in dreamy landscapes reminiscent of Picasso's Blue and Rose periods. The writer, producer, and director Delmer Daves called her a "poetess with paint."[2] The show was written up in the San Francisco and Los Angeles papers; the accolades came a year after the opening of Tony and Beegle's acclaimed studio on Robertson Boulevard. Beegle's work was well known to her friends and was commissioned by Elsie Mendl and many other patrons of Tony's.

In a story that appeared in *The San Francisco Examiner*, Beegle said that her paintings were done from memory, that she rarely used models or sketches, and that for the de Young show she often had as many as twelve canvases going at once. The *San Francisco Chronicle* reviewer wrote, "Elizabeth Duquette handles the human figure very skillfully but rather bloodlessly." Another critic described her paintings as "very much like their creator. Delicate of color, pure of line, tranquil, serene, with a disarmingly artless, medieval sort of grace." The reviewer went on to add, "And what is true of the slender blonde wife of the famed interior decorator Tony Duquette seems also true of her work, to wit: Everyone loves her."

The real treasures of her hand, however, can be found in letters and sketchbooks that she embellished with drawings of people and places encountered in her travels with Tony. She painted all of the canvases for Elizabeth Taylor's character in Vincente Minnelli's 1965 movie *The Sandpiper*, most of which Taylor purchased when the filming was completed. During work on that film, MGM insisted Beegle work with acrylic paints rather than her traditional oils, to which she never returned.

In 1995 when Beegle succumbed to Parkinson's disease at the age of seventy-eight, she was still startlingly beautiful and as impeccably dressed as ever, with her blazing orange silk scarf pulled through a lapis lazuli ring at her neck. On the day of Beegle's death, Liza Minnelli arrived at Dawnridge, the house Tony had shared with Beegle since 1949. Together they held hands and watched every MGM movie on which Liza's father Vincente and Tony had worked.

OPPOSITE This photograph was taken in the garden at the Duquette Studio on Robertson Boulevard in Hollywood. Beegle usually enjoyed painting in the solitude of her studio, but on occasion would move outdoors.

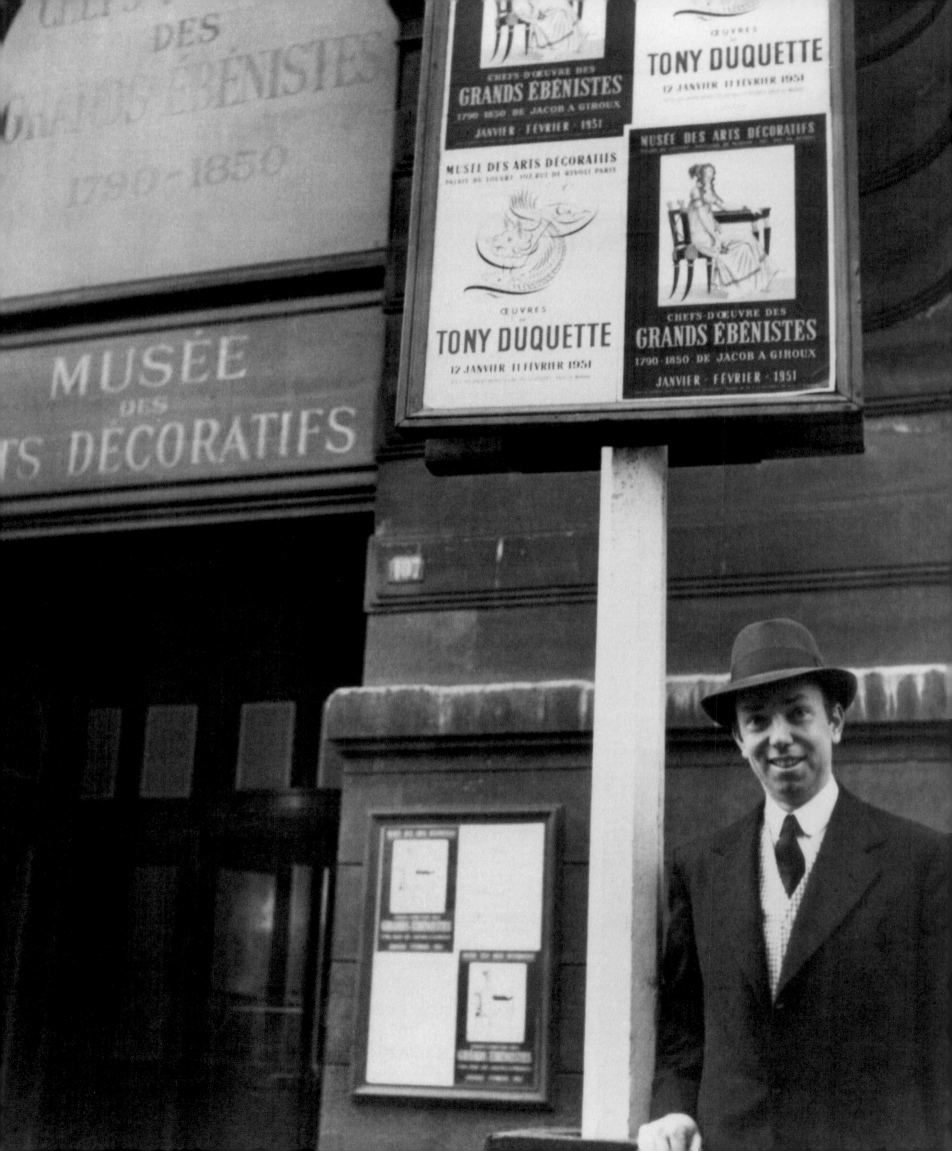

PARIS

I didn't think anyone would come.

Tony Duquette on the night of his opening at the Louvre, Paris, January 1951, from Cobina Wright's column, "Society as I Find It"

Tony's first trip to paris was with Lady and Sir Charles Mendl in 1947. He set out on a four-month whirlwind tour to meet potential patrons and reconnect with the numerous Europeans he had met in Beverly Hills, where many had gone to sit out the war.

One of those old friends was Paul-Louis Weiller, who, at Elsie's urging, sponsored Tony's one-man show at the Louvre Museum a few years later (the first for an American). Weiller, a rich industrialist and war aviator, had a passion for eighteenth-century decorative arts and for collecting the best of everything, including numerous historic houses, many of which Elsie had decorated. In 1939 he purchased the Jubilee Diamond from Cartier, one of the five largest diamonds ever cut. His after-dinner trick was to take the diamond out of his pocket and try to balance the stone on one of its facets. He liked to carry it around in his pocket like a set of worry beads.

OPPOSITE Duquette poses under his exhibition posters in front of the Pavilion de Marsan of the Louvre, c. 1951.

L' oeuvre de Tony Duquette
n'est pas plus concertée que
le rêve.
 Ses oeuvres sont des rêves pris
aux filets de la réalité

Louise de Vilmorin

30 Déc. 1950

"The works of Tony Duquette are no more preconceived than dreams,
...orks are dreams caught in the net of reality." – Louise de Vilmorin.

...ITE Duquette at the Pavilion de Marsan at the Louvre.

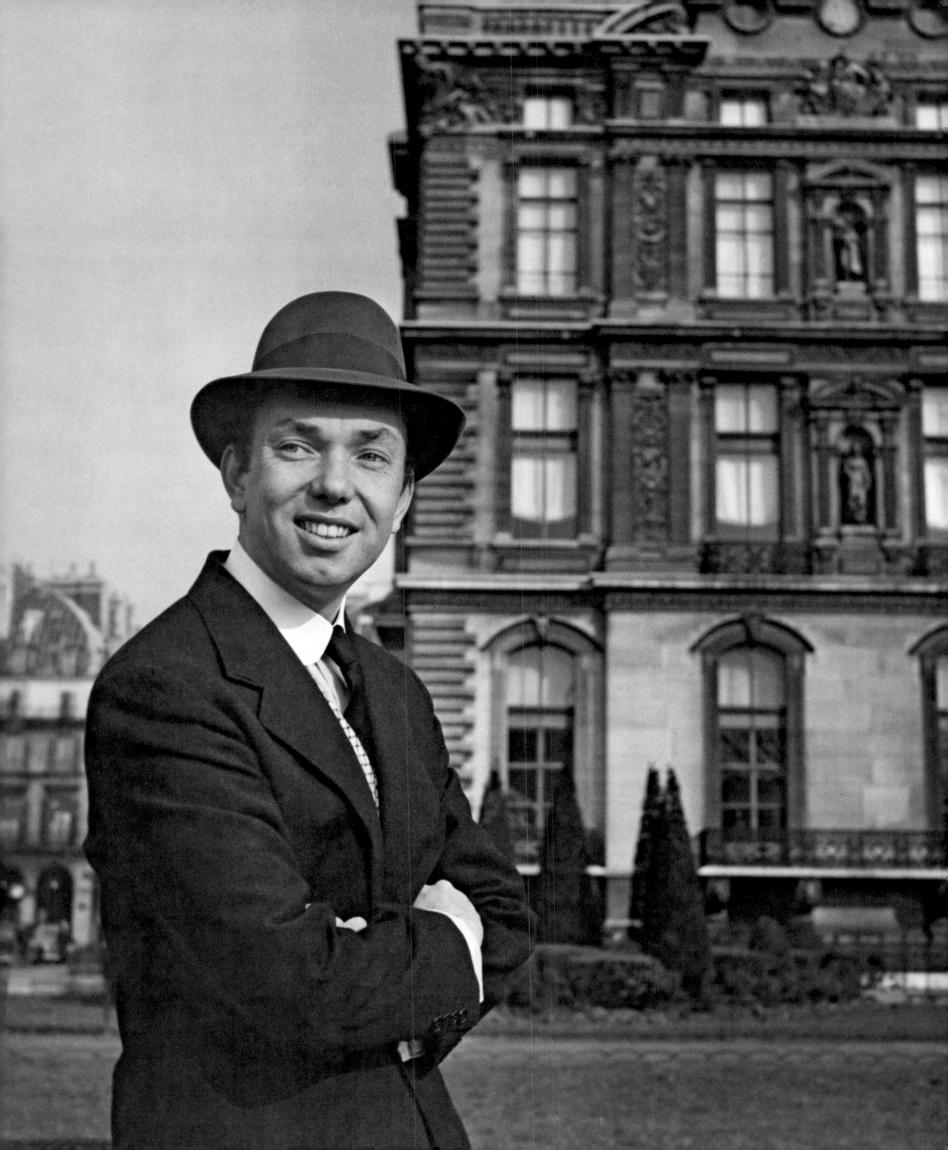

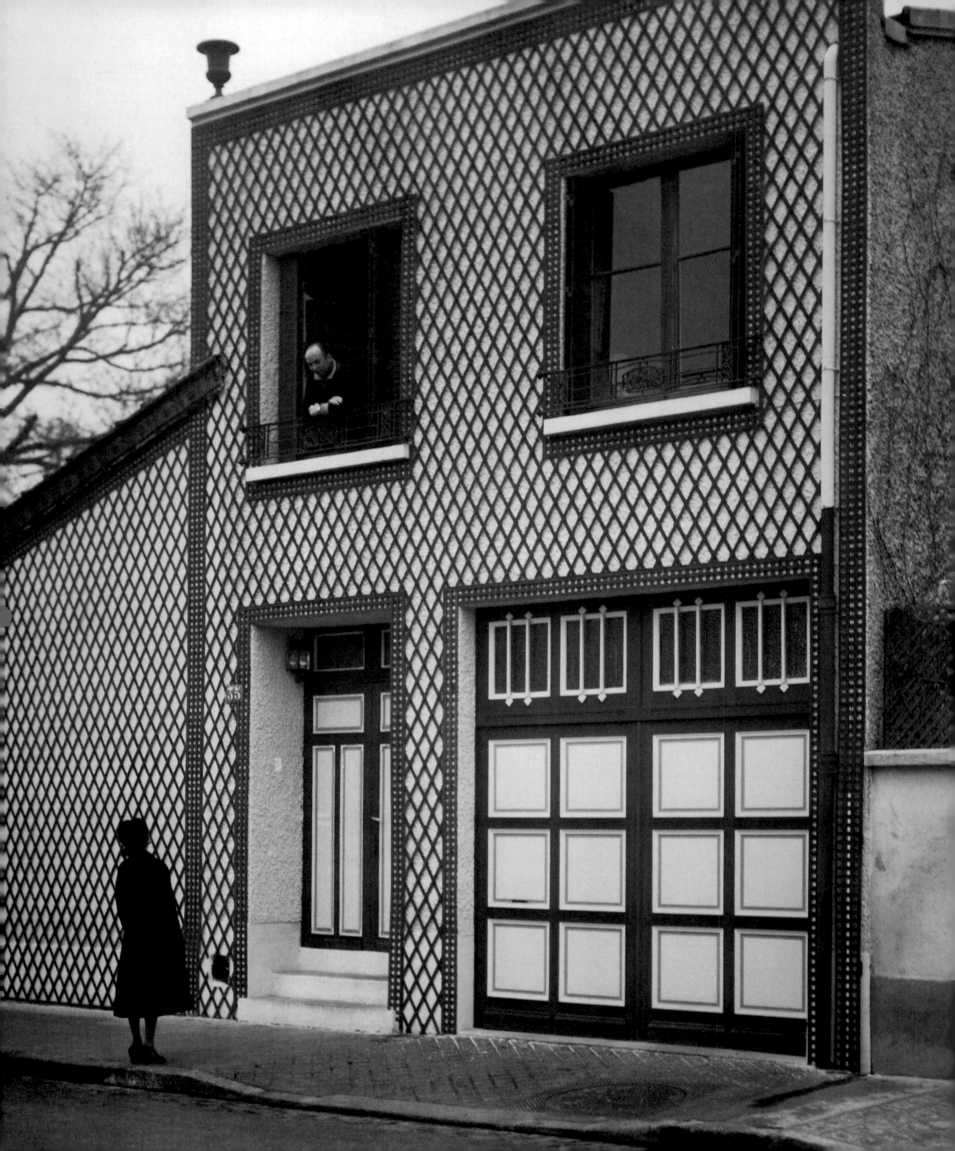

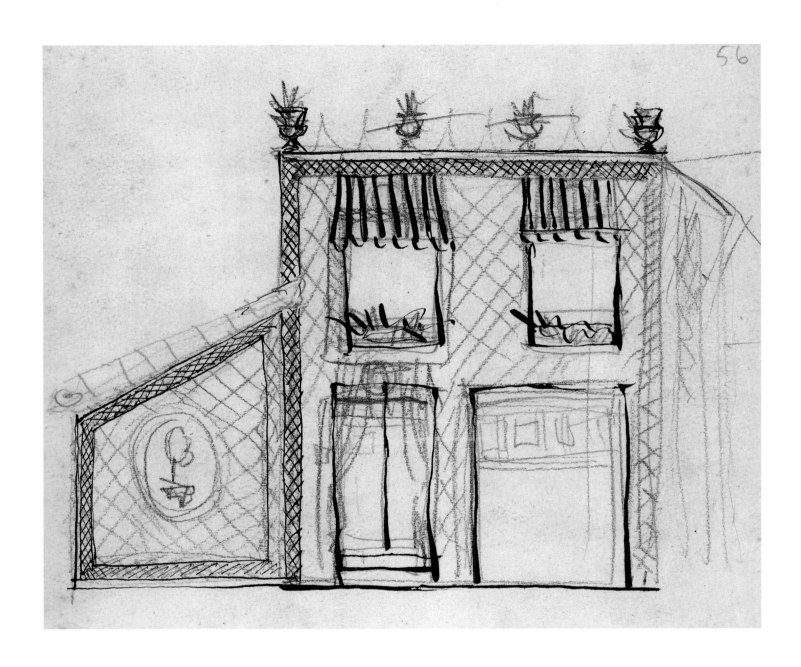

OPPOSITE Tony Duquette talking to Beegle from the window of the Porcelain
Pavilion, their carriage house in Neuilly, France, c. 1951.

ABOVE Original sketch of exterior of the Porcelain Pavilion, Neuilly.

OVERLEAF LEFT Interior view of the Porcelain Pavilion staircase.

OVERLEAF RIGHT Original sketch for the staircase of the Porcelain Pavilion.

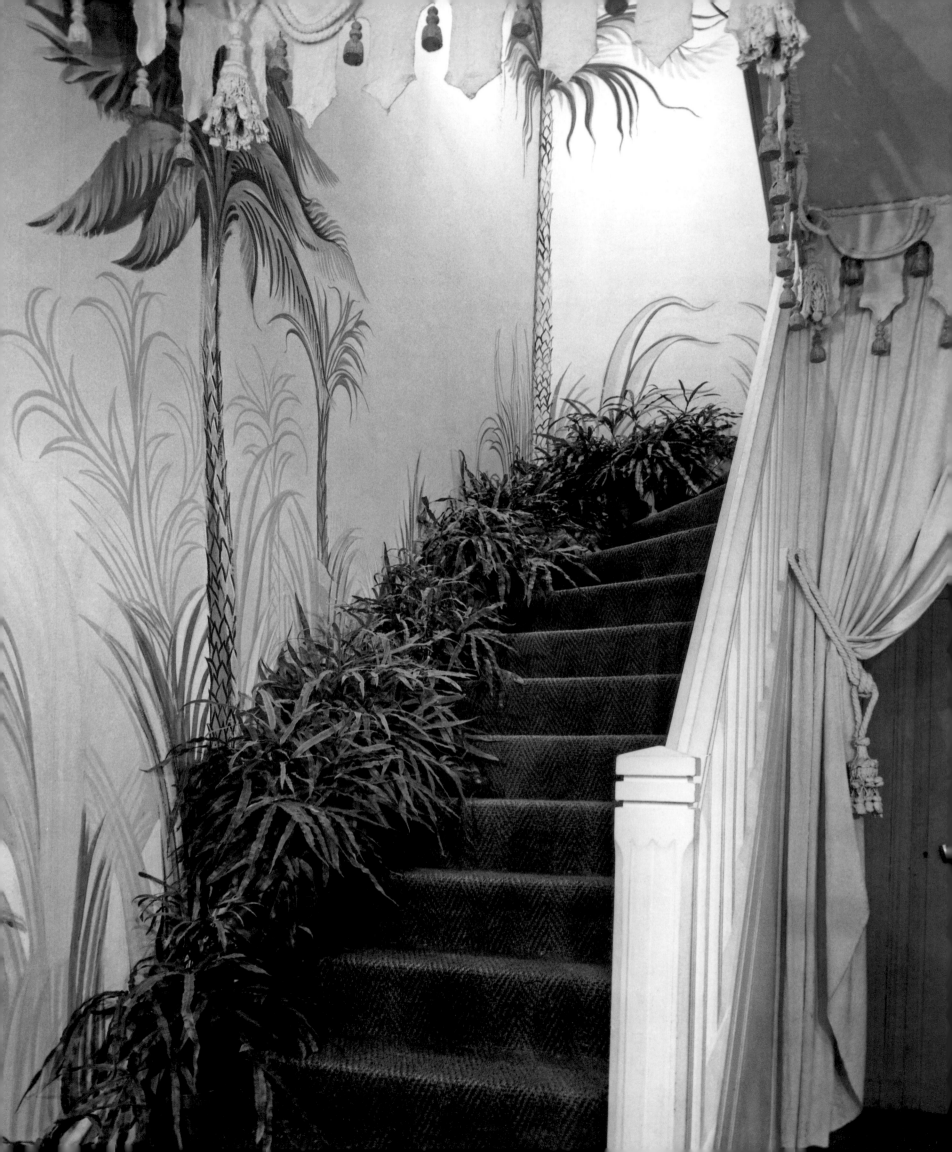

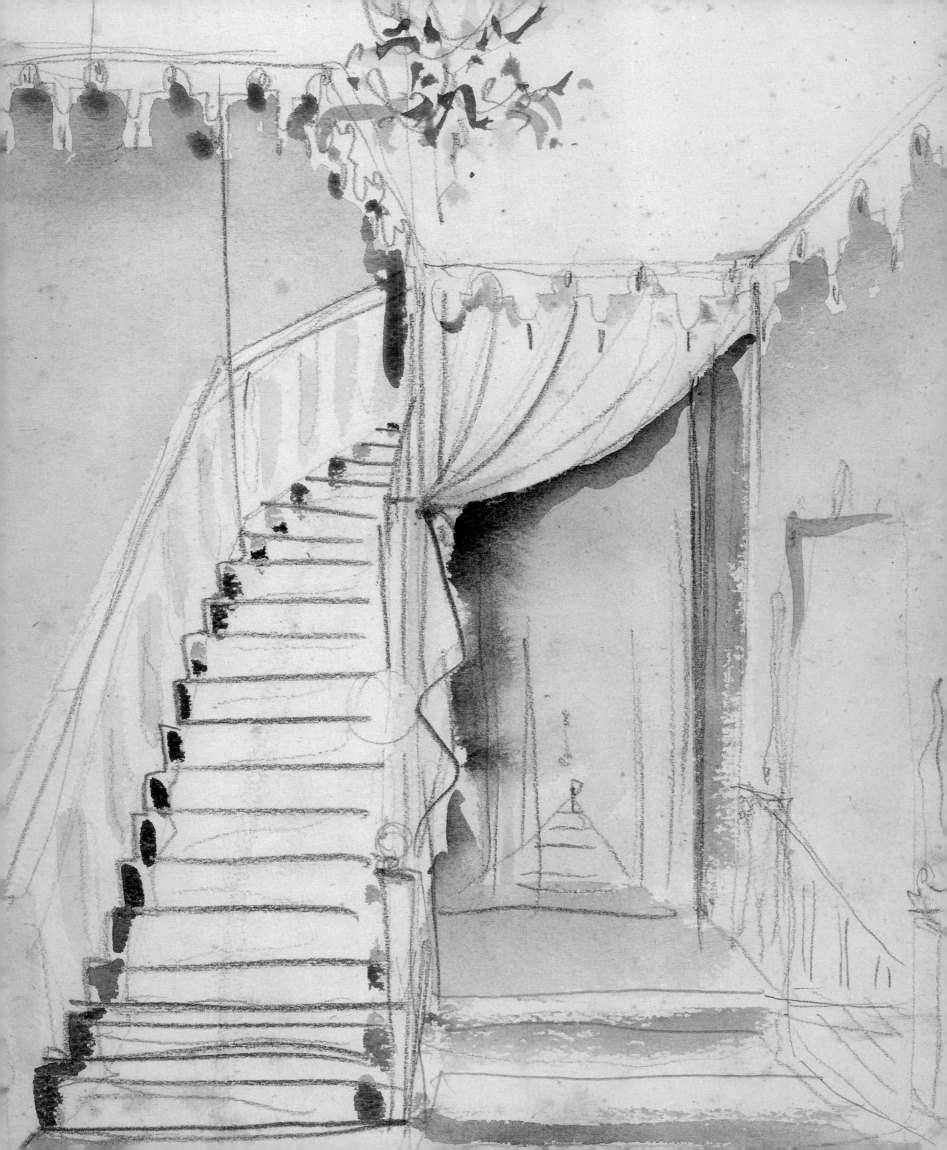

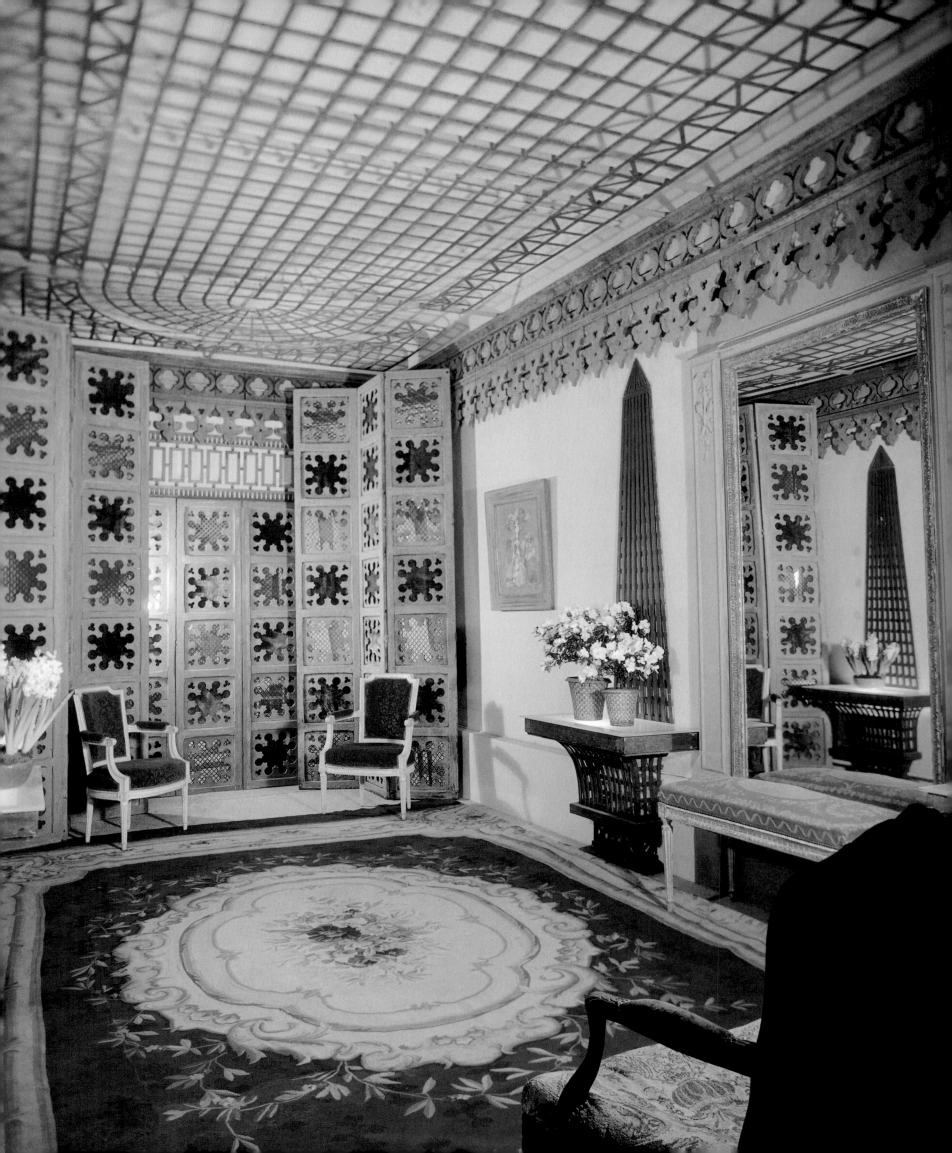

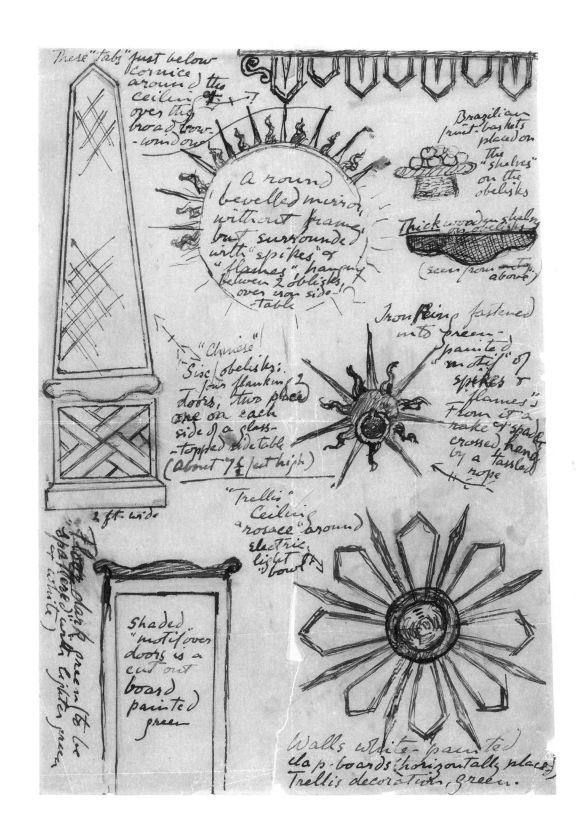

OPPOSITE Former carriage house designed by Duquette as a drawing room, with fragments of old treillage he discovered in the Paris flea market.

ABOVE Duquette's sketches and notes for treillage consoles and obelisks.

Weiller, in his quest for the best, made a deal with Elsie to buy the Villa Trianon, as well as her famous three-strand pearl necklace. He did not take possession of either until after Elsie's death in 1950.

For anyone visiting Paris right after the war, the romance and adventure of the dazzling city had to have been tempered by the trauma of the recently ended German occupation. In February 1947, Christian Dior made fashion history by revitalizing French couture with the first collection under his own name. The wasp-waisted, full-skirted silhouettes so excited *Harper's Bazaar* editor Carmel Snow that she declared the collection had ushered in the New Look.

A month after the fashion press went wild for the New Look, an incident illustrated the sense of outrage that many Parisian women felt in the aftermath of the war's deprivation and rationing. During a photo shoot on location in the middle of the Rue Lepic market in Montmartre, models wearing Dior's extravagant dresses were attacked and physically beaten by a group of women who tried to tear the clothes off their backs.

In this atmosphere of underlying tension mixed with the excitement of the new, Elsie and her entourage embarked on their return to her beloved Villa Trianon in Versailles. Aside from Tony and Sir Charles, she was accompanied by her secretary, Hilda West, her health guru, Gaylord Hauser, and the writer Ludwig Bemelmans, whose fanciful account of the trip is described in his book *To the One I Love the Best*.

The hardships of postwar Paris simply wouldn't dampen Elsie's spirits. The first stop before arriving at Versailles was at the Ritz Hotel for a night, where the group discovered the grand institution humbled by the lack of heat, electricity, and elevator service. Once at the villa, they again found no heat, electricity, or running water, but Elsie was in heaven nevertheless. According to Bemelmans's account, at one point Elsie asked Tony to go into Paris and buy a Picasso she had seen in a gallery on the Place Vendôme—"an old blue Picasso."[1] When Tony pointed out that the painting cost twenty-five thousand dollars, Elsie was undeterred.

Settling back into the villa brought one surprise after another. The SS officers who had used the house as headquarters during the occupation had failed to find a well-hidden gold unicorn by the Renaissance goldsmith Cellini. What they did find was Elsie's silk underwear, which they donned in an impromptu cabaret scene featured in the home movies that—legend has it—were later discovered.

Elsie's determination brought the forlorn villa back to life. For Tony it must have been paradise to help reinstate Elsie in her legendary home. He was certainly enraptured discovering the neighboring Palace of Versailles. He wrote to his aunt Lucy of touring the private apartments of the royal families, citing a clock of Marie Antoinette's and "the little music room of Madame Adelaide where the child Mozart came to play." He explored the palace gardens at midnight by the light of the moon and a gatekeeper's lantern. He could roam the historic grounds by direct access through a secret garden gate, which he found unlocked at the back of Elsie's property. Because Villa Trianon was a former royal property, the

OPPOSITE Entrance to the Porcelain Pavilion with Tony's catbird figurine perched on the console.

OVERLEAF Beegle posing in the upstairs sitting room of the Porcelain Pavilion, c. 1951. She is wearing a gown fashioned from an antique court train found in the Paris flea market.

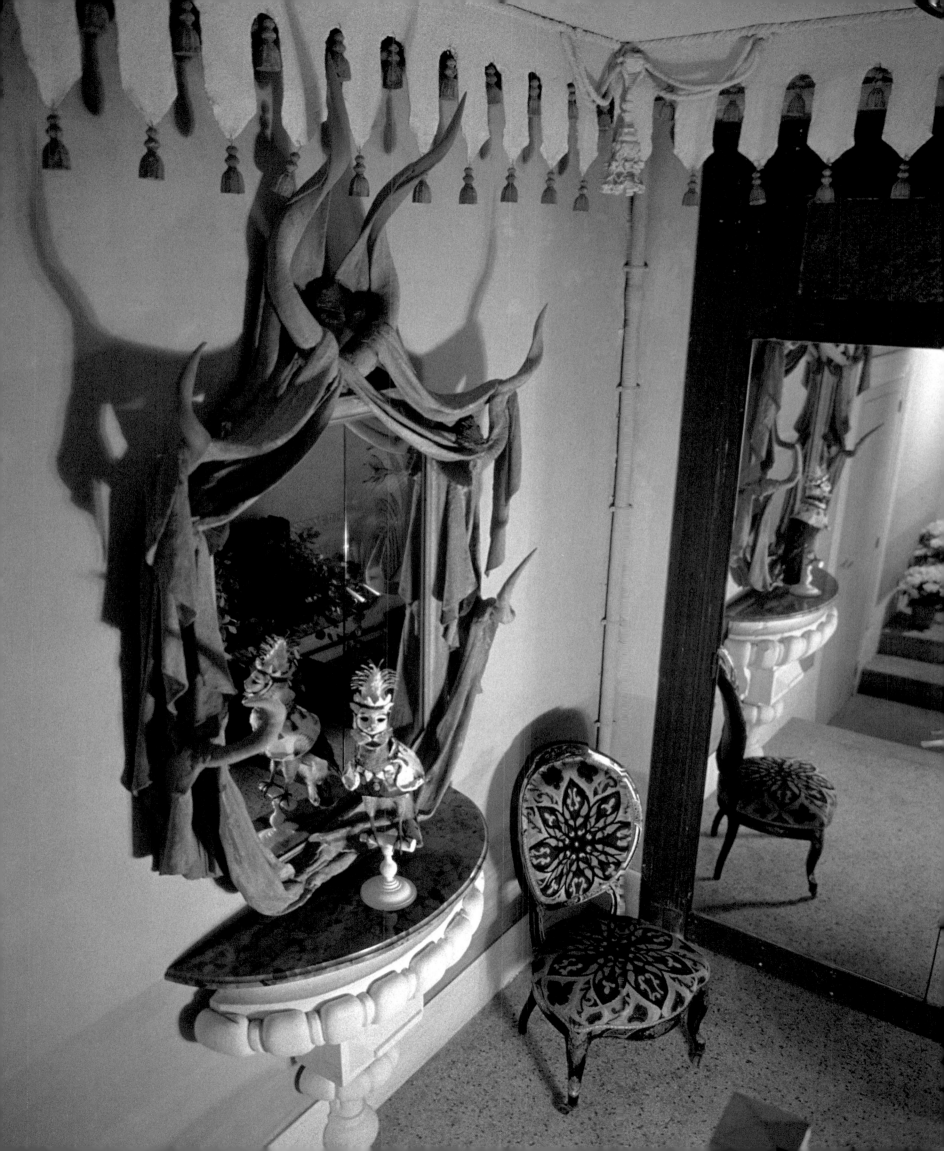

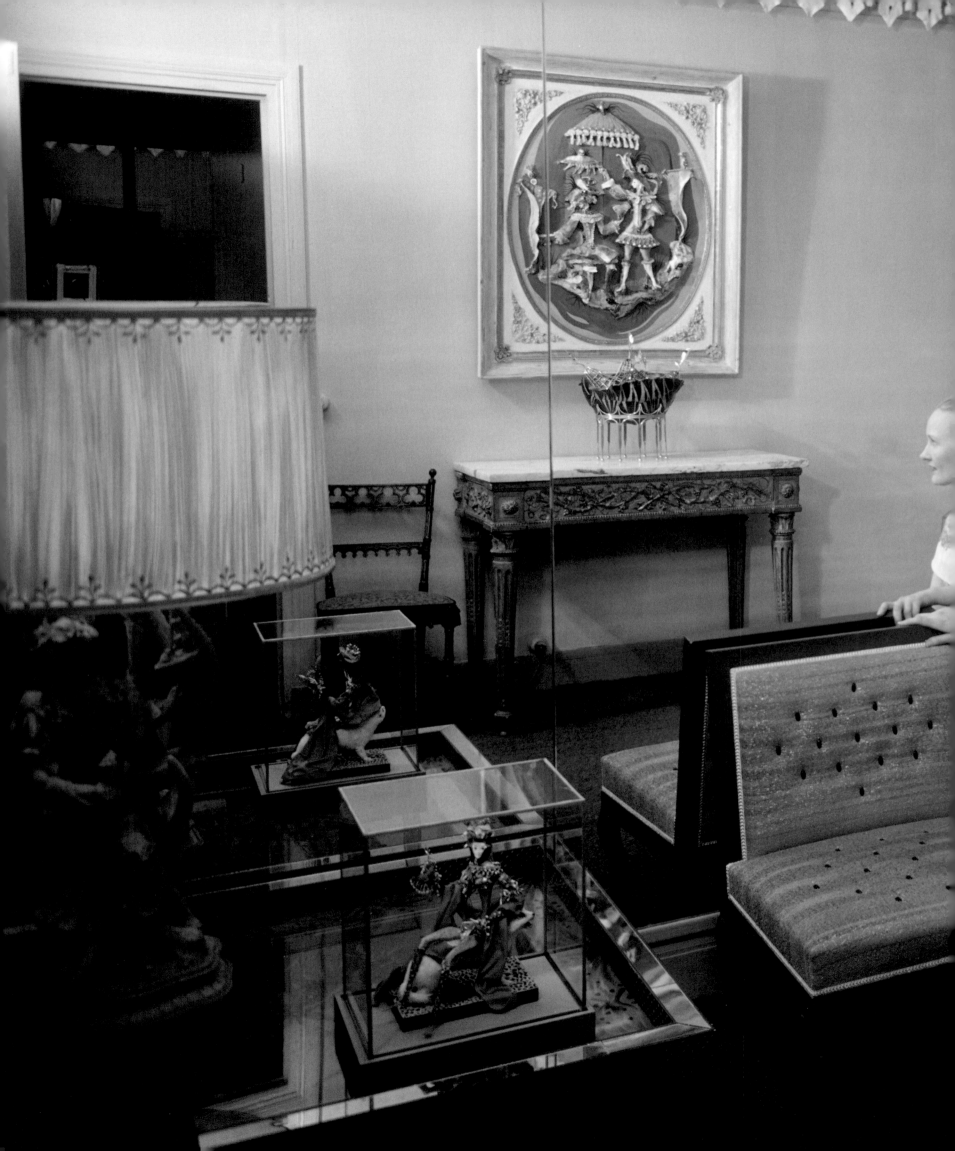

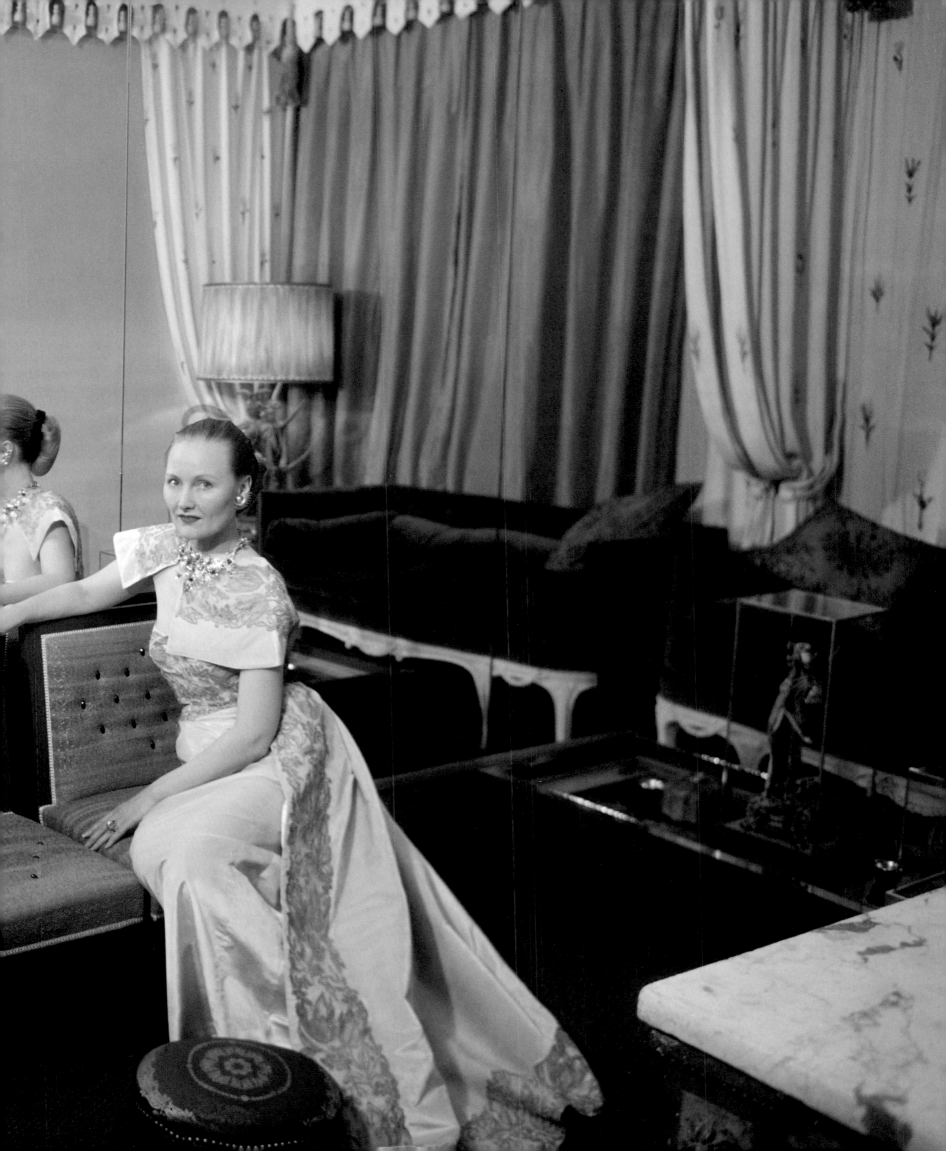

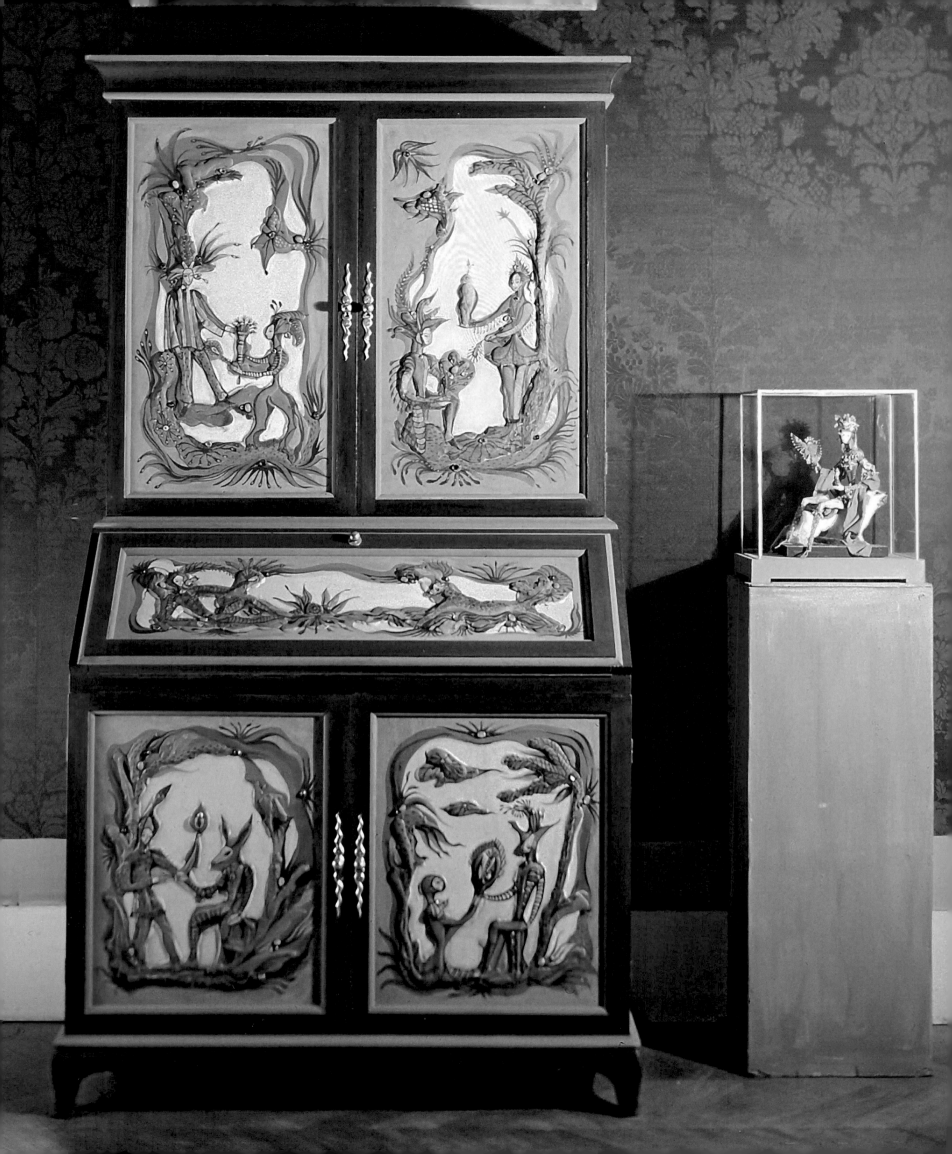

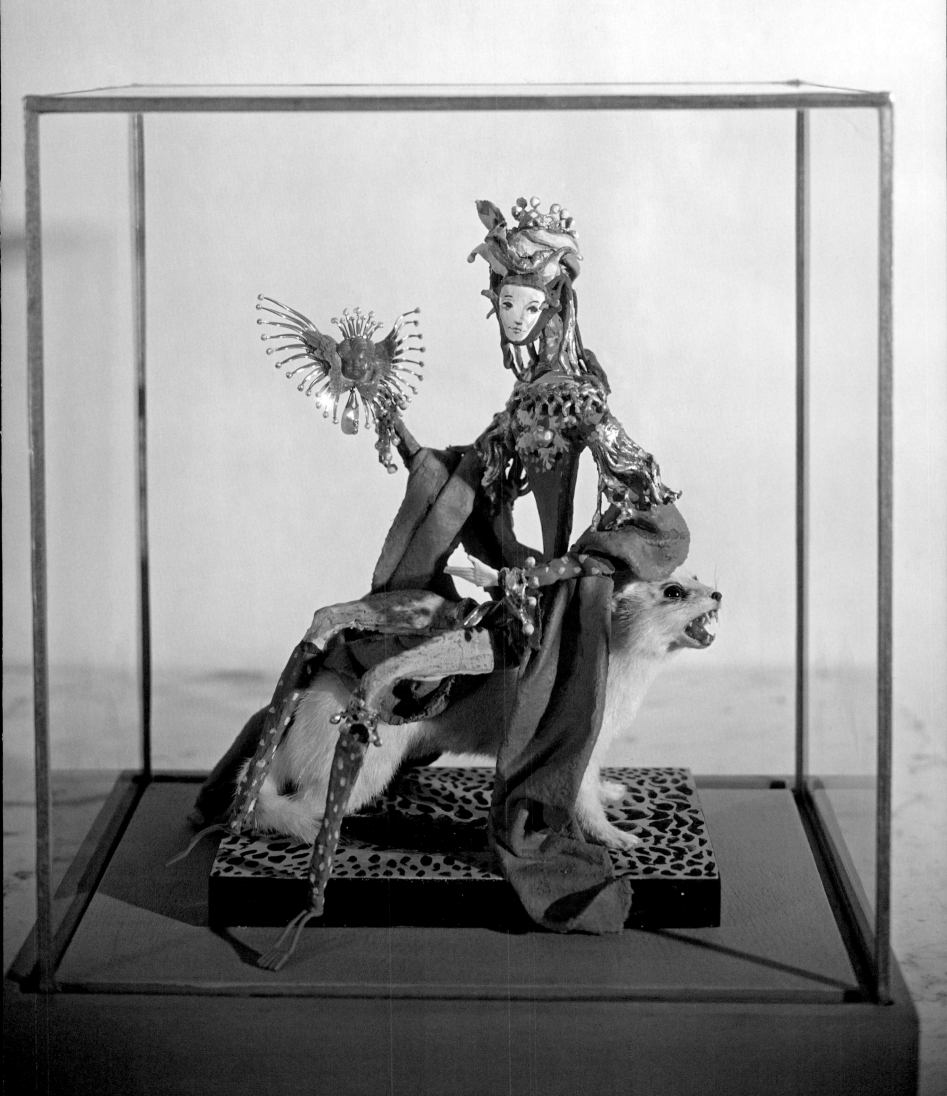

French king reserved the right to access it from his own palace at Versailles, but until the night that Tony found the gate open, Elsie had always presumed it had been permanently locked since the French Revolution.

The events of this trip opened the door to the total immersion of creativity that would define the rest of Tony's days, marking 1947 as a turning point in his life. On this trip Tony would have visited, at Elsie's suggestion, the famous Barozzi collection in Venice and, of course, fallen in love with everything Venetian. He was coming off the success of his first exhibition at the Mitch Leisen Gallery in Los Angeles and had ten thousand dollars in cash to spend, a fortune at the time. He reported that right after the war he could buy a stack of eighteenth-century paintings in the back of any church in Italy for fifty dollars.

He also amassed a good deal of antique furniture on this trip. One of his favorite finds was a beautiful Louis XVI stool, of which he was very proud. When showing his "rare" find to Elsie, she shattered his enthusiasm by saying, "Very nice—a dime a dozen on the Rue de Rivoli!"

Elsie returned to Beverly Hills between 1947 and her death in 1950. After Tony and Beegle's wedding, she invited the newlyweds to come to Versailles as part of their honeymoon. Tony returned to Paris with Beegle in May 1950 to organize his upcoming Louvre show. This was also to be the last year of Elsie Mendl's life; she was dying, but still holding court at her Versailles villa. While Tony was ministering to Elsie and working out the installation of his exhibition, he and Beegle were also ambitiously tackling the logistics of fixing up a small carriage house in Neuilly. It had been lent to them by their patron Paul-Louis Weiller for the duration of their stay in Paris.

They dubbed the pint-size establishment the Porcelain Pavilion and entertained in the grand, bohemian style for which they would become famous. The French were captivated. *The New York Herald* reported, "It is the only house we have ever seen anywhere that has an Aubusson carpet in the garage."[2] In the same article Tony explained, "When the party is over, we just roll up the rug and drive the car in. It's really the only thing to do in a house as small as this one."

In fact, Tony believed garages to be a useless waste of space and always converted his into sitting rooms. With a birdcage hanging over the bathtub, and its mirrored and hand-painted walls, the house was a microcosm of Tony's unique style. The total transformation of the run-down carriage house into a Neobaroque, Surrealist jewel box enchanted all who saw it. The frenetic pace of accomplishing the transformation was detailed by curious journalists eager to track the glamorous American couple. Their progress was reported back home in one headline that read, DUQUETTE'S PREVIEW A NIGHTMARE.

"At last the worst part of everything seems to be over," Beegle wrote in a letter to a friend back home. "We had a difficult time doing the house and the exhibition at the same time, particularly as it became too cold to work in the garage all the time and the painters were here at least three months. Now that the rug is down they have decided to install central

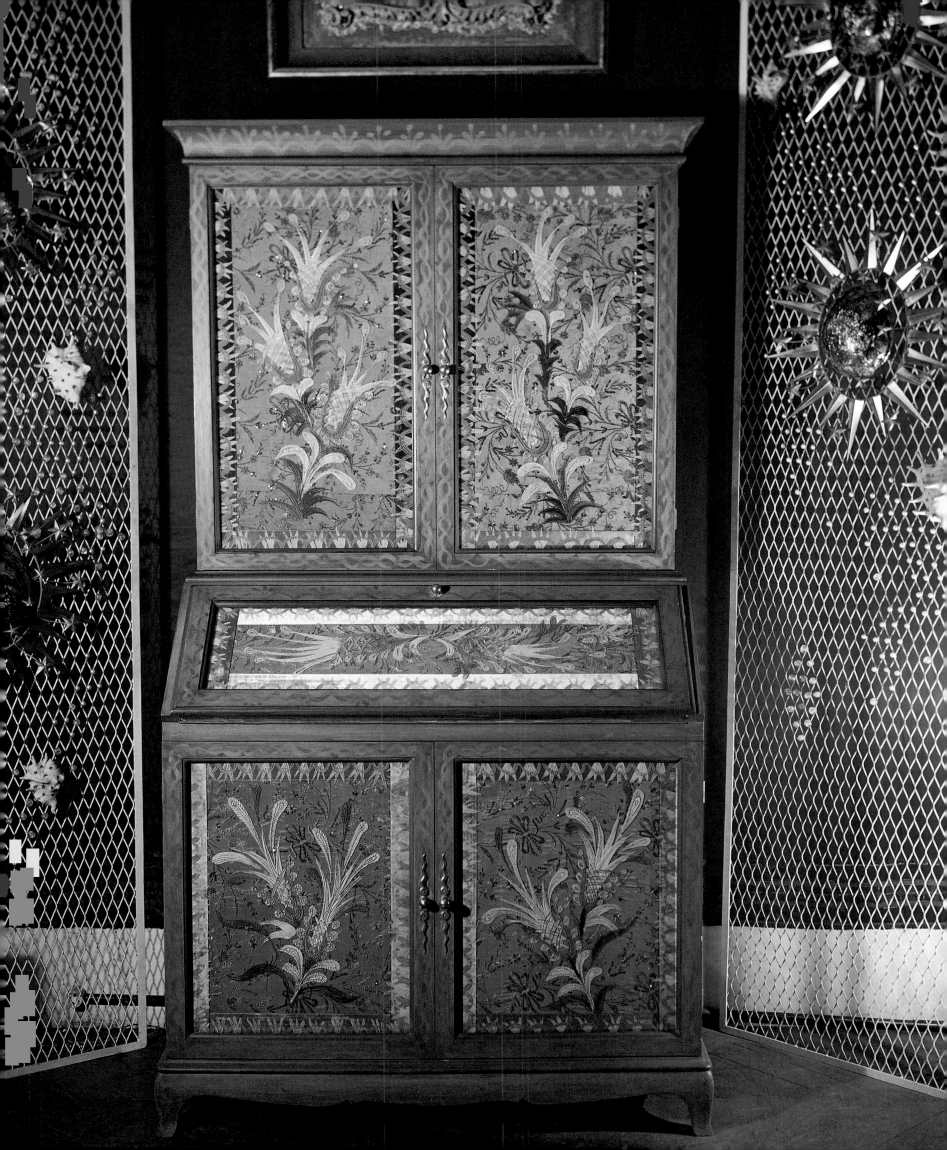

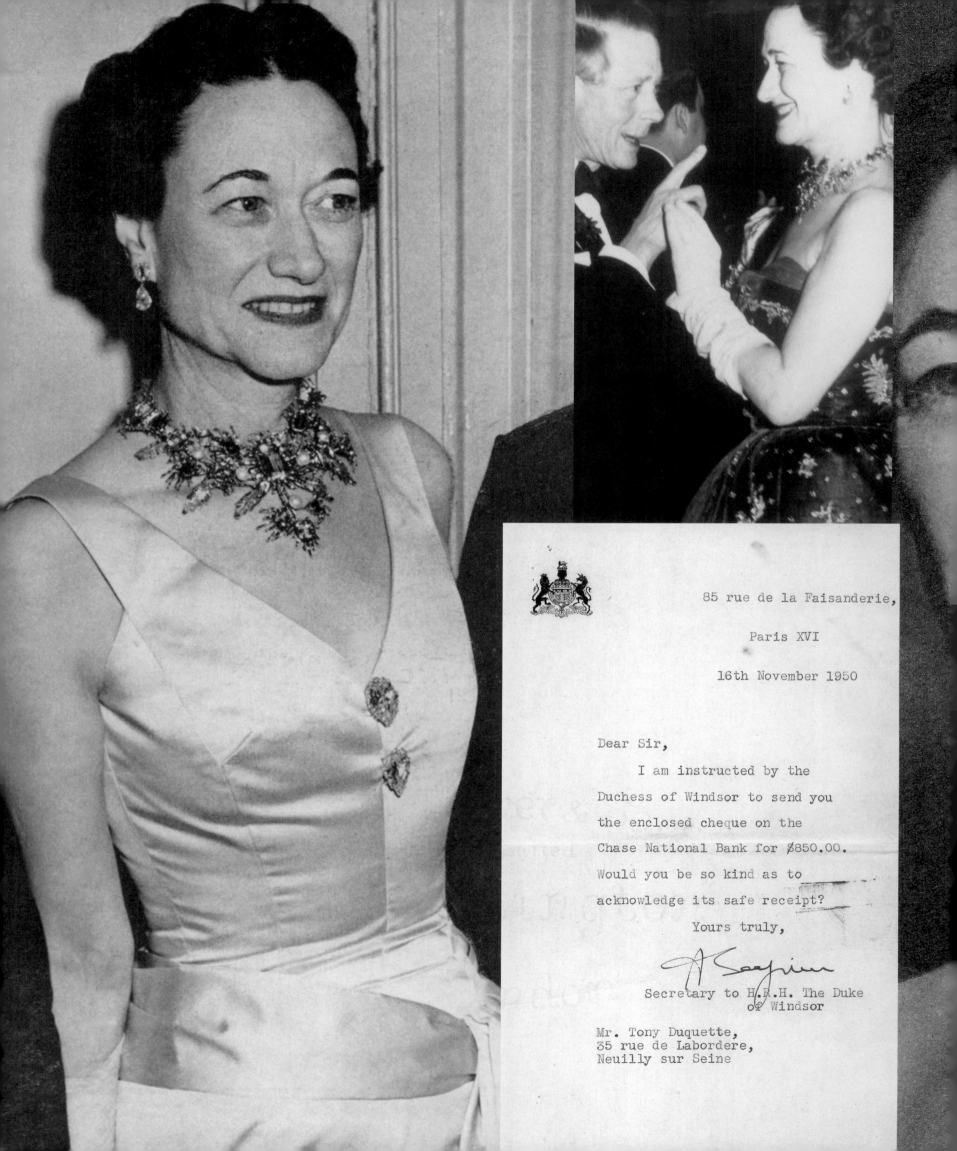

85 rue de la Faisanderie,

Paris XVI

16th November 1950

Dear Sir,

I am instructed by the
Duchess of Windsor to send you
the enclosed cheque on the
Chase National Bank for $850.00.
Would you be so kind as to
acknowledge its safe receipt?

Yours truly,

Secretary to H.R.H. The Duke
of Windsor

Mr. Tony Duquette,
35 rue de Labordere,
Neuilly sur Seine

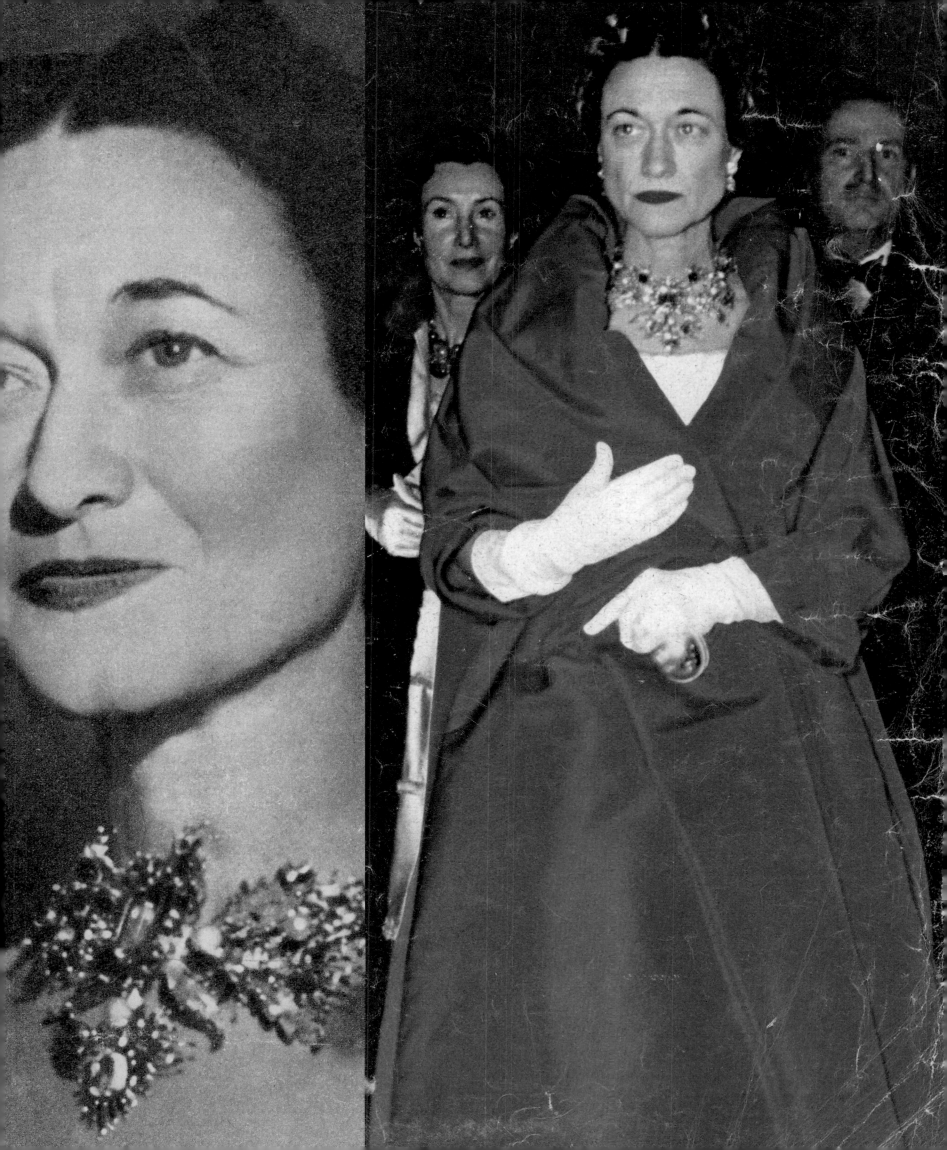

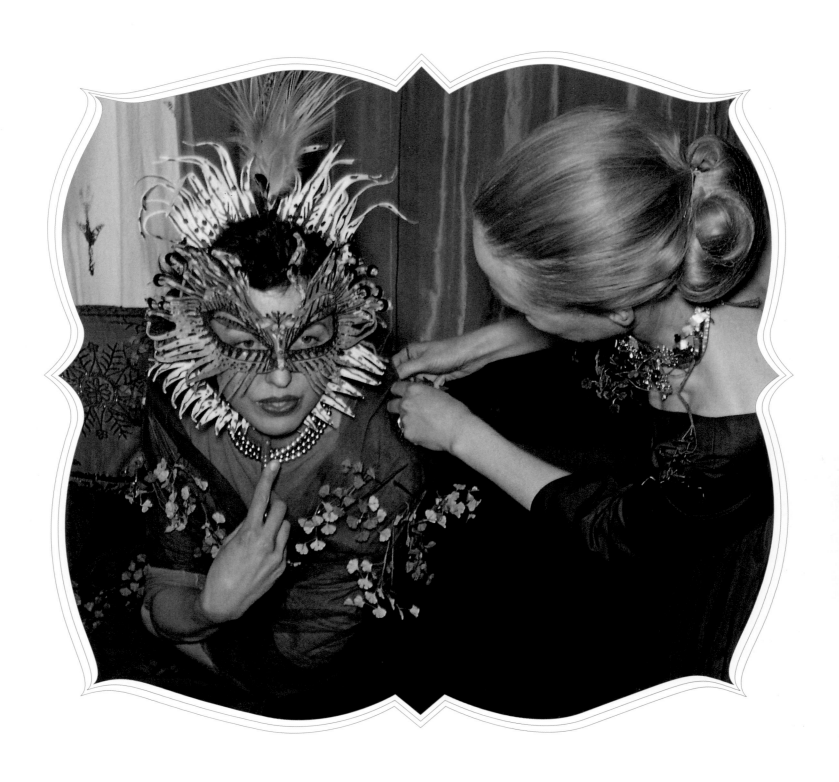

ABOVE Beegle fits a Duquette-designed mask on Mrs. Harrison Williams for the Vicomtesse de Noailles's ball.

OPPOSITE Beegle dressed as the forest at the Noailles's ball, *La Lune sur La Mer*, c. 1951.

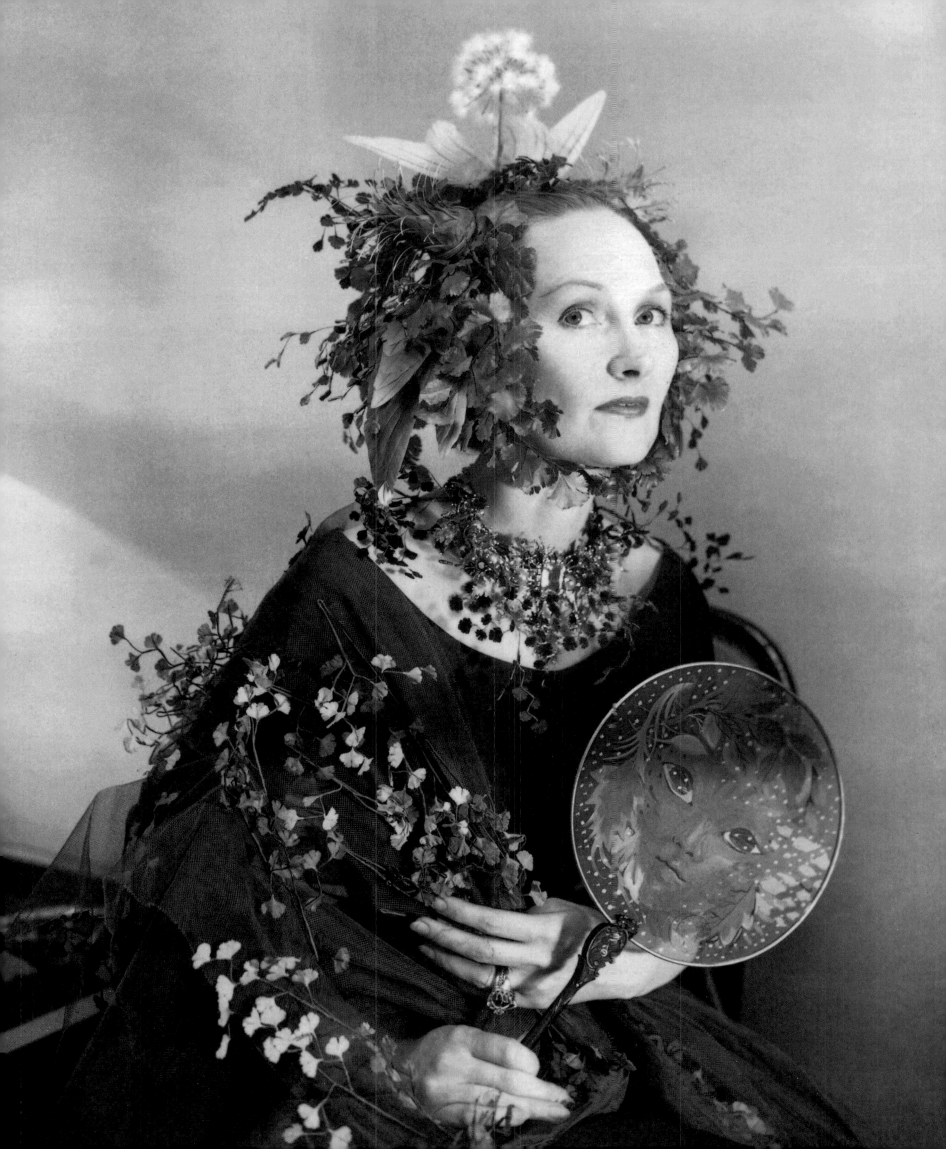

heating and are going to be doing that for the next ten days. Our patron is delighted with the house (and Louvre) and wants to do everything for us again so we hope he stays in that mood until February." She added, "We sold a necklace to the Duchess of Windsor which she is to wear at the Knickerbocker Ball in New York so save the clippings that you might see."

The letter further reveals that French cuisine was not to their taste: "We have a cook that cooks French style so we dream longingly of plain wonderful American food. She is forever dreaming up some hideous concoction and serving it triumphantly expecting us to die with delight."

Tony and Beegle were the toast of Paris, with dinners and lunches held in their honor, and they attended some of the most famous balls of postwar Paris. Sir Charles Mendl hosted a dinner in their honor; Lord Duff and Lady Diana Cooper, a lunch; they went to a ball at the home of the couturier Elsa Schiaparelli, as well as one given by the legendary Paris hostess and art patron Marie Laure de Noailles. Called *La Lune sur la Mer*, her ball was legendary, and Tony made many of the masks. Guests included Christian Dior, who went as a postman, and Ambassador and Mrs. Evangeline Bruce, who played waiter and barmaid. Jean Cocteau went as a clown, and the writer Louise de Vilmorin as a postmistress. Beegle made up her own forest, and Tony went as the moonlight. To complete the festivities, the Parisian town house was transformed into a provincial seaside vacation setting.

On January 11, 1951, Tony's show finally opened, in the Louvre's Marsan Pavilion, in the Musée des Arts Décoratifs, and was attended by more than a thousand people. Pamela Churchill (who was later to rent the Porcelain Pavilion, with its Duquette décor), Evangeline Bruce, Daisy Fellowes, Arturo Lopez Wilshaw, Mona Bismarck, and Carlos de Beistegui were among the many admirers who thronged the gallery. Nearly all of the treasures Tony designed were sold before the opening. The program was made up of five categories: décor, jewelry, aquarelles, *bas-reliefs*, and theater. These were represented by installations of original watercolors, mirrors, lamps, furniture, and fantasy objects unlike anything seen before.

Interviewed at his Paris apartment in the historic Hôtel Lambert a few days before his death, Baron Alexis de Rede, who was present at the opening, reported that Tony made an indelible impression: "People were amazed by his extraordinary talent." And in the show's catalogue Louise de Vilmorin wrote, "The works of Tony Duquette are no more preconceived than dreams, these works are dreams caught in the net of reality."

It was fitting that in this same gallery, only a few years earlier in 1945, another show had captivated the collective imagination of Parisians, who were then so badly in need of a renewed sense of life and beauty. The artist, Christian Berard, created the setting for the first showing of couture fashion after the occupation. This magical presentation was executed in miniature; each couture house designed clothes for small dolls made of wire. No detail was spared. The dolls had real hair and real jewels, supplied by the greatest jewelers in Paris. Even exquisite underwear was made of the finest silk and lace. These dolls became the characters in a grown-up fairy tale depicting scenes of Paris life. Artists

OPPOSITE Duquette with the necklace he designed for the Duchess of Windsor on his wire mermaid sculpture at the Louvre, c.1951.

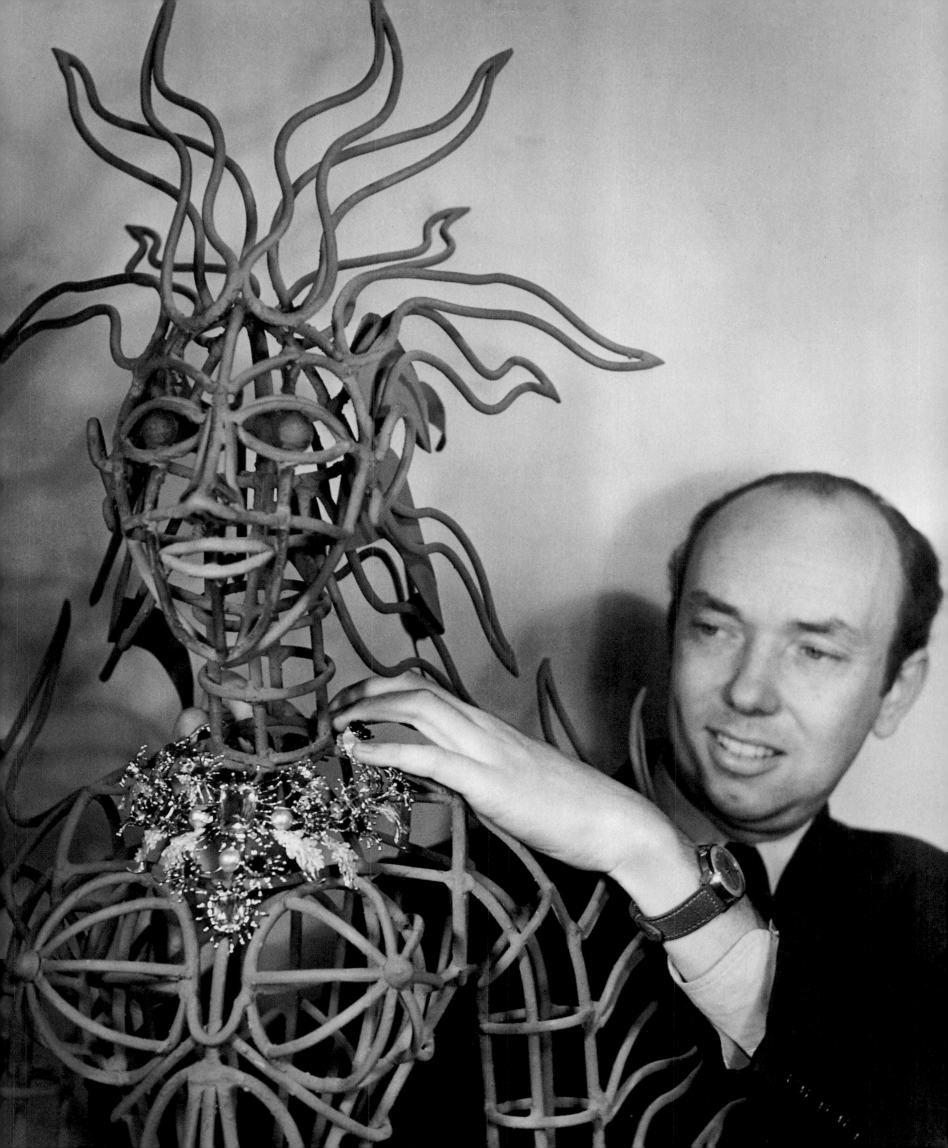

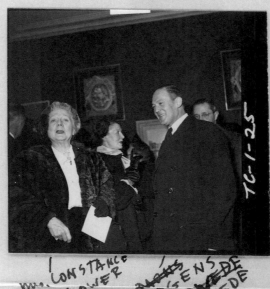

TC-1-26

TC-1-25

TC-1-24

mrs. CONSTANCE
GOWER

MRS
MOGENS
TVEDE
TVEDE

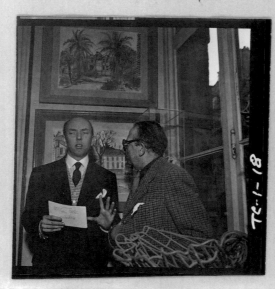

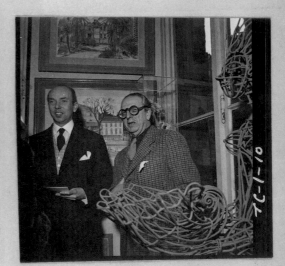

TC-1-12

TC-1-18

TC-1-10

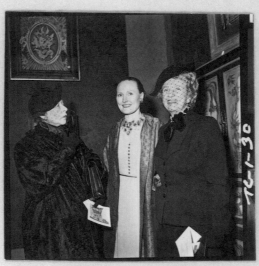

TC-1-28

TC-1-30

TC-1-13

MRS.
ECTOR
MUNN

Mrs. D

MRS
ECTOR
MUNN

MRS D.

MRS
NION
TUCKER

MARIANO
ANDREU

ARTURO
LOPEZ-
WILSHAW

J·D

such as Jean Cocteau and Boris Kochno, all friends of Berard, designed the sets.

Titled *The Théâtre de la Mode*, the show was a huge success, drawing over a hundred thousand visitors and subsequently traveling to the United States. It is not surprising that Tony's destiny was to follow in the footsteps of such a fantastic celebration of talent; having been chosen by the Louvre to represent the decorative arts of the middle of the twentieth century, his works again illustrated the power of the artist's vision to transform the experience of daily life.

OPPOSITE Party photographs taken during opening night of Duquette's exhibition at the Pavilion de Marsan of the Louvre.

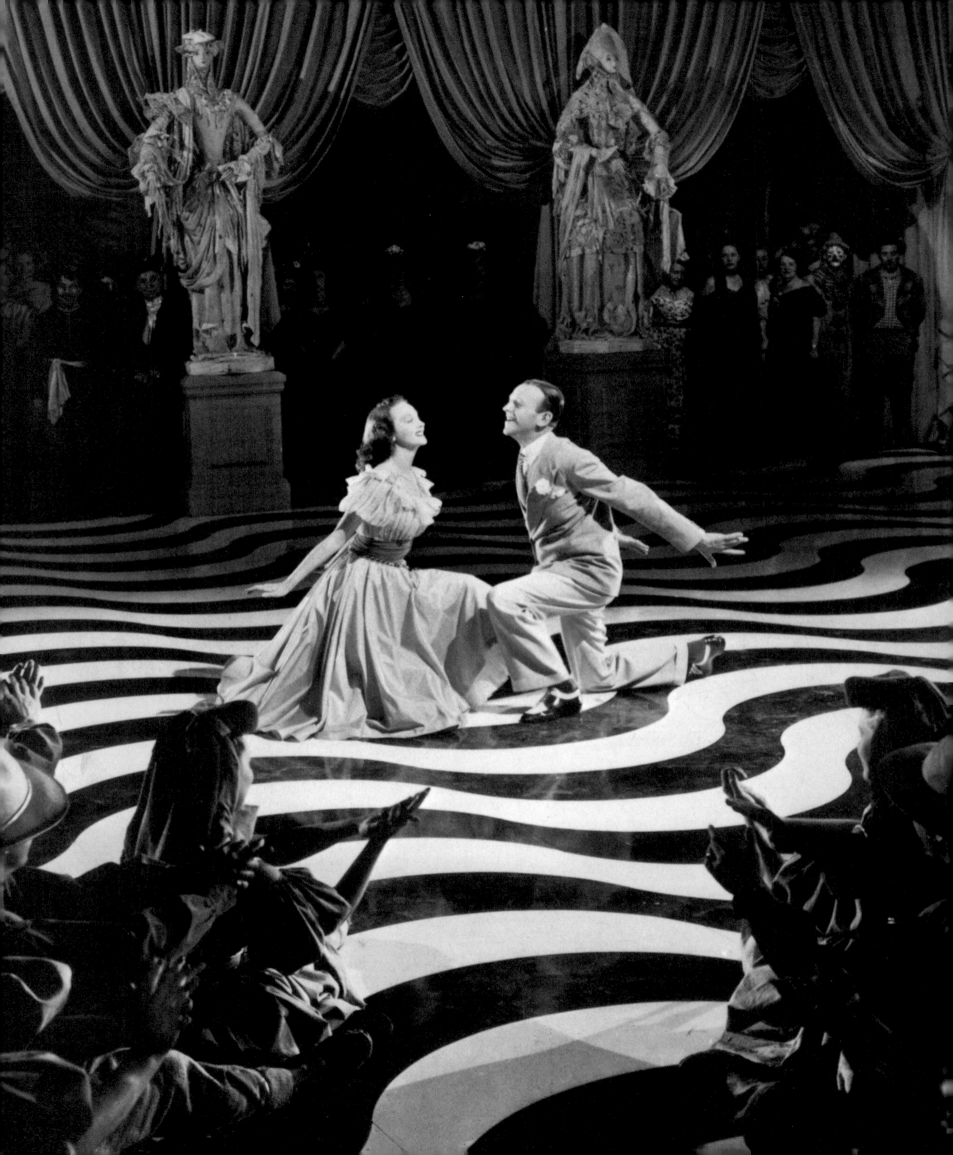

CASTING THE SPELL

In fact, there was a very funny story that I remember. Daddy was describing something that he wanted, and he said, "It should be Duquette." And everybody went back and they were looking up Elizabethan? Duquette? Finally somebody said, "We can't find the Duquette era." And he said, "What are you talking about! It's not an era! He's an artist, not a period. I'll call him myself!"

Liza Minnelli

FROM HIS EARLIEST CHILDHOOD, Tony said, he always dreamed of the theater. Living between Three Rivers, Michigan, in the summer and Los Angeles in the winter, he had many opportunities to see live productions with his family, in Chicago and in Hollywood. As his mother and aunts were well-known musicians, he had access to the theater where they performed as a string quartet. He met many actors, producers, and agents in the process.

Tony often repeated his mother's story about her backstage visit to meet Sarah Bernhardt. It was during one of Bernhardt's many farewell tours. She revealed that the old woman she met was physically hideous, that she had painted her features in great bold strokes, and that to behold her in her makeup was utterly terrifying. Later, the curtain rose and the audience saw a beautiful young woman — with the help of theatrical lighting Sarah Bernhardt had transformed from the aging actress his mother had met backstage into a beautiful butterfly.

Lucille Bremer and Fred Astaire dance the "Coffee Time" number in Vincente Minnelli's *Yolanda and the Thief* (1945) amid Duquette's plaster figurines.

5

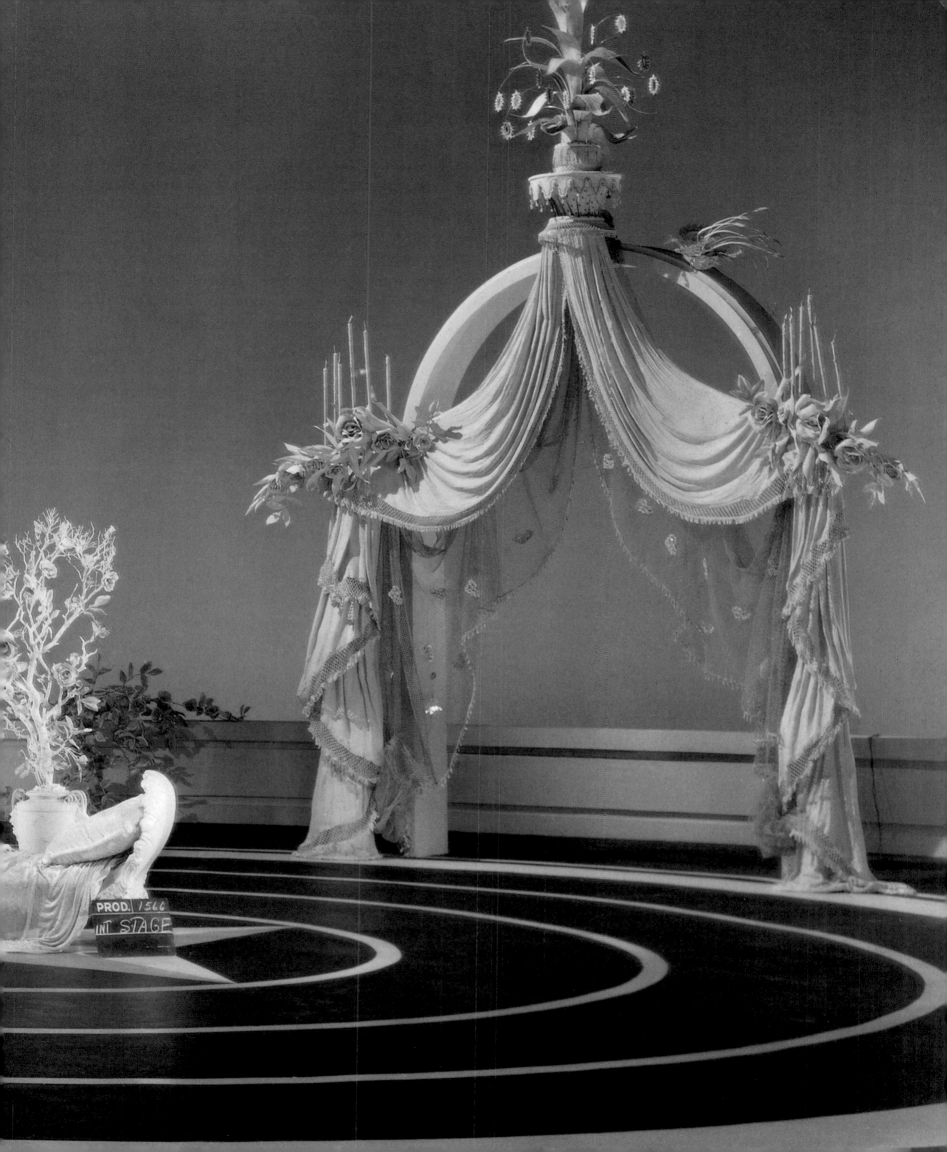

This anecdote, told to him as a young boy, was always at the back of Tony's mind. Tony realized early on that he could turn burlap into velvet and that broad brushstrokes could be transformed into soft, shadowy effects with the assistance of theatrical lighting. Whether he was decorating a house or designing for the stage or movies, he understood the magic of the theater and always used it to great effect.

Tony also loved California. He never tired of its beauty, the freedom of movement it allowed, and its many opportunities. And it was only natural that he should live there and work in cinema.

In 1945 the legendary film director Vincente Minnelli was invited to dine at the newly constructed residence of Mr. and Mrs. James Pendleton. Jimmy and Dodo Pendleton had arrived in Beverly Hills from New York and had taken the town by storm thanks to their charm, his individual style, and her wealth. Having been introduced to Tony Duquette by William "Billy" Haines, the Pendletons commissioned the young artist to create a table garniture for their dining room; the famous garniture Tony produced represented the continents Europe, Asia, Africa, and America. Like Elsie de Wolfe before him, Minnelli saw that table decoration the night he came to dine, and dreamed through all four courses how that miniature "Duquette" world of twigs, plaster, paint, and rhinestones could become a set for a movie. Vincente had to meet Tony.

Prior to meeting Minnelli, though, Tony had already worked on a film, *The Goldwyn Follies*. The art director was Bill "Wiard" Ihnen, the husband of costume designer Edith Head. Duquette was always vague about this film and how the commission had come about. Perhaps it was that Head had suggested him, as she had been a classmate of Tony's at Chouinard

School of Art. They were certainly friends from the old days and kept in touch right up until the end, Head and Ihnen often calling Tony over to their Spanish hacienda on Coldwater Canyon in Beverly Hills to pick up succulents or other plants and even a decorative gazebo to transplant to his 150-acre Malibu retreat. The only photograph of Duquette's work on this project shows a set in black and white, with architectural columns draped in Tony's signature plaster swags.

Tony's first film with Vincente was the "Coffee Time" sequence in MGM's 1945 production of *Yolanda and the Thief*, starring Fred Astaire. Tony's eighteenth-century-style figures in white plaster, which stand around the black-and-white dance floor, add a sense of glamour to the sequence's carnival atmosphere.

In 1946 Minnelli was directing *Ziegfeld Follies* for producer Arthur Freed. He wanted Tony to create a fantasy ballroom for Fred Astaire and Lucille Bremer to dance in—and through, to a garden of painted trees studded with mirrors.

The scene in which Astaire's jewel thief dances with Bremer's beautiful princess takes place in a circular pavilion with plaster-draped windows, the drapery held back by white-painted antlers. Duquette figurines surround the room holding lighted candelabra; hanging from the domed ceiling is a monumental Duquette chandelier made of dipped-plaster swags, crystals, and lighted tapers. The ballroom revolves and the walls separate to reveal a garden, into which the dancing lovers twirl. As Astaire and Bremer dance, the ballroom walls close to reveal a frieze of twenty-eight-foot-tall Duquette figurines wearing striped stockings and tricorn hats, all holding hands around the entire exterior of the structure. Moving treadmills and a revolving marbleized dance floor produce a chorus of dancers, each holding a jeweled Duquette tree.

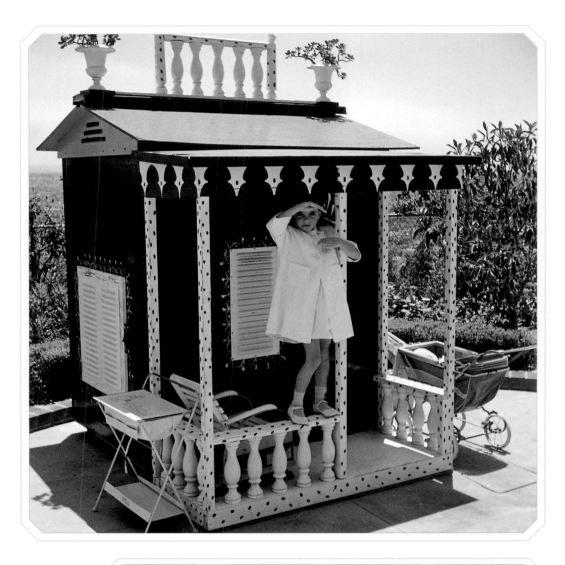

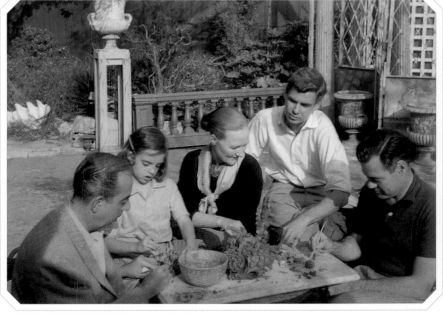

PREVIOUS SPREAD A studio still from *The Goldwyn Follies* (1938) a film that originally included dipped-plaster and floral decorations designed by Duquette.

ABOVE Duquette created a playhouse for a young Liza Minnelli, with his signature urn finials, painted ermine-tail decorations, and green-and-white color scheme.

RIGHT Vincente Minnelli with daughter Liza, Beegle, Leonard Stanley, and a friend getting creative outside the studio of Tony and Elizabeth Duquette.

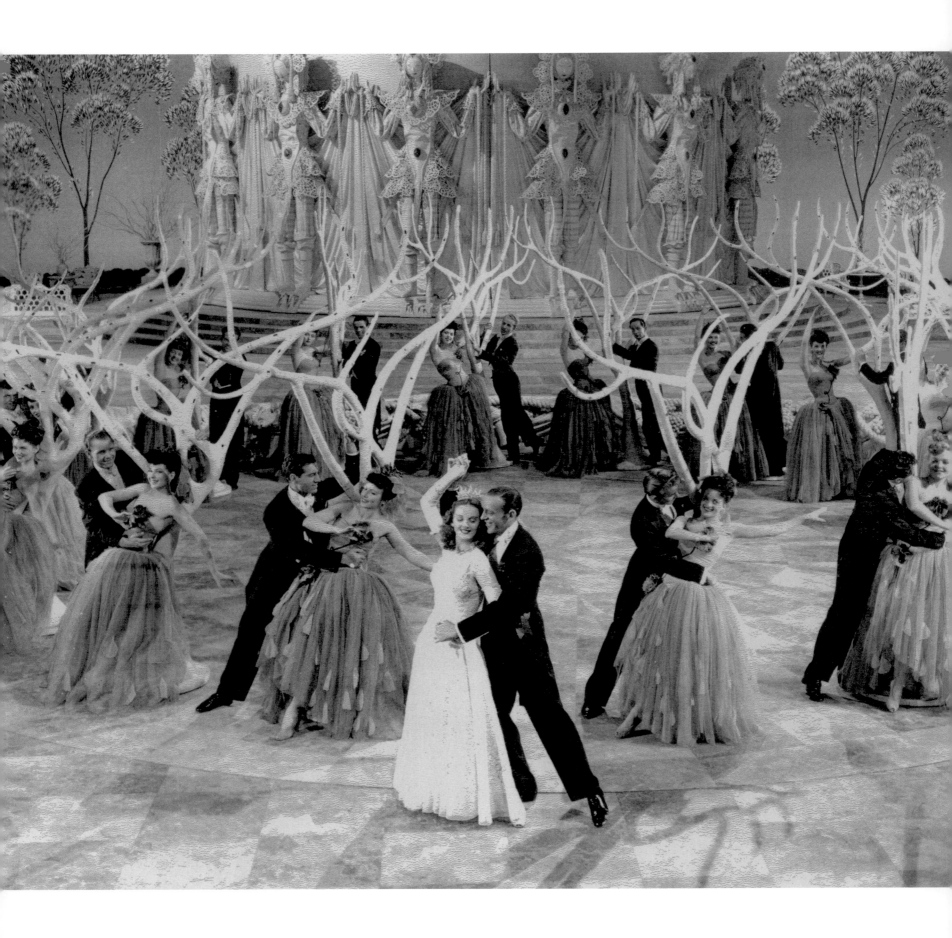

The garden furniture and other decorations, all by Duquette, are also made to resemble tree branches or giant coral. Tony was in the habit of renting his decorations to MGM, and many of the mirrored trees were still being used around Tony's studio, in the 1970s and 80s.

Tony worked with Minnelli and Adrian on these projects, along with the other members of the famous "Freed unit"—Arthur Freed being the most important of the MGM producers at that time. Freed became a friend of the Duquettes, supplying them with endless Phalaenopsis orchids from his Malibu orchid farm. To hold these beautiful floral displays, Tony would devise his famous iron-and-giant-clamshell étagères.

Lovely to Look At (1952) was an MGM musical produced by Jack Cummings, a relation of Louis B. Mayer and a man who Tony would say "wanted to be like Arthur Freed." Starring Howard Keel, Katherine Grayson, Zsa Zsa Gabor, and Marge and Gower Champion, the film is a bit of a bore as directed by Mervyn LeRoy. To create something special for the grand finale, Cummings decided to replace LeRoy and bring in the Freed unit, which consisted of Vincente Minnelli, Adrian, Tony Duquette, and other technicians. For this incredible last twenty minutes of the film—which many consider to be the most beautiful scene in the movie—Vincente, Adrian, and Tony conceived a confection of choreographed scenery, human candelabra, lighted obelisks, glittering pagodas, armorial trophies, antlered dancers, jewel thieves, opera boxes, and on and

on. It is a tour de force, the whole mise-en-scene being greater than the sum of its parts.

In 1955, Vincente Minnelli asked Tony to do the costumes for MGM's *Kismet*, a job that he took very seriously and for which he would get his first major screen credit. This was the one film Tony would do from beginning to end. Tony's particular talents were considered better suited to "special effects" in those last years of the Golden Age of Hollywood musicals. "Special effects" for Tony Duquette were not explosions or train wrecks, but rather beautiful fashion-show sequences, ballroom scenes, a ballet, dream sequence, or other specialty number that required the look to be other than the rest of the film.

Tony would say that in those days at MGM, if you wanted anything, all you had to do was ask. "I want pearls," he would say, and bags of beautiful pearls would be delivered to his workrooms. "I need one-hundred-year-old Chinese tribute silk" and the silk would be found and delivered for his approval. You can see when you look at *Kismet* the luxury and attention to detail that Tony lavished on the production. Although his screen credit is for costume design, Tony also got involved in supplying many of the props and some of the sets. You can see his work in the palanquins, the screens, the pagodas, and other decorations. He designed the jewels, the crowns, and the headdresses, and even dressed a pair of monkeys for the palace scenes. Tony was very excited about the wedding-procession sequence, and he had plans to film the entire thing reflected in water. When the budget came in from the MGM Art Department to create what Tony had proposed, the estimate was for $250,000. The sequence was scrapped, and Tony was heartbroken. He went to his friend Joe Cohn, who was the head of the MGM Finance Department and pleaded his

OPPOSITE Duquette created this set as a backdrop for Fred Astaire and Lucille Bremer's "This Heart of Mine" sequence in *The Ziegfeld Follies* (MGM, 1946). The revolving ballroom featured an elaborate ruby-and-white interior with dipped plaster draperies with antler and tree branch tiebacks, as well as fanciful "Duquettery" figural candelabras. The outdoor garden was decorated with white painted trees sprinkled with mirrors and Duquette figurines standing twenty-eight feet tall.

I started working with Tony in 1951, and was his assistant up until 1954. That summer of 1951 is when they got rid of L. B. Mayer, which they never should have done. It was like the Emerald City—going to Oz. It was such an amazing family of talent! The costumes, the sets, the photography! The best studio out here, period. Beyond. Vincente [Minnelli] did the last twenty minutes of the film Lovely to Look At *which is the fashion show, and that is how Tony got involved. Adrian did all the dresses. I was right behind the camera the whole time it was being filmed.*[1]

<div align="right">LEONARD STANLEY</div>

OPPOSITE Dolores Gray "bronzed" for costume test as Lalume for *Kismet* (MGM, 1955). Costumes by Tony Duquette.

OVERLEAF LEFT Howard Keel and Katherine Grayson star in the finale of *Lovely to Look At* (MGM, 1952) with props and additional costumes by Duquette.

OVERLEAF RIGHT Zsa Zsa Gabor stars in *Lovely to Look At* (MGM, 1952) with props and additional costumes by Duquette.

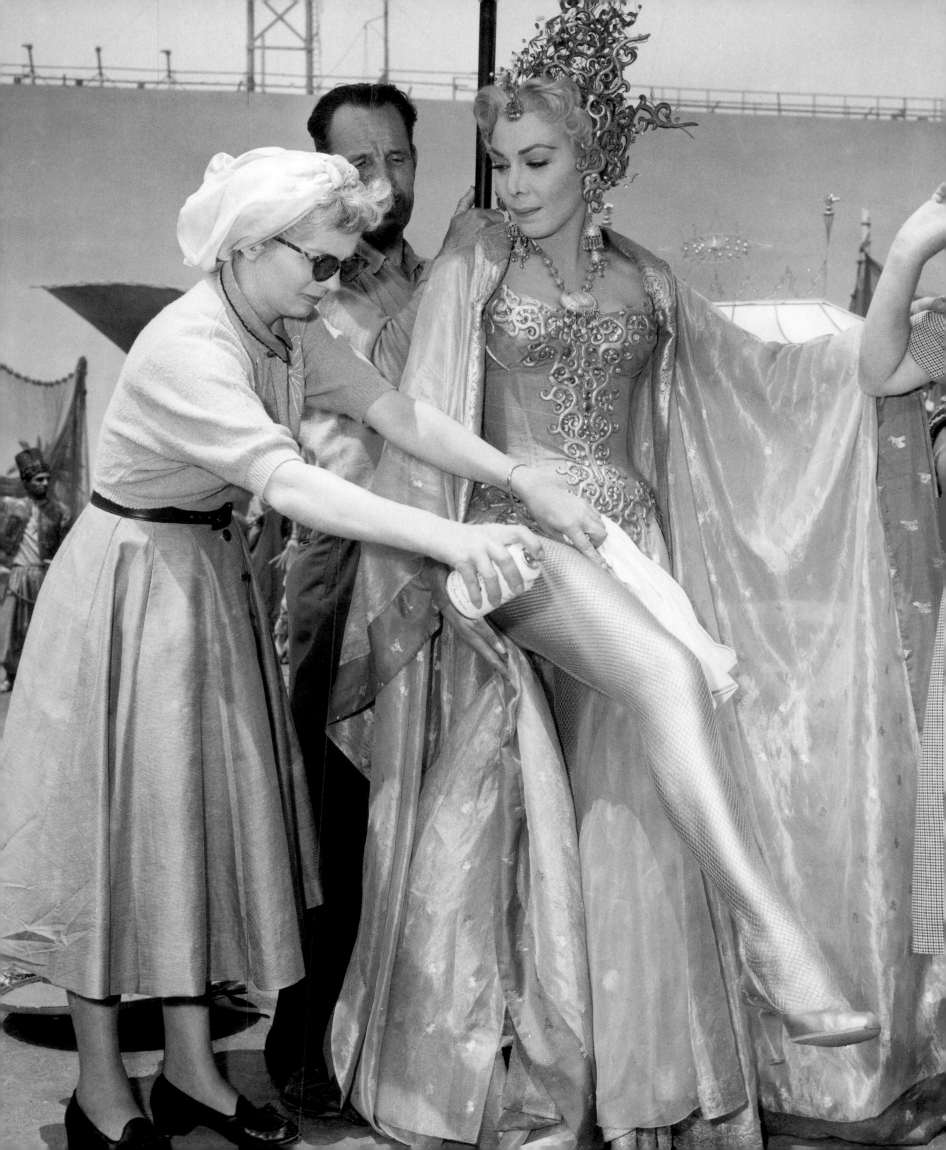

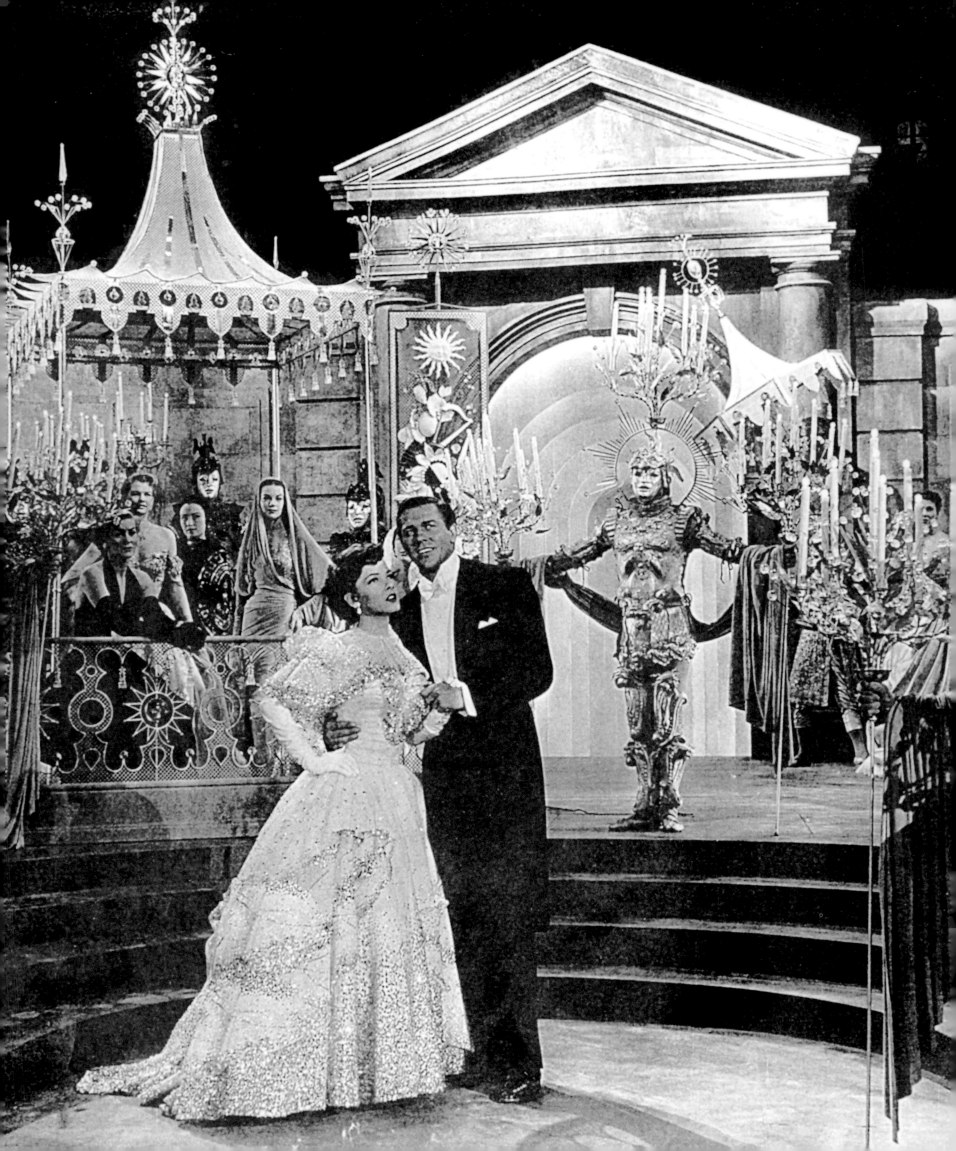

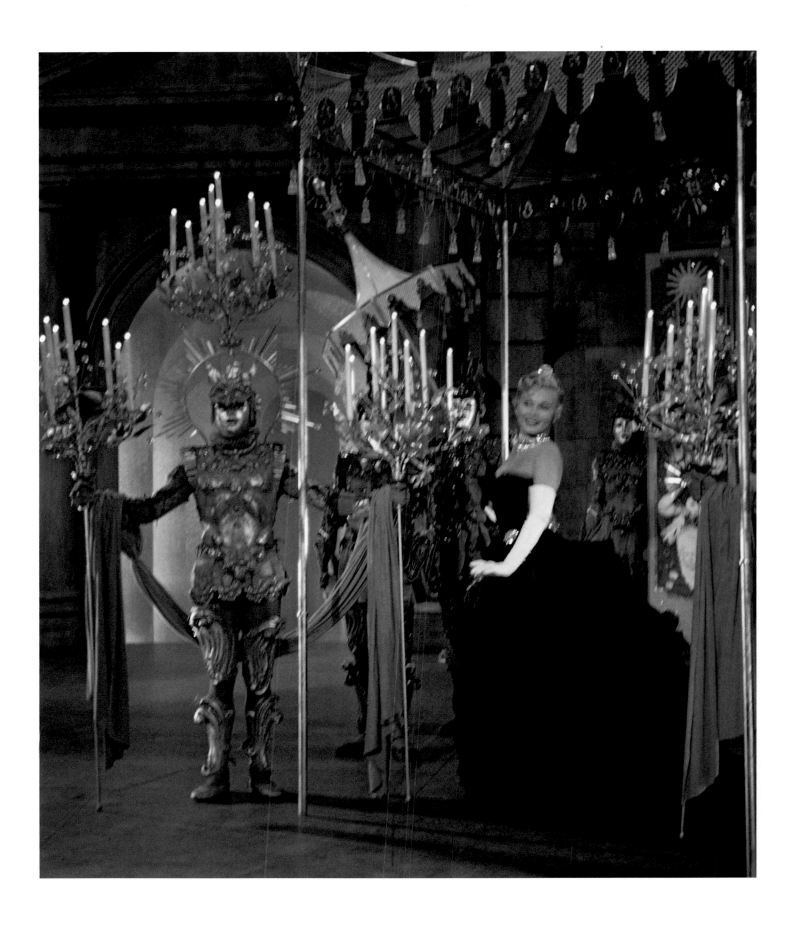

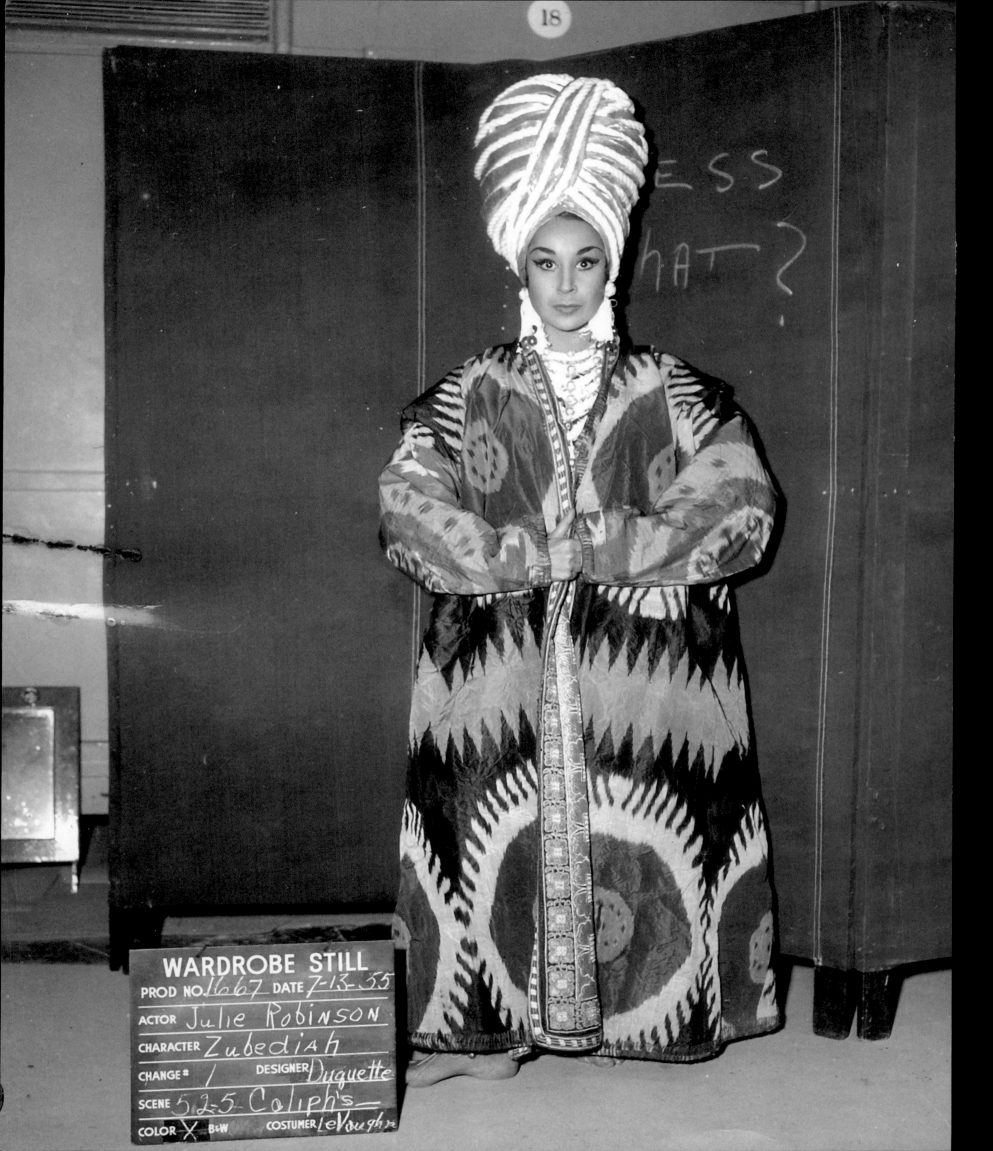

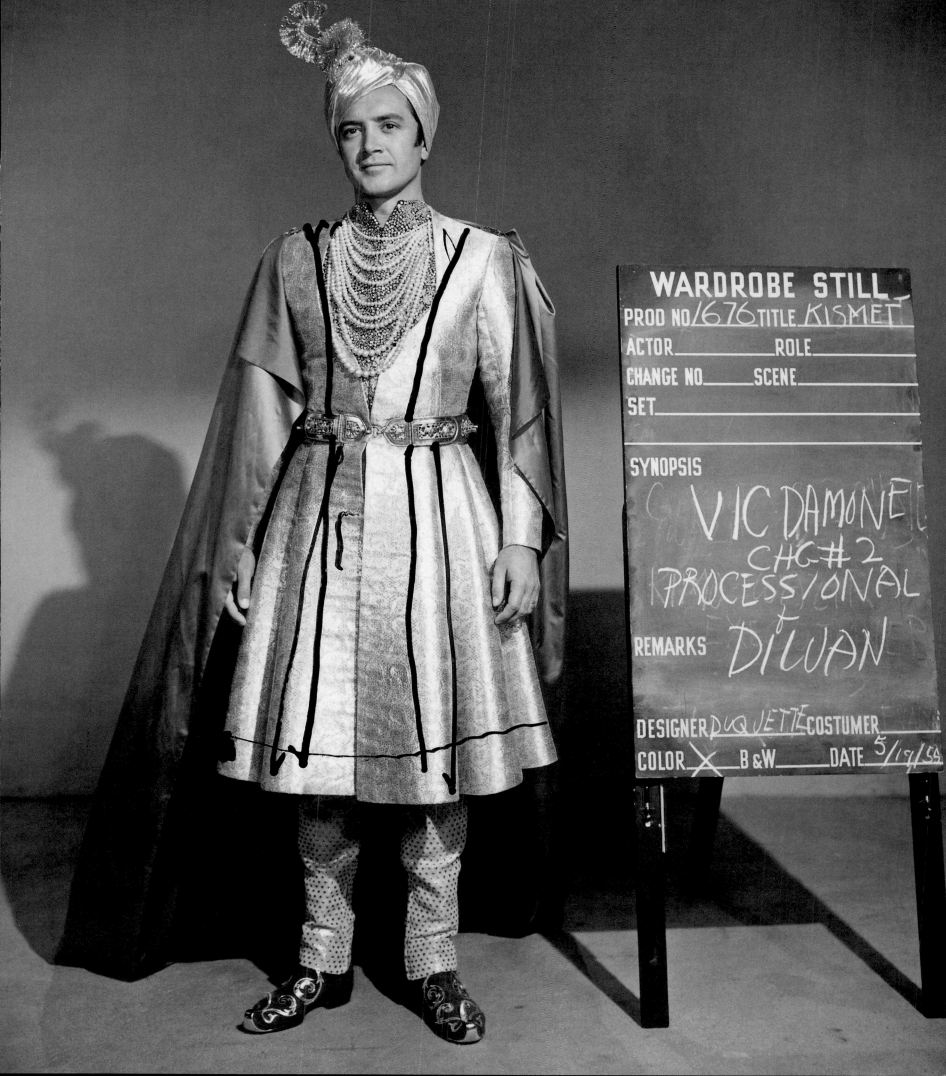

WARDROBE STILL
PROD NO 1676 TITLE KISMET
ACTOR _____ ROLE _____
CHANGE NO _____ SCENE _____
SET _____

SYNOPSIS

VIC DAMONE
CHG #2
PROCESSIONAL

REMARKS DIWAN

DESIGNER DUQUETTE COSTUMER _____
COLOR X B & W _____ DATE 5/19/55

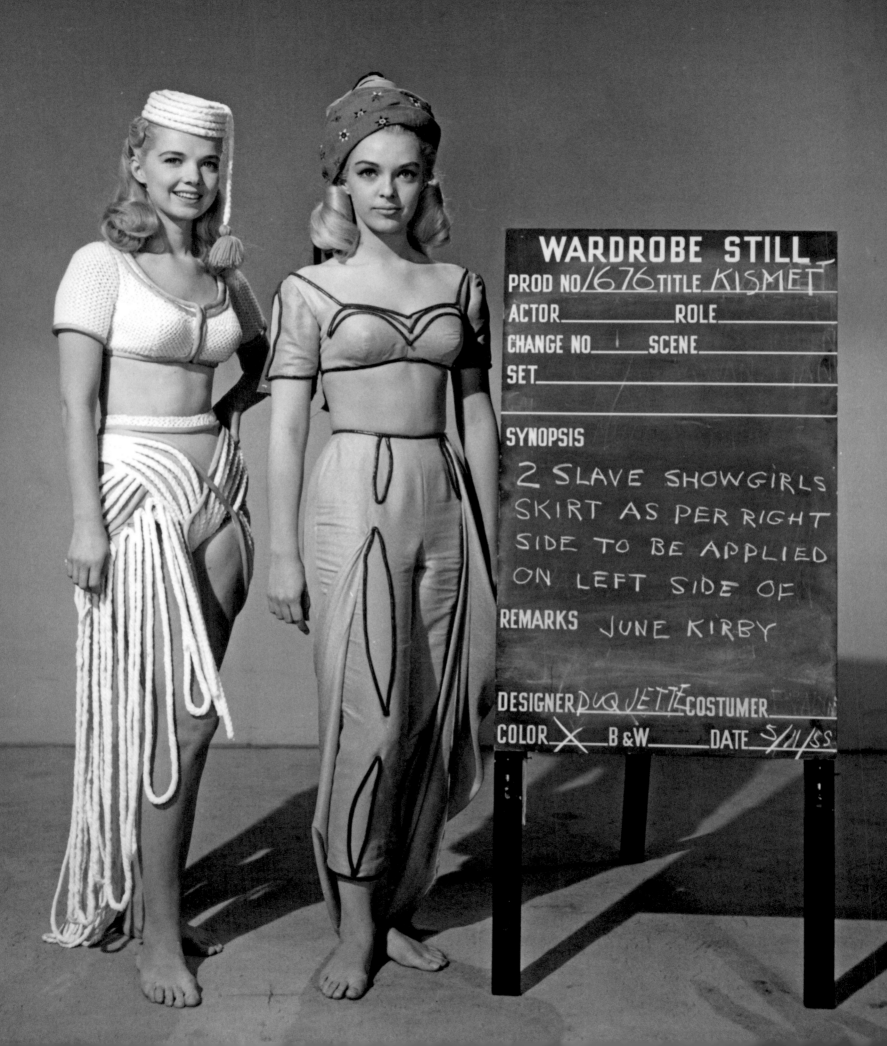

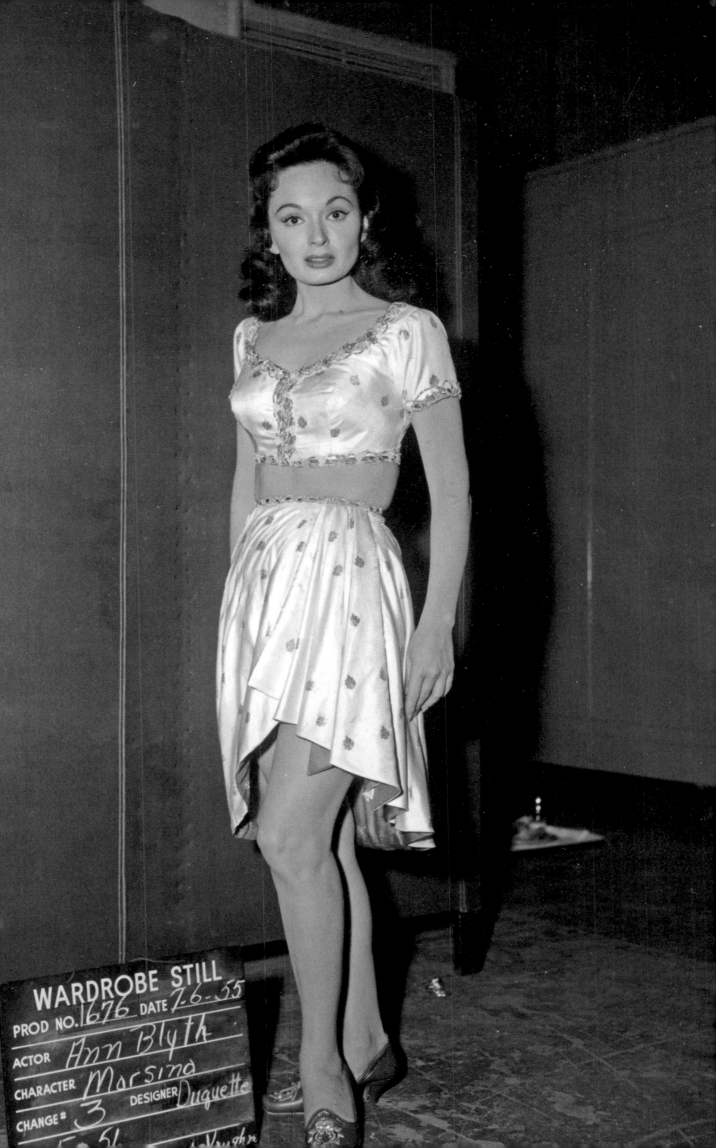

WARDROBE STILL
PROD NO. 1676 DATE 7-6-55
ACTOR Ann Blyth
CHARACTER Marsina
CHANGE # 3 DESIGNER Duquette

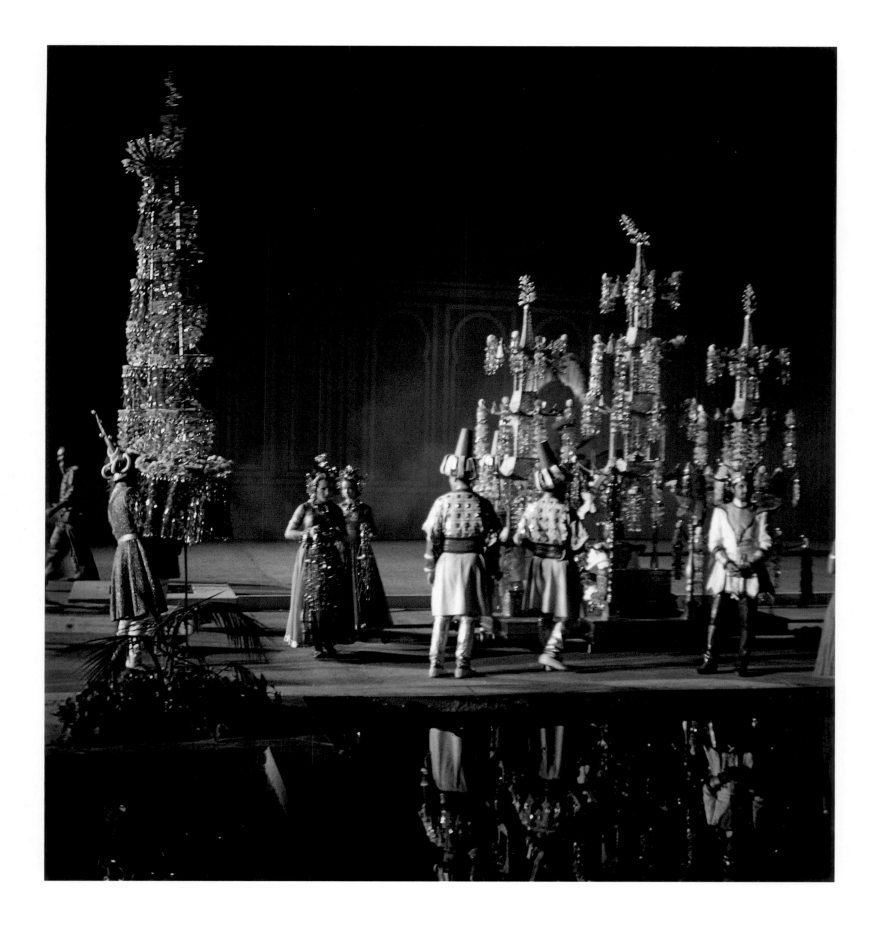

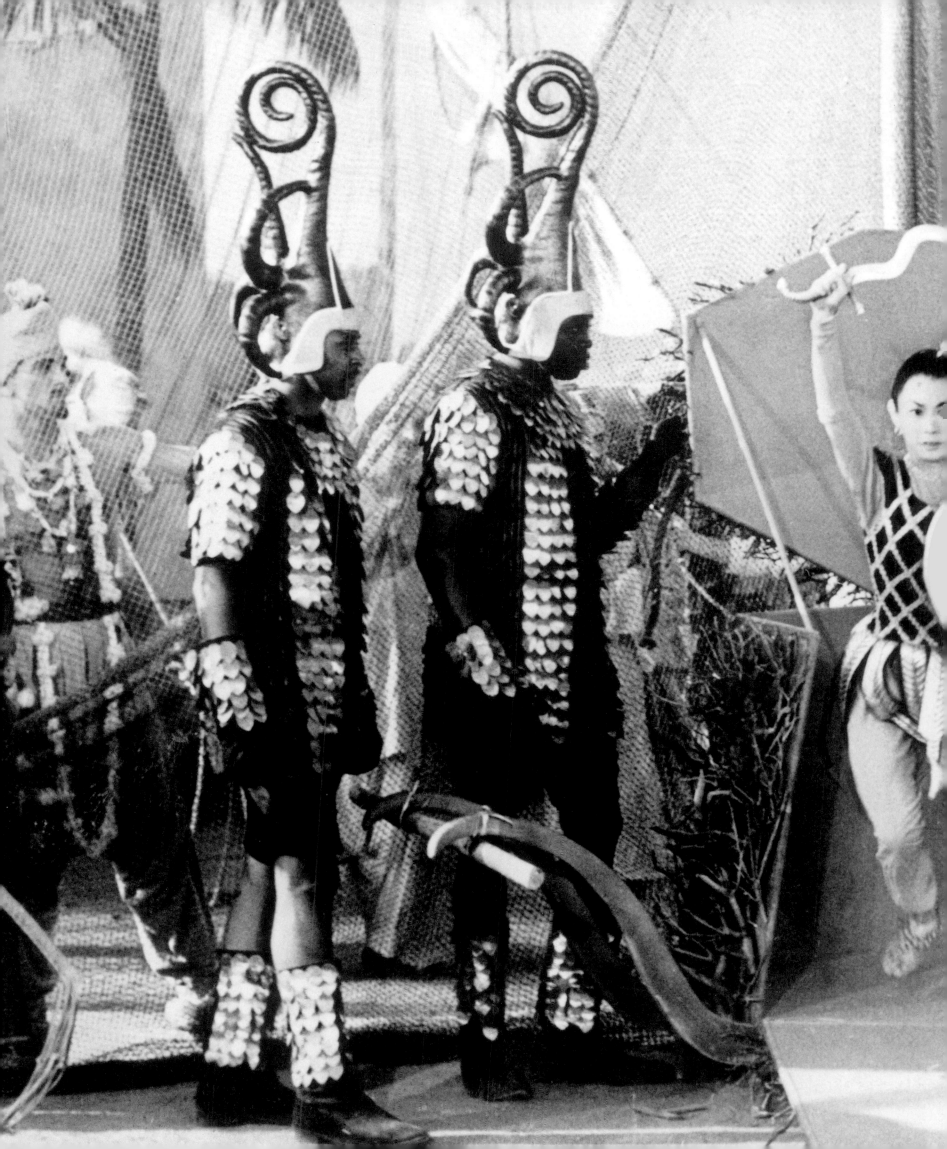

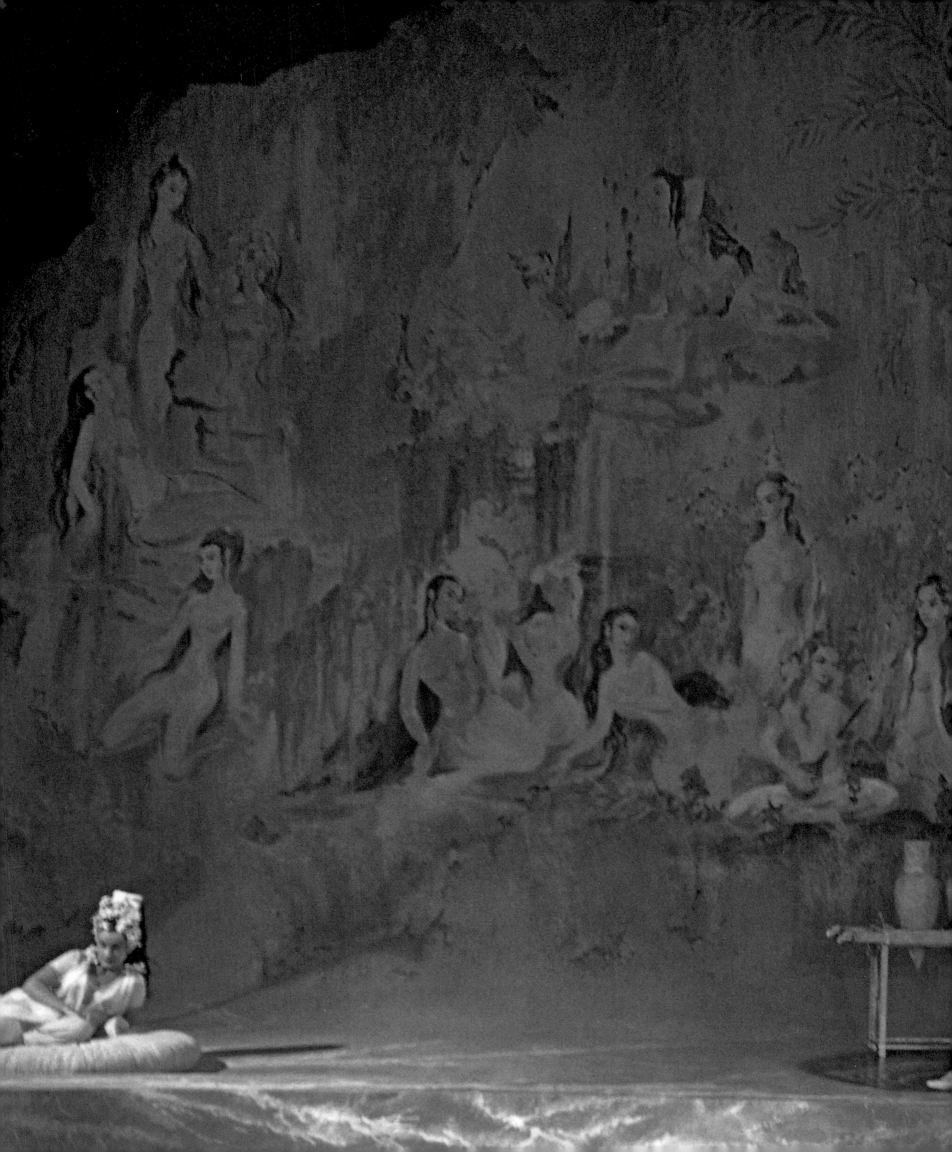

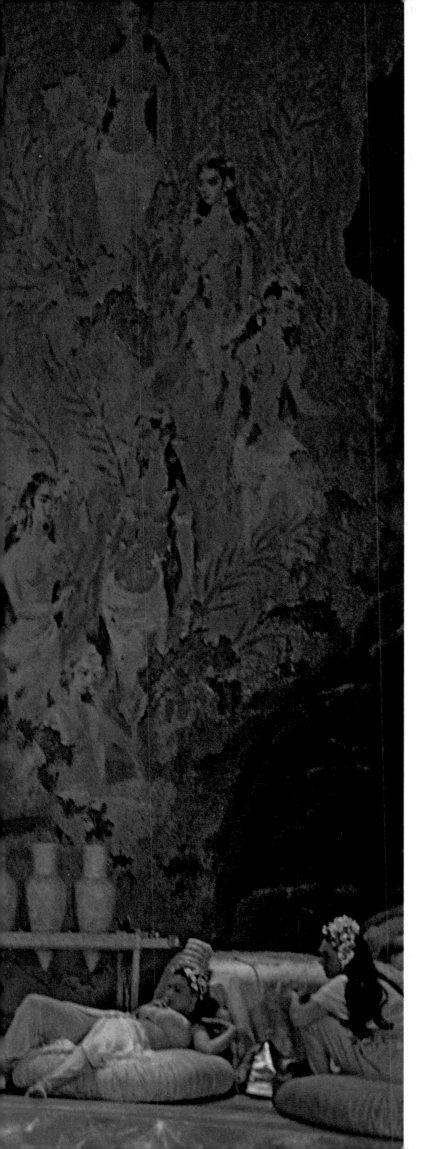

PREVIOUS SPREADS
LEFT Wardrobe still for Julie Robinson in *Kismet* (MGM, 1955).

RIGHT Wardrobe still for Vic Damone, "The Caliph" in *Kismet* (MGM, 1955).

LEFT Wardrobe still for extra "slave showgirls" in *Kismet*.

RIGHT Wardrobe still for Ann Blyth, "Marsinah" in *Kismet*.

LEFT The original plans for Duquette's "Wedding Procession" scene in *Kismet* were so costly that the studio decided to eliminate the sequence altogether. Duquette insisted that it could be done, and successfully produced the entire scene for twenty-five hundred dollars by utilizing Christmas decorations and props he discovered in Los Angeles's Japantown.

RIGHT Extras appear in *Kismet* wearing elaborate costumes and headdresses inspired by Duquette's private collection of antique African Ekoi masks.

OPPOSITE The harem scene in *Kismet* includes a monumental mural painted by Elizabeth Duquette.

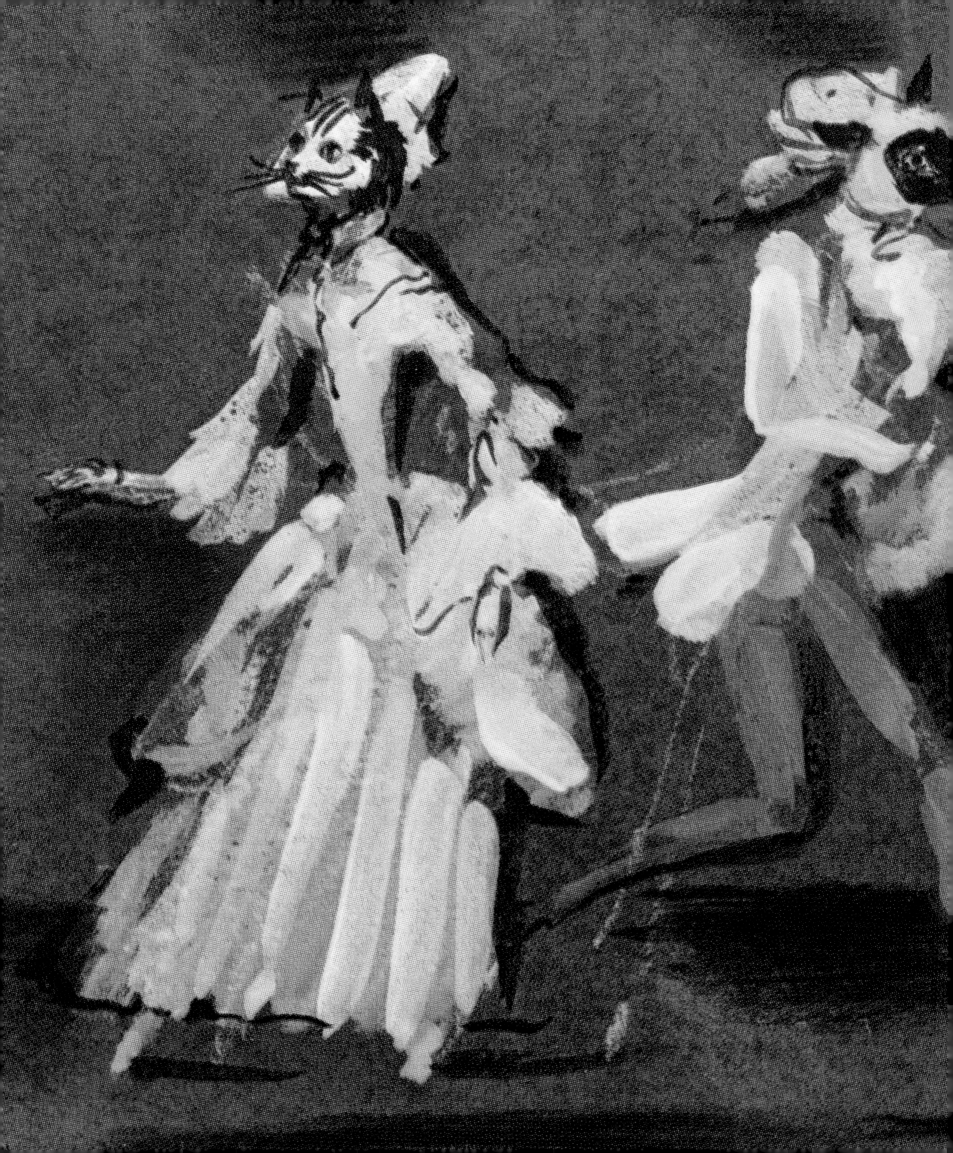

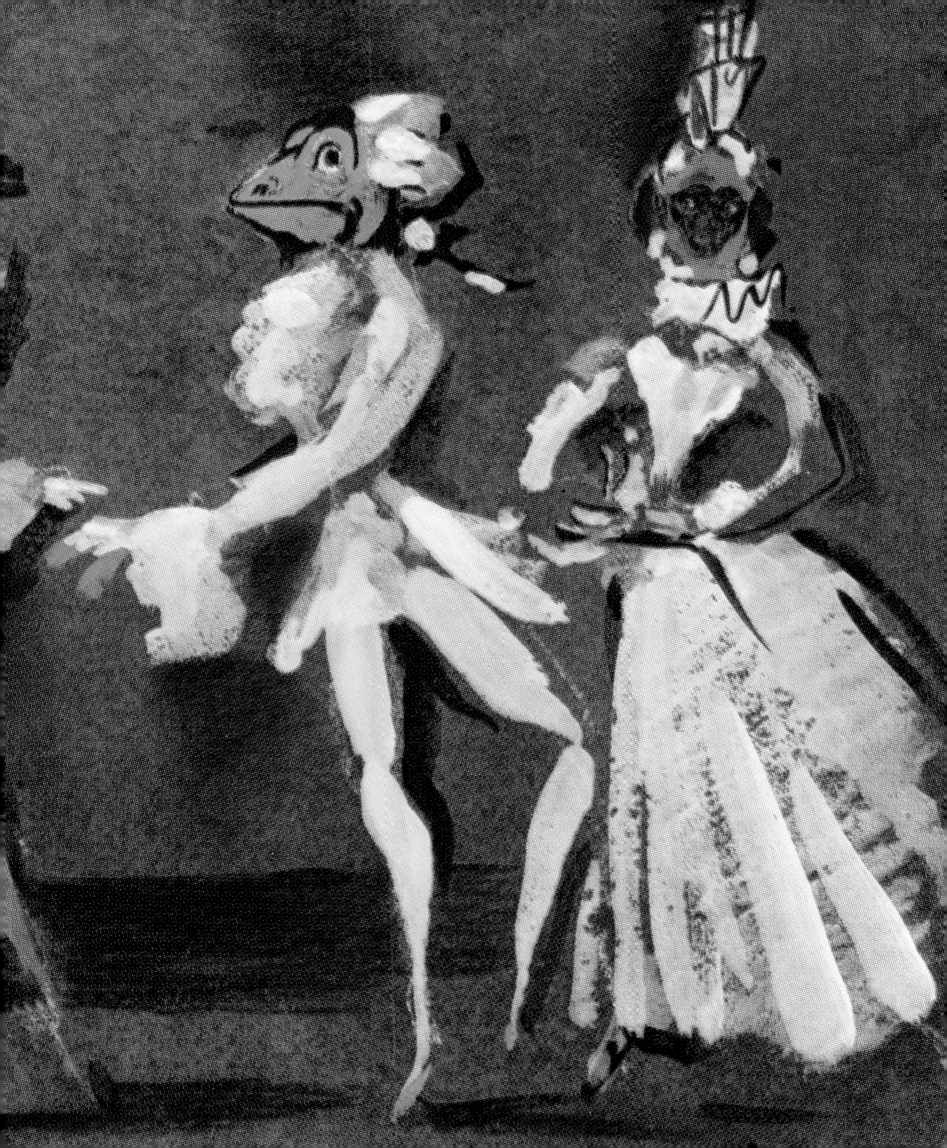

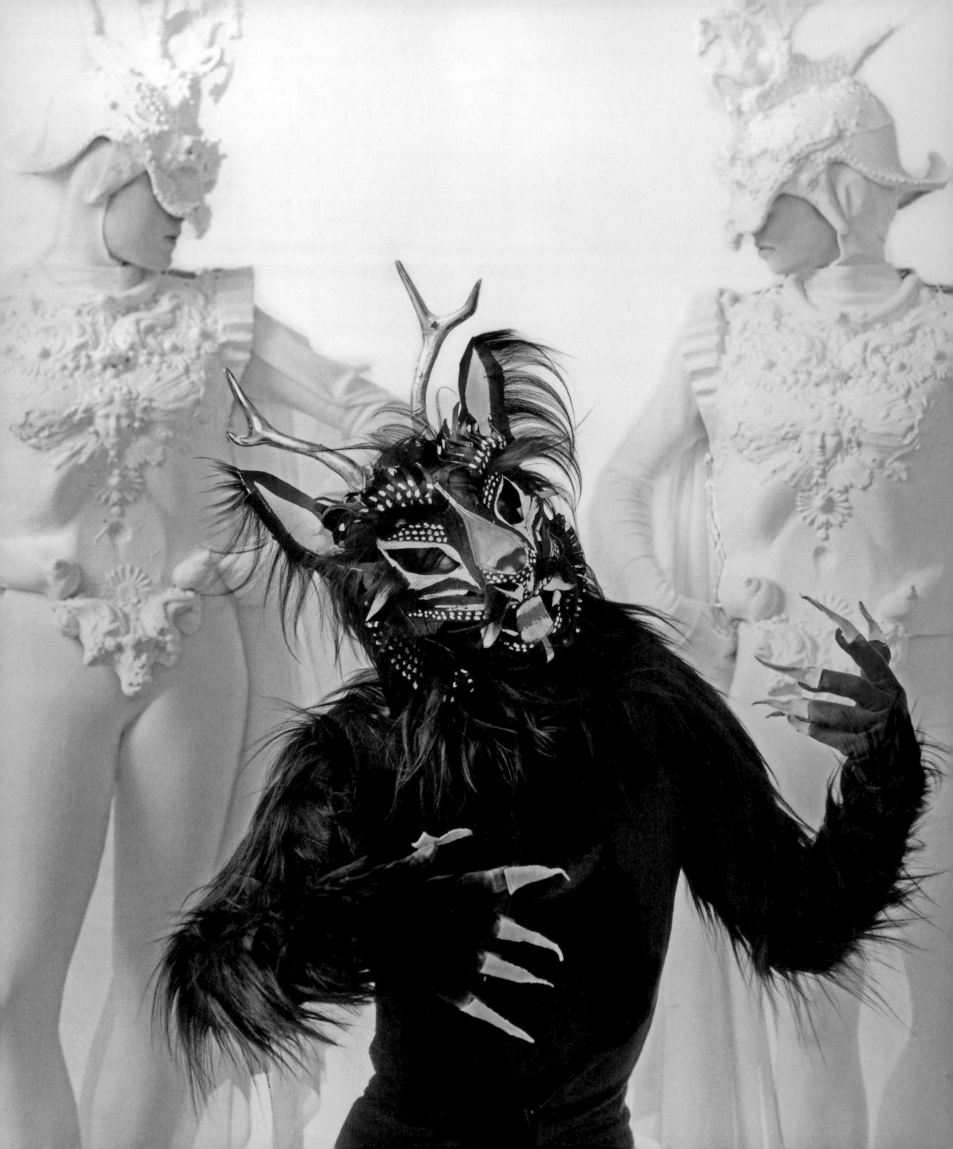

case. He said he could do it himself if he could have $2,500 to buy Christmas ornaments and gold paper decorations from Chinatown. Joe Cohn approved the funds, and the sequence, which Tony presented, was so spectacular that it later inspired a similar scene in Mike Todd's production of *Around the World in Eighty Days*.

Although he worked for and at MGM, 20TH Century Fox, and Universal Studios, Tony was always self-employed. As he often stated, "I was brought in from the outside, by separate contract. Although I belonged to the union, I was never an employee of the studios. A lot of the people in the studios really resented me coming in from outside, when they thought they could do the job just as well. So you see, I was independent, I could come and go as I pleased. . . I owned my props and things and I could rent them to the studios over and over again."

In 1960 Tony was brought in to do the "Garden of Eden" ballet sequence in the 20TH Century Fox production of *Can Can*. It was the famous scene that the Russian premier Nikita Khrushchev walked out on when he visited the studio, calling it "the most decadent thing [he had] ever seen." Tony loved the attention that Khrushchev and the press lavished on his costumes and sets for that number.

With his great success working in film and his popularly acclaimed exhibitions at the Los Angeles County Museum of Art (in 1952) and at San Francisco's M. H. de Young Museum, Tony was launched into the high society of both cities. It was unusual for anyone from Los Angeles to assume an important position

in San Francisco society, but Tony and Beegle were accepted with open arms by the Bay City. He would explain that San Francisco had "a tradition dating from the gold rush of welcoming visitors with open arms, especially if they could sing or dance or play a musical instrument. When Los Angeles was still a sleepy little pueblo, San Francisco was a vital metropolitan city."

In the 1950s Lew Christensen was the producer and director of the San Francisco Ballet and he used Tony's talents for designing costumes and sets repeatedly—notably, on productions of *Beauty and the Beast* (1958), *Divertissement di Auber* (1959), and Stravinsky's *Danses Concertants* (1959). Other San Francisco Ballet productions Tony designed costumes and sets for include Tchaikovsky's *Seranade* and von Suppe's *Caprice*, as well as Serge Prokofiev's *Fantasma*, Luigi Boccherini's *Sinfonia*, and Sir Arthur Bliss's *The Lady of Shalott*.

During this time Tony was also commissioned by the San Francisco Opera to create the costumes and sets for a new production of *Der Rosenkavalier*. Tony worked on this project as if he were living in the eighteenth century, creating a signature "Duquette" style of Rococo that enchanted the audience with its color and exuberance.

Later, in the 1960s, while working in Hawaii on the interiors for the Hilton Hawaiian Village, Tony noticed workmen standing on stilts installing an acoustical tile ceiling. "What a great idea for a ballet," he thought, and the *Jest of Cards* was born. Tony's idea to make a ballet in which "the costumes became sets" was revolutionary. Standing on stilts, the dancers were twelve and fifteen feet tall from their feet to the tops of their headdresses and scepters. The ballet was a sensation, even appearing on the cover of *Life* magazine. Tony

PREVIOUS SPREAD Costumes designed for the San Francisco Ballet production of *Beauty and the Beast* (1958) featured elegant courtiers and dancing animals with human attributes.

OPPOSITE San Francisco Ballet production of *Beauty and the Beast* (1958) featured men in armor created from seashells, lizards, and insects.

not only envisioned the production, but he also raised the funds for the San Francisco Ballet to present it and commissioned the specially composed music (first going to his friend Stravinsky, who—no longer a young man—answered that he already had enough work to keep him busy for the next hundred years, were he to live that long).

In 1961 Tony was invited by Gottfried Reinhardt, the son of the famous theatrical impresario Max Reinhardt, to design the first postwar production of *Jederman* (*Everyman*) for the Salzburg Festival. Tony loved this commission, living in Salzburg at the Hotel Goldener Hirsch and having the costumes made in Berlin. He lovingly nicknamed Countess Harriet Walderdorff (who owned the hotel) the Discountess, because she was so kind to them over their bill. He and Beegle spent their spare time shopping for eighteenth-century Austrian peasant furniture, filling several containers with armoires, trunks, chests of drawers, beds, tables, and chairs, which were all destined to adorn their ranch in Malibu. They also took the opportunity to outfit themselves from head to toe in loden, which they continued to wear anytime they were in the countryside for the rest of their lives. One day their ranch in Malibu was broken into and robbed. The thieves left a note: *You have wonderful taste, we would like very much to meet you.* Tony was both outraged and charmed. They had taken all of his Tyrolean hats, several of his loden suits, the shirts he had made from antique linen bedsheets, and so many of his other favorite Austrian clothes and decorations. Terry Stanfill remembers seeing Tony's production of *Jederman* on her first visit to Salzburg; long before she met Tony and became his close friend, she found herself enthralled by his theatrical magic.

OPPOSITE San Francisco Ballet production of *Beauty and the Beast* (1958), featuring costumes by Duquette.

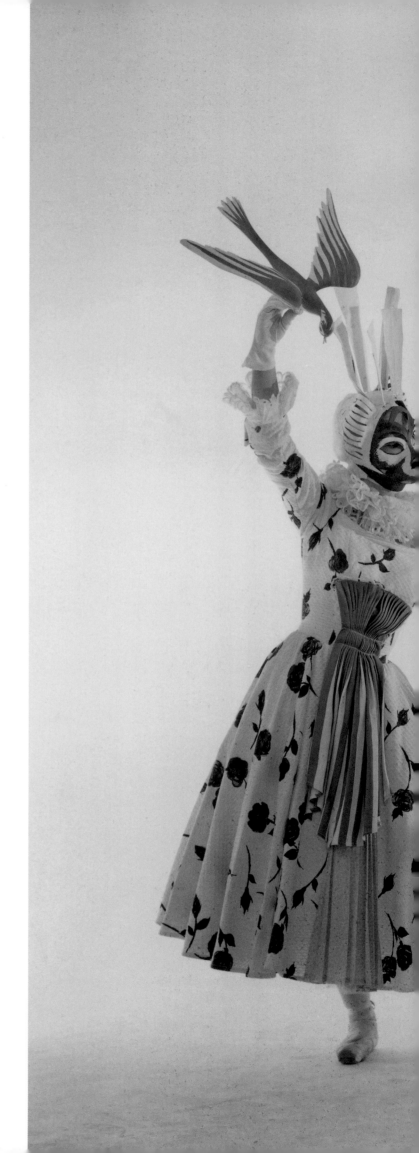

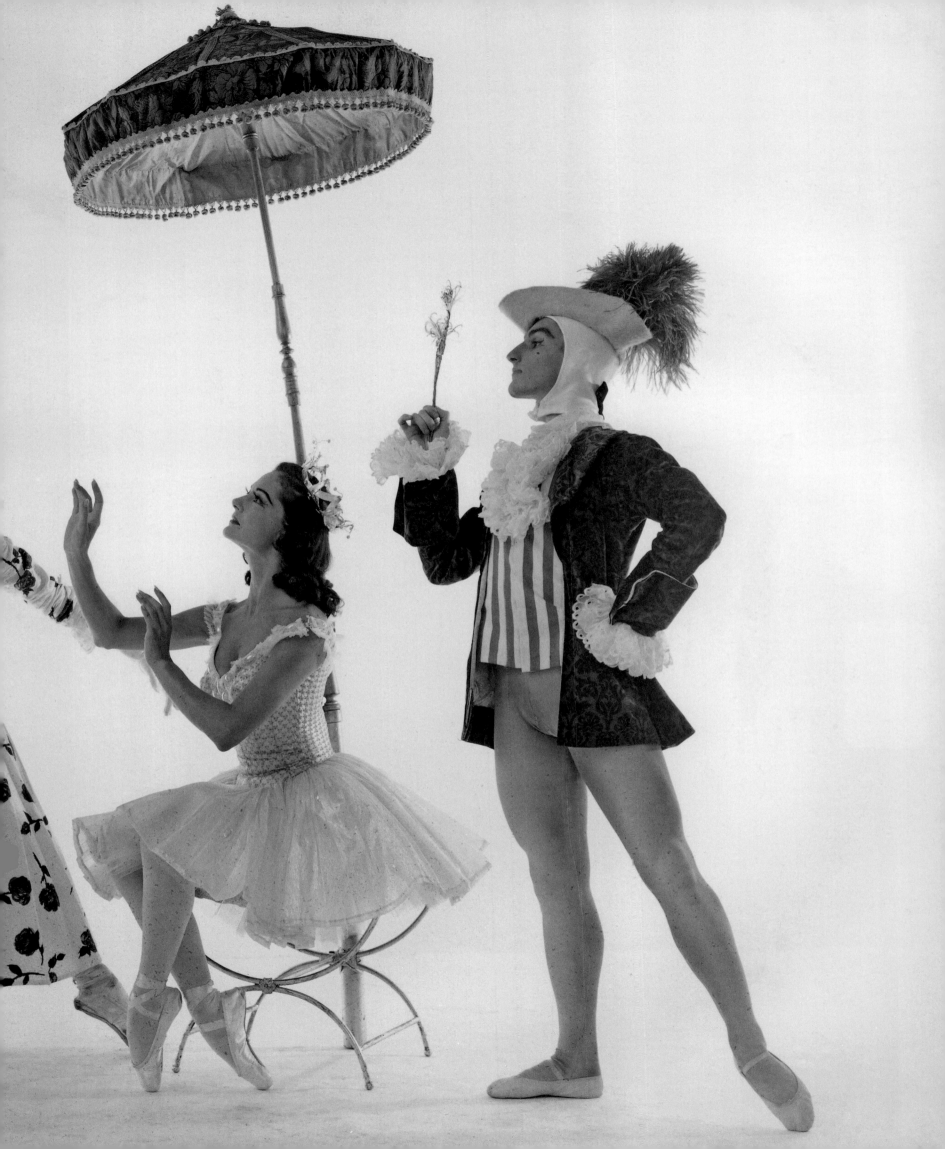

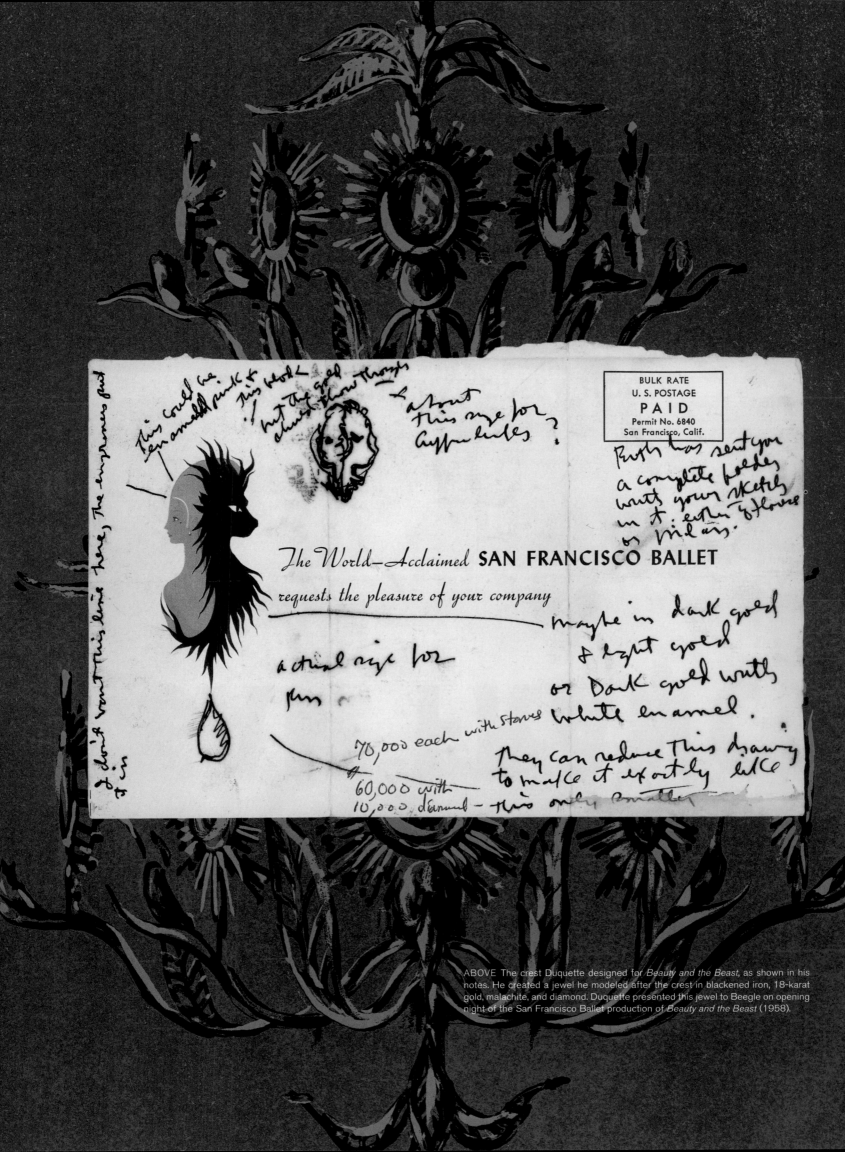

ABOVE The crest Duquette designed for *Beauty and the Beast*, as shown in his notes. He created a jewel he modeled after the crest in blackened iron, 18-karat gold, malachite, and diamond. Duquette presented this jewel to Beegle on opening night of the San Francisco Ballet production of *Beauty and the Beast* (1958).

In 1962 Tony was asked to create the costumes and sets for the Los Angeles Opera Guild's production of *The Magic Flute*. He agreed to do the production on a very small budget on the condition that he could procure the assistance of volunteer schoolchildren. With the aid of these teams of untrained children and their parents, his vision for Mozart's great opera was realized. It was staged at the Shrine Auditorium, the largest stage in Southern California, and the entire Los Angeles Unified School District was bussed in to see it. The critics wrote that it was the first time the vast stage at the Shrine Auditorium had been completely utilized, Tony having filled it from corner to corner with obelisks, palm trees, and giant tapestries. Tony later decorated the garden at his Dawnridge estate with many of these unique props.

In 1955 Alfred Hitchcock hired Tony to create the costume-ball sequence in *To Catch a Thief*, starring Cary Grant and Grace Kelly. The scene opens up on Tony Duquette chandeliers hanging from tree branches in the garden and progresses through a sequence of entrées, all choreographed by Tony.

One movie production number often mistakenly attributed to Tony Duquette is the "Place de la Concorde" scene in *An American in Paris* (1951). The fountain is entirely "Tony Duquette"—and yet Vincente Minnelli did not ask Tony to do it. At the time, Tony and Beegle were living in Paris, where he was working on his show for the Louvre. This giant undertaking must have precluded Tony helping Vincente with the project—but Tony was always pleased that his work helped inspire the ballet dream sequence in the film. It would seem that Vincente was able to find somebody else to reproduce the "Tony Duquette" look. Tony always contended that the studio technicians were the best in the world; "there was nothing they couldn't do or reproduce," he would say. Other productions

that used rented Tony Duquette props—but not Tony—to great effect include *The Band Wagon* (1953), *The King and I* (1956), *Bell, Book, and Candle* (1958), *Sweet Charity* (1969), *Airport 1975* (1974), and *Call Me Madam* (1953), to name a few.

Once, years on, wandering around the back lot at MGM, Tony discovered the giant treadmills he had used for the opening sequence in Vincente Minnelli's *Four Horsemen of the Apocalypse*. Tony was so excited to see these giant contraptions, on which the four horses had galloped against a cloudy sky. "I covered the horses with fake rubber skins, which were shredded and horrible… And when the horses would gallop and we filled the stage with fog, the effect was terrifying, as if the horses' flesh was coming off and you could see their bones underneath!" He was particularly proud of the special effect, and of the intricate golden andirons he had concocted of antlers, plaster, and other found objects, representing Death, Pestilence, Famine, and War. Debbie Reynolds purchased these andirons from the MGM sale for her Hollywood Motion Picture Museum. One day Tony got a call from Debbie, and after saying hello she blurted out, "Death is missing!" Tony came to her rescue, making her a near-duplicate andiron representing Death, gratis.

When Lerner and Lowe were planning their production of *Camelot* for the Broadway stage, they hired Adrian to do the costumes. Before any of the costumes could be made and before Adrian had finished all of his sketches, the designer died of a heart attack. Adrian's wife, Janet Gaynor, immediately recommended their old friend Tony Duquette to take over the project. Tony was so pleased to be asked and so honored to be following in Adrian's footsteps that he insisted on sharing any residuals with Janet. Tony shared not only the residuals from the production but also the Tony Award with

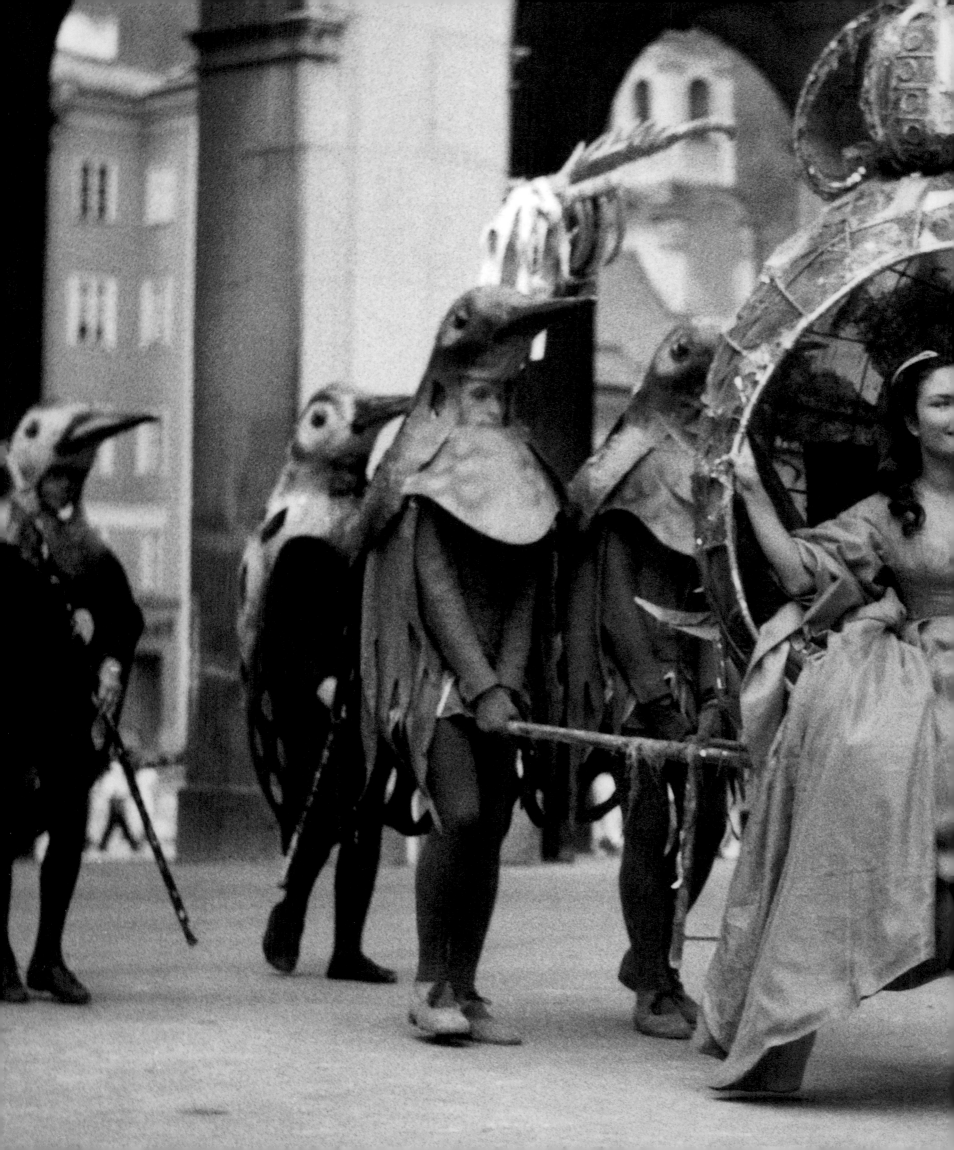

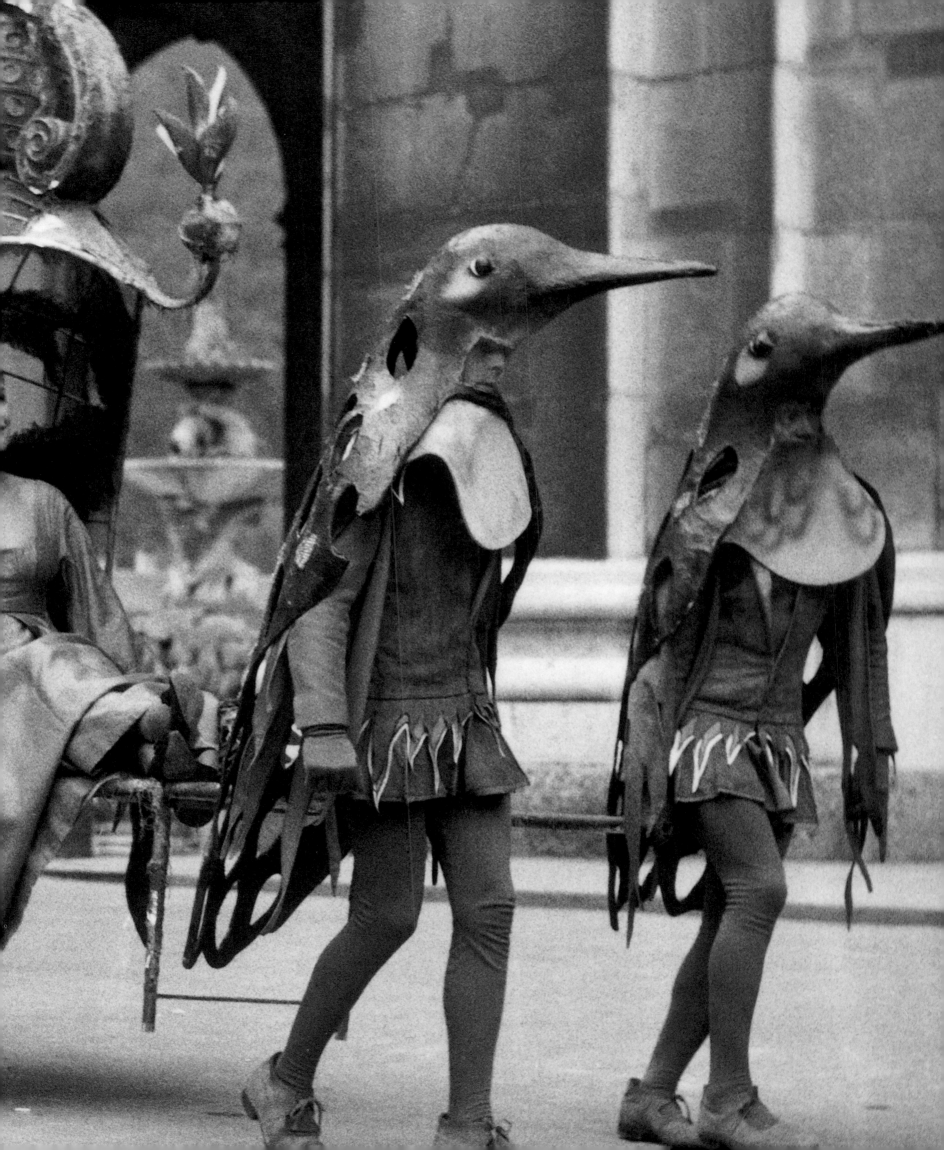

Janet and Adrian, insisting that Adrian receive his due, even though the greater percentage of the costumes were his own original concepts. Of the 240 costumes designed and executed for the general company, thirty were Adrian's designs using Duquette's colors; the rest were Duquette originals. Of the sixty-one principals' costumes, two of Arthur's were by Adrian and ten by Duquette; eight of Guinevere's were by Adrian and three by Duquette; and all of Lancelot's, Pellinore's, Mordred's, Merlyn's, and Morgan Le Fay's costumes were by Duquette, using his colors.

Tony insisted that *Camelot* contain a ballet sequence, which he called the Magic Forest ballet. He envisioned a scene in which all the animals in Morgan Le Fay's dominion take on human attributes and dance. The production number was a great success and one that Tony was particularly proud of.

Tony's time at MGM and the other studios was well spent. He met and became friends with all the major stars and film luminaries of the period. The art dealer Irving Blum, recalling the first time he dined at the Duquettes' studio, remembers, "There were many tables of eight people, four men and four women at each. The other three men at my table were Fred Astaire, Cary Grant, and Gary Cooper. Don't even ask me who the four women were."

Later, when MGM decided to auction off its props and costumes, Tony had the inside track; he knew that many of the pieces used in the films were fine seventeenth- and eighteenth-century antiques, painted gray so they would photograph better in black and white, but easily restored to their original beauty with a little paint stripper. Tony was able to buy all of these hidden treasures at that time. He had so little sales resistance that he did not dare go to the sale itself, but instead sent his friend

John Adams, the grandson of the famous film director King Vidor, another Duquette family friend. From that sale Tony came into possession of the famous eighteenth-century corner cabinets that graced his dining room in San Francisco, which held eighteenth-century portraits of Emperor Franz Joseph and his finance minister. The portraits had been turned around and covered with a plain panel when the cabinets were used in a film; only Tony knew that the paintings were behind those panels. Other purchases included a pair of Louis xvi chairs featured in *The Thin Man*, a pair of ornamental Capricorn sculptures featured in *Marie Antoinette* and *Singin' in the Rain*, props from the *Ziegfeld Follies* "Lime House" sequence, Regency console tables, Biedermeier display cabinets, seventeenth-century oil portraits of English nobles, Chippendale tables, framed mirrors, and any number of other amusing decorations.

In the end, when MGM sold off its amazing back lot to make room for a housing development, former MGM executive Joe Cohn called Tony and said, "If you have a use for it, you can come over and take anything you want. The bulldozers will be knocking it all down in a couple of weeks and so; if you have a use for it, come and get it." Tony had "a use for it." As it turned out, Tony had a use for everything. Two enormous trucks with eight laborers entered the back lot of MGM following Tony in his own car. Tony would point and the trucks

PREVIOUS SPREADS
Duquette created the proscenium curtain lined with ermine tails for the San Francisco Ballet production of *Beauty and the Beast* (1958).

Duquette's costumes for *Der Jedermann* (1961), the first new postwar production of the Salzburg Festival.

OPPOSITE San Francisco Opera production of *Der Rosenkavalier* (1952). The Marchaline's bedroom decor and costumes by Tony Duquette.

OVERLEAF A maquette of Marchaline's bedroom, designed by Duquette for the San Francisco Opera production of *Der Rosenkavalier* (1952).

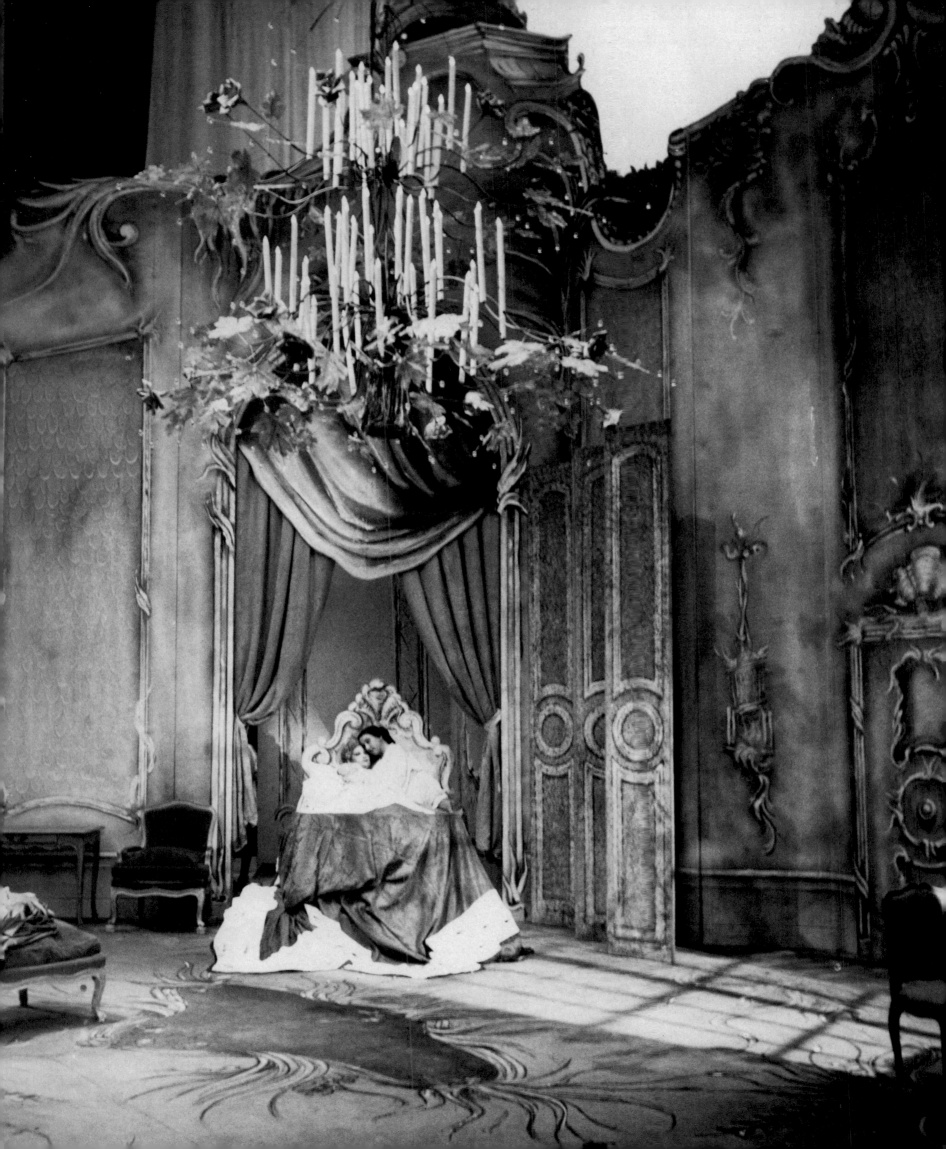

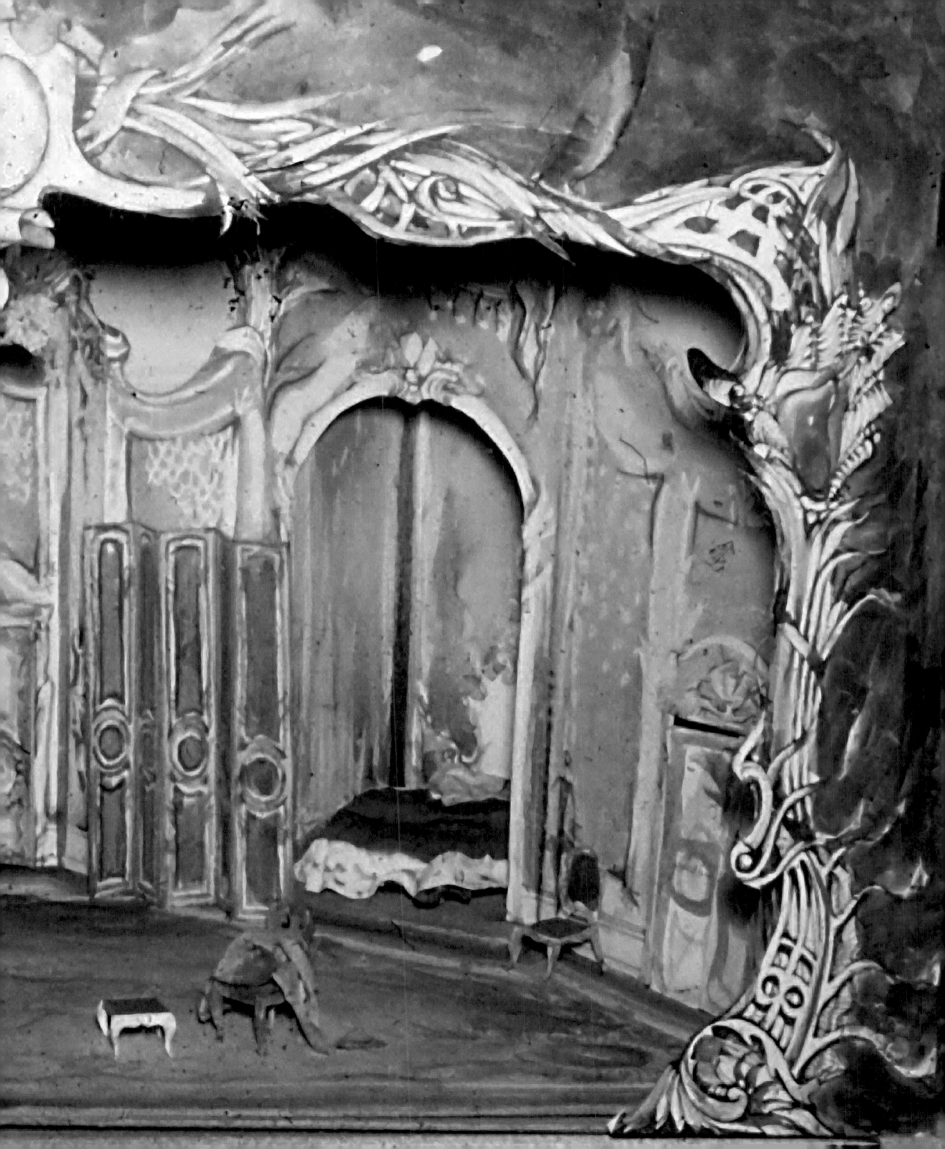

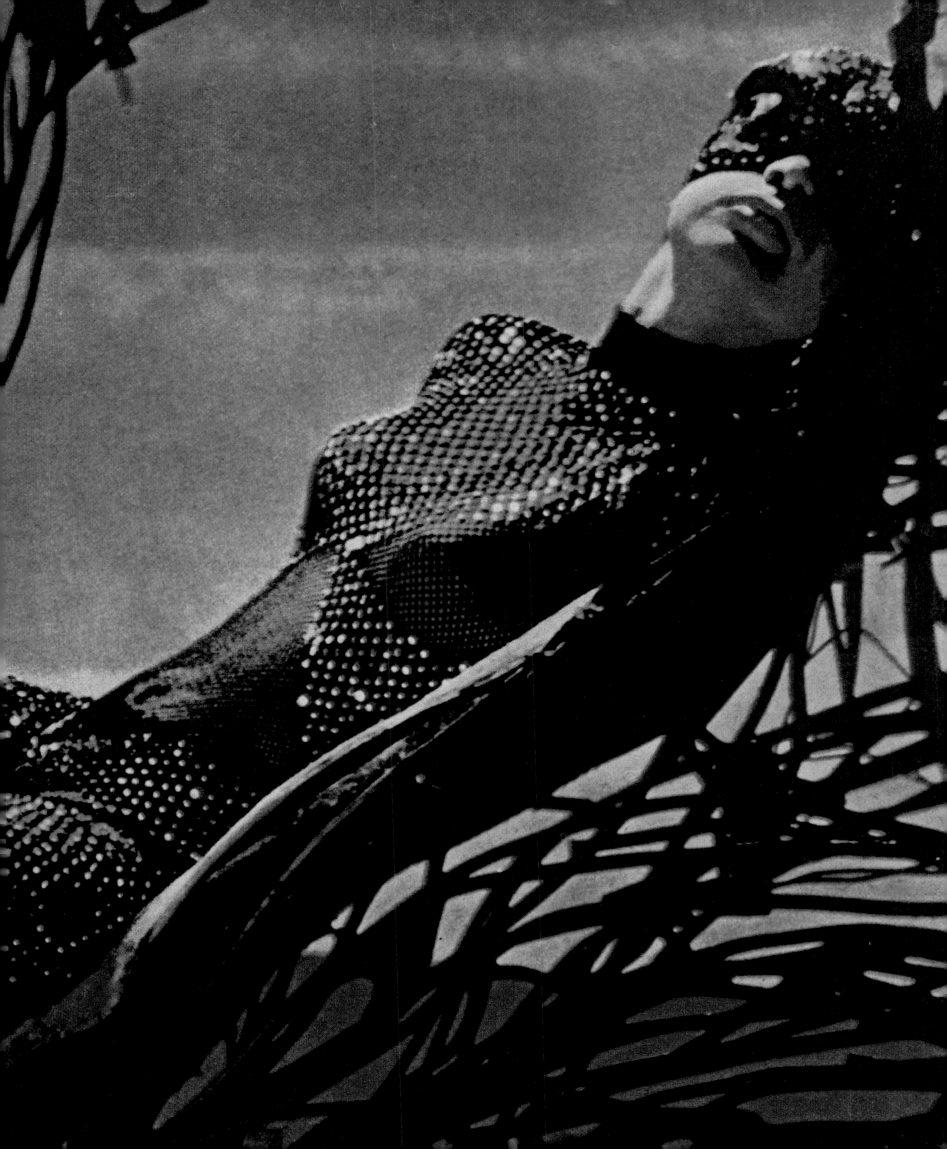

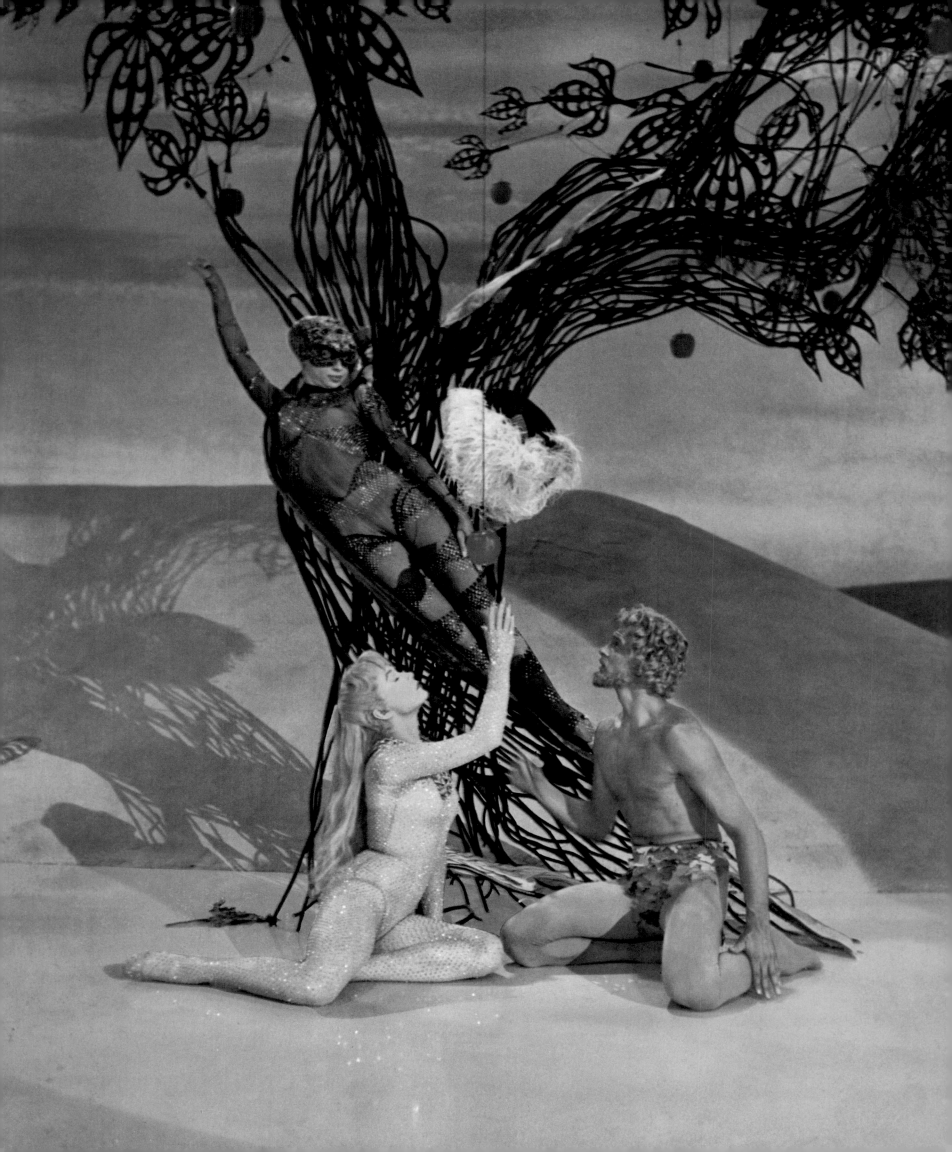

would stop and pick up whatever he wanted. There were eighteenth-century fireplaces lying by the side of the road, the front doors to Tara, Scarlett O'Hara's house in *Gone with the Wind*, entire facades of houses and shop fronts. There was the New York Street and the facades from *Singin' in the Rain*, and the school with its clock tower from *Good News*. Behind one of the facades he found the railings that he had designed for *Lovely to Look At*, which immediately went into the truck. There were all the Directoire-style ballroom chairs that featured in every MGM film whenever there was a restaurant or party sequence, and the enormous high chairs from the baby sequence in *The Band Wagon*. Esther Williams's swimming pool, the street where Andy Hardy grew up, the train station, the lake, the Chinese village, the European village—bits and pieces and whole sections of all of these went into the trucks, to be reassembled at a later date at Tony's studio on Robertson Boulevard and at his vast ranch in Malibu.

On another occasion Tony got a call from Warner Bros. Studios. They were going to bulldoze their ranch—and if Tony wanted anything he should come and get it. He drove over the vast Warner Ranch, where so many Westerns and epics had been made. Rounding a bend in the road he stopped in awe as an entire Chinese palace loomed before him. Of course Tony took the entire palace: the doors, the columns, the roof with its intricate dragon end tiles, and even the paved courtyard. The elements of that fabulous palace ended up

here and there—the courtyard went to the ranch; the roofs, to Dawnridge in Beverly Hills; the doors and columns were sold to a client for a beach house in Malibu.

Vincente Minnelli approached Tony one last time to work on a film. Vincente had an idea for a film that stemmed from a clipping he found in an old *Vogue* magazine, which showed the gloved hand and jeweled wrist of an unseen woman holding a pair of jeweled Fabergé-style binoculars. This was the premise for the film; as yet there was no script, no plot, and no budget, just an idea sparked by the image of a mysterious woman looking through jeweled binoculars. Vincente asked Tony to make the binoculars and some headdresses. One day Vincente showed up at the studio with Merle Oberon. They came to inspect the binoculars and the headdresses. The movie never got made; it never went any farther, just an idea, one of Vincente's whims.

After the success of Tony's Personal Culture exhibition at the Municipal Art Gallery in Los Angeles, a generous patron offered to supply film to King Vidor and a group of USC film-school students if they would document the exhibition.

Filming commenced and after several days Tony said, "If anyone had told me that King Vidor would be making a film about me and my work, I would have been so excited; now that it is actually happening, I am so bored!"

Before the film was finished, King Vidor was called away on a project and Tony asked Vincente Minnelli to take over. Liza Minnelli later said that Tony and her father were the only two men she knew who could carry on a complete conversation, neither of them ever finishing a sentence, but both of them knowing exactly what the other one was talking about.

PREVIOUS SPREAD AND OPPOSITE Shirley MacLaine, Marc Wilder, and Juliet Prowse in "Adam and Eve," Duquette's ballet sequence for *Can Can* (20th Century Fox, 1960).

OVERLEAF LEFT AND RIGHT Duquette's ballet costumes for *Jest of Cards* were inspired by workmen on stilts. He wanted costumes that became sets, and designed his towering kings, queens, dancing jokers, and backdrop figurines up to twenty-four feet tall. Duquette also commissioned a composer for the orchestra for this private production at the San Francisco Ballet.

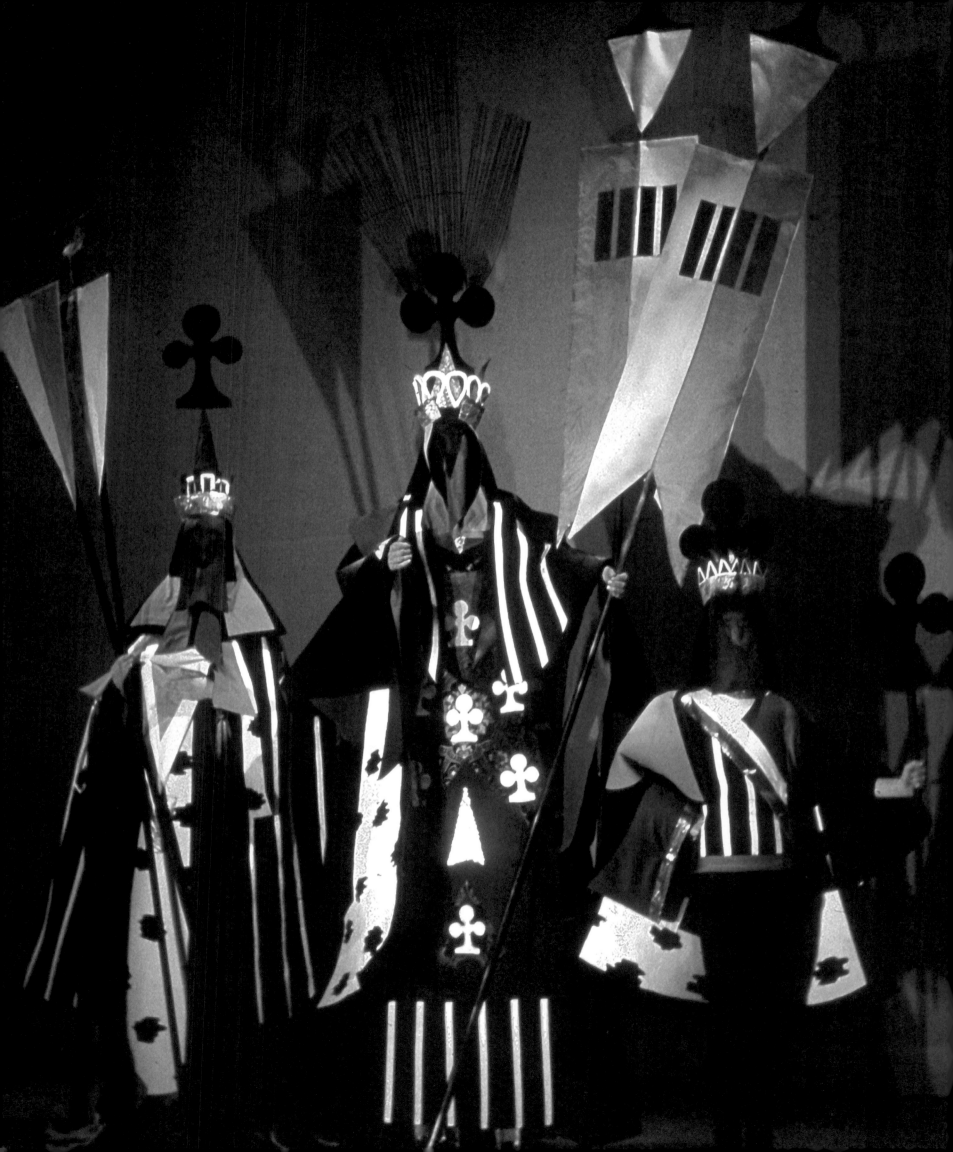

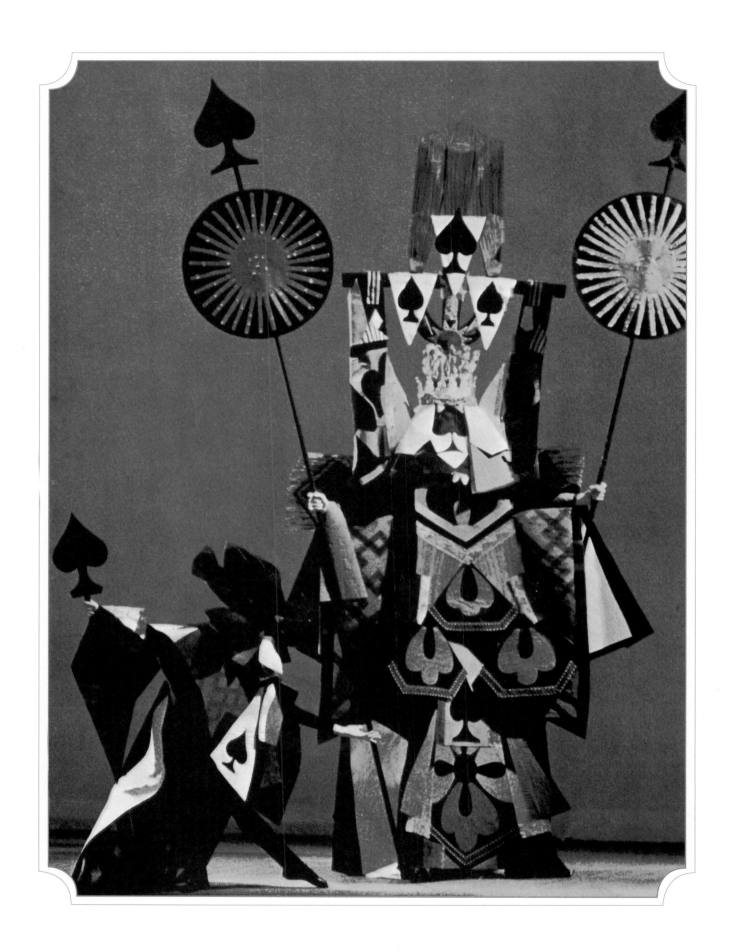

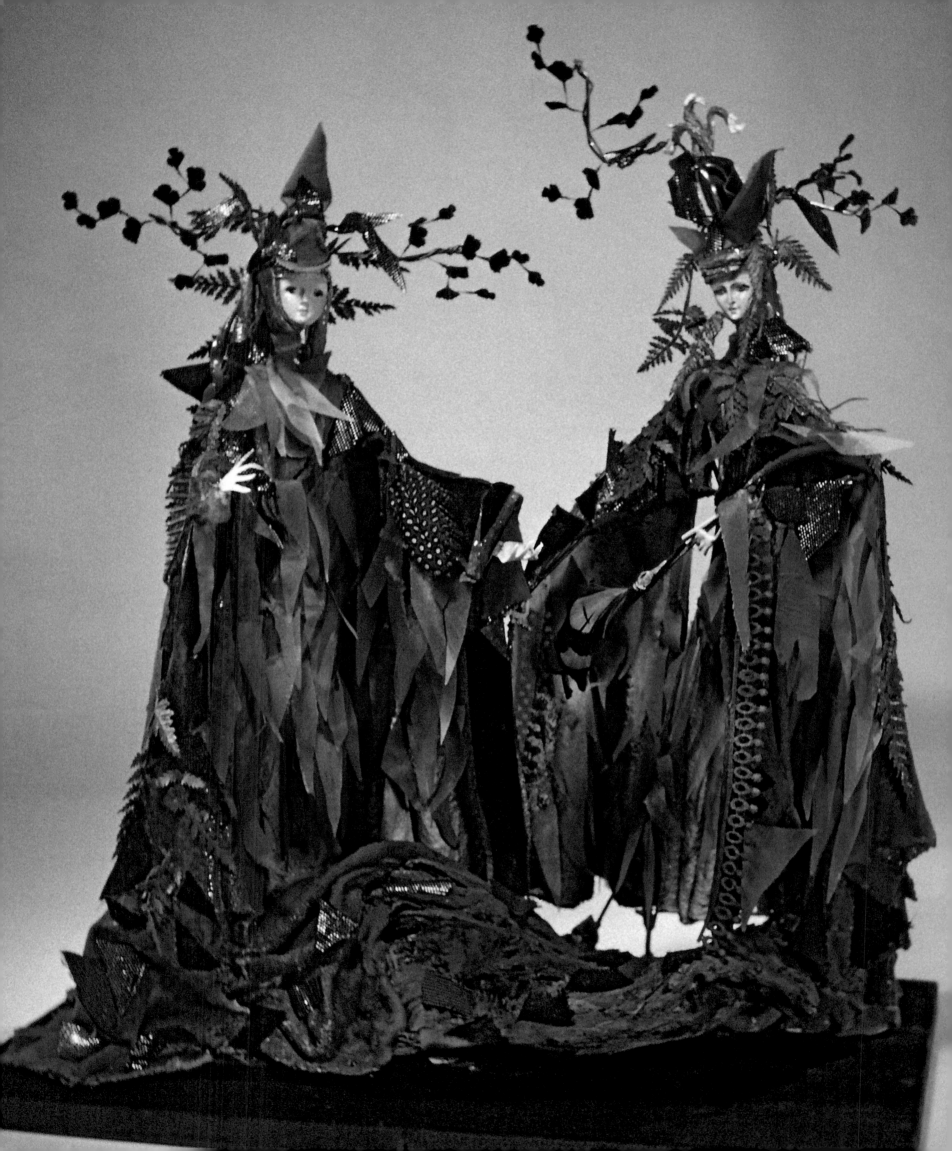

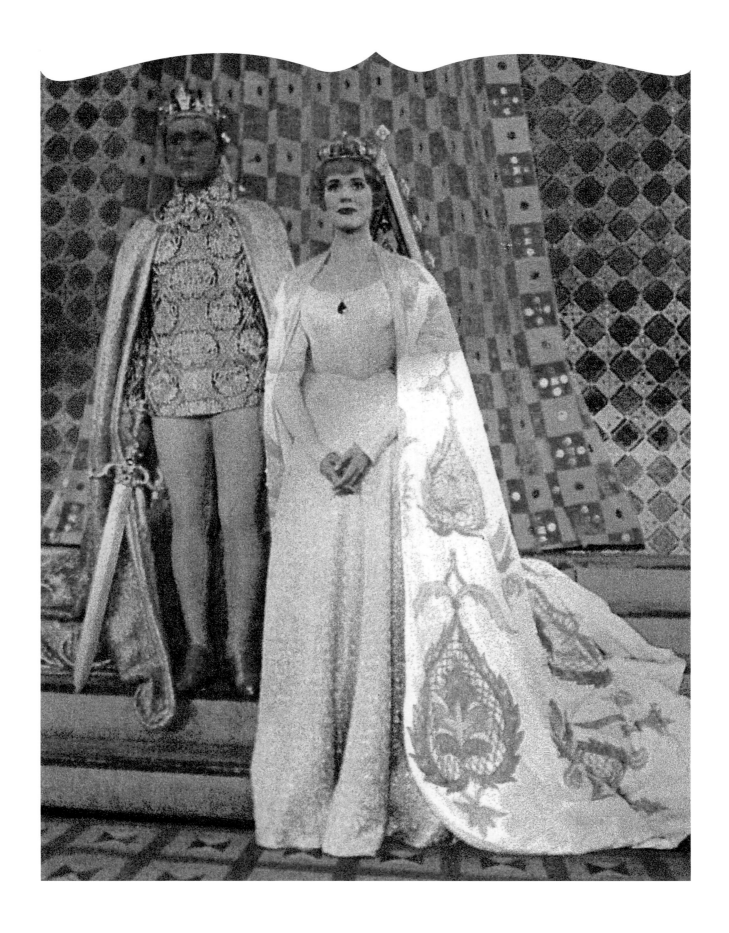

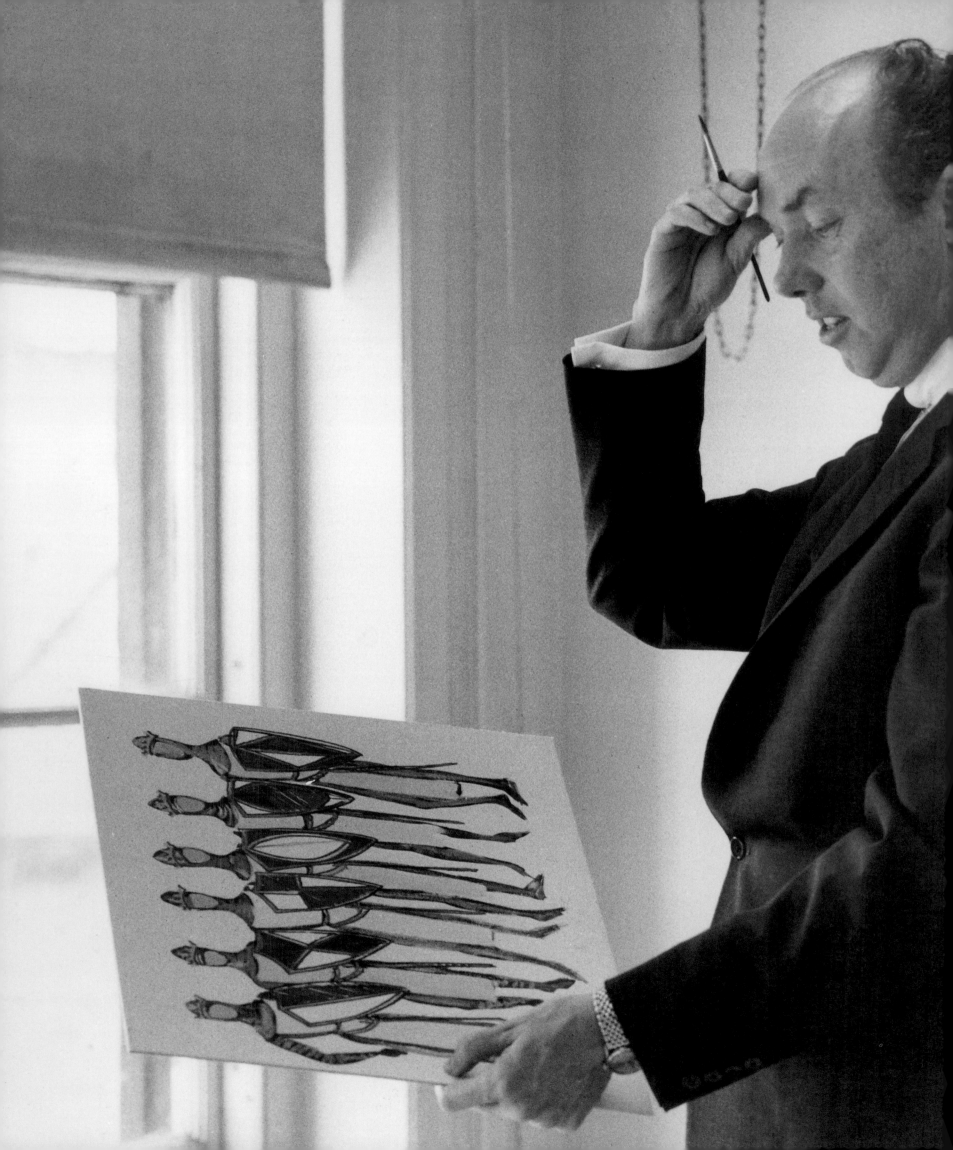

PREVIOUS SPREAD
LEFT *Camelot* three-dimensional costume designs by Tony Duquette.

RIGHT Richard Burton as Arthur and Julie Andrews as Guinevere in Duquette-designed costumes for the original Broadway production of *Camelot*

OPPOSITE Duquette in his New York studio, sketching costumes for the original Broadway production of *Camelot*.

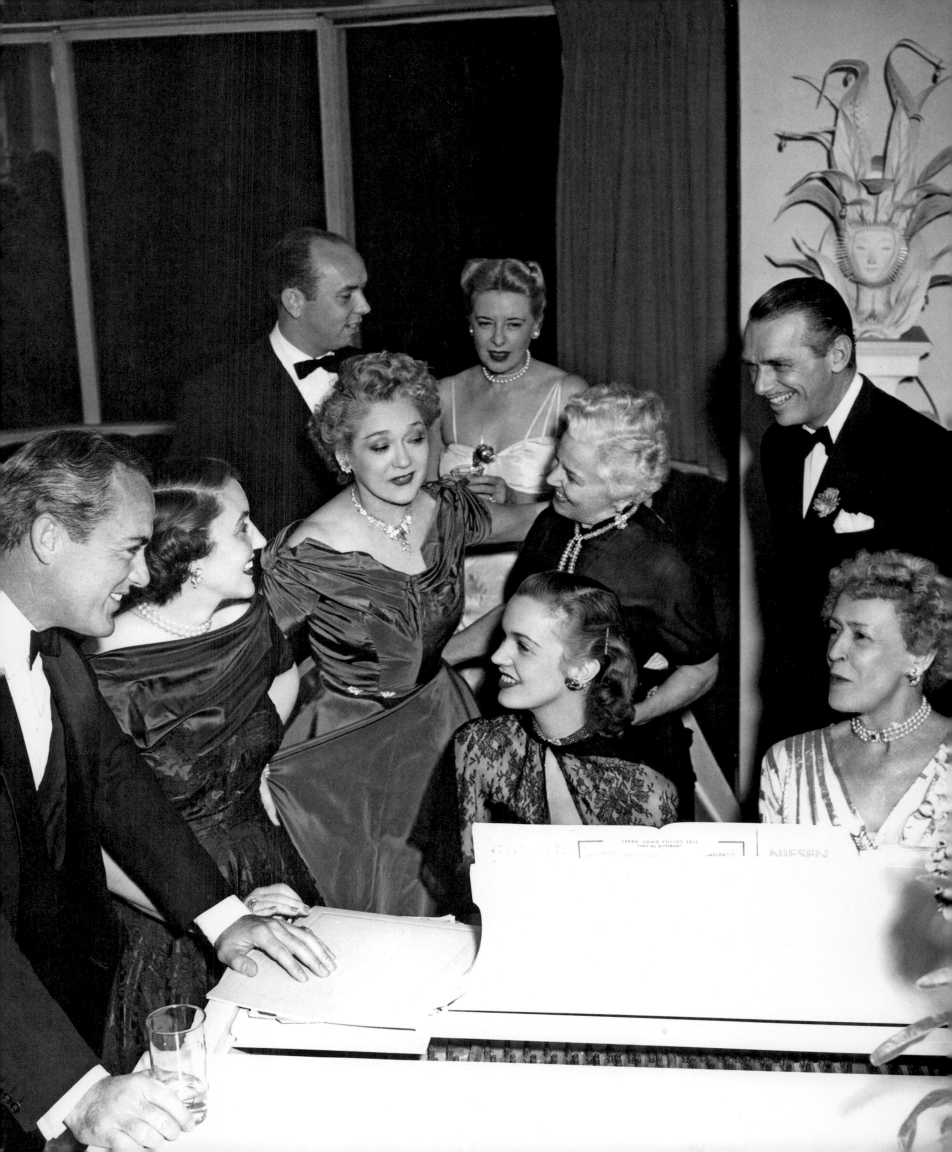

MAGICAL ENVIRONMENTS

We spoke the same language. And he always told me to let the eye go, just go beyond, let it pass into something else. And I didn't quite understand what he meant. He said the eye is the key to the mind. It changed my taste. I was no longer afraid. I suddenly, quite frankly, looked around my house and the furniture I bought when we were married in England. Too Puritan! I wanted to be more daring. And I started buying Venetian furniture. Gradually, you know—I didn't buy it overnight. I sold most all of my English furniture. He gave me confidence in my own vision. I was seeing another kind of aesthetic.

Terry Stanfill

TONY BELIEVED A HOUSE SHOULD CHANGE ITS SKIN, like a reptile. He was responsible for the decoration of his parents' interiors, which changed constantly. As a young boy, fascinated by the discovery of King Tut's tomb, which he learned about in *National Geographic*, young Tony created his own Egyptian-style stools and chests, which were added to the family décor.

His later fascination with the Far East led him to paint folding screens with Art Deco–styled cranes and herons for his mother. And during a winter visit to Los Angeles, he purchased his first piece of furniture, a red-lacquered Chinese cabinet from the venerable Asian antiques dealer F. C. On, for the princely sum of twenty-five dollars. The dealer would remain one of Tony's favorite sources for Oriental art right up to his death in 1999.

OPPOSITE Cobina Wright loved to entertain in her Duquette-decorated house. Charles "Buddy" Rogers, Gladys Knapp, Mary Pickford, Tony Duquette, Helen Hayes, Douglas Fairbanks, Jr., Cobina Wright, and two unidentified guests surround the piano, 1950s.

OVERLEAF In the years following the death of Elsie de Wolfe, Cobina Wright became the most important sponsor in Duquette's life. He designed a dramatic interior for her using many of his own creations, including the modern snowflake patterned screen, his figural lamps, and a *trophé* of musical instruments.

6

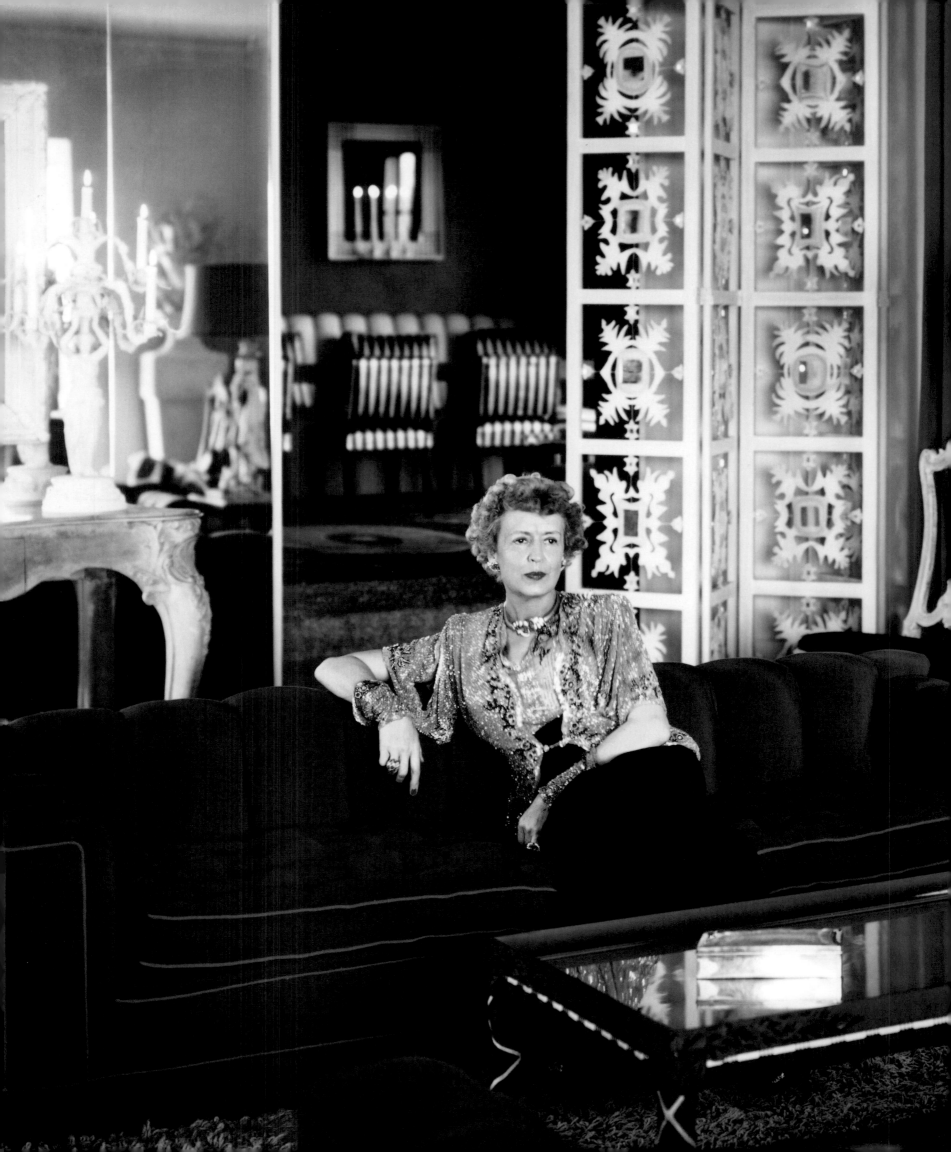

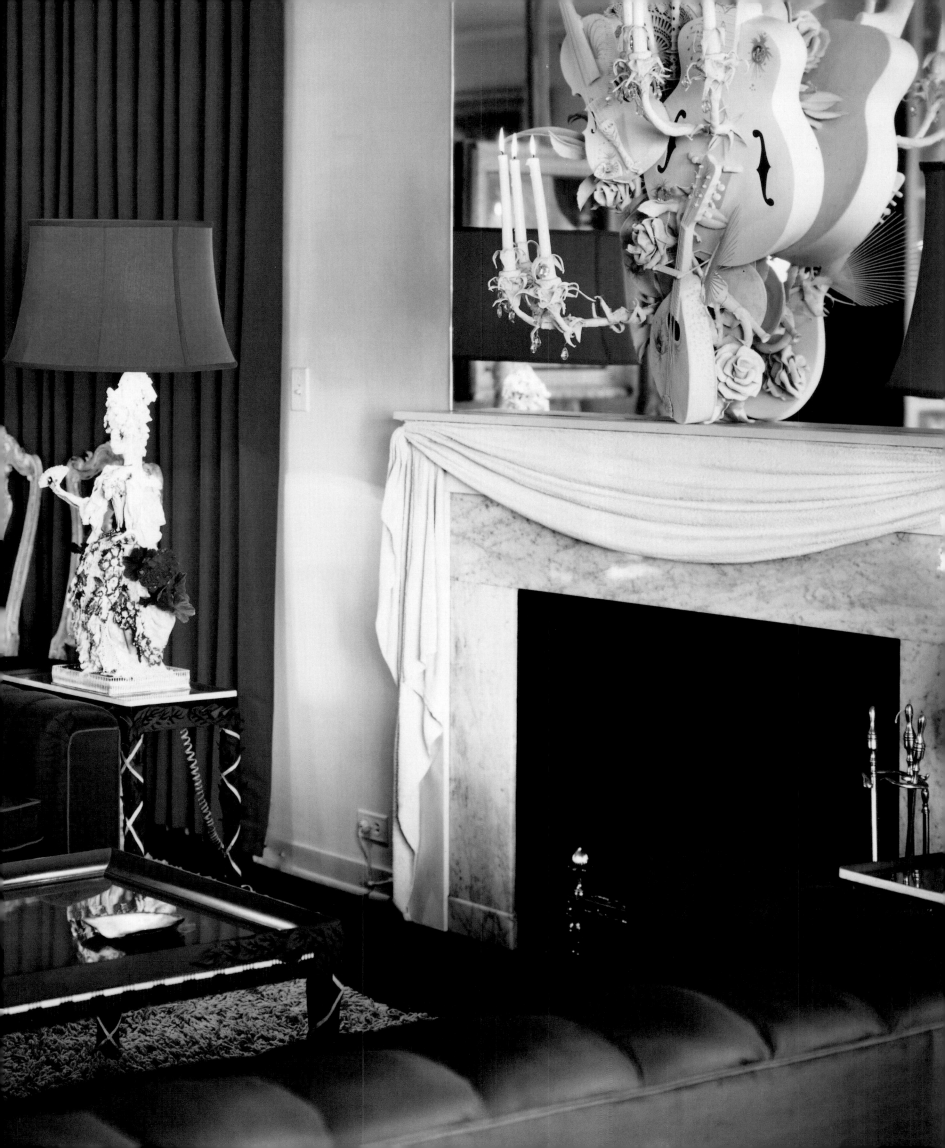

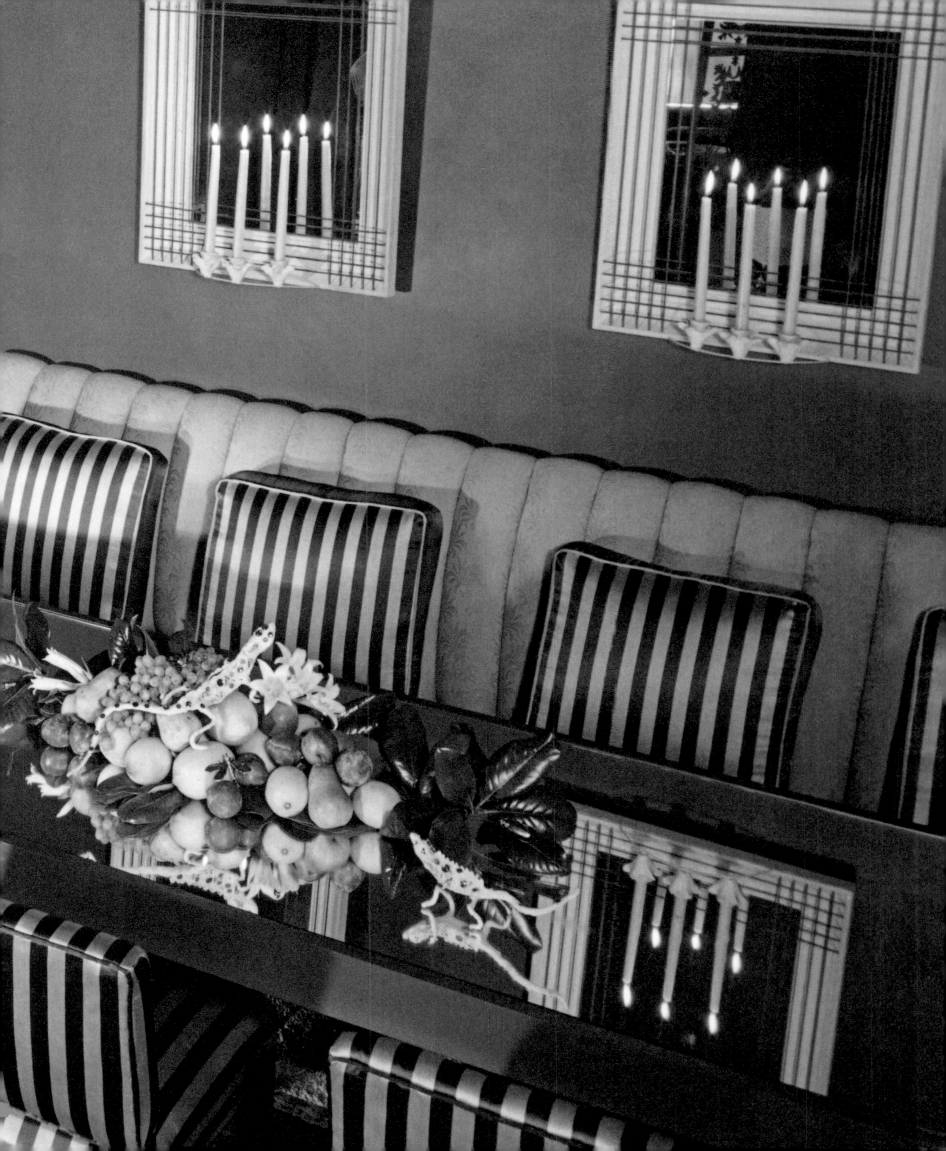

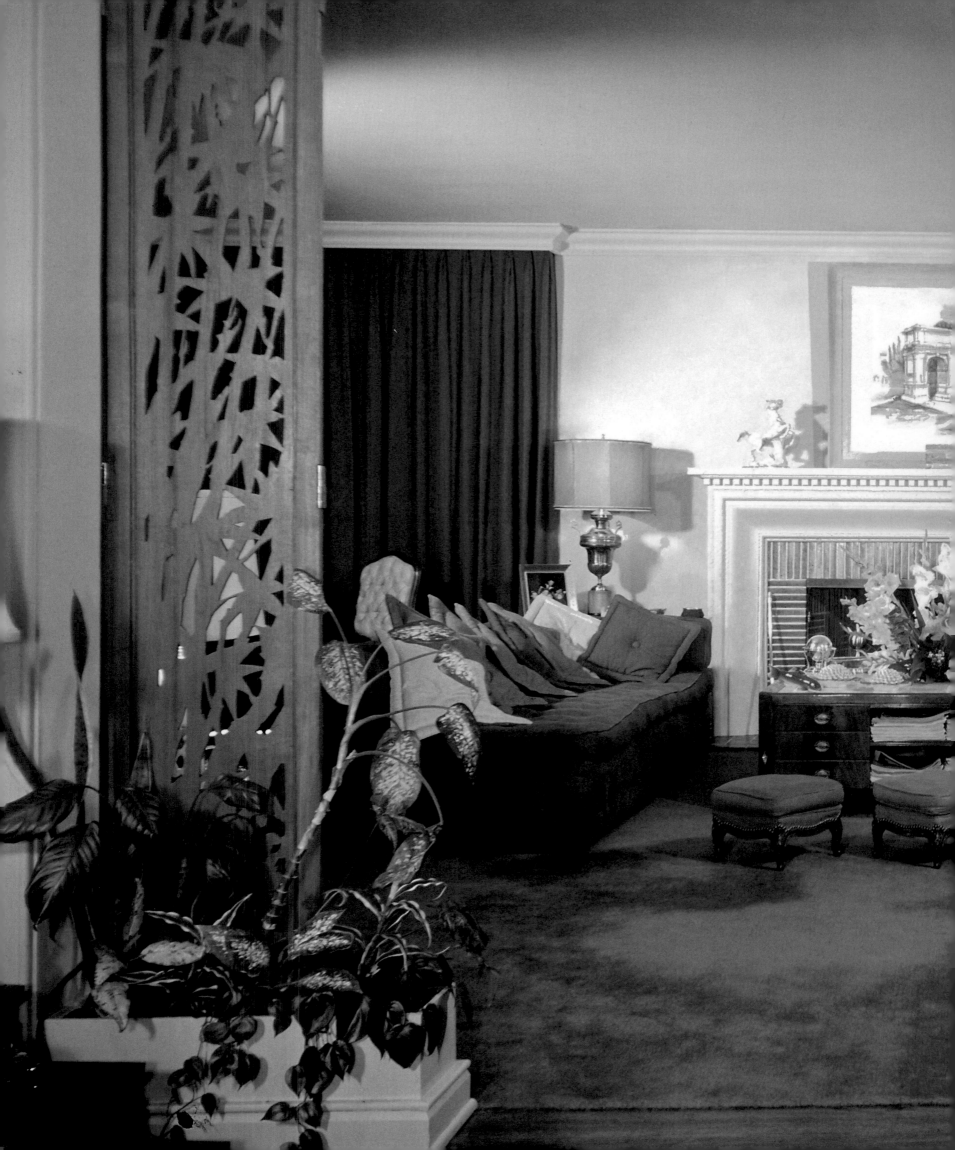

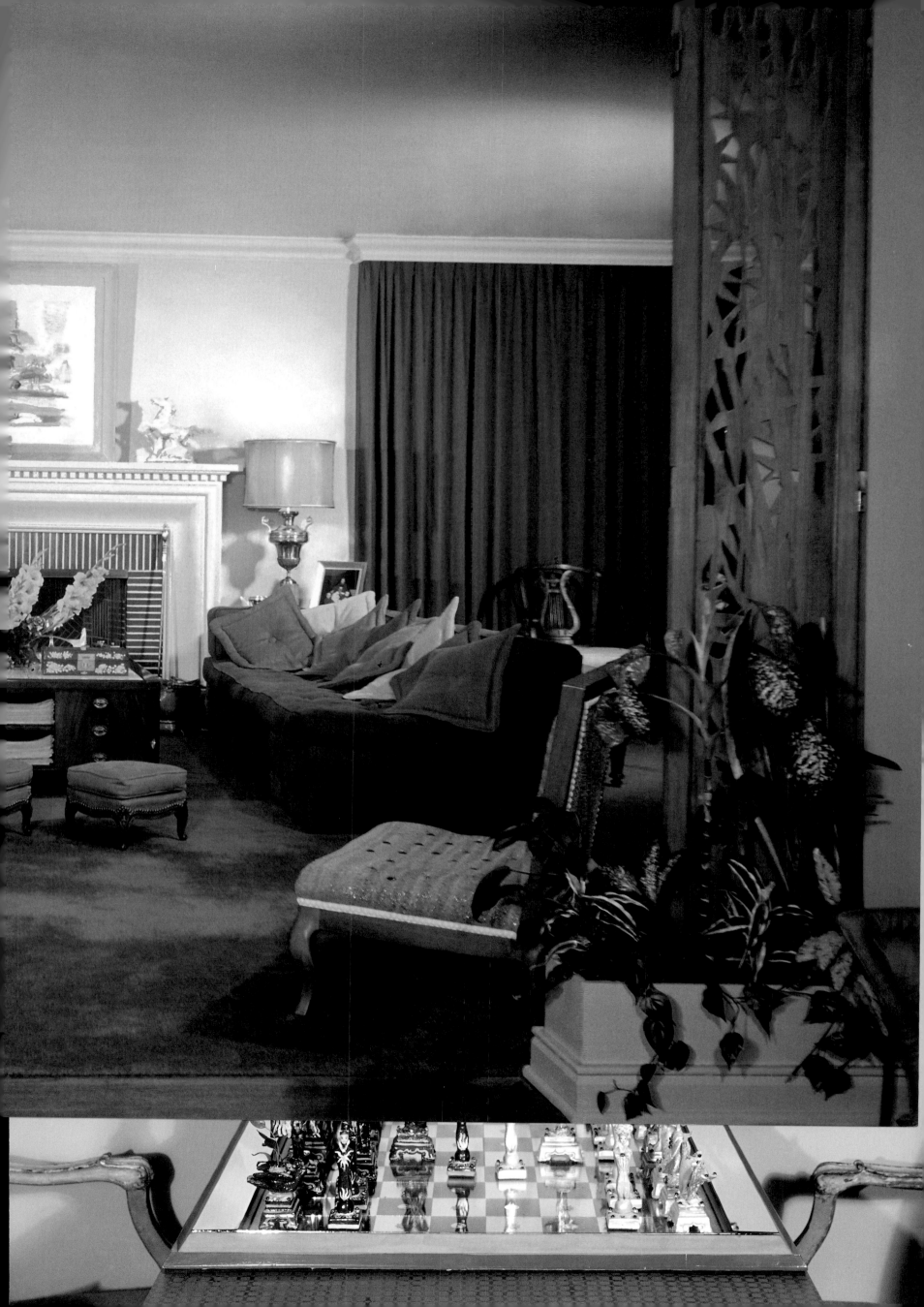

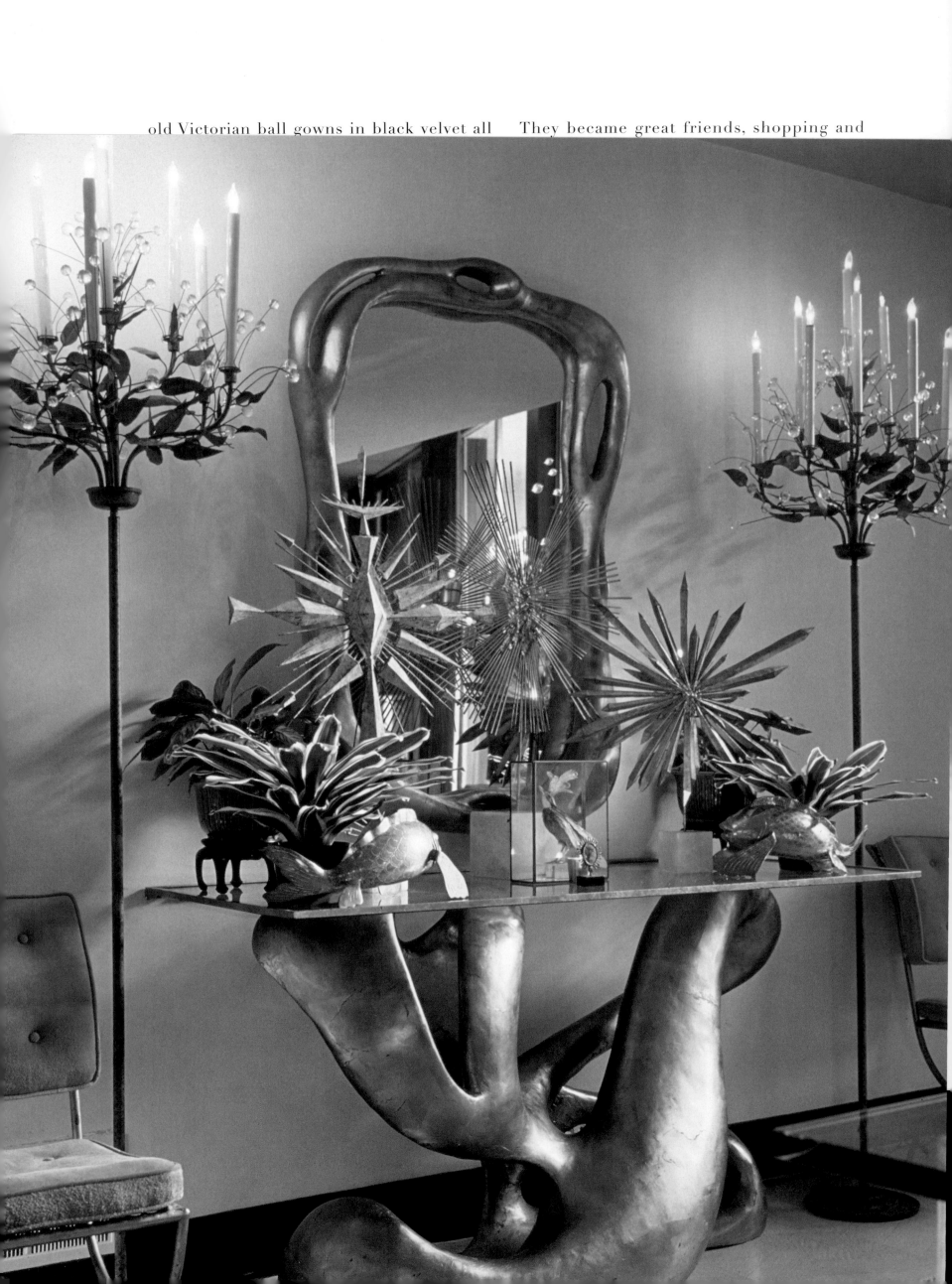

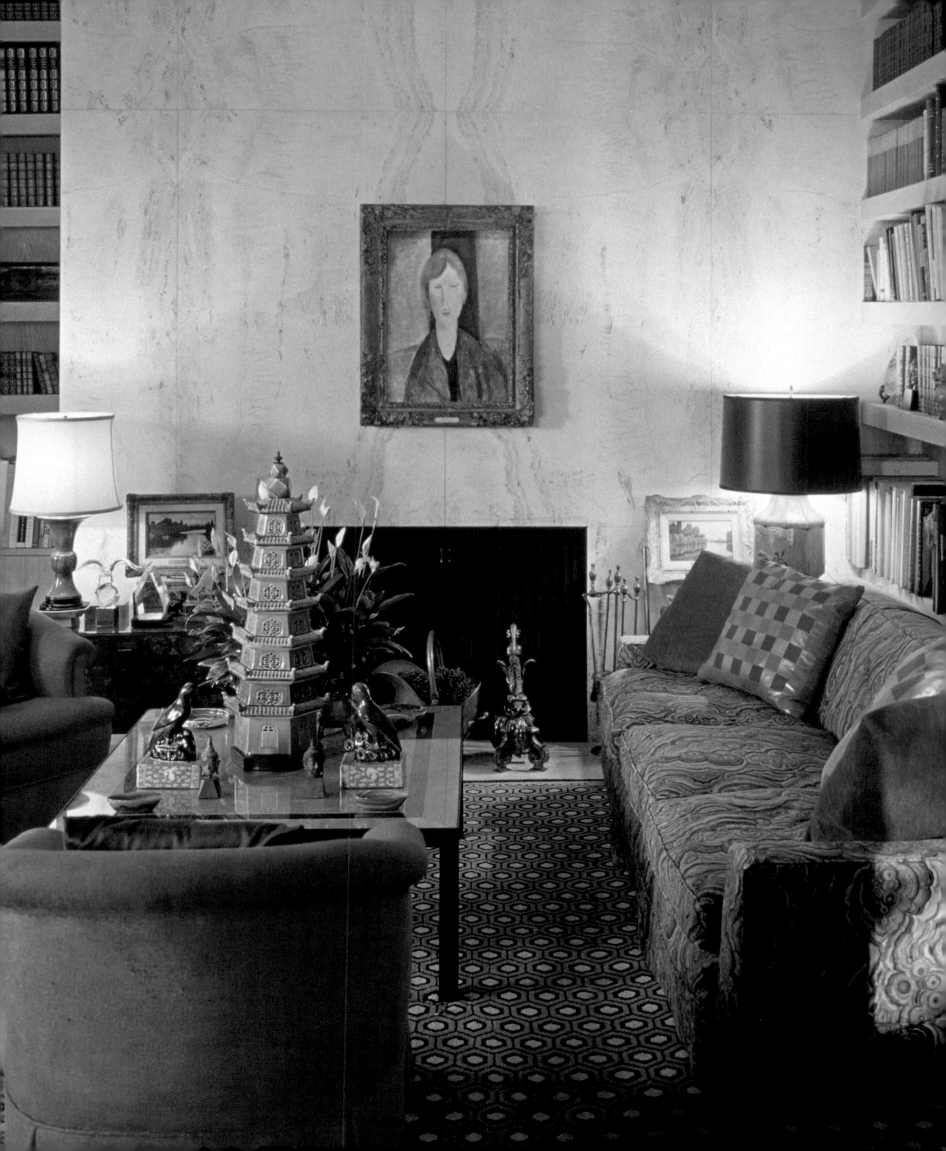

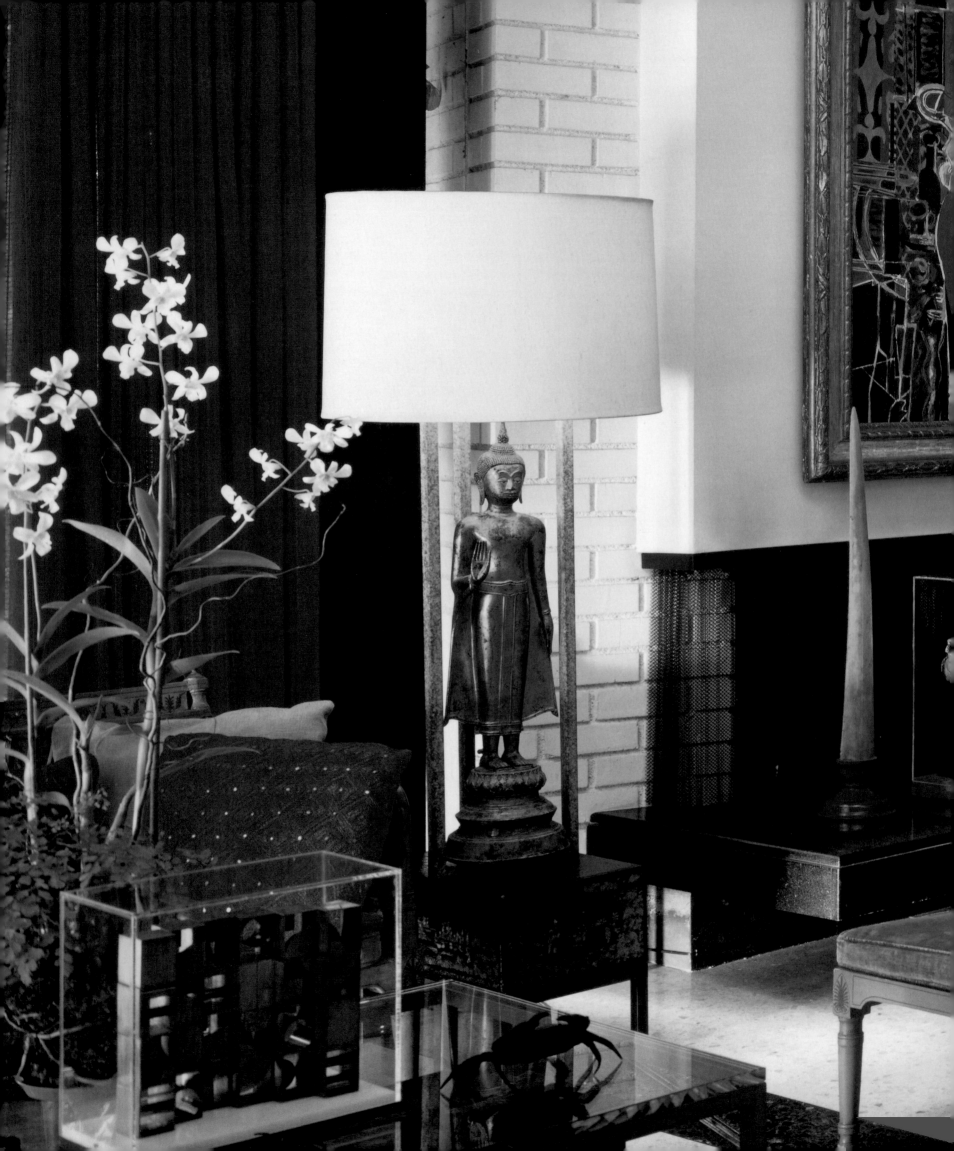

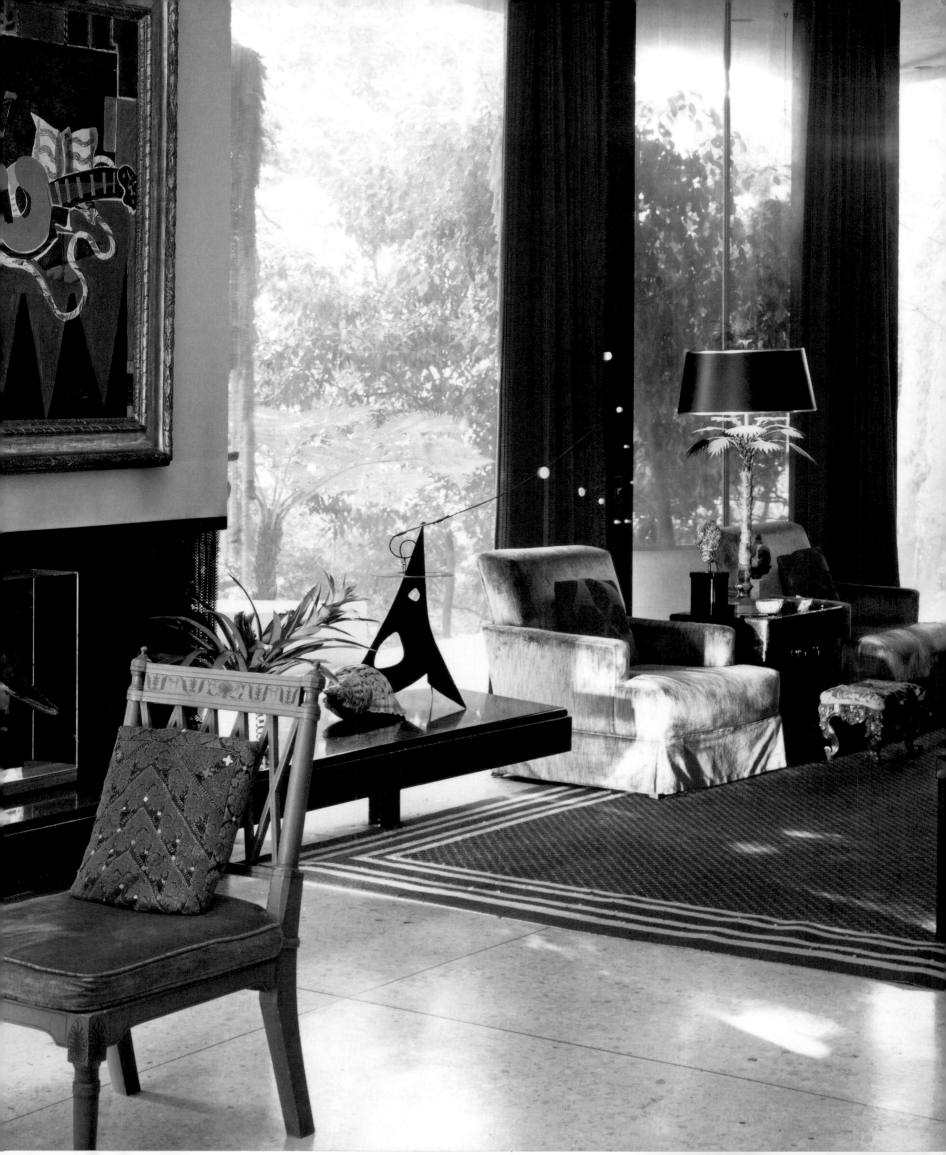

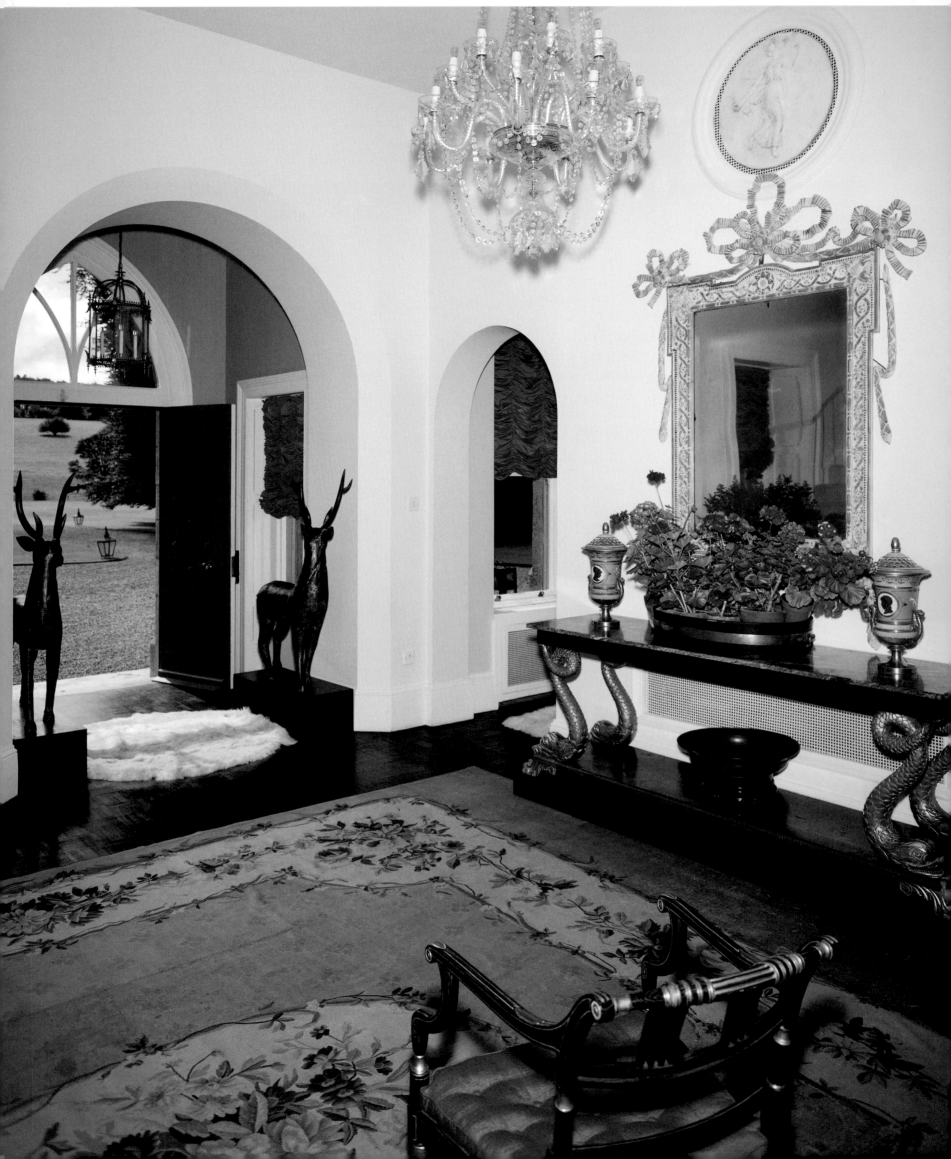

Tony and Beegle entered the 1960s head on. The original rich hippies, they entertained in brocaded and embroidered robes, caftans, and jewels at their newly redecorated Robertson Boulevard studio, where Tony had installed a light show. Black lights, projected pulsating and rotating light patterns, and a constantly changing electric traffic signal all became an integral part of the décor. When they weren't entertaining at home they were out, invariably in black tie, at the various Los Angeles nightclubs, such as the Daisy or the Factory. Another favorite was the short-lived Club John, without a doubt the most beautifully decorated nightspot and one of the most opulent. In fact, Tony had done the place, with all his signature pieces, including antique Gobelin tapestries framed in leopard-print velvet, crystal chandeliers of his own design, gilded antlered heads, multipatterned walls, jewel-colored velvets, shell-and-leopard-print-framed mirrors, carved and gilded antique Spanish doors, and on and on. Everyone wanted to get in to see the décor. As a club it was a dismal failure, but as a showplace it was a hit.

A pattern had developed in Los Angeles over the years. Clients of Billy Haines would often find their way to James Pendleton; then when Pendleton retired they would move on to Tony Duquette. This was the case where Mary Gross was concerned.

The eminently patrician Mary Gross was the wife of Lockheed chief Robert Gross, a well-loved member of Los Angeles society and a lifelong friend to Tony. Tony freshened up the couple's house by adding his own creations, including a charming Chinese pagoda he

designed and built for the garden. The celadon green and coral treillage pagoda, with its carved wood tassels and elegant finial, was also one of Mary Gross's favorite new possessions, and it was highly photographed and talked about at the time.

When Mary Gross died, her daughter, Palmer Ducommun, gave the pagoda back to Tony before she sold the house, and Tony moved the three-tiered lattice structure to his Malibu ranch, where it took on a prominent position at the entrance to his own Frogmore House.

Palmer Gross Ducommun became one of Tony's best friends and most important clients. After marrying Charles Ducommun, the Ducommun Steel heir, she asked Tony to design their Bel Air home as a mid-century Modernist dream to house their family and their collections of fine art.

The house itself had been remodeled for the Ducommun family by Mike Morrison, a talented designer who had worked for Billy Haines as an architect and decorator. Morrison provided Tony with an intriguing pared-down space, which Tony immediately began to fill with his own vision of the future. The entrance hall had a floating staircase that Tony finished to look like bronze, onto which he laid a specially woven bronze-colored carpet. The windows were hung with curtains woven to look like ermine tails. The panels and closet doors of the entrance hall were overlaid with a collection of antique carved gilt-and-lacquered Chinese doors. Hanging from the ceiling was Tony's original stalactite chandelier in molded glass. Finally, the terrazzo floors were covered in antique Moroccan rugs, which set the mood for the rooms to follow.

Palmer Ducommun was an extraordinary woman. She was a very serious artist and

OPPOSITE Entrance to Elizabeth Arden's Barretstown Castle.

OVERLEAF Elizabeth Arden's drawing and breakfast rooms, decorated by Duquette at Barretstown Castle in Ireland, c. 1960s.

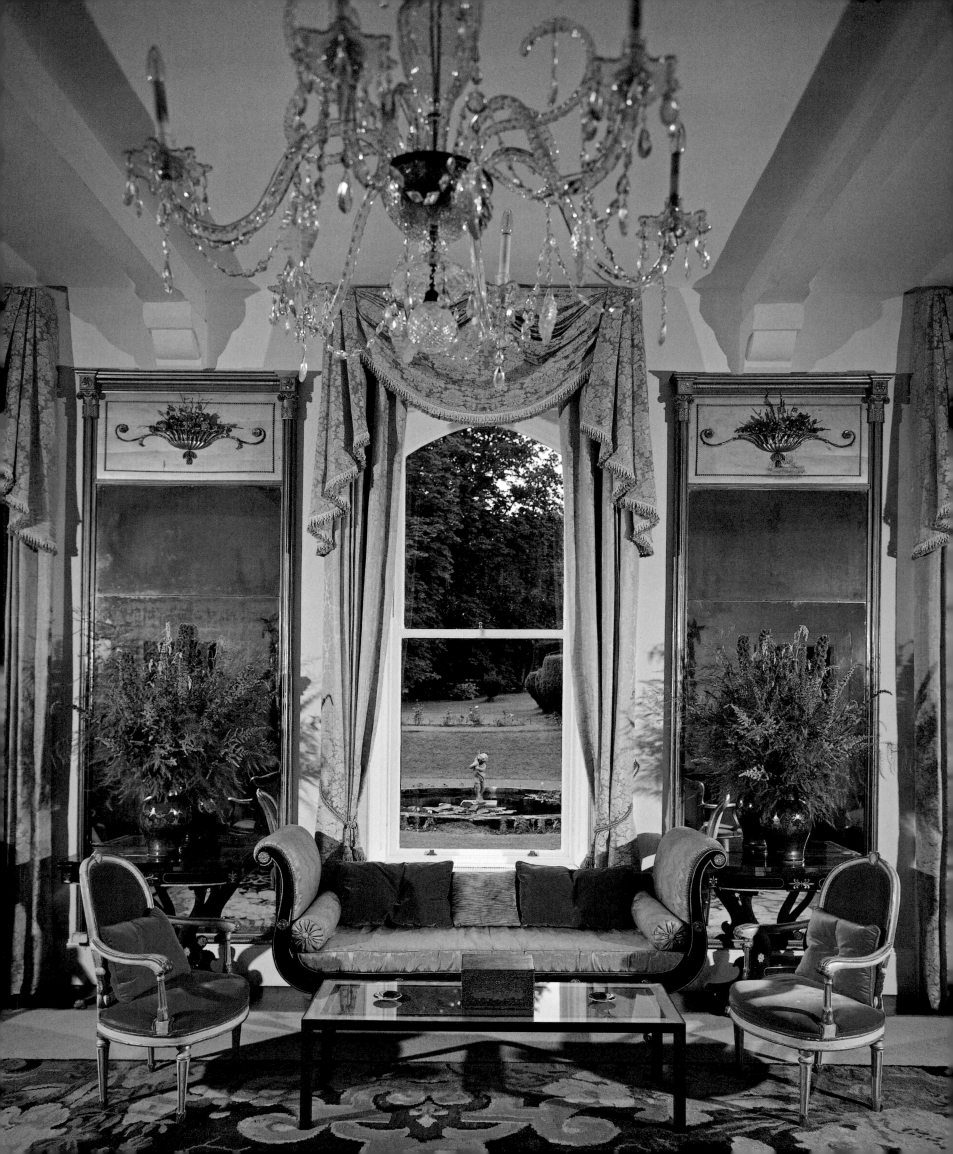

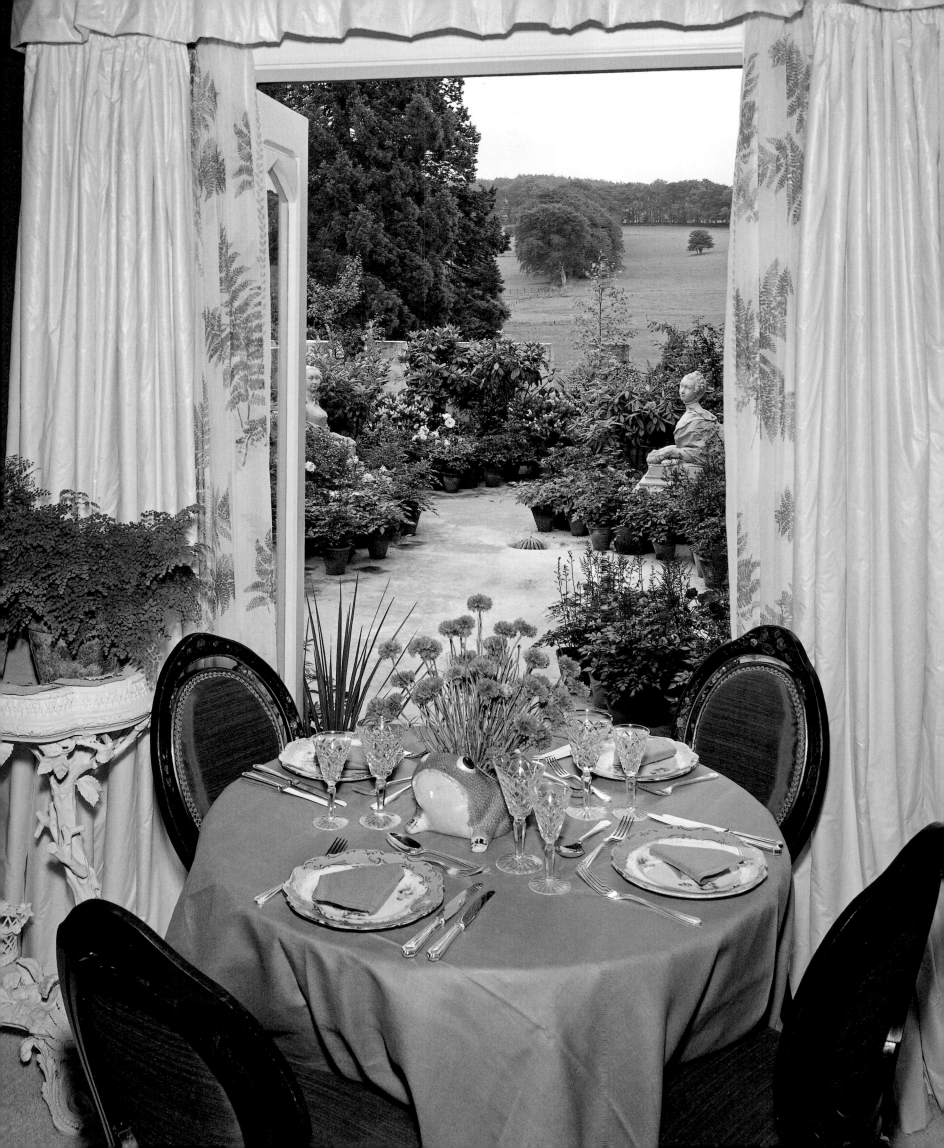

collector. Her sense of color was extreme. When shown a sample of a brilliant, blinding, neon ruby-red sari fabric for use in one of the rooms, she asked, "Can't you find something with more color? I really want *red*!"

The house was a riot of corals, amethysts, malachite greens, fire reds, and white. Tony worked with the Ducommuns' collection of modern masters—including paintings by Georges Braque, Amedeo Modigliani, and Raoul Dufy—to create an aggressively opulent yet modern interior. A gigantic white polar-bear rug embellished the entry to the drawing room. Hanging from the ceiling was Tony's iconic metal-and-abalone-shell chandelier. The built-in sofas, created by Mike Morrison, bore Billy Haines's distinctive signature. Tony took care of the rest with rich satins, striéd silk velvets, lacquered Chinese trunks, and brocade inlaid tables of his own design, themselves strewn with treasures from the Ducommun collection, including miniature Alexander Calders, small ancient Egyptian sculptures, carved ivory saints from Goa, and gilded and jeweled objects of Tony's own invention. A koi pond graced the entry to the library, and a path of stepping-stones led past a black-lacquered grand piano. The library—with its Billy Haines–style book-cases and its travertine marble fireplace—also featured a deep sofa covered in Tony's signature malachite printed-and-quilted cotton. The draperies were specially printed to match the carpet pattern; behind them, in the garden, stood a tall metal verdure screen Tony had constructed as a "living Coromandel," with wire pagodas and hanging baskets of spider plants.

Of all the rooms in the house, however, the guest powder room was by far the most over-the-top. The walls were alternately mirrored or paneled with crushed abalone shell, and two incredible iron-and-abalone lamps stood on the vanity. Anything in the room that was not mirrored or covered in abalone was painted a brilliant turquoise green—making the abalone all the more vivid. The overall effect was awe inspiring.

The dining room held Tony's famous biomorphic console and mirror in gold leaf. This one-of-a-kind piece was created specially for the Ducommuns; Tony repurchased it after their deaths, and it is now reproduced commercially. On top of the console Tony arranged a collection of gilded sunburst votive light holders, which created the perfect party ambiance when illuminated. Tony had a shag carpet woven to resemble tiger skin and placed a specially designed bronze-and-glass dining table at its center, surrounded by his original gold-leafed iron and suede chairs. At the table's center a mirrored shelf sat just below the glass surface, onto which Tony placed large gilded, articulated metal fish, rock crystals, seashells, coral branches, and pearls. The dining table had two matching sidepieces that could be pulled up to accommodate more guests, but typically these two separate tables were pushed against the sidewalls, creating a serving console or a table for two by the window.

Tony and Palmer Ducommun were the best of friends. They spoke daily on the telephone, and she never tired of asking him over to "move things around." The house was a constant work in progress; Palmer loved to purchase new items, change things, and keep the interior alive. She consulted with Tony on every aspect of her life in the house—and life in Los Angeles in general. She gave Tony her mother's old jewelry to remodel; the jewels he crafted for her are among his most interesting

OPPOSITE Duquette decorated Mr. and Mrs. James Coburn's home in Beverly Hills. He covered the beams with seashells, painted black and white stencils around the doorways, and hung the windows with blue brocade trimmed with coral velvet, c. 1970.

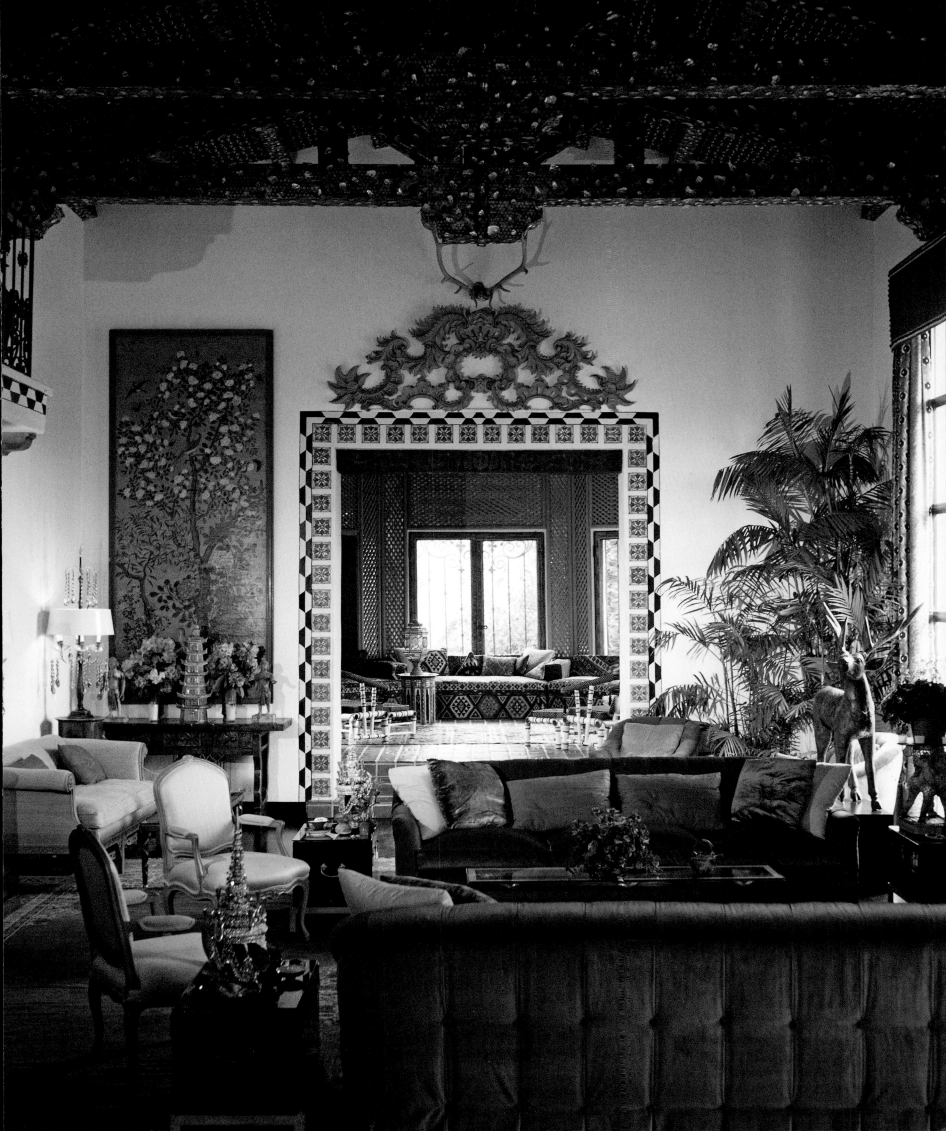

and important creations. He helped her with her parties and her charities, and they often entertained together—with spouses Beegle and Charles as willing accomplices. The Duquettes and the Ducommuns took several trips together—to the Far East, Lebanon, Greece, Turkey, and Egypt—where they shopped and shopped and drew inspiration for new changes to the Ducommuns' Los Angeles house, as well as their house in Palm Springs, which Tony also decorated.

Elizabeth Arden was another of Tony's clients-turned-friend. He had wanted to work for the Canadian cosmetics magnate since he was a Chouinard student. He hadn't realized that Elizabeth Arden had been discovered by Elsie de Wolfe and Elisabeth Marbury—but the thread that bound them all together was to continue unbroken. As an art student Tony would sit for hours in Arden's waiting room, hoping to show her his sketches depicting his ideas for packaging and advertising.

Although she rejected the young student, Ms. Arden was later reintroduced to the mature artist, through Cobina Wright, who told Ms. Arden that she was destined to hire Tony Duquette. Thus the seeds of a strong friendship were sown. Tony was hired to design Elizabeth Arden's stores worldwide, along with her packaging and advertising, and he worked for her in Paris, Rome, London, and New York.

When Ms. Arden purchased Barretstown Castle outside of Dublin, she asked Tony to take care of the decorations. For this Irish castle Tony worked with drapers and upholsterers in London and brought furnishings in from London and Dublin, as well as his own creations from Beverly Hills.

Tony found the light in Ireland to be "different"; he devised a trick of painting each wall in a room a different shade of the same color, so that the entire room would appear to be one color.[1] He used Ms. Arden's favorite shades of pink, leaf green, coral, and Wedgwood blue. He discovered the Parisian wallpaper house Mournay and had old documents from its archives reprinted for Barretstown. He used wallpaper borders and *passementerie* to great effect, creating a warm and friendly country house for Ms. Arden and her guests.

When the house was completed Tony held a party for Ms. Arden and her entourage of models, saleswomen, and executives. He desperately needed extra men for the fête, so he called up all the gentry in the surrounding countryside. If the man's wife answered the telephone, Tony would make chitchat and hang up. If the husband answered, Tony would ask about the whereabouts of his wife—and if she were away in London or elsewhere, he would invite the husband to come along. Tony hired bagpipers to play, and they stomped around the drawing room playing, until Elizabeth screamed, "Make them stop!" A small child from the village was also brought in to sing and dance, and to present Elizabeth with a wildflower bouquet. The child sang and sang and danced and danced, until Elizabeth finally cried, "Would someone please get that child out of here!"[2]

Elizabeth Arden never spent another night in her beloved castle. She died shortly thereafter, and the castle and all its furnishings were sold by her estate. "If I had known that she was going to die," Tony said, "I never would have left all those pretty things in that house!"

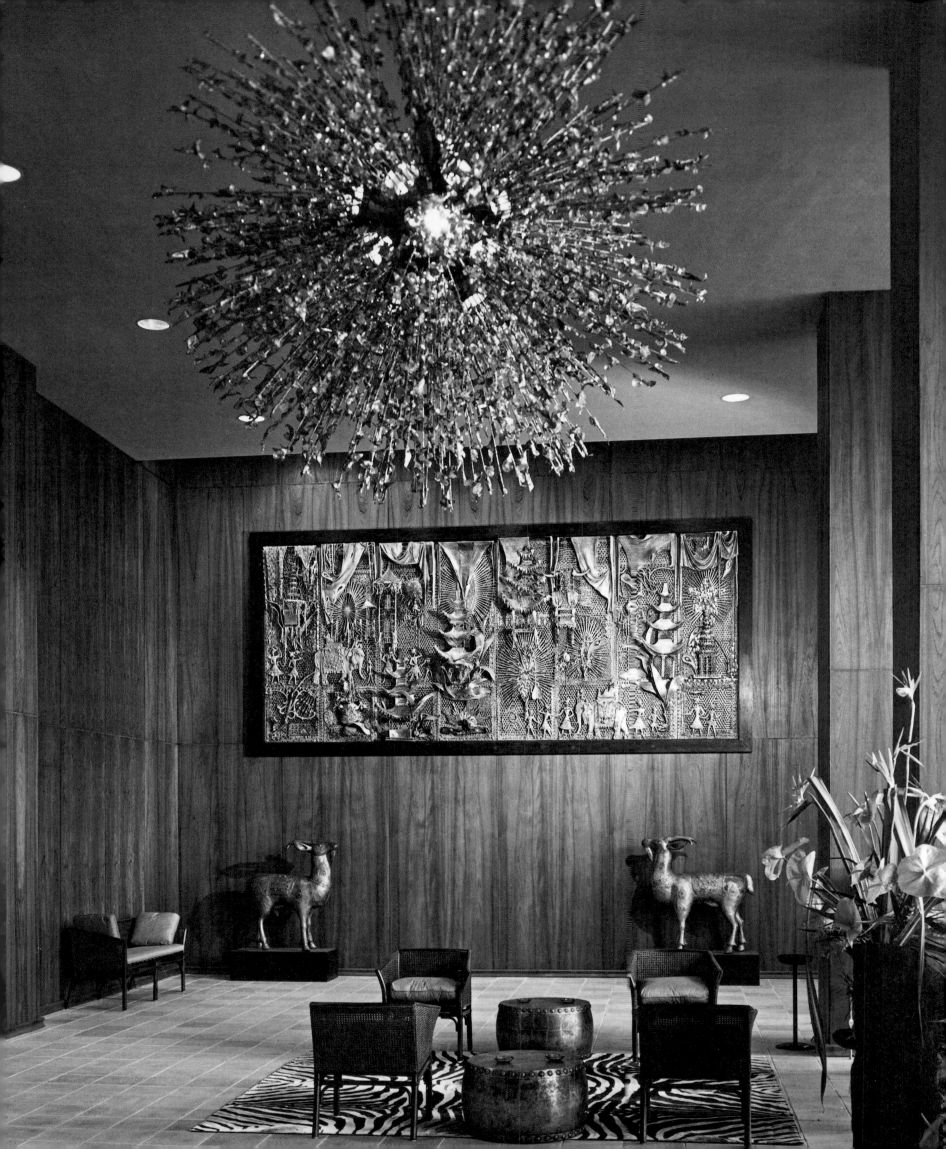

In the same neighborhood, Tony created a house for the Spanish millionaire José Drudis, whose family's California land grants made him one of the richest men in town. For the Drudis residence, Tony devised another uncharacteristically square interior, with Spanish Colonial overtones. Over the fireplace he hung Beegle's portrait of Mrs. Drudis—who later added rouge and lipstick to the portrait, which both enraged and amused the Duquettes to no end.

As a gesture to their long friendship, Tony happily created an interior, gratis, for Vincente Minnelli's Beverly Hills home—a house by John Woolf on Sunset Boulevard—by lending him a houseful of furniture. The interiors of the Minnelli house included enormous embroidered Chinese tapestries, Egyptian-style Victorian parlor suites, Duquette's own crystal bouillotte lamps, and his watercolors and costume and set designs—all of which Minnelli adored and appreciated. For Minnelli's daughter and Tony's goddaughter Liza, Tony created a miniature Palladian playhouse, replete with balustrades and urns, ermine-painted draperies, and signature Duquette green walls.

Tony also created a cozy Pasadena house—full of red lacquer, black-and-white cow skin, Moroccan grillwork, and his original sculptures, tapestries, and paintings—for Mr. and Mrs. Charles Smith. Edna Smith had been an executive at the Bullock's stores and had known Tony since the early days. She was a great friend and used Tony not only to design two family houses but also to set her precious gems.

The costume designer Jean Louis and his wife Maggie also called on Tony to decorate their Malibu beach house, where he supplied them with printed Indian cottons, white wicker, and cool colors.

Another of Tony's eventual clients, whom he had known since she was a child, was Ann Woolworth. Her mother, Elizabeth Coleman Crocker, was now the Dowager Duchess of Manchester and had used Tony to design all of her daughters' coming-out parties and weddings. The duchess, who only used Frances Elkins as her decorator, kept houses in Pebble Beach, London, and Venice. Her daughters were great friends of Tony's, young, beautiful, and full of life. They were all a big part of Tony and Beegle's life in the 1960s, when they often visited the Robertson Boulevard studio and attended all the parties.

In San Francisco Ann Woolworth purchased a Maybeck house on Pacific Street, which Tony transformed with acid greens, coral reds, and modern patterns, in keeping with the then-current interest in ordered-pattern designs, as promoted by David Hicks.

Tony's decorating commissions were not limited to residential interiors. Hotels, theaters, stores, executive offices, restaurants, and clubs would all provide fertile ground for his creativity during his long career.

The Park Plaza Hotel in St. Louis, Missouri, was an early commission brought to Tony through his friendship with Cobina Wright; specifically, he was engaged to decorate the ballroom for the annual Prophet's Ball. To this day many St. Louis debutants claim that their debut parties were decorated by Tony Duquette, because they were held in that ballroom.

Tony was also responsible for the decoration of many of the public rooms in the Las Vegas Sands Hotel. His interiors can be seen in the 1964 Elvis Presley movie *Viva Las Vegas*. Around this time he also created similar carnival-inspired rooms for the Fairmont Hotels.

The Airport Marina Hotel was one of a series of hotel interiors that Tony would complete for the Hilton-Burns Hotel Company. One of Tony and Beegle's best friends was F. Patrick Burns, a rich Los Angeles man-about-town who lavished his generosity and hospitality on all of his friends, including Tony and Beegle. The Airport Marina Hotel was designed at the same time Tony was doing *Kismet* at MGM, and an *Arabian Nights* theme would rub off on Tony's interiors there.

The Hilton Hawaiian Village was another Hilton-Burns development, this one in Honolulu. Tony and Beegle loved the Hawaiian Islands and traveled there often with Doris Duke and the Matson family. They had many friends there among the highly social old guard, including the Dillinghams, the Cooks, and the Shingles. And for the Duquettes, being paid to work and live there was a dream come true.

For the Hilton Hawaiian Village, which also included the Hilton Lagoon Apartments and the Hilton Dome Convention Center, Tony installed specially woven tiger-striped carpets, giant abalone *étagères*, sunburst ceiling lights, and his unique fabric-mosaic tapestries, which were inspired by and recalled the feathered capes of the ancient Hawaiians. At the Hilton Dome he installed a custom chandelier of gold-leafed iron, measuring more than twenty-five feet in length. At the Hilton Lagoon Apartments, residents entered under a giant Duquette sea-anemone light fixture whose pierced spikes measured twenty feet in length. The lobby sported an exploding sunburst chandelier in crystal, as well as an original Duquette three-dimensional mural, inspired by a Southeast Asian theme.

The *pièce de résistance* was the two-storied penthouse, with its soaring walls of crushed abalone and Tony's signature coral and abalone chandelier. There were also restaurants and clubs, a coral ballroom, and endless public spaces that Tony furnished with his unique tables, chairs, and light fixtures.

The Los Angeles Music Center consisted of three theaters; Mrs. Dorothy Buffum Chandler asked Tony to be the volunteer art director for all three. The architects were Welton Becket and Associates. Mrs. Chandler hired Leonard Stanley as the designer. Tony designed the "California Sunburst" curtain for the proscenium arch of the Dorothy Chandler Pavilion.

As president of the Elsie de Wolfe Foundation, Tony was able to procure funds to purchase beautiful furnishings for donation to the Music Center, including a rare seventeenth-century Venetian secretary, a pair of eighteenth-century red and black lacquered cabinets, and a fine eighteenth-century Coromandel screen. His three-dimensional costume designs for the San Francisco Opera production of *Der Rosenkavelier* were prominently displayed for years in the downstairs bar of the main theater. Tony also provided the cut-abalone mosaic wall at the entrance to the Mark Taper Forum. And when asked to supply a design for the stamped asbestos curtain at the Ahmanson Theatre, he produced from his pocket the Art Deco gold cigarette case that had belonged to the MGM art director Cedric Gibbons—a gift to Tony from Gibbons's widow—and said, "Copy this." He even designed the ultraglamorous costumes for the ushers and an elaborate caped costume with a plumed hat for the crier who announced the curtain call. After the construction and decorating was done, Tony designed the costumes and sets for *Salome*, the first opera performed at the Dorothy Chandler Pavilion.

The early 1960s, with the construction of the Los Angeles County Museum of Art (LACMA)

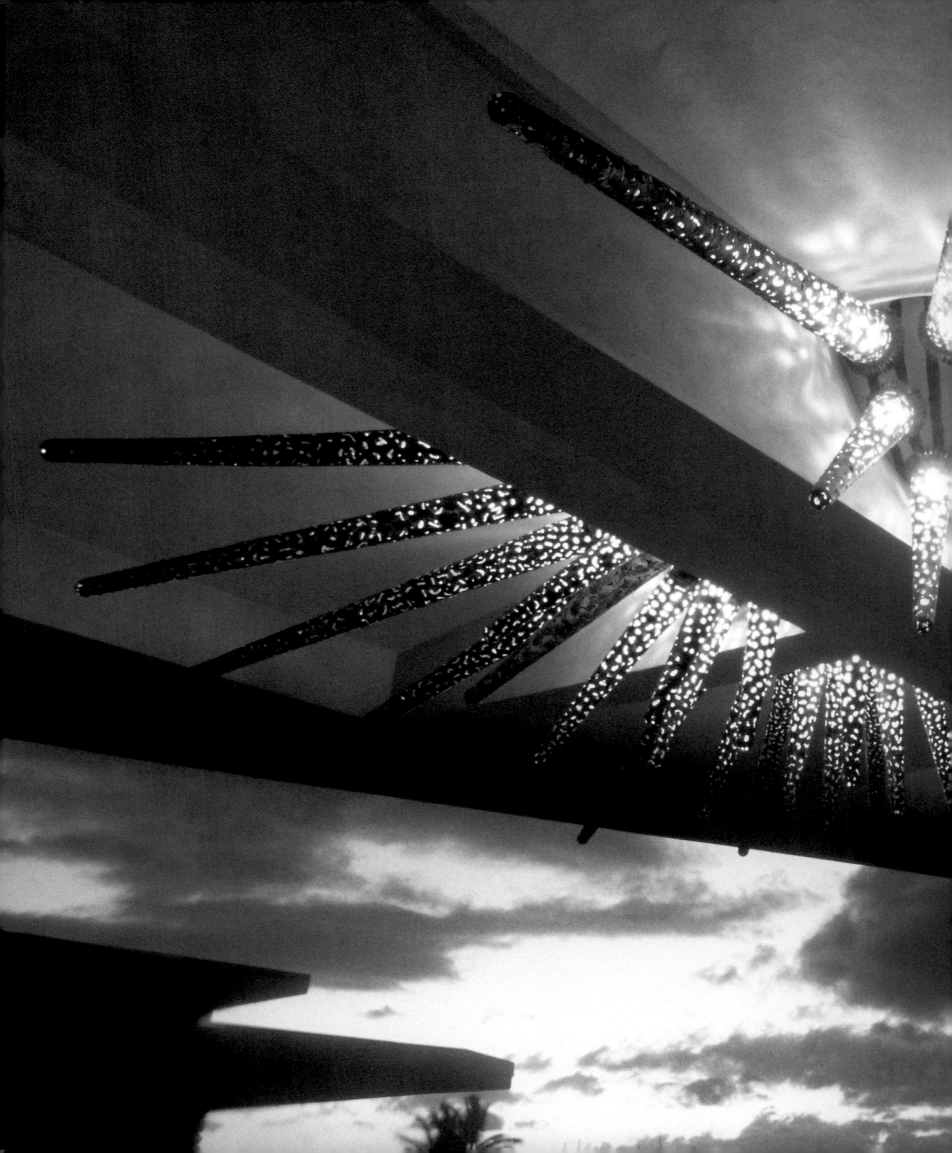

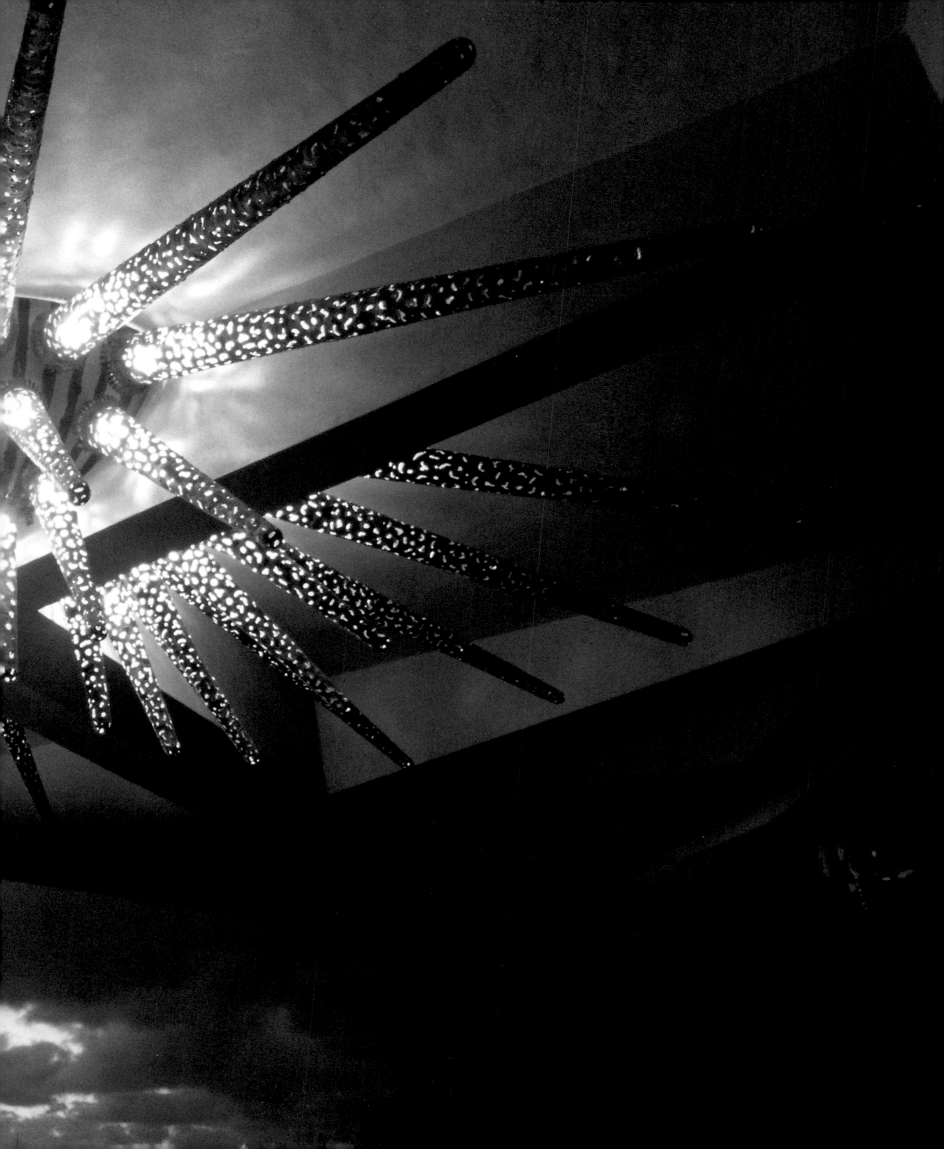

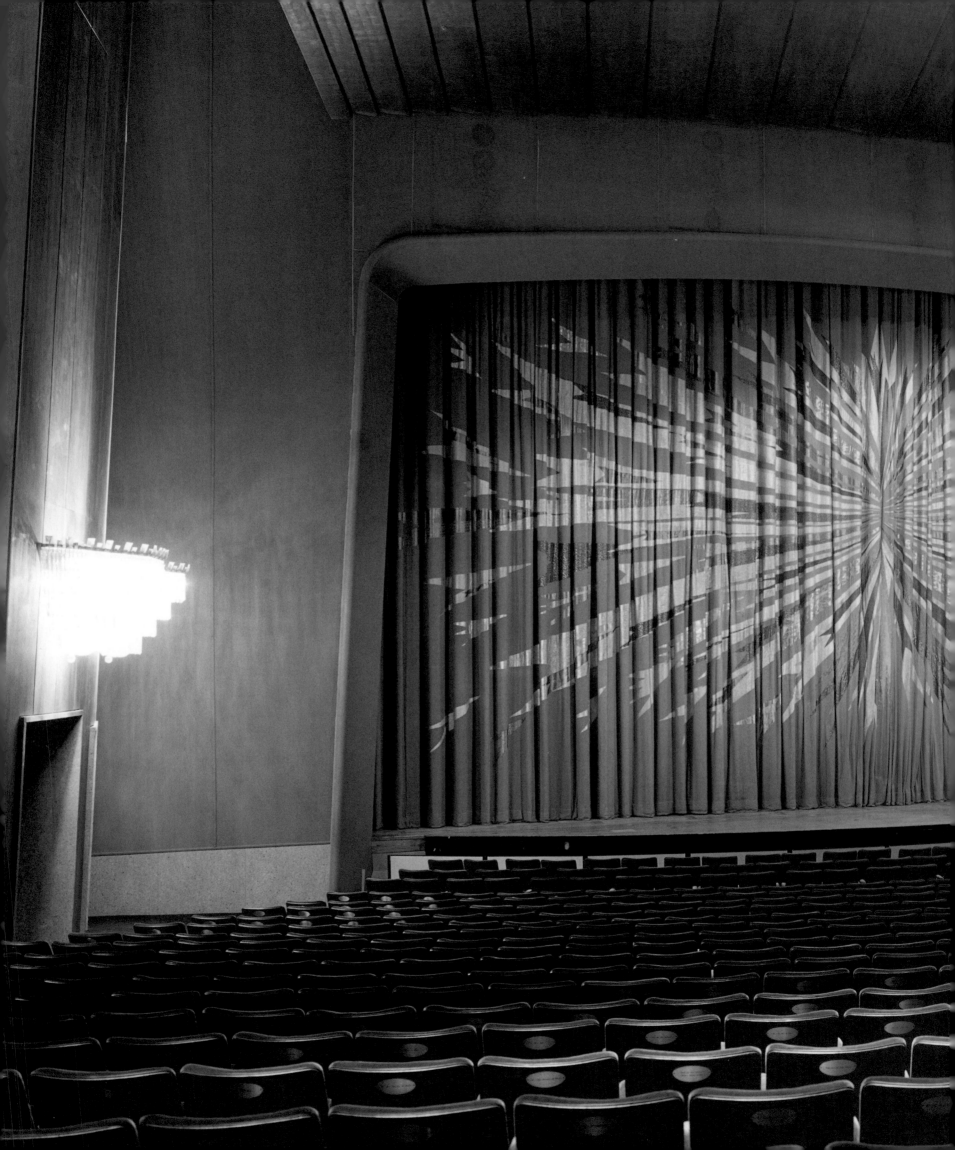

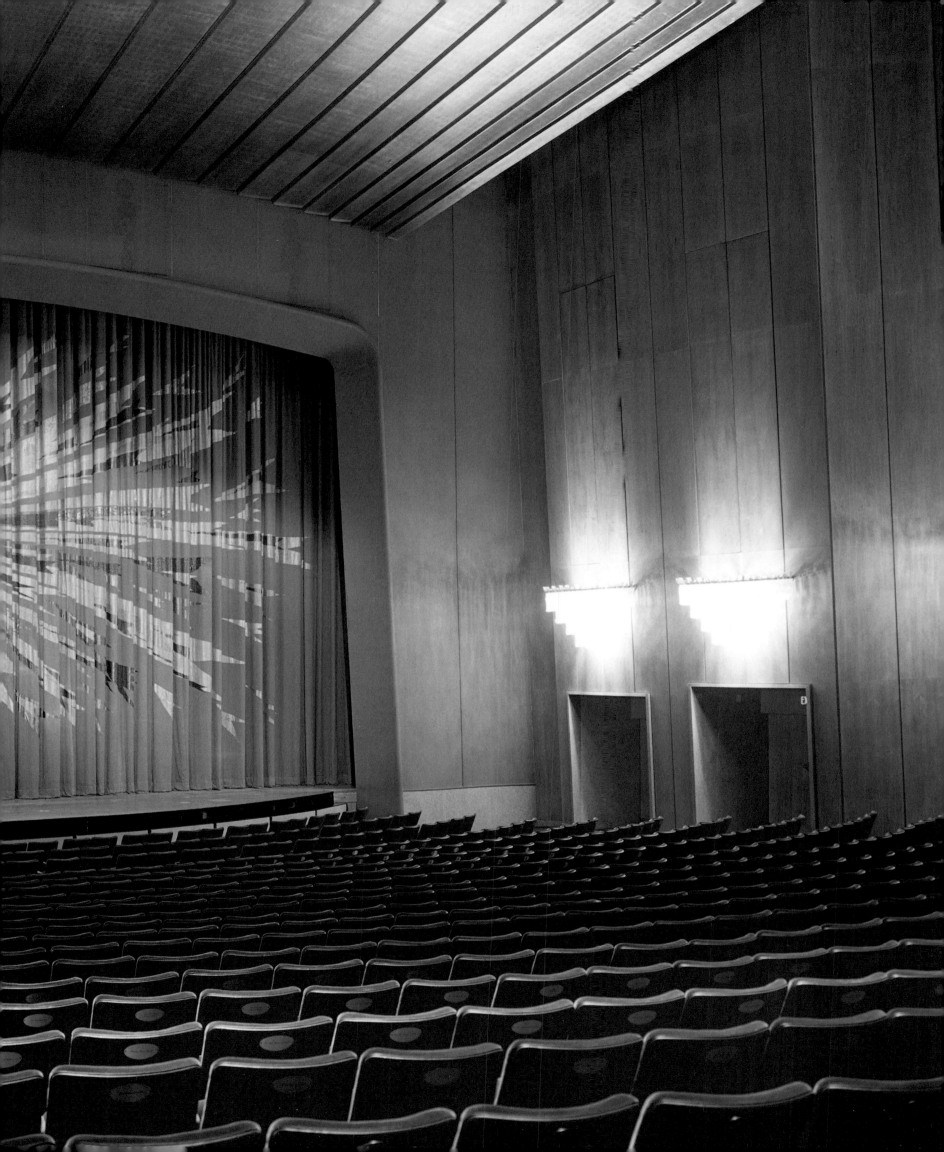

I think that whenever you were with him, or you were in a place that he had made something, something magical and totally out of the ordinary happened. There was that strange sense of just magic and witchcraft, but very positive, and voodoo, and all kinds of really great things if you were open to it.

<p align="right">BRUCE WEBER</p>

My first impression [of Dawnridge] was WOW! *And, yes, I could live here very easily. It was one of the most amazing places I had ever seen. It was this magical jewel box of insanity!*

<p align="right">STEVEN MEISEL</p>

and the Music Center, was an important time in Los Angeles. Tony later remembers, "Before the construction of LACMA and the Music Center, all my friends in New York and Europe would ask, 'Why do you live in Los Angeles?' After the Music Center and LACMA were built they would say, 'Tell us about Los Angeles.'"

Tony was so proud of his city and so delighted to be a part of the Music Center project. Because of his successful collaboration on the project, Welton Becket asked Tony to work on many more commercial installations. One was for Buffum's department stores, which were owned by Dorothy Buffum Chandler, the great benefactor of the Music Center and the wife of the *Times-Mirror* chief. For Buffum's, which was opening satellite stores all around Southern California, Tony created a series of decorations including murals, chandeliers, display pavilions, and fixtures. Simultaneously, Tony was working on other store interiors around the country and in Europe—for Strawbridge & Clothier, Lanz, and Elizabeth Arden.

During all of this commercial success, Tony's regular clients continued seeking his services for their residential needs.

When Jennifer Jones married the well-known businessman and collector Norton Simon, she asked Tony to come down to their rented Malibu beach house and take care of the interiors. The house, which was designed by Jack Woolf, had been decorated for John and Evans Frankenheimer by Leonard Stanley.

Another Malibu beach house that Tony worked on was for Mr. and Mrs. Herb Alpert. Herb Alpert, who is one of the founders of A&M Records, is a man of great style and taste. His Tijuana Brass had created the sound of a whole musical epoch. With his wife, Lani Hall, who had been the lead singer for Sergio Mendes and Brasil '66, he was ready to create a new world at the beach, and he chose Tony to provide the magic.

For this house Tony covered the wooden beams with cork and overlaid them with gnarled grape

PREVIOUS SPREADS
Duquette created the ceiling lights for the porte cochere at the Hilton Hawaiian Village to resemble a gigantic sea urchin.

California Sunburst curtain at the Los Angeles Music Center.

roots; he then placed brocade fabric between the beams. From the ceiling he hung a giant Chinese bronze lantern. Large, overstuffed sofas in blue Chinese brocade, red-lacquered coffee tables, silver-leaf eighteenth-century Venetian armchairs in silk, and eighteenth-century French antiques were blended with the Alperts' own amazing collections of fine and decorative arts. Giant ceramic jars, banquettes, Moroccan grillwork, and paintings by Rufino Tamayo all mixed together with Alpert's own sculptures and oils on canvas. It all worked collectively to create a unique aesthetic.

With their mutual love of gardens and exotic plants, Duquette and Alpert worked together to landscape the many acres leading from the main house to the beach. There were Japanese bridges, rock koi ponds, groves of palms, banks of bromeliads, and any number of Oriental decorations, statues, deities, spirit houses, temple bells, fountains, waterfalls, and outdoor seating areas.

While he was at work designing their beach house, Duquette was asked by the Alperts to decorate their Century City town house. This was a high-ceilinged space that was lined in Buddhist orange and saffron, as a background for Alpert's collection of Tamayo paintings and his own works. The house also featured Art Deco panels, French furniture, Besarabian carpets, and exotic Tai Ping carpets—woven originally for the Royal Hawaiian Hotel to the designs of Frances Elkins.

Tony and Herb had a wonderful working relationship. Later Tony would ask Herb to compose some music for his one-man exhibition The Canticle of the Sun, which was presented at the Duquette Pavilion in San Francisco.

Like so many of his clients, Tony had met the Helis sisters through his mentor, Elsie de Wolfe,

back in 1941. The sisters offered to give Tony and Beegle a silver tea set for their wedding, which Tony refused—asking instead for the front doors of their house. Cissy and Adrienne Helis were about the funniest two women in Los Angeles. Slightly reclusive, they lived together in a big house on Parkwood Street in Holmby Hills. They called Tony out of the blue one day in the 1980s and said they had bought a beach house on a whim and wanted him to decorate it.

Together they transformed the ugliest house on the beach into an Oriental fantasy, replete with Chinese paneled and mirrored walls in the dining room, Coromandel screens in the stair hall, giant antique Chinese ceramic pagodas, Thai silks, and an indoor swimming pool styled to look like a tropical rain forest. Every day Tony would go down to the beach, his vans loaded with red-lacquered baby elephants, Chinese stands, Art Deco jade-handled flatware, rare porcelain dishes, *lac burgauté* trunks, inlaid Goan chests, and pierced Indian screens.

It was unknown if the sisters ever spent the night there. They would talk about it, and they would go down for the day now and then, but there was never any evidence that they actually moved in. There were husbands who were never seen or who were ever away in Los Angeles—a completely reclusive existence.

At one point, Ann Mudd called and asked Tony to come over at once and make her "the sexiest bedroom in town." The house that the Cyprus Mines Corporation executive Henry Mudd built for his new wife was enormous and very modern—and difficult to decorate. Tony went to work, filling the courtyard with massive carved wooden Thai murals and golden statues of horses from the palace at Chiang Mai. Furniture by Robsjohn-Gibbings and metal-framed sofas of Tony's original design

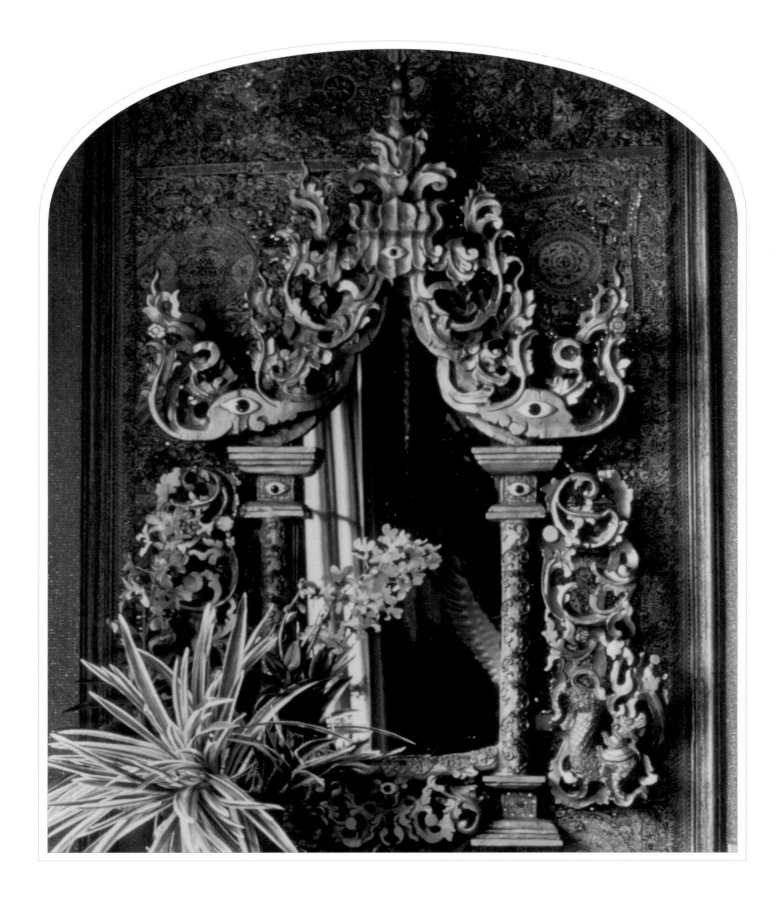

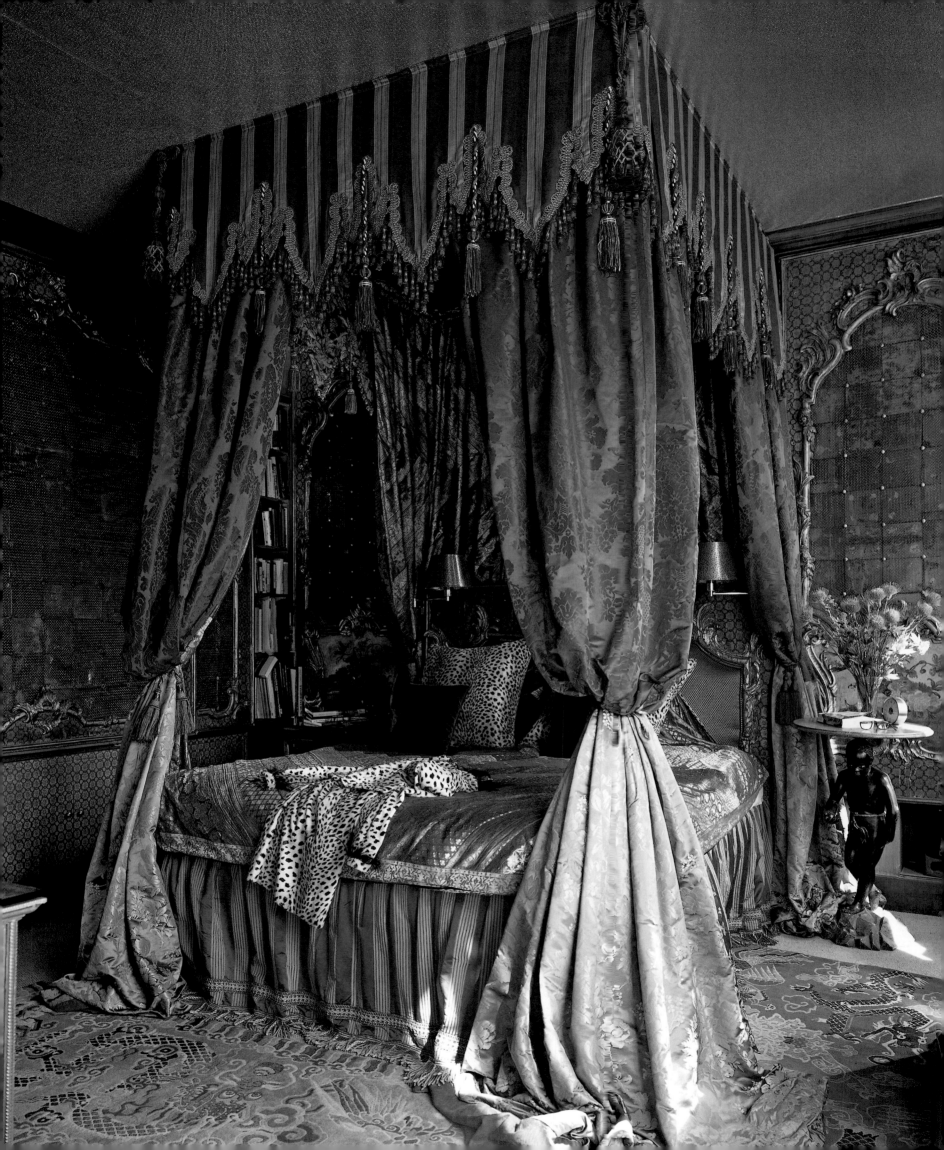

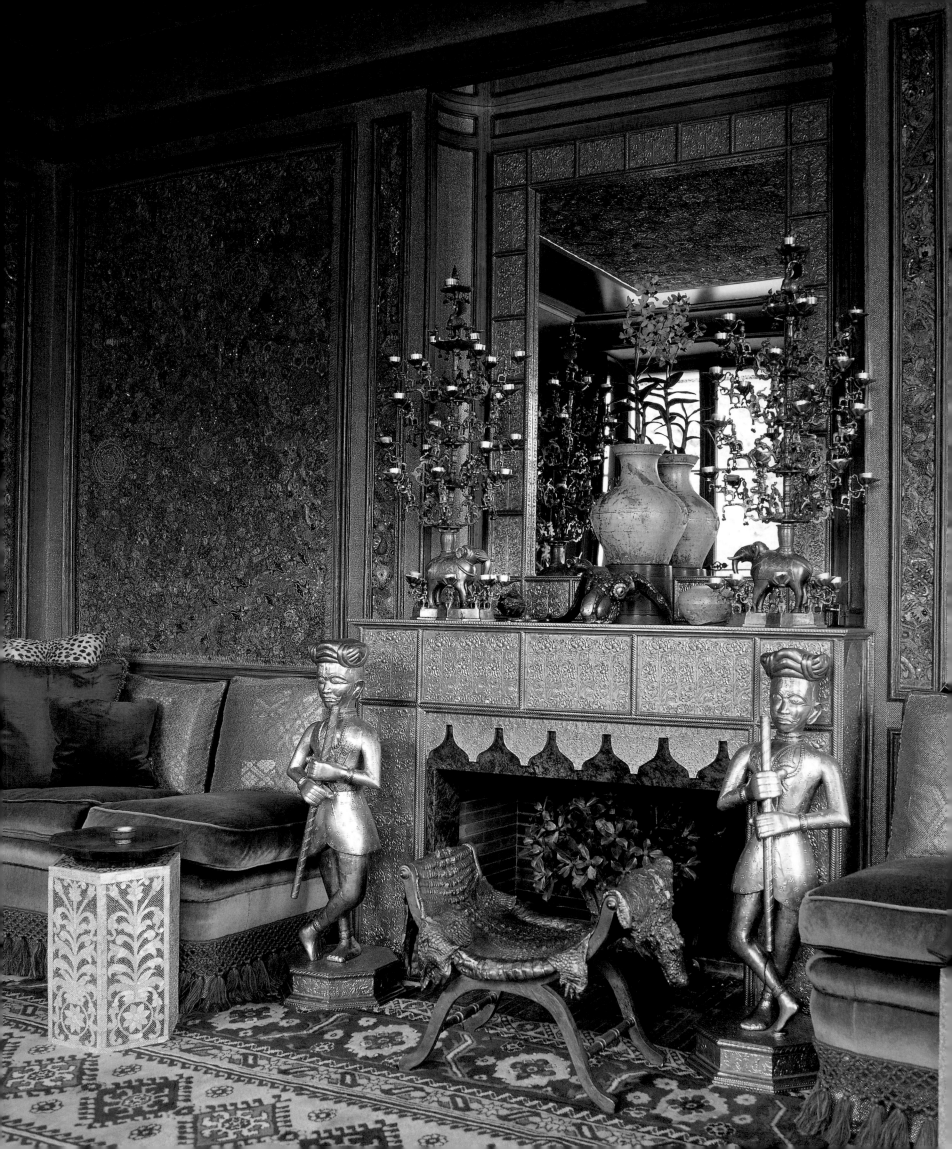

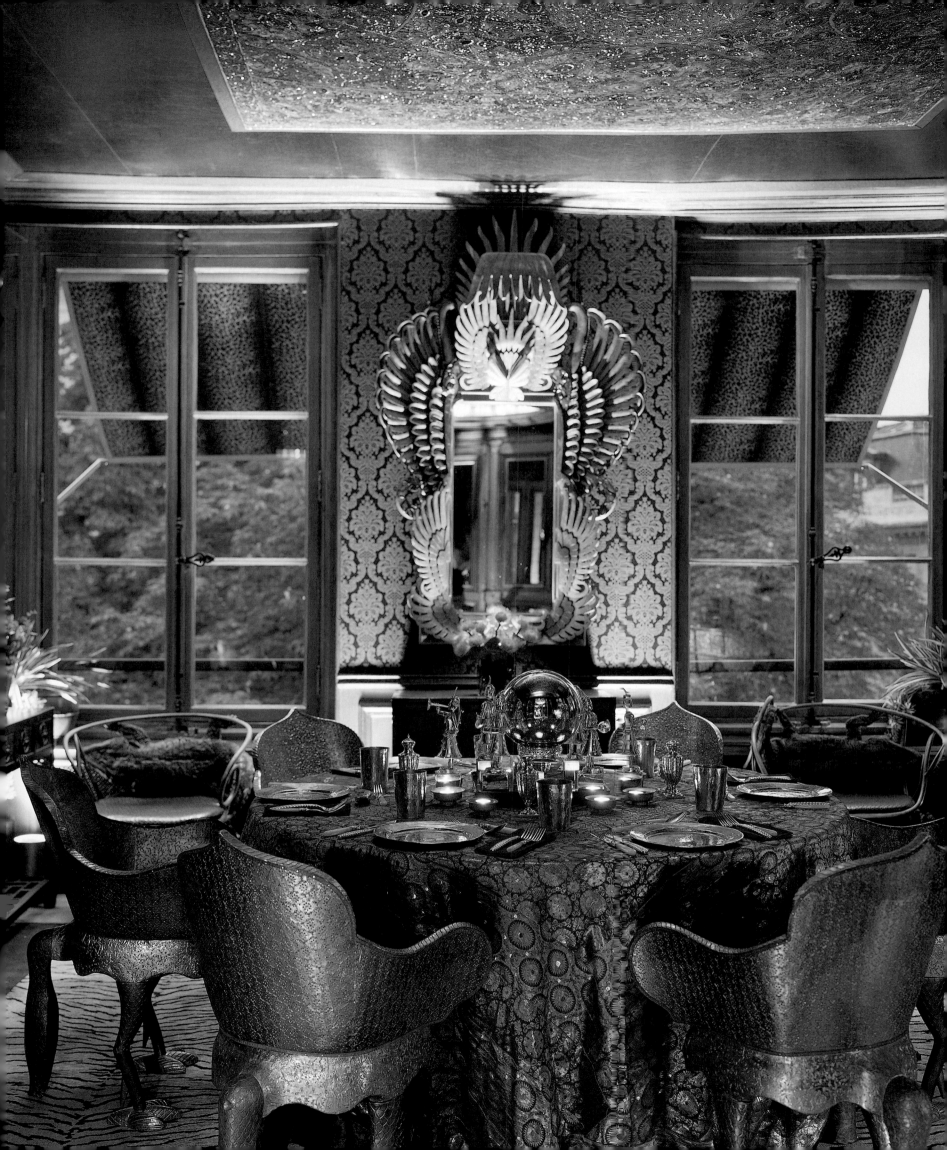

filled the living room. There were enormous Oriental carpets in the dining room, French-printed linens in the kitchen and family rooms, and no end of decorations and works of art to be placed here and there in the vast space.

In the bedroom, he installed a brilliant yellow Thai-silk-canopied bed with a mirrored ceiling—a standard Duquette bedroom feature. The couple divorced shortly thereafter, and the house was dismantled and sold. Ann Mudd never held Tony responsible, however; she remained one of his best friends and staunchest supporters.

When photographer Shirley Burden, the great-great-grandson of Cornelius Vanderbilt, married his second wife, the Chilean Julietta Lyon, in 1971, he moved her into his magnificent house in Holmby Hills, Los Angeles. The old Burden house had been built for Frederic March and decorated for the first Mrs. Burden by Jimmy Pendleton. With its fine architecture, interior details, hand-painted eighteenth-century Chinese wallpapers, and collection of fine furniture, silver, and porcelains, it was one of the most beautiful homes in Los Angeles.

When Mr. Burden remarried the house was completely redone in bright, clear colors—imperial yellows, robin's-egg blues, leaf greens,

and, of course, Tony's signature coral accents. The chosen fabrics were European flowered chintzes, hand-painted silks, and Balinese batiks; all were used together with great sensitivity. The furniture was pure Vanderbilt, all eighteenth-century, mostly English mahogany, with some gilt wood and some painted Italian pieces for good measure.

The end result was a triumph of understatement snatched from the mouth of Hollywood glamour. After the Burdens passed away, the house went up for sale, and among real estate agents word was there was actually a beautiful house, in good taste, for sale in Beverly Hills.

Tony had designed special suites for the Sheraton Universal Hotel when it was built by the founders of Music Corporation of America (MCA), Jules and Doris Stein. Later the Steins asked Tony to redecorate the top-floor nightclub, which had seen better days. For the project he hung curtains printed in shades of pink and green, and pelmets with plaster tassels. He placed giant pagoda-like parasols made of metal throughout the room, painted the ceiling to look like a cloud-filled sky, and hung a monumental mosaic tapestry across the back wall. He added his specially designed *fleur-de-lis* carpeting, coral-branch carpeting in the hallways, and additional lighting in the lobbies. When the elevators came up, a bouquet of Venetian-glass flowers would light up to alert guests that the car had arrived.

In the 1980s Tony was preoccupied with investing in real estate, which included buying, remodeling, decorating, and renting or selling apartments, houses, and commercial buildings. Tony was also at work inventing and installing the museum exhibitions that he called Celebrational Environments. During this time he continued working for clients such as the Ducommuns and Herb Alpert, but Tony took

PREVIOUS SPREADS
LEFT Duquette created the only mirror that looks back at you for the Paris apartment of Mr. and Mrs. John N. Rosekrans.

RIGHT The Parisian bedroom of Mr. and Mrs. John N. Rosekrans. Tony Duquette and Hutton Wilkinson draped the bed in antique green and red brocades and a pelmet they found in a Paris flea market. The mirrored eighteenth-century Venetian boiserie from the collection of Rose Cumming was brought in by the Rosekrans from San Francisco.

LEFT Duquette upholstered the boiserie in the Rosekrans's Paris apartment with a collection of antique mogul embroideries. He designed the silver mantelpiece as a "slipcover" for the existing eighteenth-century limestone mantel.

RIGHT The dining room of the Paris apartment of Mr. and Mrs. John N. Rosekrans with copper chairs and brass copies of the peacock throne of Shiva.

on fewer and fewer decorating commissions, preferring to focus his talents on his own ranch and on his beloved Dawnridge, where he started developing the gardens into their present exotic state.

In 1987 Tony and Beegle lived for the better part of the year at Cow Hollow, the birdcage Victorian house in San Francisco that they had purchased in the 1960s with the residuals from *Camelot*. They had recently purchased an old, derelict synagogue on Geary Boulevard between Fillmore and Steiner streets, and their days were taken up with remodeling and redecorating the building. The Duquettes were now dividing their time between San Francisco (where they spent six months of the year), Malibu (three months), and Beverly Hills (three months), constantly going back and forth between the locations to accommodate their social schedules. The Geary Boulevard synagogue, which became known as the Duquette Pavilion, was by far their most ambitious project at the time.

During those San Francisco years Tony helped his old friend Jane Swinerton with the decoration of her Pacific Heights house, high on a hill overlooking the Bay and the Golden Gate Bridge. The charming house had an unusual layout perfectly suited to Tony's eccentric ideas. Tony added giant antique Chinese panels framed in Plexiglas, enormous antique carved and gilded Chinese framed mirrors with reverse paintings on glass; rare Oriental carpets; antique French painted window shades; and dramatic brocade curtains.

Tony's old client and friend Herb Alpert asked him to design a recording studio in Santa Monica where "musicians could feel free and express themselves." Tony pulled out all the stops. Tony installed old paneling from the 1920s, vintage textiles, Oriental exotica, Art Deco light fixtures, and antique carpets. The effect was exactly what the doctor ordered, full of Duquette magic and imagination.

One of the most fascinating couples in San Francisco was John and Dodie Rosekrans. Their Pacific Heights house was astounding. Decorated by Michael Taylor, it was full of rare furniture, fine art, and treasures from every corner of the world. Dodie's personal style is legendary; her wardrobe of couture dresses, her magnificent jewels, and the way she put them all together with individuality and creativity made her the most sought-after client in the world.

Tony had known the Rosekranses socially for years. After Michael Taylor died, Dodie immediately asked Tony to help her. When she decided ultimately to take a place of her own in Paris, Tony got the call and he immediately went to Paris to see what she had in mind.

The apartment she had chosen was not a grand one. It was small, with low ceilings, and not at all dramatic. With all of their riches and treasures, the Rosekranses could easily have out-Frenched the French. Instead, Tony suggested a completely opposite approach. Rather than fine French furniture and great works of art, which the Rosekranses owned in droves in San Francisco, Tony proposed an exotic décor, to be found in India on a series of five trips, which he would install with great style and much acclaim in Paris.

The paneled walls were painted in shades of green—which Tony insisted was a neutral color—and the ceilings were upholstered with gold leaf on leather. The boiseries framed a collection of antique Mogul embroidered panels, set with precious and semiprecious stones, which he had found in Rajasthan. The limestone

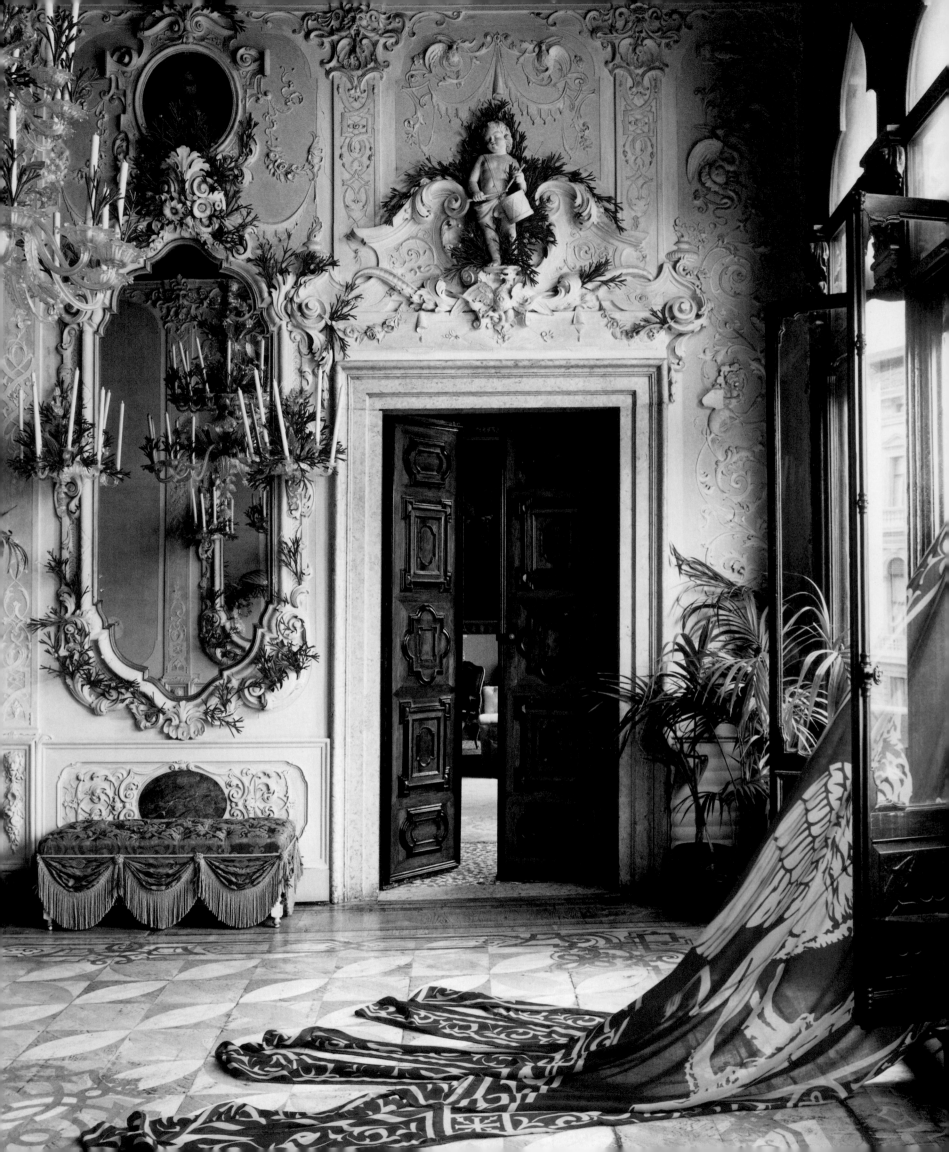

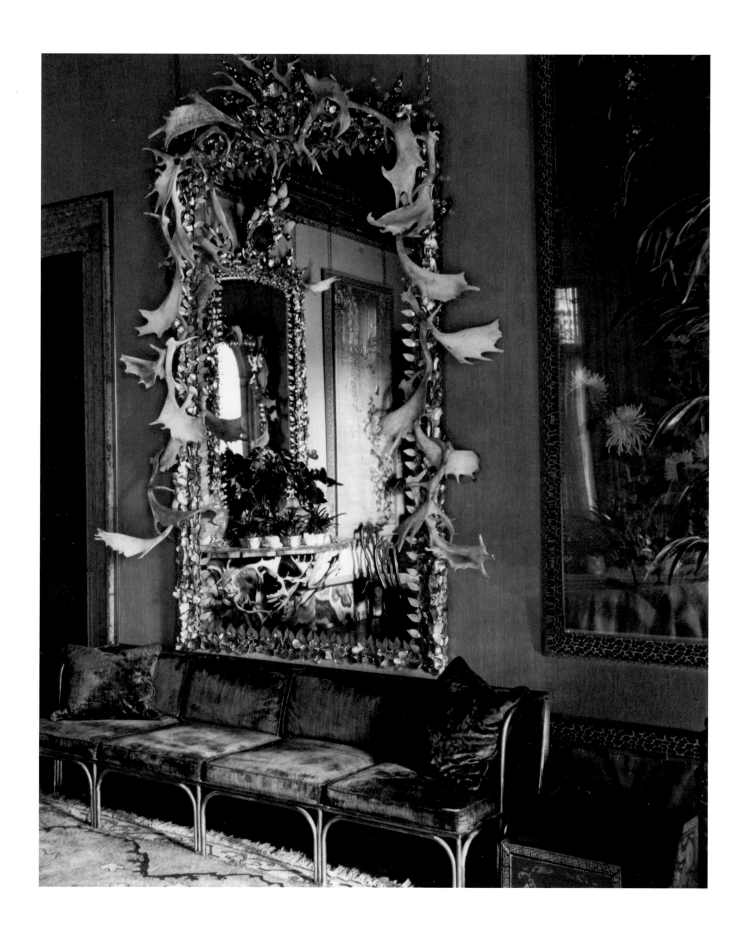

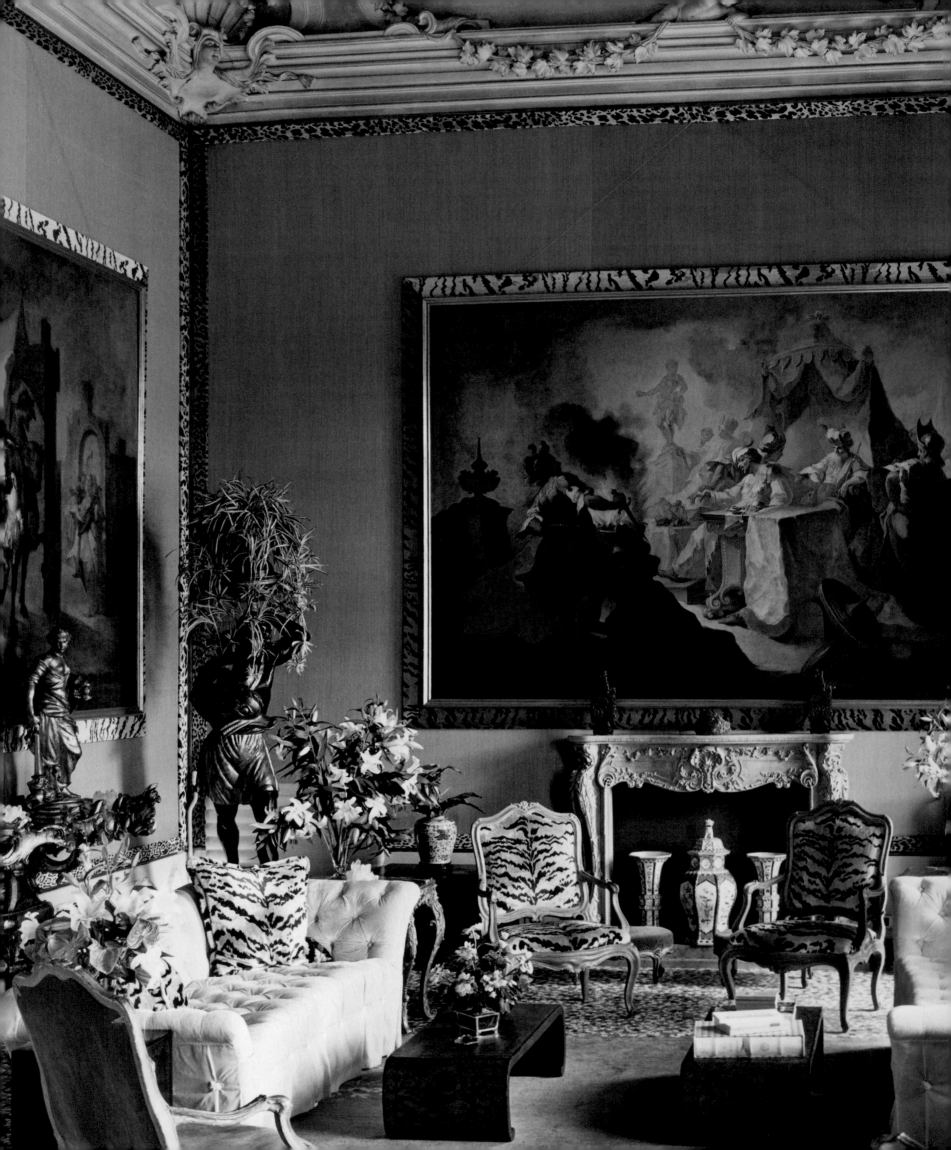

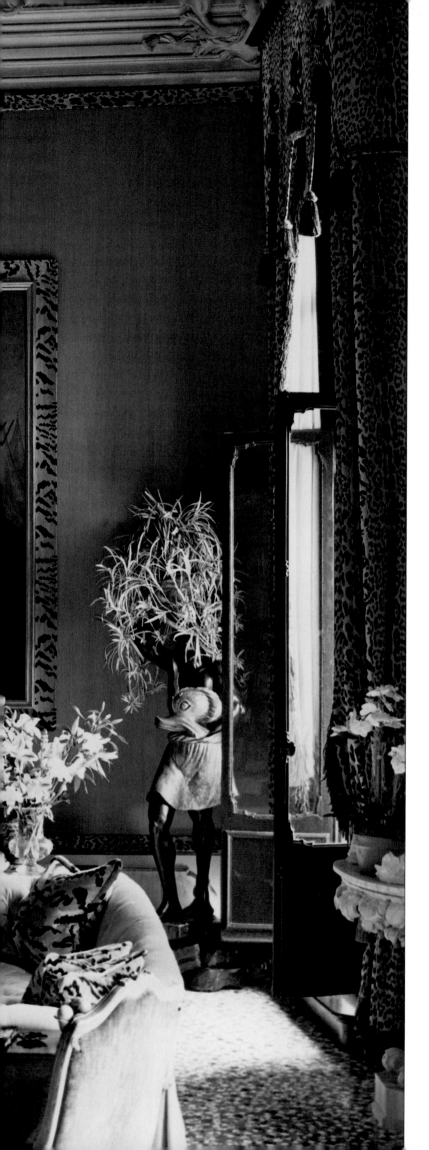

Mr. and Mrs. John Rosekrans's apartment in the Palazzo Brandolini on the Grand Canal in Venice. Duquette's original antler-framed mirror at the palazzo.

OPPOSITE The drawing room at the Palazzo Brandolini is trimmed in leopard velvet. The eighteenth-century Venetian armchairs from Duquette's own studio were purchased from Adolf Loewi decades earlier.

French mantelpieces were "slipcovered" with tooled and silvered metal enclosures. He used the existing velvet banquettes, overlaying them with gold net and adding rows of tassels and antique Indian sari appliqués. Small tables inlaid with mother-of-pearl were lighted from within like lanterns, and even the white canvas awnings at the windows were lined in leopard-printed canvas.

The bedroom was paneled in eighteenth-century Venetian mirrored boiserie, which Dodie had purchased from the collection of Rose Cummings, and hung with a collection of antique red and green brocade. The floors were strewn with Tibetan carpets, and the bathroom was entirely paneled in pierced wooden screens backed in mirrors. The Parisians were enchanted by the apartment's originality and glamour.

The minute the apartment in Paris was completed, Dodie started fishing around for another project they could do together. She asked where else in Europe she should look for a house, and Tony answered spontaneously, "Venice, of course!"

After looking for palazzos in their favorite city on the sea, the end result was the twelfth-century Palazzo Brandolini on the Grand Canal. The magnificent apartment that the Rosekranses rented, which had undergone fourteenth- and nineteenth-century additions, comprised the entire piano nobile of the palazzo. The grand floor was a dream come true, with its monumental staircase and vast rooms, including an entrance hall, ballroom, drawing room, library, dining room, and garden room—with an expansive terrace overlooking the garden—as well as a guest suite and master bedroom suite complete with two bathrooms, two dressing rooms, and a study. In the palazzo, which had previously been decorated by the

great Italian designer Renzo Mongiardino, Duquette had a great deal of good material with which to work.

With views toward the Rialto and Accadamia bridges, the palazzo couldn't have offered the Rosekranses a more ideal setting for their fantasy lifestyle. Having been asked by the landlords, Count and Countess Brandolini, not to touch the fabrics on the walls, he proceeded to fill the vast rooms with seventeenth- and eighteenth-century Venetian antiques, velvet upholstered sofas, magnificent oil paintings, and furnishings and fixtures of our own invention. The Venetians, on hearing of the decorations going in, were baffled and sometimes angry about the changes.

American *Vogue* editor Hamish Bowles sums it all up. "I think the Venetians were initially fairly appalled at the prospect of this iconic establishment being made over like this. But in the end, I think it is difficult not to applaud something that has the courage of its convictions on that scale and intensity, and it was a really extraordinary mix. You suddenly would have an important early eighteenth-century throne chair from the Houghton sale and other quite glorious antiques juxtaposed with the sort of effects that would normally be associated with theatrical ephemera. I think only a client like Dodie could have embraced all that."

Many Venetians wanted to know what was taking place or whether what they had heard was true. They said "But you can't have leopard skin in Venice!" "But you can't have only

OPPOSITE The master bedroom at the Palazzo Brandolini. In this room Tony installed eighteenth-century hand-painted Chinese wallpaper, which they had removed from Pickfair, the Beverly Hills home of Mary Pickford and Douglas Fairbanks. The bed is an original construction, hung in blue silk taffeta and lined in Indian silk gauze.

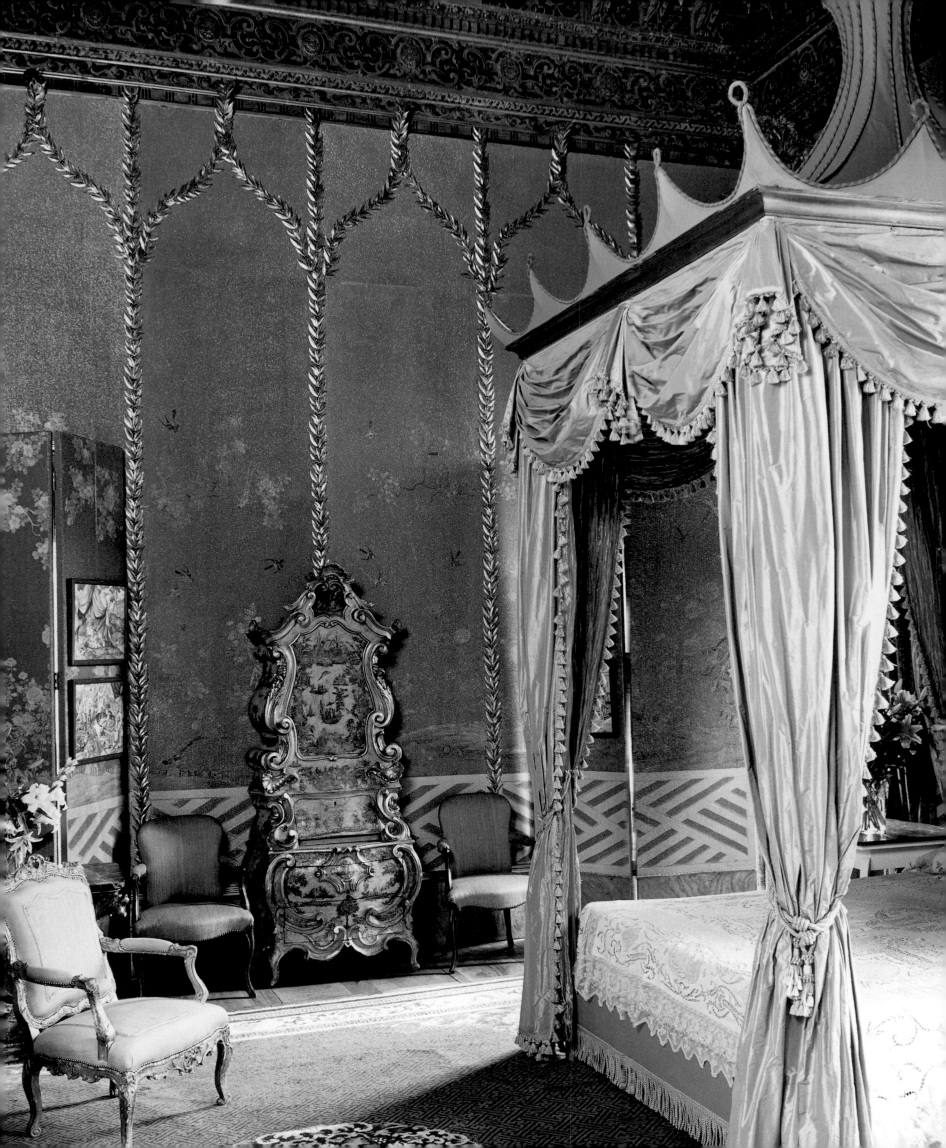

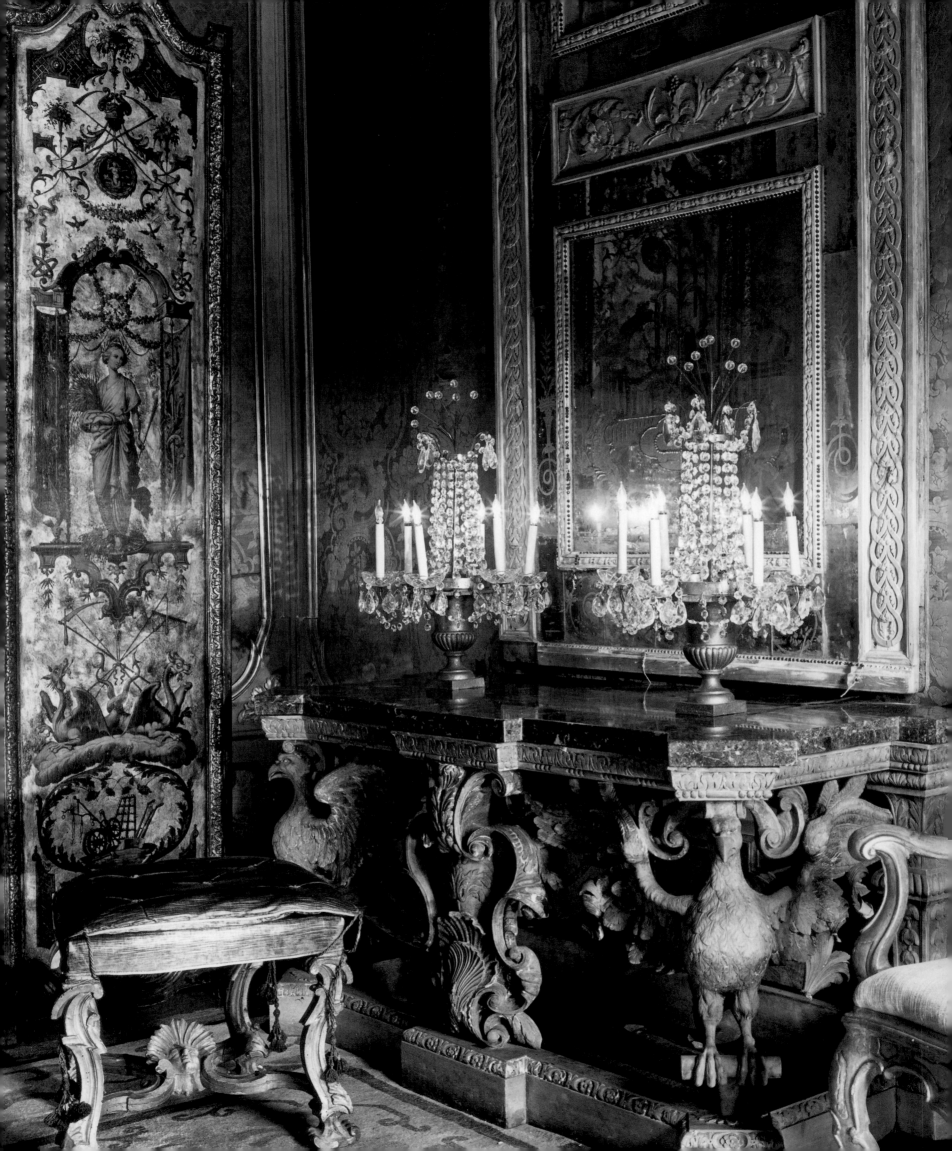

armchairs at the dining room table!" "But it has to be Louis XVI!" When asked "Why not?" their answer was always the same: "Because it is not Venetian!"

What Tony discovered was that nothing had changed in Venice in the way of taste since the early nineteenth century. When Tony hung three enormous Venetian flags across the front balcony on the Grand Canal, the Venetians all commented on the American lady who was so proud to be in Venice that she had hung flags outside her apartment. The flags had nothing to do with anything except that there were three existing and very substantial bronze flagpoles on the balcony, and that the Venetian flag, with its golden lion, coral background, and crenellated edge was so beautiful. To fly those flags outside the ballroom and drawing room windows was to create movement and drama and to bring the facade to life when seen from the canal. That was the reason for the flags, a decorative one

that seemed to make perfect sense to everyone but the Venetians.

Brooke Hayward Duchin recalls: "That is where my funeral took place, in Dodie Rosekrans's place." "I had a funeral while I was still alive so that I could be in control of the music. So we did it there in that beautiful ballroom, and it was fabulous, because it was all baroque music, composed in 1700, so you would have heard the music in those days in that room. It was a perfect room for it, everybody was weeping with joy, fabulous."

In the end the same Venetian detractors, most of whom Tony knew socially, came around and admitted that the décor was magnificent and extremely successful. The Rosekranses opened the Palazzo with a dinner and dance for three hundred friends on June 11, 1999, which Tony decorated. It would be Tony's last undertaking. He died September 9, 1999, shortly after he completed the project.

OPPOSITE A corner of the seventeenth-century mirrored dining room at the Palazzo Brandolini in Venice. Duquette supplied the William Kent console table, the eighteenth-century Roman stools and the eighteenth-century Venetian mirror, which had been in the collection of Adrian. The crystal and coral lamps are original Duquette creations.

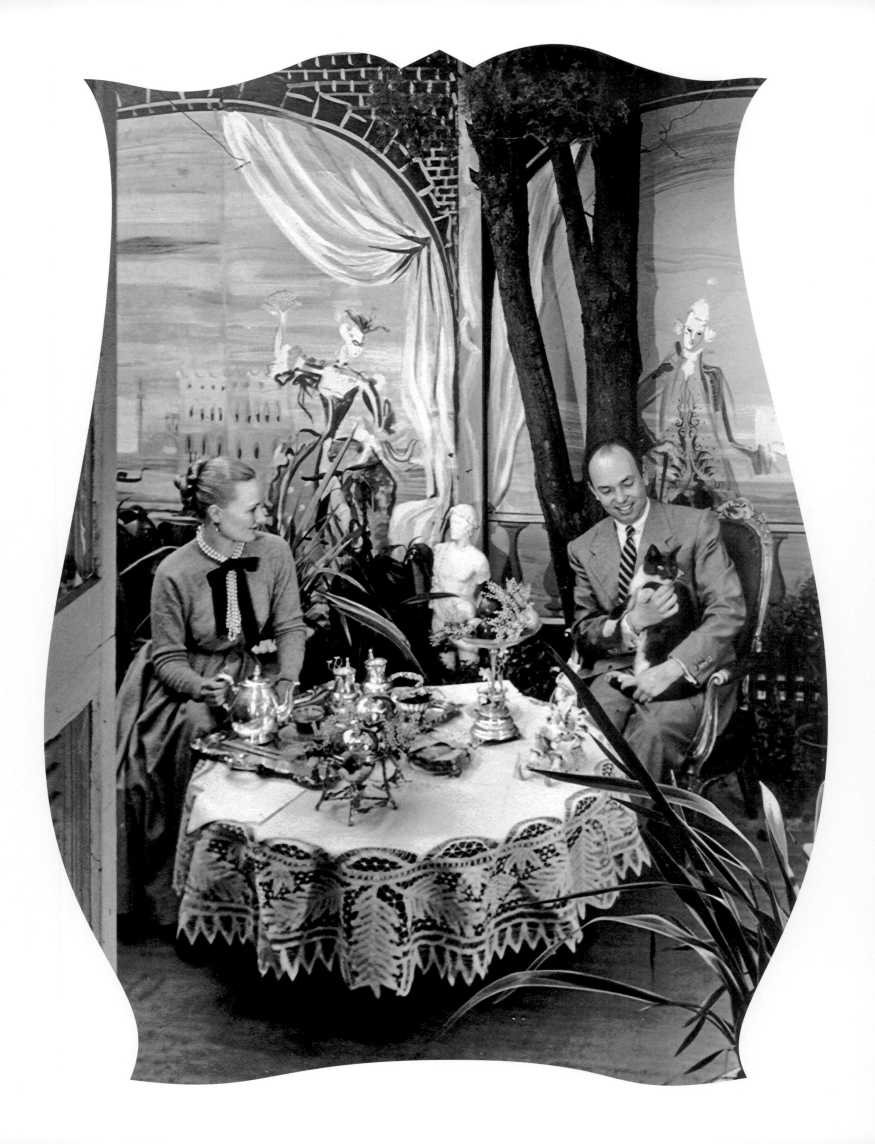

SPIRIT HOUSES

My first impression [of Dawnridge] I think was just sort of the impression that it intended to give, which is stupefaction, really, and bedazzlement. Dawnridge was designed to completely dazzle and subjugate and provide mesmeric sparkle and razzle-dazzle, sometimes even achieved through some crude technical effects. But it is all theater and show. That was just the essential Tony. He had that great theater and razzle-dazzle showmanship, really. So I was awed by it, you know.

Hamish Bowles

TONY'S MOST ASTOUNDING WORK was always within his own homes. There, with no constraints, he could let his imagination run wild. After his marriage, Tony bought what everyone else thought was an impossible piece of real estate not far from Pickfair in Beverly Hills—a lot overlooking a ravine.

Two old family friends—one a real estate agent, the other a banker—asked Tony to contact them when he was ready to build his house. Tony called the real estate agent and said that he found the land he wanted to buy. The agent said, "I love you too much, Tony, to sell you that land. It has no front lawn, it is on a hill, and are you crazy?"

Tony went to the banker, who said, "You're an artist, Tony, you don't know what you're doing, there is no front lawn, it is on a hill, and you're going to lose your shirt, so I can't lend you the money!"

OPPOSITE Tony and Beegle, recently returned from their year in Europe, at home in their Fountain Avenue studio, c. 1951. Beegle painted the Venetian murals on the walls adjoining the driveway, where this picture was taken.

7

I had no idea where I was or where I was going, but when I walked into the Bal Derrière, it was magic. Tony had hanging masks in gold and silver, and chandeliers hanging from the ceiling made of wood—it looked like driftwood— which was sprayed in gold. It was Never-Neverland. I learned so many intricate things. He had pots of diamonds, which weren't really diamonds, and pearls and emeralds, and rubies, and feathers. Oh, he loved feathers.[1]

ARLENE DAHL

"But it was only fifteen hundred dollars," Tony would later say. "Can you imagine? Those poor saps, they had absolutely no vision."

Tony never quite got over their rejection and shortsightedness but, of course, he went right ahead and bought the land and built his house without their help. He hired the architect Casper Ehmcke to help him realize his vision. Casper and Tony used to ride the streetcar together when they were students working downtown. Tony always promised Casper that one day he'd hire him to build a house. Though trained as a modern architect, Casper was able to bring to life Tony's dream of a dramatic Hollywood Regency–style house. Ironically, Dawnridge was such a success that many of Tony's friends hired Ehmcke to design their own Hollywood Regency–style houses, making his work in this style—rather than in his signature modern Bauhaus style—very much sought after. For Dawnridge, Ehmcke designed a thirty-by-thirty-foot cube housing a grand drawing room with a balcony, a tiny kitchen and powder room, two minuscule downstairs bedrooms with baths, and a one-car garage (which Tony instantly converted into a dining room). Beegle painted murals throughout the entrance hall, complete with the image of an eighteenth-century footman at the door. Tony created extraordinary dipped-plaster pelmets at the windows and an amazing Venetian-glass chandelier. They filled the house with French and Venetian antiques and objects of their own creation, and ultimately created one of the grandest houses in Beverly Hills.

The newlyweds originally christened the house Fiddler's Ditch, because it was built on the side of a canyon. They immediately began entertaining lavishly, their first party being a *bal derrière*—or a "bustle ball," as Tony called it. Beegle wore a beaded black-lace gown by Adrian that was lined in flesh tones, and Tony provided her with a bustle of sequined butterflies and dragonflies. Loretta Young wore an evening gown with a bustle made of helium balloons, which had been cleverly tied around her waist and which followed her around the room. The ball was a big success and a wonderful prelude to the galas the Duquettes and their friends would go on to enjoy.

The Duquettes barely lived at Dawnridge for a year before they left for Paris and the promise of an exhibition at the Louvre. While they were away, Marlon Brando rented the house; he was filming *Julius Caesar* at the time (1950).

OPPOSITE The exterior of "the fortune teller's house," the name neighbors gave to Duquette's studio on Fountain Avenue in Hollywood because of the entrance curtains he'd stenciled with fleurs de lis.

Brando told Tony he loved to lie on the living room carpet and contemplate the flowered Murano-glass chandelier, which Tony had designed specially for the room.

Upon their return home from Paris after one year, the Duquettes moved into their old studio on Fountain Avenue rather than returning to their honeymoon house. For the next twenty years Dawnridge was rented to various Hollywood celebrities, including Zsa Zsa Gabor, Glynnis Johns, Sue Mengers, as well as to the Duquettes' society friends, like the F. Patrick Burns and Nancy Oakes.

In 1956 Tony came upon an abandoned silent-film studio that had been built for Norma Talmadge by producer Joseph Schenk. He seized the opportunity to save its life and to create something unique in Los Angeles. The Tony Duquette Studios on Robertson Boulevard in West Hollywood would become famous not only for Tony's vast and eclectic interiors but for the parties and creative endeavors that went on under its roof.

What the Duquettes created was similar to a Palladian villa or a Venetian palace, with a pair of sixteenth-century Spanish nail-studded elephant doors—the wedding present from the Helis sisters. The sisters' house had been built by the renowned MGM executive Winfield Sheehan and contained architectural treasures from around the world. (In fact, the sisters did not send one pair of doors, but three: two were sixteenth-century Spanish doors and one was a seventeenth-century Italian doorway, which was installed at Dawnridge.)

Just past those doors at the Robertson Boulevard studio was a travertine-lined entrance hall. The moldings around the ceiling were from the Hearst collection. The crystal chandelier was eighteenth-century Irish. There were Chinese screens in the corners, embroidered with gold threads; an eighteenth-century Chippendale Chinese cabinet filled with rare porcelains; and a Portuguese Colonial chest of drawers, a gift from Frances Elkins, surmounted by a mirror in a gilt wood frame. On the floor was an eighteenth-century Chinese palace carpet, and on each side of the doorway Tony installed the windows from the bedroom of John Gilbert and Greta Garbo, which he had salvaged from the David O. Selznick house on Tower Grove when he was remodeling and redecorating it for Selznick and Jennifer Jones. And that was just the entrance hall.

Through another pair of sixteenth-century Spanish doors, a long hallway ran perpendicular to the first. The walls were hung with a striped lamé in two shades of gold, a backdrop for Tony's collection of seventeenth-century Venetian oil paintings. An original Duquette abalone-and-Peking-glass chandelier hovered above.

Across this hallway and through a set of folding doors paneled in natural wood with gold and black edging was the ballroom. The "big room," as the Duquettes called it, was the heart of the old studio. It was an amazing one hundred feet long, twenty-five feet wide, and twenty-eight feet tall. Tony had a stage built at the end of the room so that he could showcase his costumes, sets, and production work for producers and directors—perhaps an unnecessary measure. "Just being invited to the building was enough to have them sign me up," he would say later. "I never had to show them anything."

OPPOSITE The drawing room at Dawnridge, c. 1949, with Duquette's unique sunburst torcheres, snowflake screens, and dipped-plaster lambrequins.

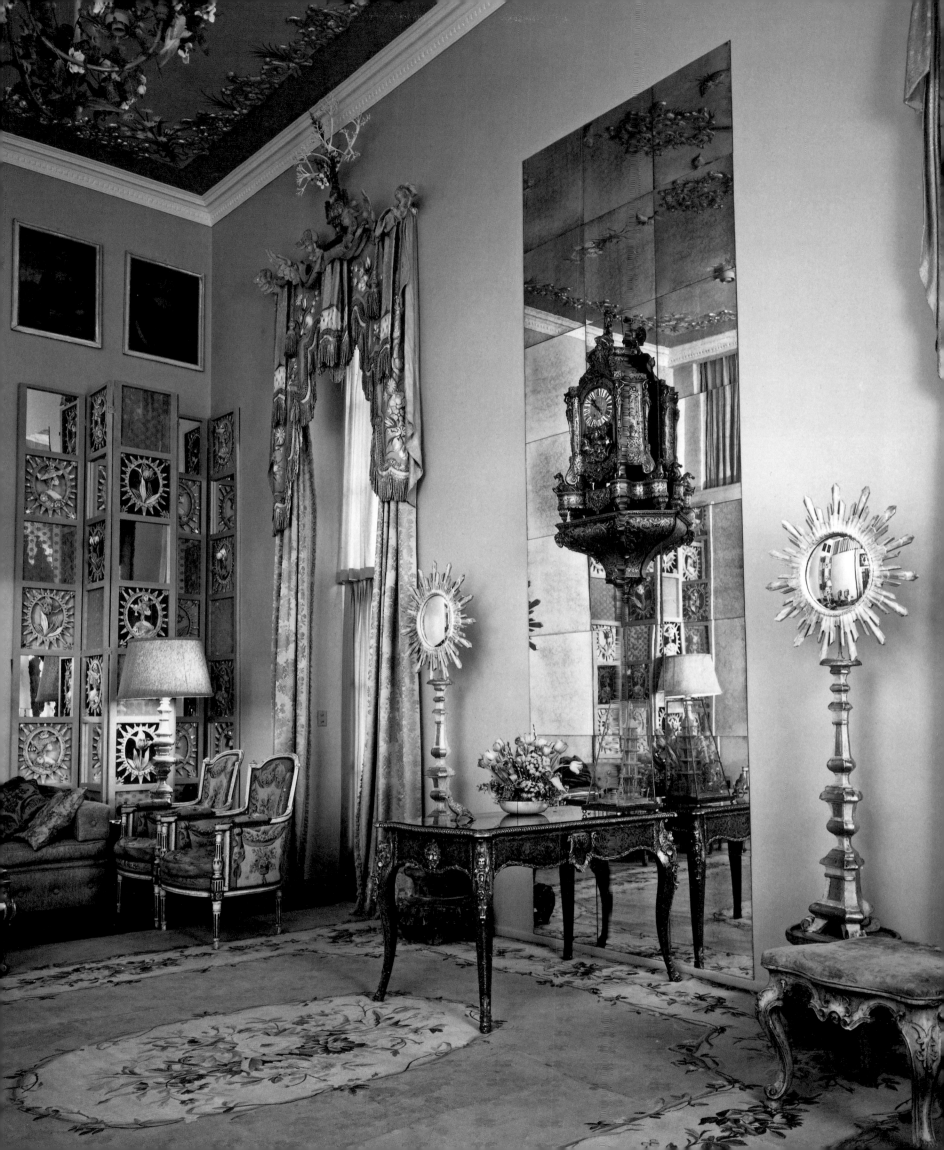

ABOVE The exterior of the newly built Dawnridge, c. 1949.

OPPOSITE The exterior of Dawnridge fifty years later, in the 1990s.

OVERLEAF LEFT A view into the entrance hall of Dawnridge, c. 1950s. The seventeenth-century Italian doorway was a wedding present from Cissy and Adrian Hellis.

OVERLEAF RIGHT The entrance hall at Dawnridge, c. 1990.

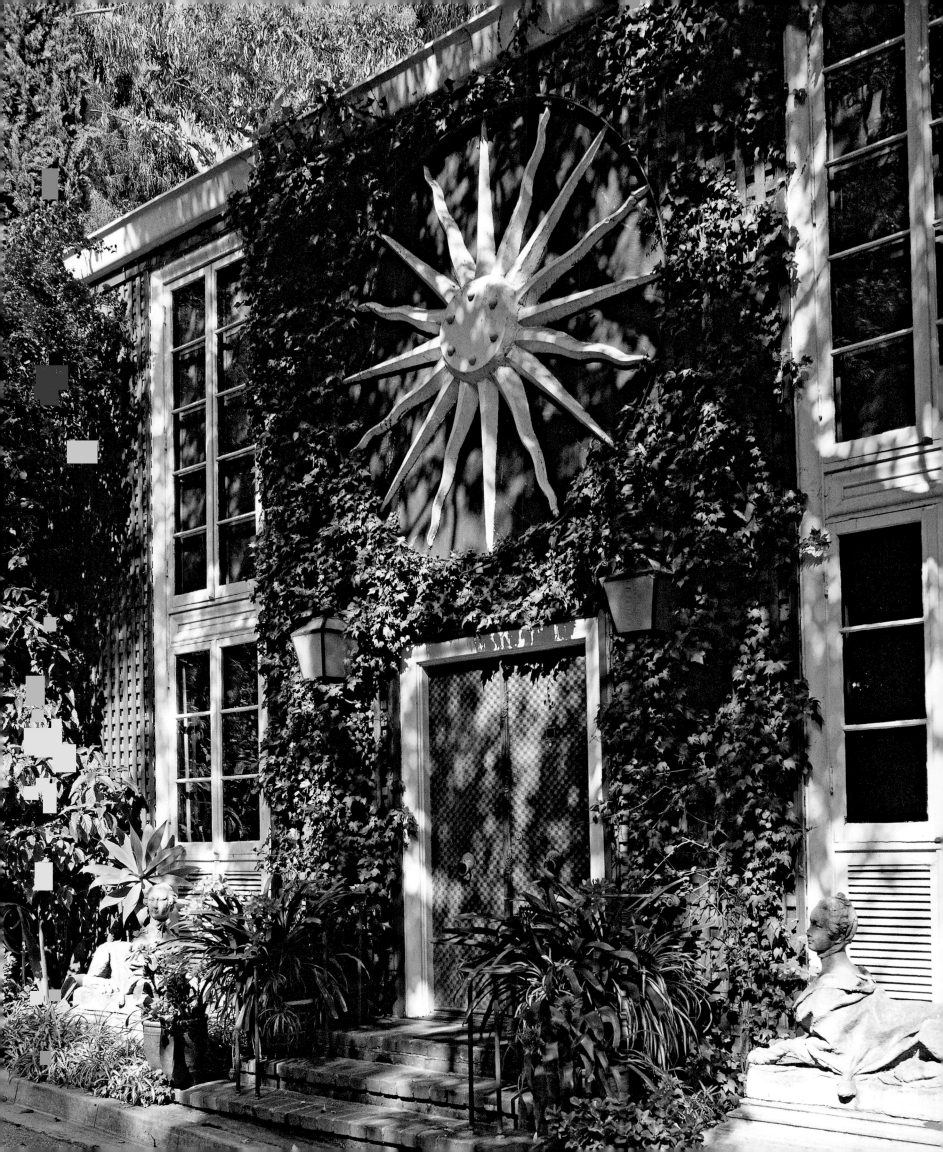

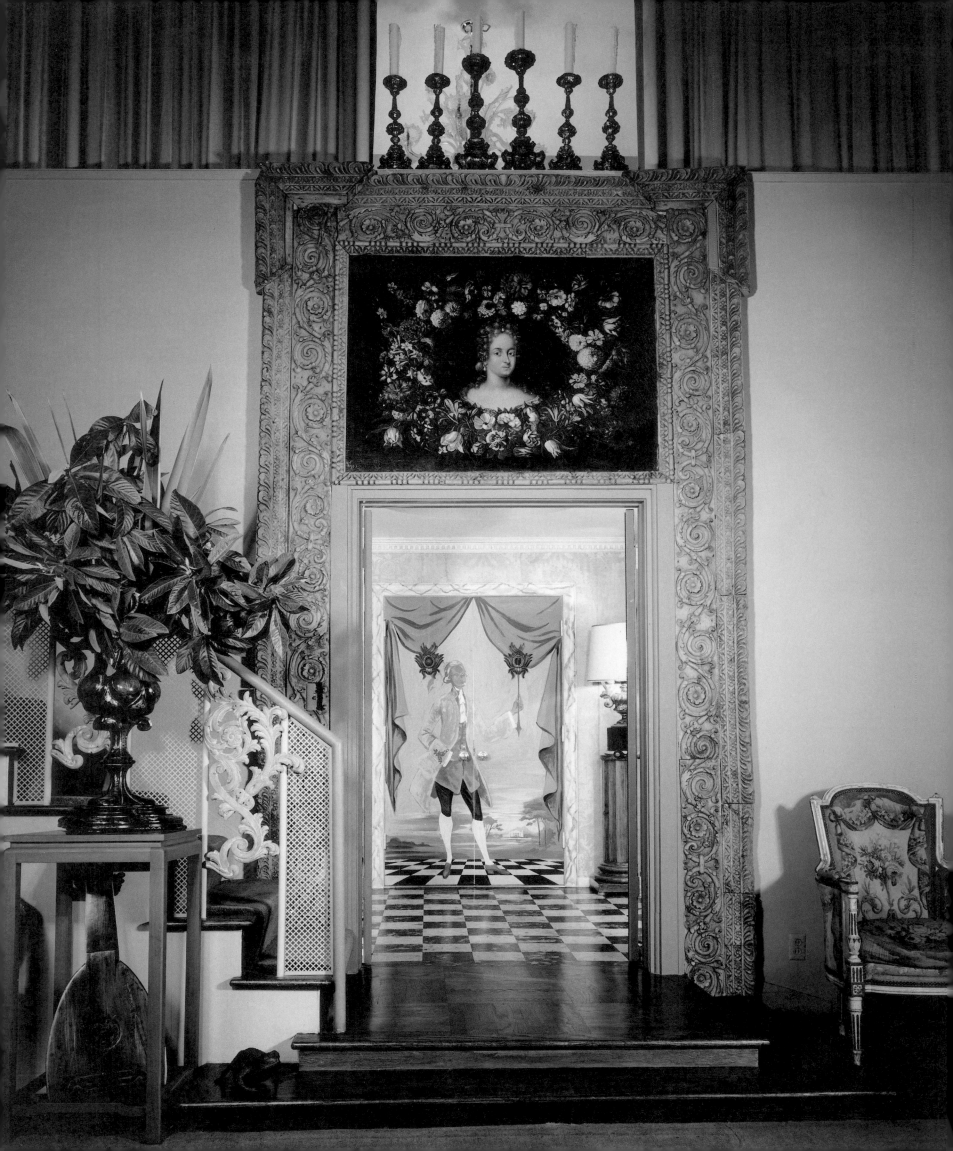

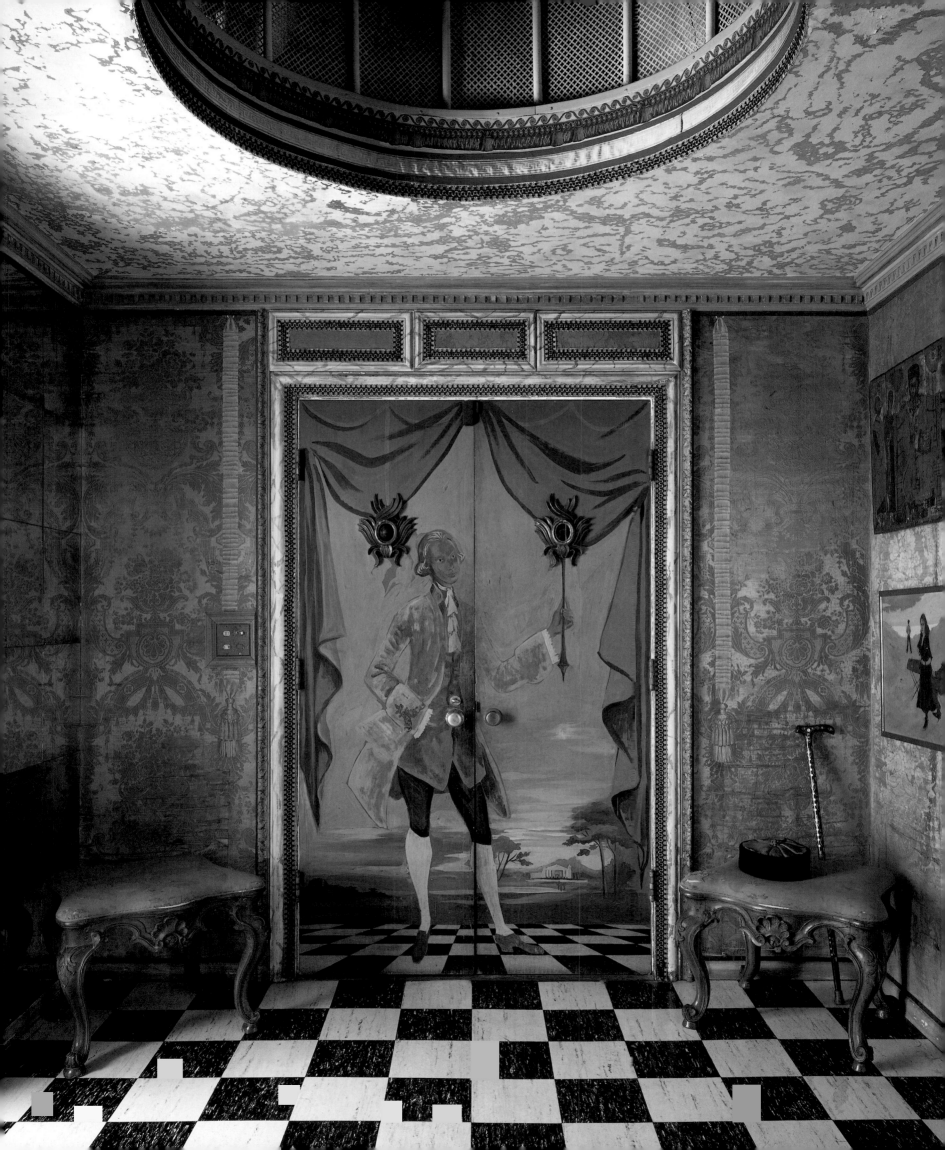

The stage was curtained with the original fabric—in various shades of felt and gold Lurex—woven by Dorothy Leibis for the Adrian Salon in Beverly Hills. The vast studio room was hung with white glass cloth, which was pulled back to reveal doorways that led into other alcoves and, from there, into other suites of rooms.

Flanking the entrance to the room was a "Venetian" staircase that Tony had constructed from bits and pieces of eighteenth-century gilded Venetian carving. At the head of the stairs was a balcony, which the Duquettes often used for dining, gambling, or viewing *divertissements* in the room below. The floor of this enormous room was painted in malachite green and was often spread with a giant coral-colored silk Tabriz carpet. The textured ceiling, which originated as painted cardboard, was achieved by the application of hundreds of egg cartons and Styrofoam grapefruit packing cases, giving it the appearance of a lid for a giant candy box. From the ceiling hung five original Duquette chandeliers, which were replaced several times over the years. In the 1950s, the chandeliers featured Venetian-glass flowers; later, those were replaced with more traditional crystal chandeliers; finally, those were swapped out for crystal chandeliers that Tony designed to resemble splashing water.

Eighteenth-century Venetian armchairs, paired with brass-and-velvet sofas of Duquette's own design graced the room. Iron-and-abalone coffee tables sat on rich Oriental carpets and held jeweled objects in glass cases and flowering plants in porcelain cachepots. Crystal bouillotte lamps of Tony's own invention sat on modern tables whose glass-covered tops he had specially crafted from ancient Coromandel-lacquered panels. Lighted Louis xv vitrines, lined in coral silk velvet, held three-dimensional costume designs that Tony had created for Charles

Laughton's Theatre in the Round. These were topped with giant pink-glazed antique Chinese vases with palace markings.

Around the room were eighteenth-century French marble-topped console tables surmounted by towering gilded nineteenth-century pier glasses; sets of seventeenth-century Roman stools upholstered in silk velvet with *passementerie* and tassels; and eighteenth-century red-lacquered Venetian side chairs from the collection of Frances Elkins, upholstered in coral suede. Hanging on the walls were Tony's own framed watercolors and Beegle's large framed oils, side by side with seventeenth- and eighteenth-century works of art, Japanese screens, gilded antlers, lobsters and crabs, giant prehistoric elk horns that had been found in an Irish bog, electric street signs, architectural fragments, antique tapestries, and tapestries of Tony's own design.

The "big room" was always changing. One day the carpets would be cleared away and the furniture pushed back so that teams of workers could lay out some gigantic project on the floor. Later at night it would all be put back, and Tony and Beegle would entertain their friends in black tie. Parties were important to the Duquettes. They liked to entertain, and they did it with style. As taught by his mentor Elsie de Wolfe, Tony would have dinner served all over the house—on the stage, on the balcony, in the dining room, in the kitchen, and on a small terrace outside of his office. Each new space offered the promise of a new idea, a new arrangement, an occasion to use another set of dishes or silverware—and the Duquettes had many to choose from.

OPPOSITE The frescoed ceiling in the drawing room at Dawnridge with its original Tony Duquette Venetian glass chandelier that Marlon Brando used to contemplate from the living room floor when he rented the house.

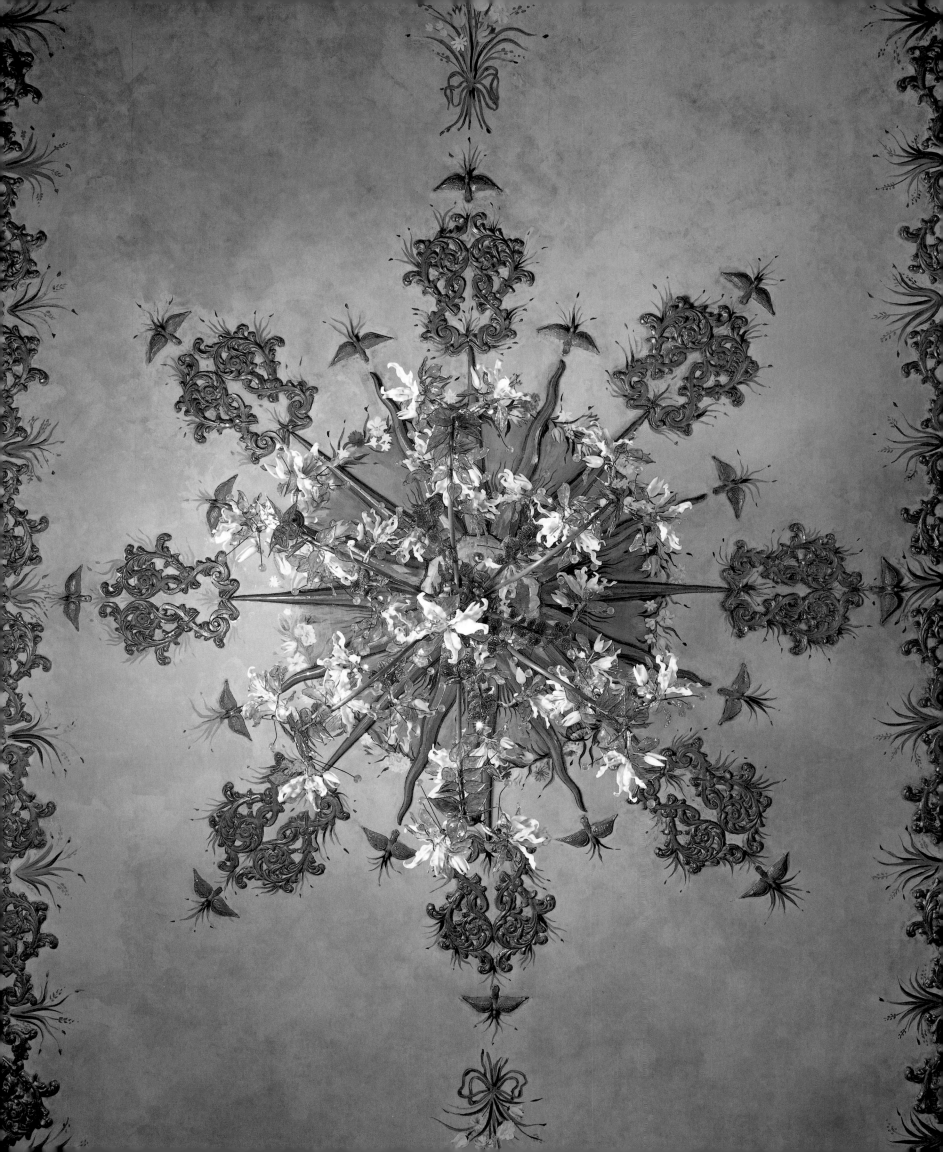

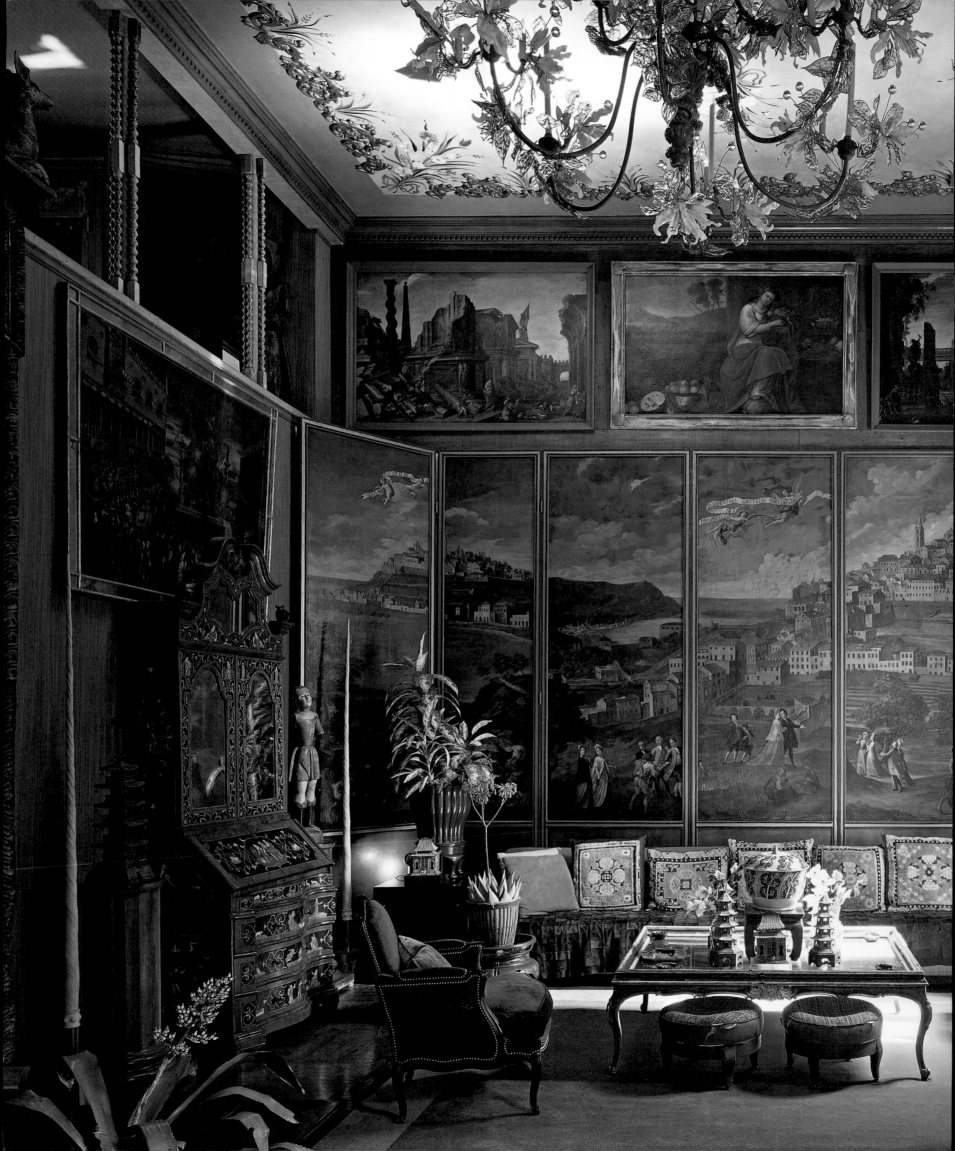

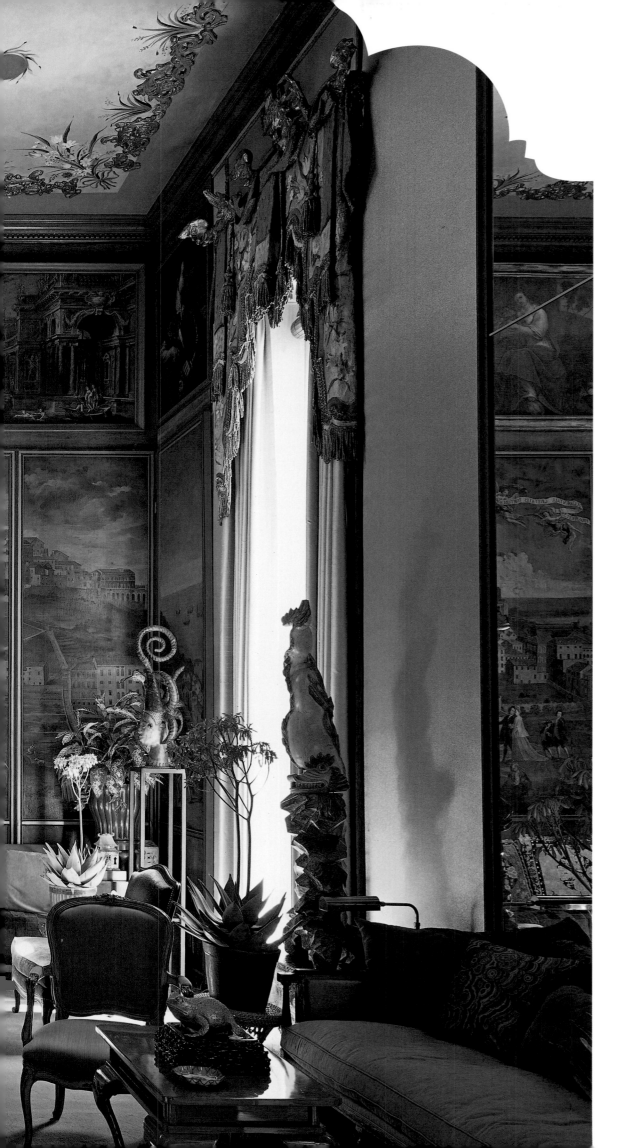

OPPOSITE The drawing room at Dawnridge, c. 1990s, with its wall of eighteenth-century paintings, Piedmontese secretary, Venetian dolphins, and Billy Haines banquette sofa.

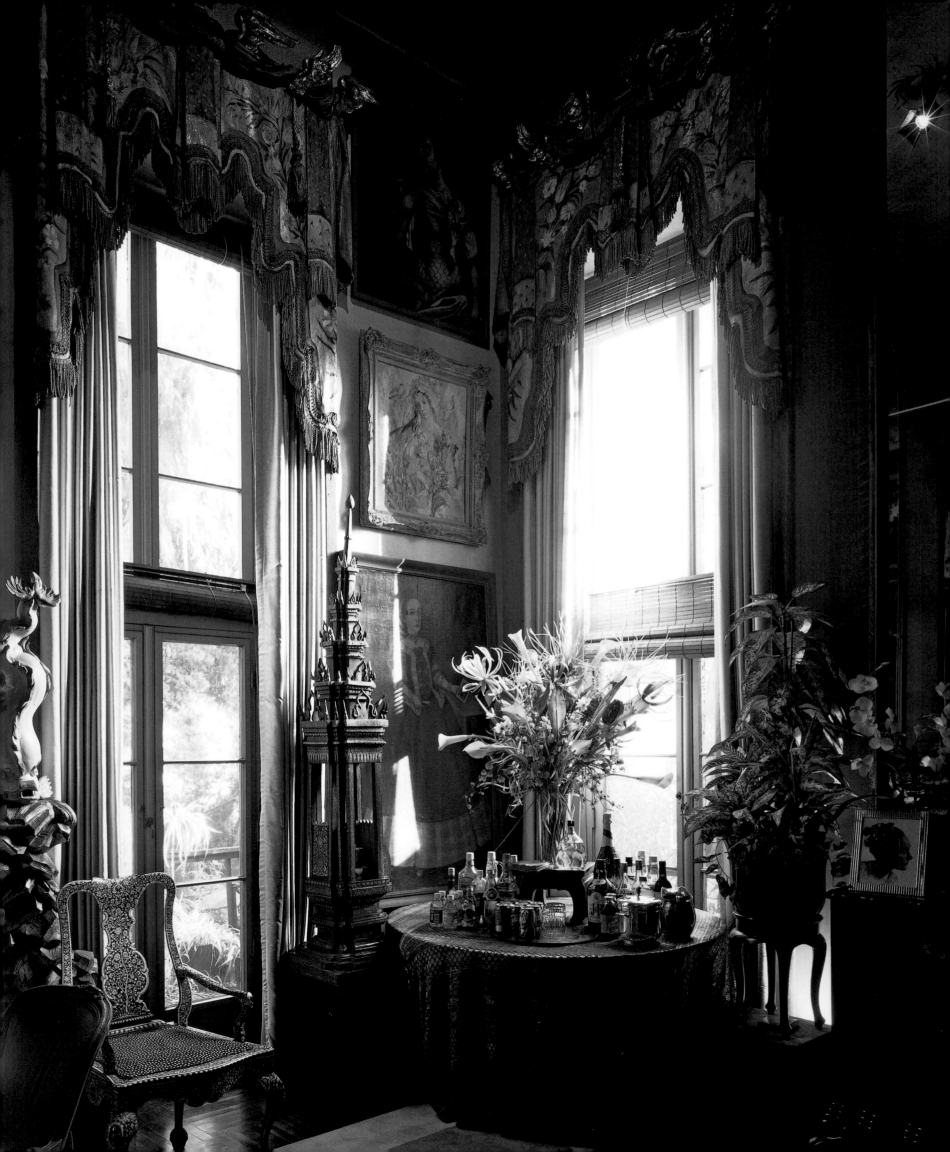

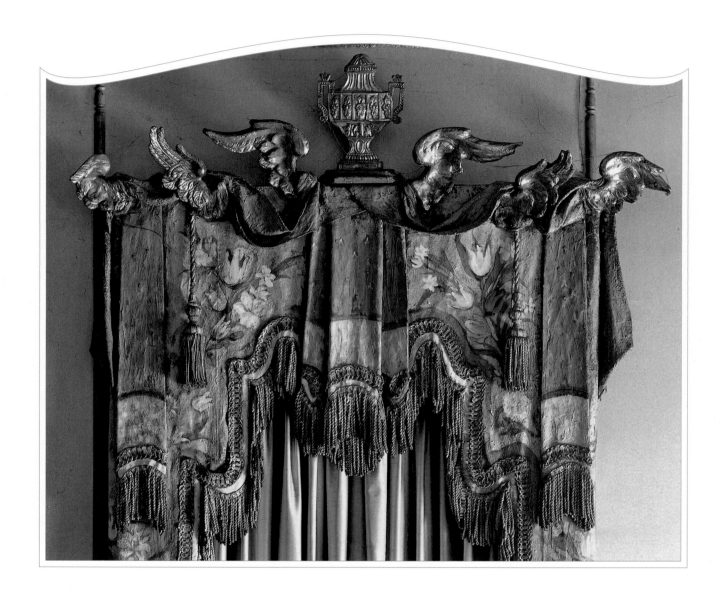

OPPOSITE A corner of the drawing room at Dawnridge with a bar set up on the nineteenth-century papier-mâché and mother-of-pearl inlaid table. To the left is an eighteenth-century Lady Harland chair made in Goa, India.

ABOVE One of the dipped-plaster lambrequins the Duquettes created together for the drawing room windows at Dawnridge. The fabric has been painted to resemble tooled leather and the lambrequins are crowned with eighteenth-century Italian carved wooden wings and Spanish silver urns.

OVERLEAF Tony Duquette's office at Dawnridge. His desk is eighteenth-century French. The nineteenth-century mirrors are flanked by Duquette's collection of eighteenth-century apothecary boxes purchased in Verona.

211

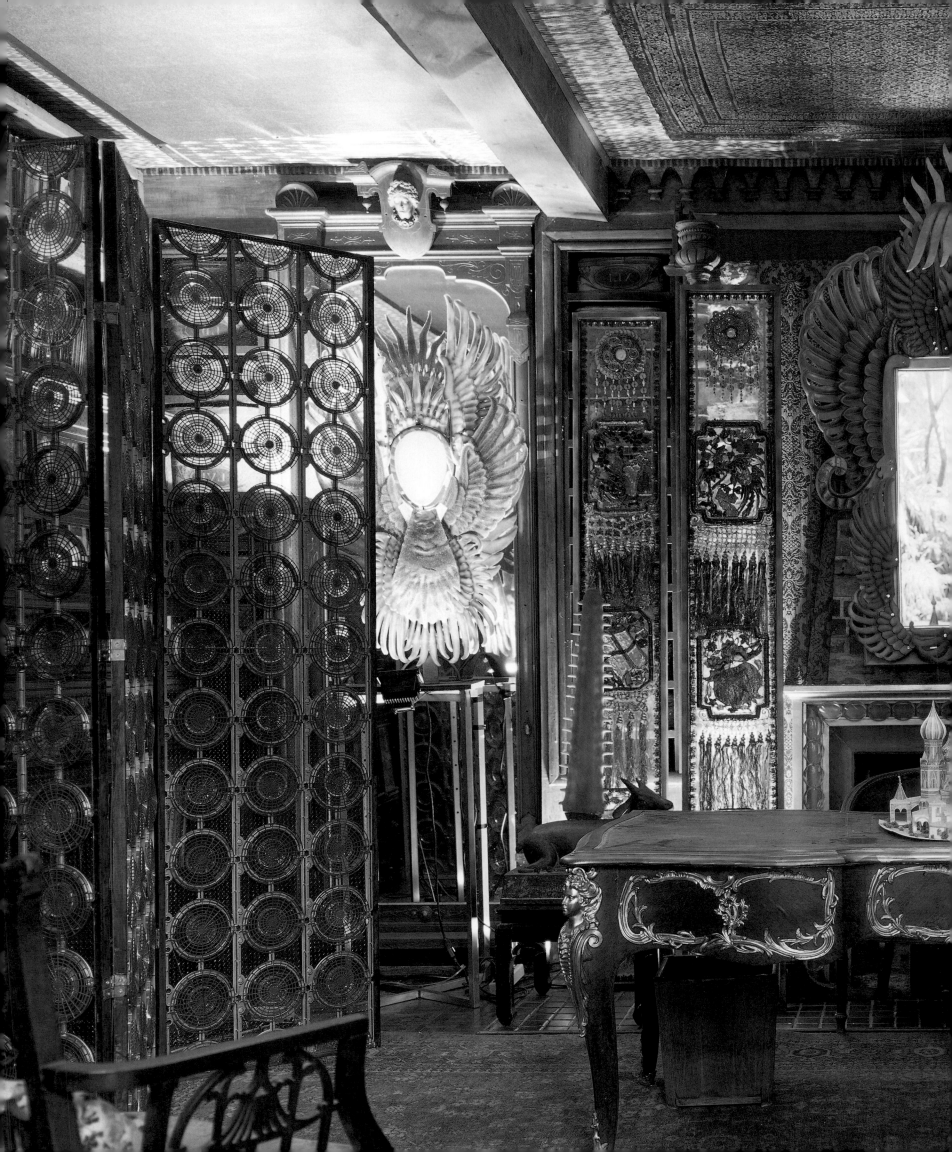

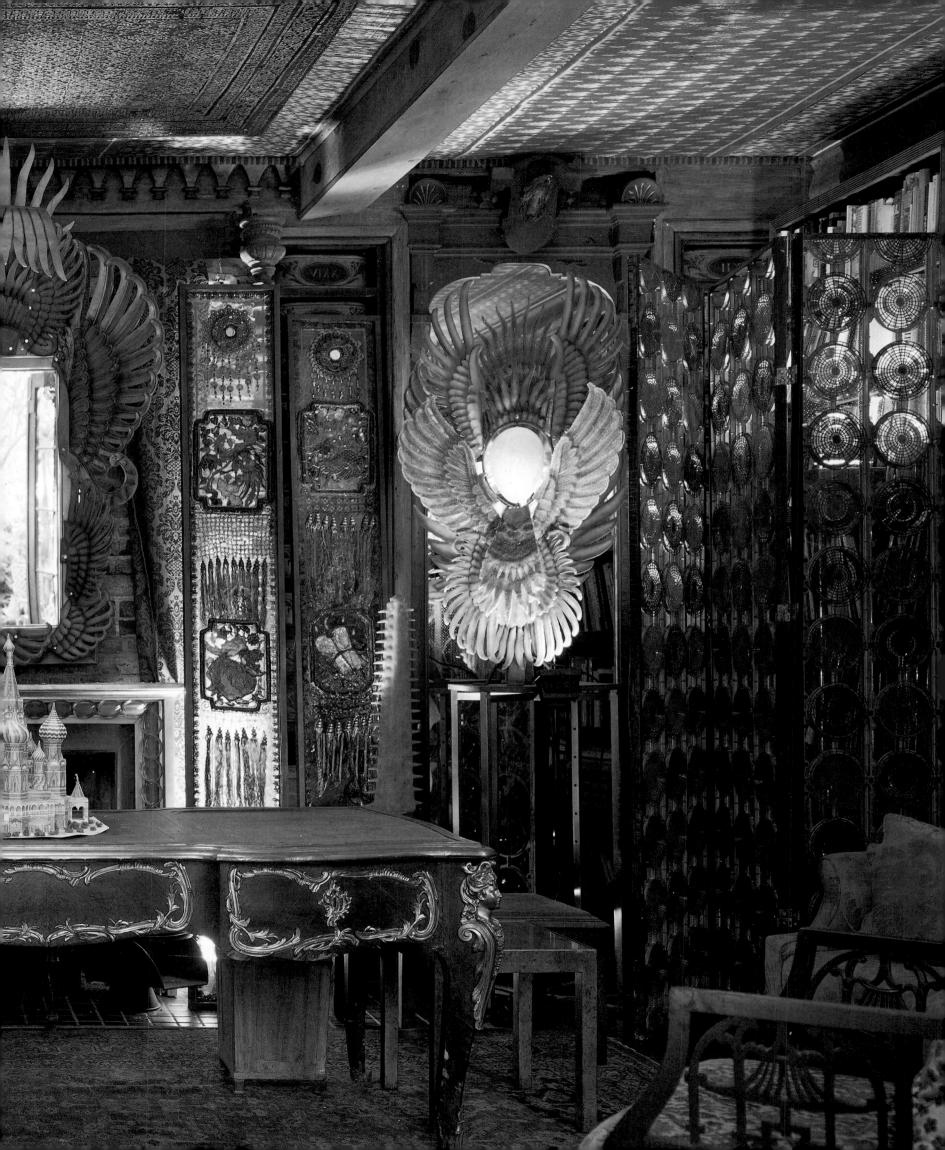

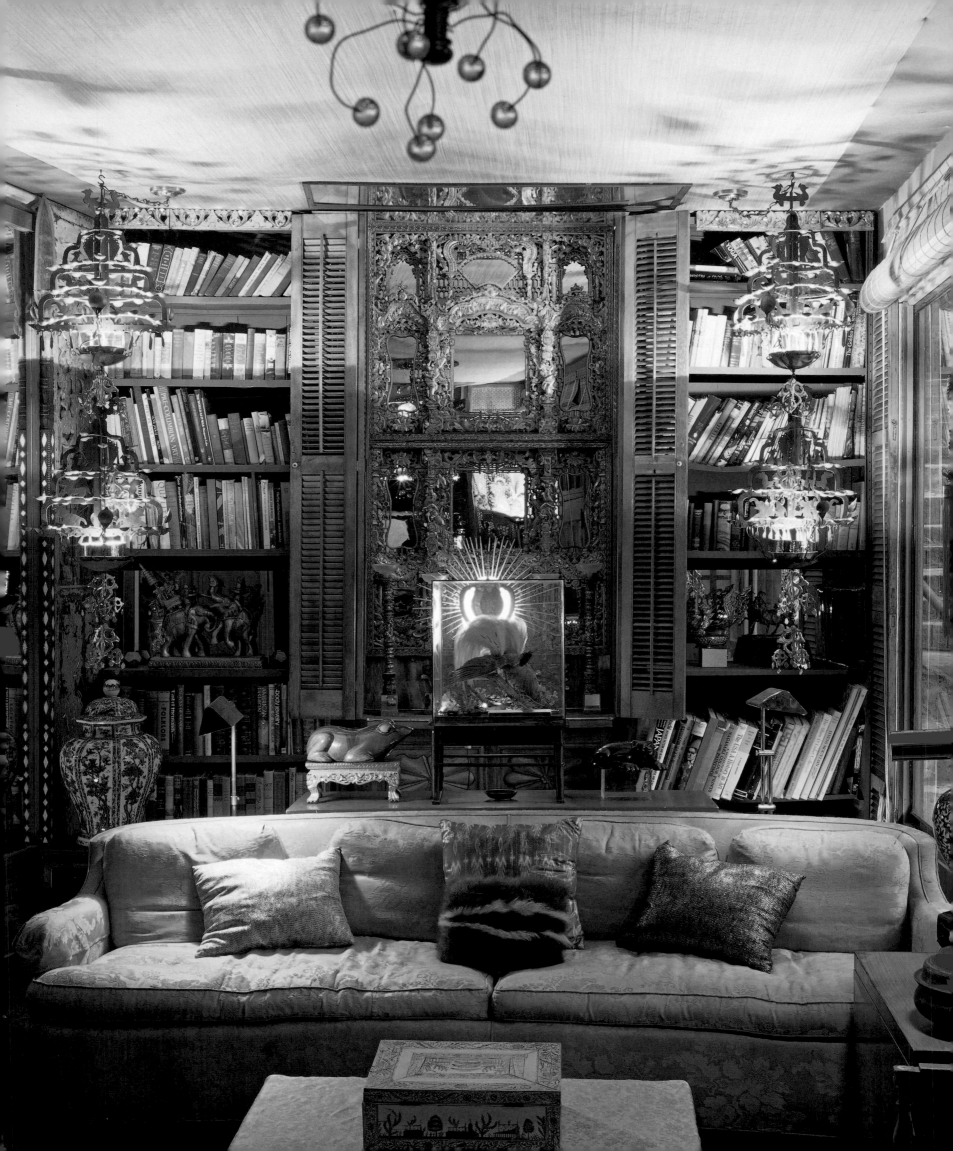

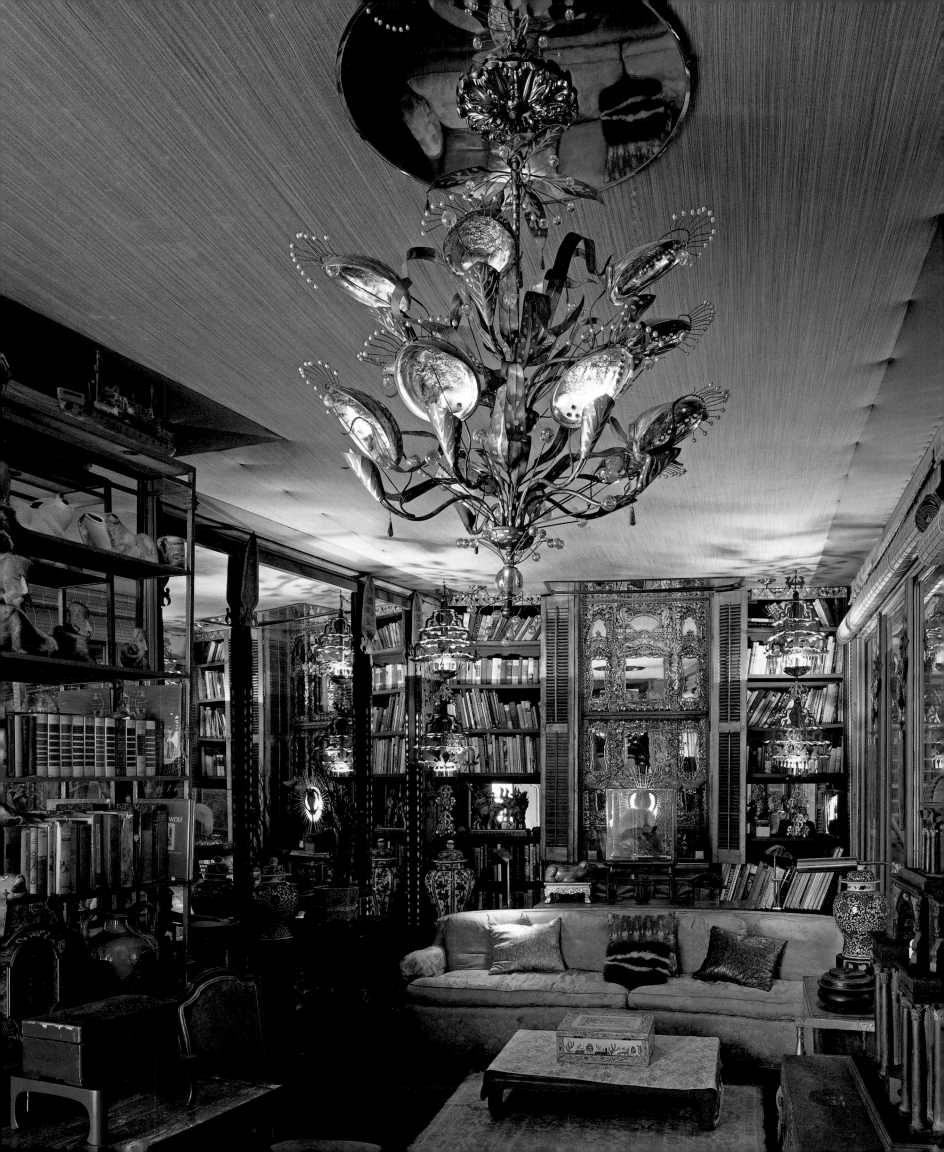

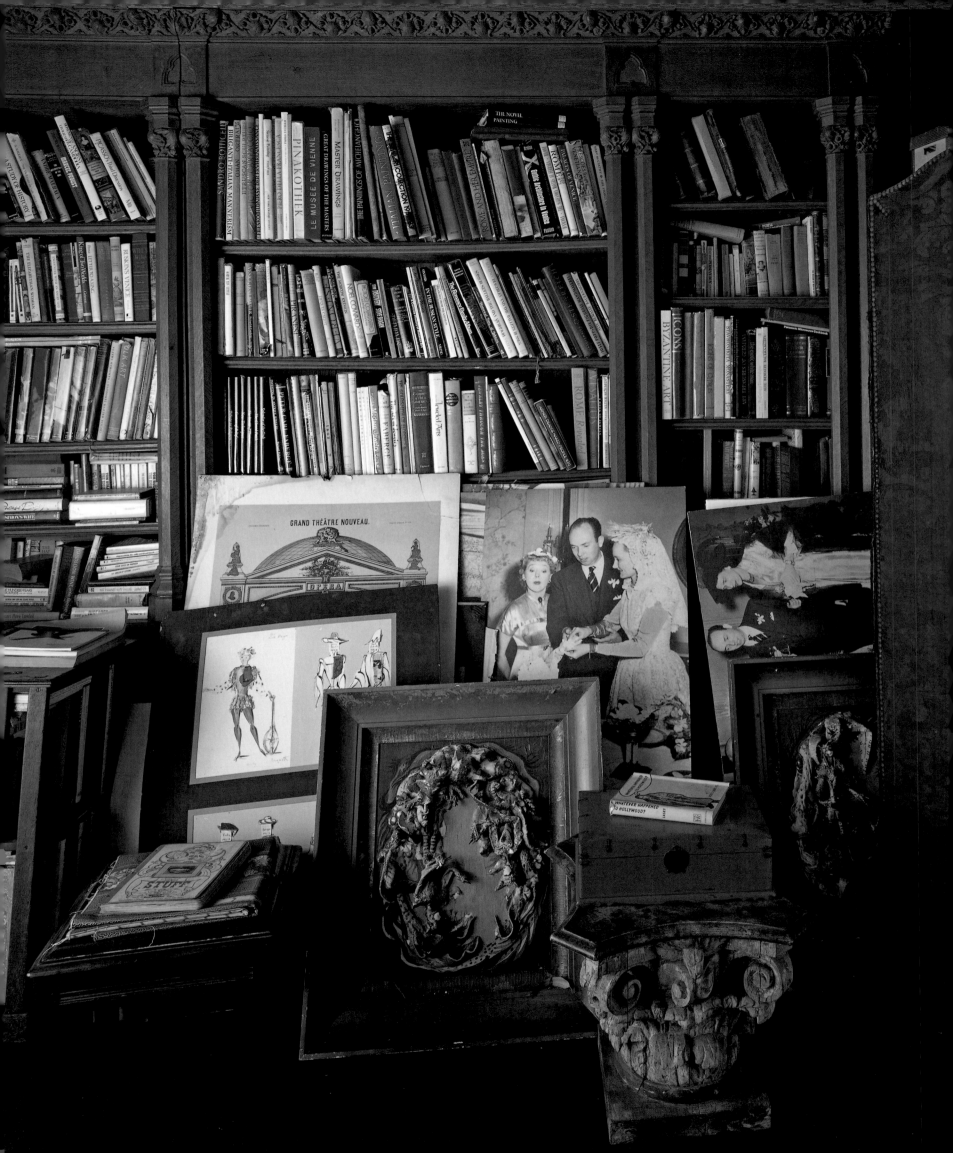

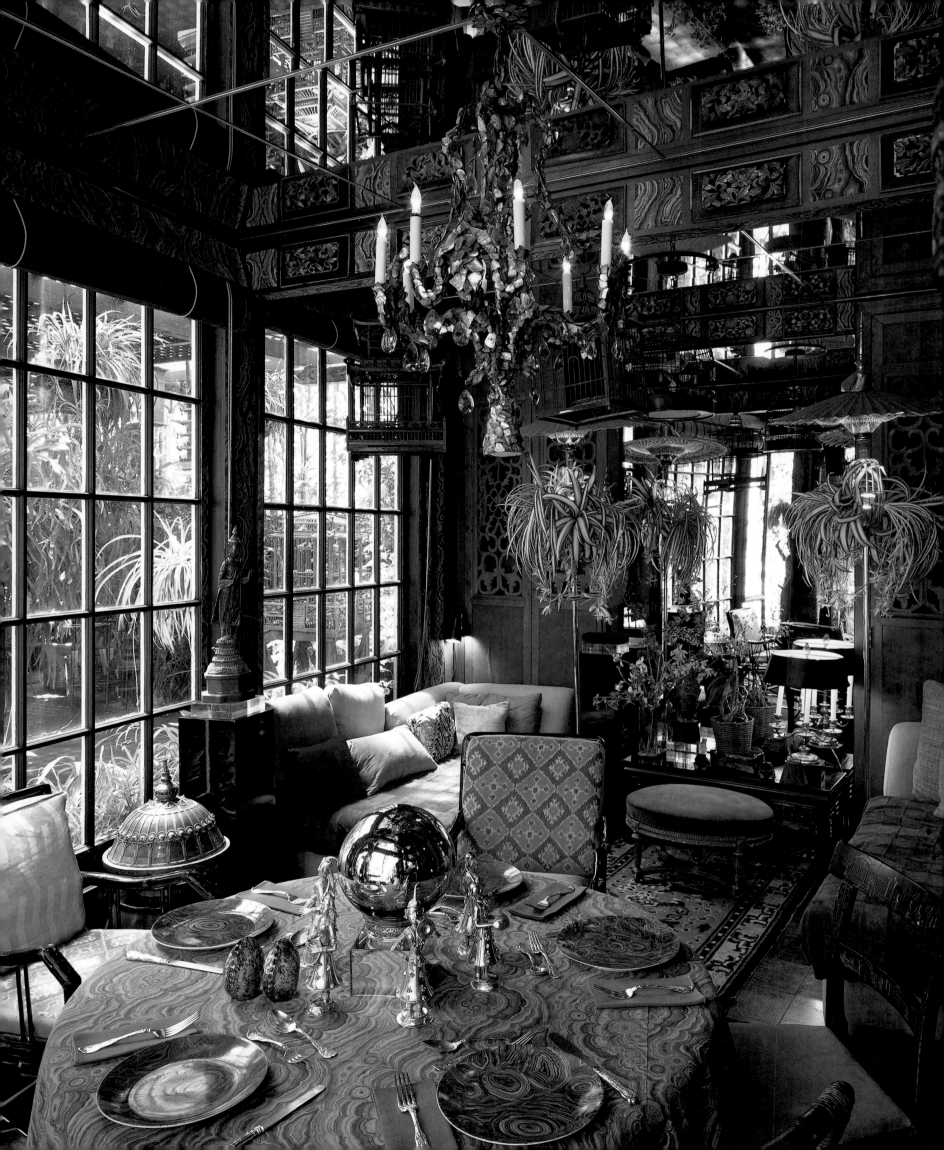

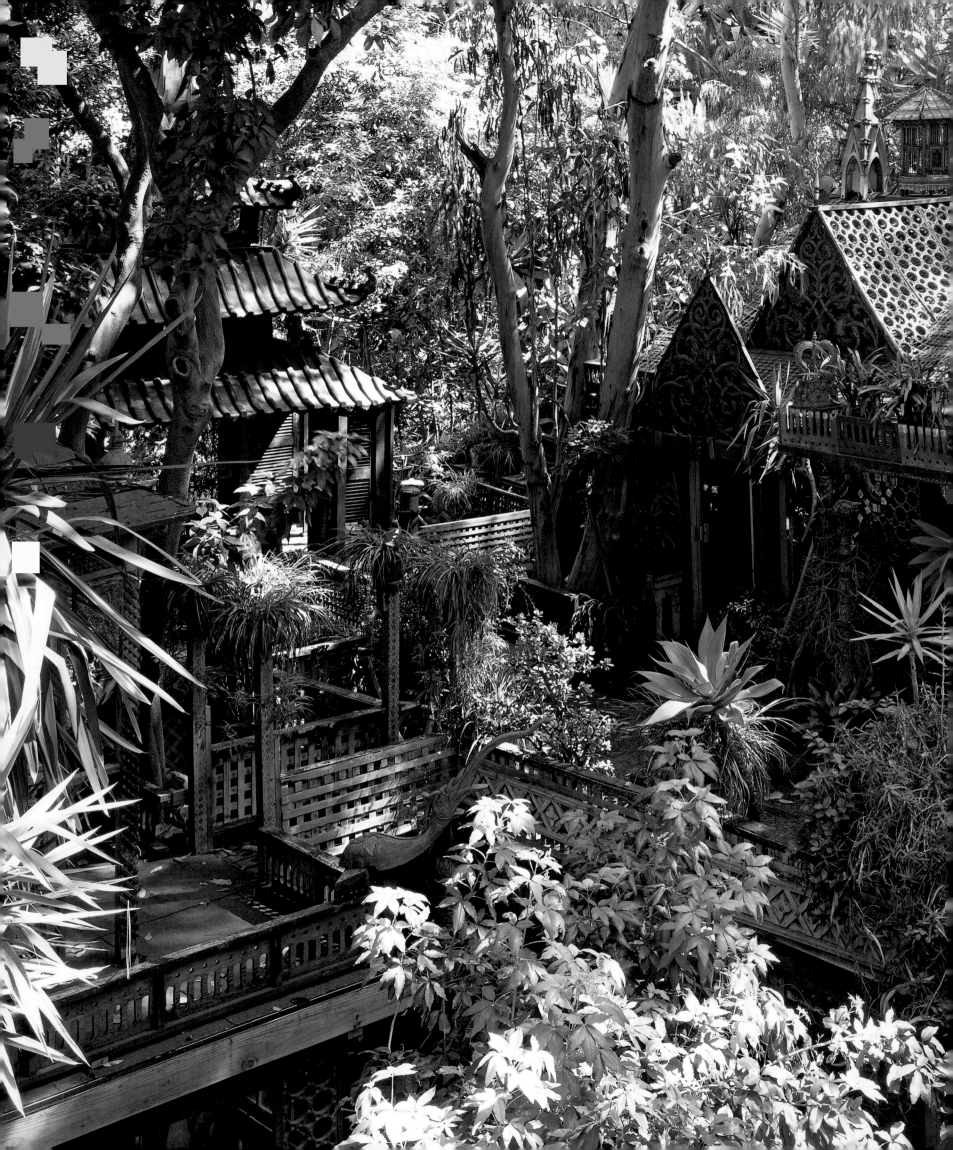

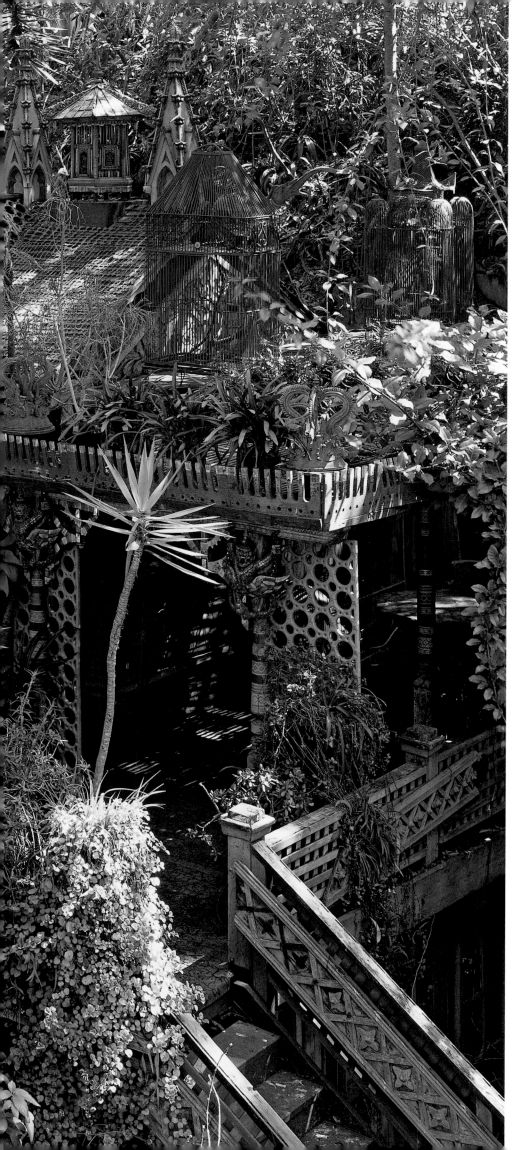

PREVIOUS PAGES
LEFT AND RIGHT Views of Beegle's painting studio—or "Beeglesville" as it was affectionately called—at Dawnridge, a two-story Chinoiserie structure with a sitting room and library downstairs and a large workroom upstairs.

LEFT A corner of Duquette's library at Dawnridge.

RIGHT The "green dining room" at Dawnridge. The walls are covered in Tony's signature Malachite printed cotton.

OPPOSITE Exotic gardens and spirit houses in the ravine at Dawnridge.

OVERLEAF LEFT Tony and Beegle often entertained al fresco on one of their many terraces at Dawnridge. Here is a typical table setting with Peking enamel bowls, antique Wedgewood dishes, Edwardian silver, Venetian goblets, and Tony's own "ashtray men" holding votive candles, all arranged on a malachite printed tablecloth.

OVERLEAF RIGHT The Thai guest house was created using old carvings and roof ends from Thailand as well as other found objects.

219

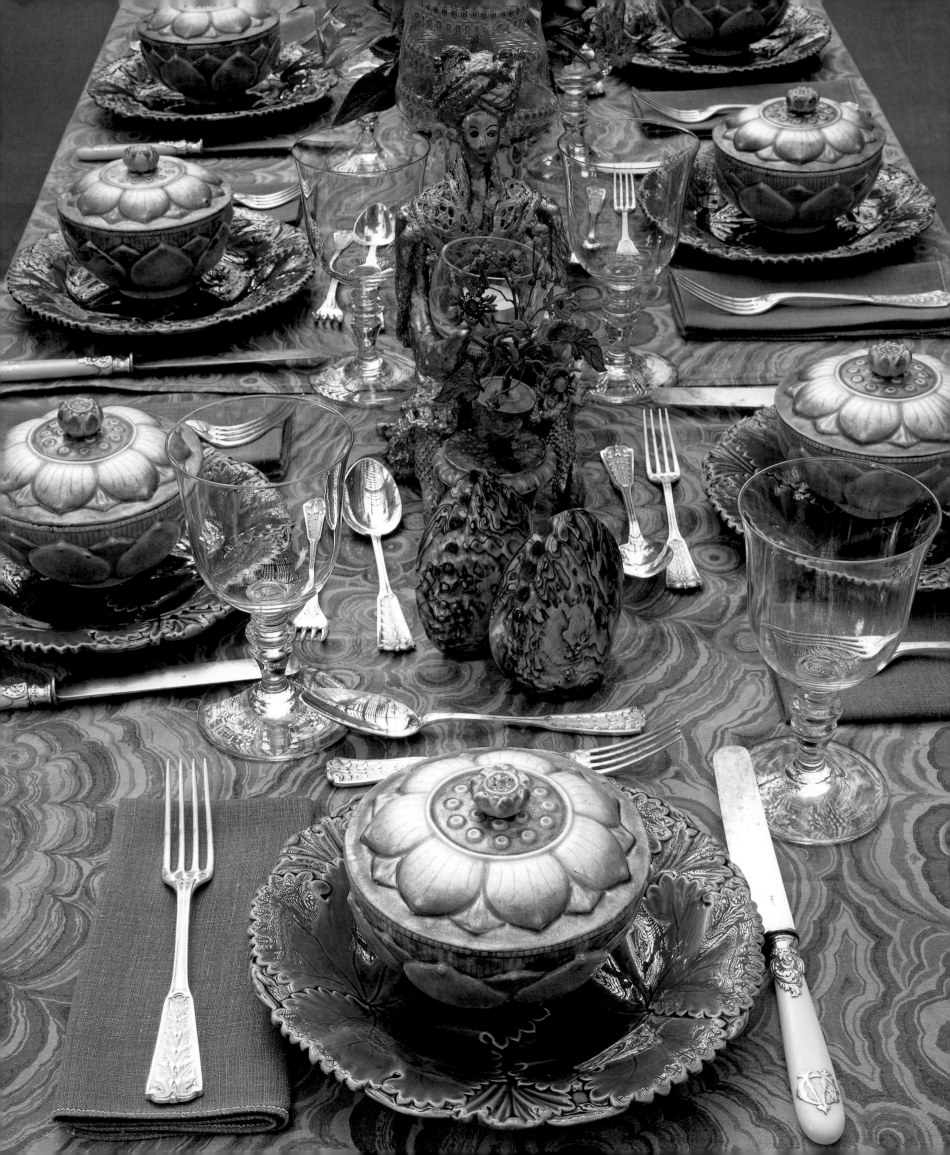

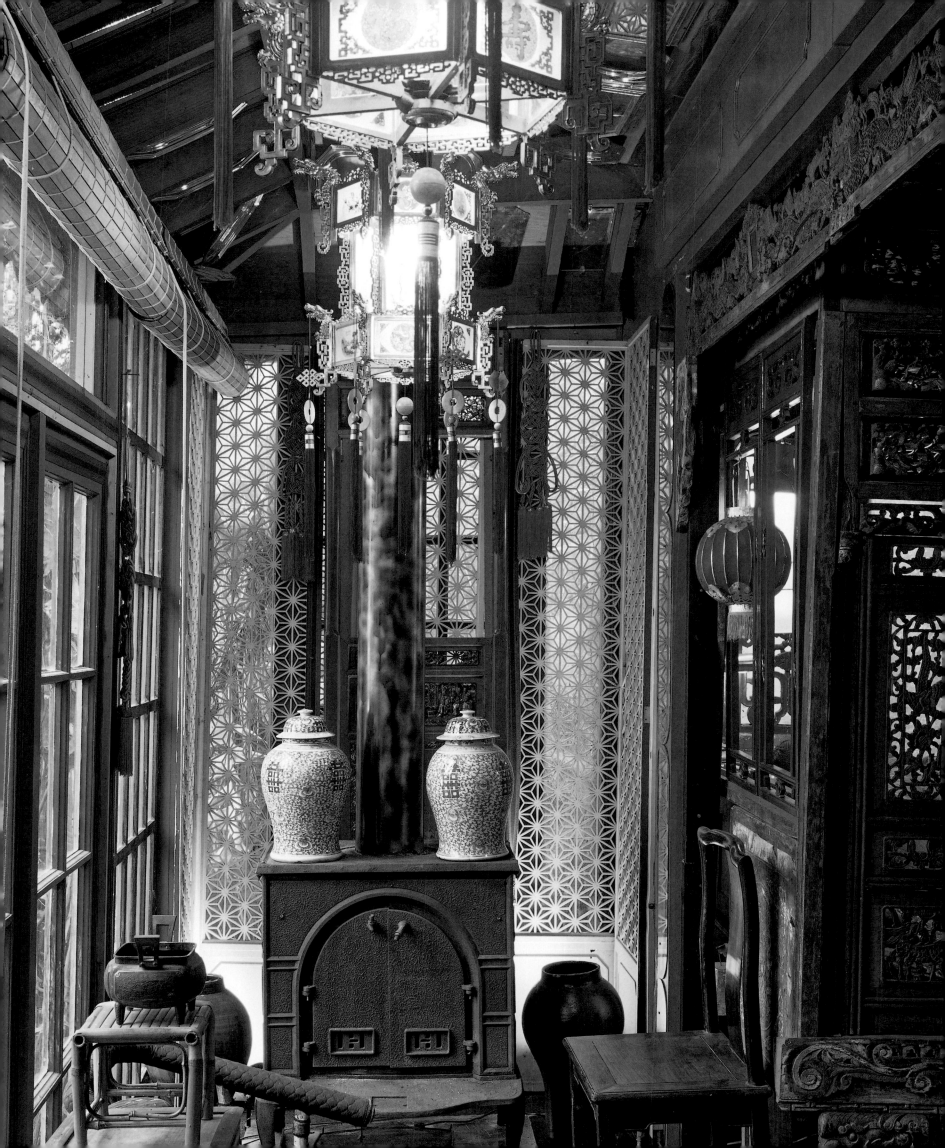

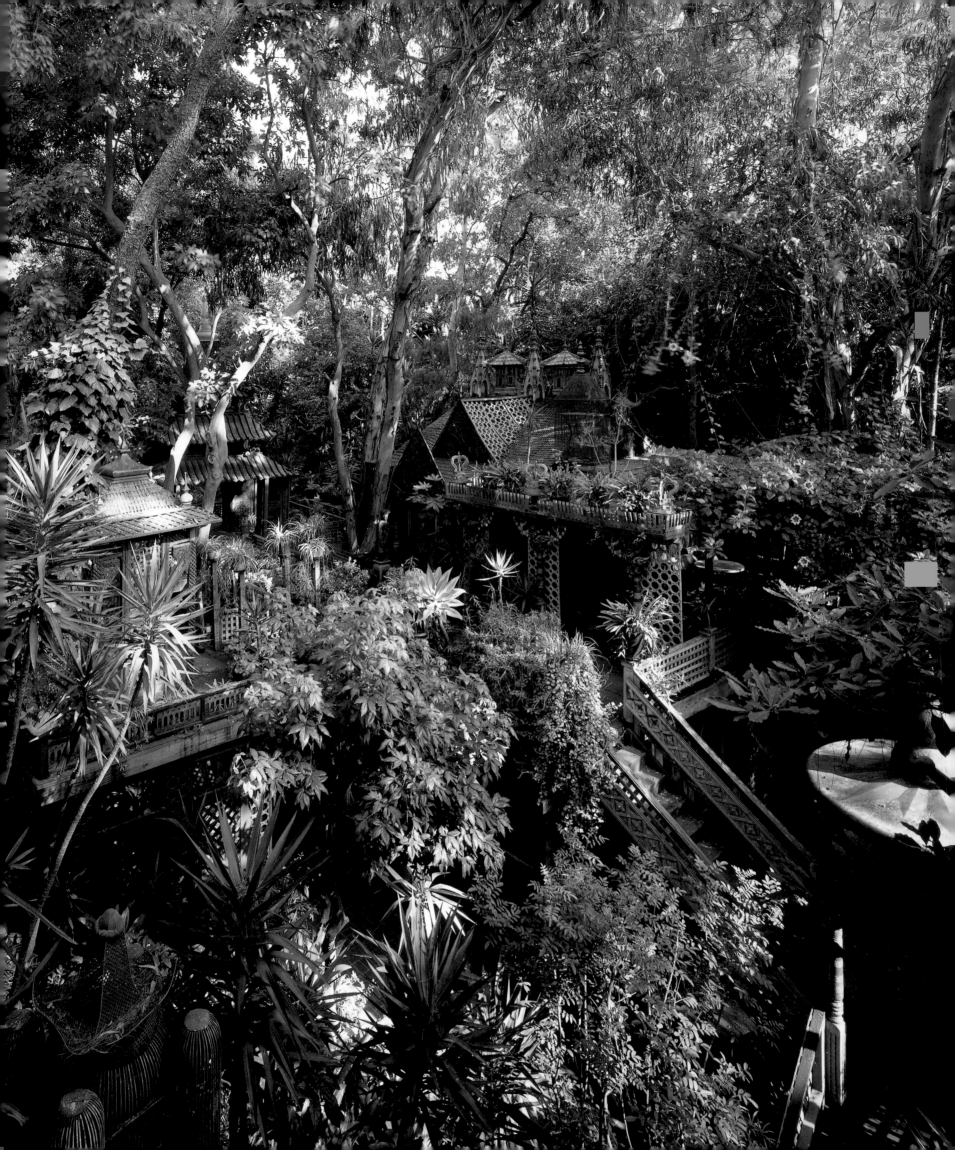

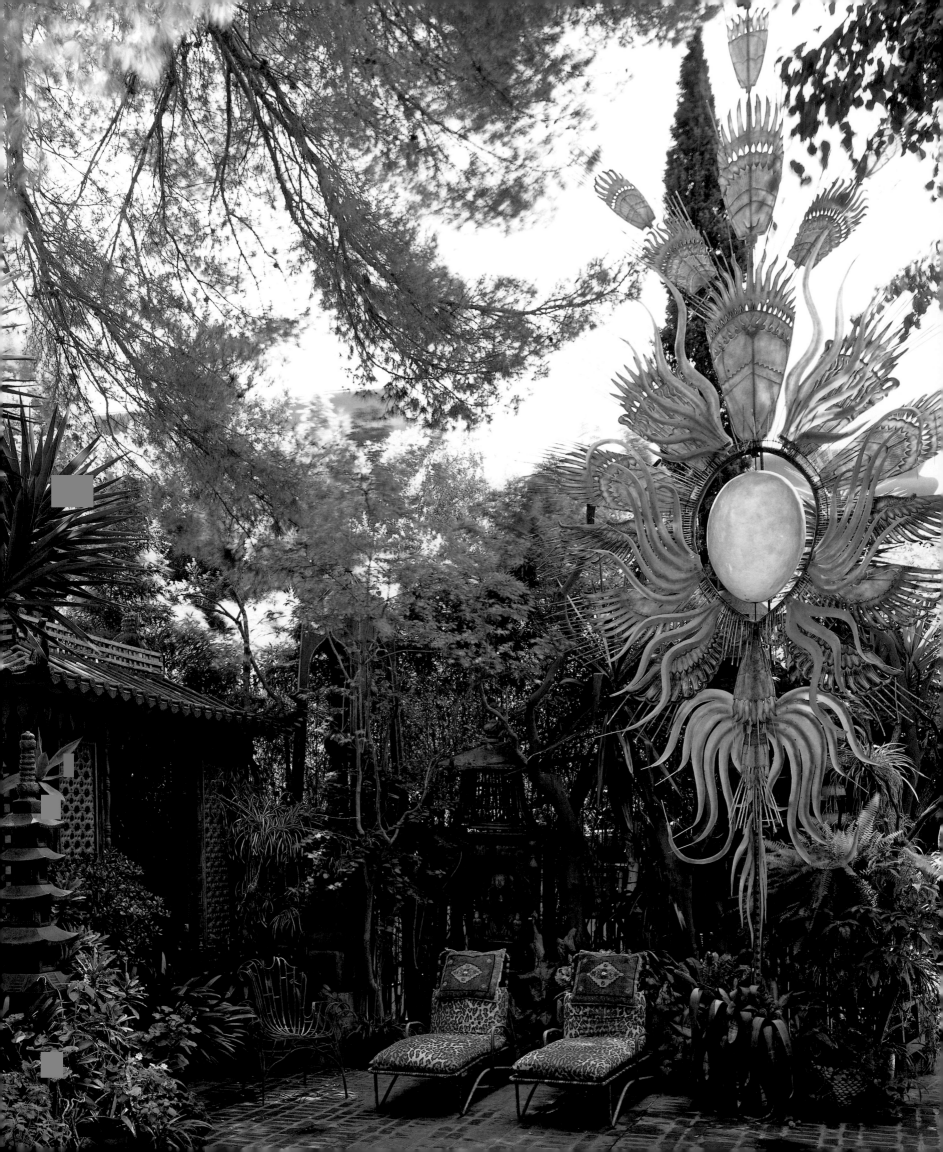

Terry Stanfill remembers her first dinner at the old studio: "It was in honor of Diana Vreeland. We were all assembled in the big room, and everyone looked dazzling in their evening gowns, jewels, and tuxedos. The butler pulled back the curtains on the stage and I had never seen anything like it. Three tables of ten with silver lamé cloths, and in the center of each was an arrangement of rock crystal, coral branches, pearls on wires, and white orchids surrounded by votive lights. The place plates were vermeil, as was the cutlery. I remember the Venetian glass goblets and the food. Tony and Beegle always served Mexican food and it was a great treat because it was all made at home. It was always so refreshing to dine there because the settings were opulent and amazing, while the food was exactly what you wouldn't expect, very simple, and very tasty."

Around the big room were various suites, including Tony's office, with its carved eighteenth-century Adam doors—a wedding present from Mary Pickford—and an enormous seventeenth-century oil painting—a wedding gift from the composer Vernon Duke (Tony had been best man at his wedding). The office was furnished with an eighteenth-century black-lacquered and ormolu-mounted French desk, chairs by Robsjohn-Gibbings, a modern sofa of Tony's design, Chinese palace carpet in beige wool with coral dragons in the corners, and a collection of eighteenth-century apothecary boxes Tony and Beegle had purchased in Verona. The walls were upholstered in burlap, and the curtains were beige linen. All of the furniture was upholstered in either rust-colored suede or black leather.

The studio also boasted a beautiful formal dining room with an eighteenth-century Austrian ceiling from the Hearst collection, from which hung an eighteenth-century Italian chandelier in crystal and gilt metal. Antique French doors found by Tony in Paris looked out on a charming walled garden decorated with old iron furniture and eighteenth-century French terra-cotta statues of sphinxes. He had acquired these statues, whose heads resembled Madame du Barry, from his friend the Baroness d'Erlanger. The dining room was large enough to include a sitting area, which boasted both an aubergine silk brocade sofa with ocelot skin draped across its back (a gift from Marlene Dietrich)—and a pair of eighteenth-century English armchairs in persimmon lacquer. On walls, between fragments of old boiserie, hung a monumental mythological eighteenth-century Gobelin tapestry, as well as seventeenth-century Venetian oil paintings, and Chinese lacquered panels; Beegle's framed paintings were displayed on lighted brass easels in the corners. The floor was spread with a leopard-pattern needlepoint rug made in Portugal to Tony's specifications; the table was always covered with a vinyl cloth in either a leopard or snakeskin pattern. Tony never invested in expensive dining room tables, since he preferred the tablecloths draped to the floor; rather, he would invest in beautiful chairs. In this case the dining chairs were antique French Louis xv frames in walnut, upholstered in cream leather that the Duquettes hand painted with amethyst-colored leopard spots.

There was also a vast double-height kitchen with a stove at its center, surmounted by a Chinoiserie-style hood with a smokestack in

PREVIOUS SPREAD
LEFT Gardens at Dawnridge

RIGHT The upper terrace at Dawnridge with Tony's twenty-eight-foot-tall *Phoenix Rising from its Flames* sculpture.

OPPOSITE Dawnridge at night with the illuminated *Phoenix Rising from its Flames*.

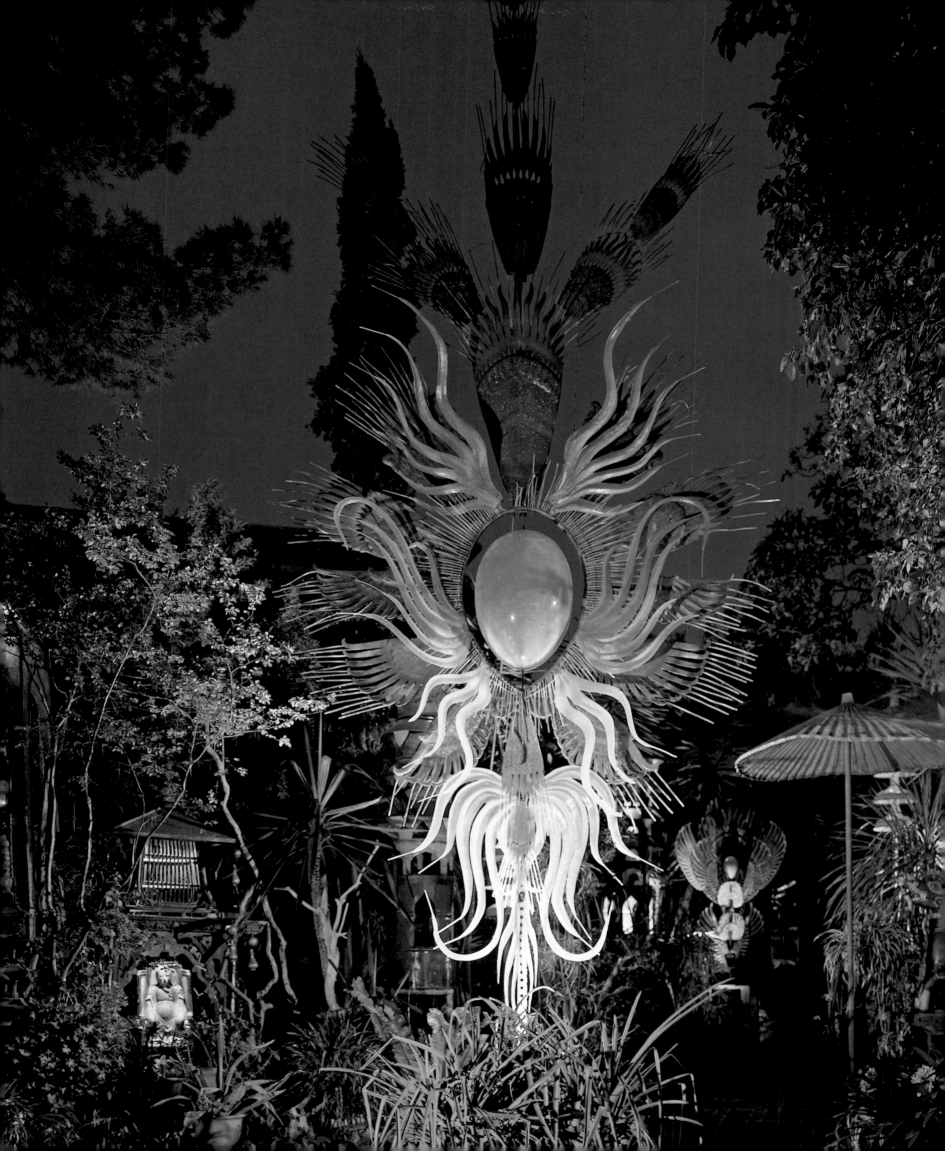

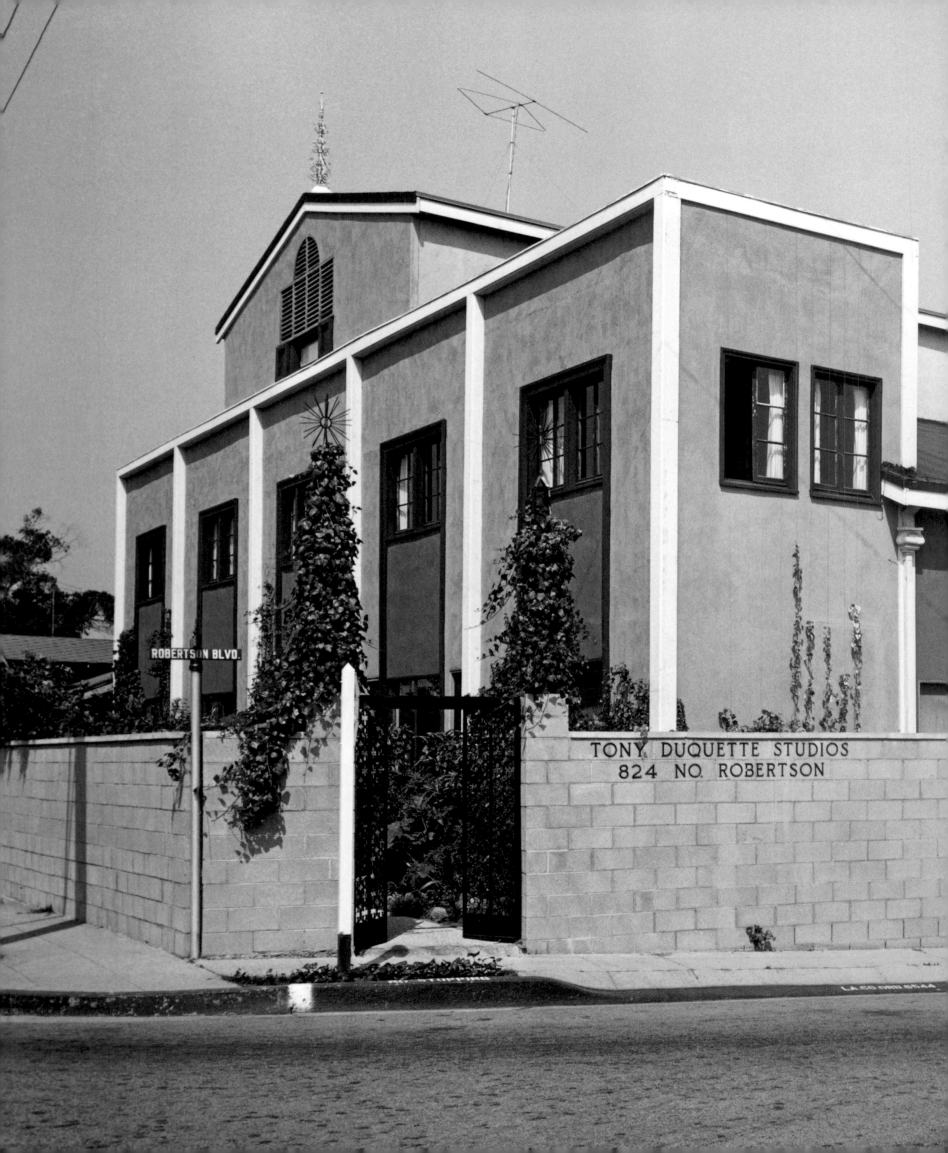

the form of a palm tree—an idea that Tony and Beegle borrowed from the Royal Pavilion at Brighton. The kitchen cabinets were crowned with blue and white Chinese porcelains, and there was a giant painted canvas—which was actually a nineteenth-century photographer's backdrop—that they brought back from Guadalajara, Mexico.

Next to the kitchen was a large, informal dining room that was sometimes used for gatherings. More often, however, it served as a catering station. Off of this room was the large studio where all the work took place, another vast, two-story room full of Tony's materials, saws and paint cans, old carvings and picture frames, work benches, tools of every description, and general chaos.

The grand staircase led to a balcony overlooking the ballroom, and off the balcony were the Duquettes' private quarters. Behind locked brocade and Fortuny-fabric-covered doors they had a beautiful apartment. Beegle and her assistant, the artist Art Fine, had marbleized the walls with *trompe l'oeil* panels in fantasy-inspired colors of marble that didn't exist in nature. The sitting room was full of treasures, as were Tony's and Beegle's separate dressing rooms and baths. Tony said that he felt their very best things should be reserved only for themselves and not displayed out in the open and shown off to friends.

In this apartment was a fourteenth-century Italian canopy bed hung with beige linen and lined in blue sateen. Hanging on the interior of the bed was a collection of antique Greek icons

PREVIOUS SPREAD The historic Tony Duquette studios on Robertson Boulevard in Los Angeles.

OPPOSITE The interior of the ballroom at the Tony Duquette studios had twenty-eight-foot ceilings.

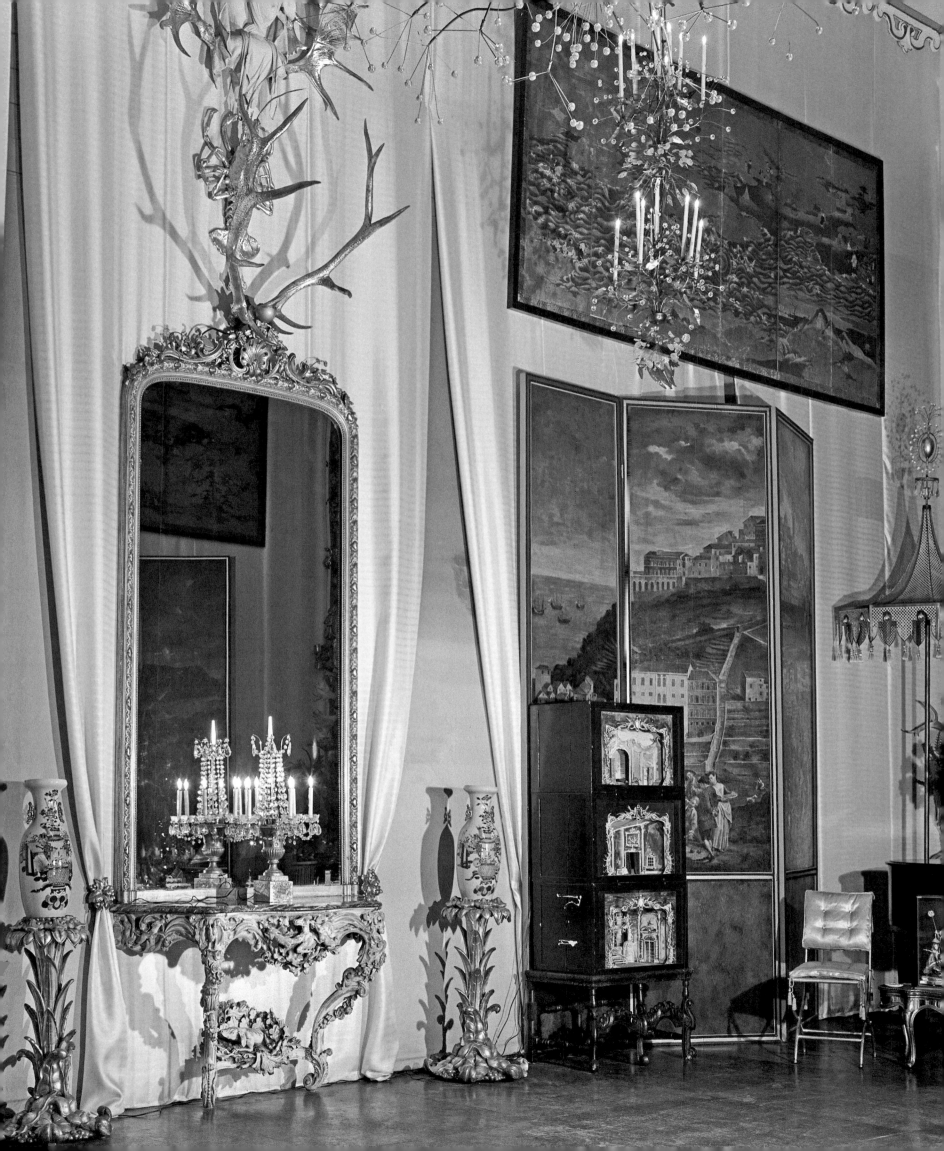

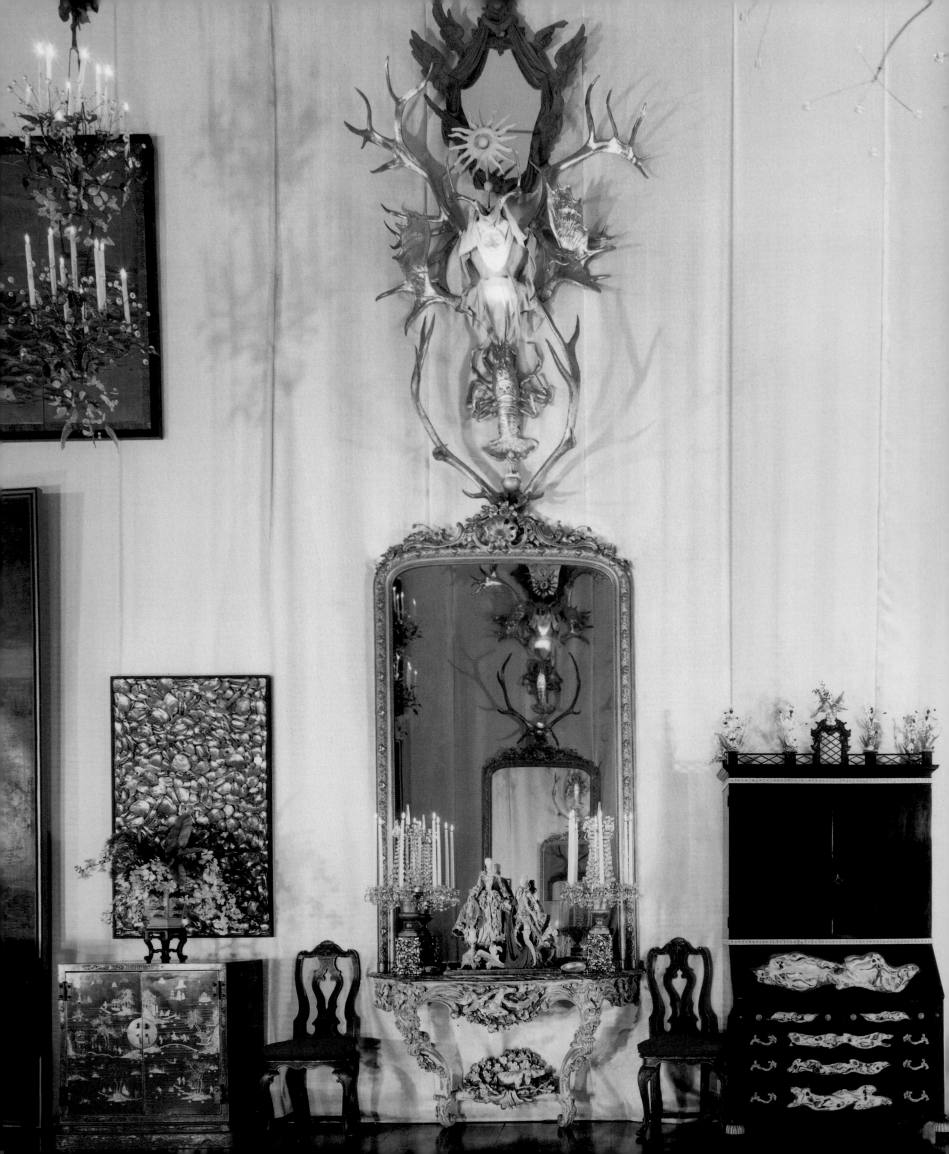

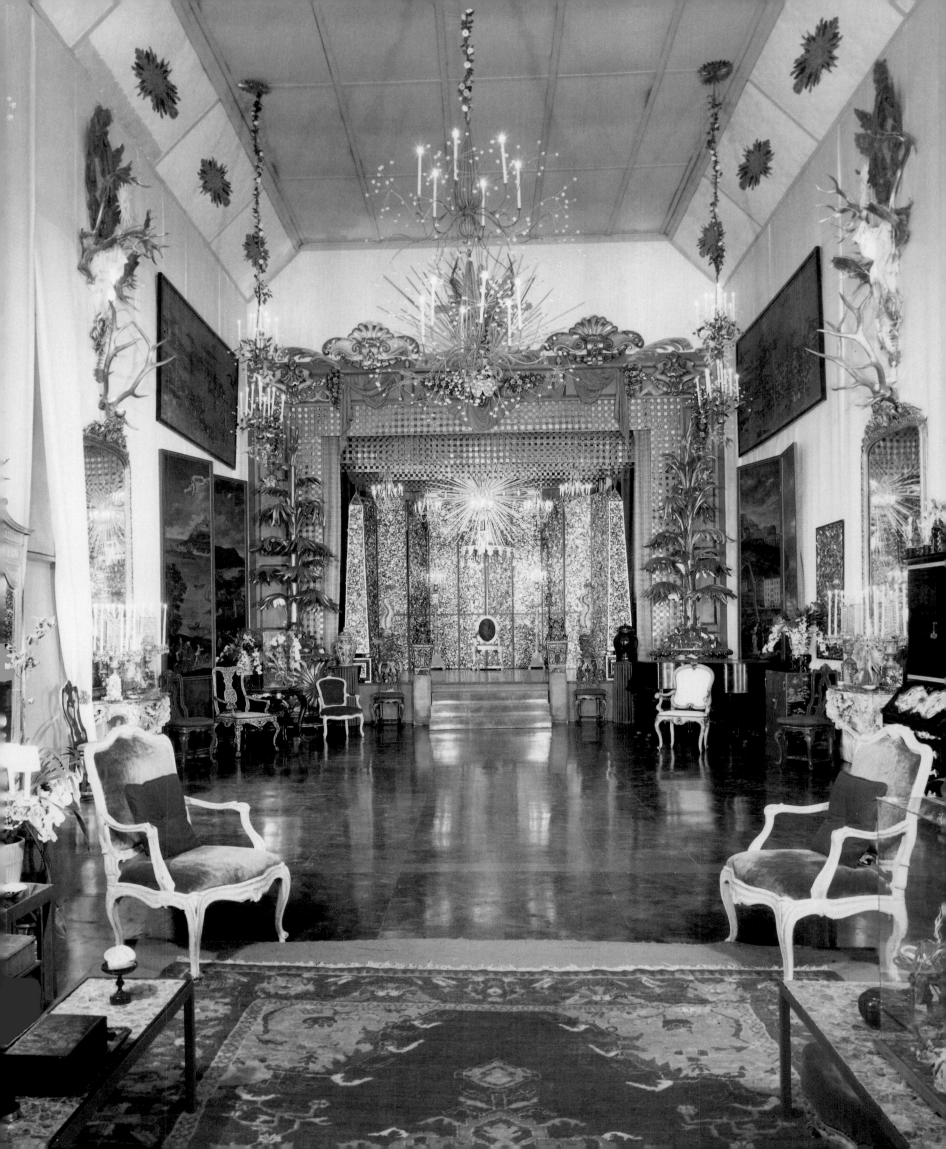

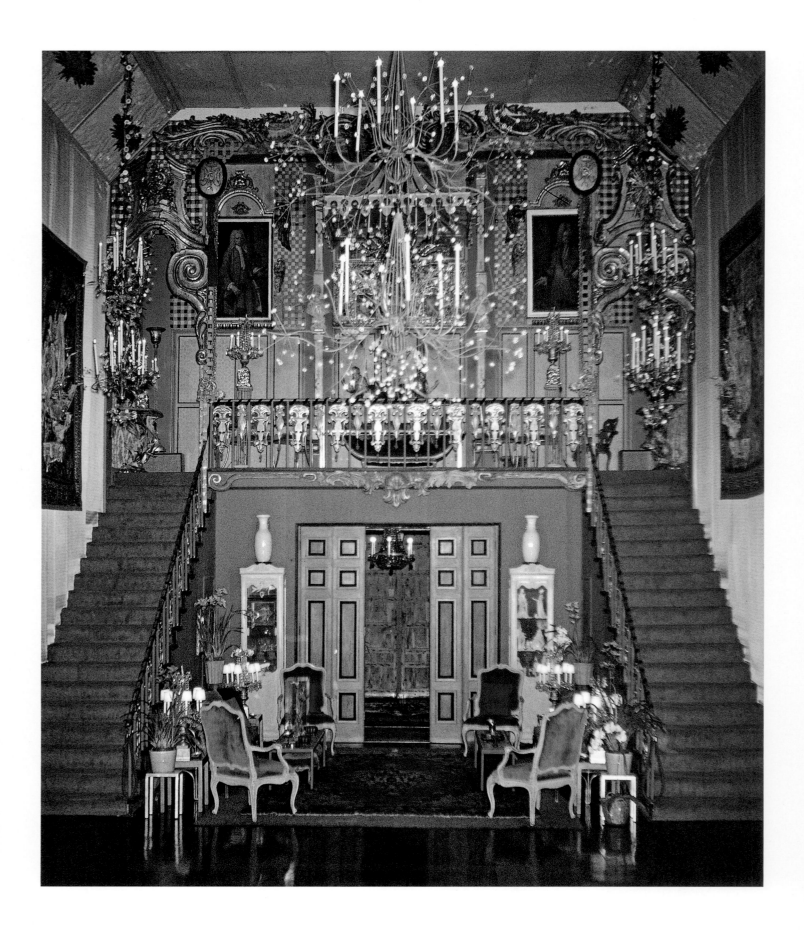

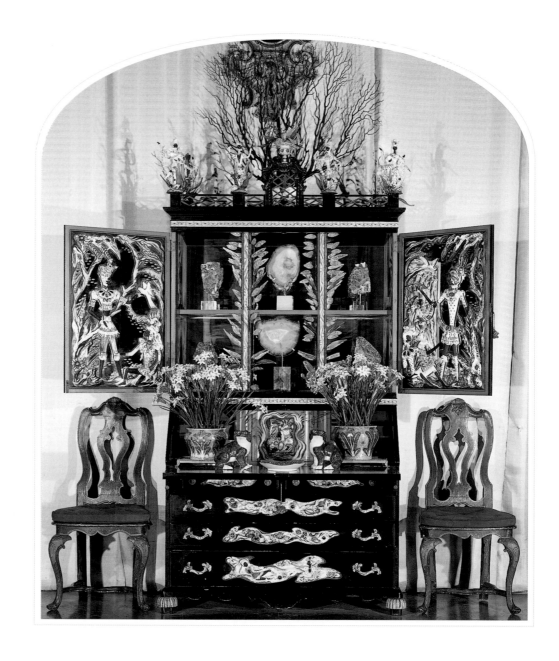

PREVIOUS SPREAD
LEFT The ballroom at the Tony Duquette studio held mirrors crowned by giant lobsters, antlers, and Tony's own "winged mirrors." On the right is the famous Elsie de Wolfe cabinet; the eighteenth-century red lacquer side chairs were a gift from Frances Elkins.

RIGHT The stage in the studio ballroom, decorated with panels of crushed abalone shell, crystal chandeliers, and a throne from the Chapultepec palace in Mexico.

OPPOSITE The staircase and balcony at the studio ballroom, which Tony created using eighteenth-century Venetian architectural fragments.

ABOVE AND OVERLEAF When Elsie de Wolfe died, she willed her "meuble" to Tony, who placed it in a prominent position in the ballroom of the Robertson Boulevard studio.

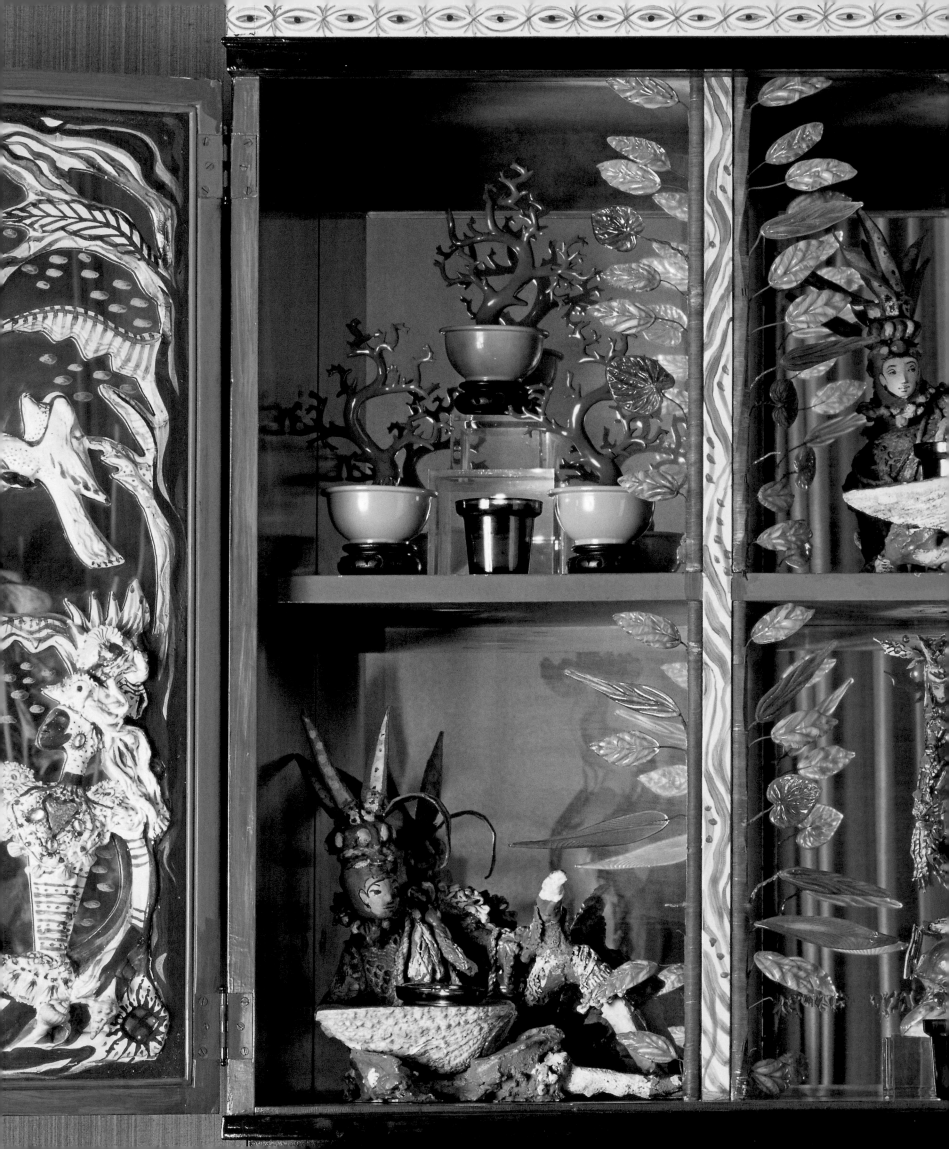

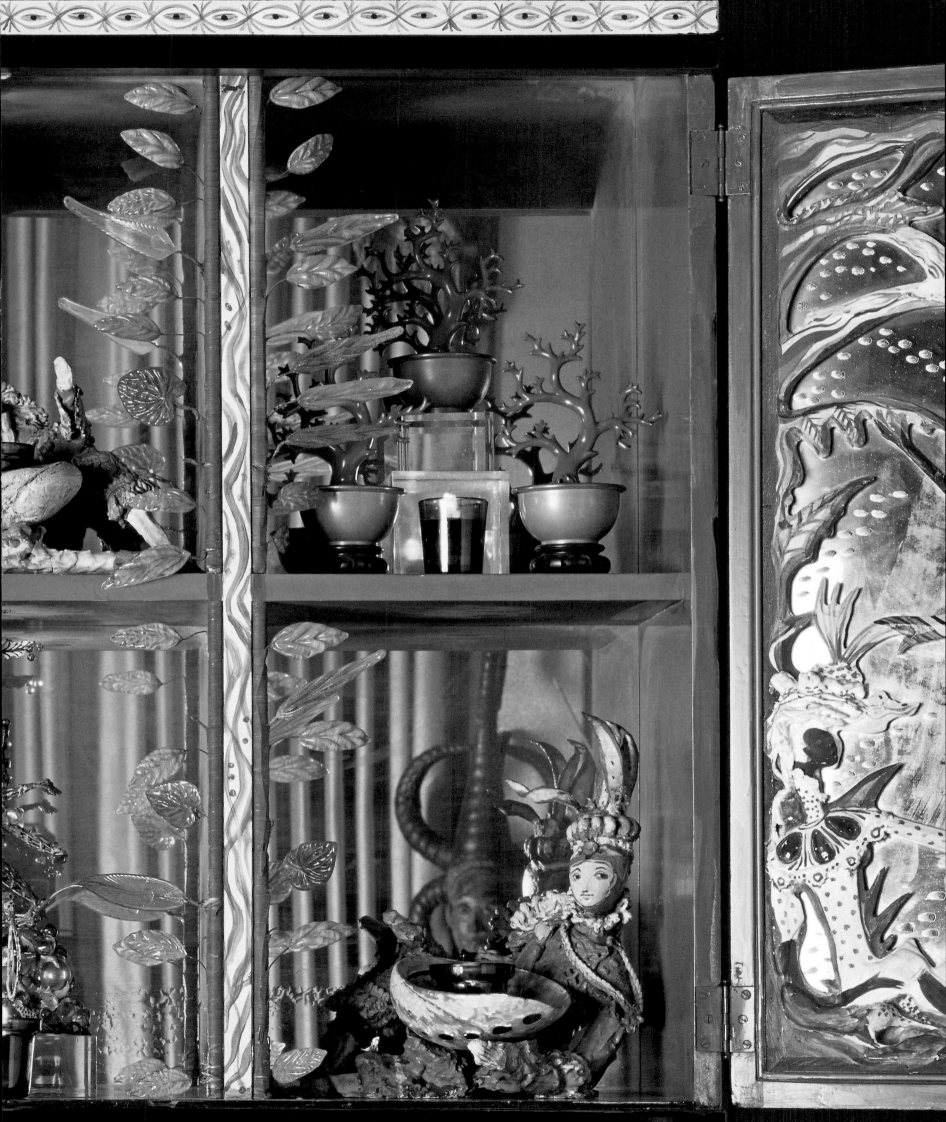

OPPOSITE Dinner for two set on a French *Régence* bureau in front of the windows in Tony's office.

OPPOSITE Gardner McKay was a frequent guest at the Duquettes' and was known to take his pet cheetah with him everywhere. Here, a typical night at the Duquettes' with Sue Vidor and Peter Paanakker sharing the sofa.

OVERLEAF The first home Tony built on his Malibu ranch, "Hamster House," using a 1920s mobile home as the base, 1950s.

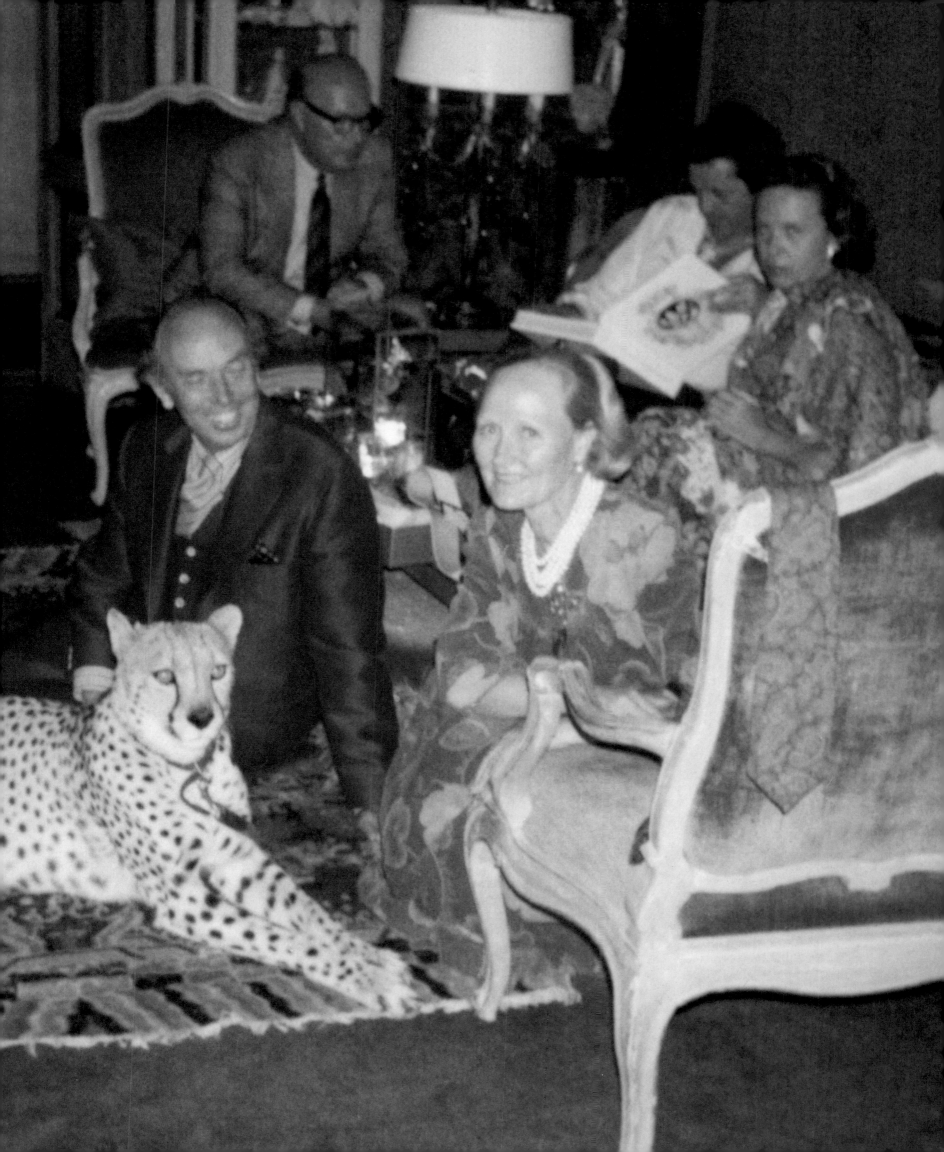

and an eighteenth-century Venetian traveling altar holding a Madonna. The bedroom was decorated with a painted eighteenth-century Venetian secretary, Louis XVI *bergères* with their original Aubusson coverings, paintings, bibelots, rare porcelains, and various *objets d'art*. The bathrooms were finished with blue-and-white Portuguese tiles and the dressing rooms hung with antique batiks and embroidered silks. Beegle's dressing room was Dresden blue with European furnishings. At its center was a Biedermeier armoire with glass doors, which held her jewels—not jewels in jewel boxes, but rather a display of jewels laid out on stands and velvet-leaved trees. Tony's dressing room was furnished with Georgian mahogany cabinets and chests, and his clothes were kept in an enormous armoire that he commissioned Art Fine to paint so as to resemble a large-scale Palladian dollhouse.

Behind Tony's dressing room, Beegle had a small book-lined study and a large skylit painting studio. The study was decorated with a grand eighteenth-century English partners desk piled high with books and manuscripts, a tiny eighteenth-century canopied bed hung in printed Indian cottons, Victorian easy chairs, and a collection of antique toys scattered across the tops of the bookshelves. The painting studio, which was strictly off-limits to uninvited workers or visitors, was piled with finished canvases stacked against the walls, and easels, which sometimes held two or three works in progress. This was Beegle's retreat, where she could be left entirely alone with her paints, books, and the cigarettes of which Tony did not approve.

Next to Beegle's studio was the costume closet, which was filled with masses of clothing from every century and country. Clothes by Worth, Adrian, and Poiret hung side by side; then

came native costumes from Bolivia, Austria, Greece, China, and Japan. And then came the theatrical costumes, some by Tony, some purchased at the MGM sale, including elaborate military uniforms of every description. But that was not all. The closets also contained boxes of lace, boxes of feathers, hats, jeweled buckles, shoes (from every period and country), Indian saris, Chinese tribute silks, cut velvets, fur coats (of every size and variety), handbags, and trunks of Chinese jewelry and costume jewelry. It was like Ali Baba's cave.

With museum exhibitions, the opening of the new studio, work for Vincente Minnelli at MGM, and decorating jobs for private and commercial customers pouring in, the Duquettes felt that they needed an escape from the pressures of work. They were offered the "farmer's house" at the Malibu ranch of Ann Chamberlain, who was a dear friend of long standing. Tony and Beegle took the ramshackle old house, which sat in a field high above the Pacific Ocean, and transformed it into an enchanting country retreat, using their collections of Victoriana and folk art as decoration.

The farmer's house was a triumph, and Tony and Beegle reveled in their weekends in the country. Dressed as country folk, they invited their friends out for lunch, and everyone thought they had found paradise in the remote hills just one hour north of Los Angeles.

Unfortunately, their landlady also thought it was too charming for words, because she decided that she would rather live in the newly Duquette-restored farmer's house than in her

OPPOSITE A garden pagoda at Hamster House fashioned from an old elevator cage salvaged from the demolition of the Hollywood Hotel.

OVERLEAF Sortelegium, looking toward Boney Mountain with Duquette's wire-spool pagodas, flying gemini banners, and his greenhouse, named "Bosphorus," in the center.

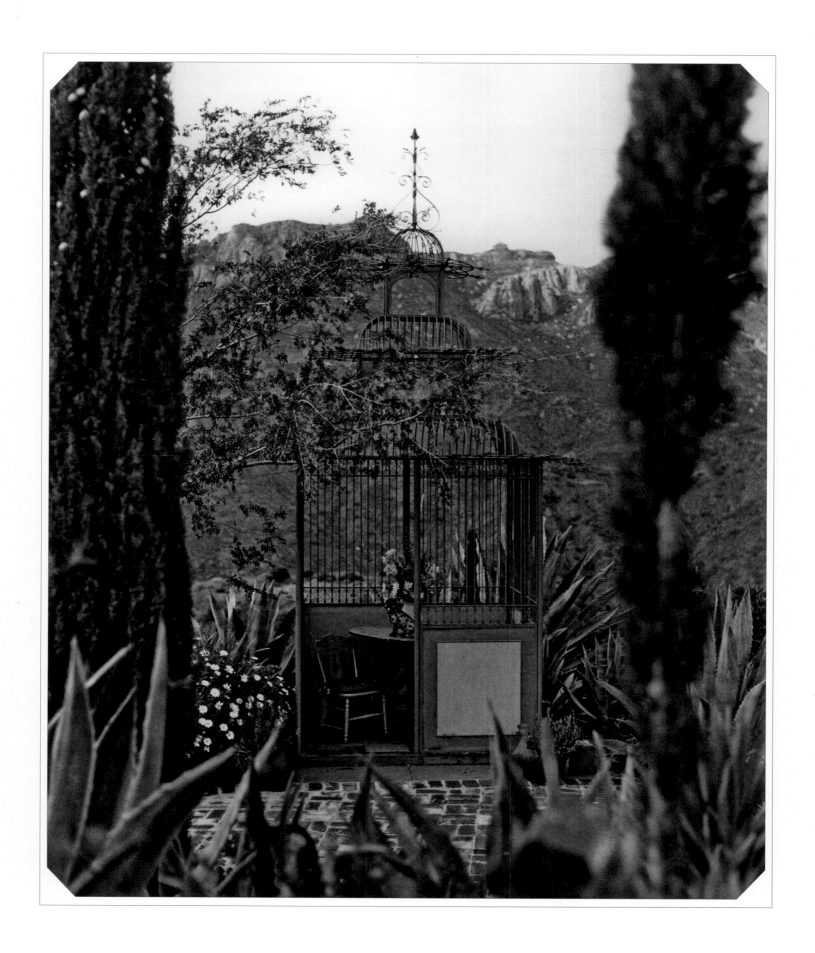

243

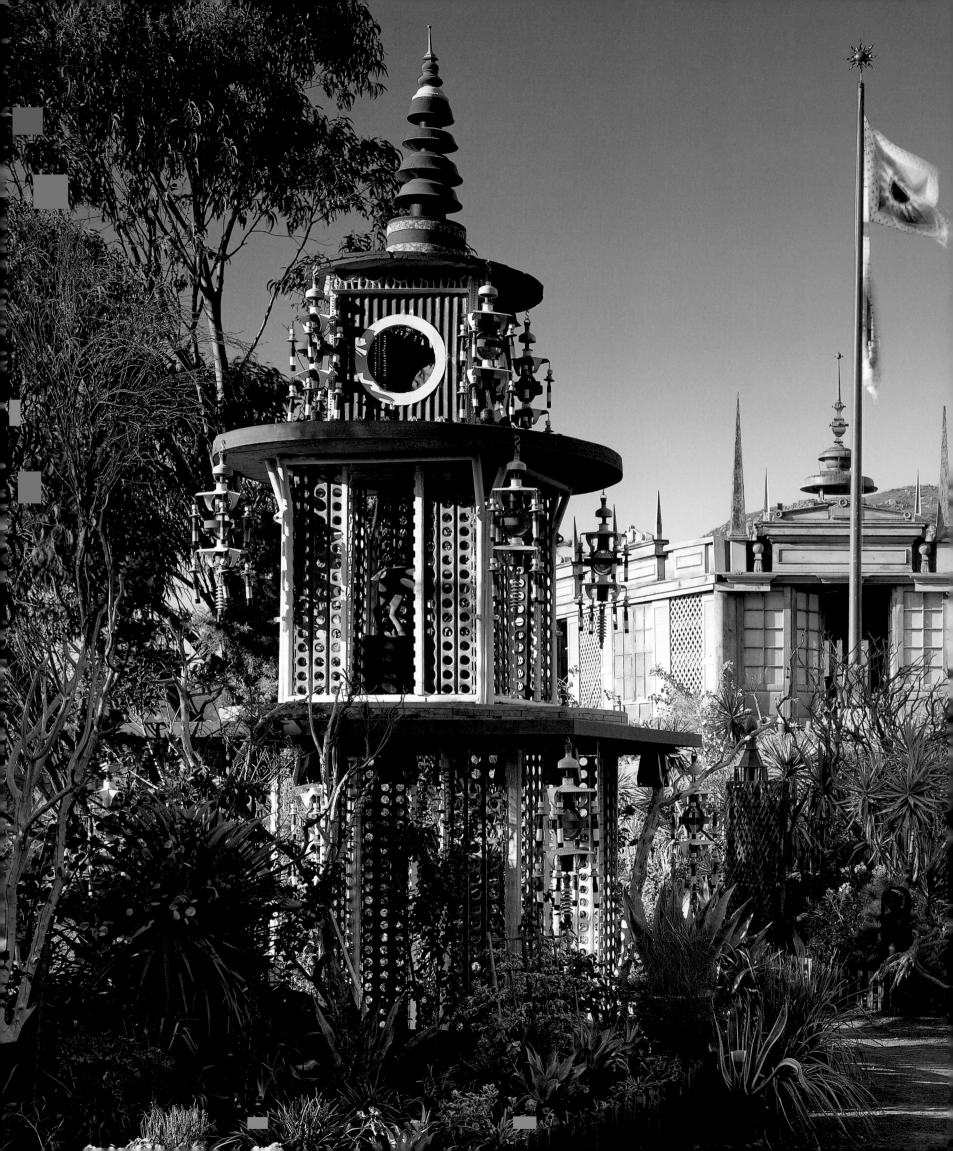

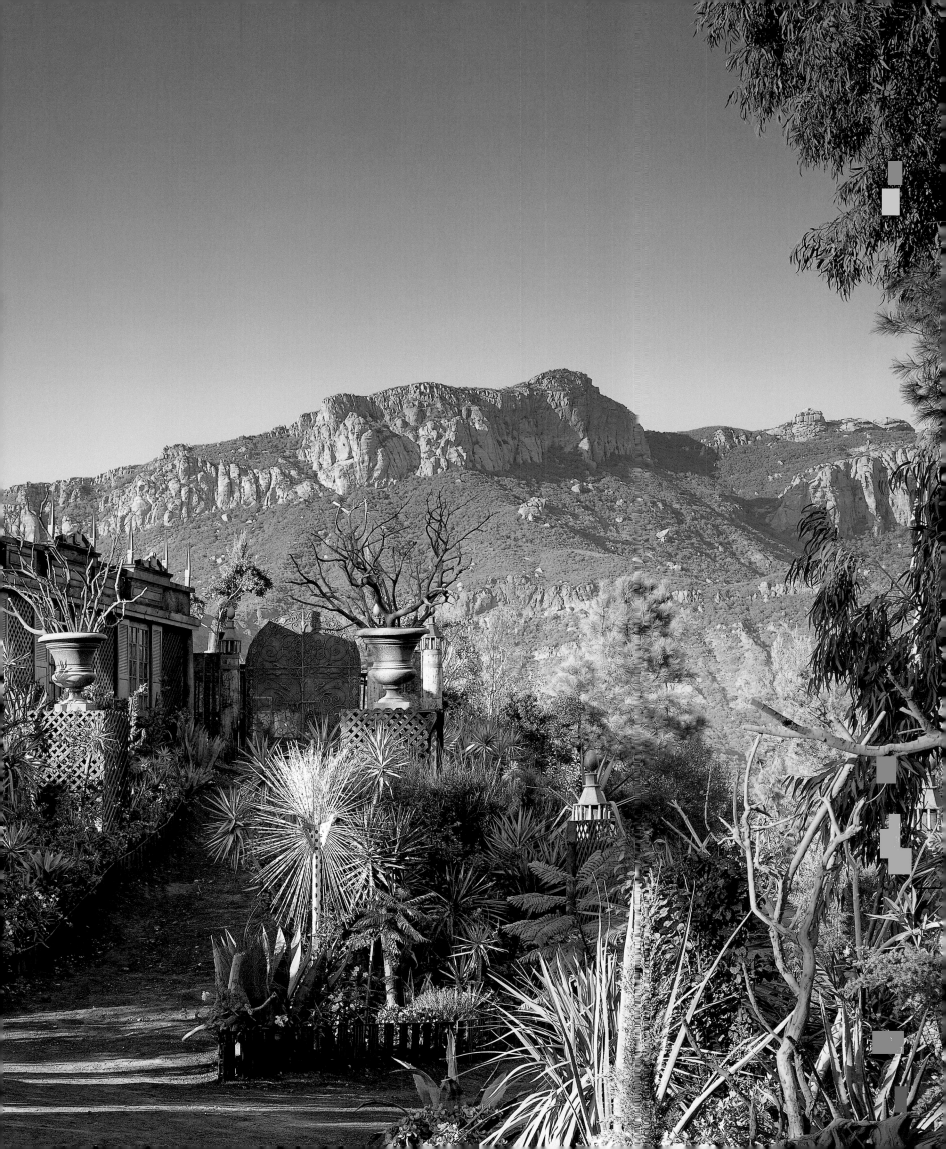

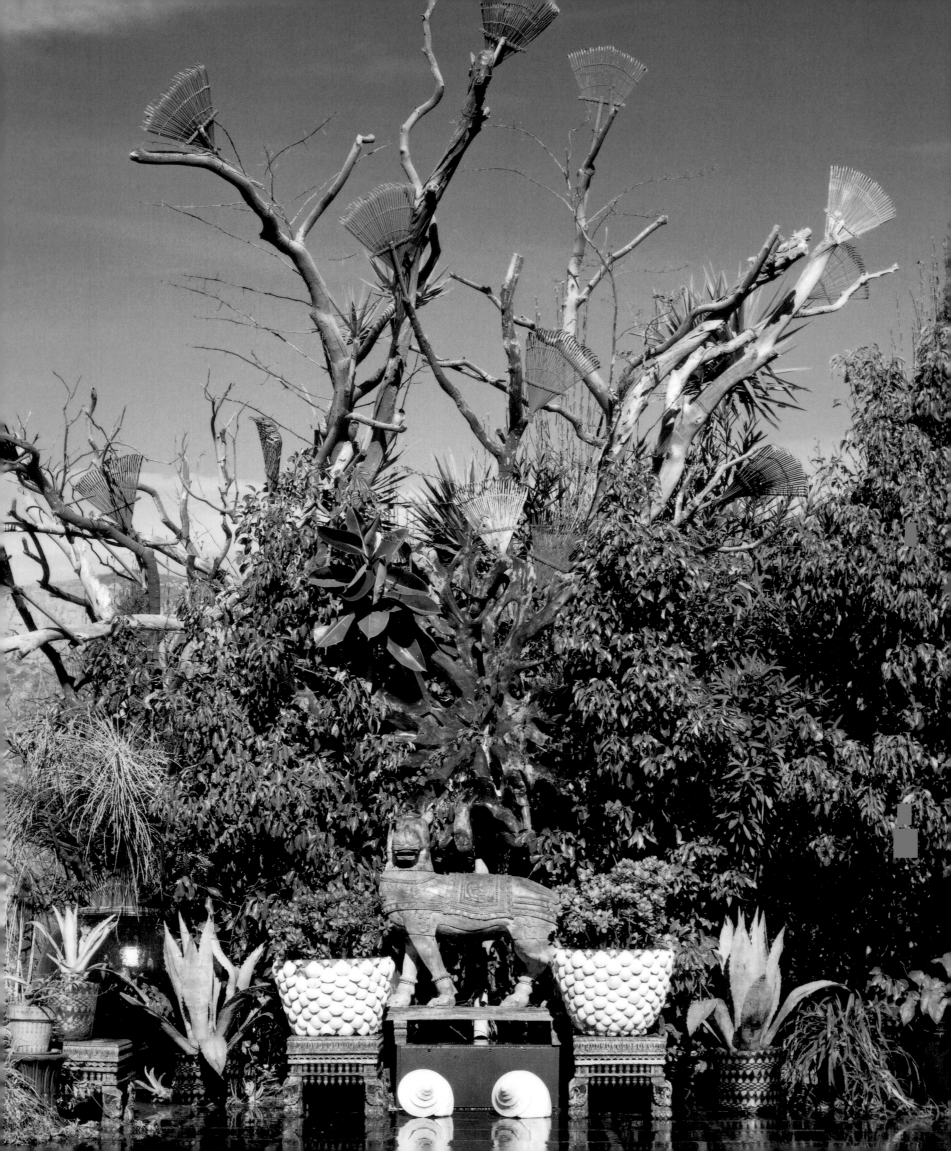

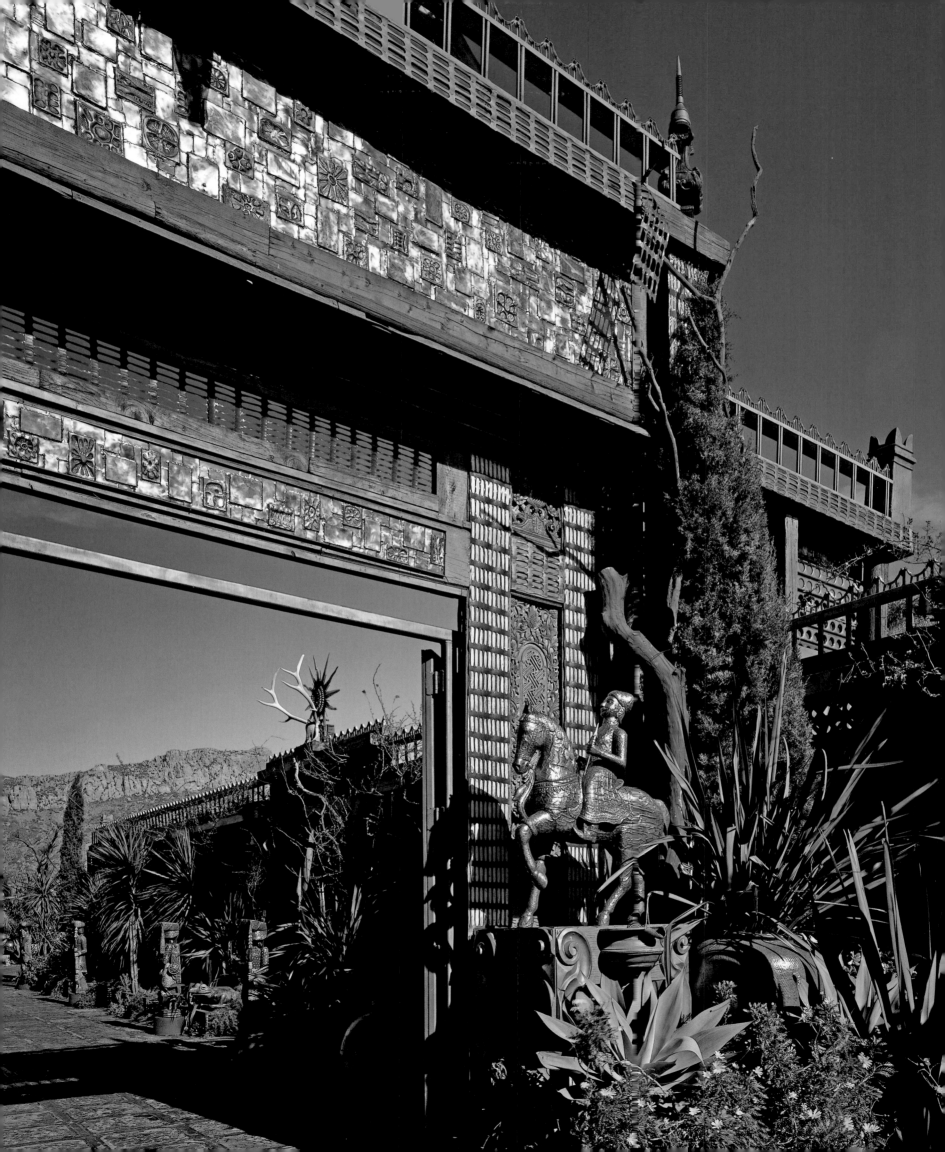

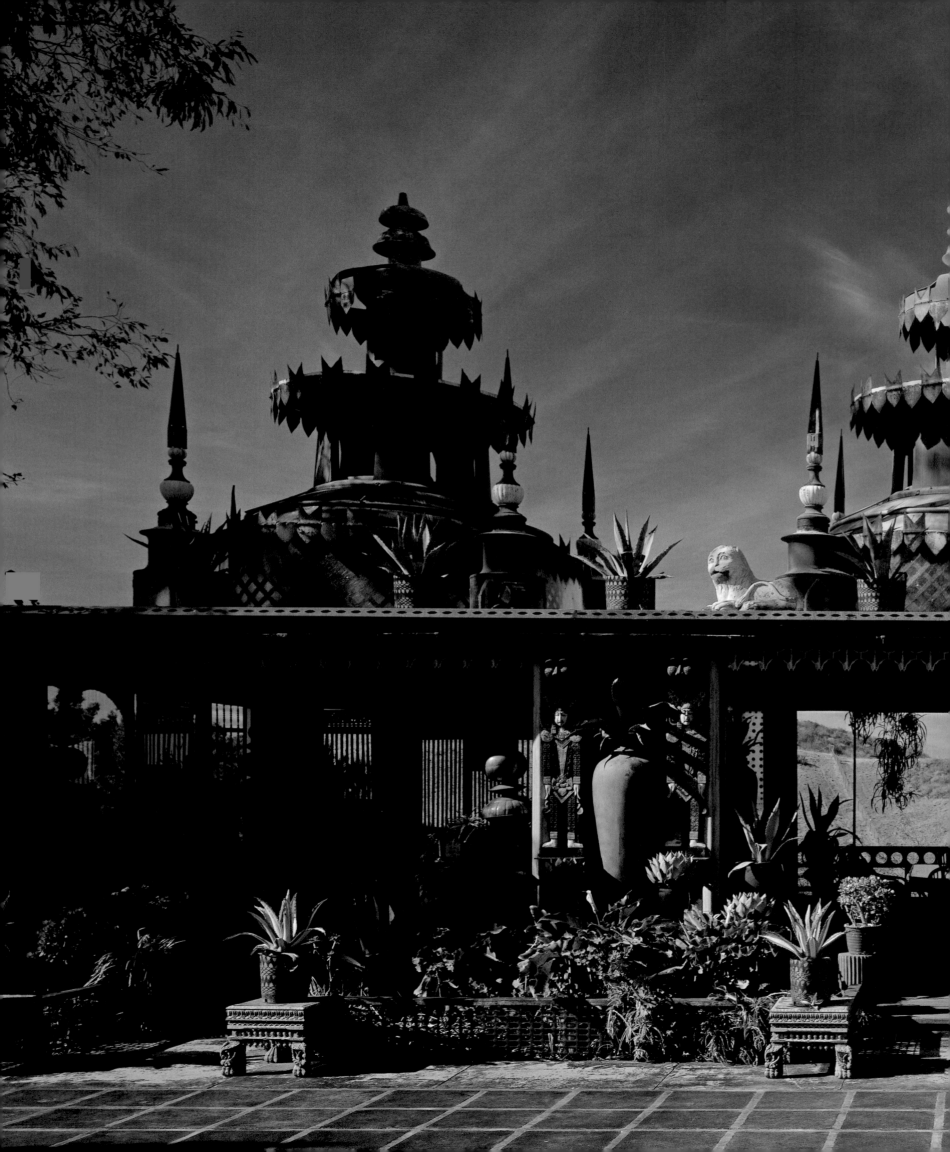

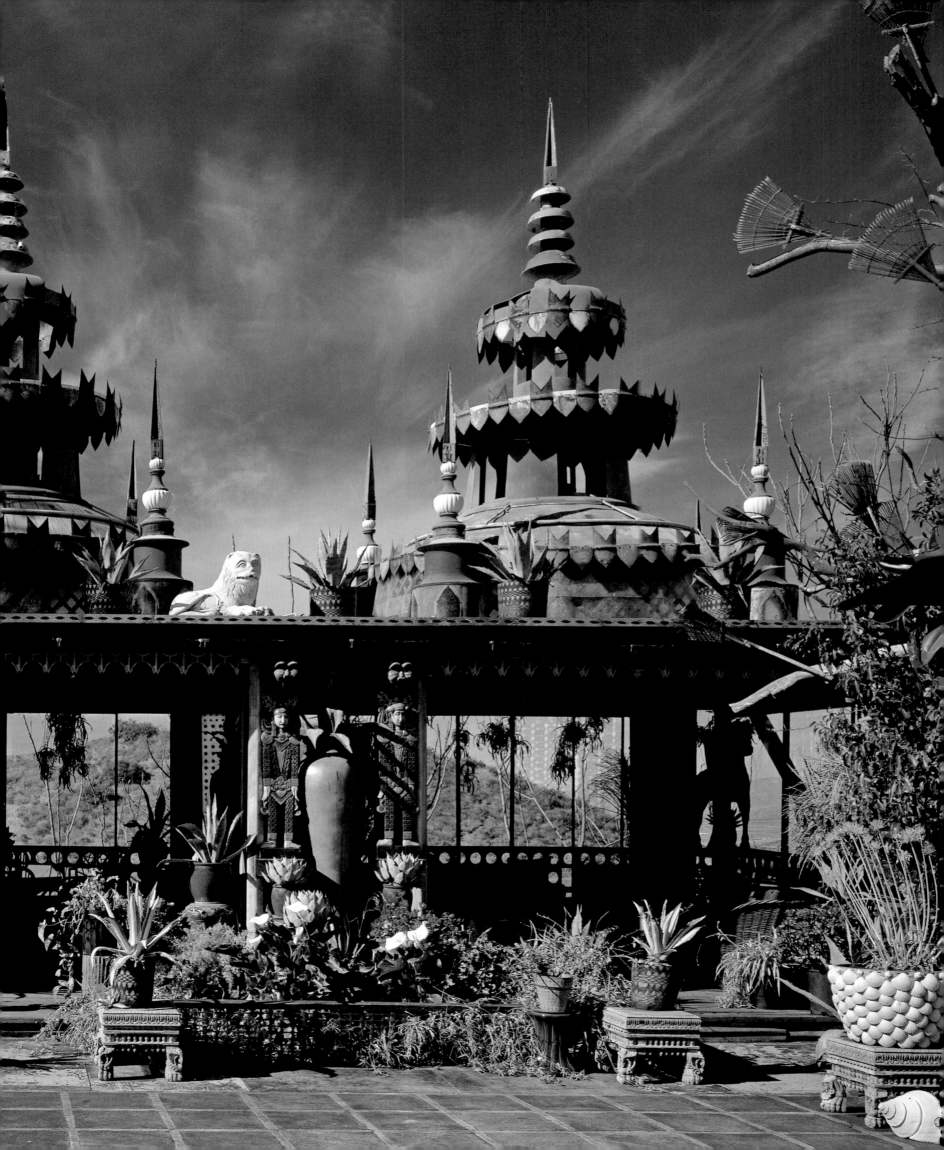

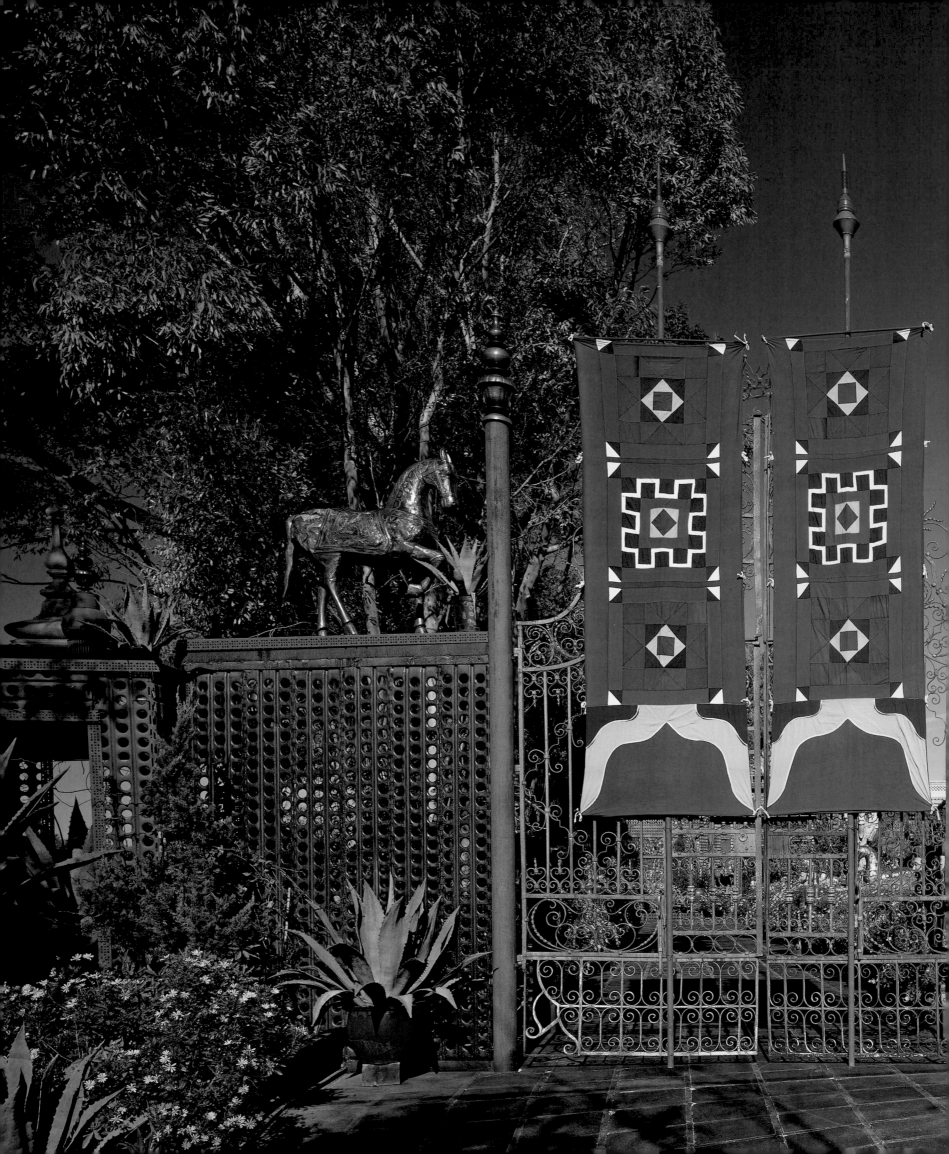

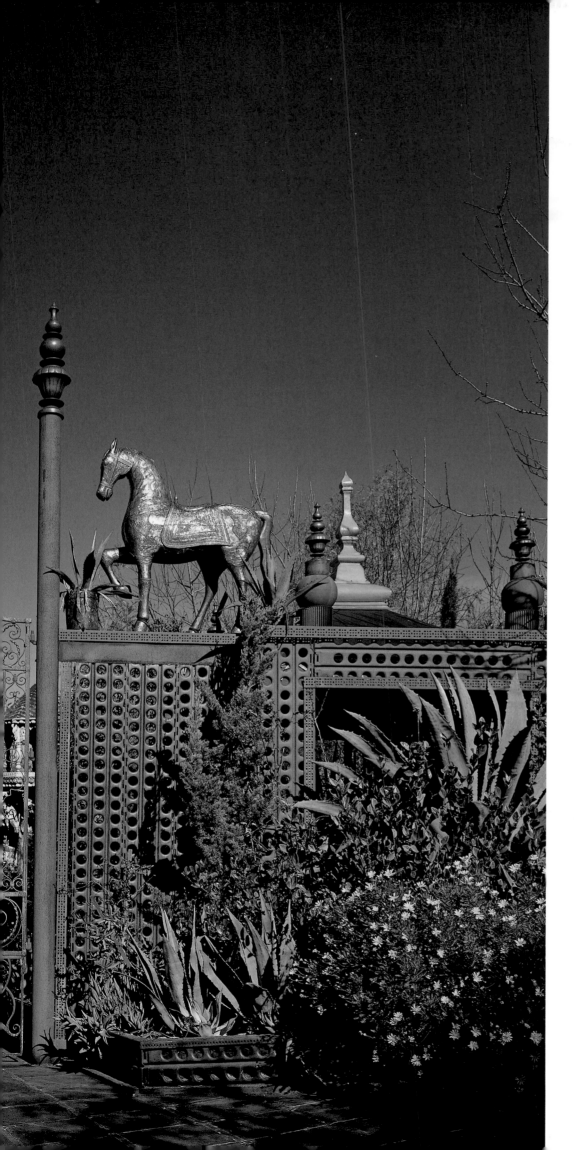

PREVIOUS SPREAD
LEFT A Duquette tree sculpture made with garden rakes.

RIGHT The entrance to Duquette's new design kingdom at the Wilkinson guest house. Duquette built this architectural pastiche after the fire on the Wilkinson property.

OPPOSITE A Duquette-designed gate with precious and mundane recycled objects.

OVERLEAF LEFT The entrance to Frogmore House with its three-story lattice pagoda. The original house was a twenty-by-twenty-foot metal shed which had been thrown out on Santa Monica Boulevard in Hollywood.

OVERLEAF RIGHT Sortelegium with Boney Mountain in the background with Tony's antique Venetian gondola placed on the roof.

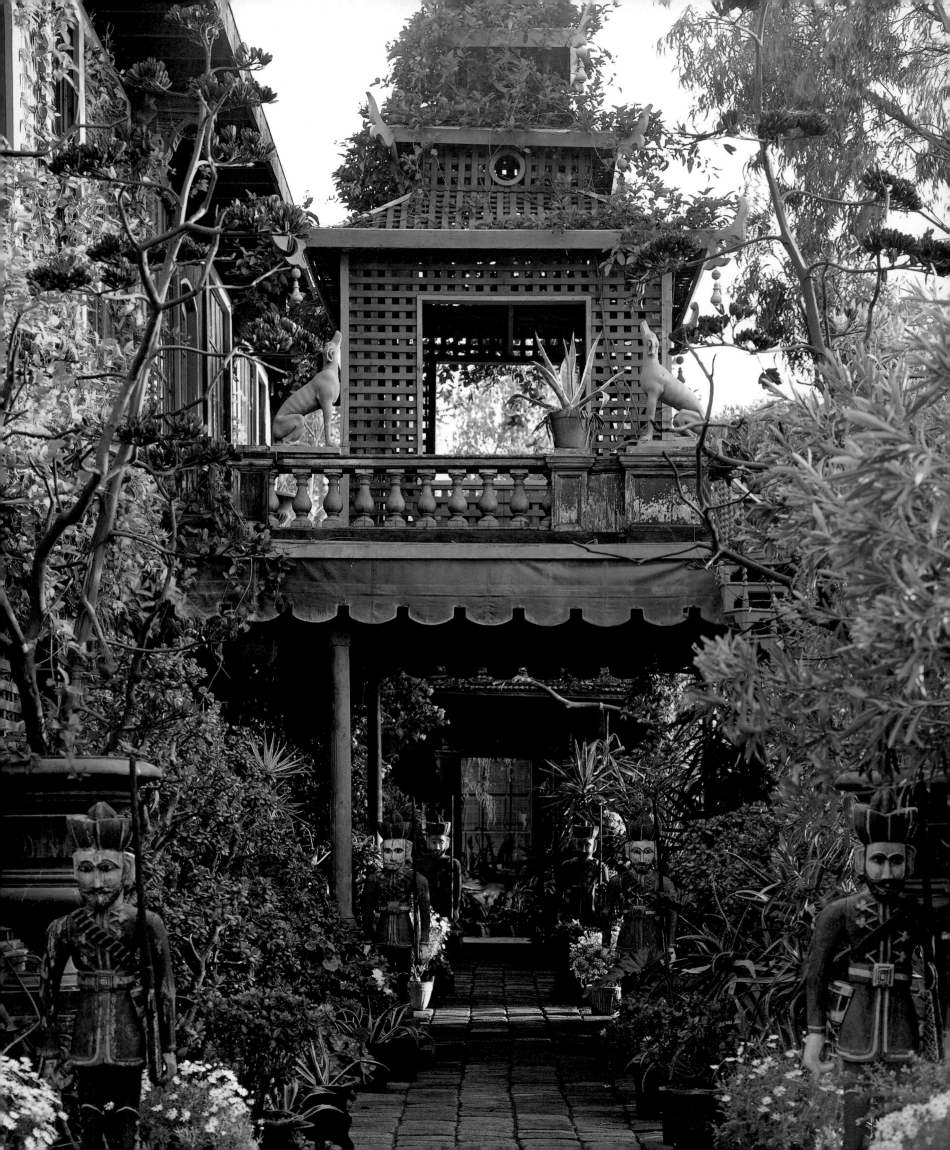

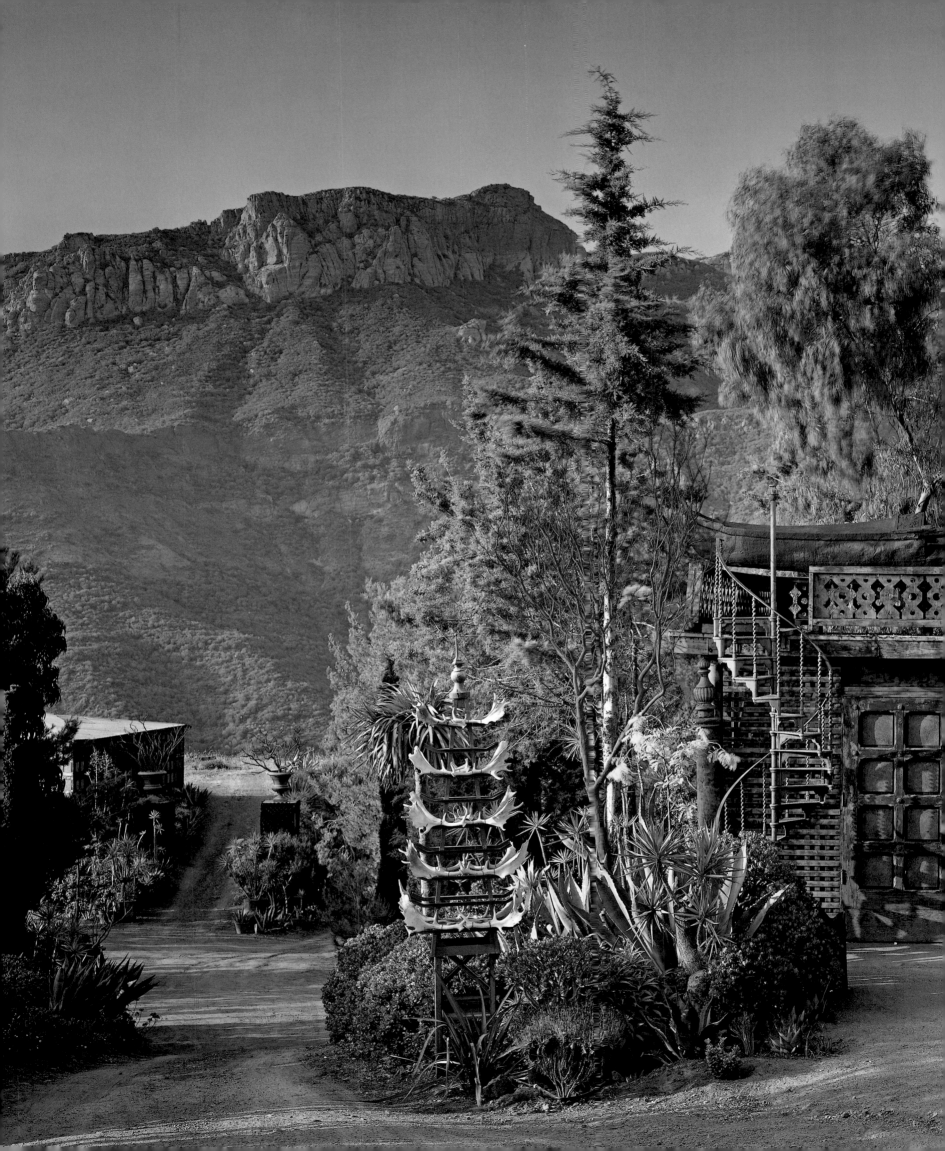

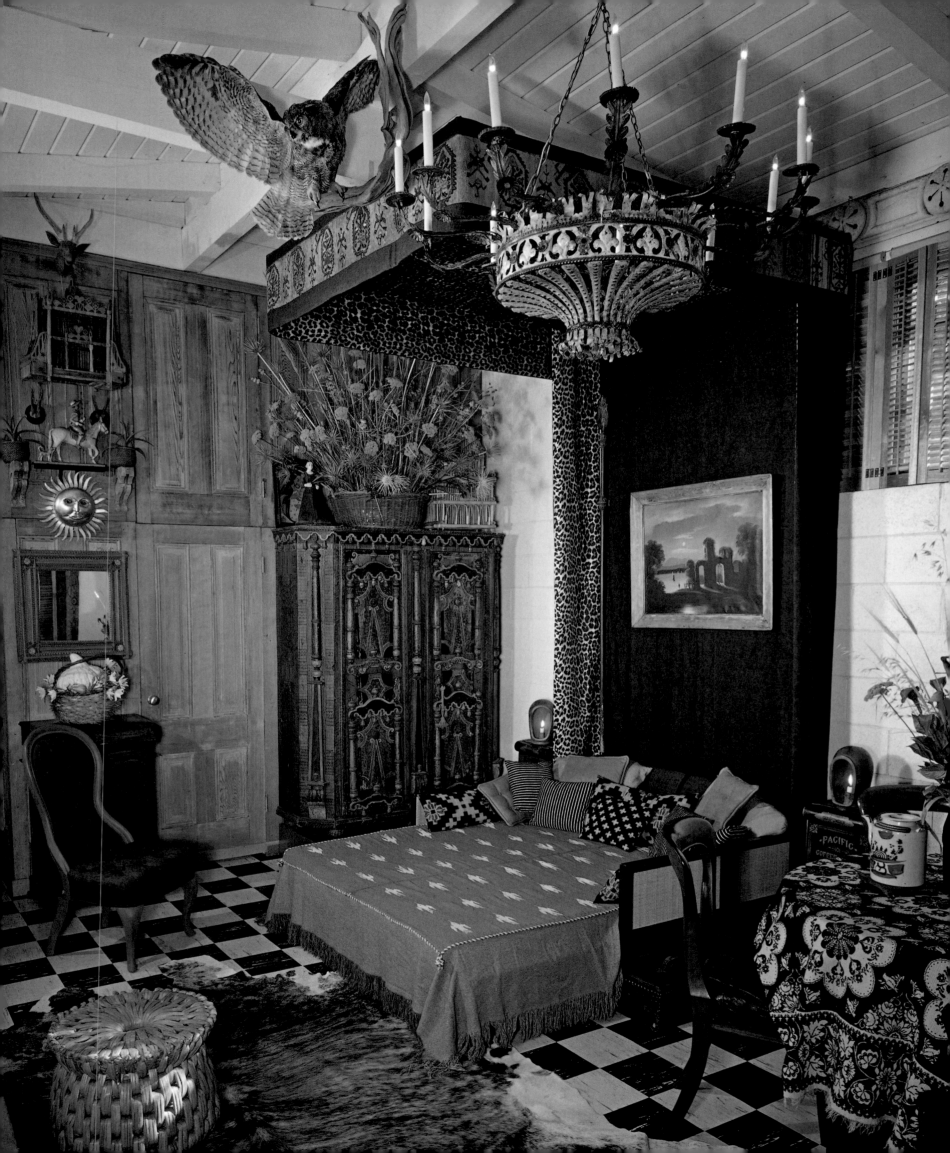

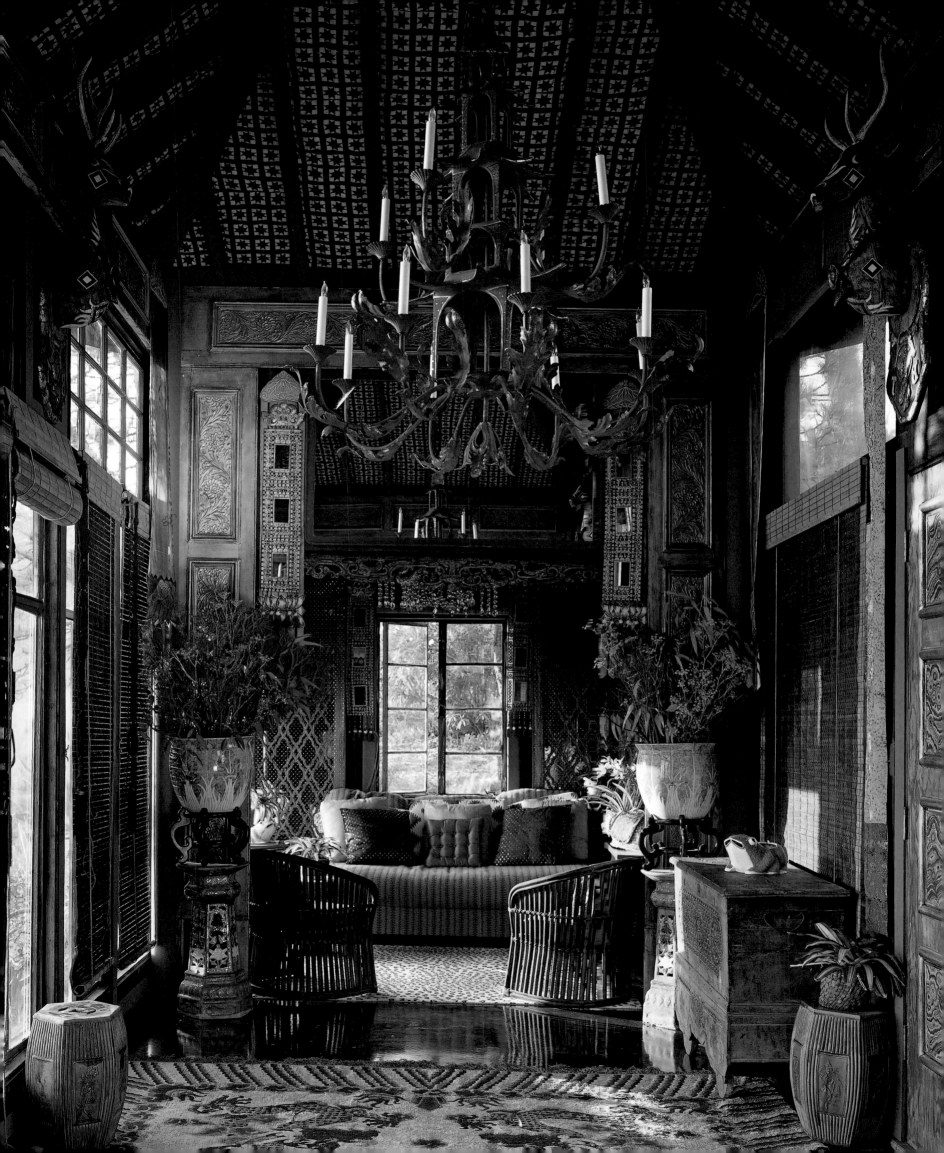

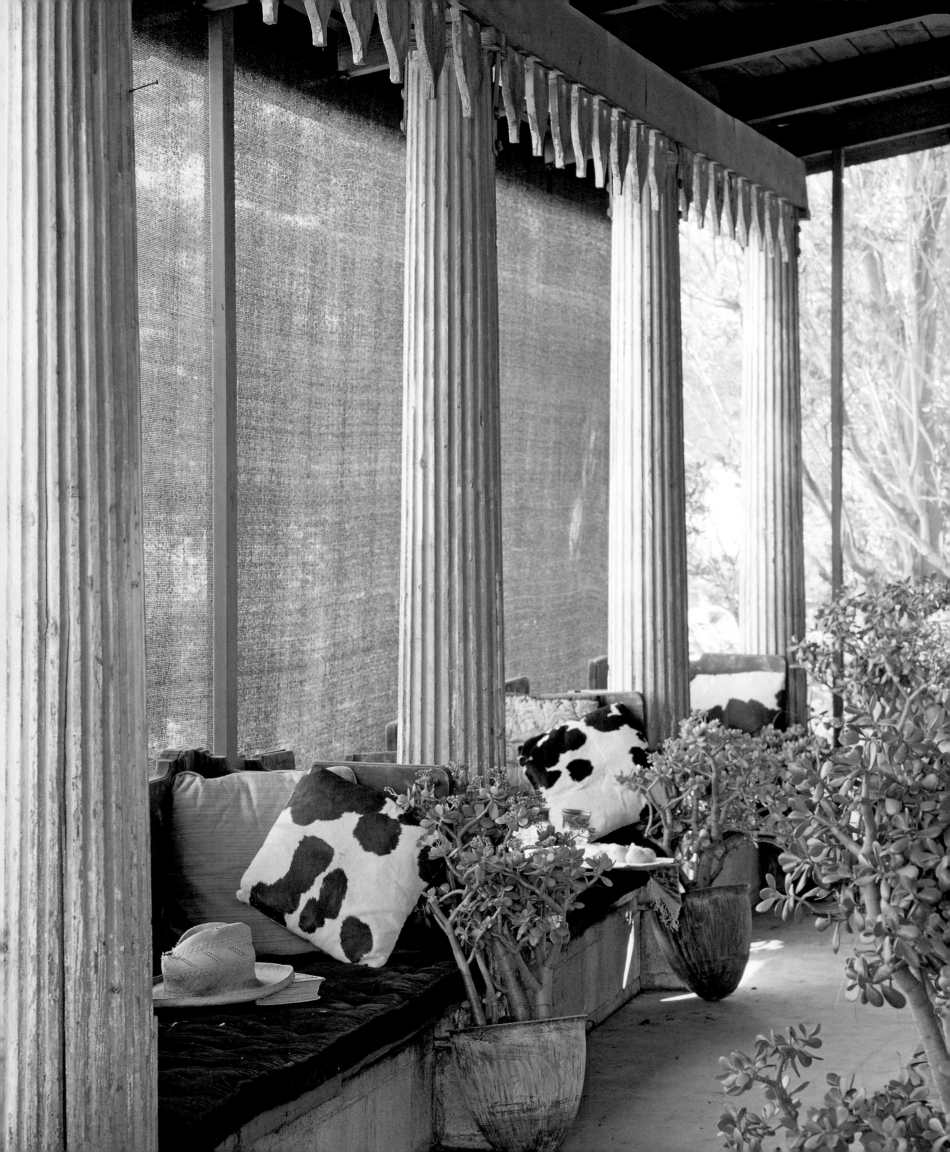

Lyle Wheeler–designed ranch house (Lyle Wheeler was the Academy Award–winning head of the 20th Century Fox Art Department). Tony and Beegle were crushed at what they considered a betrayal of friendship, and as he would often say, "I was so outraged . . . I went right out and discovered who owned all the land around the neighborhood and bought as much as I could." That turned out to be 150 acres, on which he would commence building his own "empire."

Tony did not stay mad at Ann Chamberlain for long. He actually thanked her for forcing him to go out and buy his own land. "I am just a little French peasant; the land means everything to me," he would always say.

At the "empire," which Tony later called Sortilegium, he built a total of twenty-one structures, each one based on a different theme. To erect his fantasy houses he collected architectural fragments, Georgian shop fronts from Dublin, Chinese roofs, columns, doors, windows, bathtubs, pavilions, mobile homes, backs of trucks, old windows, and much more. Each house had a different name, and they were all fascinating.

There was China, inspired by a wonderful beam Tony had found in a wrecking yard that he just had to build a house around; it was furnished and trimmed with red and gold Chinese carvings and furniture. The bathroom was famous for both its amazing antique bathtub, which had come from the old Brant ranch in the San Fernando Valley,

and its stained-glass windows, which Tony had rescued from Bunker Hill, the opulent Los Angeles Victorian neighborhood, now destroyed. There was Ireland, a 1920s mobile home with an antique Irish Regency shop front—which Tony had purchased in Dublin around the time he decorated Barretstown Castle for Elizabeth Arden—installed as its facade.

The Bullocks' Wilshire house was a streamlined modern mobile home filled with Art Deco and modern furniture. Just outside was a large iron cage, where Tony's niece Alex kept her pet tiger. Tony also kept peacocks, golden pheasant, cats, dogs, and songbirds at the ranch—and a pet cow named Beaumont that would dance every time Tony came by its corral. All of these creatures inhabited Tony's world.

At the top of the hill was a guest house named Horn Toad, which had a kitchen installed with an antique Regency sideboard; windows from John Gilbert's and Greta Garbo's bedroom installed in a room that was made out of the back of a moving van; and a canopy bed hung in blue denim and Gobelin tapestry, with a stuffed owl perched on top.

Hamster House was Tony and Beegle's own place. To what had originally been a small mobile home, they added on a large, high-ceilinged room with a black-and-white-checked floor and brought in their collection of Austrian peasant furniture, which they had acquired while doing *Jederman* (*Everyman*) for the Salzburg Festival, plus masses of white daisies. On visiting Hamster House for the first time, the couturier Gustave Tassell recalls having the most marvelous time admiring the charming house—every inch of which had been marbleized, upholstered, mirrored, and tasseled—and enjoying the good food and wine.

PREVIOUS SPREAD
LEFT The master bedroom at Sortilegium.

RIGHT The tea house at Sortilegium, Tony and Beegle's 150-acre Malibu ranch. Tony covered the area between the ceiling beams with quilted bedspread fabric.

OPPOSITE The front porch at Horntoad, Tony and Beegle's first guest house at Sortilegium.

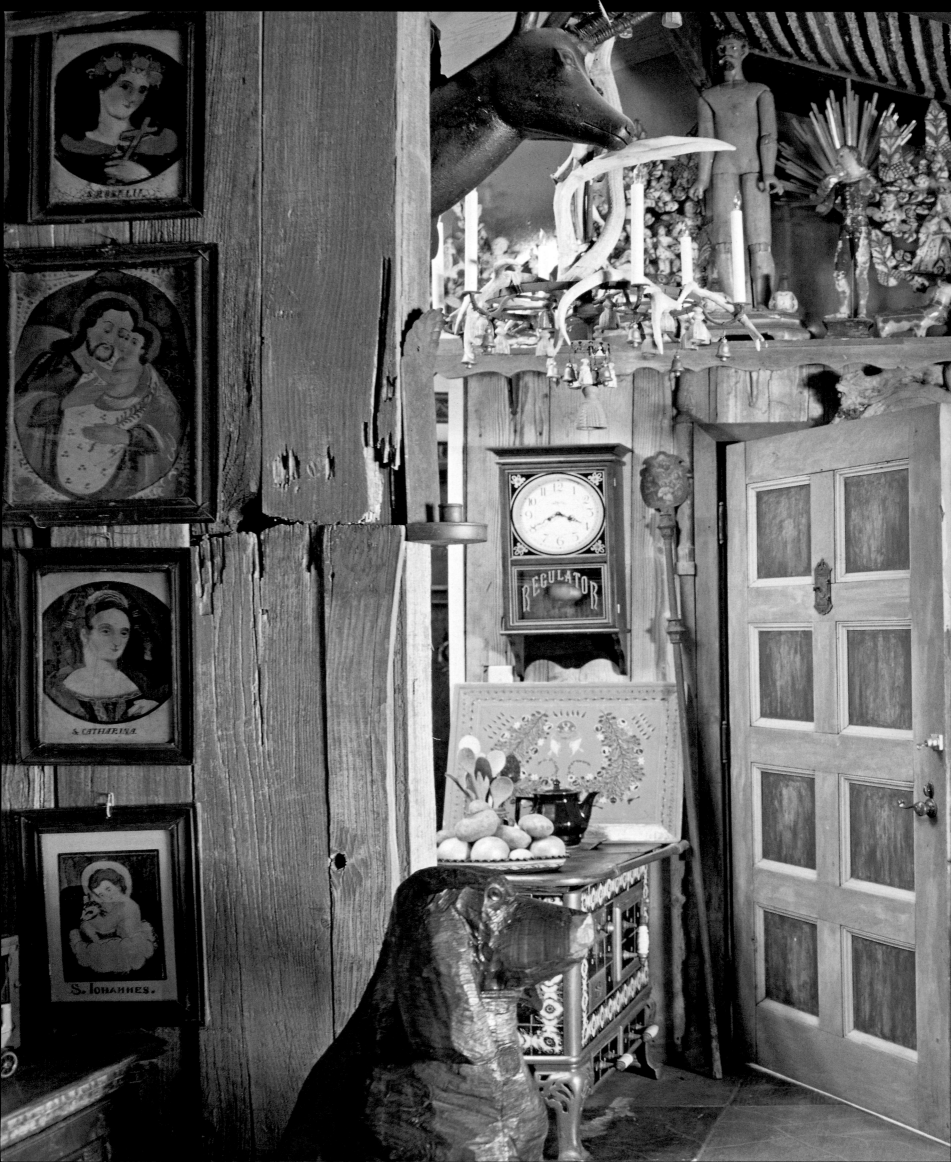

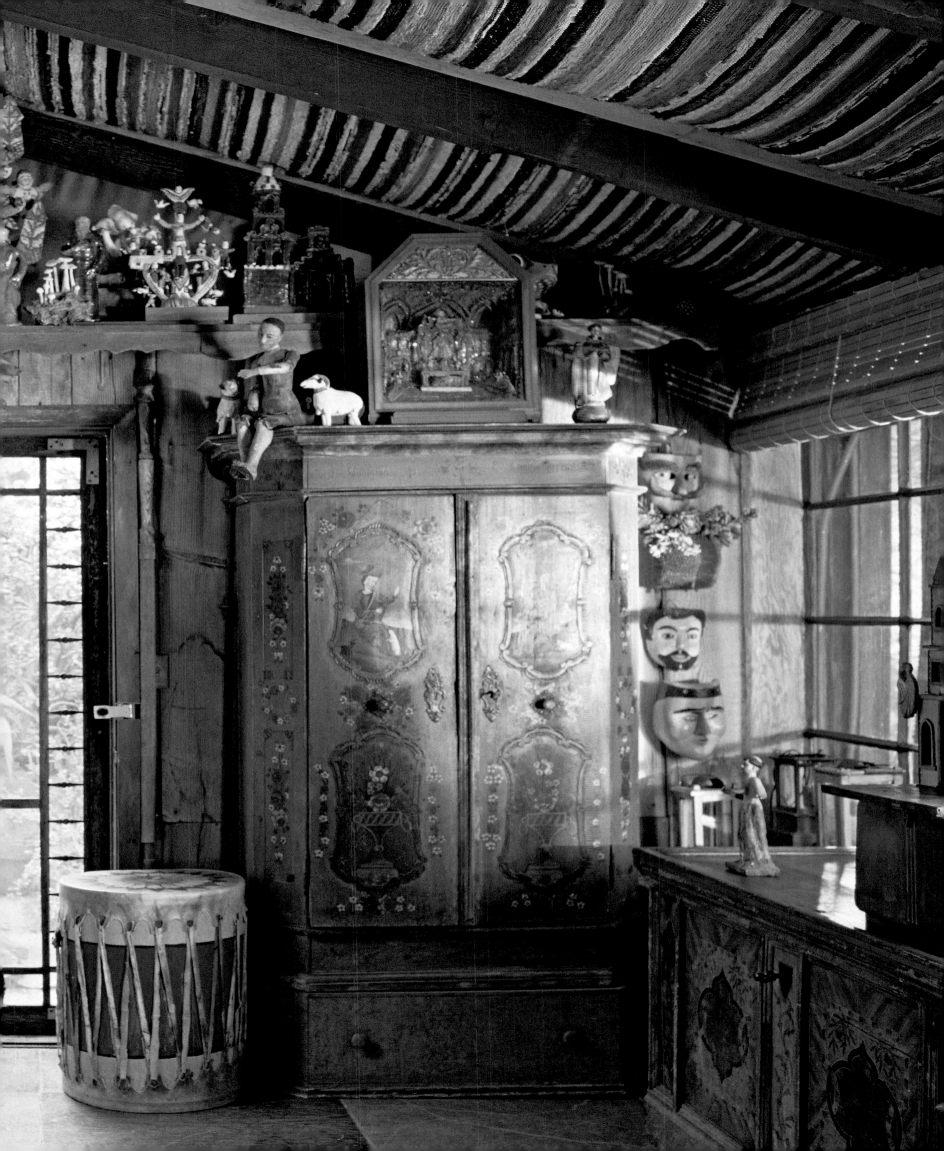

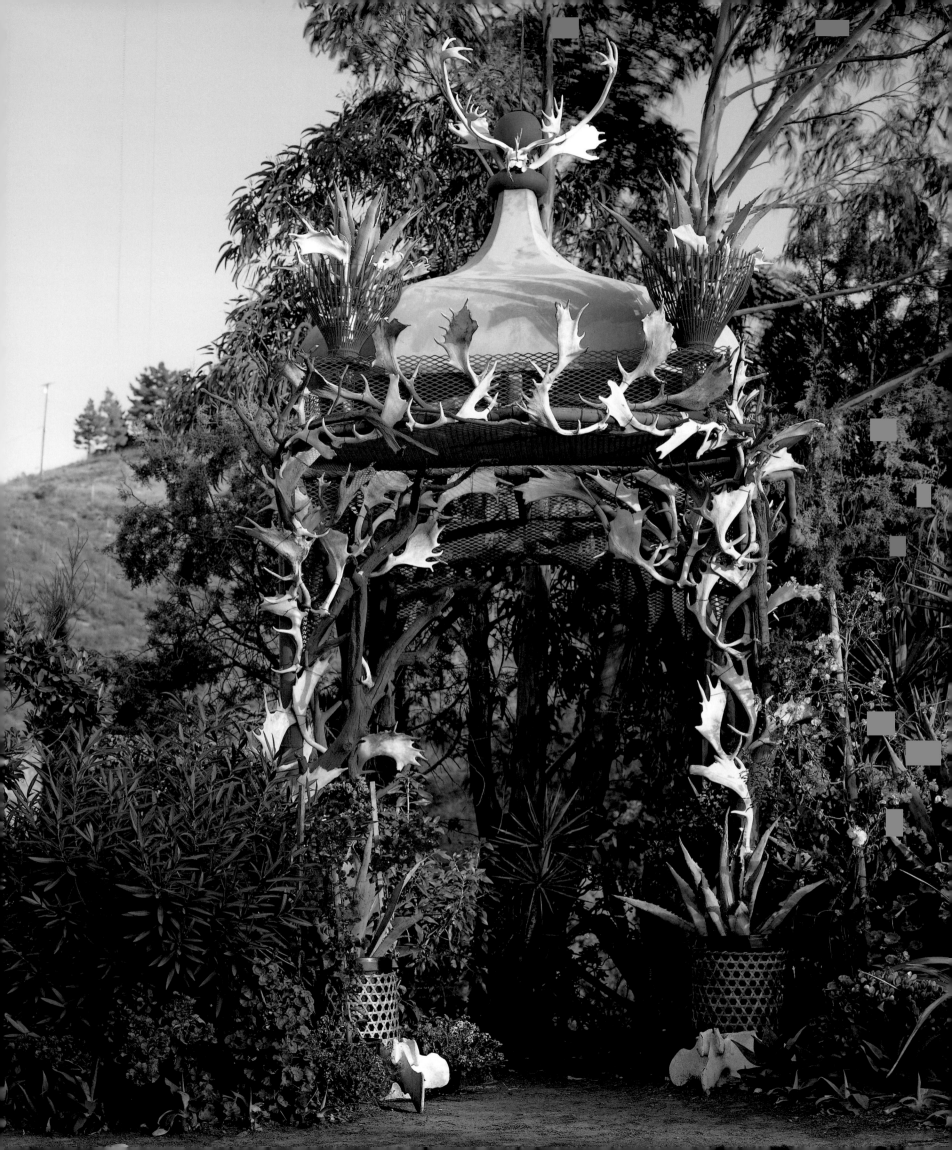

Getting up to use what turned out to be a very compact little bathroom, he was confused, and then amazed, to discover that he was actually in a mobile home. Going back to the table, Gustave turned to the woman on his right and said, "You know, I think we're in a mobile home."[2]

"You're crazy," she replied. "It's not possible."

When they asked Tony, he answered, "Of course it's a mobile home. But we did the marbleizing!"

Other structures on the property included Portugal, the Star Barn, the Tea Pavilion, and Frogmore. In the end, Frogmore turned out to be the Duquettes' official ranch residence. Over the years Tony expanded it from a twenty-by-twenty-foot tin building—which had been thrown out on Robertson Boulevard—to a rambling two-story gathering of connected pavilions, pagodas, and terraces.

Frogmore was where the Duquettes could entertain 150 people for lunch—and they often did just that—with Mexican food, mariachi music, Thai and Balinese parasols, banners, flags, and lots of flowering plants. The ranch was completely destroyed in October 1993 in the Green Meadows fire, which burned more than thirty-eight thousand acres in Malibu and destroyed thirty homes. The ranch was never rebuilt, and Tony never set foot on the property again.

PREVIOUS SPREAD The kitchen at Frogmore House. Tony found an old fence in a Beverly Hills alley and used it to panel the walls the ceilings are covered in Greek rag rugs.

OPPOSITE A Duquette-designed folly embellished with antlers from the Hearst ranch and other recycled materials.

OVERLEAF Even the old water tower at Sortilegium was transformed into a pagoda with Thai roof ends and Moroccan panels Tony had used on the set of the MGM film Kismet.

Tony spent the next several years transforming a simple guest house into a Balinese fantasy complete with roads, towers, gates, bridges, pagodas, temples, and altars.

With his work for the opera and the ballet in San Francisco, Tony felt that he should have his own house in the City by the Bay. Tony claimed a great love for San Francisco, maintaining that he had been conceived there—but born in Los Angeles—and that he had an affinity with all cities on the water, including Venice and Hong Kong. Prior to buying his own San Francisco house he had been staying with friends and clients, including Jane Swinerton and Ann Woolworth, whose houses and jewels both had his signature.

The Little House of Flowers is the name he gave to his pre-1906 San Francisco birdcage Victorian farmhouse, which he discovered in the Cow Hollow district. Situated between Green and Union Streets on Octavia, the house was reawakened under Tony and Beegle's magic spell, and adorned with more and more gingerbread from neighborhood wrecking yards.

Pretending he was a sea captain returning home to San Francisco from a voyage to the Orient, Tony filled the house with Victoriana, eighteenth-century curiosities, rare Chinese silks and brocades, and dozens of gold-framed mirrors. The house had jalousies of Moroccan grillwork over the windows, as well as newly added Duquette copper domes and carved wooden tasseled valances on the porches. There was a playful gazebo topped by an iron sailing ship in full regalia, under which those entering passed to reach the front door. The door itself was painted to look like malachite, and Tony installed a beveled full-length mirror to one side of it so that visitors could straighten themselves up before ringing the bell.

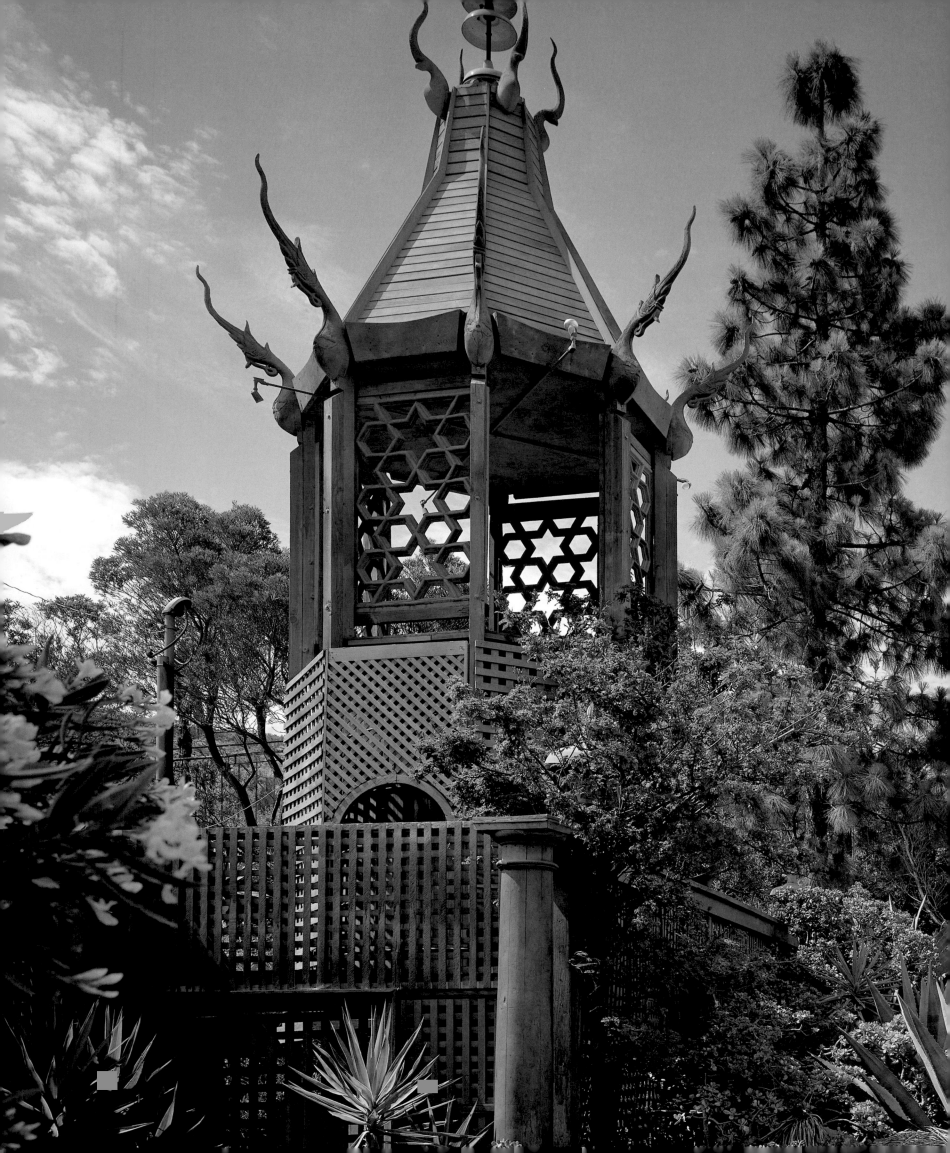

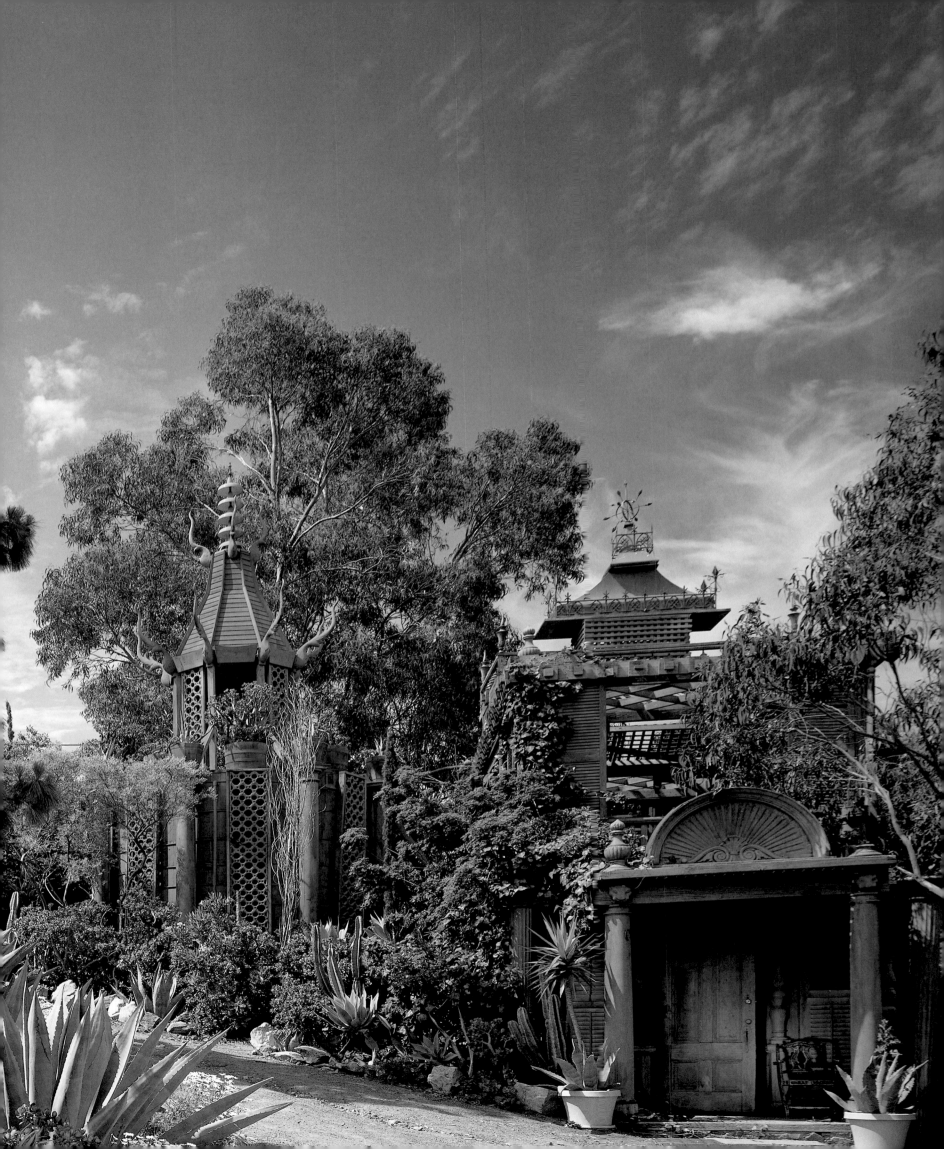

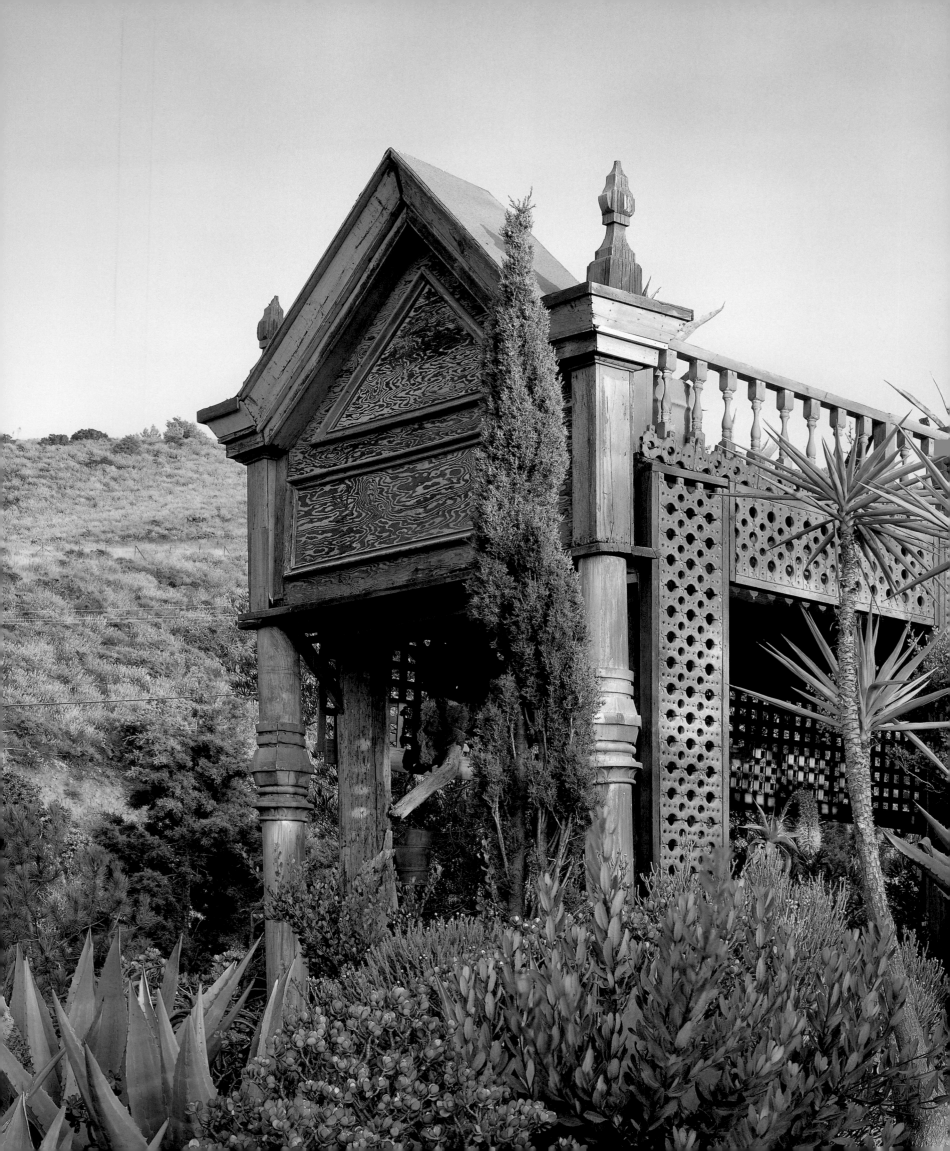

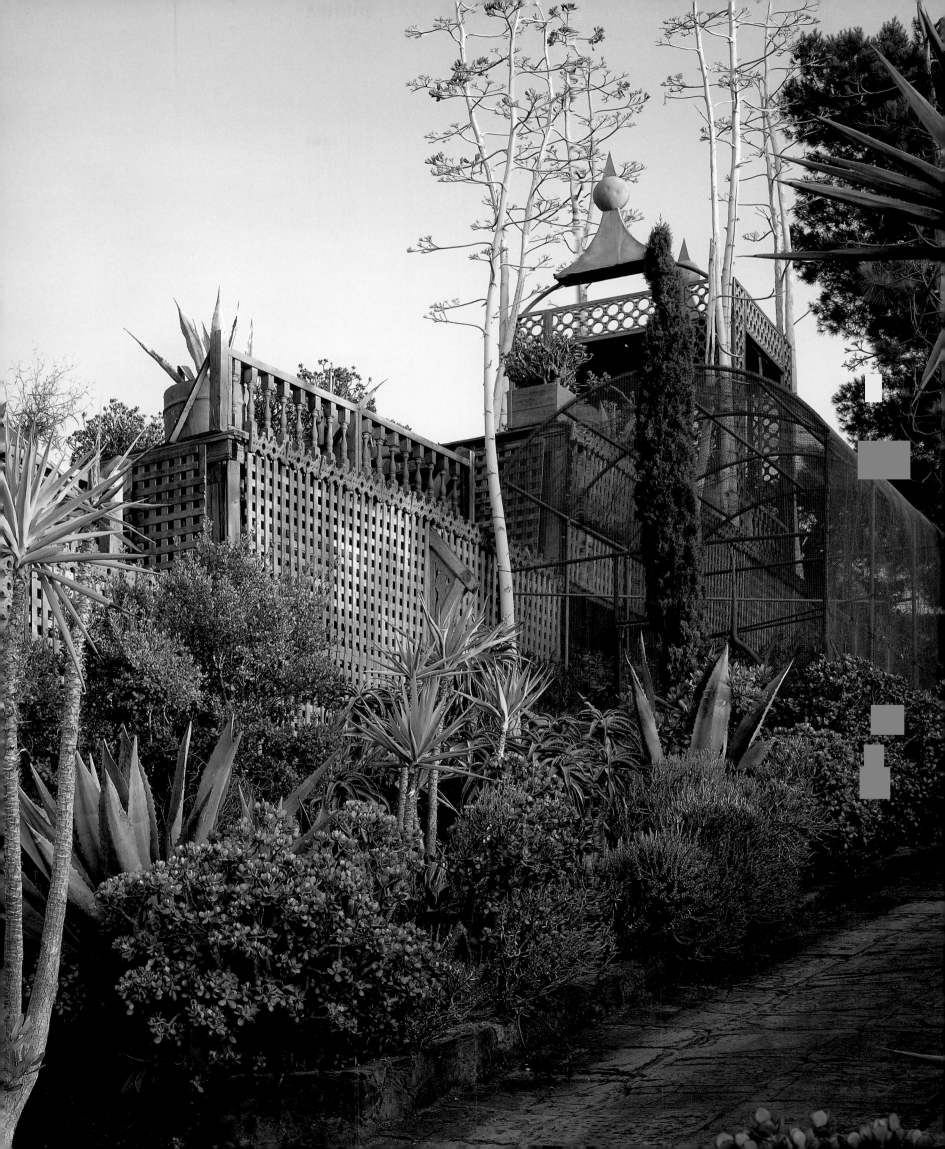

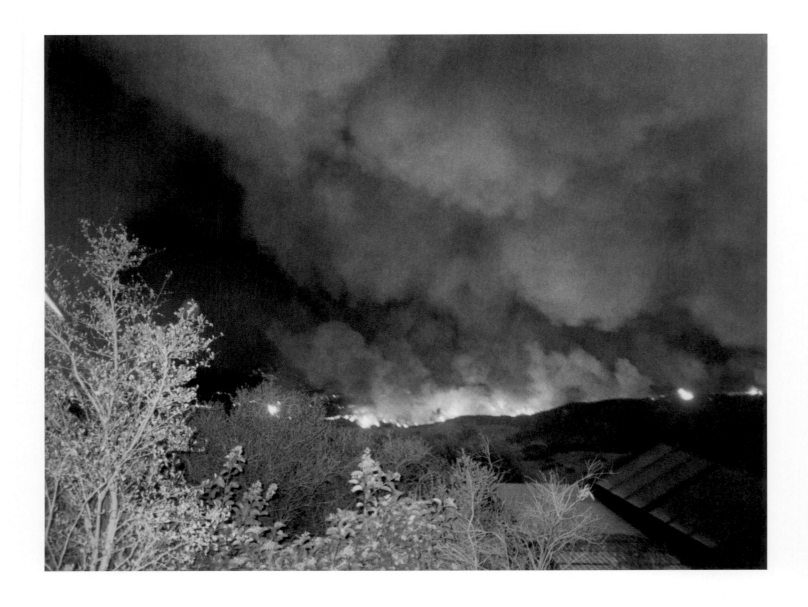

PREVIOUS SPREAD "The Rose Parade" is the name Tony gave to this lath house trimmed with old Victorian architectural fragments.

ABOVE The Green Meadows fire destroyed the ranch and all of its buildings in less than an hour.

OPPOSITE The Green Meadows fire heading west to the ocean over Boney Mountain. Sortilegium was right in its path. Tony said that "even in its last moments each little house and pavilion lighted up in glory and was beautiful, and then they were gone."

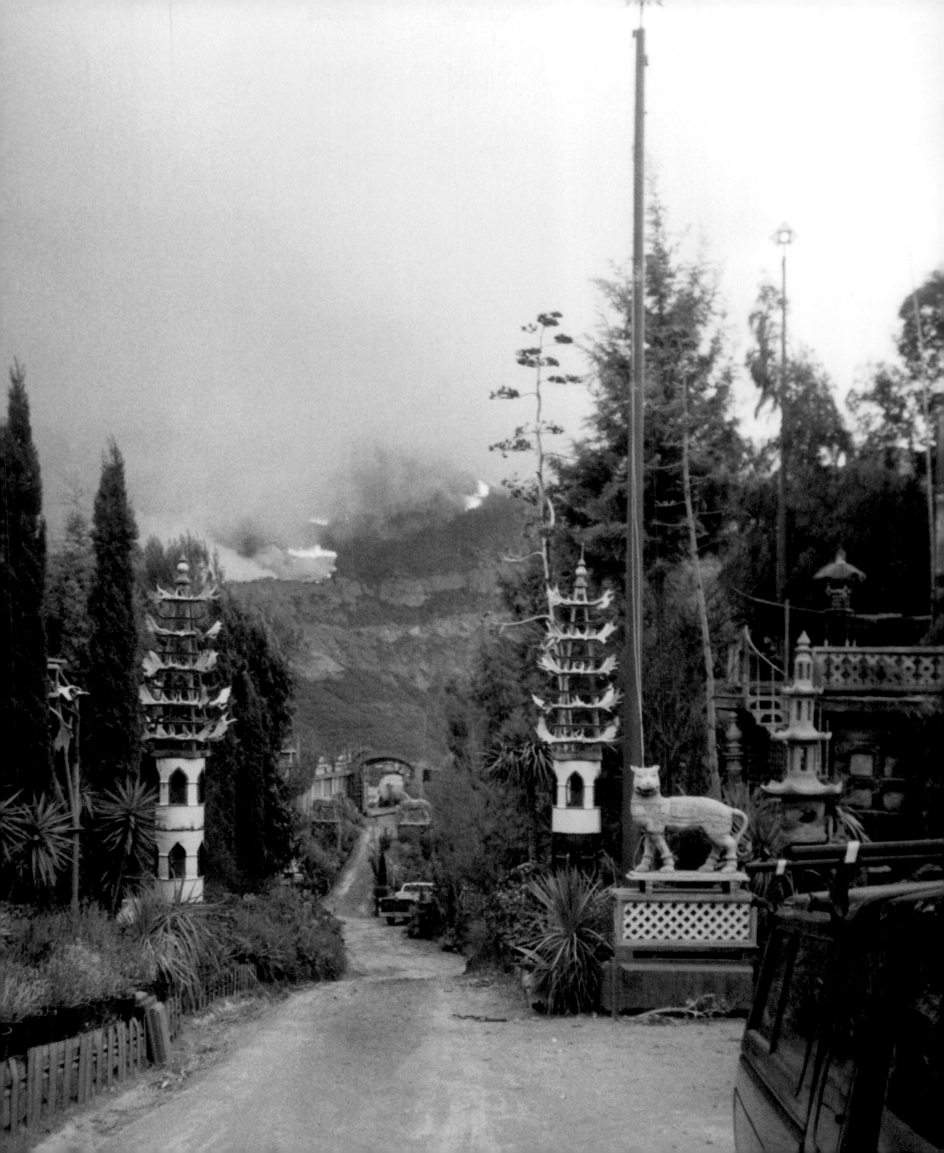

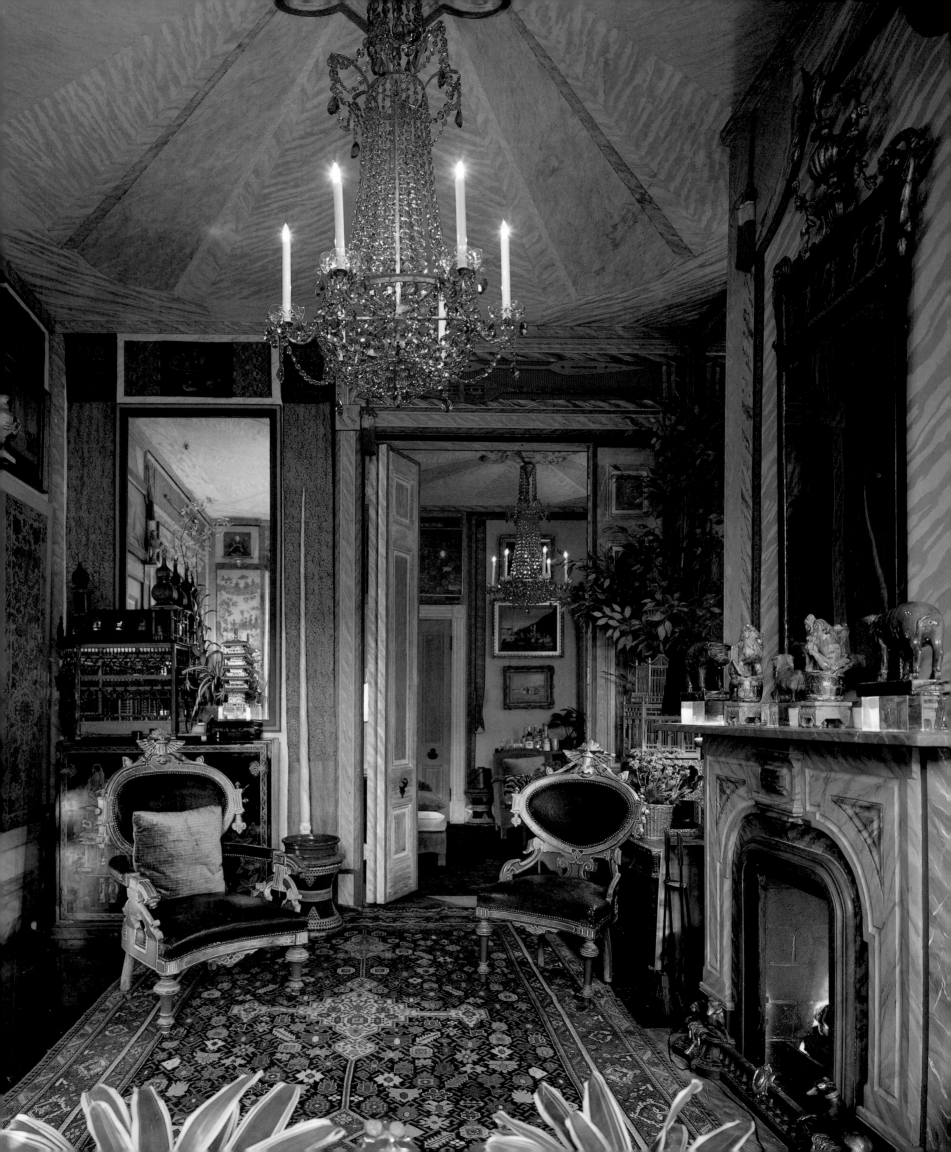

The entire interior of the seemingly huge little house was marbleized in fantasy color combinations—including the white marble fireplace, which Tony explained "was painted to look like marble because it was the wrong color to begin with." There were black-lacquered floors covered in rich Oriental carpets, lacquered seventeenth-century cabinets, carved birdcages, painted eighteenth-century Chinoiserie screens, and fanciful lamps with bronze cow heads fashioned out of Indian walking sticks. Each room was hung with an original Tony Duquette crystal chandelier in amethyst or topaz crystal.

The dining room boasted a ceiling that was painted to look like the sky, with ribbons and bows in the corners. An amazing pair of eighteenth-century Austrian Louis XVI corner cabinets held portraits of the emperor Franz Joseph and his finance minister. A breakfront cabinet of Tony's own invention also graced the space, made from diverse elements that included a Victorian chest upholstered in old Fortuny, eighteenth-century Venetian carvings, an antlered head, and silver repoussé urns from Spain. The kitchen was completely nonfunctional but very pretty, with its panels of blue and white Portuguese tiles, and shelves lined with blue and white Chinese porcelains. Even the refrigerator was painted to resemble blue and white porcelain tile.

Off the kitchen was a terrace that Tony enclosed with old French doors, to which he applied decorative passementerie trimmings and a magnificent Tiffany stained-glass window. He also created a lighted ceiling using old

stained glass that he had originally employed on the set of *Can Can* at 20TH Century Fox. There was a powder room with an abalone-shell-encrusted Victorian bathtub, and a guest room entirely upholstered in a blue and white fleur-de-lis print; this alternated between a blue ground with white fleur-de-lis and a white ground with blue fleur-de-lis. Even the hinges and doorknob (on the fleur-de-lis-covered doors) were painted with a matching fleur-de-lis pattern.

The house was full of treasures, including Gobelin tapestries that Tony had bordered with brown, black, and white zebra-skin-patterned cut velvet; a monumental mirror by William Kent; any number of eighteenth-century Venetian lacca povera pieces; paintings; photographs of famous friends; and sketches by Erté and Cecil Beaton, both of whom Tony knew and had entertained.

Although some would consider the house small, it was full of rooms in which the Duquettes could sleep an army of willing workers, who they would enlist to help on the ballets and other projects in San Francisco. Out of all the bedrooms, however, the Duquettes'—with its canopied bed in citrine silk brocade and pelmets of hand-painted birds and flowers—was the most spectacular. Covering the walls were panels of hand-painted antique Chinese wallpaper; a flock of painted clay Rajputani birds sat on wooden perches that Tony had drilled into the panels. There was wonderful antique French, English, and Venetian furniture, including chests of drawers, chairs, benches, desks, lamps, and carpets. Hanging from the blue satin ceiling was one of Tony's original Venetian- and Peking-glass chandeliers, which he had made for Elsie de Wolfe at After All. Every room in the house had at least one sofa or divan that would double as a bed, and these were often filled to capacity when we were

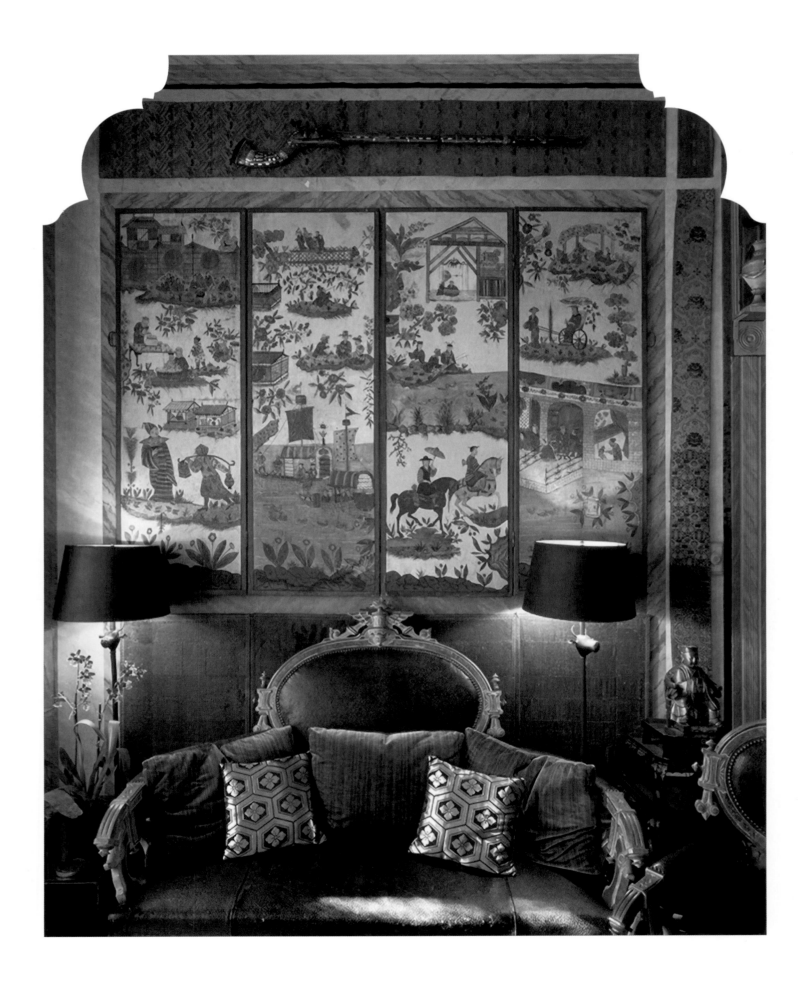

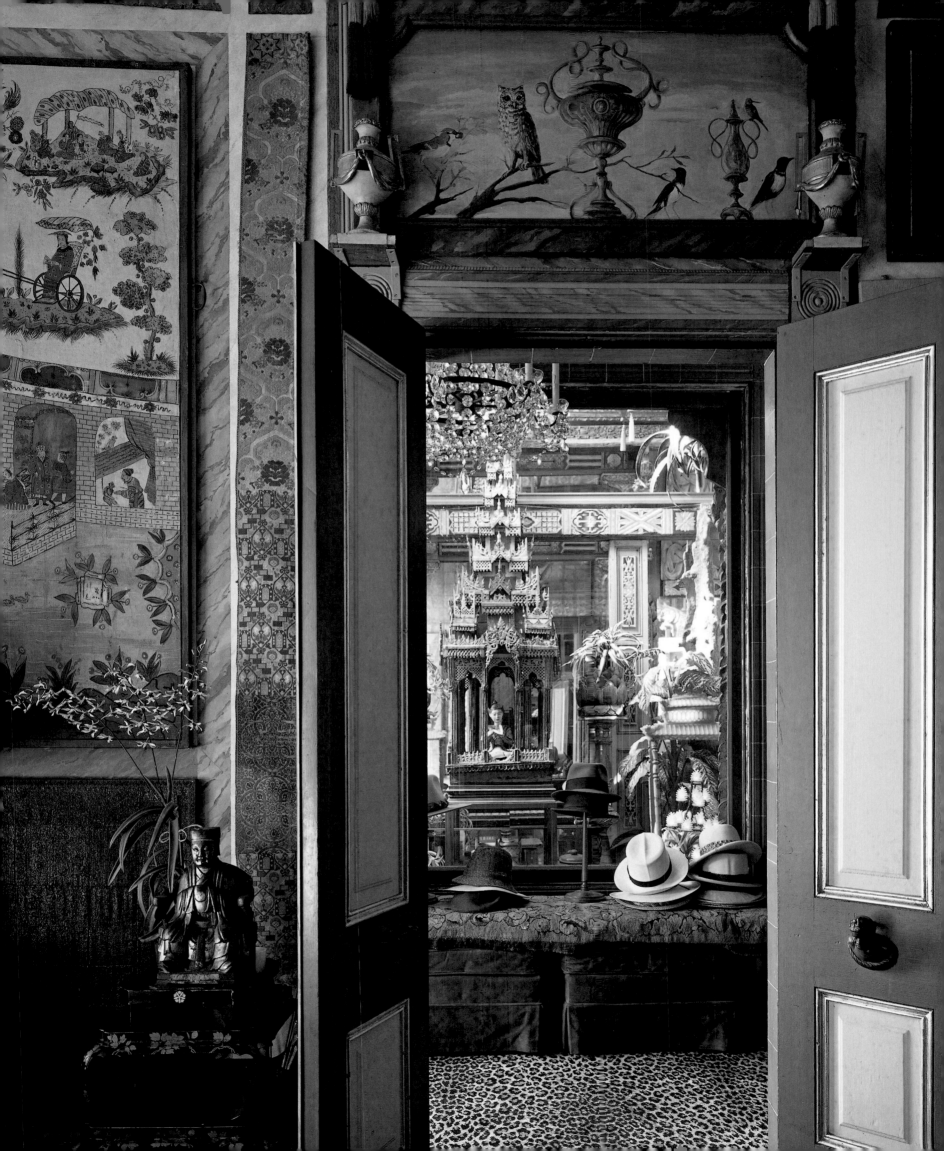

installing a house, working on a debut ball, or just redecorating.

Behind the house was a small walled garden with old brick paving. Tony created a decorative screen at the rear of the garden; made of old treillage and Victorian gingerbread, and composed of mirrored alcoves—an architectural trick he had learned firsthand from Elsie deWolfe—it was one of his most creative constructions. There were old European statues, plants in pots and in giant clamshells, French iron garden seats and tables, and an army of ceramic frogs placed strategically under plants and on top of balustrades.

On the roof of the house Tony created a captain's cabin and a garden with views out over San Francisco Bay to the Golden Gate Bridge. He loaded the roof with flowering daisies and hanging baskets, laid down embroidered Indian rugs, and installed finials and flagpoles topped with gold-leaf toads. Tony followed the same custom he did at the ranch, whenever he was in residence with Beegle; they would fly the double Gemini flags he had designed, to let their friends know they were in town.

Traveling to San Francisco with Tony and Beegle was always an adventure. They had to bring their flowers, their books, and their clothes and jewels, plus lots of presents for everybody. They would often drive in caravan from Los Angeles, cars and vans packed to capacity with workers, pets, and personal belongings. There were regular stops all along the way at favorite little towns with interesting antique shops. Purchases were invariable, as were the stops at ice cream and fruit stands and at favorite roadside restaurants. They often visited the historic California missions, and there was always a special stop for peach pie when it was in season, or a certain view that needed to be "seen to be believed," or a visit to friends along the way in Santa Barbara, Carmel, or Pebble Beach. Tony called these trips his "royal progress."

PREVIOUS SPREAD LEFT AND RIGHT The drawing room at Cow Hollow. The painted panels were a gift to the Duquettes from Adrian. The cow head lamps were made from cast bronze Indian walking sticks.

OPPOSITE The interior grotto at Cow Hollow could be seen from a glass plate window in the entrance hall.

OVERLEAF LEFT Tony's three-dimensional costume designs for Camelot sit beneath an eighteenth-century French clock.

OVERLEAF RIGHT An alcove Tony designed for the opera singer Lily Pons with antique Chinese doors and embroideries

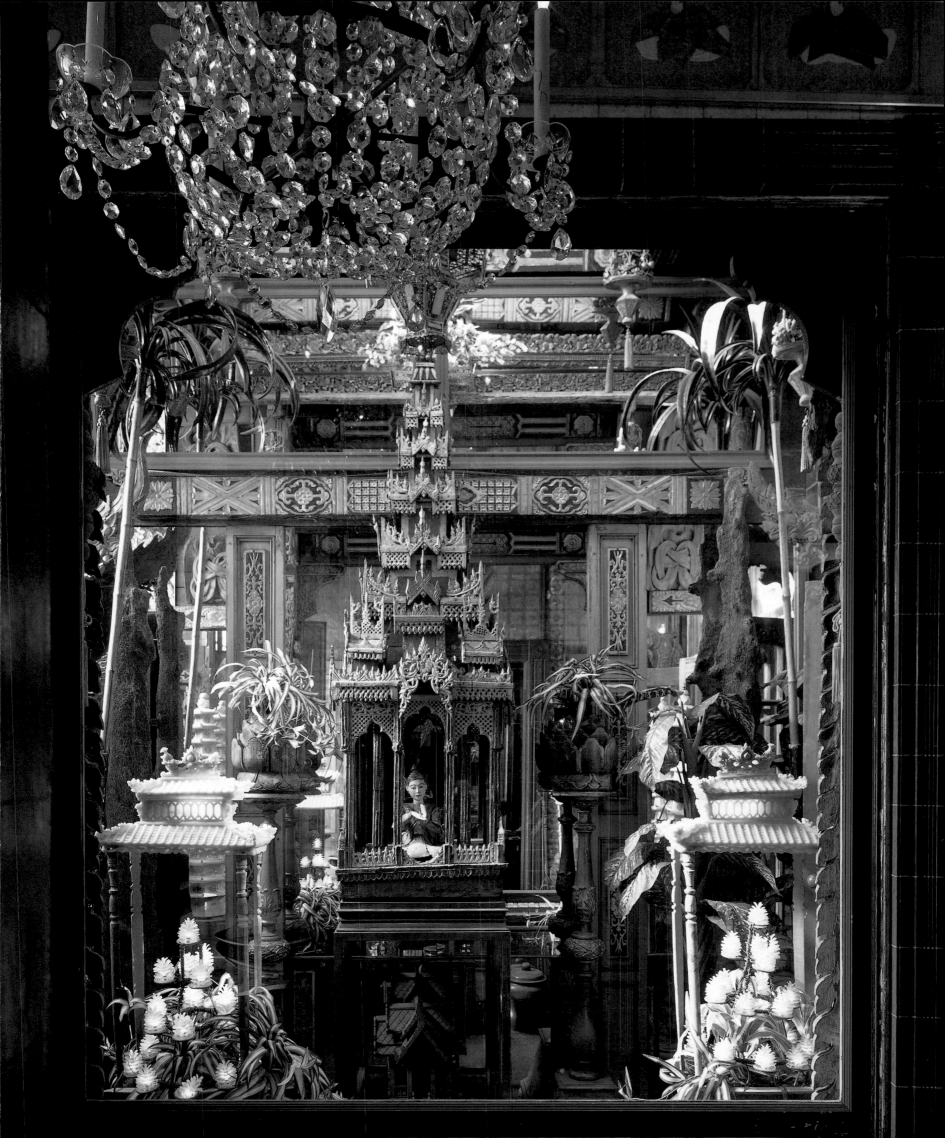

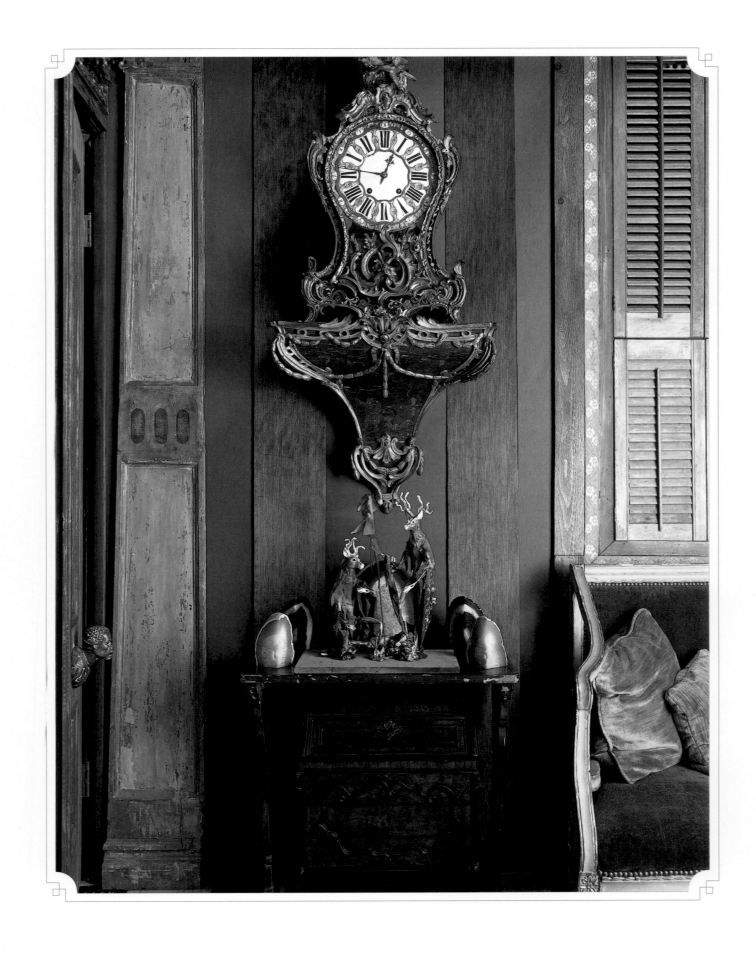

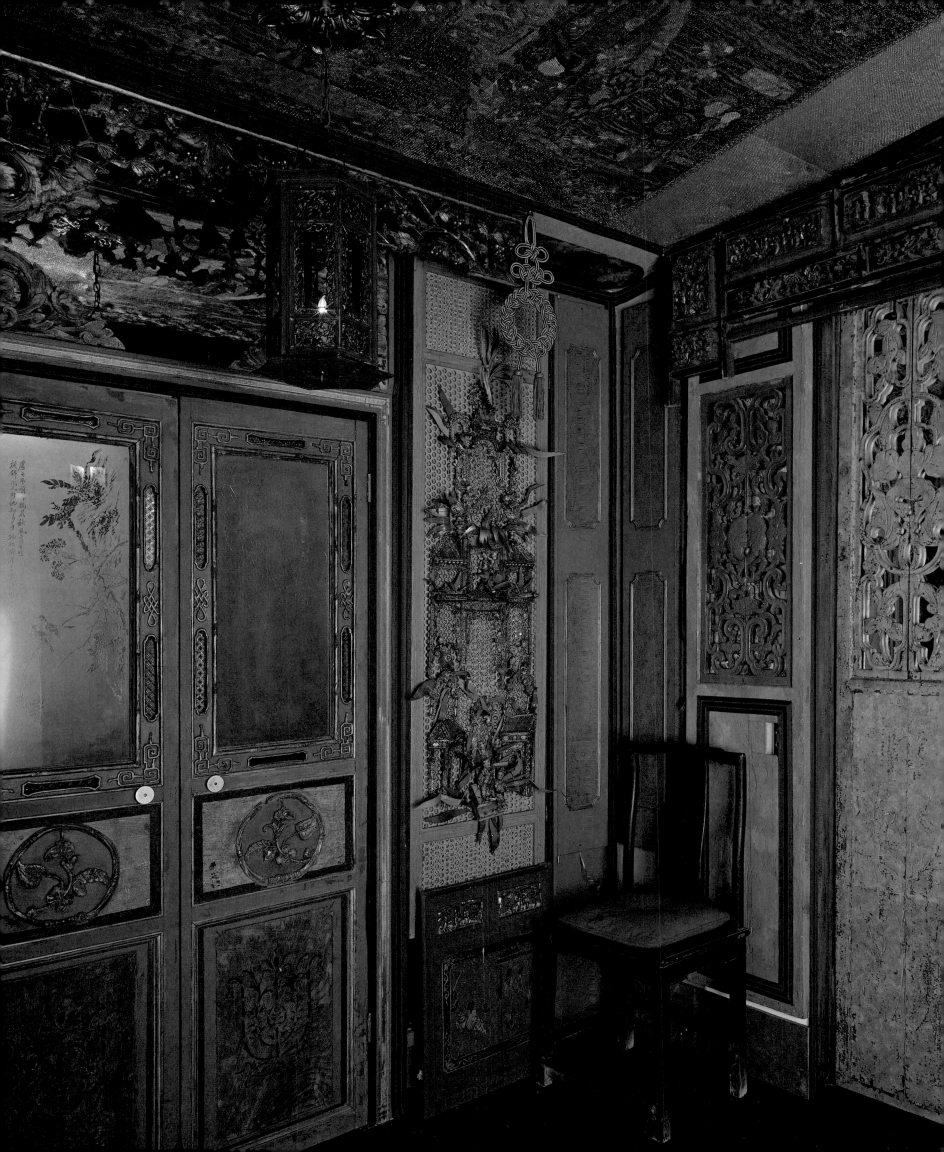

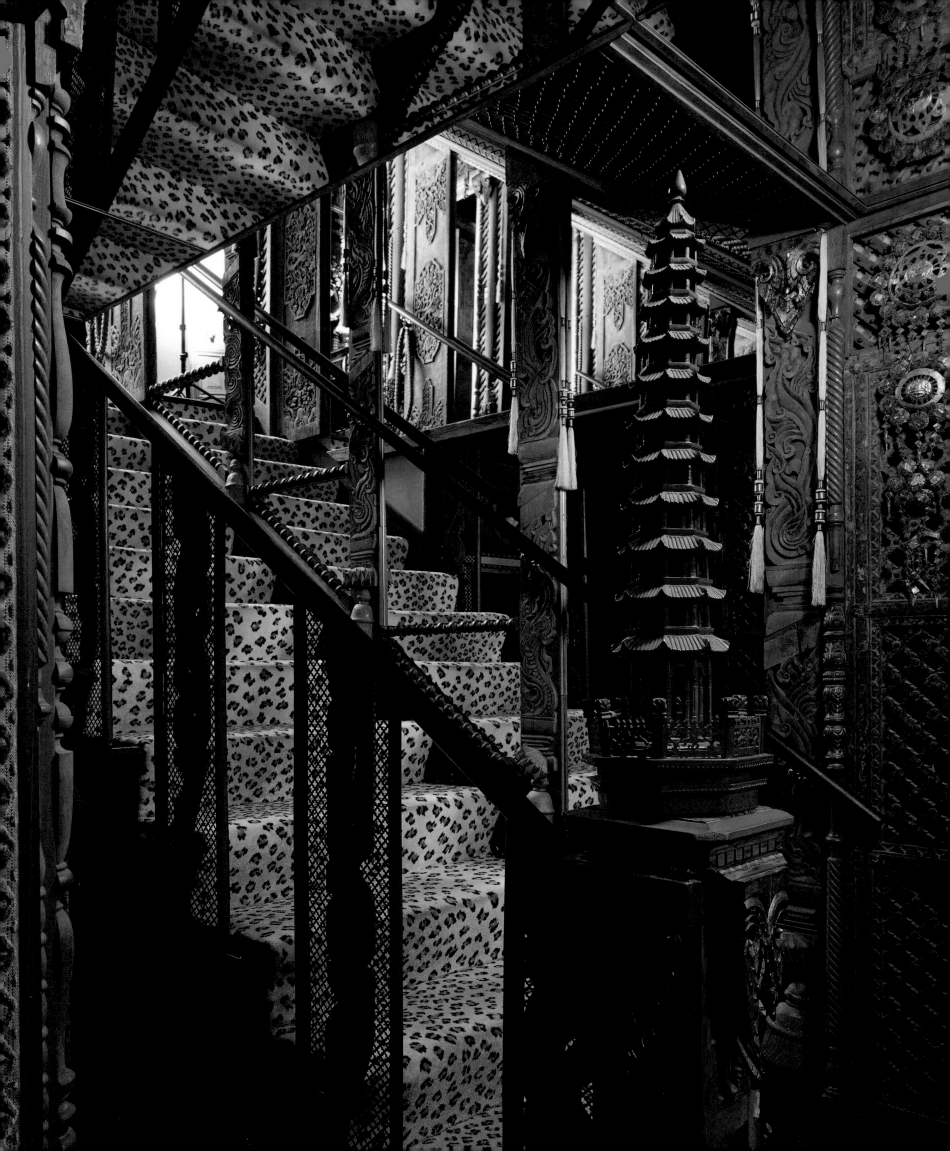

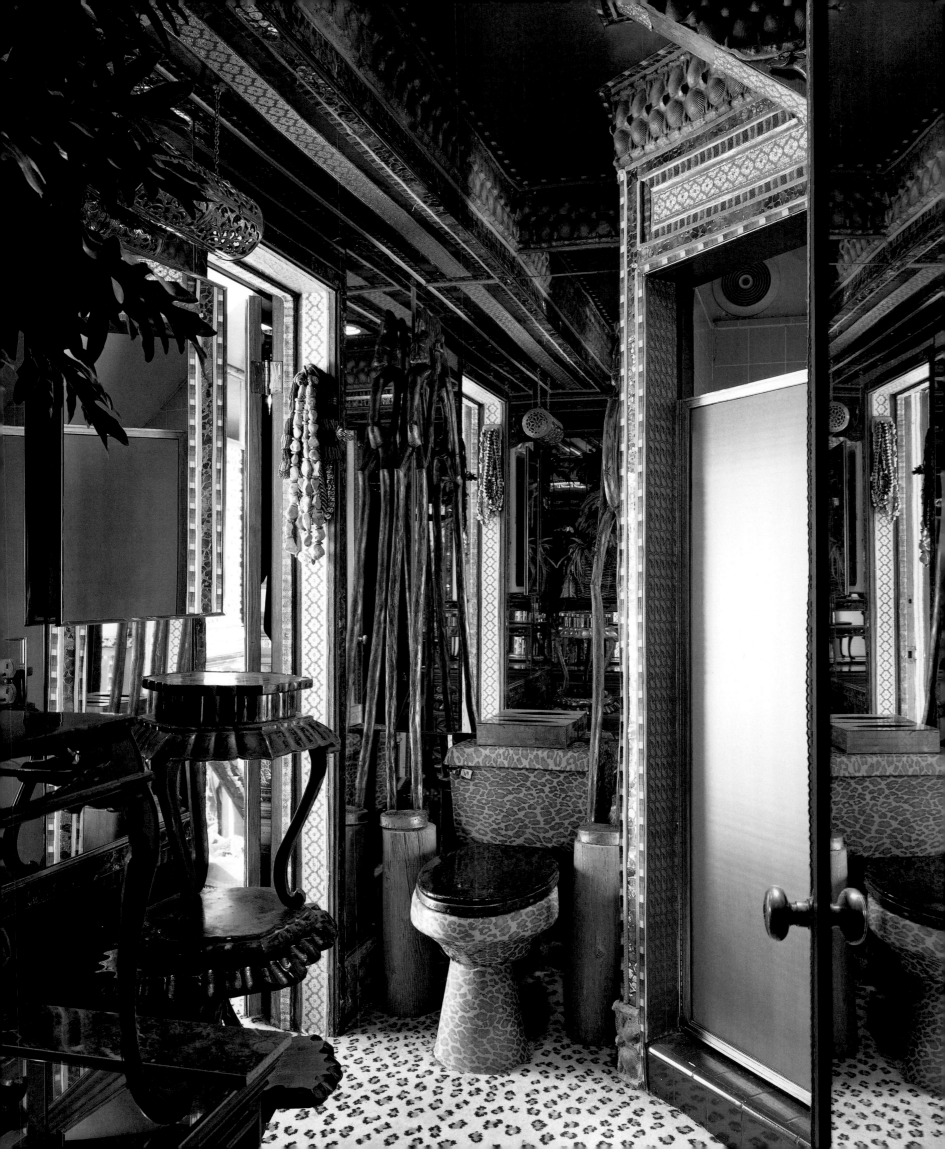

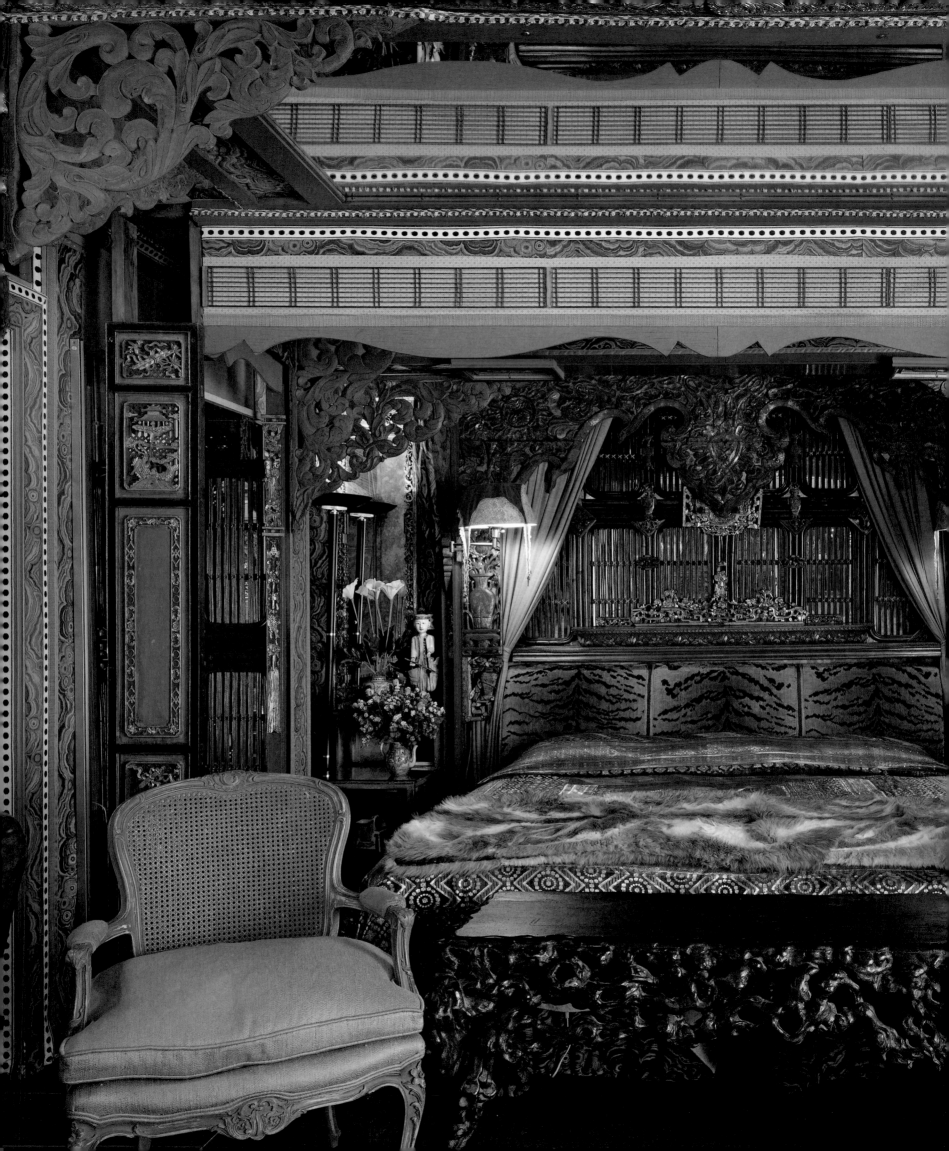

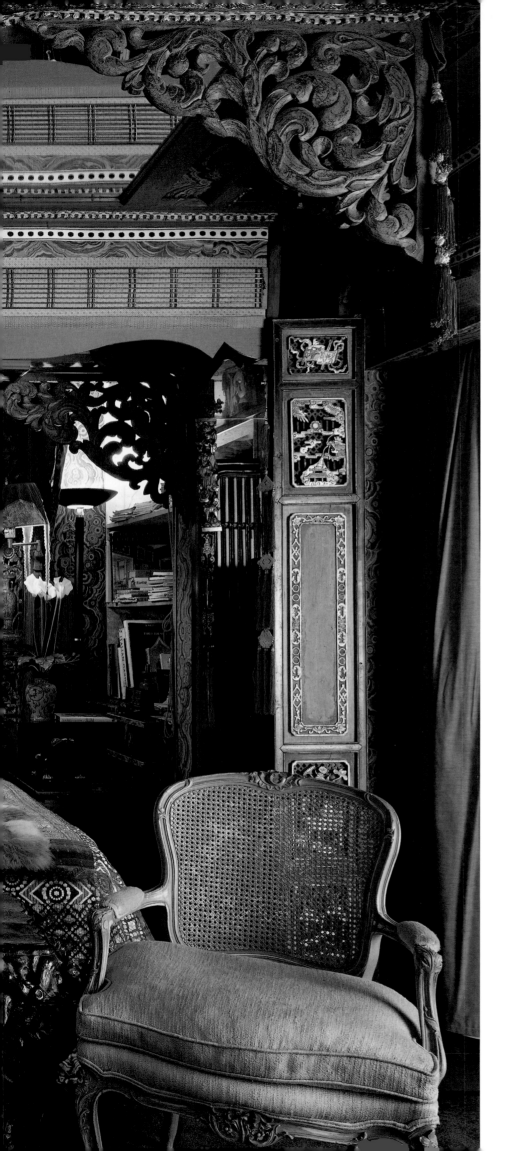

PREVIOUS SPREAD
LEFT Tony was inspired to decorate this stairway after visiting an old palace on the Bosphorous.

RIGHT Tony could leave no surface untouched. He even glued leopard-print silk chiffon onto the toilet in his bathroom.

OPPOSITE One of Tony Duquette's bedrooms.

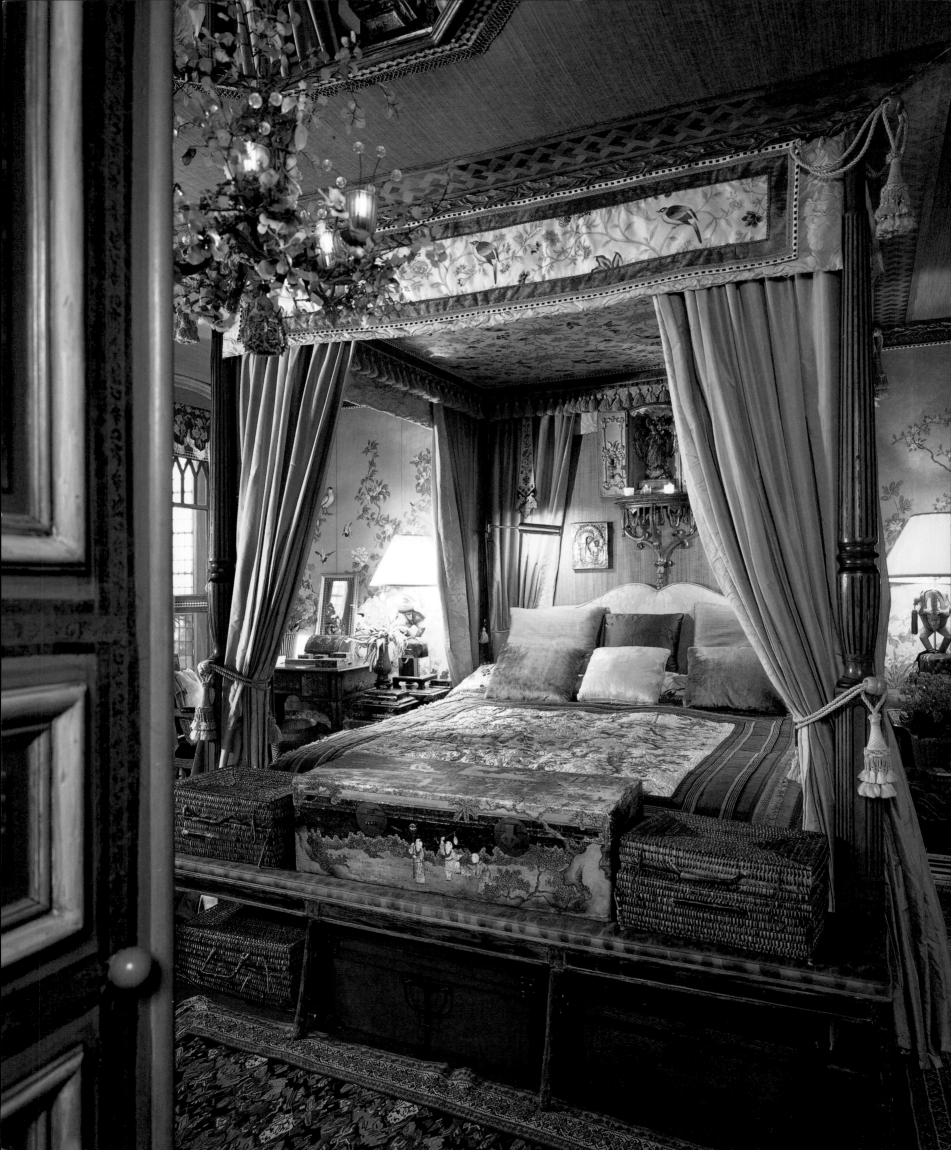

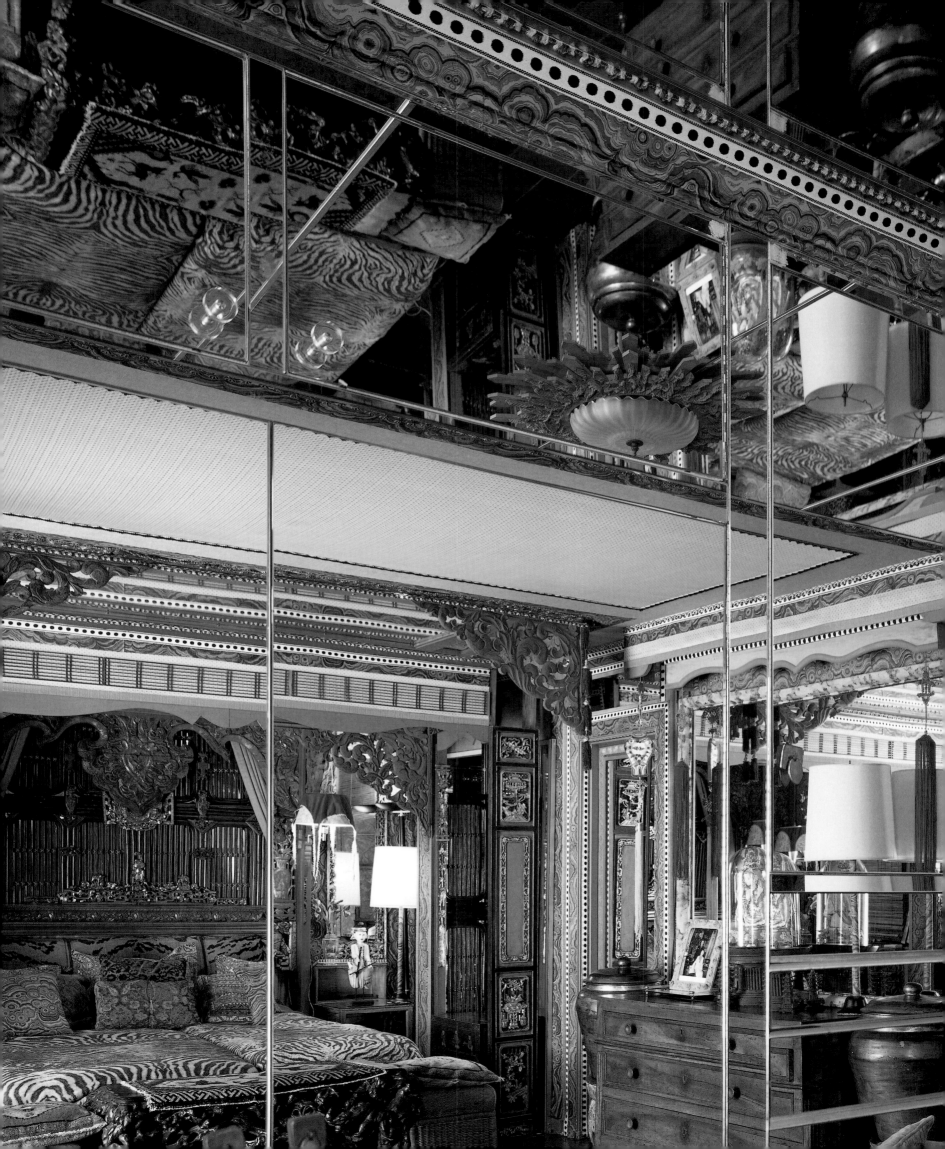

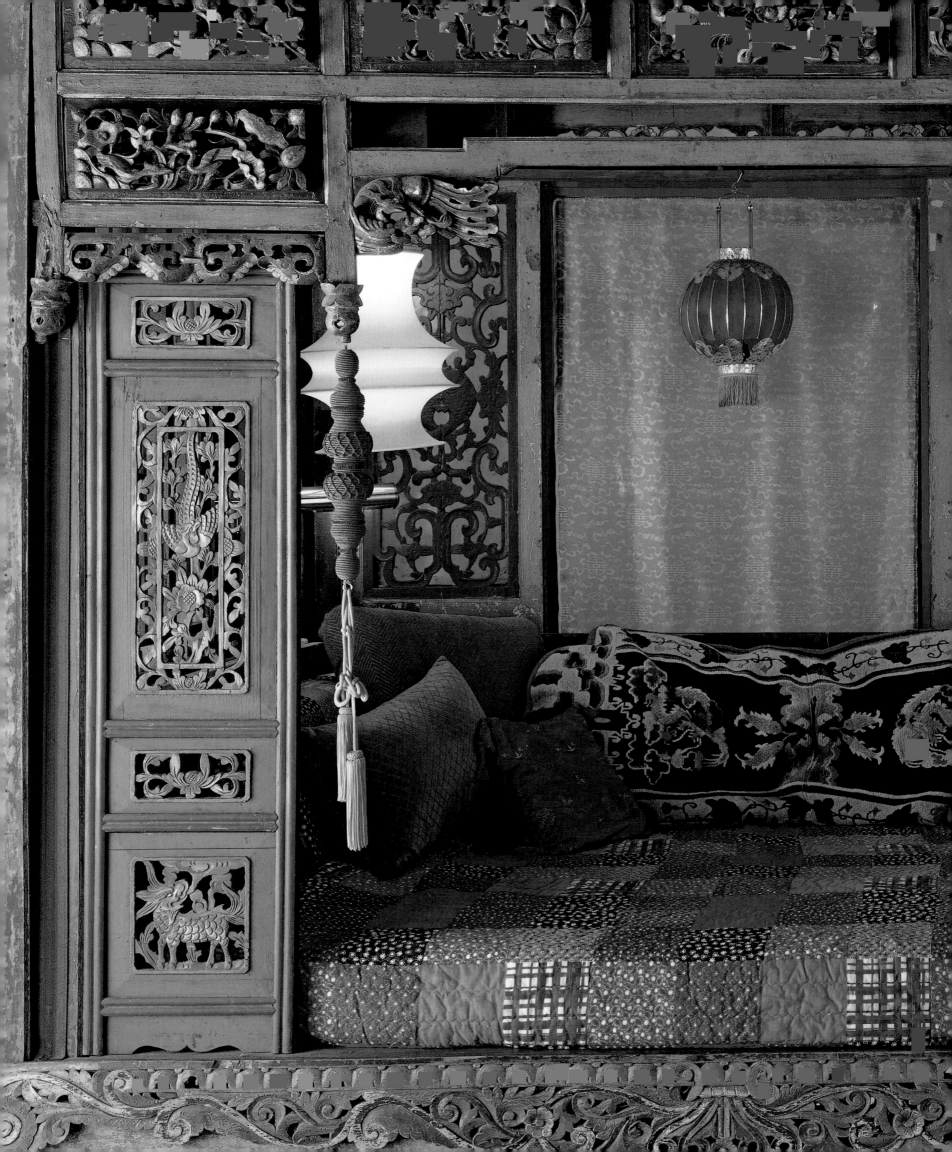

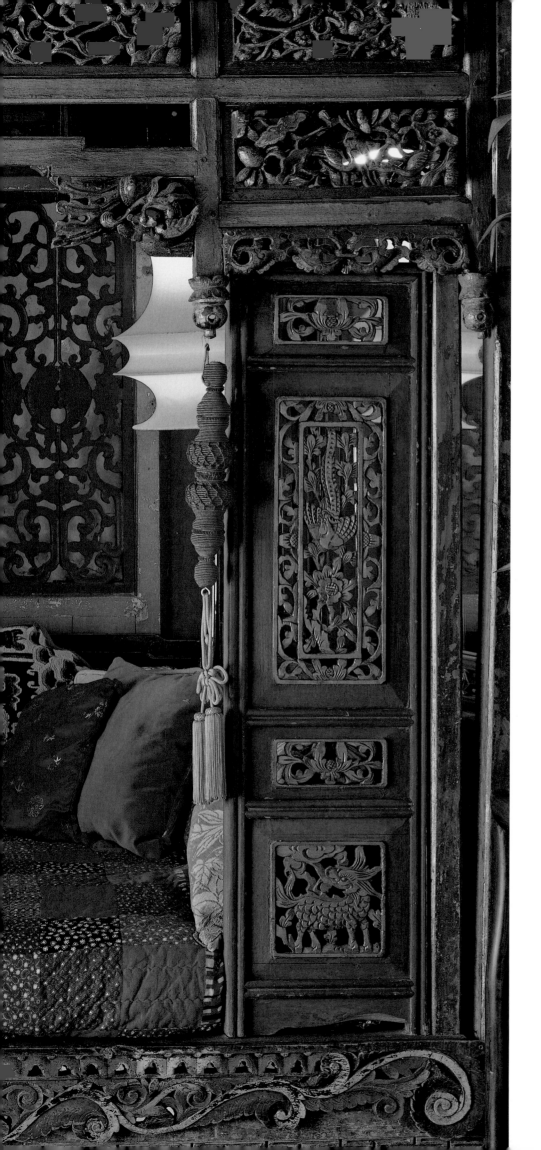

PREVIOUS SPREAD
LEFT The bedroom at Cow Hollow with its hand-painted Chinese wallpaper. The chandelier in the foreground was originally made for Elsie de Wolfe at After All.

RIGHT Tony loved using mirrors to further mystify and enhance his designs.

OPPOSITE A Chinese opium bed. Tony was always interested in little alcoves, small pavilions, and enclosed spaces that he could enchant with mirrors and tassels and rich silks.

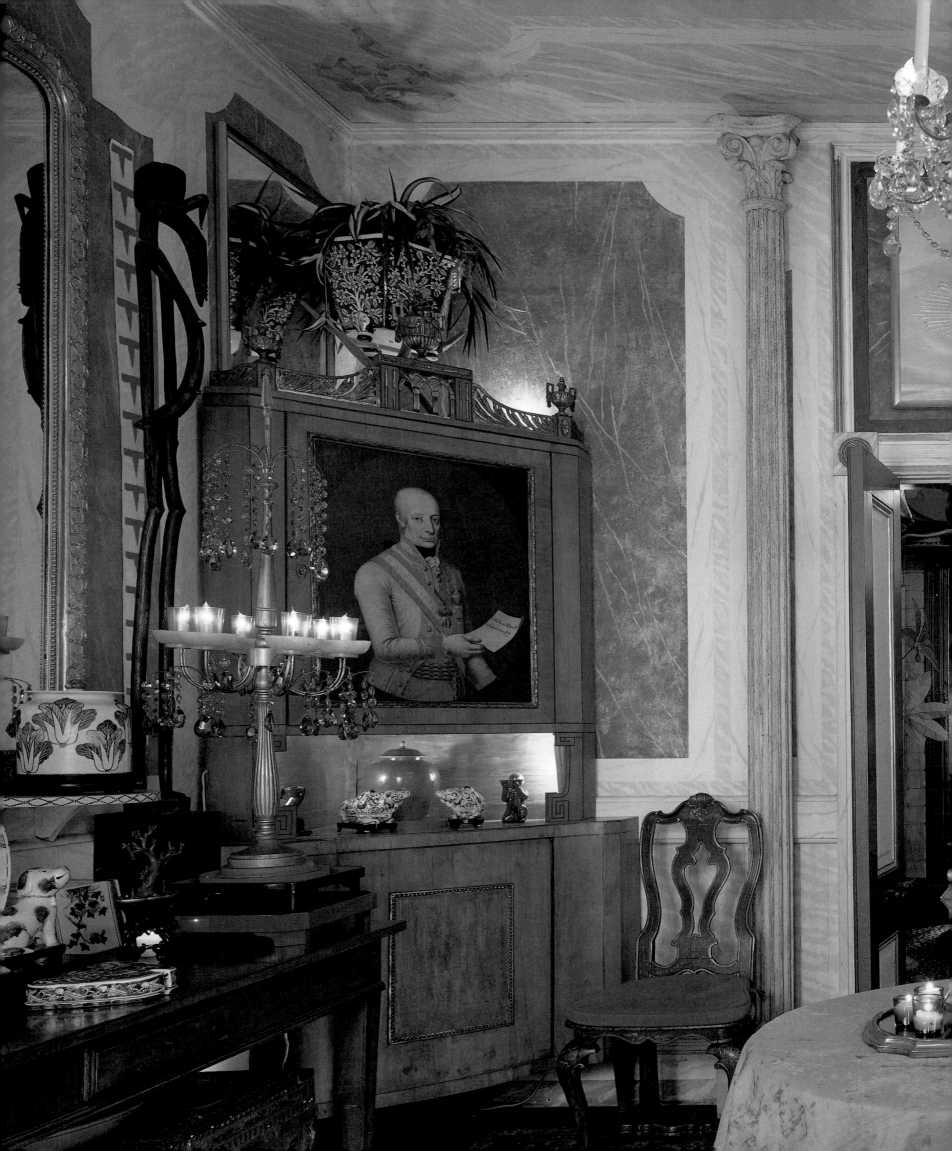

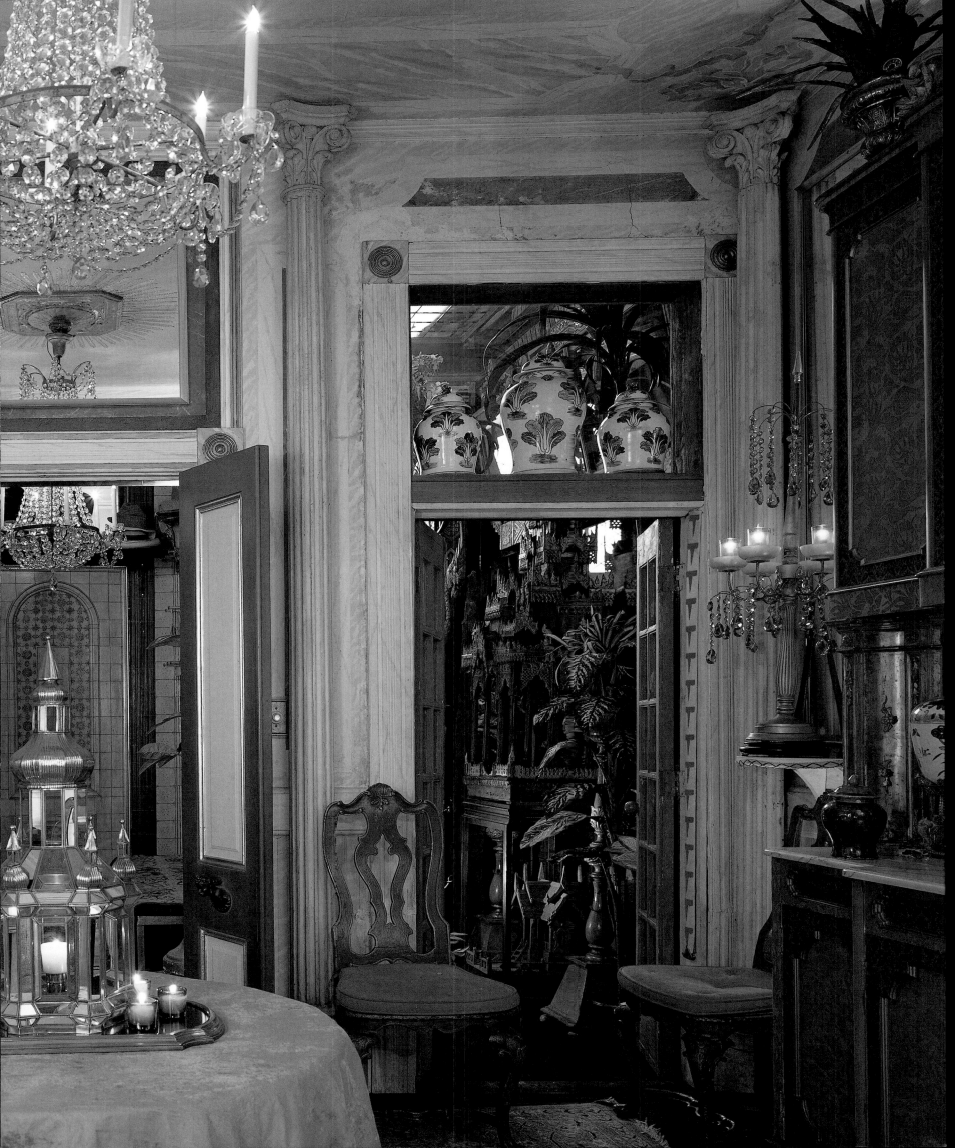

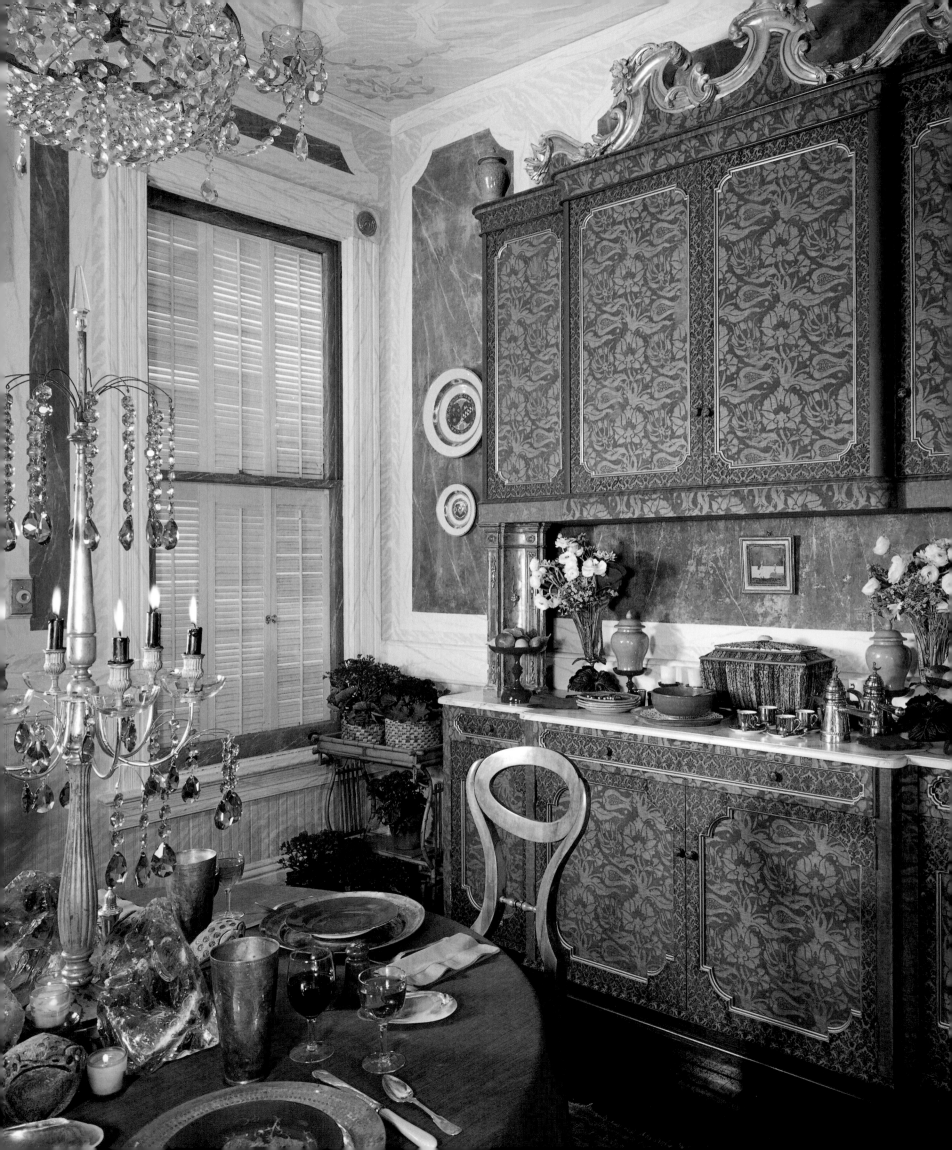

PREVIOUS SPREAD The dining room at Cow Hollow in the 1990s. The chairs are eighteenth-century Venetian, a gift from Frances Elkins.

OPPOSITE The kitchen at Cow Hollow in the 1960s. Tony and Beegle upholstered the large cabinet with antique Fortuny fabrics and crowned it with an eighteenth-century Venetian carved lambrequin.

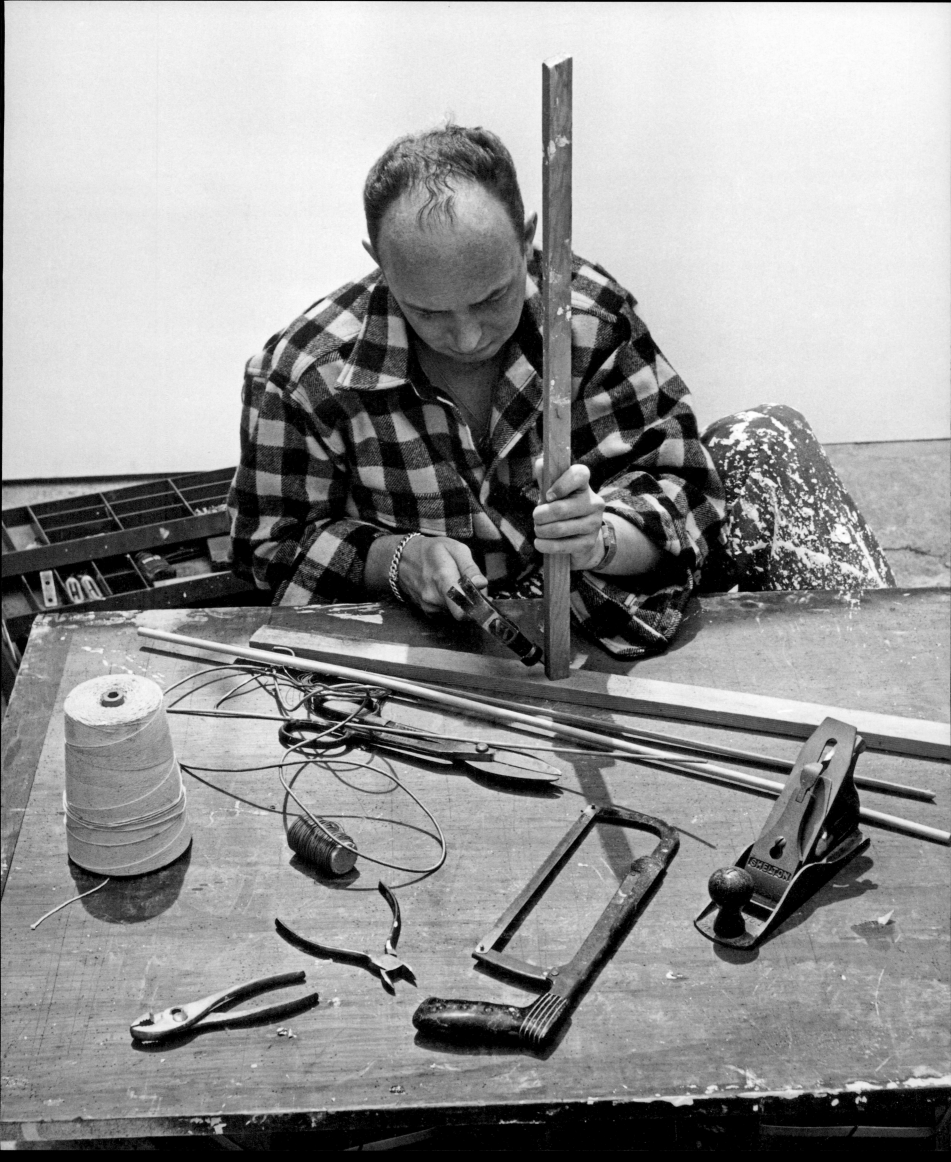

THE DO-IT-YOURSELF
DI MEDICI

Tony shopped until he dropped. He just loved shopping. When we went to a 99-cent store, he would always say, "Oh can I come?" We had the station wagon, and there is this sort of incredibly brightly lit hospital lighting with huge Flash Gordon plastic carts, and he went whipping around the store, piling stuff off every shelf—he thought he was in Aladdin's cave. Tony is the only person we know who could spend $1,000 at the 99-cent store.

Tim Street-Porter

"I WORK EQUALLY WELL WITH GOLD PAPER OR solid gold," Tony would say. When still very young Tony started creating decorative objects, first for his mother and the family house, and later for his own pleasure, with hopes of selling them to others.

And he never re-created anything that he could find in nature. "Why copy a bird feather or a seashell?" he would ask. "I am only interested in using the real thing."

Bird feathers, seashells, frog's skeletons, snake and bird vertebrae—all of these fascinated him and went into his works. As did wire postcard holders, plastic wastepaper baskets, rubber sandals, juice squeezers, and metal vegetable steamers. Like a modern-day Cellini—sometimes using solid gold but more often gold paper—he delighted in using nontraditional materials to derive traditional effects. Rocks and crystals, jewels, and bits of rag and lace all combined to shape his strange and unique creations.

OPPOSITE Tony Duquette in his studio creating an armature for one of his dipped-plaster figurines, c. 1947.

8

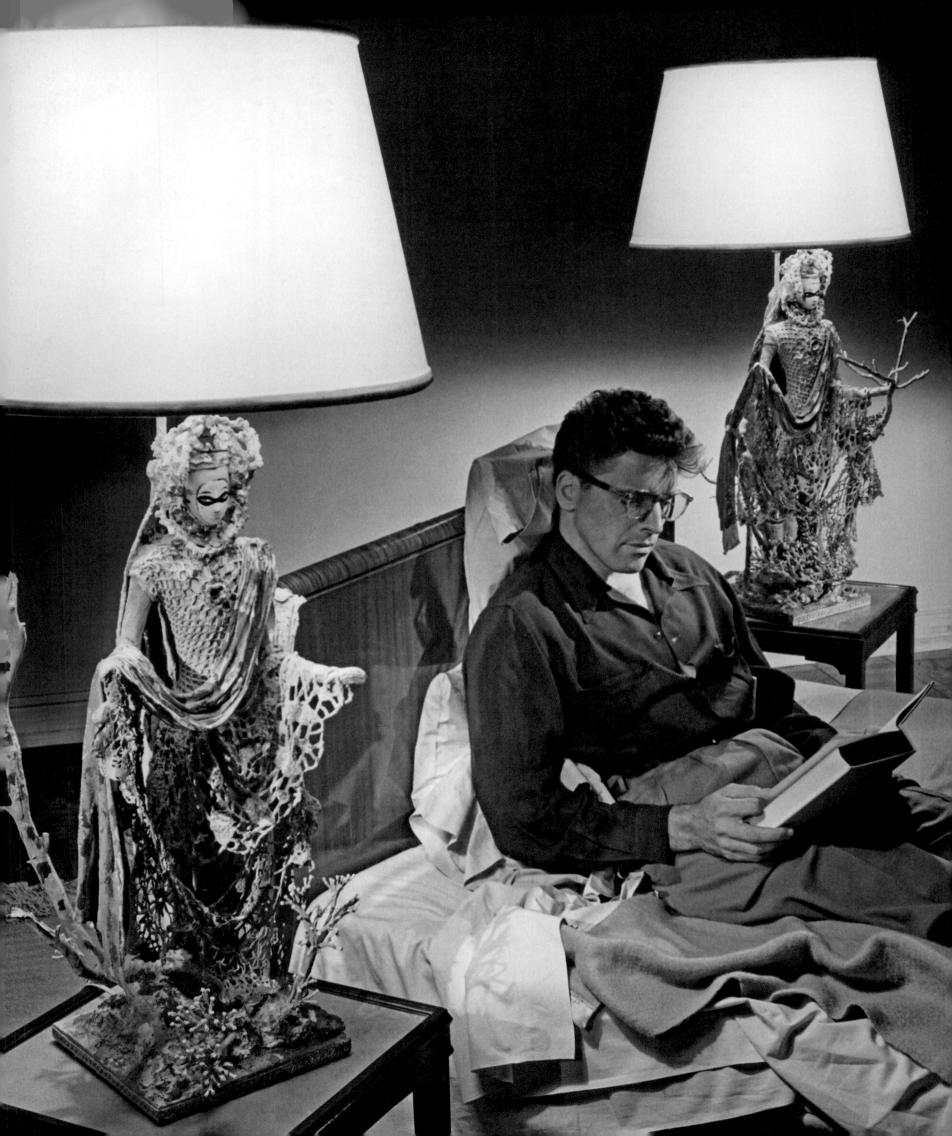

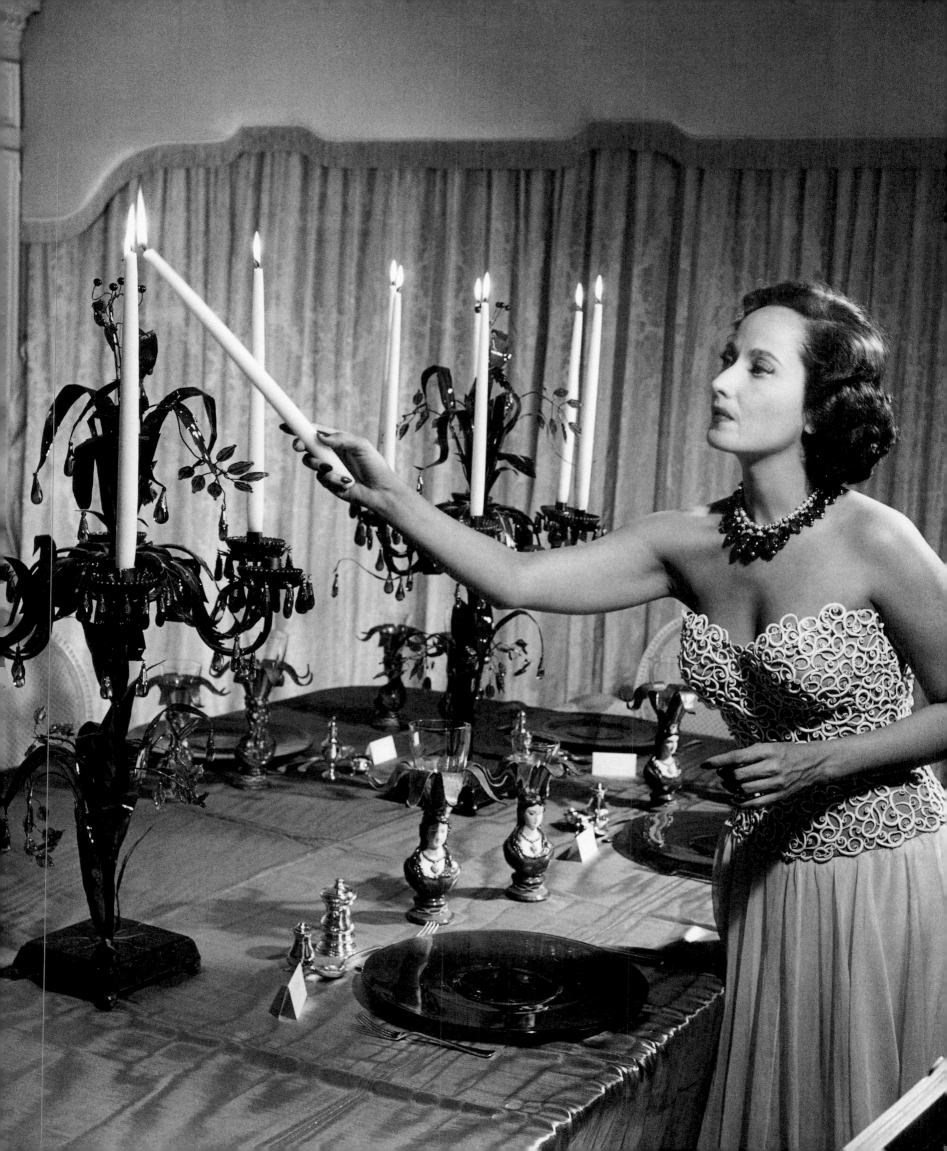

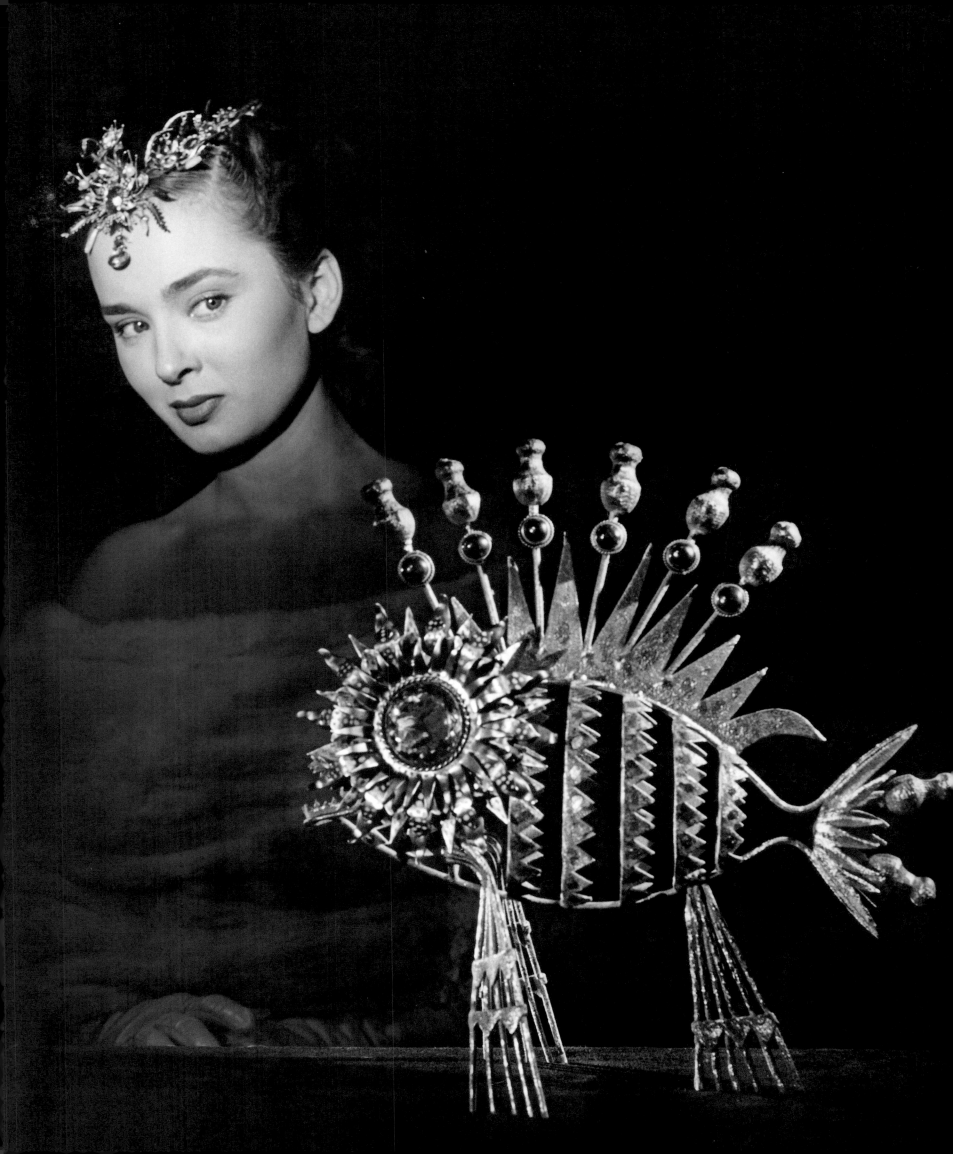

I remember seeing Terry Stanfill's brooch at that party for Tony, and never seen gems like that before. How raw they were. It's a whole different thing than the gems you see today, and the color saturation is so different. I just remember . . . my jaw dropping when I saw it because I think it had baroque pearls and coral and I had never seen anything so beautiful.

<div align="right">ANNA SUI</div>

Tony Duquette's objects often comprised entire worlds of their own, encased in glass or Plexiglas boxes. These also served as three-dimensional sketches for costume designs, just as his bas-reliefs functioned as miniature murals for installation in a plaza or other public space. The tabletop articles he created in the early 1940s, when he hadn't the financial resources to make them in gold or silver, were merely prototypes for luxury items that could not yet be realized.

Recurring themes in Tony's repertoire included chests, screens, mirrors, lamps, figurines, garnitures for dining tables, and objects for entertaining. Tony had an ingrained sense of hospitality that revealed itself from his earliest childhood. Entertaining and setting a table so that it was festive and an interesting topic of conversation was uppermost in his young mind. Using gilded tortoise shells he created silvered chariots that were pulled along by snails, sea horses, or unicorns, with putti, skeletal figures, or stuffed baby alligators (in tricorn hats) holding the reins. These table garnitures held casseroles or cakes and other sweets and were used on Tony's buffets.

There were also eccentric chess sets—though it is questionable Tony ever played chess in his life—that gave him the opportunity to match Incas against conquistadores, Indians against Chinese, and Captain Cook against the Hawaiians on *verre églomisé* chessboards. These "games of chance," as he called them, relied on the freedom of the players to move the objects around and juxtapose them amid other, more serious, decorations.

His first jewel, which he created for his mother, was a "jade" necklace made of painted clay and strung on kite string.

Tony's early jewelry, constructed for his mother and aunts and later for Beegle, was made from antique Victorian pieces found in thrift shops. He would add on to these pieces in silver, soldering other jewels to them— citrines, garnets, and pearls. Realizing that women rarely had the pleasure of looking at their own jewels, as they are either wearing their jewels and then putting them away in a vault at night, he devised a series of decorative figurines that could be placed on a dressing table to hold them. The inventive jewel bearers included strange courtiers, sea people, and fish and insect-men.

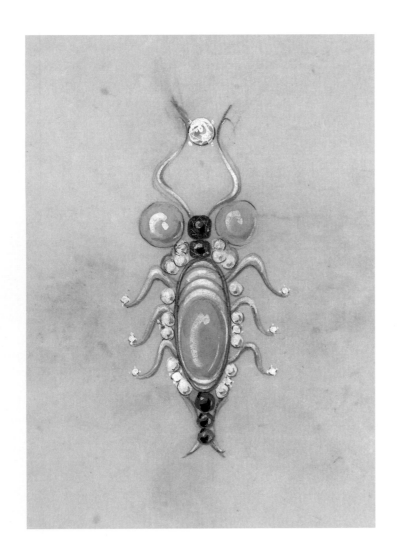

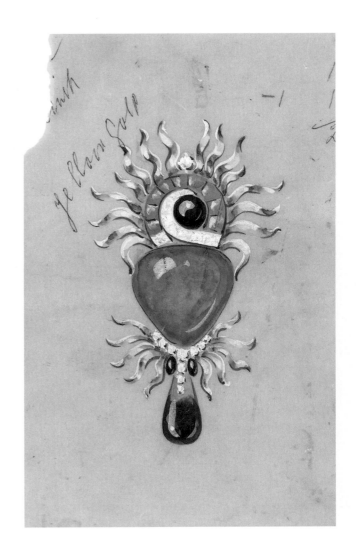

LEFT An original sketch by Tony Duquette for a jeweled insect brooch created as a special commission for Delmer Daves as a gift for his daughter, c. 1960s.

RIGHT An original sketch for a votive heart brooch created for Palmer Ducommun using stones from her mother's collection of old Chinese jewelry, c. 1960s.

OPPOSITE An original sketch for an emerald, diamond, and pearl pendant brooch which Tony presented to Beegle for the opening of the original Broadway production of Camelot.

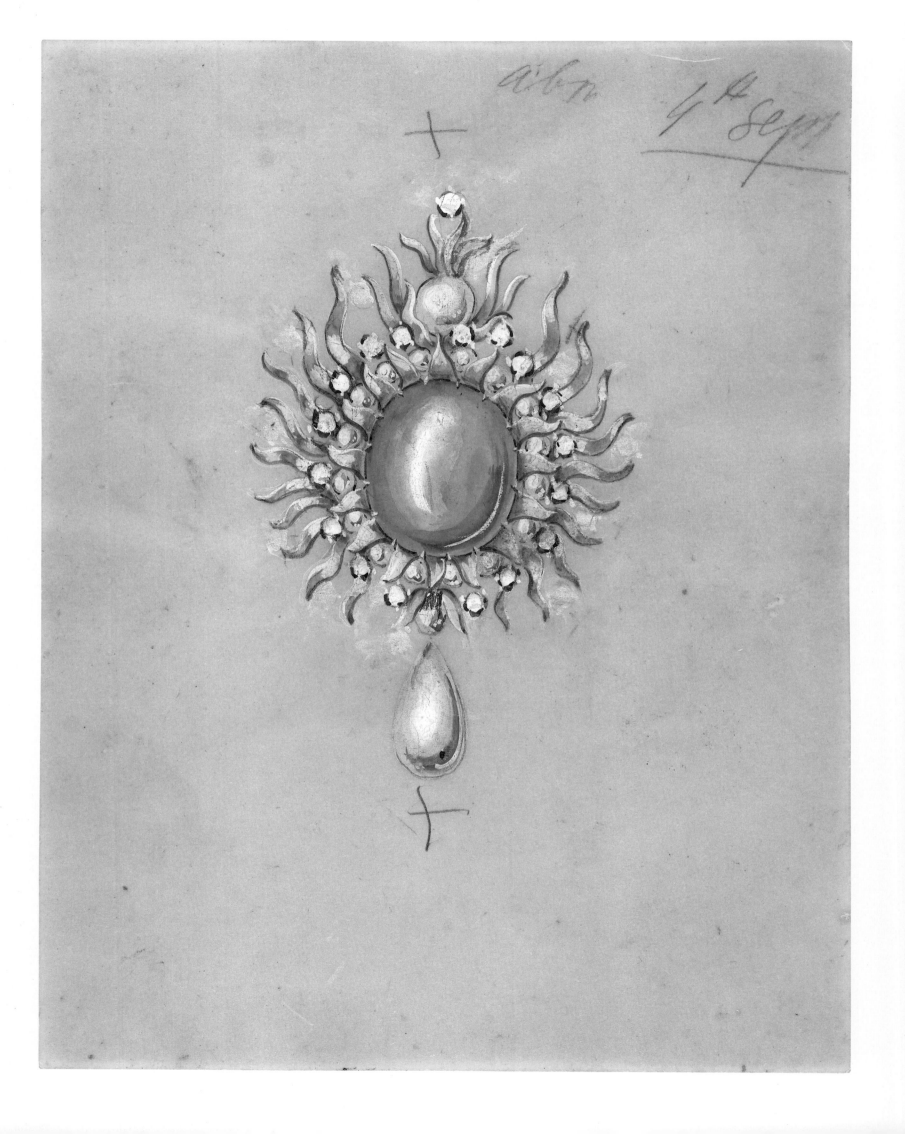

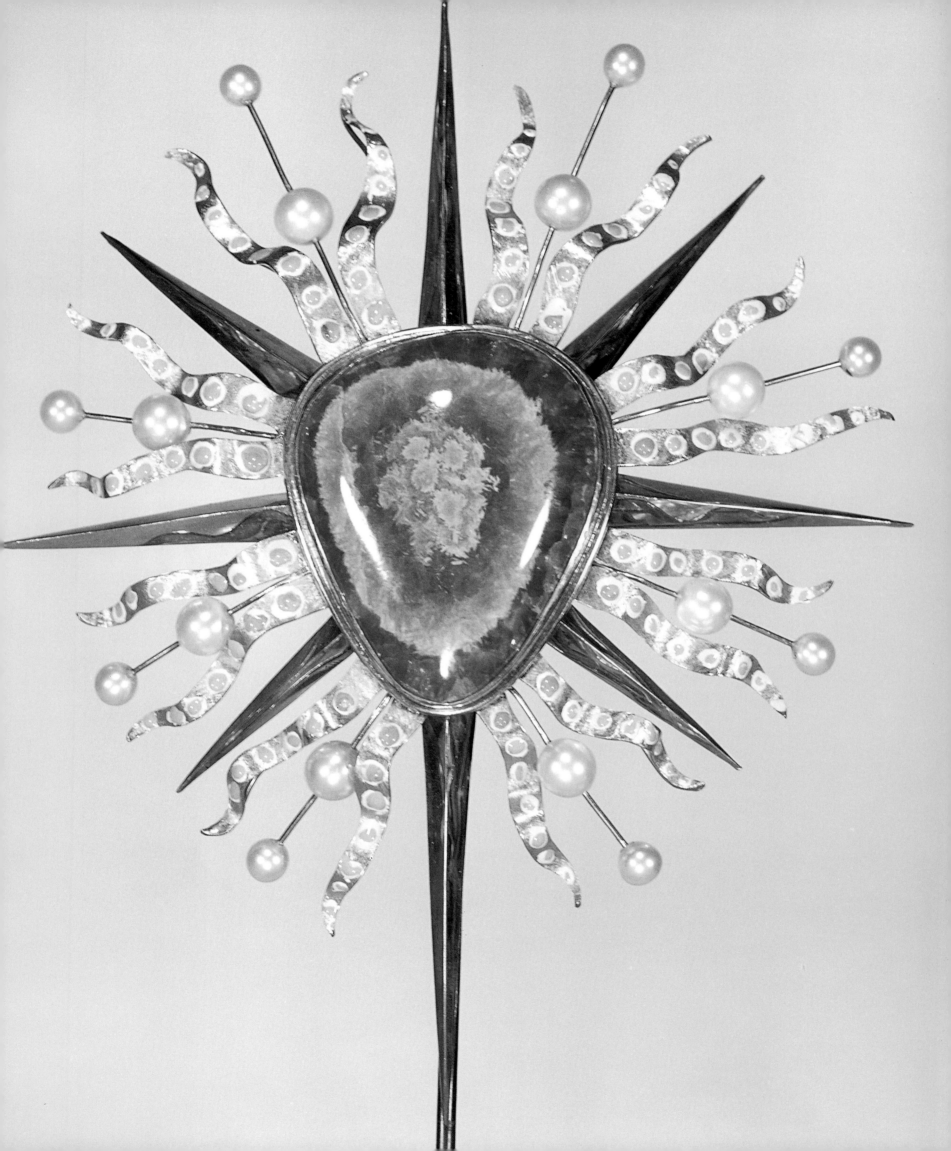

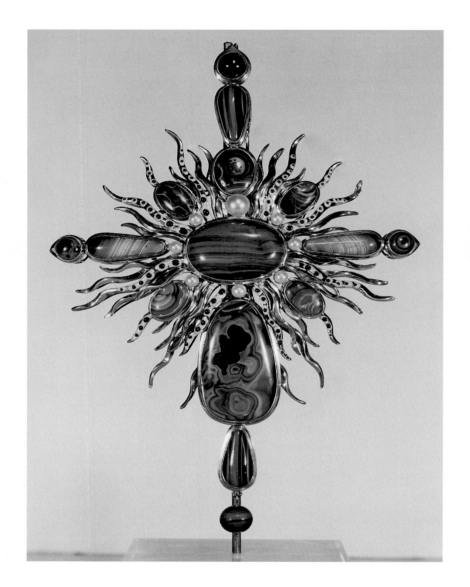

OPPOSITE A rhodocrosite and pearl votive cross brooch Tony created for his Personal Culture exhibition in Los Angeles, c. 1972.

LEFT A malachite and pearl votive cross brooch created for Tony's Personal Culture exhibition.

RIGHT A jeweled seashell Tony created for Susan Vidor set with enameled 18-karat gold and citrines.

OVERLEAF LEFT Tony Duquette created this jeweled brooch using crystal copies of famous diamonds set in enameled 18-karat gold and moonstones.

OVERLEAF RIGHT A jeweled insect in kunzite and amethyst made for Ruth Wilkinson, c. 1960.

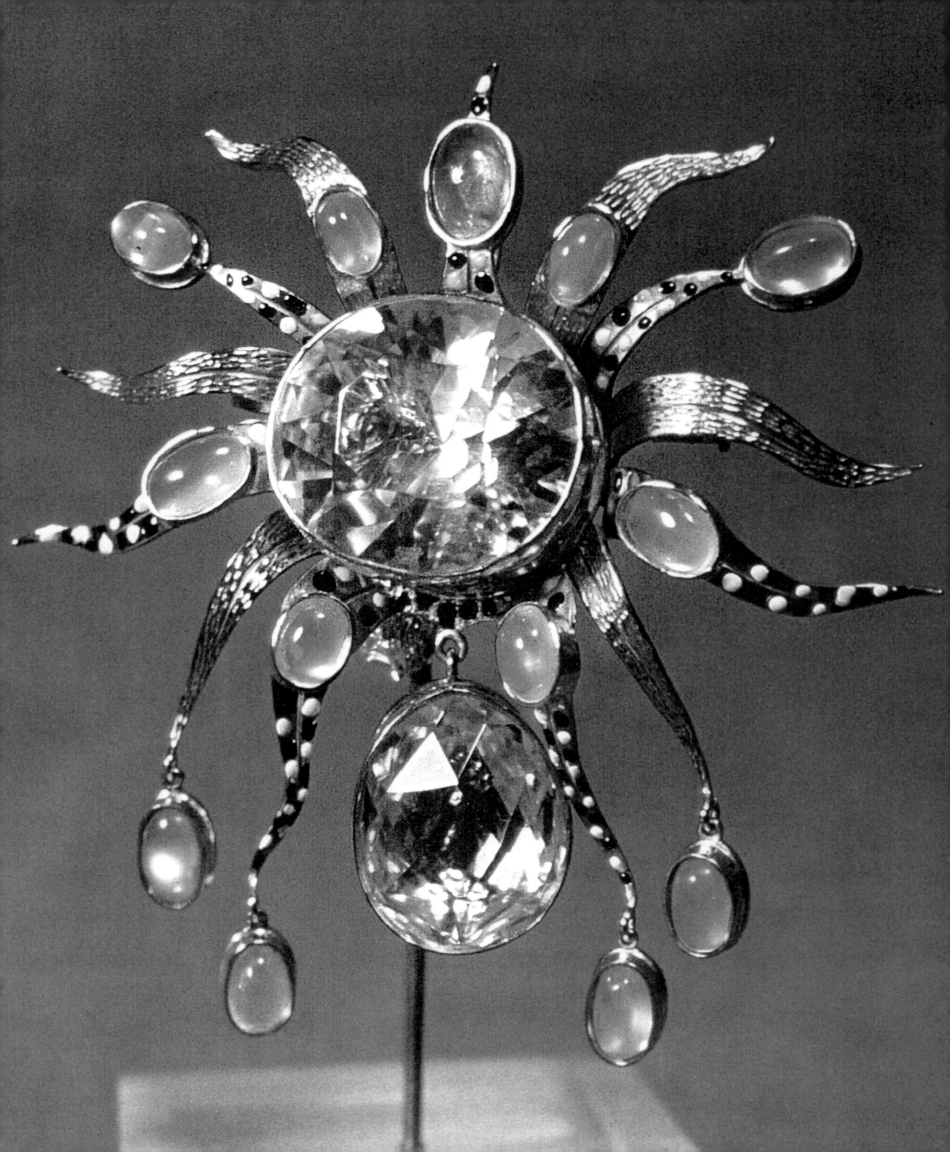

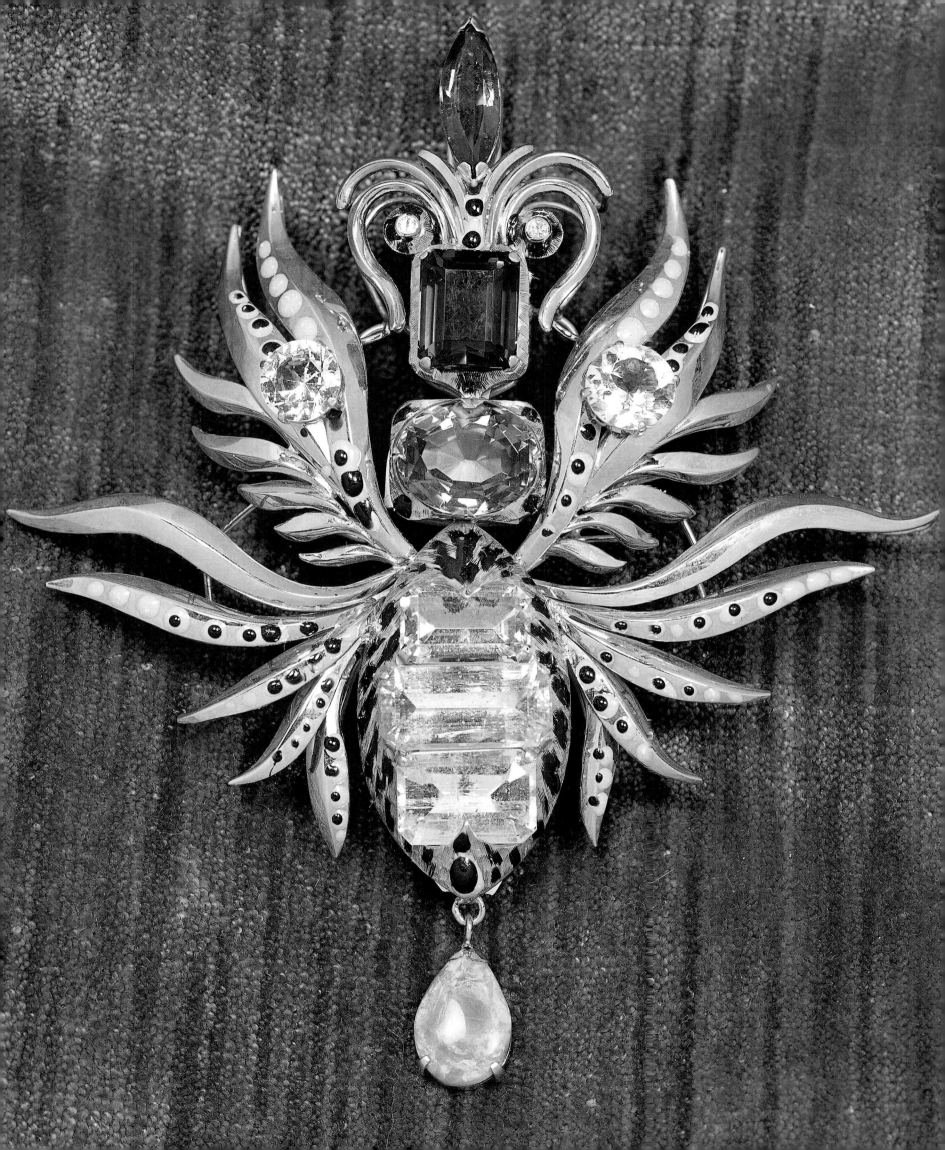

For the party celebrating victory in Europe that Elsa Maxwell gave at New York's Waldorf Astoria Hotel, Elsie de Wolfe commissioned Tony to make a tiara of green Lucite stars "like emeralds." It was probably Tony's first commissioned piece of jewelry.

When they were married at Pickfair in 1949, Tony gave Beegle a heart-shaped amethyst surmounted by a large diamond from his mother's family collection. He had it set in 18-karat gold, in a unique mounting.

In 1950 and 1951, for his exhibition at the Louvre, Tony had the opportunity to have a collection of jewelry made in 18-karat gold. When Elsie de Wolfe introduced Tony to the Duke and Duchess of Windsor, they asked to see his jewelry. Included in this group was a coral cherub with 18-karat-gold wings, diamonds, and pearls. The duchess had a hard time keeping her hands off it, but instead commissioned Tony to make her a necklace of citrine, peridot, and pearls.

Tony found the stones in Paris and had them set as a wreath of leaves and flowers in 18-karat yellow gold. At the time, this design was an innovation, since most important jewels were set in platinum or white gold. When the duke saw the necklace for the first time he asked Tony, "Don't you think the stones are a bit yaller?"—referring to the yellow citrines. But, wearing the necklace, the duchess started a fashion for yellow gold donned in the evening. It was her favorite jewel, and she wore it and was photographed in it throughout her lifetime. Tony didn't sign his work at the time, and when the duchess's jewels were sold

at Sotheby's, he was not credited with the necklace's design.

Following his exhibition in Paris and the success of his commission from the Duchess of Windsor, word got around about Tony Duquette's skill as a jeweler. In fact, his old friend and patron Jimmy Pendleton asked Tony to give up decorating altogether and go into jewelry full time. Later in life, Danielle Haskell—a young friend of Tony's who enjoyed reading palms—told him, "You will be remembered for your jewelry." But Tony was not a gemologist and was not really interested in going into jewelry as a profession. Instead, he was satisfied to make jewels for Beegle and to reset his clients' old diamond bracelets into new creations straight from his imagination.

His best jewelry client had to be Palmer Ducommun, who had Tony reset all the jewels that had belonged to her mother, Mary Gross. The collection he made for her was amazing, and she wore the jewels regularly, to great effect.

Most all of Tony's friends and clients had at least one special piece that he had designed for them using their own stones. Edna Smith had a magnificent brooch of cabochon emeralds and diamonds that Tony designed so that the center stone could pop out and be worn as a ring. Mary Lou Daves, who prayed every night that her husband—the famous Hollywood writer, producer, and director Delmer Daves—would break down and buy her a diamond bracelet from Cartier, gave Tony all her husband's gifts of Victorian cameos and diamond bow-and-circle brooches to make into something more unusual. Delmer, who was a bit of a rock hound, gave Tony a handful of stones he had quarried to make three brooches, one for each of his daughters, Debby and Donna, and one for his daughter-

OPPOSITE Elizabeth Duquette's wedding ring, which Tony designed using a heart-shaped amethyst surmounted by a diamond and set in an 18-karat gold cage, c. 1949.

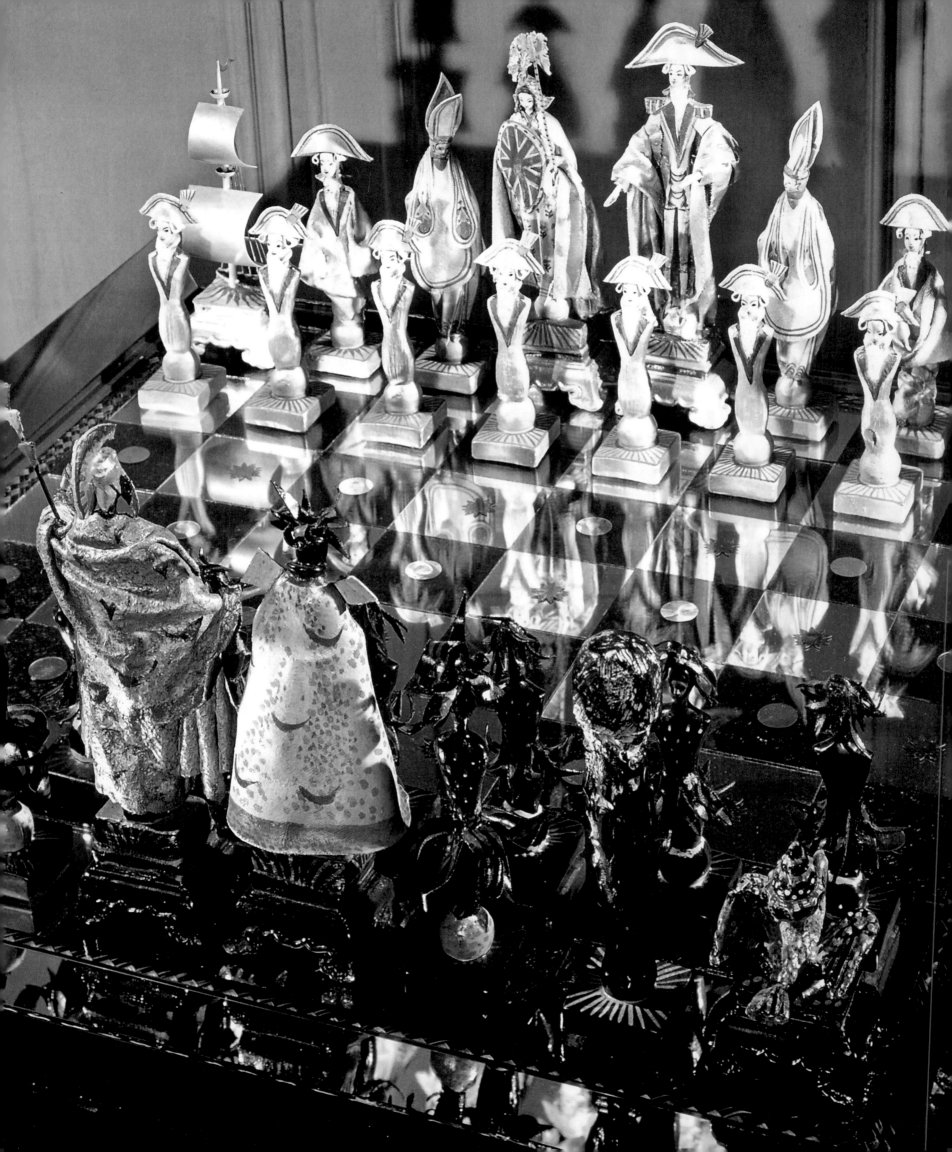

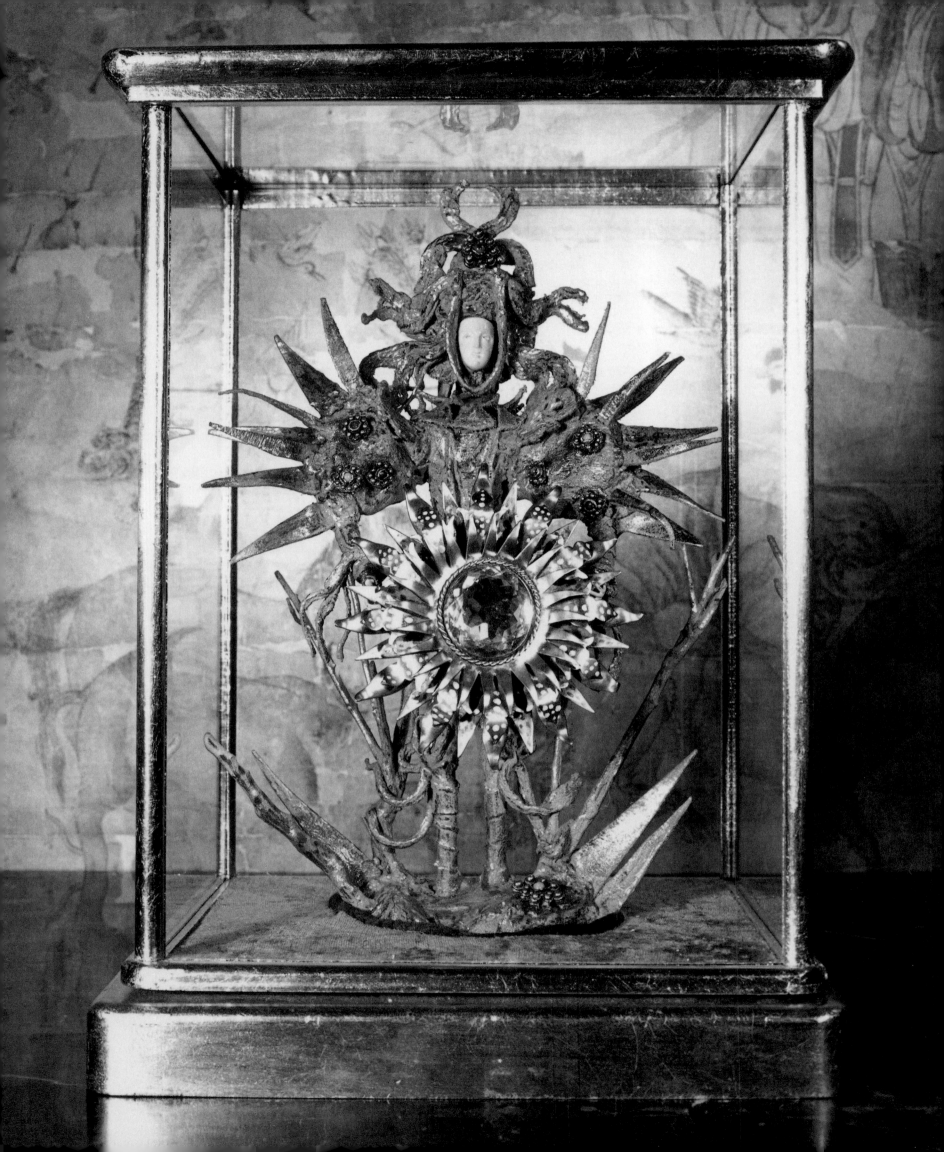

in-law Diana. Tony turned these bits of turquoise and malachite into dazzling insects set in 18-karat gold. Later Mary Lou purchased several brooches from Tony's Personal Culture exhibition, and Debby, whom Tony had known since she was a child, asked him to design her wedding ring.

Not everybody loved Tony's imaginative creations, however. Beverly Hills socialite Ginny Milner gave Tony a sackful of emeralds, which he set into a necklace using the vertebrae of a rattlesnake he had killed out at the ranch. Beegle and her cook were given the delectable job of boiling the snake until the bones were clean of meat, and then Tony bleached the vertebrae and had the emeralds and bones set in 18-karat gold. Ginny Milner hated the necklace, never wore it, and promptly had the stones reset by another jeweler in a more conventional way.

Furniture moguls John and Eleanor McGuire, on the other hand, loved Tony and Beegle and their inventive designs. John purchased from Tony a brooch made of black pearls and shark teeth and commissioned him to set a collection of fluted emeralds—from the Maharani of Baroda—into a necklace for Eleanor, a commission that Tony made the drawings for, but unfortunately never realized.

Dennis Stanfill, chief of 20TH Century Fox, asked his daughter Francesca to help him select a Tony Duquette jewel for his wife, Terry. The citrine egg with moonstones and garnets from Tony's Personal Culture exhibition long remained one of Terry Stanfill's favorite jewels. After Beegle died, Tony gave Terry a parure of coral and diamonds from Beegle's jewelry box, which he knew she would appreciate.

From 1951 to 1989, when his San Francisco pavilion was destroyed by fire, Tony continued making jewelry every now and then. After the fire, Tony went around the world, starting in Hong Kong, and then moving on to Singapore and India. All along the way Tony shopped and shopped, not only for textiles, furniture, and carvings, but also for gemstones—thousands of them—pounds and pounds of unset gemstones.

Every now and then, when people came over for dinner, Tony would haul out a box of jewelry which he would invariably give away. High-powered executives at Bergdorf Goodman in New York, got wind of the jewelry and asked to see it. Tony went to New York to show what he had done, and fortunately, he had the good sense to bring along some of Beegle's personal jewelry in 18-karat gold and precious stones as well.

Although the Bergdorf executives loved the creativity of the gold-plated silver, they understood the salability of the 18-karat gold pieces. They immediately commissioned the Tony Duquette Collection. The concept was still the same, one-of-a-kind pieces only, hand-crafted in America with 18-karat gold. The first collection was an immediate success, garnering major interest from the fashion press and fashion designers. Oscar de la Renta asked to use the jewelry for the Balmain couture collection in Paris on two different occasions, and for his own collection in New York. Other designers—including Badgley Mischka, Tom Ford, and Andrew Gn—also included Duquette jewelry in their fashion shows. After Tony's death in 1999, Tony Duquette Inc., under the direction of Hutton Wilkinson, continues making one-of-a-kind pieces, based on Tony's personal aesthetic.

Old friends like Nan Kempner, who was the daughter of Tony's decorating clients Al and Irma Schlesinger, purchased many pieces of Tony Duquette jewelry.

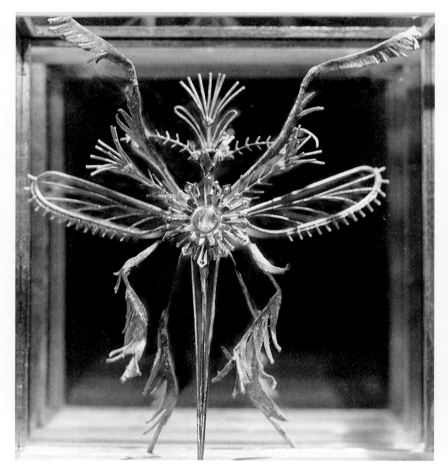

LEFT A unique chess set designed by Tony Duquette, pitting Captain Cook and his sailors against the ancient Hawaiians in their feathered capes and headdresses.

RIGHT Tony created unique costumed figurines and caparisoned animals to hold his jewelry under glass as decorations for his clients' dressing tables.

ABOVE LEFT A jeweled insect figurine c. 1947 shown with a citrine and gold brooch.

ABOVE RIGHT An ostrich egg mounted as a decoration by Tony Duquette for his one-man exhibition at the Louvre's Pavilion de Marsan, c. 1951. It was later purchased by Mary Pickford and Buddy Rogers.

Beverly Hills in the 1960s was one of the most social cities in the world. More so than Paris, London, or Rome, because they had the mixture of Hollywood and the socialites of Los Angeles. The parties at the Duquettes were unbelievable. The way they entertained. And I'll never forget the first time I came in there and the floor was malachite, and I said, "Oh, look at this malachite floor." And Tony said, "We painted it to look like malachite, it's plywood." It was all created. Everything around you was created. I mean you turned this way and that way and it was magic.

GUSTAVE TASSELL

Tony's mother instilled in him a sense of hospitality, as well as impeccable manners and a sense of propriety, all of which stayed with him throughout his life. He knew that when he was invited out it was his duty to dress attractively, to be amusing, to ask the hostess and everyone else at the table to dance, and to reciprocate the invitation. He was what Elsie de Wolfe called a "trained seal."

In the 1940s, when Tony was first stepping out into social Los Angeles under the wings of Elsie de Wolfe, this kind of conduct was a no-brainer. "In those days," Tony would say, "the movie stars wanted to live like ladies and gentlemen, and they knew how to behave. Today they only want to be actors and actresses. They don't want to be stars and they prefer to live like slobs."

The changes in the world around him never stopped Tony from living the only way he knew how: with constant, convivial entertaining, complete with liveried footmen, orchestras, vermeil service for 150, and variety in decorations and themes.

OPPOSITE The Duquettes opened their new house, Dawnridge, hosting a *bal derriere*, or bustle ball. Here Tony and Beegle are greeting Mr. and Mrs. William Riley. Invitations specified white tie for the gentlemen and gowns with bustles for the ladies.

In the 1940s and 1950s the Pendletons hired Tony to create extravagant decorations for their many themed parties. Tony remembered these as regular, if not monthly, extravaganzas. Most memorable were the paper- and Oriental-themed balls, for which Tony provided the decorations.

One of the first parties Tony and Beegle gave at Dawnridge, their *bal derrière* — for which all the women were invited to wear bustles on their gowns — was both a christening for their new home and an amusing antidote to two other balls given in Los Angeles that month — both of which promised to take themselves too seriously. Of course Tony and Beegle attended the *bal de tête* and *bal masque*, and contributed costumes for their special clients, but their private ball turned out to be more fun!

Simple dinners at Dawnridge were always black tie and always included an after-dinner *divertissement*, such as a performance by a troupe of Balinese dancers, a Russian balalaika ensemble, Spanish flamenco dancers, the Indian dancers Sujata and Ashoka, or some other exotic entertainment.

The opening-night party at the Robertson Boulevard studios featured costumed footmen

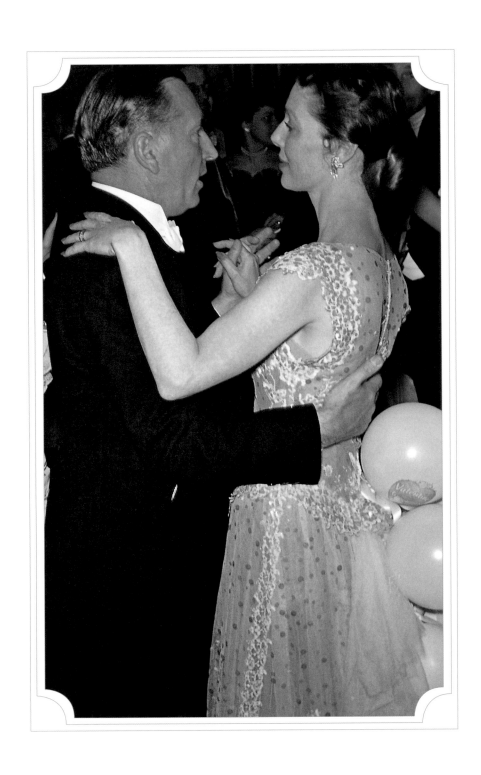

ABOVE Loretta Young dances at the *bal derriere* wearing a bustle made of balloons.

OPPOSITE Mrs. George Newman, Mrs. Nash Carlan, and Mrs. Ed Harrison at the ball.

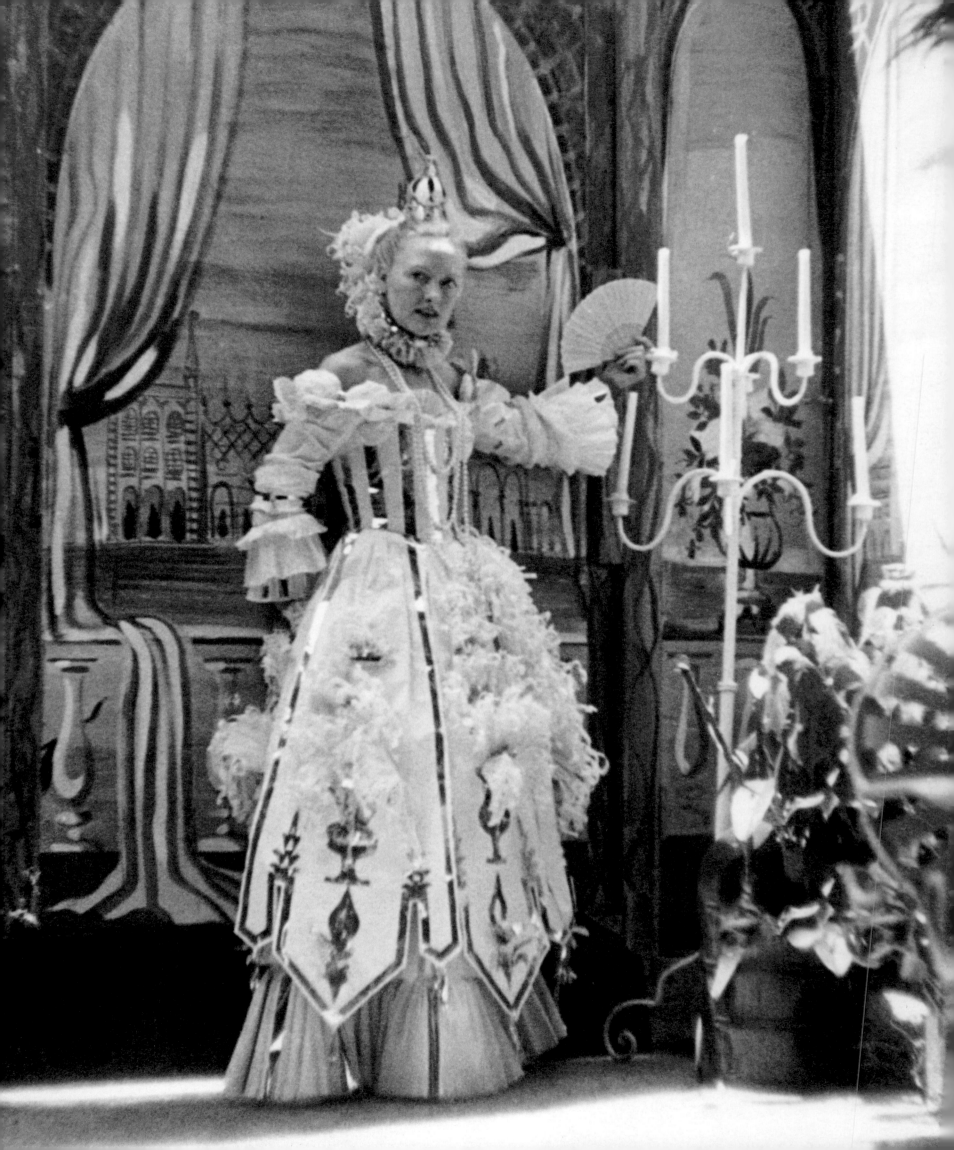

OPPOSITE Beegle poses at the old Fountain Avenue studio in her costume for Jimmy and Dodo Pendleton's paper ball. Tony created her costume entirely of paper.

ABOVE Beegle wore an Adrian couture gown in bianchini silk taffeta with cascading moonstone earrings designed by Tony to the opening of the Tony Duquette studios, c. 1956.

dressed in eighteenth-century Venetian livery (which Tony had purchased from the Baroness d'Erlanger) and holding silver candelabra as they lined the walk from the curb to the red-carpeted steps before the entrance. This formal party meant white tie and tails for the gentlemen and ball gowns for the ladies. Beegle greeted her guests in a one-off Adrian gown in Bianchini silk taffeta. The party, specifically a dance, started at ten o'clock. The guests arrived from dinner parties—including one hosted by the Patinos—that had been arranged in private houses all over town. In the ballroom an orchestra played for dancing, and a supper was set out at midnight.

Tony had prepared three original *divertissements* for his guests' pleasure. There were two original ballets, complete with Duquette costumes and sets, and Agnes Moorehead playing Sarah Bernhardt as Phaedra.

"The studio on Robertson, well it was strange, it was theatrical," Frances Brody remembered. "You walked in and it was a stage, and it was consciously a stage. It was deliberately a stage—there was no doubt about it. And he entertained divinely there. They all did in the old days."

At other parties at the Duquette studio, Tony would astound his guests with square dancing; or gamboling; or a specially created Chinese ballet, complete with original Duquette costumes and headdresses. There would always be a surprise: tables set behind the stage curtain, an unexpected guest of note, a (tame) leopard on a leash mingling among the guests, or a pet peacock brought in for cake. One night, the peacock, whose name was Sebastian, was startled by a visiting cheetah and flew to the ceiling, landing on one of the branches of the central chandelier. The butler, Jeff, had to coax the bird down with pound cake until it landed on the tea cart and could be wheeled out of the room.

There was always an occasion, always something to look forward to. Arthur Rubinstein, Igor Stravinsky, Leonard Pennario, and even Oscar Levant were known to perform on the Steinway after dinner, as were Bobby Short and Michael Feinstein. Stravinsky told Tony, "In this room one should only play very ancient music or very modern music." Max Showalter would sing songs for his newly proposed Broadway musical, and Judy Garland was known to have cried to the guests assembled around the piano, "Let's all sing really loud!"

New and exciting guests and visitors were always passing through Los Angeles. Gottfried and Sylvia Reinhardt from Salzburg, Tamara de Lempicka from Cuernavaca, Dolores del Rio from Mexico City, Claudette Colbert just in from Barbados, or Merle Oberon—descending the staircase. When Clare Booth Luce was present, all table conversation would stop so guests could hear what she had to say. Anita Loos came by with her niece Mary Anita; they spoke about old Hollywood and Hearst and Marion Davies. Always invited were the movie directors Vincente Minnelli, George Cukor, and King Vidor. Liza Minnelli came with Robert De Niro, or Desi Arnaz, Jr., or Marisa Berenson—you never knew who Liza was going to bring.

The dress designers were represented by James Galanos, Gustave Tassell, Jean Louis, and Sybil Connolly, all of whom had dressed Beegle beautifully. Margot Fonteyn and Rudolf Nureyev were guests of honor at the Duquette studio the night after they were released from prison in San Francisco; the dancers had

OPPOSITE Opening night at the Tony Duquette studios on Robertson Boulevard in Los Angeles, c. 1956.

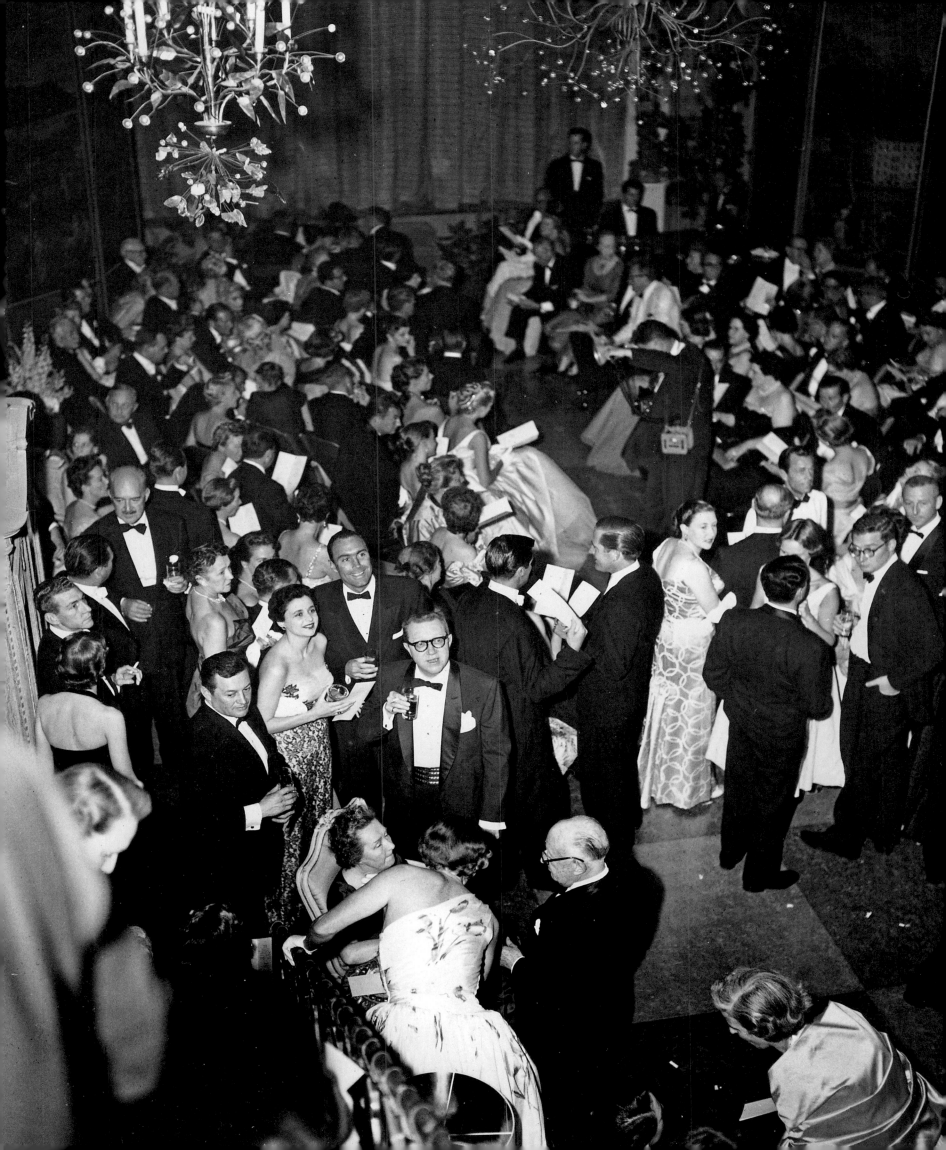

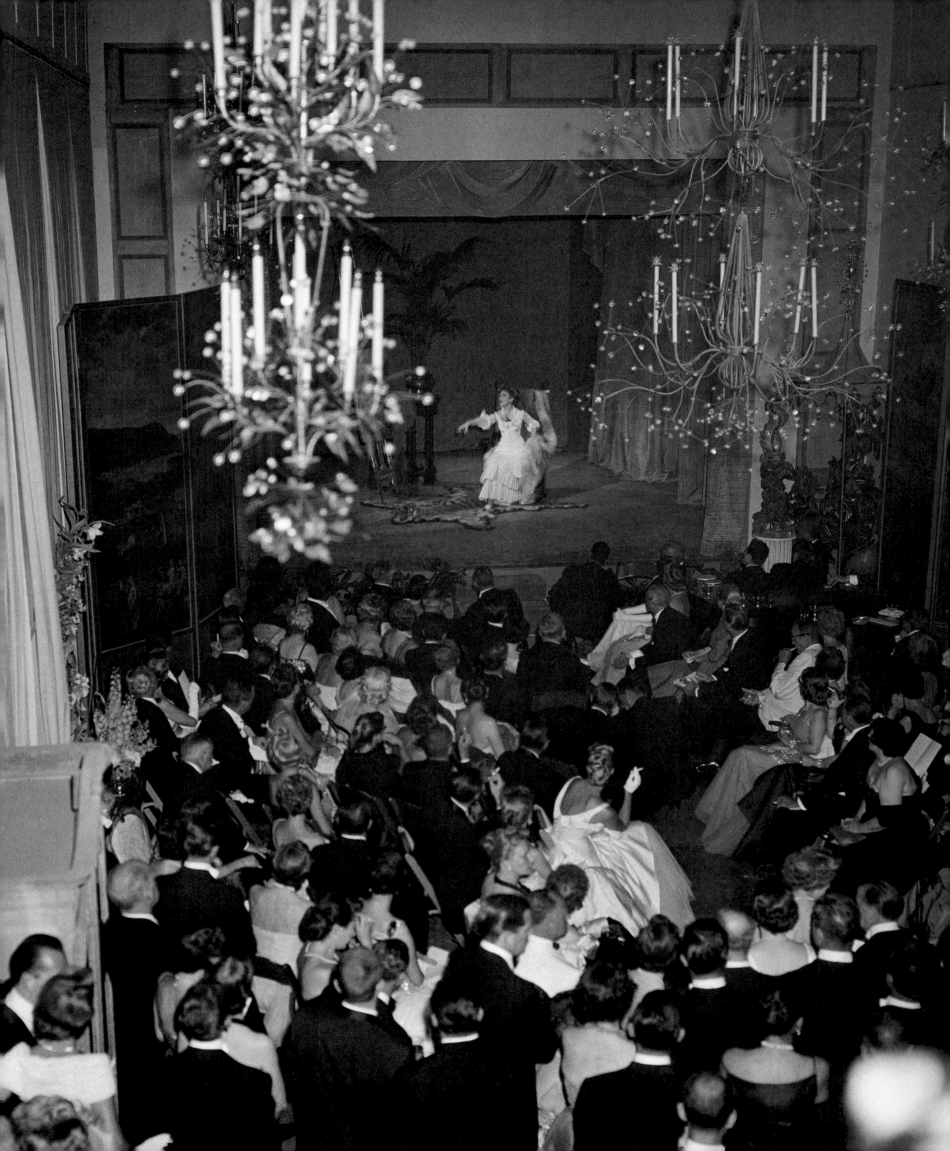

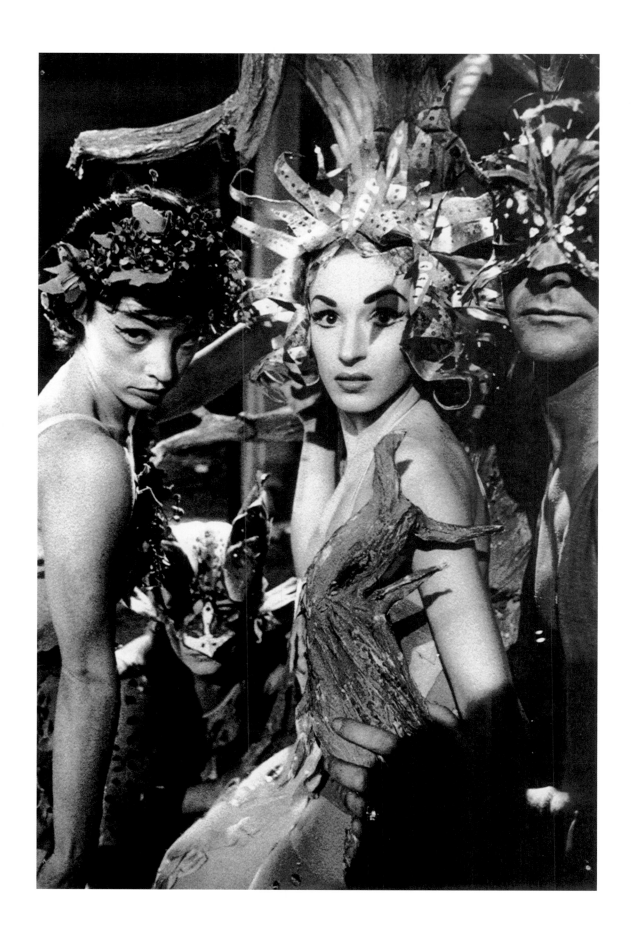

been arrested when the party they attended in Haight-Ashbury was raided for drugs. Nureyev and Fonteyn arrived directly from the airport; of course, their adventure was the discussion of the evening. Tony debuted a new "physchodelic" light show that evening to his guests' delight, and Nureyev took great pleasure in helping the technicians work the lights. Later, when Nureyev disappeared, Tony found him trying on all of his hats in the mirror outside his office. This scene enchanted Tony, and the two began trying on hats together. Art-world figures, too, joined in the fun at the Duquettes', including Andy Warhol, Roy Lichtenstein, Salvador Dali, and the dealers Margo Leavin and Irving Blum.

Guests of royal stature were favorites of Tony's, and all the visiting maharajas—including Kapurthala, Mysore, and Indor—were feted at the studio, as were various English lords, dukes, and knights. Other guests included Princess Grace and Princess Caroline of Monaco, as well as French counts and viscounts and a number of Spanish grandees, Russian pretenders, and the Portuguese Duke de Palmela.

Hollywood royalty were also invariably in attendance, including Gregory Peck, Burt Lancaster, Irene Dunne, Janet Gaynor, Loretta Young, Richard Burton, and Elizabeth Taylor. The collectors were represented by Norton Simon, J. Paul Getty, Douglas Cooper and his son Billy McCarty Cooper, Henry McIlhenny, Wright Ludington, and John Gregg Allerton. Society was represented by Alfred and Betsy Bloomingdale, Nan Kempner, Dolly Green, Doris and Jules Stein, and Dorothy and Norman Chandler. Authors such as Christopher Isherwood, Dominick Dunne, Ray Bradbury, and Will and Ariel Durant were also frequently invited.

Young people—debutantes and the handsome sons of Tony's friends—were always close at hand. He felt you also needed to invite "people with talent—artists, writers, actors—young people to give the party vitality, and always at least one very beautiful woman."

These groups of friends were never what Tony would call a "mixed bag." He hated such a motley idea, and always made sure that the people he invited would be comfortable with one another and contribute to the evening's overall ambiance. The studio was a constant whirl of activity, with Tony and Beegle giving at least one black-tie dance each month to honor special friends or to celebrate a birthday or anniversary—any excuse for a party was a reasonable one.

One of Tony and Beegle's most famous parties was the ball they gave in honor of Princess Lalanesa, the sister of the king of Morocco. The Duquettes invited all of social Los Angeles to meet their friend. Everyone arrived in advance of the princess's making her spectacular entrance down the Venetian staircase on Tony's arm.

In the 1960s Tony and Beegle invited their friends to their ranch for what they called a "Spa Ma Ma," which was a kind of love-in for rich hippies. It was designed to be a day of health food, exercise, meditation, and good fun. The hour for the guests to arrive came and went, and Tony was getting nervous as all his parasols, flags and banners, Oriental carpets, pillows, flowering plants, and buffets

PREVIOUS SPREAD
LEFT Guests at the opening night party for the Tony Duquette studios enjoyed three original *divertissements* between dancing and supper. Here Agnes Moorehead plays Sarah Bernhardt as Phaedra on the studio stage.

RIGHT A dancer during a performance at the opening night party.

OPPOSITE Beegle and Tony prepare to greet their guests at the opening night party of the Tony Duquette studios on Robertson Boulevard in Los Angeles, c. 1956.

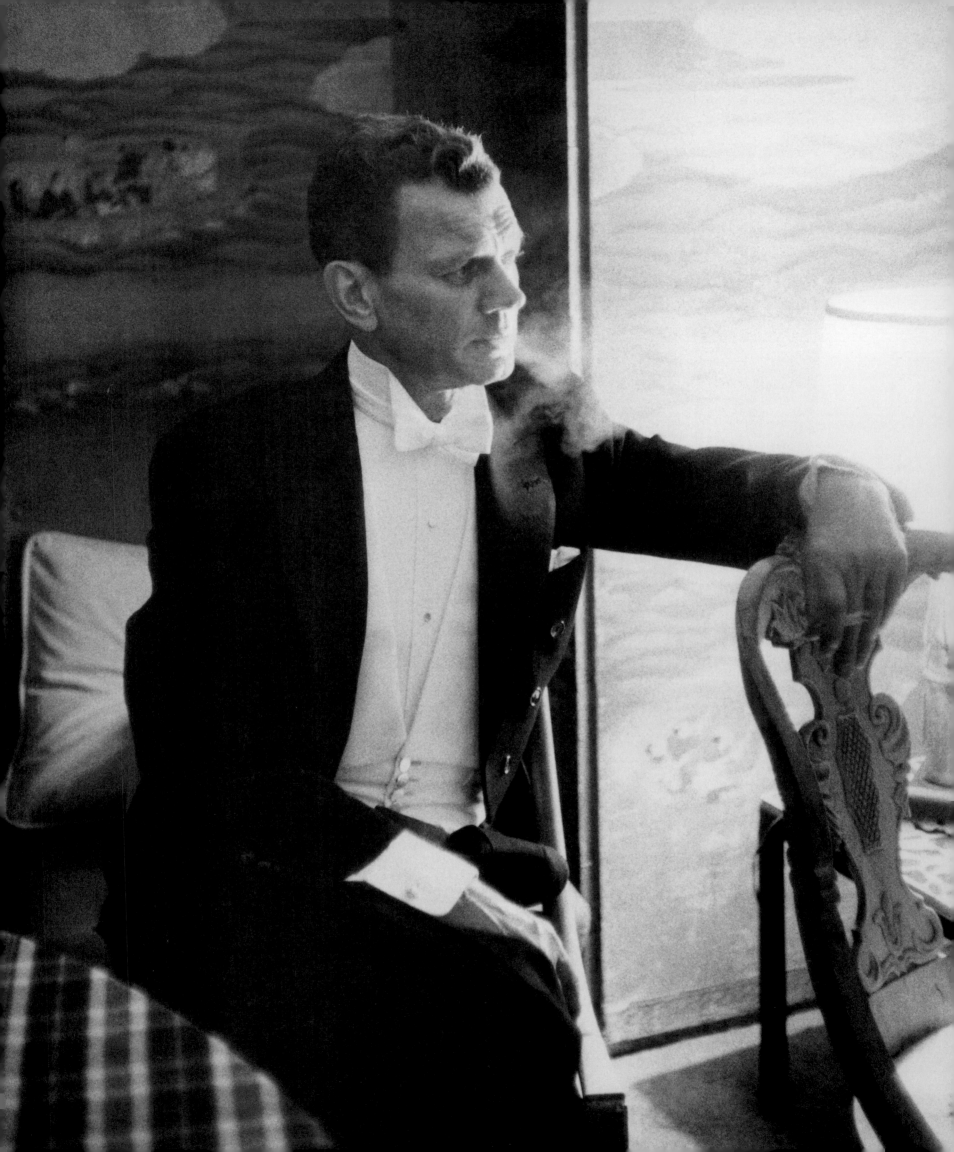

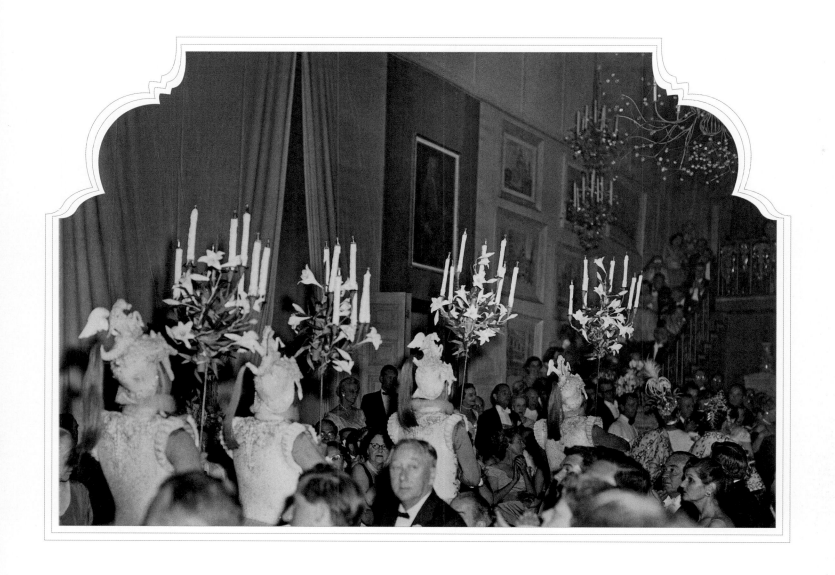

OPPOSITE Actor Joseph Cotton at the opening night of the Tony Duquette studios in Los Angeles, c 1956.

ABOVE Costumed attendants announce the beginning of one of the *divertissements* at the opening night party.

had been placed, raised, laid, arranged, and prepared in a frenzy of work that had begun at sunrise.

The minutes passed, then a half hour, then an hour, and then Tony saw the first car slowly rounding the treacherous bend in the mountain road. He saw the caravan of Rolls-Royces weaving their way around the mountain, very, very slowly, until they finally made it to his eighteenth-century gates. Tony thought the sight of that caravan was the funniest thing he had ever seen, "the rich folk going to the country for a Spa Ma Ma!"

It must have been tremendous fun, because Tony never stopped talking about that day and always wanted to re-create it. Instead, he regularly entertained at the ranch with Mexican food and mariachis, sometimes for as many as 150 guests.

One of the great parties given in Los Angeles with Tony's help was a *durbar* hosted by George Frelinghuysen. A descendant of the Vanderbilts, George was well known in Los Angeles for his magnificent and varied collections of decorative arts, as well as for his generous hospitality. He hired Tony to re-create the *durbar* given for and attended by Queen Victoria and Indian potentates and maharajas. Tony went all out, taking down all the crystal chandeliers at the Beverly Hills Hotel and installing his own creations for the night. There were papier-mâché tigers, giant cobras, belly dancers, and all kinds of entertainment—including the actress Ann Sothern. She was a friend and a guest, but she was also asked to portray Queen Victoria, thereby making her George's guest of honor.

OPPOSITE Guests at the opening night party for the Tony Duquette studios included Rosalind Russell, Mary Pickford, Buddy Rogers, Joseph Cotton, Henry Fonca, and Oscar Levant.

Tony was hired to do his share of parties in Los Angeles, but it was San Francisco that really appreciated his talent for entertaining. Mrs. William Matson Roth, the Matson steamship heiress, was by far his most important client in this respect. At her fabled home Filoli, which is now registered with the National Trust for Historic Preservation, Tony was known to plan parties a year in advance, usually for the debut balls of her favorite granddaughters.

These extraordinary parties often cost as much as $300,000 for the decorations alone. In the 1960s this was considered an enormous fortune, yet Mrs. Roth hired Tony over and over again to create magic for her soirees. When discussing the ornamentation for a particular party, Tony mentioned to Mrs. Roth that he would like to create giant bouquets of sunflowers "like those seen in Flemish paintings." Several months later Mrs. Roth called him up and asked him to come to San Francisco. She picked him up from the airport and drove him immediately through field after field of sunflowers. "Will this be enough sunflowers for you, by party time next year?" she asked. Tony was floored, of course, not only because she owned the fields of flowers but because she had actually listened to what he had said and had the forethought to prepare so many months in advance.

For Lurline Roth he created an "Undersea" ball, with shell-encrusted walls, obelisks, and chandeliers, and tents and tablecloths in pale blue felt with gauze overlays. Then there was a "blue and white Chinoiserie" ball, with everything painted to resemble blue and white Chinese porcelain. And there was the Flemish-themed ball described above, with the flowers and decorations looking as if they came out of an old Dutch painting.

One of Tony's greatest extravagances for Mrs. Roth was to light the mountains far in the

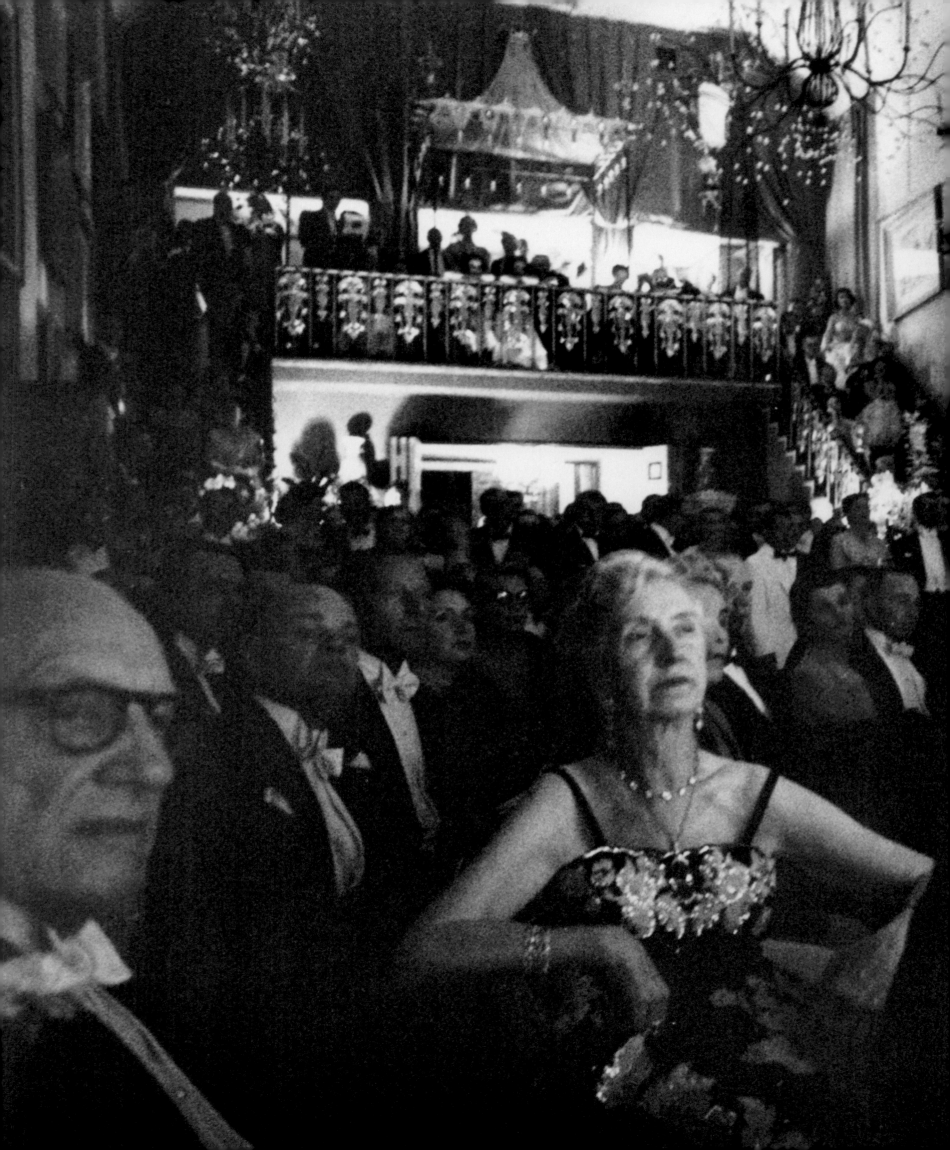

distance; when breakfast was served, around four o'clock in the morning, the electricians would turn the floodlights up very slowly, on a rheostat, and it would appear that the sun was coming up. Then there were the parties for Mrs. Roth that were not given at home, but at the Burlingame Club. These were amazing debuts, in pink-and-white-striped tents with patchwork tablecloths; or in tents lined in yellow and orange Thai silk, the clothes and chairs in Thai silk with gauze overlays.

A party for the debut of author Danielle Steel's daughter Beatrice Lazard was to be a re-creation of the famous snow scene from *Doctor Zhivago*. Tony built a ballroom inside the ballroom, all made of French windows, some with broken-glass panes that had dead tree branches coming through them. Snow was everywhere, outside and inside the ballroom, all white and crystalline. Even the votive lights on each table were made to look like shards of ice lighted from within by flame.

An eighteenth birthday party for John Rosekrans's granddaughter was one of the final parties that Tony worked on. An *Arabian Nights*–themed ball, to be given at the San Francisco museum the Palace of the Legion of Honor, was to top all others yet staged by Tony. Planning began a year in advance, and five trips to India were necessary to order all of the special decorations and costumes for the various waiters and attendants. One million dollars and five days of intensive labor by a team of workers went into readying the forecourt of the museum for the Rosekrans's guests.

The valets wore embroidered costumes and turbans, and costumed attendants escorted the guests up to the front door under antique

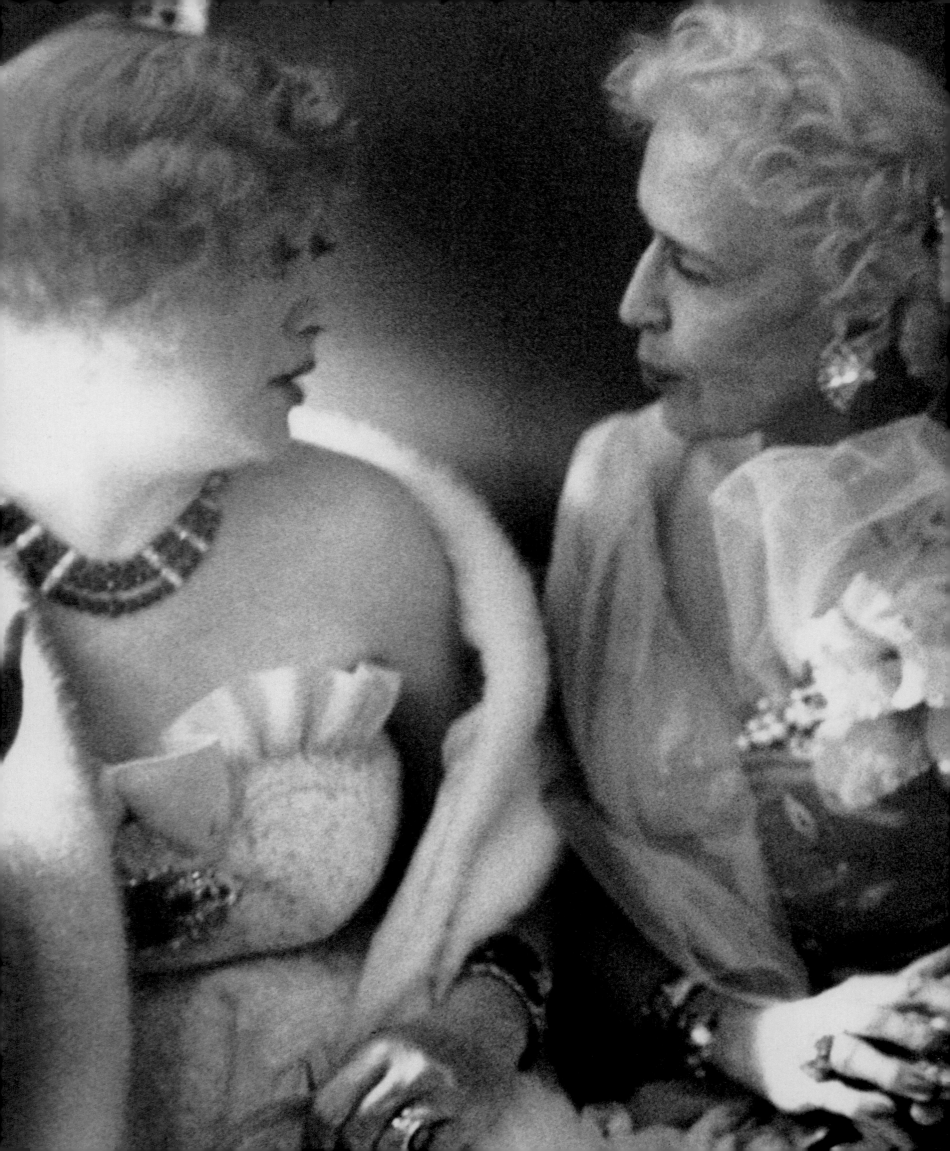

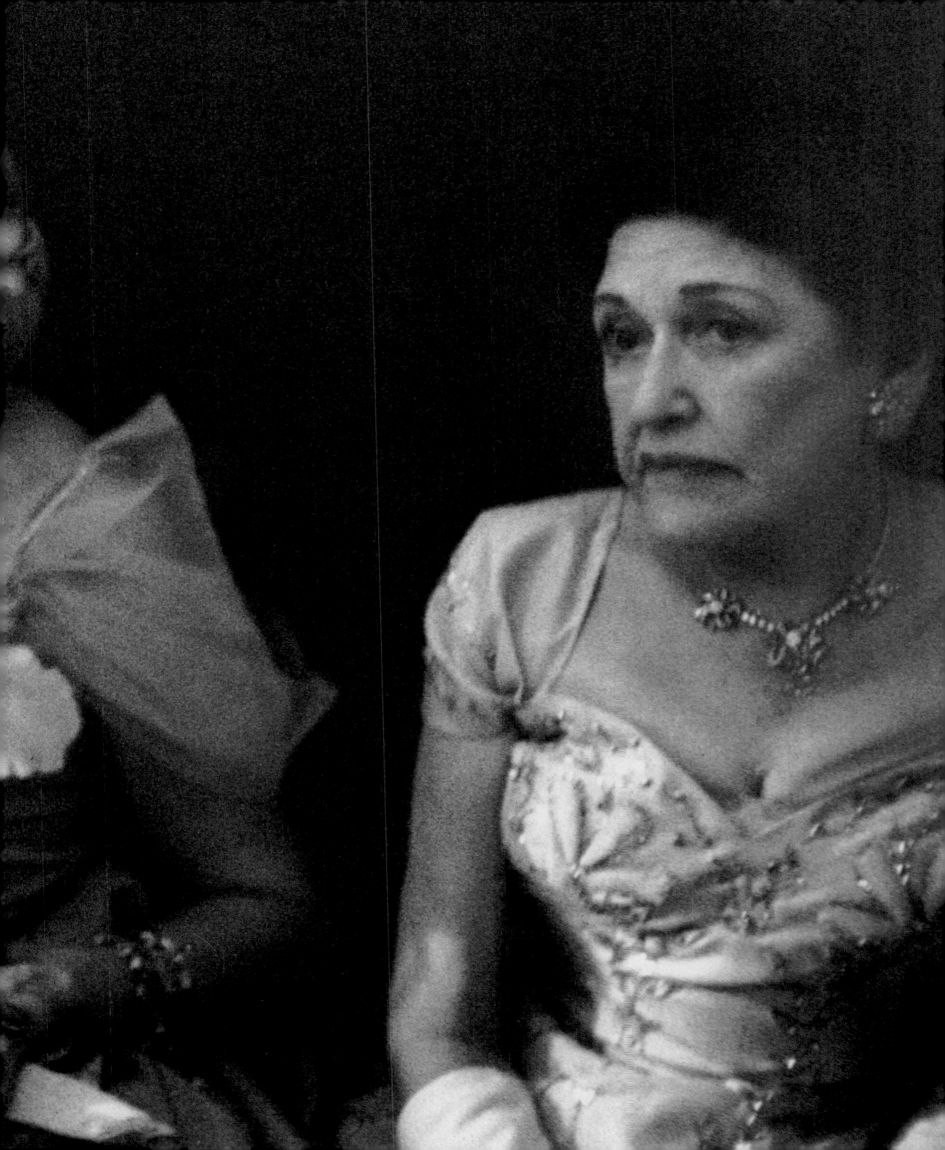

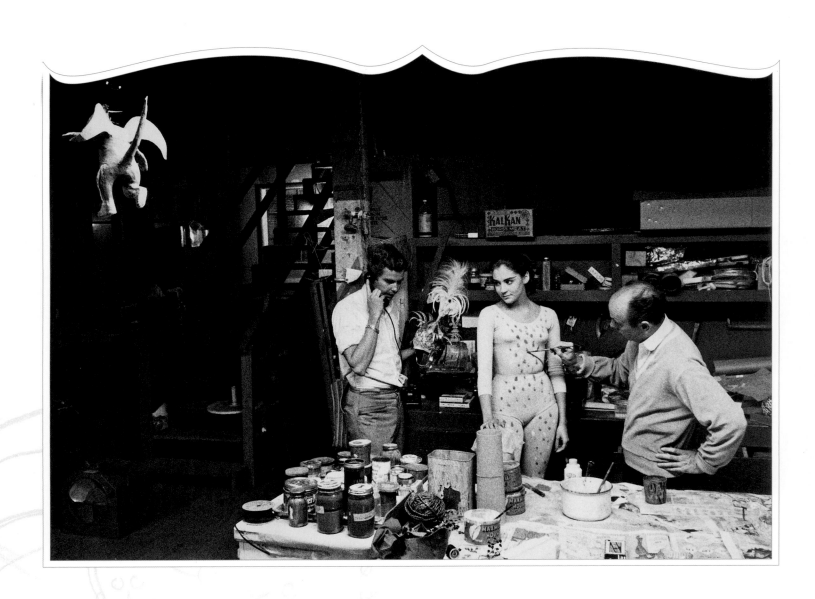

PREVIOUS SPREAD From left, Marion Davies, Cobina Wright, and Luella Parsons gossip during the opening night festivities.

ABOVE Leonard Stanley and Tony Duquette prepare costumes for the opening night gala.

OPPOSITE A ballet dancer at the opening night celebration at the studio.

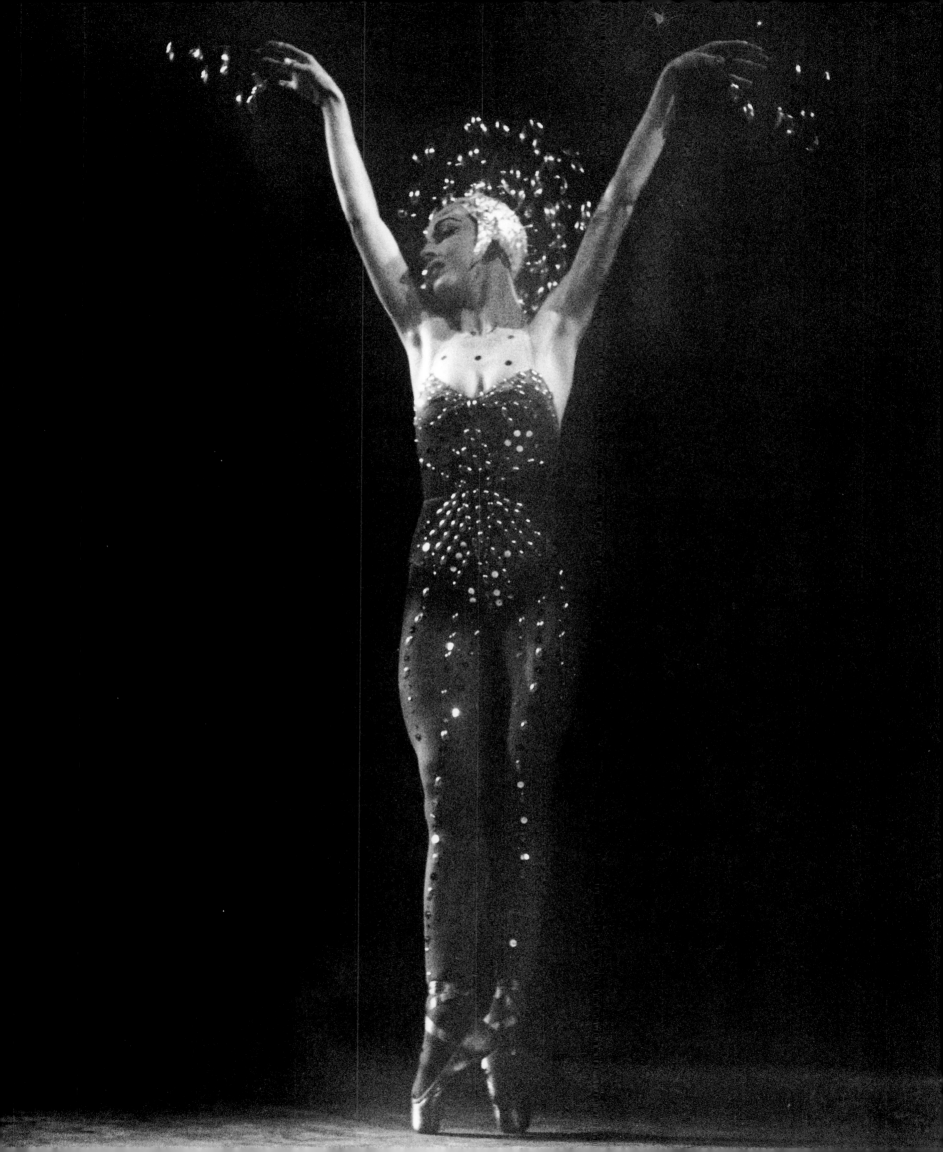

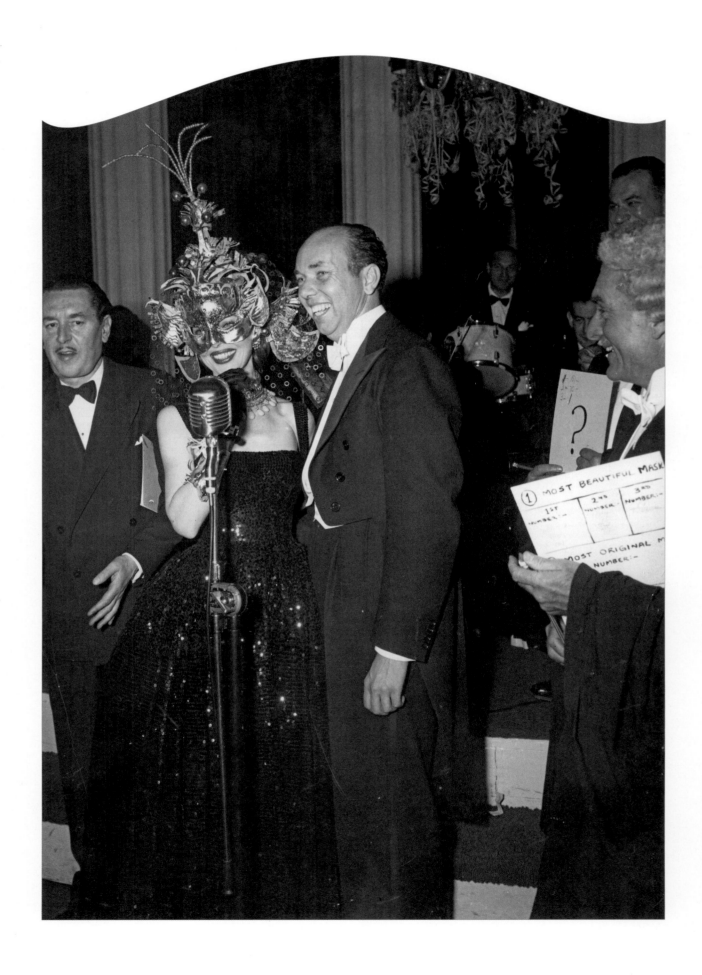

He was a scrap enthusiast. And I think it's marvelous to be able to see something that is totally recognized as ugly and trash and turn it into a thing of beauty. It's sort of a psychological thing, isn't it? But that you can make beauty out of trash, [that] gives hope for everybody.

<div align="right">FRANCES BRODY</div>

Tony is also unique in the sense that he created these effects really often with the most mundane, humdrum, everyday objects, which almost takes it into a different level of extreme folk art, in a way. It's like tramp art for aesthetes.

<div align="right">HAMISH BOWLES</div>

embroidered Mogul umbrellas. The walkway was covered in carpets specially woven in India for the occasion, and lined with carved statues of caparisoned Mogul horses with riders, each covered with an embroidered parasol. Between the horses were carved statues of Rajasthani soldiers, and between these were pierced-brass lanterns. On the lawns adjacent to the walk were scattered more pierced lanterns, with flames. The museum's facade was covered in a gigantic painted mural depicting the Amber Palace at Jaipur, flanked by towers holding giant coral branches. Inside, the museum's courtyard had been tented with clear plastic so that guests would see the midnight fireworks. In the center of the courtyard a glass pyramid was covered with a specially constructed stage that held an Indian temple made of carved wood, and angels playing musical instruments in each

corner; a full-scale carved Indian orchestra sat on the roof gallery. Peter Duchin's orchestra and a rock-and-roll band played for dancing from underneath the Indian temple.

Around the courtyard each column had been draped with an appliquéd panel, so as to give the illusion that the columns were inlaid with ceramic tiles. The four walls of the courtyard were hung from floor to ceiling with specially fitted appliquéd Indian tent panels. The tablecloths, buffet tables, and bars were all draped in appliquéd Indian fabrics, and the centerpieces were made of carved cross-legged figurines playing musical instruments, surrounded by votive lights.

Tony's very last major party was for the opening of the Palazzo Brandolini on the Grand Canal in Venice. John and Dodie Rosekrans had invited three hundred guests for dinner, hiring Harry's Bar to do the catering. For this occasion the tables in the Coral Ballroom were set with intense red-orange cloths, covered in gold net, which diffused them to a soft coral glow. Bromeliads and coral branches formed the centerpieces, along with rock-crystal votive lights, to add sparkle.

PREVIOUS SPREAD
LEFT Loretta Young wears her Tony Duquette mask at the bal de tête in Los Angeles. Here Tony and Loretta accept first prize for her mask.

RIGHT Tony enjoyed using his private theater for his own pleasure and also opened his house on occasion for civic and cultural activities such as the recital by a student orchestra shown here

OPPOSITE Entertainment at parties at the Duquette studios ranged from Balinese dancers to Balalaika orchestras to ballets or entire Kabuki troupes.

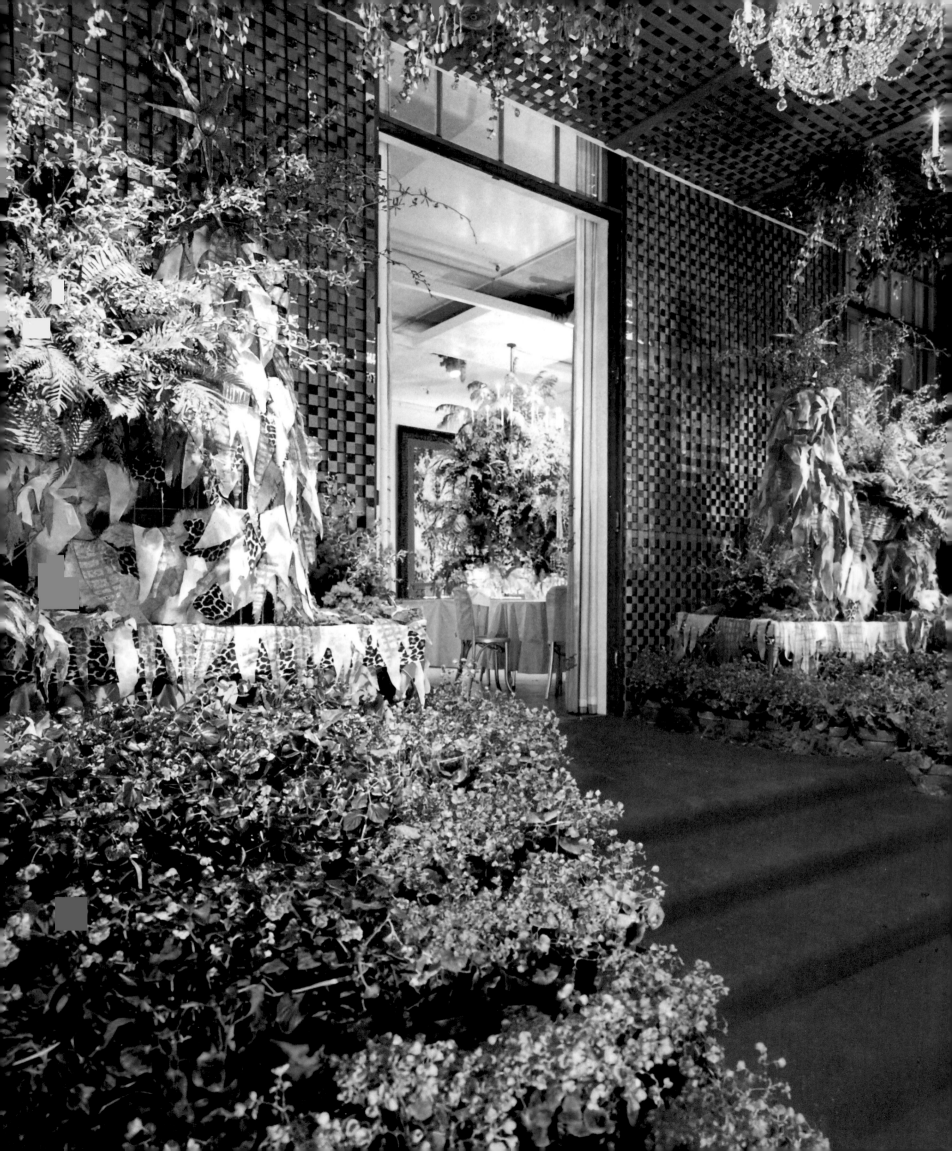

Of all the things Tony had done, his museum exhibitions made him the most proud. His first exhibition at the Mitch Leisen Gallery allowed him to create what he wanted and to express his aesthetic as he saw it. This was total freedom for Tony, who had become accustomed to clients, producers, and directors telling him what they wanted and how they envisioned it. Tony didn't take direction easily, though; he was known to walk out on clients who became too demanding. He was always sure of his taste and his work and was willing to fight for what he knew was right.

For his exhibition at the Louvre Tony upholstered all the walls of the vast gallery in yards and yards of antique ruby red silk brocade, which he found in a Paris flea market. The opening was attended by a "Who's Who" of international society: Carlos de Beistegui, Arturo López Wilshaw, Alexis de Rédé, Dolly Radziwill, Sue Railey, Walter Lees, the Duke and Duchess of Windsor, Paul-Louis Weiller, Evangeline Bruce, Mona Bismarck, Lord and Lady Duff Cooper, Daisy Fellowes, and countless others.

After the opening Sir Charles Mendl gave a dinner in Tony's honor at Elsie de Wolfe's penthouse on the Avenue d'Iéna. Elsie had died just prior to Tony's triumphal opening. Tony would go and visit her often in her last days. "She would wake up, or come out of her coma and she would grab my arm and she would say, 'You're such a sap. You can't trust anyone. You need to be careful, I'm not going to be around to protect you, you know.' And

then she would fall back to sleep." It was Tony's second tragic loss that year, his beloved mother having died not long before in Los Angeles.

Before returning to Los Angeles from Paris, Tony was asked to create three headdress masks for Daisy Fellows, Mona Bismarck, and Diana Duff Cooper, to be worn at the famous Beistegui costume ball at the Palazzo Labia in Venice. The Duquettes, also invited to the party, declined; as Tony put it, "We had to get home and start making some money." When the Louvre exhibition was over, Tony purchased dozens of old Louis Vuitton trunks in the flea market to pack up all of his treasures for shipping. He enjoyed decorating with this collection of old trunks in later years.

After the success of the Paris exhibition, the Los Angeles County Museum of Art invited Tony to bring his exhibition there. In 1952, having created some new work subsequent to the Paris show, he opened his Los Angeles exhibition. When the public arrived on the opening day they were surprised and enchanted to find Mary Pickford playing hostess and serving tea from a Georgian silver urn. For this exhibition, Tony hung the gallery walls in a pale gray blue taffeta, which he pulled back at the doorways. In the center of the gallery stood his pierced metal pagoda, which he would use for the MGM film *Lovely to Look At*, as well as his iconic metal-and-abalone chandelier.

After the Los Angeles show, Tony sent the exhibition to the M.H. de Young Museum in San Francisco, where it was very popularly acclaimed. He also added new pieces to this exhibition, including a series of watercolors of Golden Gate Park. The show's success drew the attention of the San Francisco Opera and Ballet, who began using Tony's talents for designing their costumes and sets.

OPPOSITE One of the many parties given by Mrs. William Matson Roth to celebrate the debuts of her favorite granddaughters, which Tony Duquette decorated year after year. The party shown here took place at the Burlingame Country Club, c. 1960s.

OVERLEAF The Undersea Ball designed by Tony Duquette using shell and antler consoles and mirrors and walls of crushed abalone.

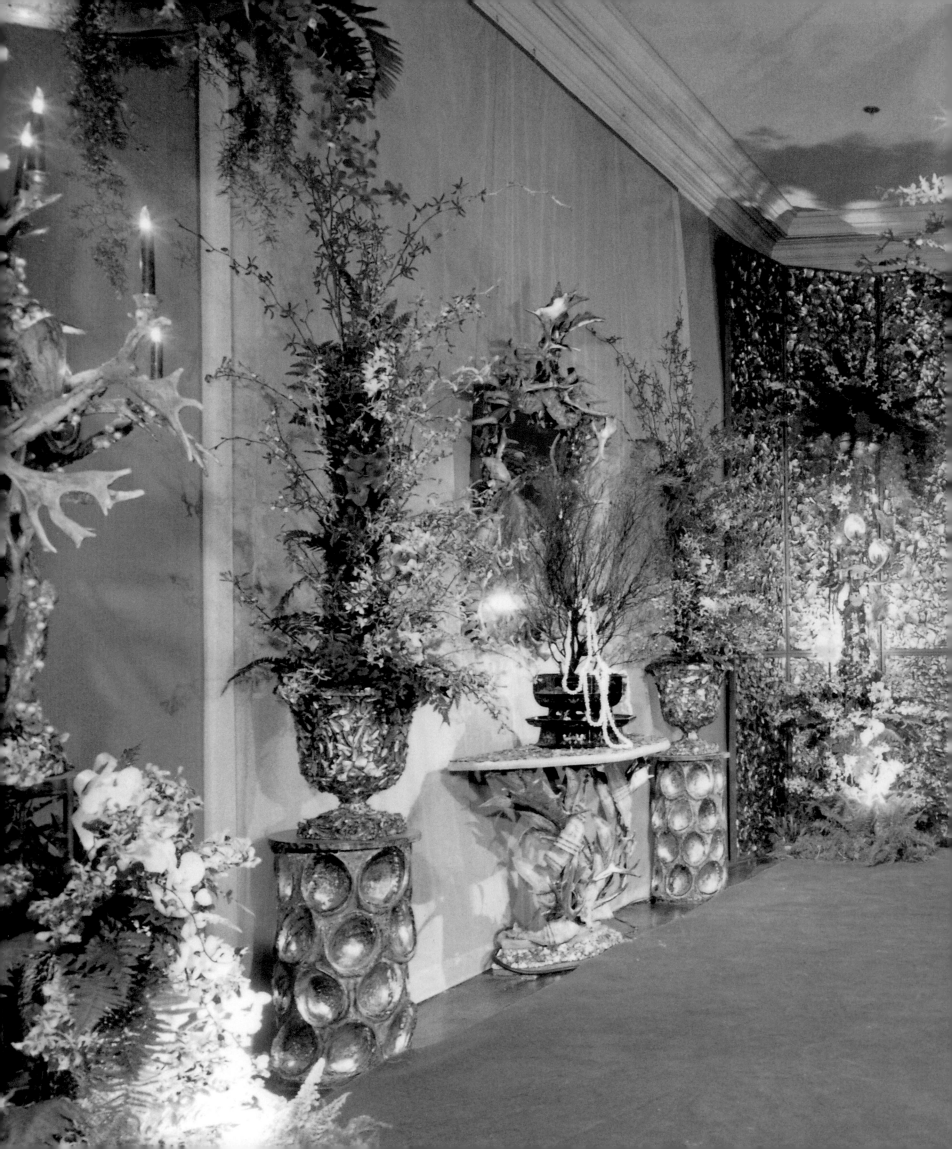

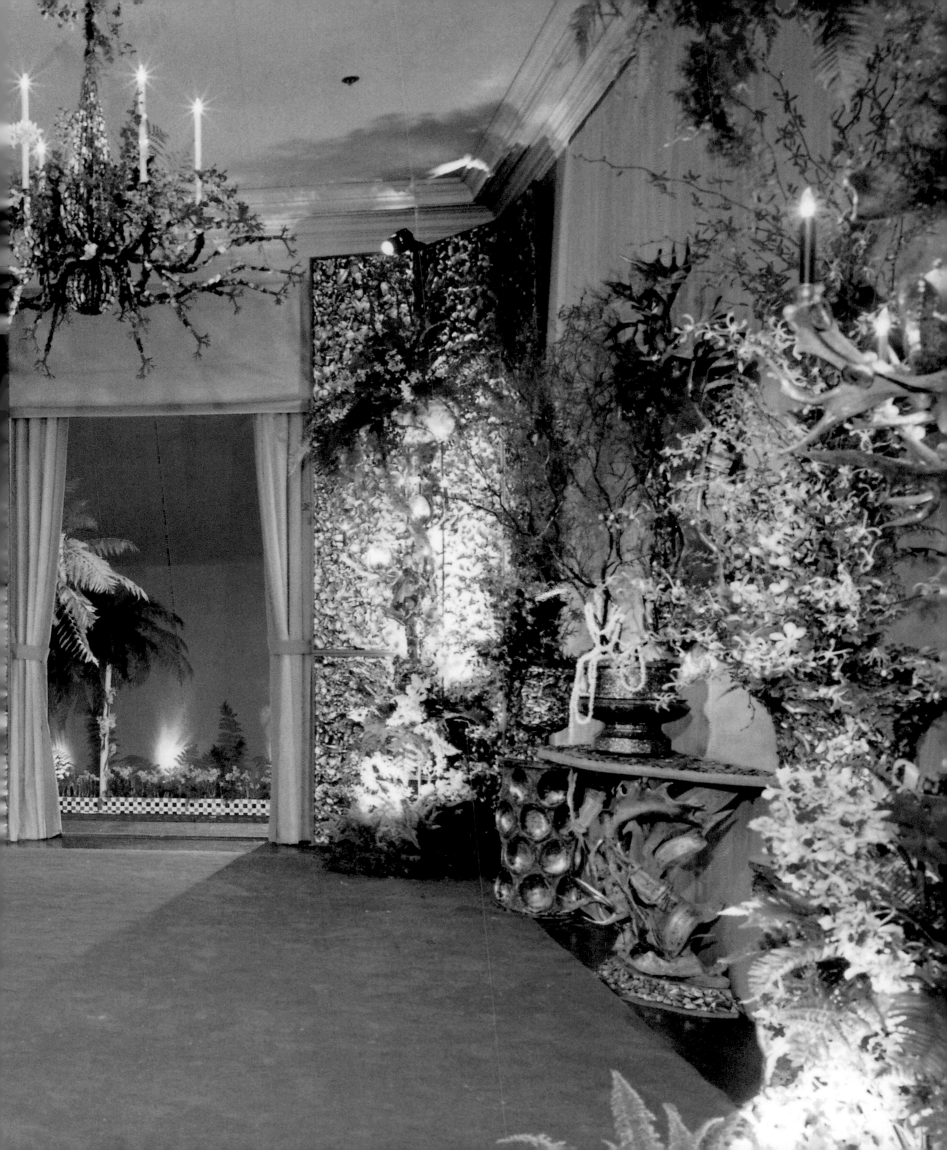

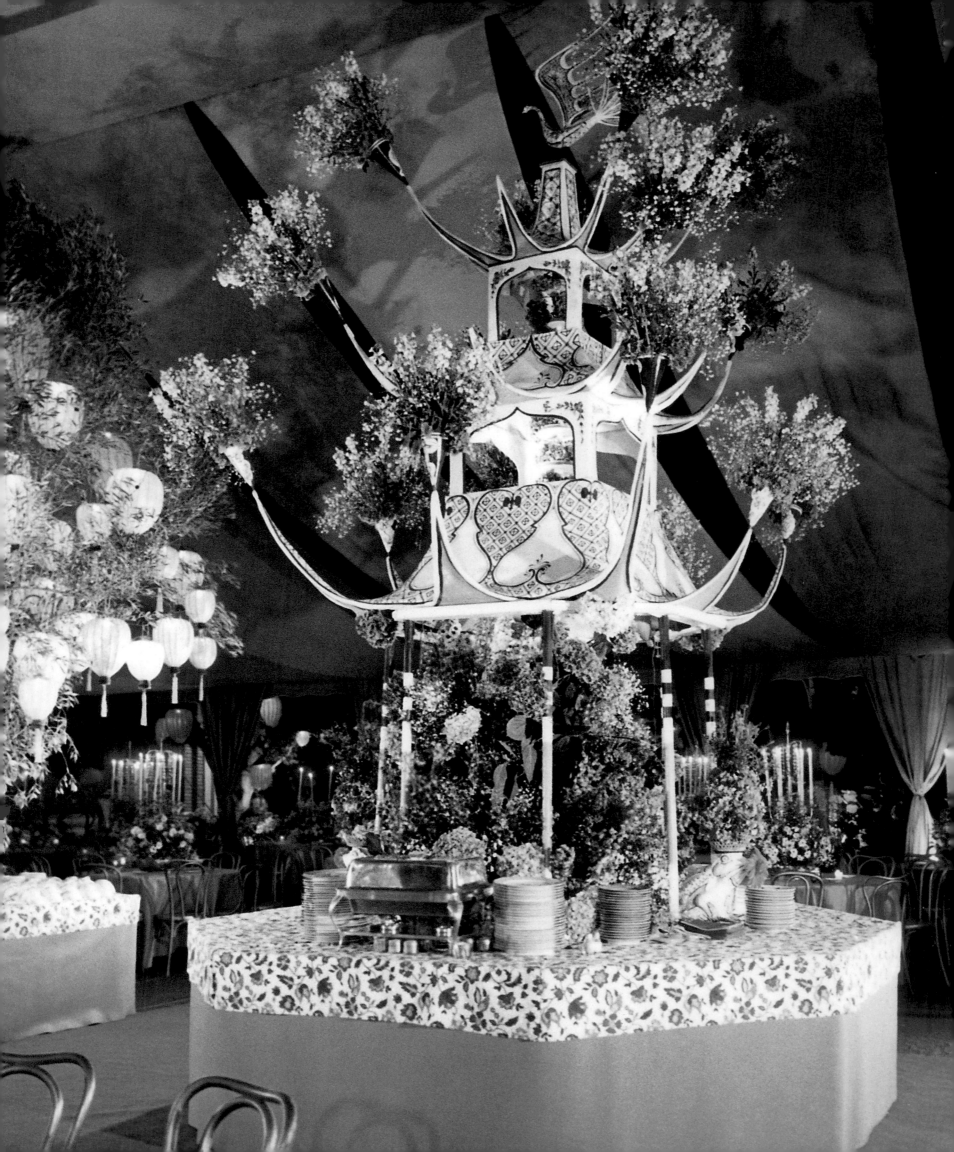

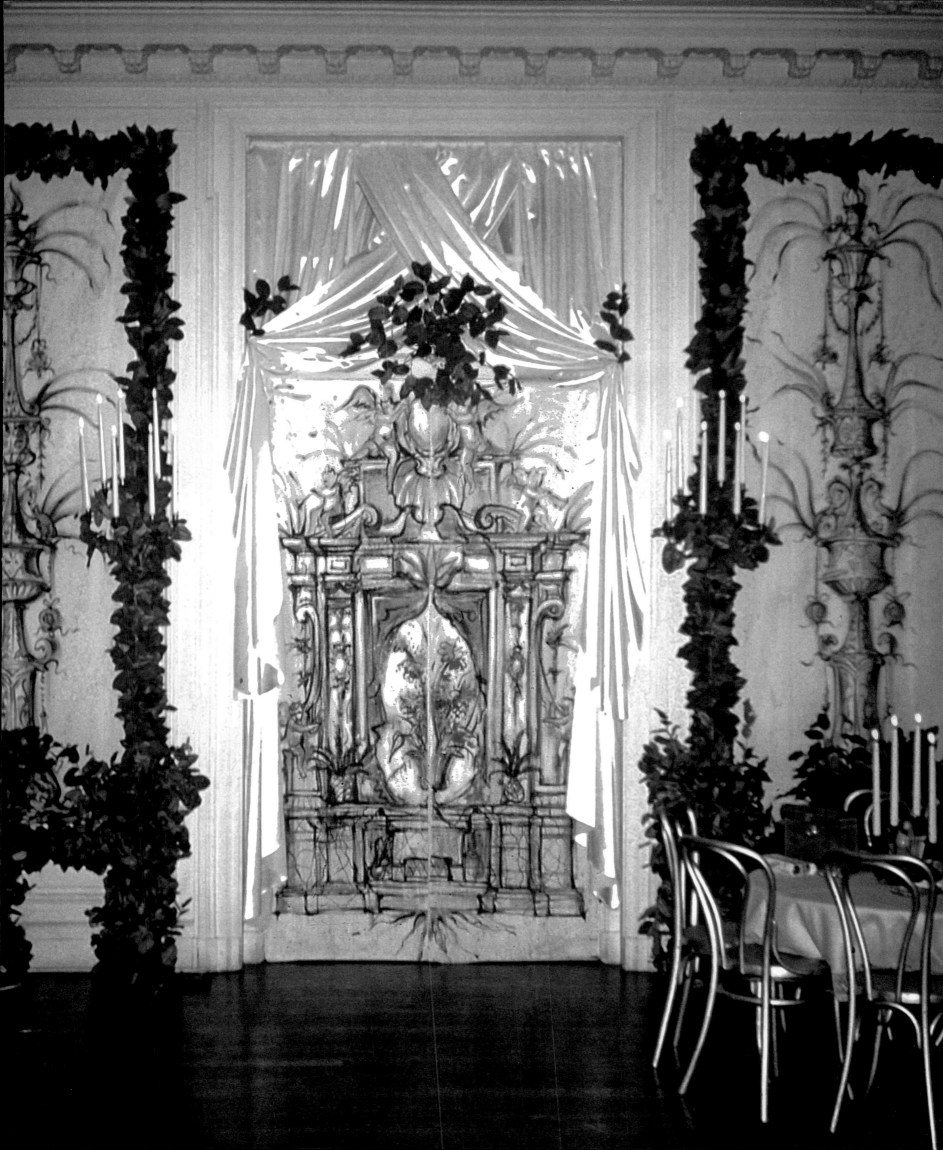

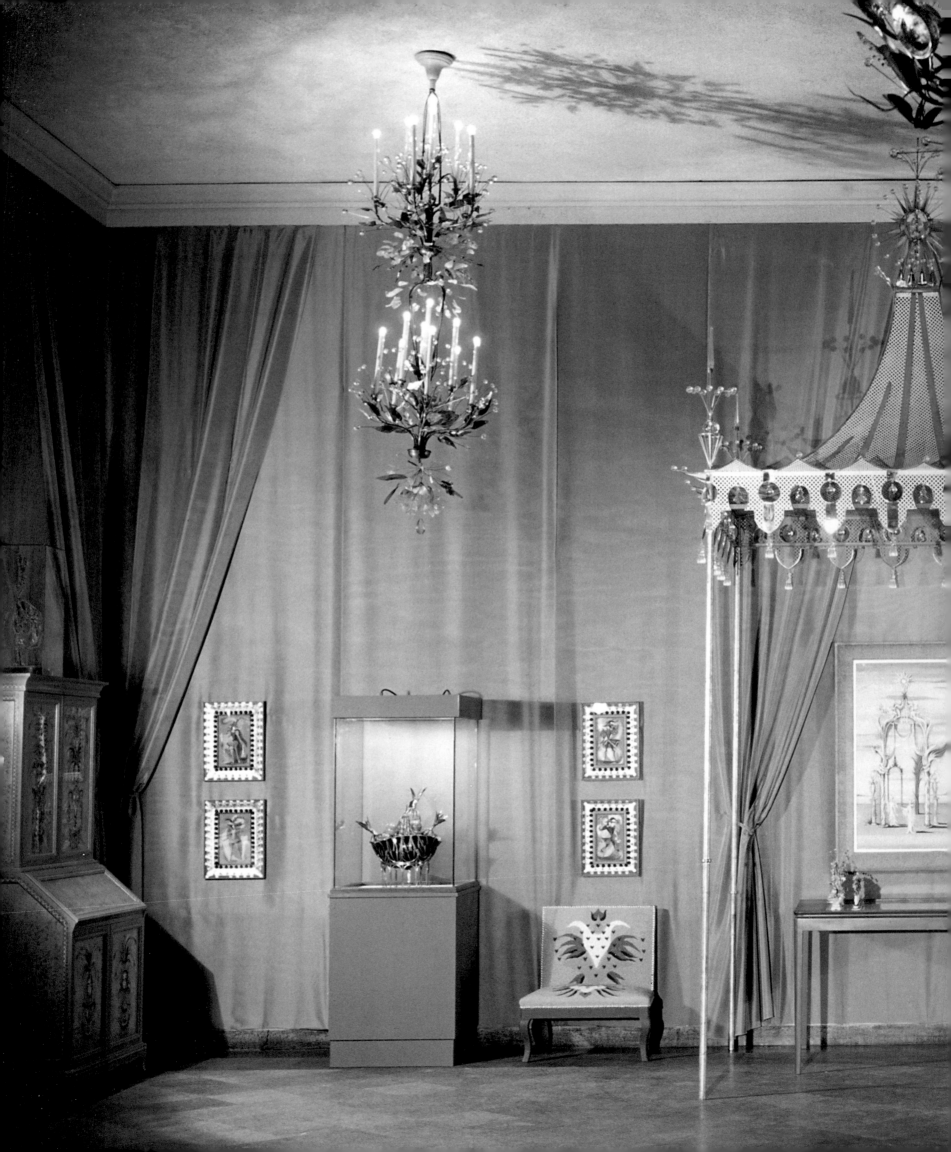

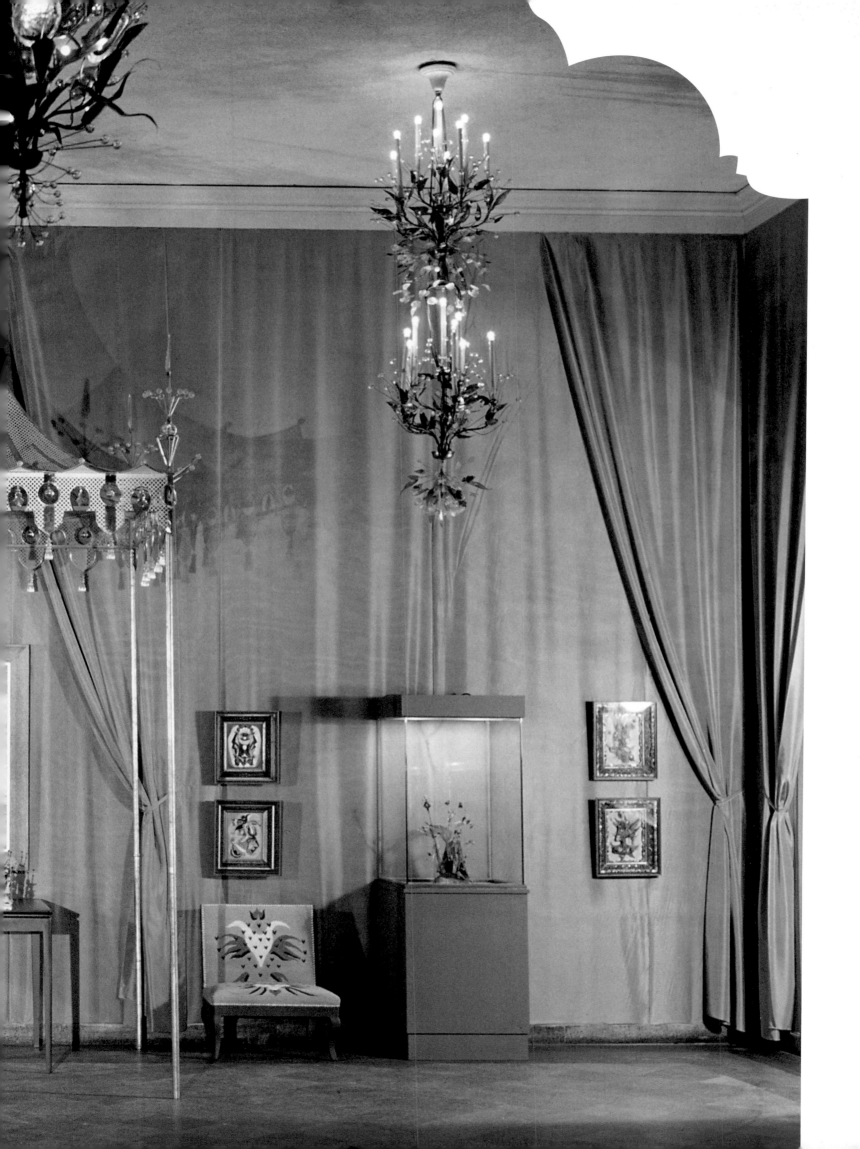

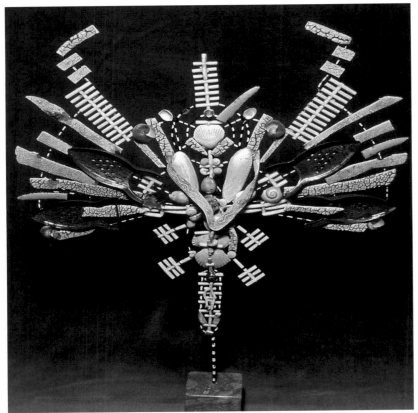

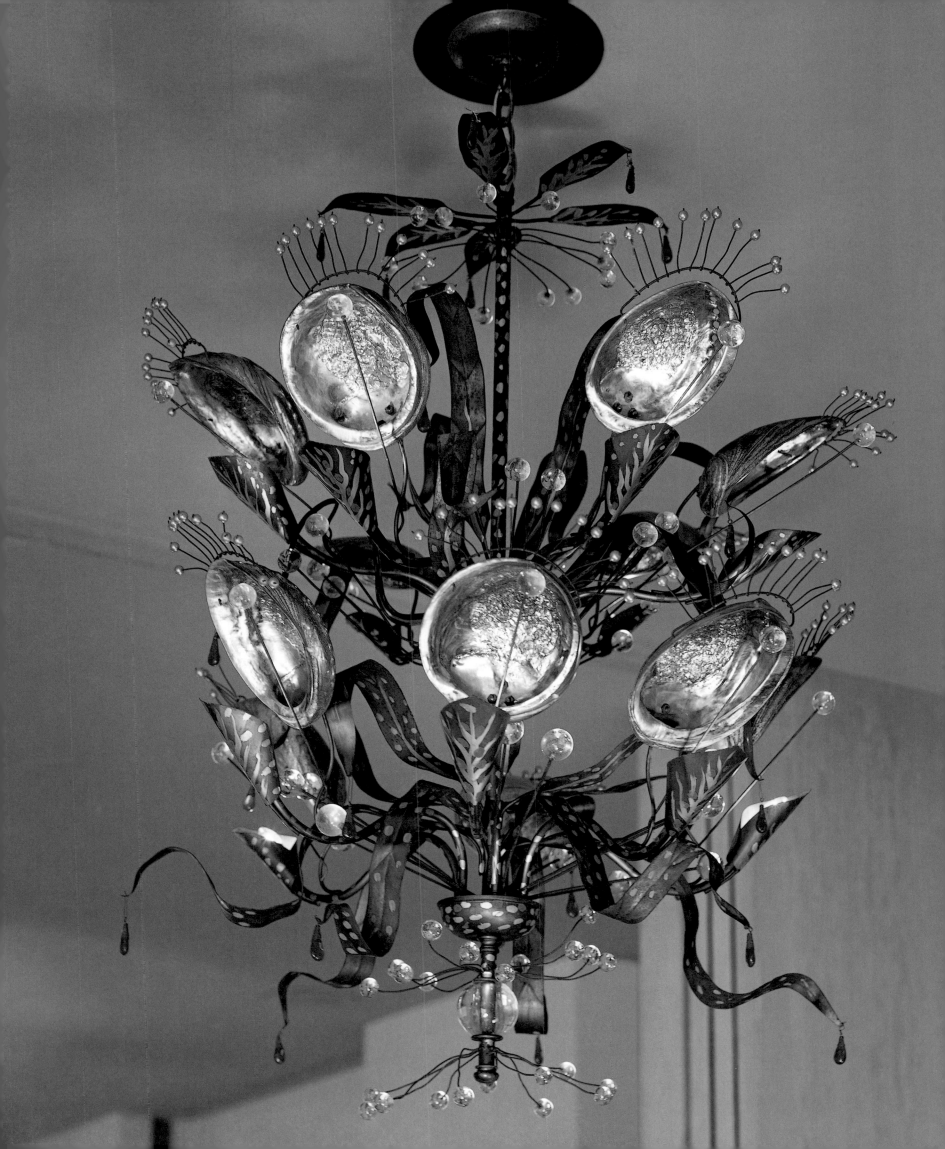

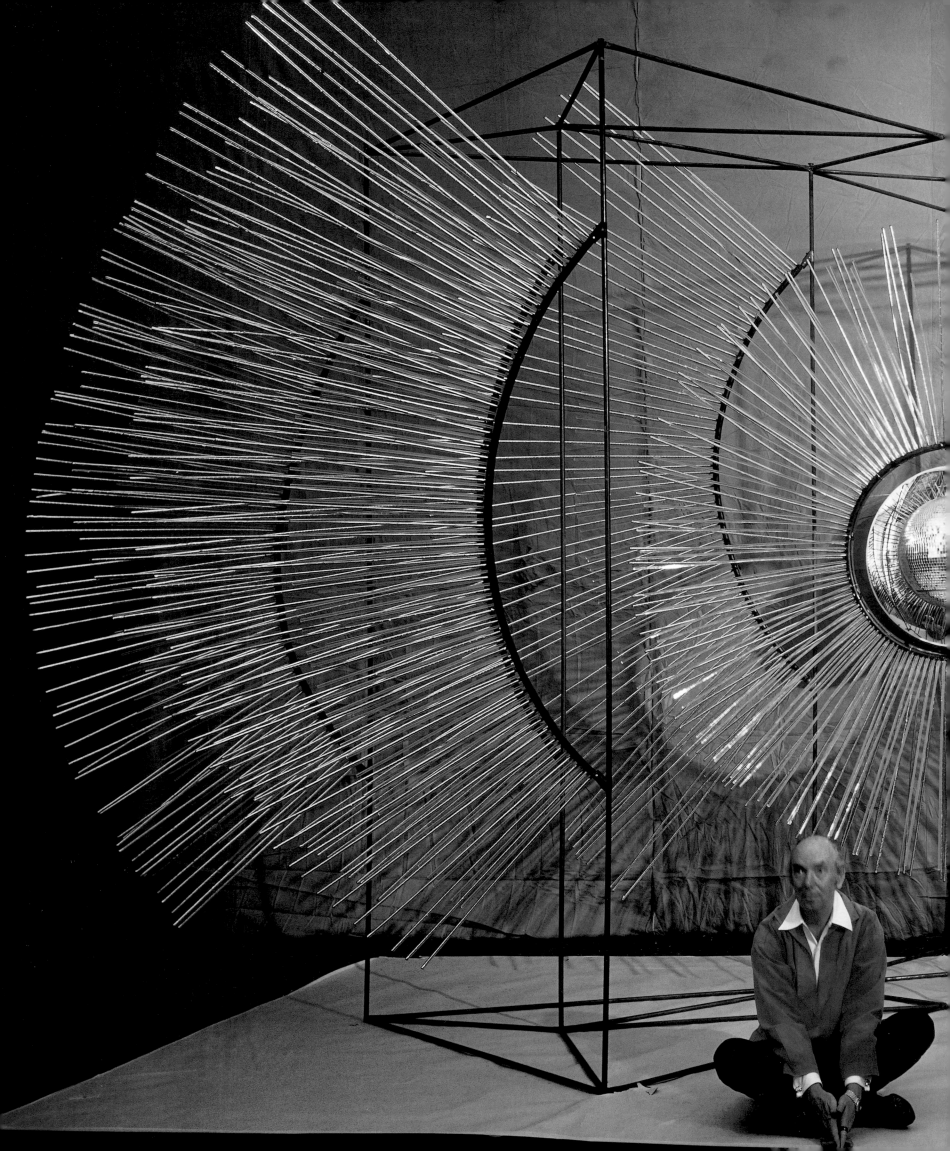

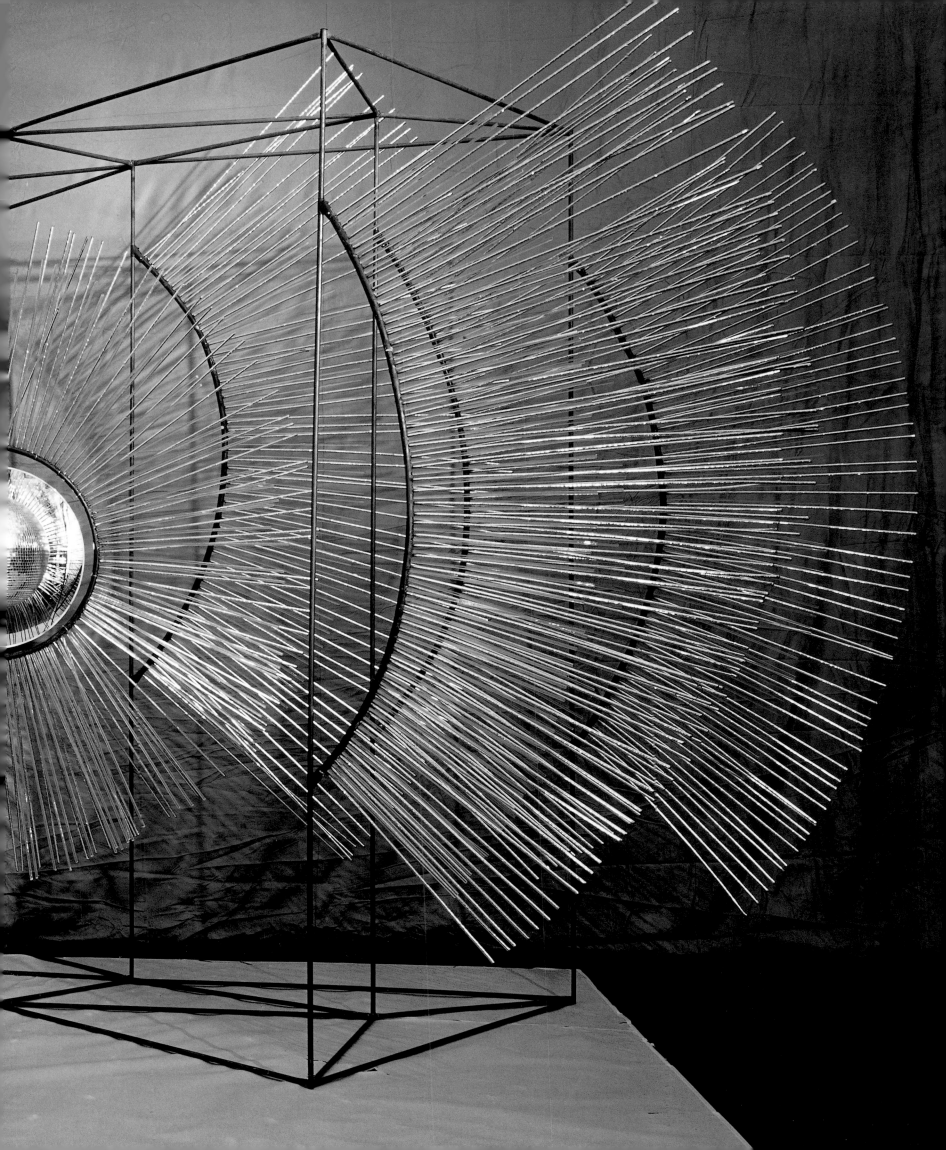

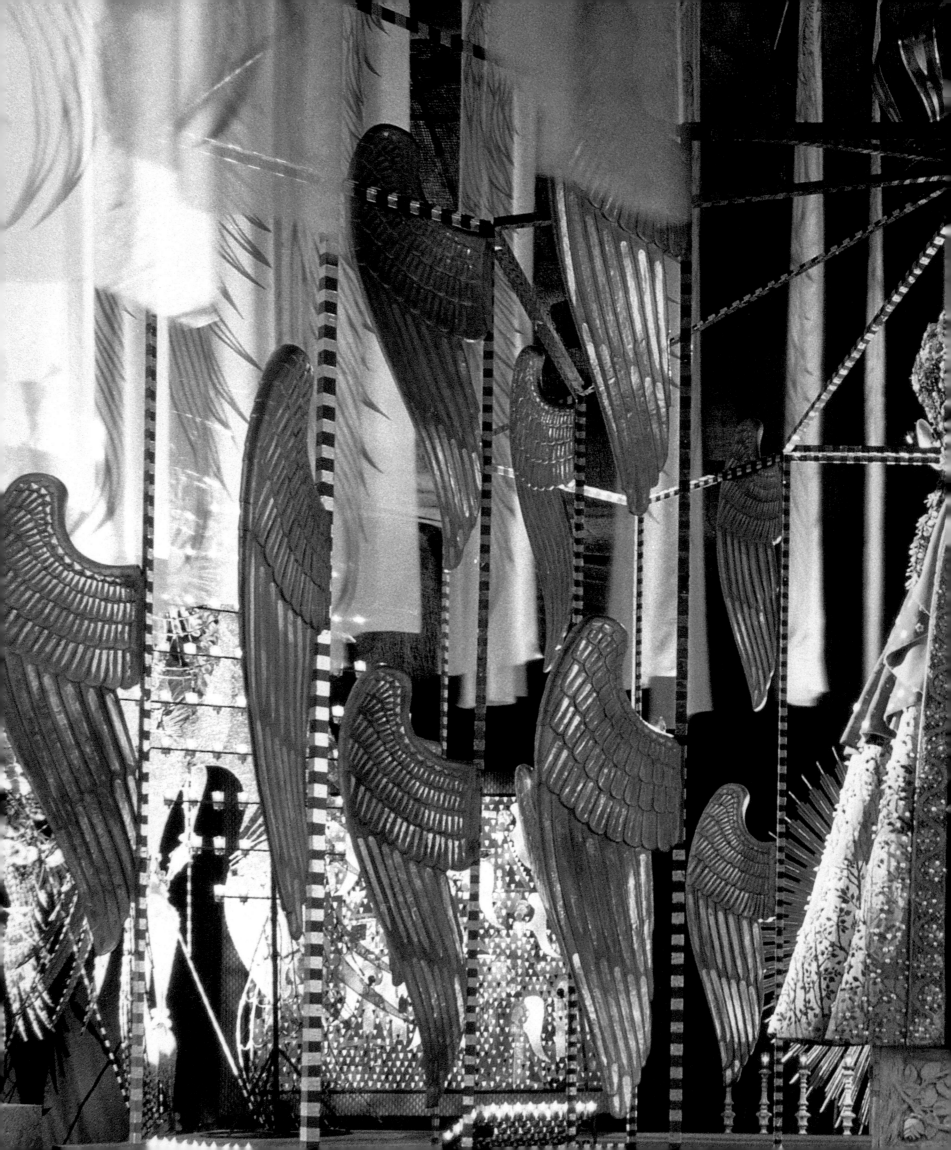

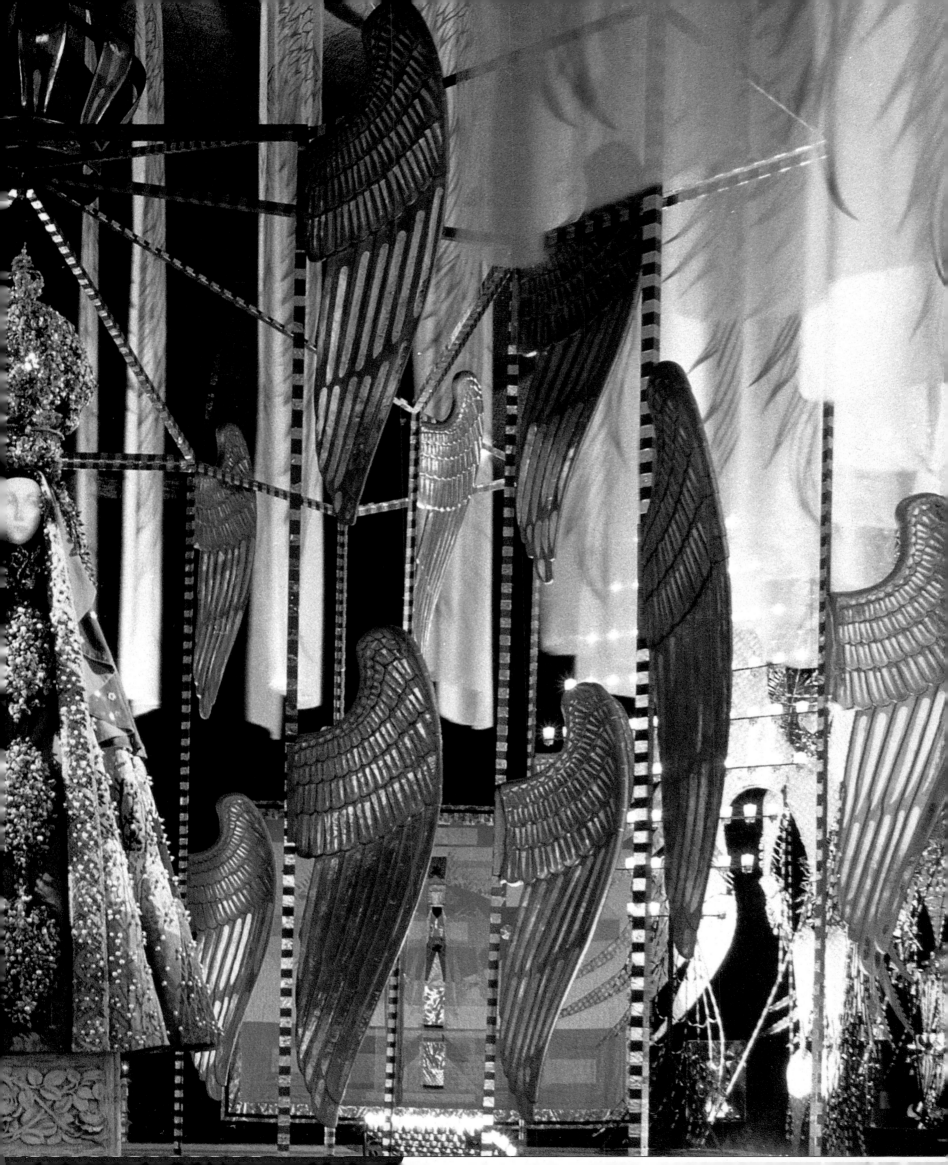

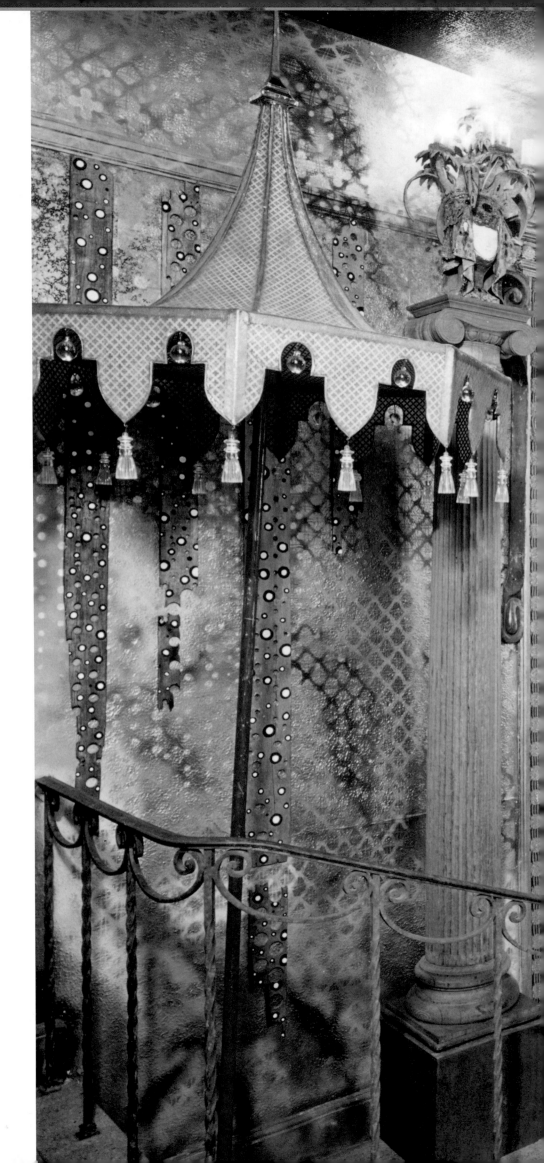

PREVIOUS SPREAD

LEFT The Duquette Pavilion in San Francisco, formerly an abandoned synagogue, with its giant Duquette-designed window, housed his exhibition The Canticle of the Sun, which he created as a tribute to the patron saint of San Francisco, St. Francis of Assisi.

RIGHT "Sea Samurai," turning towers made by Tony from old greeting card racks, were decorated with shells, felt and mirror and places on mechanized revolving wheel drums with pulsating lights.

OPPOSITE The lower hall of the Duquette Pavilion was decorated with abalone-encrusted doors, seventeenth-century Venetian paintings, and English antiques.

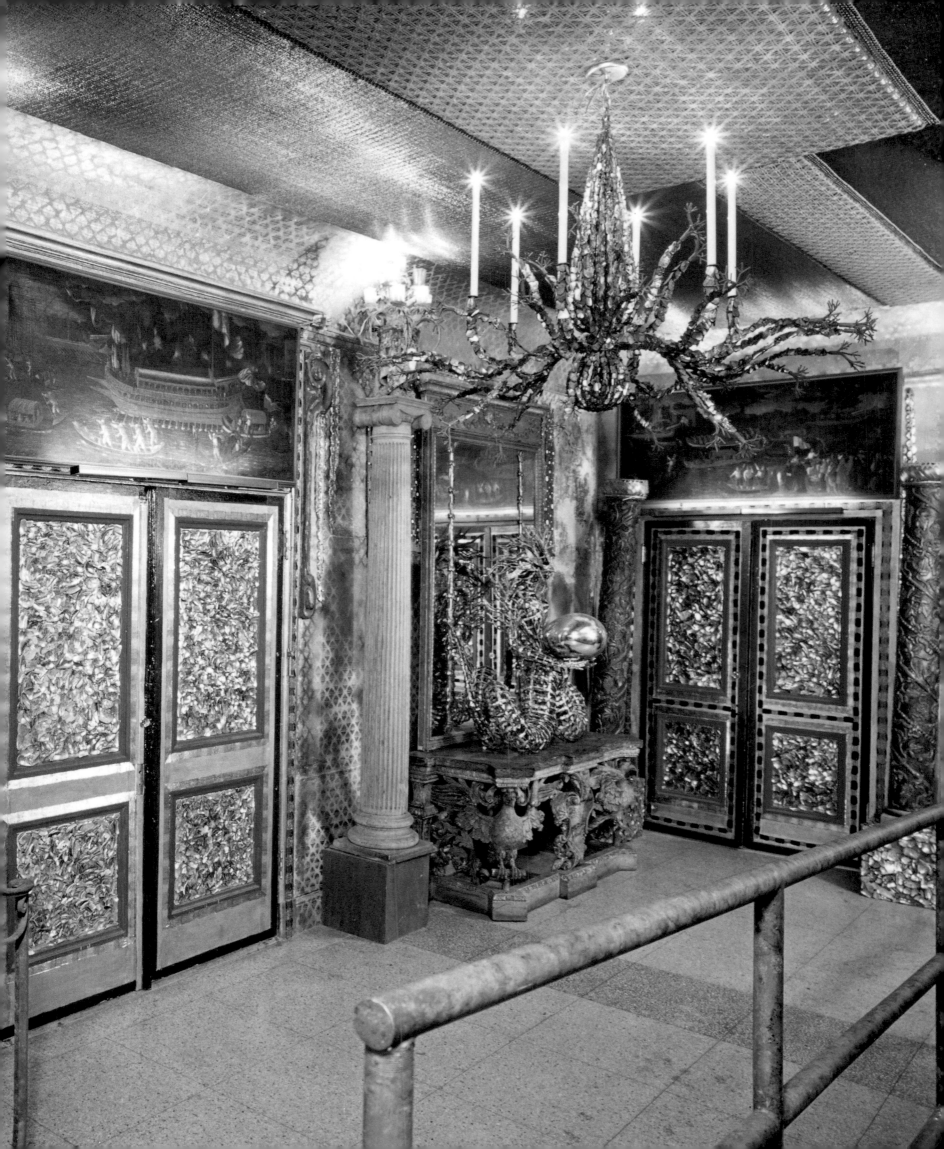

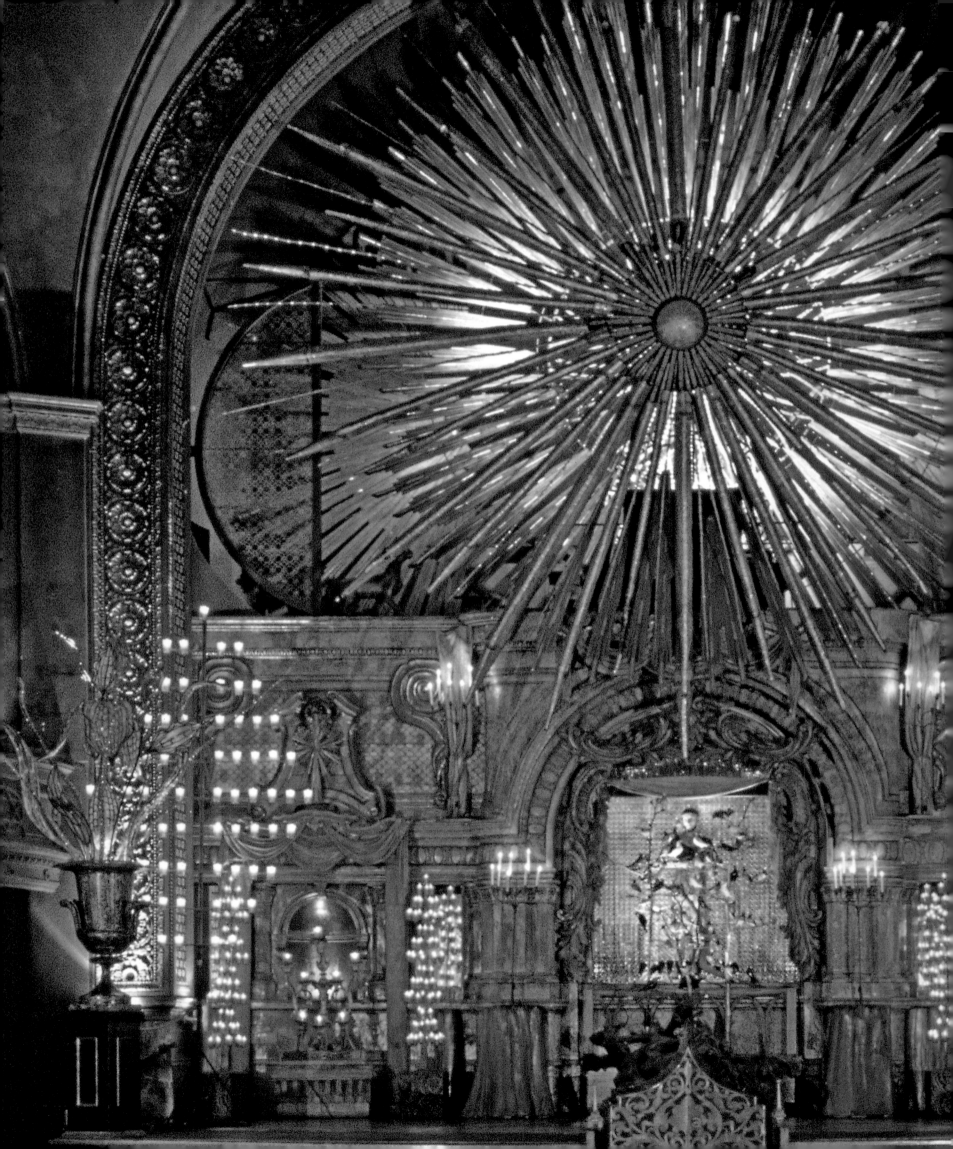

He was inspired to mount this exhibition after recalling how wonderful the MGM sets were in the old days. He used to say, "If only you could have seen those sets, if only you could have been there and walked on them and seen them from every angle—not just flat on the movie screen. They were amazing, beautiful in every way."

He wanted to make an exhibition like one of those movie sets, "where the audience was the star"—not just a series of paintings hanging on a wall but an environment that the audience could control with their actions. If they wanted to sit on the floor (which many did), or say a prayer (which also happened), or just meditate, that was all right. Finding a vast space at the old armory of the California Museum of Science and Industry at Exposition Park, he asked the museum curator if he could use it. "We are long overdue for a Tony Duquette exhibition," the curator replied. "Do anything you want."

For Tony, that directive translated to raising more than five hundred thousand dollars from friends, corporations, and foundations. After that, and with the assistance of 150 untrained volunteers—themselves under the volunteer direction of his friend Patricia Hastings Graham (the niece by marriage of his old patron Elizabeth Arden)—an exhibition was created, over a period of one year, that was meant to boggle the mind, lift the spirits, and inspire creativity and individuality in anyone who saw it. To this end Tony, Beegle, Patty Graham, and their volunteers created eight

PREVIOUS SPREAD
Tony created the giant Lucite sunburst window for the Duquette Pavilion in San Francisco out of plastic salad tossers, the bottoms of plastic drinking glasses, and old golf balls. This photograph shows the window under construction at the Duquette studio on Los Angeles prior to installation in San Francisco.

OPPOSITE The drama of the full interior of the Duquette Pavilion in San Francisco, dedicated to St. Francis of Assisi.

Above all of this was a giant copper sunburst made from the destroyed and discarded pipes of the building's original pipe organ. All around the eighty-by-eighty-foot room (and nearing the top of its forty-foot ceilings) ran a horseshoe balcony. It was on this balcony that Tony positioned his army of twenty-eight-foot-tall angels, with the eighteen-foot-tall Madonna in her pavilion holding court at the back. This entire ensemble was artfully hidden by a theatrical scrim, but when the lighting illuminated them from behind, the tableaux appeared and disappeared, to amazing effect.

Under the balcony Tony positioned various sculptures, furniture groupings, and works of art. For this celebratory environment Tony asked his friend Herb Alpert to compose the music. Once again Charlton Heston recited a new poem by Ray Bradbury, and the whole place was set to computerized lighting.

In the basement Tony set up several party rooms and various gallery spaces. The biggest of these galleries held an exhibition of Beegle's paintings. The exhibition, like Tony's other exhibitions, was a brilliant popular success. Unfortunately, after being open only a brief time, the entire building—and all of its contents, including the majority of Tony's personal collections and original works of art—burned down one night as the result of an electrical fire. That was the second major fire in Tony's life. Four weeks later his house in Beverly Hills, which was rented at the time, caught fire, causing a great deal of damage. But the fourth fire, at Tony's beloved Malibu ranch, would be the worst of all.

When his ranch in Malibu burned down in 1993, Tony lost twenty-one structures full of treasures and his original works of art in a matter of minutes. It was a brush fire, called the Green Meadows fire, and it burned all the way from the San Fernando Valley to the Pacific Ocean, and then continued south along the coast, burning several houses in Malibu itself.

When his ranch in Malibu burned down in 1993 in the raging Green Meadows brush fire, Tony lost twenty-one structures full of treasures and his original works of art in a matter of minutes. Devastated, he nevertheless did what he always did and went back to work. This terrible cleansing cleared the palette once again, and, at eighty years old, Tony created the exhibition he called the Phoenix Rising from its Flames at the Armand Hammer Museum in Westwood, California. But he would never set foot on the land of his vanished "empire" again. Instead he began rebuilding a microcosm of his lost paradise in the style Clare Booth Luce, dubbed "Organic Baroque," on land next door to the ranch.

William Rieder, the former Curator of European Sculpture and Decorative Arts at the Metropolitan Museum of Art, summed up Tony best when he said, "At first you thought he was a person who came from another planet. I think he is one of those angels who come down from heaven once in a while to visit us to make our lives happier and more delightful. I thought what he did was simply the most original, unusual kind of decoration that I had really ever seen. It was a combination of surrealism and modernism, but with a wholly different point of view that was totally his."

To the very end, Tony Duquette was always at the mercy of his relentless muses, who fueled his will to create his magnificent Eden, where he embellished and made treasure out of everything he touched.

OPPOSITE Tony Duquette created a giant forty-foot gilt metal and Lucite sunburst ceiling for the main room at the Duquette Pavilion in San Francisco using sections of the original chandelier which he created for the Hilton Dome convention center in Honolulu, c. 1960s. The Hilton returned the chandelier to Tony for just this purpose.

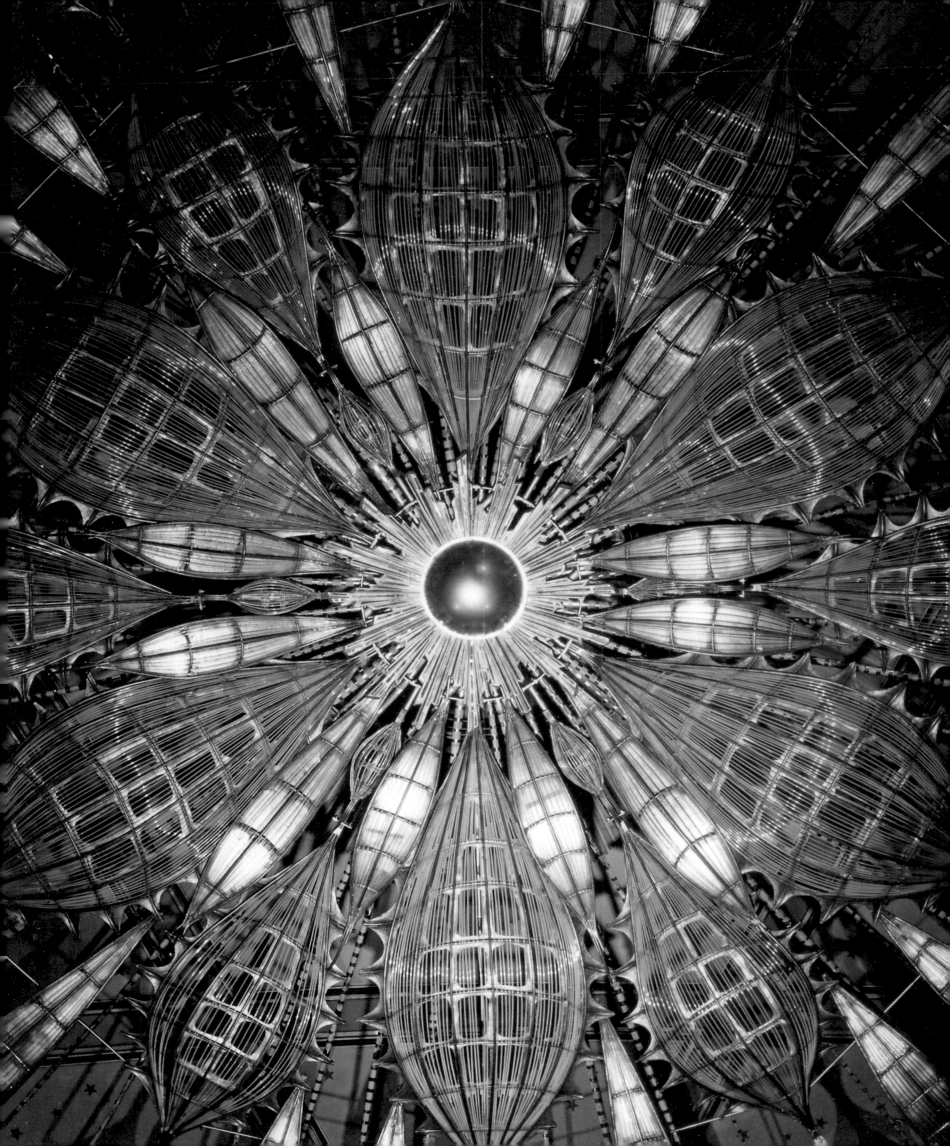

BIBLIOGRAPHY

BOOKS

Beaton, Cecil. *Cecil Beaton: Memoirs of the 40s*. McGraw-Hill, 1972.

Beaton, Cecil. *The Glass of Fashion*. Cassell, 1954.

Beevor, Antony and Artemis Cooper. *Paris after the Liberation, 1944-1949*. Penguin, 1994.

Bemelmans, Ludwig. *To The One I Love Best*. The Viking Press, 1955.

Campbell, Nina and Caroline Seebohm. *Elsie de Wolfe: A Decorative Life*. Clarkson-Potter, 1992.

Cawthorne, Nigel. *The New Look, The Dior Revolution*. The Welfleet Press, 1996.

Charles-Roux, Edmonde. *Theatre de la Monde*. Rizzoli, 1991.

Chase, John. *Exterior Decoration: Hollywood's Inside-Out Houses*. Los Angeles: Hennessey & Ingalls, Inc., 1982.

Chase, John. *Glitter, Stucco & Dumpster Diving*. Verso, 2000.

DALI: A Study of His Art-in-Jewels. The Owen Cheatam Foundation, 1959

de Wolfe, Elsie. *After All*. 1935

de Wolfe, Elsie. *The House in Good Taste*. Rizzoli, 2004.

Dior, Christian. *Christian Dior and I*. E.P. Dutton & Co., 1957.

Gutner, Howard. *Gowns by Adrian: The MGM Years 1928-1941*. New York: Abrams, 2001.

Heismann, Jim. *Out With The Stars*. Abbeville Press, 1985.

Hochman, Elaine S. *Bauhaus, Crucible of Modernism*. Fromm International Publishing Corp., 1997.

Horst Salute to the Thirties. Foreword by Janet Flanner. The Viking Press, 1971.

Isherwood, Christopher. *Christopher Isherwood Diaries Volume One: 1939-1960*. Harperflamingo, 1996.

Knight, Arthur and Eliot Elisofon. *The Hollywood Style*. The Macmillan Company, 1969.

Mann, William J. *Wisecracker: The Life and Times of William Haines, Hollywood's First Openly Gay Star*. Penguin Books, 1998.

Neutra, Richard. *Survival Through Design*. Oxford University Press, 1954.

Perine, Robert. *Chouinard: An Art Vision Beyond*. Arta Publishing, Inc., 1985.

Saeks, Diane Dorrans. *Hollywood Style*. Rizzoli, 2004.

Schifando, Peter and Mathison, Jean H. *Class Act: William Haines, Legendary Hollywood Decorator*. Pointed Leaf Press, 2005.

Smith, Jane S. *Elsie de Wolfe: A Life in High Style*. Atheneum, 1982.

Sparke, Penny. *Elsie de Wolfe: The Birth of Modern Interior Decoration*. Acanthus Press, 2005

Vreeland, Diana. *DV*. Alfred A. Knopf, 1984

Whistler, Laurence. *The Laughter and The Urn: The Life of Rex Whistler*. Weidenfeld and Nicolson, 1985.

ARTICLES

"A Jeweled Setting: Glittering souvenirs of Hollywood adorn the mountaintop pavilions of legendary California designer Tony Duquette" by Wendy Goodman. House & Garden, December 1990.

"A Parisian Jewel" by Jean Bond Rafferty. Town & Country, December 1998.

"A Strange Eden" by Wendy Goodman. Harper's Bazaar, December 1994.

"A Thirties Revival" by Gael Greene. Architectural Digest, March 1989.

"Anthony Michael Duquette" by Monica Geran. Interior Design, December 1997.

"Blooming Mad: Tony Duquette's extravagant garden is as eccentric as the man himself" by Glynis Costin. Los Angeles, April 1998.

"Fantasia: The matchlessly magic, fabulous, and forever timeless creations of California designer Tony Duquette" by Monica Geran. Interior Design, April 1999.

"Fantasy in Beverly Hills" by Anonymous. House & Garden, April 1950.

"Fruits of the Sea" by Joyce Macrae. California Homes, Summer 2000.

"Here Enter the House of a Magician" by Sarah Tomerlin Lee. House Beautiful, June 1965.

"Hollywood Romantic: Tony Duquette's sense of visual splendor is expressed in his eccentric hillside home" by John Chase. L.A. Style, October 1990.

"Home, After 30 Years of Travel and Collecting: Tony Duquette restores a relic high on a hill in San Francisco" by Bea Miller. Los Angeles Times Home Magazine, May 30, 1971.

"Home with the Tony Duquette" by Bea Miller. Los Angeles Times Home Magazine, date unknown.

"The Hungry Eye: International design darling, Tony Duquette, is still whipping it up at 82," by Glynis Costin. Buzz, February 1997.

"Is Tony Duquette Bonkers?" by Simon Doonan. Nest, Summer 1999.

"The Lure of a Baroque Imagination: Designer's Los Angeles Studio/Residence" by Tony Duquette. Architectural Digest, March 1978.

"Mr. Tony Duquette Designs a Bed Sitting Room of Magical Charm" by Sarah Tomerlin Lee. House Beautiful, March 1965.

"One Man's Magic" by Elizabeth Venant. Connoisseur, December 1990.

"Palace Coup" by Hamish Bowles. Vogue, September 1999.

"The Sorcerer's Eye: Tony Duquette transports the whole world home" by Nancy Richardson. House & Garden, December 1983.

"They Live in an Ex-Movie Studio" by Anonymous. Vogue, April 15, 1957.

"Tony Duquette" by Ellen Rome Shanahan. Venice Magazine, May 1995.

"Tony Duquette—Champion of Magic and Theatre in Residential Design" by Penelope Rowlands. Architectural Digest, January 2000.

"Tony Duquette—The Birth of a Legend" by Frances Roberts Nugent. Californian, Summer 1952.

"The Uses of Enchantment" by Lynn Morgan. California Homes, Summer 1952.

"When Sharon Met Tony" by Margy Rochlin. Town & Country, October 1999.

NOTES

CHAPTER ONE

1. 'his own elaborate productions of *Scheherazade*,' as described by Frank Duquette, in an interview with the author.

CHAPTER TWO

1. 'De Wolfe, first Lady of Interior Decoration.' From *The House In Good Taste* by Elsie de Wolfe. Century Co., London, 1913, reprinted by Rizzoli International Publications, New York, 2004.

2. 'staid tearoom.' From *Elsie de Wolfe: A Life in High Style* by Jane S. Smith. Atheneum, New York, 1982.

3. 'King Louis Philippe.' Ibid., p 31.

4. 'Elsie de Wolfe gave her last great party before the war.' Ibid.

5. Pull quotes from Arlene Dahl, as excerpted from an interview with the author.

6. 'traded in fantasy,' as described by Hamish Bowles excerpted from interview with the author.

CHAPTER THREE

1. 'Best Dressed for Her Life Award,' *Los Angeles Mirror News*, Los Angeles Mirror News, Co., 1959.

2. 'A poetess with paint,' as described by Delmer Daves to Tony Duquette.

CHAPTER FOUR

1. 'An old, blue Picasso,' from *The One I Loved the Best* by Ludwig Bemelmans. Viking Press, New York, 1955.

2. 'It was the only house...' *The New York Herald*, 1950. Center for American History, Queens Borough Public Library, New York.

CHAPTER FIVE

1. 'I started working with Tony in 1951,' quotes excerpted from an interview with the author.

CHAPTER SIX

1. 'the light in Ireland different,' as described by Duquette to the author.

2. 'Arden house-warming,' as excerpted from a conversation with Duquette.

3. 'She made appearances,' as excerpted from an interview with Brooke Hayward.

4. 'before the whole house went up in flames,' as excerpted from a conversation with Duquette.

CHAPTER SEVEN

1. Pull quotes from Arlene Dahl, as excerpted from an interview with the author.

2. 'Gustave turned to the woman on his right,' as excerpted from an interview with Duquette.

3. 'Are we inside of a mobile home?' as excerpted from an interview with Duquette.

CHAPTER EIGHT

1. 'enough sunflowers' as excerpted from a conversation with Duquette.

2. 'you're such a sap' Beegle in hospital, as excerpted from an interview with Duquette.

CREDITS

Fernando Bengoechea: 182–185, 188–190, 193–194, 276–277

Shirley Burden: 201–202, 204

Ed Carol: 68

James Chen: 344–358, 361, 366

Fred Dapprich: 28, 35, 37–39

Tony Duquette Estate: 8, 10, 14, 16, 17, 18, 19, 20–21, 23, 26, 30, 40–41, 42, 49, 56–57, 58, 60, 66, 67, 70, 72–75, 84–85, 87, 88–91, 93–94, 101, 113–117, 122, 124–127, 130–134, 136–140, 148–150, 153–154, 161–162, 164–165, 170, 172–173, 176–179, 196, 198, 211, 226–227, 239, 240–241, 243, 254, 266–267, 290–292, 294–300, 302–303, 305–306, 308–310, 320, 326, 328, 329, 330, 332, 334–343

Todd Eberle: 214–217, 220, 234–235, 246–251, 274–275, 278, 281–282

John Engstead: 4, 32, 43–47, 50, 52–53, 64–65, 142, 144–147, 288

Oberto Gili: 252, 256, 258–259

The Goldwyn Company: 98–99

Man Ray: 61

MGM: 96, 102, 105–107, 108–112

André Ostier: 76, 78, 81, 82–83

Renée: 63

San Francisco Ballet: 118, 121

San Francisco Opera: 129

Tim Street-Porter: 156–159, 167–168, 203, 205, 207–210, 212–213, 218–219, 221–223, 225, 244–245, 253, 255, 260, 262–265, 268, 270–271, 273, 280, 284–286

Danforth Tidmarsh: 229–233, 236–237

Bob Willoughby: 24–25, 48, 54–55, 311, 313–315, 317–319, 322–325, 327

ACKNOWLEDGMENTS

WENDY GOODMAN

This book would never have happened without the invaluable friendship of Hutton and Ruth Wilkinson, who first introduced me to Tony and Beegle Duquette.

Special thanks to Nancy Novogrod for giving me the wings for my first flight to Tony, and Joyce Macrae for giving me my first opportunity to enter Tony and Beegle's world. I am indebted to Eric Himmel for his patience and guidance, Andrea Colvin and E.Y. Lee at Abrams, Katrina Weidknecht, Meghan Phillips, and Eva Prinz. Special thanks to Tim Street-Porter and Annie Kelly for their friendship, insight, and generosity, and to Luke Hayman for his brilliance, kindness, and time. For making dreams come true: Linda Fargo, David Hoey, Nicholas Manville, and Mallory Andrews. I am indebted to all the wonderful photographers and writers who have brought Tony and Beegle's world to life and to Dominique Browning for her invaluable support. A bear hug to Patrick Demarchelier.

Heartfelt thanks to Herb Alpert, John Avedon, Carolina Barrie, Hamish Bowles, Frances Brody, Frederika Brookfield, Ellen Burnie, Nina Campbell, Alvin Chereskin, David Patrick Columbia, Arlene Dahl, Jimmy Douglas, Brooke Hayward Duchin, Peter Duchin, Dominick Dunne, Frank Duquette, Pamela Fiori, Paul Fortune, Dennis Freedman, Oberto Gili, Lucy Gilmour, Patty Graham, Louise Good, Arthur B. Greene, Timothy Greenfield-Sanders, Curtis Harrington, Kitty Hawks, David Hertz, Eliza Honey, Jessica Hundhausen, Tony Jazzar, Kazuko, Jay D. Kramer, Larry Lederman, Cary Leitzes, Philip Reeser, Douglas Little, Marguerite Littman, Martha Maristany, Charles Masson, Sarah Medford, Steven Meisel, Liza Minnelli, Adam Moss, Murray Moss, Victoria Munroe, Danny Murphy, Jeanne Newman, Leonora Pierotti, Mary Jane Pool, Roger Prigent, Miles Redd, Francie Rehwald, Nancy Richardson, William Rieder, Dodie Rosekrans, Margaret Russell, Bernard Scharf, Babs Simpson, Liz Smith, Dian Spence, Terry and Dennis Stanfill, Leonard Stanley, Patty Stevenson, Richard David Story, Anna Sui, Gustave Tassell, Glyn Vincent, Stellene Volandes, Nicholas Vreeland, Stephanie Warner, Kelly Wearstler, Andrew Wiley, and Bruce Weber.

And as ever, to my sister Tonne, and my entire family, who always see everything first.

HUTTON WILKINSONS

For thirty years, while my wife and I were growing up under the Duquettes' wings, we would thank them constantly for all the fun, all the glamour, and for just letting us be part of their daily lives. Today I want to thank Tony and Elizabeth yet again, for their artistic genius and individual tastes, their boundless creativity and joi de vivre, which have given us reason to celebrate them through this book. Ruth and I shared thirty years of glorious living, working, and traveling with the Duquettes and their friends. For this and all the amusing and exciting experiences, I thank them with all my heart.

I want to thank my coauthor, Wendy Goodman, for hanging in there for ten years while we both cast our spells to attract a publisher, at last conjuring up Abrams, which of course couldn't have been better! Throughout this long and drawn out ordeal Wendy has always been professional, understanding, tough, loving, and, most of all, a true friend. I think we are both glad that this is over, but I know we would both do it again together in a heartbeat. This book has truly been an adventure of discovery, a labor of love, and a test of our long friendship, which neither of us had any doubt would sail through with flying colors.

For their insight and contributions to the book I want to thank Princess Ghislaine De Polignac, Dominick Dunne, Margarit Littman, Bill Reider, Liza Minnelli, Jonathan Becker, Steven Meisel, Charles White, Judith Regan, Dodie Rosekrans, Oberto Gili, Liza Minnelli, Charles Meir, Arlene Dahl, Pat and Michael York, Gustave Tassell, Nion McEvoy, James Chen, William Gray Harris, Peter and Brooke Hayward Duchin, Tim Street-Porter, Frances Brody, Patricia Hastings Graham, Betsy Bloomingdale, and Irving Blum.

I could not have devoted as much time to this book had it not been for the invaluable assistance of my trusted friends and associates Flory Vargas, Jorge Vargas, Fred Iberri, Jee Young Kim, Sandra Graham, Mark Haldeman, Elliot Kristal, Martin Kristal, Douglas Little, and Joe McCormack, who made it easy for me to get the job done.

I want to thank my family and family of friends for their loving support in helping to make this book a reality: Ruth Wilkinson, Argyle Wilkinson, Elvira and Jim Blanchard, Travis Crilly, Sid and

Virginia Drasnin, Renee Entel, Kevin Geer, Charlotte Jackson, Dennis and Terry Stanfill, Travis and Pablo Zubiate, Bryce T. Zubiate, Hutton T. Zubiate, and my parents, Marshall and Elvira Wilkinson, who helped Tony tremendously on many of his projects and would be so pleased to see them illustrated here.

Without the interest, enthusiasm, and support of our friends and patrons who helped me and Tony over the years there would have been so much less to photograph, so much less to write about, and so much less to inspire us in creating this book. I want to thank Herb and Lani Alpert, Bill and Peggy Moffat, Rucky and Leslie Barclay, Chris and Susie Weld, Norm and Susan Barker, Angie Barrett, Carolina Barrie, Vera Bland, Philip and Jamie Bowles, Bob and Michelle Bradway, Tom Britt, Patricia Brown, Sister Mary Joseph of the Trinity, Tom and Maureen Carney, Bill Claxton and Peggy Moffet, David Copley, Missy Crahan, Ken and Patty Crews, Peggy Dark, Nancy De Herrera, Beth De Woody, Jane Del Amo, Jimmy Douglas, Roderick Coop, Robert and Lynn Ducommun, Robert Dyer, James Galanos, Harvey and Gail Glasser, Louise Good, Jeremiah Goodman, Nancy Hamon, Curtis Harrington, Judith Harris, Peter Iacono, Val and Terry Magro, George and Shirley Jagels, Albert Jagels, Maggie Jagels, Judith Krantz, Tom and Travis Kranz, Manfred Kuhnert, Betsy Link, Boaz Mazor, Gary Hunter, Peter and Kacey McCoy, Nan Tucker McEvoy, Didi Mcnabb, Mark Mcnabb, Richard and Marcia Mishaan, Glorea Morgan, Mei Lee Ney, Bob Ray and Kathy Offenhauser, Jerry and Gail Oppenheimer, Bill and Debby Richards, Fred and Suzanne Rheinstein, Kathy Gheno, Ana Roth, Jinx Rowan and Frank Lobdell, Arthur and Ann Schneider, David and Leslie Schemel, Charles and Louise Silverberg, Nick and Amanda Stonnington, Tatiana Stonnington, Mathilda Stream, Mary Thoits, Tim Torrance, Marjorie Volk, Tom and Diane Vonderheide, Willem and Izette Vorster, Connie Wald, Lisa Hubbard, Shirle Westwater, Matthew White, Tom Schumacher, Ira Yeager, Immaculada De Hapsburgo, Dave and Sondra Ott, Steven Salny, Sheryl "Velvet" Lorence, Jenny Jones, Lisa Caravella, and Doug and Caroline Brown, all of whom contributed in many ways to the success of Tony's life and to the success of this book.

For fanning the flames and recognizing the importance of Tony's aesthetic as it applies to the twenty-first century, I want to thank Hamish Bowles, John Cantrell, Amy Fine Collins, Richard David Story, Stellene Volandes, Nick and Jennifer Smith Hale, Glenda Bailey, Marin Hopper, Robert Janjigian, Peter Jones, Peter Haldeman, Shane McCoy, Lisa Eisner, Sarah Medford, Lynn Morgan, Bobbi Queen, Serge and Tatiana Sorokko, Andre Leon Talley, Pamela Fiori, Heather Severs, Anna Wintour, Kevin West, Talya Cousins, Jamie Rosen, David Patrick Columbia, Brooke Magnaghi, Grazia D'Annunzio, Luisana Mendoza, Mary Shanahan, Sally Singer, Stephanie La Cava, Dominique Browning, Burl Stiff, Oscar De La Renta, Badgley Mischka, Andrew Gn, John Galliano, Victoire De Castelane, Tom Ford, Richard Buckley, Susan McFadden, Glynnis Costin, Holly Moore, Mike Cannon, Shaun Melvin, Rachel Kohler, Randall Battinkoff, Christopher Berg, Jason Stein, Wilkes Bashford, Ken Downing, Dawn Mello, Vicki Haupt, Kelly Bensimone, Sandra Stephens, Nina Garcia, Paige Rense, Ann Slowey, and Joyce Macrae, all of whom have been instrumental in the successful continuation of Tony's legend and the making of this book.

I want to thank the following, without whose expertise we would never have succeeded in getting this book produced or launched: Eric Himmel, Andrea Colvin, E.Y. Lee, Katrina Weidknecht, Meghan Phillips, Jim Gold, Mallory Andrews, David Hoey, Nicholas Manville, Sydney Price, Abby Huhtanen, Linda Fargo, Chad Holman, Mai N. Vejjajiva, Doug Moss, Sylvia Forsythe, Julie Greer, Larry Bruce, Keith Traxler, and Ron Frasch.

And to all of those who helped on this book directly or indirectly whom I have omitted inadvertently, I apologize profusely and, along with Tony and Beegle, thank you from the bottom of my heart!

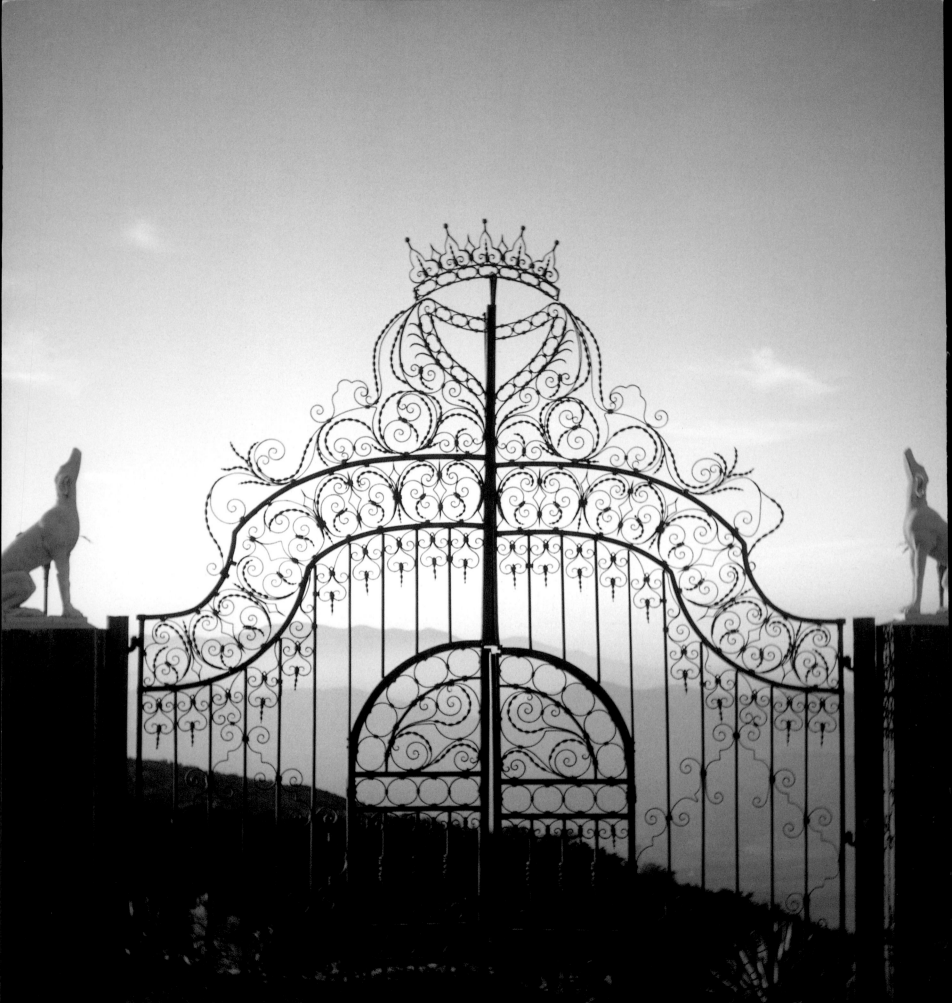

THE AUTHORS

DEDICATE THIS BOOK TO FERNANDO BENGOECHEA

Published in 2007 by Abrams, New York
An imprint of Harry N. Abrams, Inc.

Library of Congress number:
Library of Congress Cataloging-In-Publication Data:

Duquette, Tony 1914–1999
Written by Wendy Goodman and Hutton Wilkinson,
Foreword by Dominick Dunne,

ISBN 13: 978-0-8109-9437-9
ISBN 10: 0-8109-9437-2
1. Interior decorating—psychological aspects, mystic, universal.
2. Set and stage design. 3. Costume design.

Edited by Eva Prinz with Sofia Gutierrez
Designed by E. Y. Lee with Andrew Prinz
Production director Anet Sirna-Bruder with Jacquie Poirer

The text of this book was composed in Didot.

Printed and bound in China
10 9 8 7 6 5 4 3 2 1

HNA ▌▌▌▌▌
harry n. abrams, inc.
a subsidiary of La Martinière Groupe
115 West 18th street
New York, NY 10011
www.hnabooks.com